PLATE 2. Cap Shapes

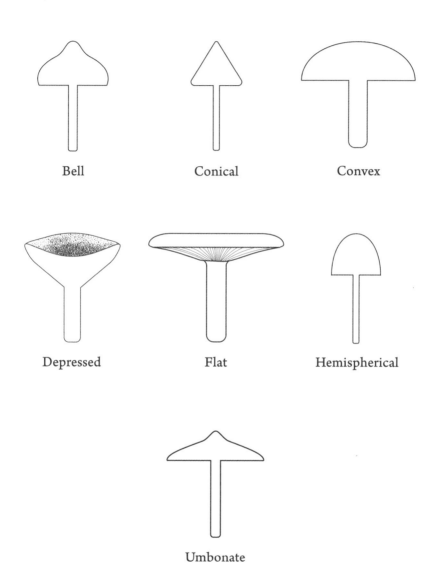

A Field Guide to the Mushrooms of Georgia

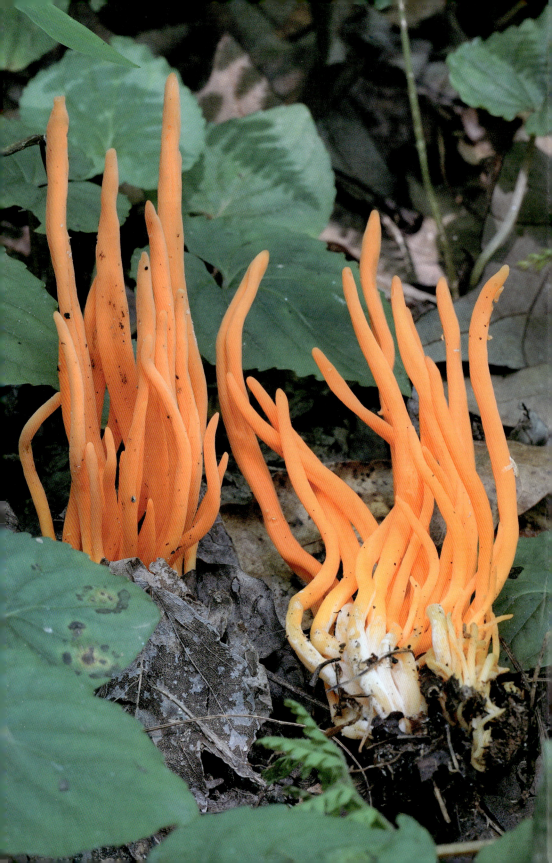

A Field Guide to the Mushrooms of Georgia

ALAN E. BESSETTE
ARLEEN R. BESSETTE
MICHAEL W. HOPPING

The University of Georgia Press
ATHENS

A Wormsloe
FOUNDATION
nature book

PUBLISHER'S NOTICE
Although this book includes information regarding the edibility of various mushrooms, it is not intended to function as a manual for the safe consumption of wild mushrooms. Readers interested in consuming wild fungi should consult other sources of information, especially experienced mycophagists, mycologists, or literary sources, before eating any wild mushroom. Neither the authors nor the publisher are responsible for any misidentifications, adverse reactions, or allergic responses that may occur with the consumption of wild mushrooms.

© 2023 by the University of Georgia Press
Athens, Georgia 30602
www.ugapress.org
All rights reserved

Designed by Lindsay Starr
Set in Arno, Gotham, and Sentinel
Printed and bound by Versa Press

The paper in this book meets the guidelines for permanence and durability of the Committee on Production Guidelines for Book Longevity of the Council on Library Resources.

Most University of Georgia Press titles are available from popular e-book vendors.

Printed in the United States of America
27 26 25 24 23 P 5 4 3 2 1

LIBRARY OF CONGRESS
CATALOGING-IN-PUBLICATION DATA

Names: Bessette, Alan E., author. |
 Bessette, Arleen R., author. |
 Hopping, Michael, 1952– author.
Title: A field guide to the mushrooms of
 Georgia / Alan E. Bessette, Arleen R. Bessette,
 Michael W. Hopping.
Description: Athens : The University of Georgia
 Press, [2023] | Series: Wormsloe Foundation
 nature books | Includes bibliographical
 references and index.
Identifiers: LCCN 2023000450 |
 ISBN 9780820362694 (paperback)
Subjects: LCSH: Mushrooms—Georgia—
 Identification. | Mycology—Georgia.
Classification: LCC QK605.5.G46 B47 2023 |
 DDC 579.609758—dc23/eng/20230126
LC record available at https://lccn.loc.gov
 /2023000450

Frontispiece: *Turbinellus floccosus*

CONTENTS

vii ACKNOWLEDGMENTS

1 INTRODUCTION
Kingdom Fungi • 1
Mushroom Hunting • 2
Can You Eat It? • 3
Mushroom Identification • 4
The Shifting Names of Mushrooms • 9
Finding Your Way Around in the Book • 10

12 COLOR KEY TO THE MAJOR GROUPS OF FUNGI

60 SPECIES DESCRIPTIONS & ILLUSTRATIONS
Bird's-Nest Fungi and the Sphere Thrower • 61
Boletes • 64
Carbon Fungi • 148
Chanterelles and Similar Fungi • 158
Corals and Cauliflowers • 169
Cordyceps and Similar Fungi • 183
Crust, Cushion, and Parchment Fungi • 188
Cup Fungi • 207
Earth Tongues and Club Fungi • 219
Fiber Fans • 228
Gilled Mushrooms • 230

Hypomyces and Other Parasitic Fungi • 459

Jelly Fungi • 465

Morels, False Morels, and Similar Fungi • 478

Other Plant Pathogens • 485

Polypores • 492

Puffballs, Earthballs, Earthstars, and Similar Fungi • 560

Split Gill and Crimped Gill • 587

Stinkhorns • 590

Tooth Fungi • 597

Truffles and Other Hypogeous Fungi • 616

623 GLOSSARY
631 REFERENCES AND RESOURCES
637 IMAGE CREDITS
639 INDEX TO COMMON NAMES
645 INDEX TO SCIENTIFIC NAMES
661 INFORMATION ABOUT THE AUTHORS

ACKNOWLEDGMENTS

As with all our books, we are grateful to those friends and colleagues who contributed their knowledge and individual talents to make *A Field Guide to the Mushrooms of Georgia* possible. We could not have asked for a better mycological team.

Anthoni Goodman created the illustrative black-and-white line drawings.

The following individuals generously provided their beautiful color photographs: Geoff Balme, Giff Beaton, Jason Bolin, James Craine, Rosanne Healy, Joan Knapp, David Lewis, Jared McRae, Curtis Peyer, Sarah Prentice, David Raney, Bill Roody, Bill Sheehan, Dianna Smith, Joseph and Frances Smith, Matthew Smith, Luke Smithson, Walt Sturgeon, Huafang Su, David Tate, Phillip Thompson, and David Wasilewski.

Karl Knudsen, Anna McHue, Devin Merkle, Mark Schoeman, and Tanith Tyrr were kind and trusting enough to take us to their collecting sites, which allowed us to discover and photograph a number of species contained in this work.

Our understanding of various species identifications was expanded and clarified by both discussion and consultation with and/or the fieldwork of Giff Beaton, Arian Farid, Django Grootmyers, Jacob Kalichman, Renée Lebeuf, Brandon Matheny, Donna Mitchell, Chance Noffsinger, Barrie Overton, Ron Petersen, Bill Roody, Bill Sheehan, and Rachel Swenie.

Sarah Prentice of the University of Florida Marston Science Library, Gainesville, Florida, again performed her magic of traveling through cyberspace—back through time and across continents—to obtain much of the resource materials we needed for this work.

We are grateful to all the staff of the Crooked River State Park in St. Marys, Georgia, and especially wish to thank park manager Jessica Aldridge and interpretive rangers Cate Ruka Williams and Tracy Worsham. They graciously allowed us to conduct research and photograph specimens in the park, making it our mycological home for over a decade.

Finally, this book would not have been possible without the support of executive editor Mick Gusinde-Duffy, acquisitions editor Patrick Allen, and the staff of the University of Georgia Press.

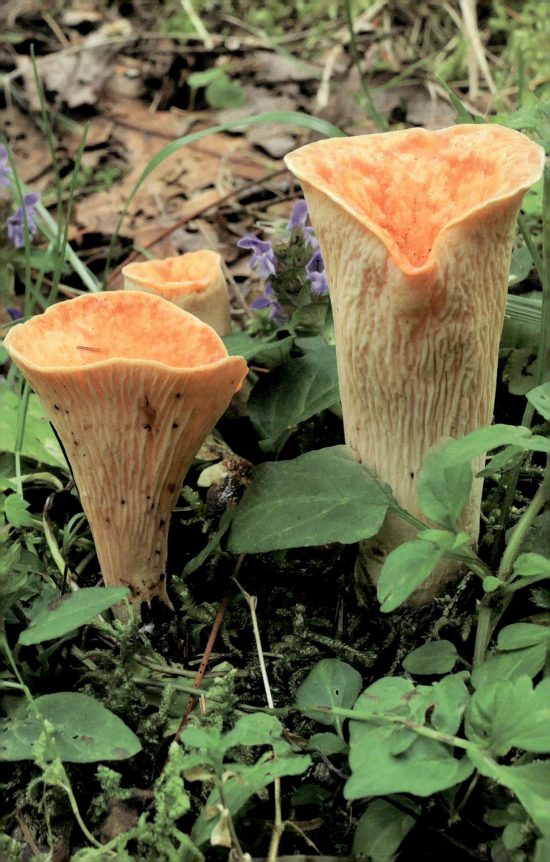

A Field Guide to the Mushrooms of Georgia

Introduction

Welcome to the world of mushrooms. If this is your first excursion into it, or maybe even if it isn't, take a few minutes to get oriented. Many of us arrive loaded down with misconceptions about mushrooms and fungi in general. We'll start by correcting some of those misconceptions and offering a glimpse of the vital roles fungi play in the environment.

Field guides may be pretty, and we hope you find ours attractive, but they are primarily intended to function as tools. You've seen wild mushrooms and wondered what kind they are. We'll explain how to apply your curiosity in a manner that allows you to observe them more clearly and discover answers to your questions.

Kingdom Fungi

Don't feel bad if you've been under the mistaken impression that mushrooms are oddball plants minus the chlorophyll. Until about 50 years ago scientists thought so too. There are superficial similarities. Mushrooms, like cabbages, are fixed in place where they grow. The body plans appear to be similar: a seed or spore-producing structure aboveground, roots below. But looks are deceiving.

The "roots" connected to a mushroom are actually the enduring body or **mycelium** of the fungal creature. Extracted intact from its **substrate**, soil, or other source of nourishment and suitably magnified, a mycelium looks like a decentralized network of interconnected threads called **hyphae**. Laid end to end, those hyphae would likely stretch on for miles. Although mycelia pass most of their lives anonymously and out of sight, those lives can be very long. The United States Department of Agriculture estimates the age of one mycelium in the Pacific Northwest at thousands of years. It eats Douglas Firs, has a subterranean footprint approaching 4 square miles, and weighs between 7,567 and 35,000 tons. It might be the largest single organism on the planet. Each fall it produces a crop of mushrooms with cap diameters seldom exceeding 10 cm.

Mushrooms or **fruit bodies** are the reproductive organs of a mycelium, and they are tasked with the manufacture and release of spores. Job done, most mushrooms rot. Not all fungi use them to reproduce (think yeasts), but those that do employ a kaleidoscopic variety of species-specific designs. They've had plenty of time to innovate. Fossil evidence of today's mushroom producers, the Ascomycetes and Basidiomycetes, dates back to 400 million and 340 million years ago, respectively.

When not reproducing, mycelia have to make a living. They are powered by sugar, the cellular equivalent of gasoline. Plants manufacture their own. Animals and fungi must import it. A fungus might accomplish this by recycling organic matter. Those that do are known as **saprobes** or **saprotrophs**. Supermarket agarics and shiitakes are familiar examples of mushrooms produced by saprobic fungi. Without them and myriad other species of fungal trash collectors, there'd be no restful walks in the woods;

we'd be clambering over the remains of trees slowly compressing into beds of coal. **Parasites**, such as the Douglas Fir eater, steal their sugar from unwilling hosts that may sicken or die from the attack. Mycelia with a more communitarian attitude choose instead to form mutually beneficial **mycorrhizal partnerships** with the roots of sugar producers. Mycorrhizal relationships are the rule, not the exception, for higher plants. Most trees enter into them, often with mushroom-producing fungi. Grasses and herbaceous plants partner with species that don't make mushrooms. In return for sugars, plants receive extra water and supplies of plant-available minerals from partnering mycelia. Trees connected together in mycorrhizal networks have also been shown to use the mycelia as living conduits to share sugar and information among themselves. Absent fungi, life on land would be a very different experience.

Mushroom Hunting

As a general proposition, mushrooms are scarce during droughts and appear in greatest number a few days after soaking rains. But fungi aren't great respecters of simplistic rules handed down by humans. Jelly fungi can be at their best while the woods are still dripping. Chicken of the Woods, which fruits on logs, stumps, and standing trees, might hold off until a week or more into a dry spell.

Mushroom species vary in their preferences for temperature and season. A few don't mind showing up during balmy spells of the Rabun County wintertime. Chanterelles opt for the height of summer. Morels fruit in spring. Blewits typically choose the shortening days and chilly nights of autumn.

If a particular species interests you, read up on its habitat requirements. Is it a creature of grasslands or woods? Under pines or oaks? Saprobes, parasites, and mycorrhizal species occur in association with their food source. For purposes of identification, the difference between species may come down to a question of whether a species flushes on conifer or deciduous wood.

Equipment needs for mushroom hunting are pretty basic. Bring a basket to transport your finds. It's best to store each type of mushroom in its own paper or waxed paper bag. Avoid plastic bags; mushrooms rot quickly in them. Cross-contamination of edibles by poisonous species is a real issue, so at least keep the table fare separate from other types. A knife and a dedicated digging implement are useful. The knife allows you to cleanly remove a bracket from a tree or cut morel stalks at ground level, avoiding damage to the buried mycelium. When collecting for identification, though, a big spoon comes in handy for digging out the entire base of a soil-dwelling mushroom. It might include a basal sac or root-like extension that proves crucial to the diagnosis. A camera or notebook can record details you might need to remember. If you forage with friends, consider a communications system, perhaps loud whistles or walkie-talkies. Bottom line: think ahead and bring what you'll need to deal with expectable circumstances.

Can You Eat It?

People want simple dos and don'ts for mushroom edibility. Unfortunately, the only one to bet your life on is the logical equivalent of a Möbius strip: "Don't trust blanket statements." Apart from that, the closest to bulletproof might be: "If you don't eat it, it won't kill you." Mushroom toxins must be swallowed to do their damage. The deadliest of species can be touched and inspected with impunity. But people with immune systems compromised by a medical condition or treatment should also think twice about sniffing mushrooms. Although odor is a standard element of mushroom assessment, the spores of a few species are able to germinate and grow mycelia at human body temperature.

Caution is the watchword for wild mushroom cookery. Learn each edible species and its look-alikes individually. Be certain of your identifications, and double check them as best you're able before firing up the skillet. Don't assume that an edible rating in this or any other field guide guarantees edibility by you. As with any foodstuff, it is possible to react badly to a commonly eaten species. Cook your mushrooms. At least three factors are at play here. Cooking kills whatever else might have been living on or in your mushroom. Cooking ruptures the indigestible chitin tubules encasing the nutritious parts. And finally, some raw edibles are poisonous. Morels, for instance, contain small amounts of hydrazine, an organic toxin boiled off by cooking. (Cooking is not a panacea for the elimination of toxins. Sautéed Destroying Angels are still deadly. Arsenic, lead, and other heavy metals are unaffected as well.)

When trying a species for the first time, employ a standardized cooking procedure. Limit your ingredients to the mushroom, butter or a preferred cooking oil, and salt. Sauté a few slices of mushroom and refrigerate the uncooked remainder. When the mushroom in the skillet has given up its water or begins to brown, take it off the heat and try one slice. Because you're using the same cooking process for each new species, you're familiar with the flavors of your oil and salt. Whatever else you taste is mushroom. Evaluate the flavor and consistency. Is it an experience you'd care to repeat? Regardless of the answer, don't eat any more of it. Store the cooked leftovers in the fridge. If nothing untoward happens during the next 24–48 hours, you and that species are compatible. Eat away. But if gastrointestinal or other symptoms develop, the refrigerated uncooked mushrooms will be a big help to medical providers. Mushroom toxins vary between species and require different sorts of intervention.

The edibility status of each species in this book is denoted by one of four qualifiers: edible, inedible, poisonous, and unknown. Being edible is obvious, but an inedible classification is reserved for those mushrooms that are not worth the trouble of collecting or are unpalatable for a number of reasons but are not toxic. Poisonous is poisonous, while unknown is just that: we do not have enough information to either recommend or warn against eating them. Consuming mushrooms whose edibility is unknown is not recommended.

Mushroom Identification

Human vision is a curious thing. There is seeing, and then there's awareness of what's being seen. It's as if our minds were in the habit of showing us executive summaries, omitting what they consider to be unnecessary details. This shortcut often simplifies things in a helpful way, but it's detrimental when trying to identify mushrooms. Awareness of color, size, and the presence of a cap and stalk simply isn't enough to get you very far. You'll need to teach yourself to notice details. We convey most of them in plain English, but that isn't always possible. When you encounter an unfamiliar term, look it up in the glossary. Terms with applications limited to one category of mushrooms may also be defined in the header for that group.

Take an organized approach to mushroom assessment. What are the major parts? How would you describe the features of each? Where was the mushroom found? Growing on what? Near what trees, if any? In what ecological setting? Photographs taken prior to collection and/or depicting essential features create a permanent record of detail you might have forgotten or failed to notice. Microscopes access a level of detail closed to many of us but one that might be required to separate species. Chemical testing is another useful toolset. Anyone can obtain three of the most important test substances. If you do nothing else, invest in a metric ruler and a magnifier. A 10× loupe works well and can be worn on a lanyard around your neck in the field.

Remember that mushrooms and other fungal fruit bodies are reproductive organs. Somewhere on or in the mushroom will be **fertile surfaces** where millions of cells are specialized to generate spores. Other parts of the fruit body support that function and take remarkably different but characteristic forms. Classical mycology divides mushrooms into major categories based on these factors. Let's overview the fundamentals.

FERTILE SURFACES. Gilled mushrooms deploy their spore-producing cells on the sides, or **faces**, of gills. Boletes and polypores typically have a layer of **tubes with pores** instead of gills on the underside of their caps. Spores are manufactured on the inner lining of the tubes and escape by falling through the pores. Tooth mushrooms have fertile surfaces on the icicle-like **teeth** where gills or a pore surface might otherwise have been located. Chanterelles have low, gill-like ridges. The fertile surfaces of puffballs, truffles, and similar species are visible, at least when spores mature, as a **spore mass** contained within an outer shell or rind. Stinkhorns slather their foul-smelling, greenish brown spore mass in plain sight. The location of fertile surfaces on corals, crusts, jellies, and several other types of fruit bodies aren't so obvious, but you'll soon get to know them.

SUPPORT STRUCTURE. The parts of a mushroom other than its fertile surface can be thought of as a support structure. This might consist of a rind, cup, amorphous blob, or branched coral, to name a few. But

most often there's a cap with or without a stalk. Whatever the details, pay attention to them. Some gilled mushrooms and boletes shield their immature fertile surfaces from below with a temporary protective barrier, the **partial veil**. This radial sheet of tissue, connecting the stalk to the outer margin of the cap, may be a solid membrane (**membranous**), cobwebby (**cortina**), **fibrous**, or so fragile that it disappears as soon as the cap opens (**evanescent**). Partial veils are not to be confused with a **universal veil**, the membranous "eggshell" from which Amanitas, stinkhorns, and some other species "hatch." After hatching, any sac or pieces of universal veil left at the base are known as a **volva**. Pieces of universal veil adhering to the top of the cap may be **powders**, **warts**, **patches**, or **slime**, depending on the size and consistency of remnants.

In addition to mushroom shapes and dimensions, notice surface textures, colors, and other features. Mushroom caps often change color as they mature and are somewhat variable anyway. Cap color might fade markedly with loss of moisture; this is termed **hygrophanous**. Caps may be dry, damp, sticky, or slimy. Capless stalks, rinds, cups, and other features have their own sets of characteristics. Additional diagnostic clues reside in the **odor** and **taste** of a raw mushroom. Not all smells and tastes have commonly understood names; **farinaceous** indicates an odor or taste described as mealy, cucumbery, or like watermelon rind. If you choose to taste a mushroom, be aware that some are **acrid** (unpleasantly burning) or peppery and might irritate your mouth if chewed for too long. To safely taste an unknown mushroom, take a small bite, chew it toward the front of your mouth for a few seconds, then spit it out and assess the taste. If it is not acrid or peppery hot, take another small bite, chew it for 15–30 seconds, then spit it out. Acrid or bitter tastes may be slow to develop. *Remember that some mushrooms are deadly poisonous. Do not swallow any of the mushroom tissue!* Rinsing your mouth with water is a good practice after taste testing an unknown mushroom.

SPORE PRINTS. When working to identify gilled mushrooms and occasionally others, you'll need to know the color of the spores. Don't assume that spore color will be similar to gill color or that of a pore surface. The initially pale bluish gray gills of *Entoloma serrulatum* drop pink spores. Those of the poisonous and orange-gilled Jack O'Lantern are white.

Sometimes individual fruit bodies or clumps of mushrooms help out by dropping spores on the cap of shorter mushrooms they overlap or on surrounding wood, decaying leaves, or vegetation, producing a naturally occurring spore deposit. When that's not the case, take the time to make your own spore print. The idea is to create heaps of spores visible to the naked eye. Simple methods are often best. Cut the cap from a healthy, mature mushroom. Lay it, fertile surface side down, on a piece of white paper and place an inverted cup or bowl on top to prevent the cap from drying, which would inhibit spore deposition. Walk away. A few hours later or the

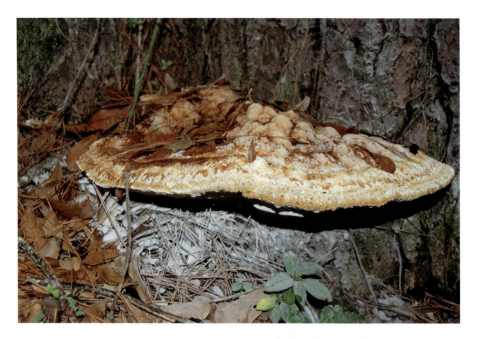

Naturally Occurring Spore Deposit

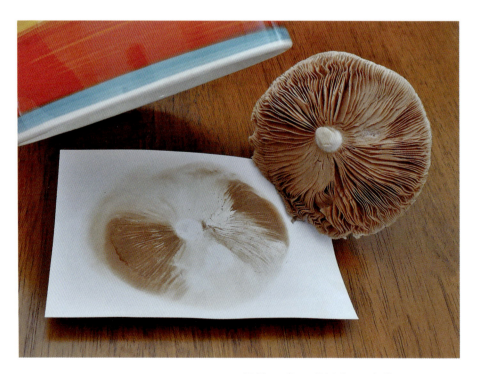

Making a Spore Print (example 1)

next morning, remove the humidity dome and lift the mushroom cap to see what you've got. If all you see is white, the spore print could be white. Hold your paper at a steep angle to a lamp or other point source of light and inspect the paper surface for shadows cast by the spore equivalent of white sand dunes. (Alternatively, when white spores are a possibility, you could do the spore print on black paper, clear glass, a mirror, or aluminum foil. White spores show up well on these surfaces.)

Spore print success with a wet or juicy mushroom entails keeping the fertile surface out of direct contact with the paper. One way to do this is to cut a stalk-sized hole in a 3 × 5 card. Insert the mushroom so that the cap is a quarter inch or so above the card. Set this arrangement over the mouth of a glass or jar with a rim small enough to support the card but deep enough to suspend the stalk.

Another helpful hint: except for mushrooms with liquefying gills, spore prints are dry. Juice prints occur from time to time, but they tell you nothing about spore color.

HABITAT AND ECOLOGICAL NICHE. Mycelia, like animals and plants, have habitat and dietary preferences. Those with a mycorrhizal lifestyle will be found in the vicinity of their woody plant partners. *Suillus spraguei* relates exclusively to Eastern White Pine and won't appear elsewhere. Other species are less finicky, but even these tend to associate with either deciduous or conifer trees, not both. The same deciduous vs. conifer divide frequently exists between species of wood-digesting saprobes. Recyclers that appear on logs typically belong to species different from those found on sticks. Leaf recycling is another specialty, as is grass thatch. The better your mental, photographic, or written notes on the living circumstances of an unknown mushroom, the greater the chance for a reliable identification.

MICROSCOPIC FEATURES. With so many mushrooms out there, it's inevitable that some look too much alike to distinguish on the basis of form or habitat preference. Microscopy comes into its own here. Every

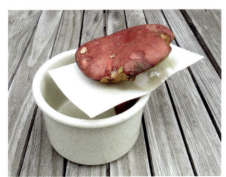
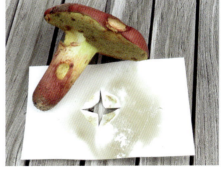

Making a Spore Print (example 2)

species makes spores of a characteristic color, size, shape, and texture. The observable difference between species might be limited to a few thousandths of a millimeter (microns, or **μm**) in spore length.

Fertile surfaces vary in layout design and the types of cells found there. The two basic divisions of mushroom producers have distinctive spore-generating cells. In **basidiomycetes**, such as gilled mushrooms and boletes, this fertile cell is known as a **basidium**. Basidia are chunky to elongated cells attached at one end to the underlying support structure. The other end, usually open to the air, is crowned by two or four little points. Each of these anchors a developing spore that will eventually break free and fall off. In **ascomycetes**, the division containing morels and cup fungi, fertile cells are called **asci** and look like spore-filled sacks or Roman candle tubes. Most contain eight spores, which are ejected under pressure when mature. In both Basidiomycetes and Ascomycetes, the fertile cells are commonly surrounded and supported by tubular sterile cells. In gilled mushrooms the general term for these is **cystidia**. In cup fungi they are **paraphyses**. Polypores often have **setae**. When we need to delve into this, the header section for that group of mushrooms will include an explanation.

MACROCHEMICAL TESTS. Certain mushrooms develop useful color reactions to contact with special chemicals. We'll focus on three readily available solutions: ammonium hydroxide (household ammonia, **NH_4OH**), dilute potassium hydroxide (**KOH**), and a ferrous sulfate (**$FeSO_4$**)

solution. An ounce or two of each can safely be stored in small plastic squeeze bottles. Carry these and a supply of cotton swabs in a sealed plastic container to mitigate spills.

Macrochemical information supplied in a species description indicates what part of the mushroom is being tested and the color change or changes observed at that site. For example, if the cap of a bolete is said to produce a green flash and then stain dull orange-red with NH_4OH, this means that a succession of changes occurs when the cap surface is moistened with a swab application of ammonia. Green appears first but, within a second or two, transitions to a longer-lasting shade of orange. Reactions of the mushroom flesh or pore surface often differ from those of the cap.

Conduct your tests on a wedge or section of tissue removed from the mushroom. Wet a fresh cotton swab with a solution and drag it across the test surface. When results from all three solutions are desired, get into the habit of drawing the same sequence of stripes on the test surface (e.g., the one on the left is NH_4OH). The mushroom you're testing should be healthy and as fresh as possible. Age, refrigeration, and dehydration can alter test results.

A word about **Melzer's reagent**. Melzer's is a critically important solution in mycology, typically used to test spores. Those that turn bluish gray or bluish black in Melzer's have an **amyloid** response. If they turn reddish brown, the spores are **dextrinoid**. No color change is an **inamyloid** response. Melzer's reagent is difficult for the average person to obtain. Although it is an iodine compound, another

ingredient is chloral hydrate, a federally controlled substance. That said, we do include Melzer's reagent information on spores.

Ammonium Hydroxide (NH4OH): Plain household ammonia without added scents, soaps, etc. In addition to its usefulness in macrochemical testing, ammonia has applications in microscopic work. It is a good mounting medium for dried mushrooms that have been rehydrated in a 70%–95% solution of ethyl alcohol (140–190-proof clear liquor).

Potassium Hydroxide (KOH): 5%–14% solution in distilled water. KOH is another mounting medium for microscopy with fresh or dried specimens. Water is a fine mounting medium for spores, but the colors reported in the mycological literature are often assessed in KOH. *KOH causes chemical burns. If you get any on you or your clothes, wash it off immediately.* KOH slowly corrodes glass as well, which is why it should be kept in a sturdy plastic bottle.

Iron Salts (FeSO4): 10% solution, by weight, of crystalline ferrous sulfate in distilled water. This solution starts out green but oxidizes to rust brown and loses potency within a month or two. Mix only as much as you'll need for that period of time.

The Shifting Names of Mushrooms

Prior to the middle of the 18th century, the names of mushrooms and other life forms depended solely on local language and custom. A chanterelle in Georgia is still a German's Pfifferling. Needless to say, this variability impedes scientific study.

Swedish botanist Carl Linnaeus set the taxonomic house in order for scientific purposes by devising a system of fixed **binomial Latin names.** The first term, or **genus,** denotes a group of closely related organisms. It is followed by a **species epithet** identifying a member of that group. The first letter of a genus is capitalized; the first letter of a species epithet is lowercased: *Entoloma serrulatum.* If physically distinct variations of a species are known, genus and species may be followed by a lowercase identifier of the **variety**: *Humidicutis marginata* var. *marginata.*

Building on this foundation, scientists set about constructing a grand tree of life to show the relationships between living things. Trees are remodeled as needed to account for new information, such as the fact that fungi differ so profoundly from both plants and animals that they deserve their own taxonomic kingdom. Scientific names for species also change as new relationships emerge.

The tree-remodeling process proceeded at a leisurely pace until it became possible to read and compare genetic sequences. Molecular studies sometimes revealed unexpected kinships. Other species concepts fragmented. The Golden Chanterelle, formerly known in the United States as *Cantharellus cibarius,* turned out to be a cluster of species. None of the three or four that might occur in the Southeast got to keep the name *Cantharellus cibarius.*

Today, molecular mycology is revolutionizing fungal taxonomy at a dizzying

pace. Last year's *Boletus frostii* became last week's *Exsudoporus frostii* and yesterday's *Butyriboletus frostii* and has now been returned to *Exsudoporus frostii*. How are everyday mushroom hunters to cope? Learn whatever name is in vogue when you are introduced to a new species. Try not to stress too much about earlier names and those that may follow. Don't expect uniformity of scientific names in different field guides. Many of them, including ours, will list recently used names as synonyms of the current one.

Finding Your Way Around in the Book

It is important that you understand how to use this book. Field guides adopt various approaches to these tasks. Here, we present a stepwise strategy that anyone can operate with success.

IDENTIFICATION KEYS. The first identification step is to use the self-explanatory Color Key to determine the major group to which your unknown species belongs: gilled mushrooms, polypores, cup fungi, etc. When you've decided on the major group, flip to the page where coverage of it begins.

If the major group is large or very large, as with boletes, gilled mushrooms, or polypores, we divide it into more manageable sections with question-and-answer keys. Each numbered question consists of a **couplet** or pair of alternative statements.

Beginning with the first, you're to choose the alternative that fits your unknown mushroom. Read the couplet carefully, attending to the difference between statements requiring a perfect fit with several attributes and those permitting partial agreement or providing a range of choices. Be alert to the meaning of qualifiers as well. "Usually," for example, doesn't mean "always." When you decide which half of the couplet fits your mushroom, take the step indicated by that choice. Only answer couplets as directed by your previous response, skipping all others. Eventually, you will come to a point where you are given one or more species as possible candidates for your mushroom.

The final step is to assess your unknown against the written descriptions of candidate species. When both the photo and description match your mushroom, you've got an identification. But remember, that won't always happen. We don't cover every species of mushroom known from Georgia. Some without full descriptions are mentioned in the Comments section for a similar species and might also be illustrated in the Color Key.

The more you use a key, the easier it gets and the more success you will have arriving at a satisfactory identification. If you find yourself unsure of which choice to select, choose the one that seems best while noting on a piece of paper the couplet number where you were stymied. That way, if you reach a dead end, you can return to that couplet and try the alternative choice. Another useful and fun tip to become

familiar with using keys such as those included in this book is to take a mushroom that you know, find it as an "answer" in the key, and then follow the choices backward to the beginning. This will sharpen your observational skills, increase your comfort level with terminology used, and help you to better understand the process when you try it with an unknown in hand.

SPECIES DESCRIPTIONS. Species descriptions are presented in a standardized format.

Scientific Name and Author(s): This is or was the currently accepted scientific name for the species. It is accompanied by the name of the author(s) responsible for it. By convention, many of these authors' names are abbreviated. A name or abbreviation appearing in parentheses tells us who first named the species. Subsequent names are of mycologists who modified that original name.

Synonyms: The equal sign (=) indicates a former or alternative scientific name.

Common Name: One or more common names are listed, if they exist.

Macroscopic Features: A detailed description of the mushroom's physical features.

Microscopic Features: Basic information on spore shape, size, and surface texture, sometimes augmented with microscopic details about other cellular structures.

Spore Print: Spore color as seen by the eye in sunlight.

Habit, Habitat, and Season: Information about lifestyle, habitat, and seasonal fruiting patterns.

Edibility: Based on past reports, if any. *These do not guarantee edibility for any particular person.* Normally edible species might also be rendered poisonous by environmental contamination. Morels found in old apple orchards are liable to contain high levels of lead or arsenic due to pesticides sprayed decades ago. Mushrooms found along busy roads can also be laced with lead. Mushrooms growing in golf courses, tree farms, and other chemically treated areas are best avoided as well.

Comments: This section may include an explanation of the species epithet, thumbnail descriptions of look-alike species, and other interesting facts about the mushroom.

Color Key to the Major Groups of Fungi

Bird's-Nest Fungi and the Sphere Thrower (p. 61)

Bird's-nest fungi are small cone- to vase-shaped or barrel-like fruit bodies that contain numerous tiny egg-like sacs of spores called peridioles. They grow on wood chips, mulch, branches, leaves, dung, and other organic matter. The Sphere Thrower, *Sphaerobolus stellatus*, is very small, up to 3 mm wide. It has a puffball-like peridium that splits open when mature to form a miniature, star-shaped structure surrounding a single, tiny round peridiole. When light and moisture conditions are correct the peridiole is forcibly thrown up to 10 feet away. Like the bird's nests, it grows on woody substrates, dung, and other decaying matter.

Crucibulum laeve (p. 62)

Cyathus striatus (p. 62)

Boletes (p. 64)

Boletes are fleshy mushrooms with a cap, a stalk, and a sponge-like undersurface composed of vertically arranged tubes, each of which terminates in an opening called a pore. The tube layer is often easy to separate from the cap tissue. Boletes typically grow on the ground and form mycorrhizal relationships with trees.

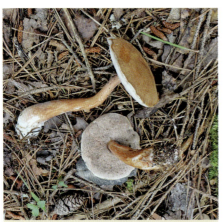

Austroboletus gracilis (p. 75)

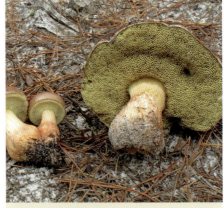

Boletus abruptibulbus (p. 73)

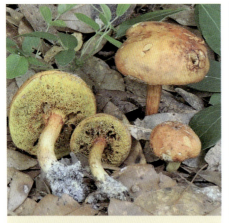

Boletus ochraceoluteus (p. 79)

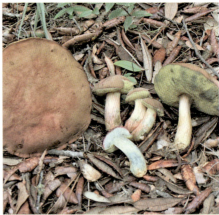

Boletus patrioticus (p. 81)

COLOR KEY TO THE MAJOR GROUPS OF FUNGI

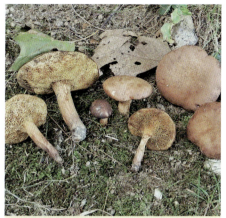
Bothia castanella (p. 128)

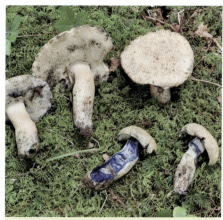
Gyroporus cyanescens (p. 99)

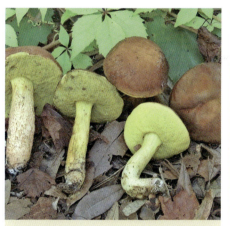
Hemileccinum rubropunctum (p. 109)

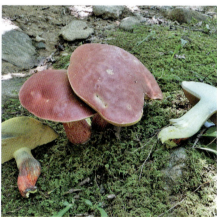
Lanmaoa pallidorosea (p. 76)

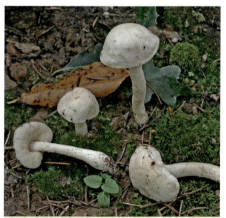
Leccinum albellum (p. 111)

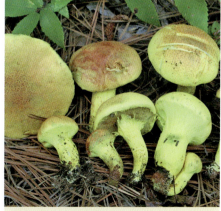
Pulveroboletus ravenelii (p. 70)

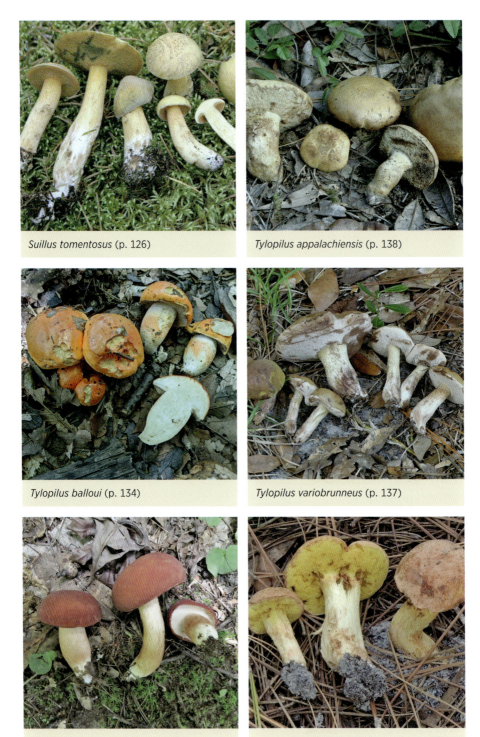

Suillus tomentosus (p. 126)

Tylopilus appalachiensis (p. 138)

Tylopilus balloui (p. 134)

Tylopilus variobrunneus (p. 137)

Xanthoconium purpureum (p. 145)

Xerocomus illudens/tenax group (p. 147)

Carbon Fungi (p. 148)

Fruit bodies of carbon fungi are hard, black, cinder-like, and variously shaped. Some are flat and spreading; others are erect, cylindric to club-shaped or antler-like. The fertile surface is roughened like sandpaper (use a hand lens) due to the presence of partially submerged clusters (perithecia) of spore-producing cells. These species grow on living or decayed wood, leaves, nuts, cones, or fruit.

Chanterelles and Similar Fungi (p. 158)

Fruit bodies typically with a cap and stalk, sometimes funnel-shaped. Undersurface of the cap with blunt, gill-like ridges that are often forked and crossveined or nearly smooth. They usually grow on the ground.

Camarops petersii (p. 150)

Cantharellus cinnabarinus (p. 160)

Xylaria hypoxylon (p. 157)

Craterellus odoratus (p. 162)

Corals and Cauliflowers (p. 169)

Fruit bodies in this group are of three types: bundles of simple, erect, worm-like branches often fused at their bases; or erect, coral-like, repeatedly forking branches; or a rounded, lettuce-like or cauliflower-like cluster of flattened branches attached to a partially buried stalk-like base. Most members of this group grow on the ground, sometimes at the base of trees. A few grow on wood.

Clavulinopsis aurantiocinnabarina (p. 171)

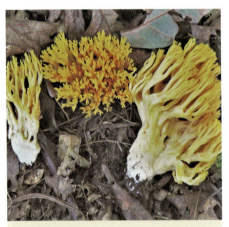

Ramaria aurea group (p. 178)

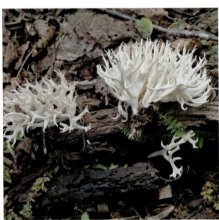

Scytinopogon angulisporus (p. 177)

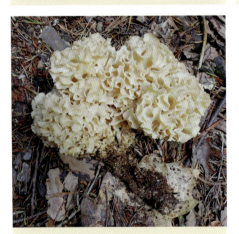

Sparassis americana (p. 182)

Cordyceps and Similar Fungi (p. 183)

Members of this group are parasitic. Some infect hypogeous, truffle-like fungi. Others prefer the larvae, pupae, or adults of arthropods. Fruit bodies often have a distinct stalk and head with a fertile surface roughened like sandpaper, but a few species cover their hosts with mycelium, causing them to appear furry or mummified.

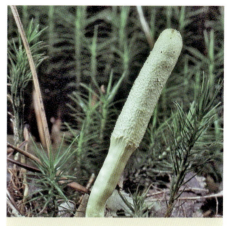

Cordyceps olivascens (p. 184)

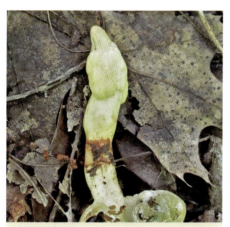

Ophiocordyceps melolonthae (p. 185)

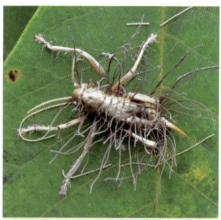

Parasitic Fungus (p. 184)

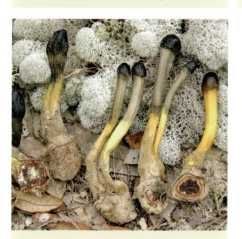

Tolypocladium capitatum (p. 186)

Crust, Cushion, and Parchment Fungi (p. 188)

Fungi in this mixed bag of basidiomycetes and ascomycetes can be crust-like and spreading, cushion-shaped, or parchment-like. Shapes are extremely variable, often mimicking those commonly seen in other major groups. Fertile surfaces may be smooth, roughened, warty, wrinkled, cracked, toothed, or poroid. Although many grow on wood, some occur on other substrates.

Annulohypoxylon cohaerens (p. 186)

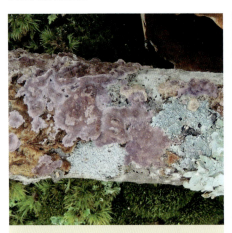

Chondrostereum purpureum (p. 203)

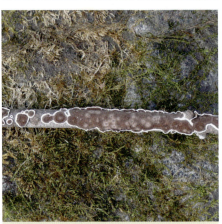

Dendrophora albobadia (p. 203)

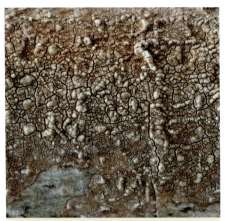

Hydnoporia corrugata (p. 193)

Perenniporia subacida (p. 189)

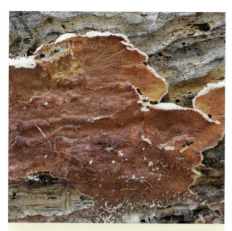
Phlebia tremellosa (p. 196)

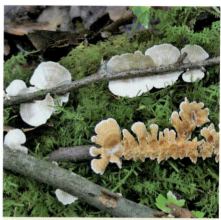
Stereum striatum (p. 202)

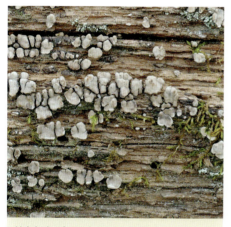
Xylobolus frustulatus (p. 205)

Cup Fungi (p. 207)

Fruit bodies in this group resemble small cups or plates and often have thin, brittle flesh. Some have stalks; others are stalkless. They grow on the ground, on wood, or sometimes on other substrates.

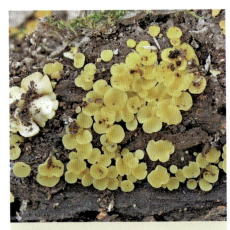
Bisporella citrina (p. 208)

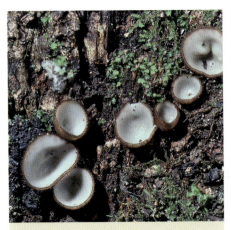
Humaria hemisphaerica (p. 216)

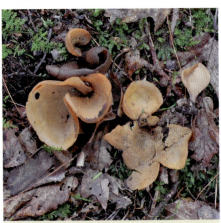
Otidea unicisa (p. 208)

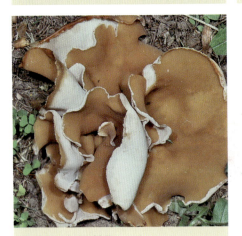
Peziza varia (p. 214)

Earth Tongues and Club Fungi (p. 219)

Species in this heterogeneous group resemble erect tongues or clubs with heads ranging in shape from rounded to oval, spatula, spindle-like, or cylindric. Although they may occur in groups, the stalk bases are not fused, and they are typically unbranched. Fertile surfaces may be smooth, wrinkled, or minutely bristly but, with the exception of *Trichoderma alutaceum*, are not roughened like sandpaper. They grow on the ground, wood, or decaying leaves.

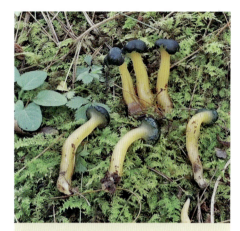

Leotia viscosa (p. 221)

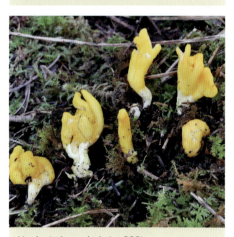

Neolecta irregularis (p. 222)

Fiber Fans (p. 228)

Fan- or vase-shaped fruit bodies that are leathery to fibrous-tough, sometimes with split or torn margins. They are typically some shade of brown or gray, with or without a whitish margin. Their fertile undersurfaces may be smooth or wrinkled and warted but lack pores (use a hand lens). They usually grow on the ground.

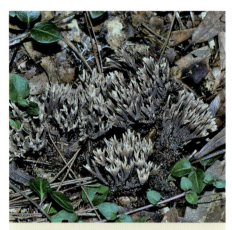
Thelephora anthocephala (p. 229)

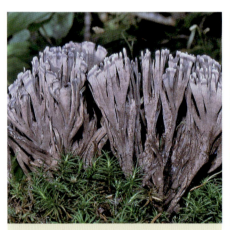
Thelephora palmata (p. 229)

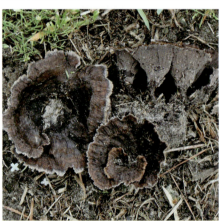
Thelephora terrestris (p. 229)

Thelephora terrestris f. *concrescens* (p. 229)

Gilled Mushrooms (p. 230)

The undersurface of the cap has knife-blade-like, thin gills that radiate from a stalk or, on stalkless species, from the point of attachment to a woody substrate. Species in this group grow on a variety of substrates. A few species with gill-like undersurfaces may also be found in the Bolete, Chanterelles and Similar Fungi, and Polypore groups.

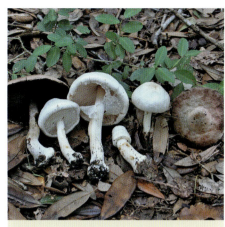
Agaricus abruptibulbus (p. 241)

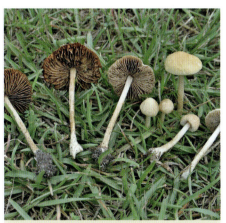
Agrocybe pediades (p. 243)

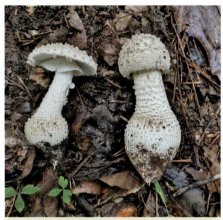
Amanita atkinsoniana (p. 261)

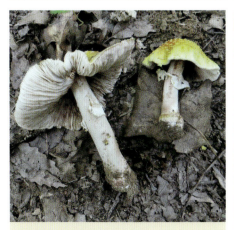
Amanita flavorubens (p. 270)

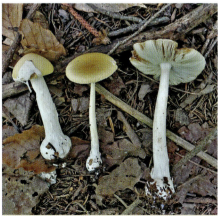
Amanita praecox (p. 245)

COLOR KEY TO THE MAJOR GROUPS OF FUNGI

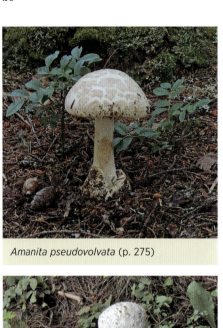
Amanita pseudovolvata (p. 275)

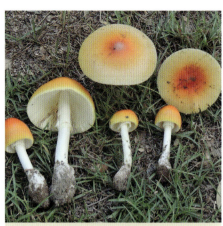
Amanita species ARB1328 (p. 255)

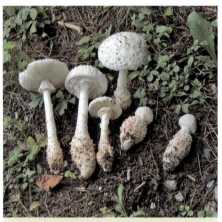
Amanita subcokeri (p. 249)

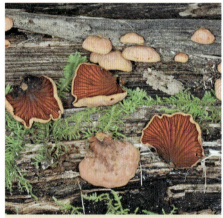
Anthracophyllum lateritium (p. 310)

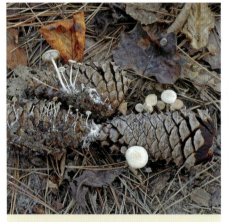
Baeospora myosura (p. 280)

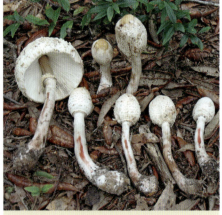
Chlorophyllum subrhacodes (p. 286)

COLOR KEY TO THE MAJOR GROUPS OF FUNGI

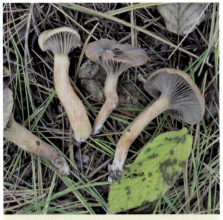
Chroogomphus ochraceus (p. 287)

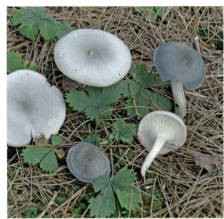
Clitocybe odora (p. 289)

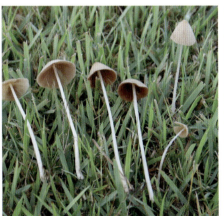
Conocybe apala (p. 281)

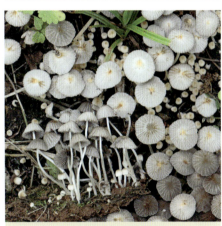
Coprinellus disseminatus (p. 291)

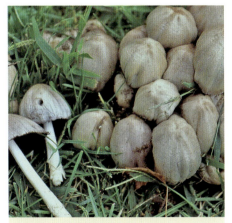
Coprinopsis atramentaria (p. 292)

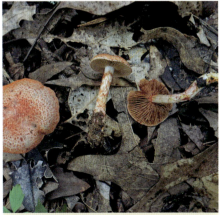
Cortinarius bolaris (p. 297)

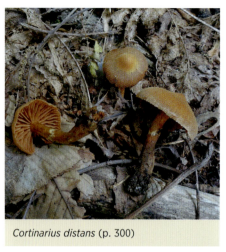
Cortinarius distans (p. 300)

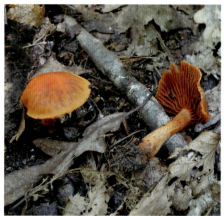
Cortinarius hesleri (p. 303)

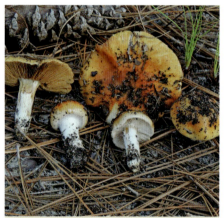
Cortinarius mucosus (p. 299)

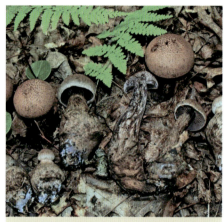
Cortinarius squamulosus (p. 307)

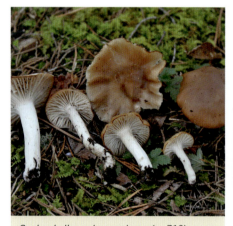
Cuphophyllus colemannianus (p. 312)

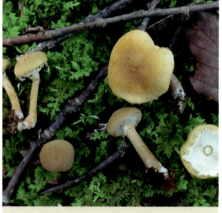
Cystoderma amianthinum (p. 351)

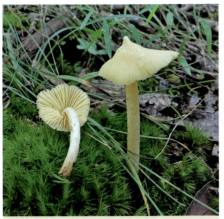
Entoloma murrayi (p. 319)

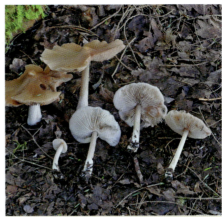
Entoloma strictius (p. 318)

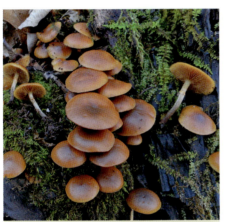
Galerina marginata (p. 323)

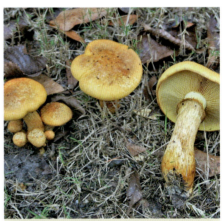
Gymnopilus armillatus (p. 327)

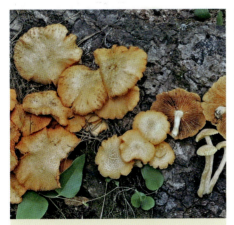
Gymnopilus lepidotus (p. 328)

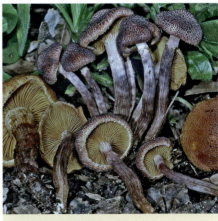
Gymnopilus luteofolius (p. 327)

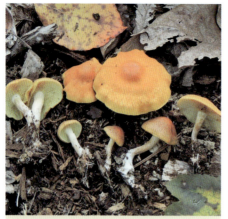
Gymnopilus sapineus (p. 282)

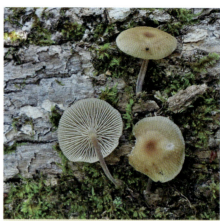
Gymnopus dichrous (p. 329)

Gymnopus iocephalus (p. 401)

Gymnopus subsulphureus (p. 331)

Hebeloma sinapizans (p. 335)

Hygrocybe cantharellus (p. 340)

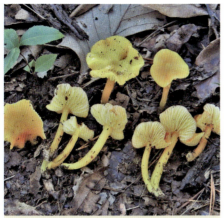
Hygrocybe flavescens (p. 337)

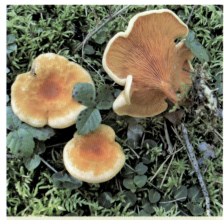
Hygrophoropsis aurantiaca (p. 403)

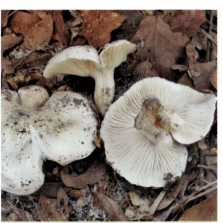
Hygrophorus subsordidus (p. 314)

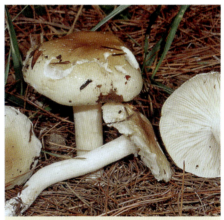
Hygrophorus tennesseensis (p. 342)

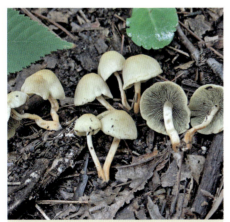
Hypholoma subviride (p. 345)

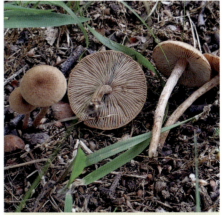
Inocybe lacera (p. 351)

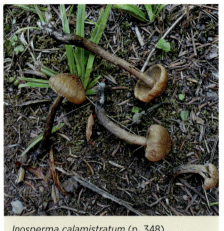
Inosperma calamistratum (p. 348)

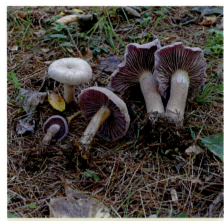
Laccaria ochropurpurea (p. 352)

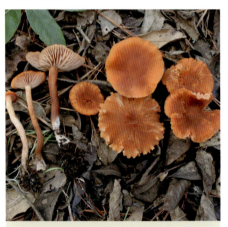
Laccaria trichodermophora (p. 353)

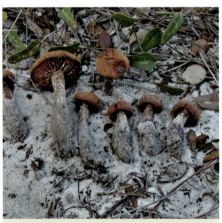
Laccaria trullisata (p. 352)

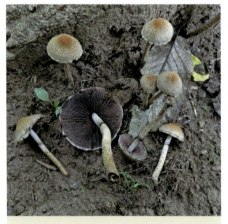
Lacrymaria lacrymabunda (p. 418)

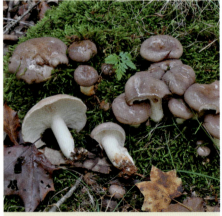
Lactarius argillaceifolius (p. 366)

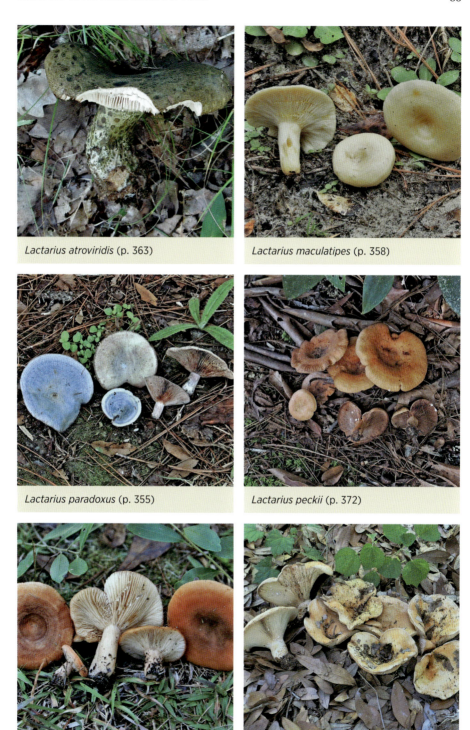

Lactarius atroviridis (p. 363)

Lactarius maculatipes (p. 358)

Lactarius paradoxus (p. 355)

Lactarius peckii (p. 372)

Lactarius proximellus (p. 356)

Lactarius psammicola (p. 356)

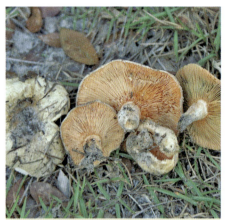

Lactarius pseudodeliciosus (p. 357)

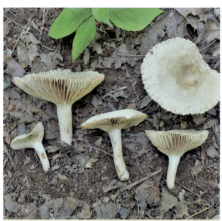

Lactarius subplinthogalus (p. 367)

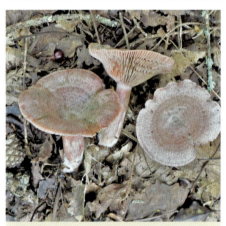

Lactarius subpurpureus (p. 355)

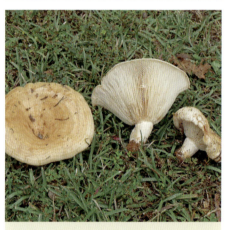

Lactarius yazooensis (p. 358)

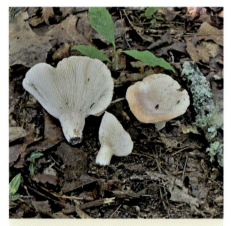

Lactifluus allardii (p. 366)

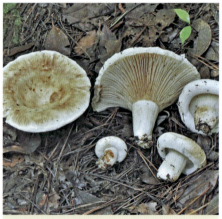

Lactifluus deceptivus (p. 371)

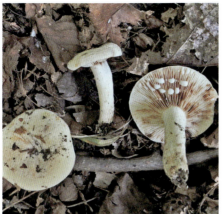
Lactifluus luteolus (p. 368)

Lactifluus subvellereus (p. 371)

Lactifluus volemus var. *flavus* (p. 372)

Lepiota cristata (p. 379)

Lepista subconnexa (p. 347)

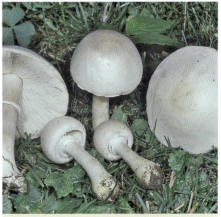
Leucoagaricus leucothites (p. 247)

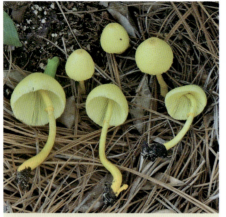
Leucocoprinus birnbaumii (p. 409)

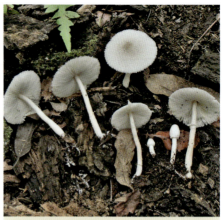
Leucocoprinus cepistipes (p. 379)

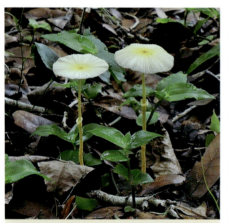
Leucocoprinus fragilissimus (p. 409)

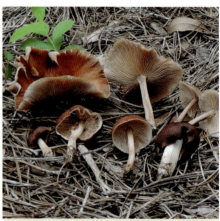
Marasmiellus luxurians (p. 332)

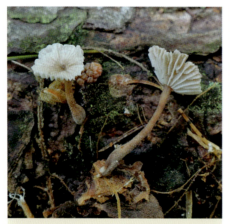
Marasmiellus praeacutis (p. 389)

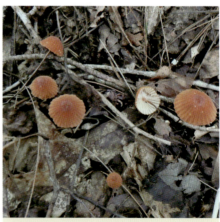
Marasmius fulvoferrugineus (p. 394)

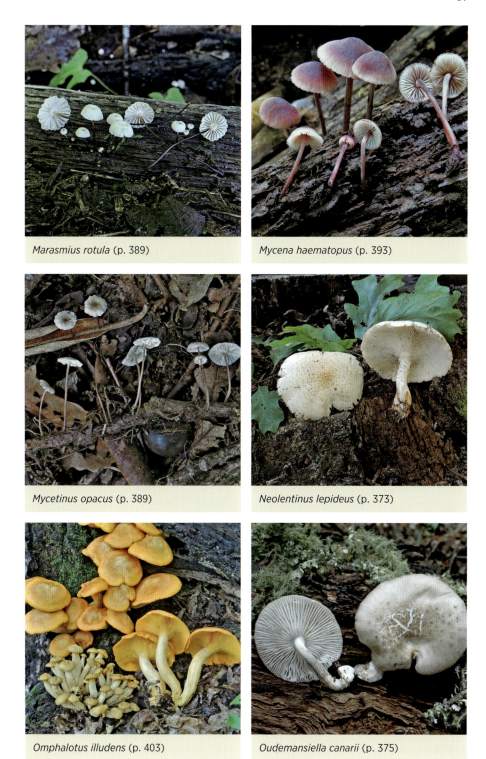

Marasmius rotula (p. 389)

Mycena haematopus (p. 393)

Mycetinus opacus (p. 389)

Neolentinus lepideus (p. 373)

Omphalotus illudens (p. 403)

Oudemansiella canarii (p. 375)

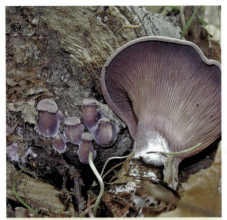
Panus conchatus (p. 408)

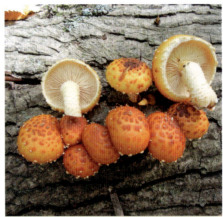
Pholiota aurivella (p. 411)

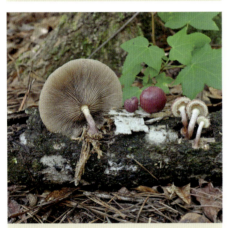
Pholiota polychroa (p. 410)

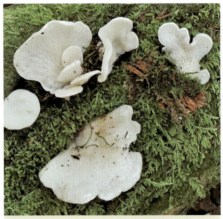
Pleurocybella porrigens (p. 414)

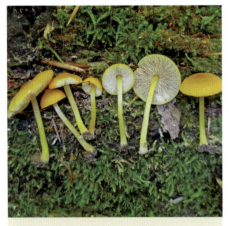
Pluteus chrysophlebius (p. 315)

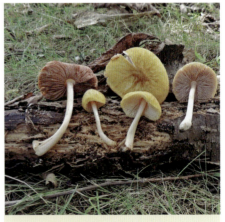
Pluteus flavofuligineus (p. 315)

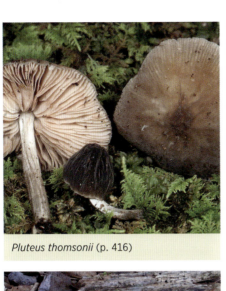
Pluteus thomsonii (p. 416)

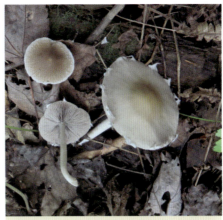
Psathyrella candolleana (p. 419)

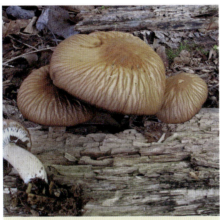
Psathyrella delineata (p. 300)

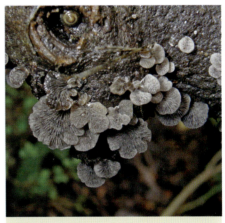
Resupinatus trichotis (p. 427)

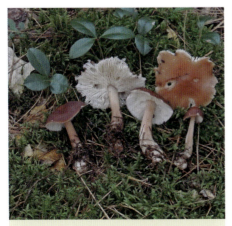
Rhodocollybia butyracea (p. 331)

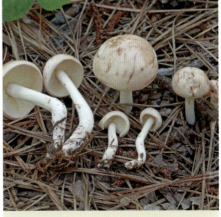
Rhodocollybia maculata (p. 331)

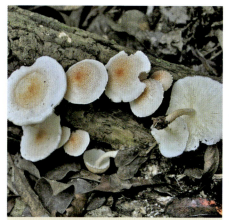
Ripartitella brasiliensis (p. 333)

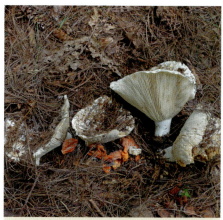
Russula brevipes (p. 441)

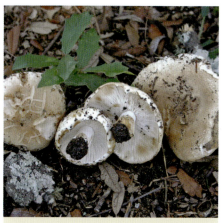
Russula compacta (p. 432)

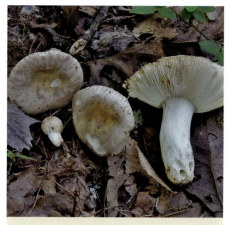
Russula crustosa (p. 437)

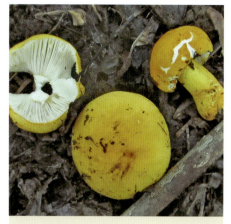
Russula flavida (p. 433)

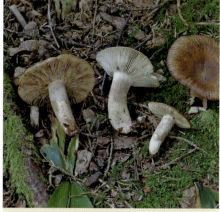
Russula foetentula (p. 432)

COLOR KEY TO THE MAJOR GROUPS OF FUNGI

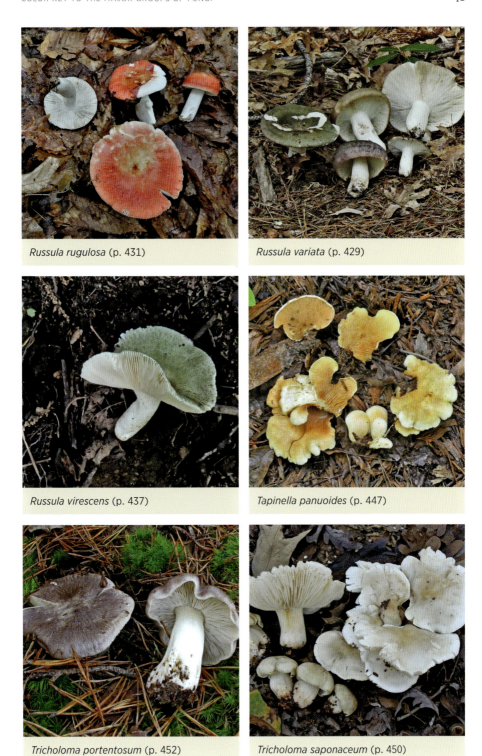

Russula rugulosa (p. 431)

Russula variata (p. 429)

Russula virescens (p. 437)

Tapinella panuoides (p. 447)

Tricholoma portentosum (p. 452)

Tricholoma saponaceum (p. 450)

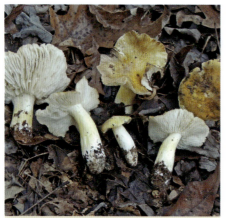
Tricholoma subluteum (p. 449)

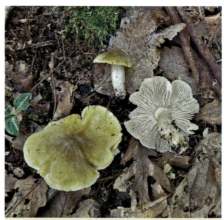
Tricholoma subsejunctum (p. 451)

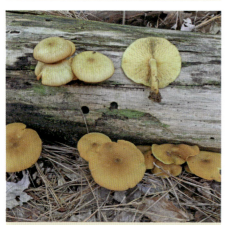
Tricholomopsis decora (p. 454)

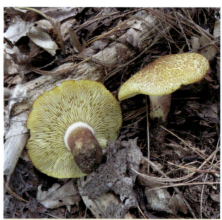
Tricholomopsis rutilans (p. 454)

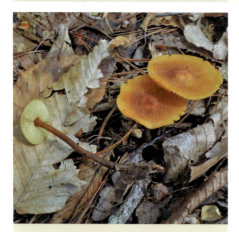
Xeromphalina tenuipes (p. 456)

Hypomyces and Other Parasitic Fungi (p. 459)

Fungi in this group include parasitic species that partially or completely cover and disfigure many types of fungi, most commonly gilled mushrooms, boletes, and polypores. Some coat their host organisms with a thin surface layer roughened like sandpaper. Others produce a powdery or moldy coating.

Dicranophora fulva (p. 461)

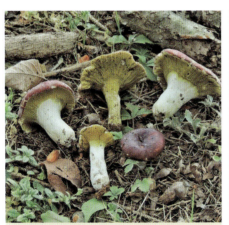

Hypomyces luteovirens (p. 464)

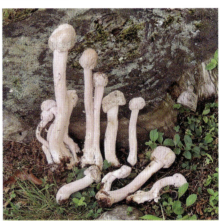

Mycogone rosea (p. 462)

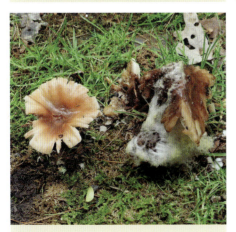

Syzygites megalocarpus (p. 462)

Jelly Fungi (p. 465)

These distinctly gelatinous species may have a soft, rubbery, or leathery to fibrous-tough consistency. Most are cushion-shaped or brain-like. A few are erect and spike- to antler-like or irregular. They often grow on wood but sometimes envelop or encrust plant stems, leaves, cones, and other organic debris.

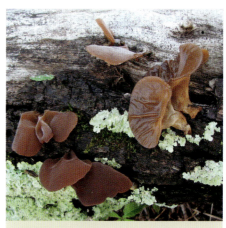
Auricularia angiospermarum (p. 466)

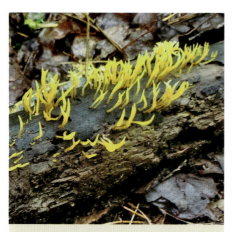
Calocera cornea (p. 468)

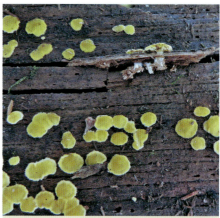
Dacrymyces variisporus (p. 469)

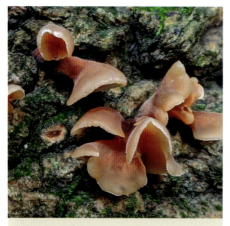
Dacryopinax elegans (p. 470)

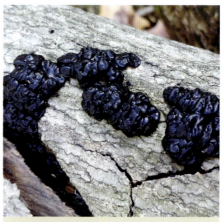
Exidia glandulosa (p. 472)

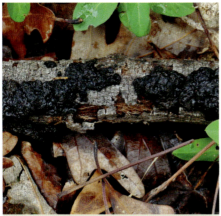
Exidia nigricans (p. 472)

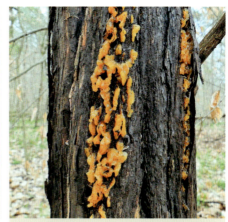
Gymnosporangium clavipes (p. 469)

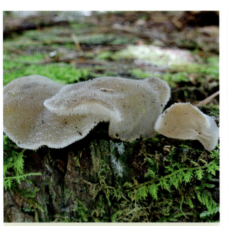
Pseudohydnum gelatinosum (p. 471)

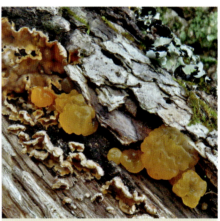
Tremella aurantia (p. 469)

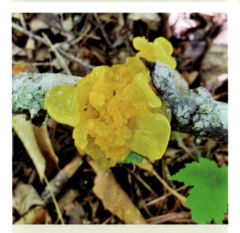
Tremella mesenterica (p. 476)

Morels, False Morels, and Similar Fungi (p. 478)

Fruit bodies have a distinct cap or sponge-like head and a conspicuous stalk. Caps or heads may be conic to bell-shaped with pits and ridges or brain-like, saddle-shaped, saucer-like, or irregularly lobed. Mature stalks are hollow or multichambered. They grow on the ground or on well-decayed wood. Edibility ranges from choice to deadly poisonous.

Gyromitra infula (p. 479)

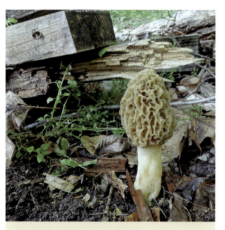
Morchella americana (p. 482)

Morchella punctipes (p. 482)

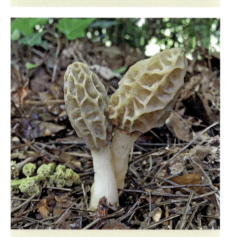
Morchella sceptriformis (p. 484)

Other Plant Pathogens (p. 485)

This section includes plant parasites from fungal groups not previously covered. Some cause gall-like swellings on flowers, leaves, and shoots, while others produce tumor-like growths on ears of corn or jelly-like horns on cedar trees. One attacks the first-year cones of pine trees.

Exobasidium ferrugineae (p. 489)

Gymnosporangium juniperi-virginianae (p. 488)

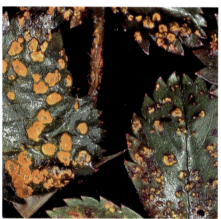

Pucciniastrum potentillae (p. 491)

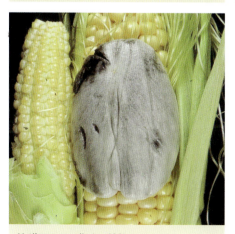

Ustilago maydis (p. 490)

Polypores (p. 492)

Fruit bodies in this group of fungi may be hard and woody, tough and leathery, or sometimes firm but flexible. They are often kidney-shaped to semicircular or fan-shaped but may be circular, irregular, or highly distorted. They vary in size from rather small to very large. Some polypores occur singly, while others form large clusters. Species in this group may be stalkless or centrally to laterally stalked. They usually grow on wood but sometimes on the ground. Most have obvious pores on their fertile surfaces, although these can be minute and often require a hand lens to visualize. At other times, the pore surface is modified to resemble gills or maze-like labyrinths intermediate between gills and pores. Some species exhibit a phenomenon called glancing, whereby the fertile surface shines like highlights in polished wood when held at a certain angle. The tube layer is not easily separated from the cap tissue.

Albatrellus confluens (p. 498)

Cerioporus leptocephalus (p. 501)

Coltricia cinnamomea (p. 504)

Cryptoporus volvatus (p. 509)

COLOR KEY TO THE MAJOR GROUPS OF FUNGI

Daedalea quercina (p. 505)

Fomitiporia calkinsii (p. 508)

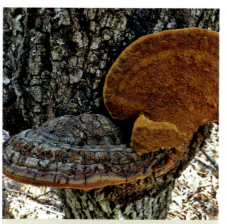
Fulvifomes everhartii (p. 542)

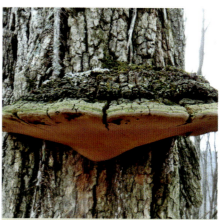
Fulvifomes robiniae (p. 542)

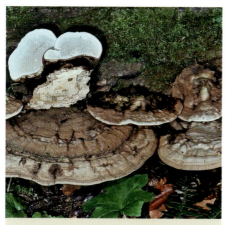
Ganoderma applanatum (p. 515)

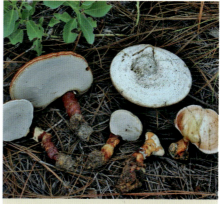
Ganoderma curtisii f. sp. *meredithiae* (p. 514)

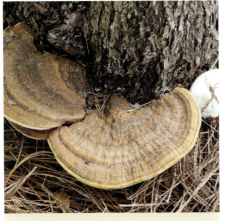
Ganoderma lobatoideum (p. 515)

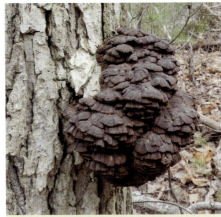
Globifomes graveolens (p. 511)

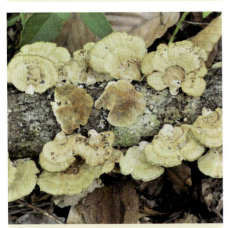
Gloeophyllum striatum (p. 520)

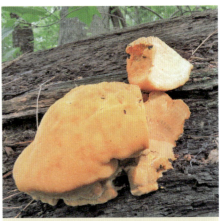
Hapalopilus croceus (p. 522)

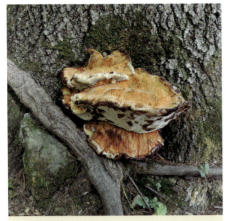
Inonotus quercustris (p. 527)

Irpex lacteus (p. 545)

COLOR KEY TO THE MAJOR GROUPS OF FUNGI

Laetiporus cincinnatus (p. 530)

Laetiporus sulphureus (p. 530)

Loweomyces fractipes (p. 534)

Meripilus sumstinei (p. 521)

Microporellus dealbatus (p. 534)

Neoalbatrellus caeruleoporus (p. 498)

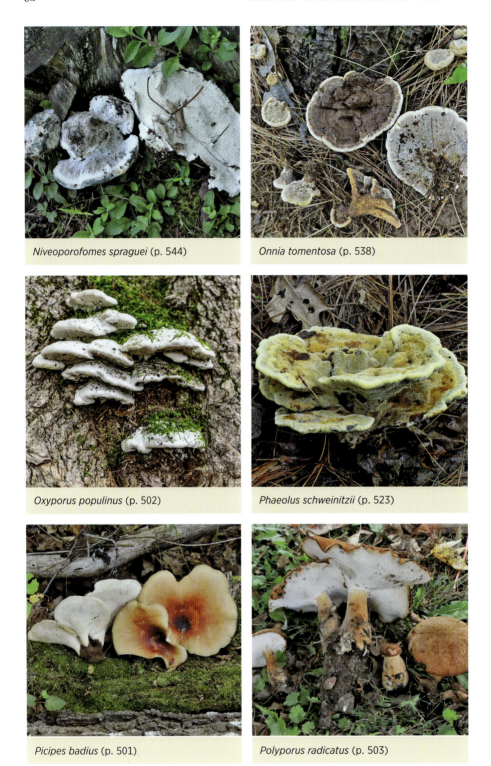

COLOR KEY TO THE MAJOR GROUPS OF FUNGI

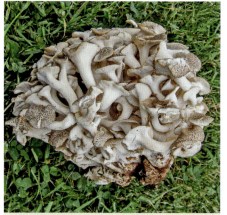

Polyporus umbellatus (p. 521)

Porodaedalea pini (p. 523)

Pseudoinonotus dryadeus (p. 527)

Rhodofomes cajanderi (p. 551)

Trametes cinnabarina (p. 551)

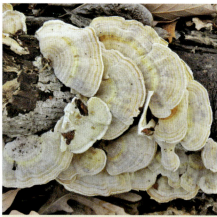

Trametes pubescens (p. 549)

Puffballs, Earthballs, Earthstars, and Similar Fungi (p. 560)

Fruit bodies are rounded, oval, pear- to turban-shaped, or star-shaped. Most are stalkless, but some species have a short stalk or stalk-like base. The interior is usually white when immature but may be orange to reddish or black. The mature interior (gleba) often becomes powdery and yellow, purple, brown, or black. They grow on the ground, underground, or on wood.

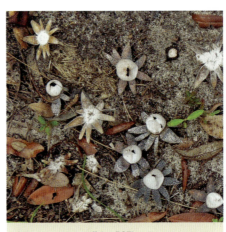
Astraeus morganii (p. 563)

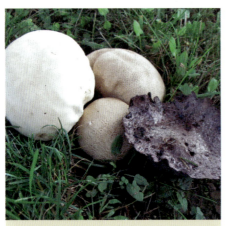
Calvatia cyathiformis (p. 568)

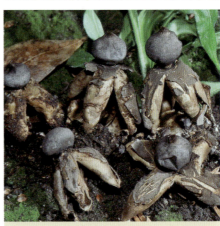
Geastrum quadrifidum (p. 572)

Lycoperdon americanum (p. 574)

Lycoperdon americanum (p. 574)

Split Gill and Crimped Gill (p. 587)

Species in this group have fruit bodies that are stalkless or have only a short lateral stalk and grow on wood. Their fertile surfaces are gill-like and split longitudinally or are distinctly crimped, often forked, and vein-like.

Scleroderma floridanum (p. 585)

Plicaturopsis crispa (p. 588)

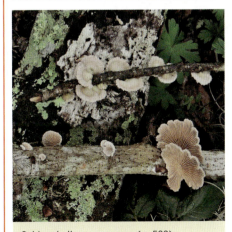

Schizophyllum commune (p. 589)

Stinkhorns (p. 590)

Species in this group have fruit bodies that are egg-shaped when young. They "hatch" to become erect and phallic with a head and stalk, or pear-shaped to nearly round with or without a stalk, or squid-like with arched, tapered arms. Parts of the fruit body are usually coated with a foul-smelling, slimy gleba that attracts a variety of arthropods. Stinkhorns grow on the ground, mulch, wood chips, or decaying wood. Although stinkhorn "eggs" are edible, the experience tends to be poorly reviewed, and there is a risk of misidentification with other species such as puffballs and *Amanita* "eggs," some of which are deadly poisonous. When sectioned vertically an *Amanita* "egg" will reveal the outline of a small, gilled mushroom inside.

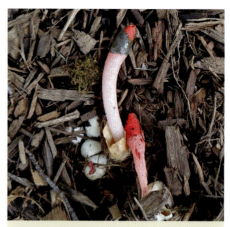
Mutinus ravenelii (p. 593)

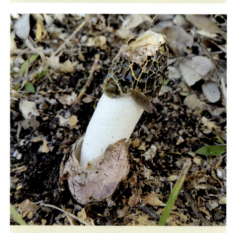
Phallus hadriani (p. 594)

Tooth Fungi (p. 597)

Fleshy, leathery, or tough fungi with downward-oriented, uniformly shaped, soft spines. Some species have a cap and stalk, while others are fan-shaped to shelf-like or icicle-like. They grow on the ground or on wood.

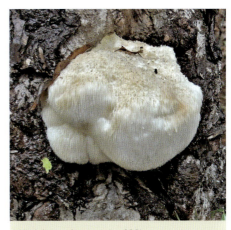

Hericium erinaceus (p. 600)

Hydnellum aurantiacum (p. 604)

Hydnellum caeruleum (p. 604)

Hydnellum peckii (p. 605)

Hydnellum scrobiculatum (p. 602)

Hydnellum spongiosipes (p. 602)

Hydnum mulsicolor (p. 608)

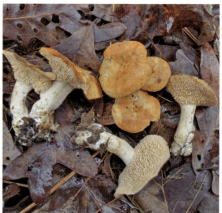
Hydnum subconnatum (p. 607)

Truffles and Other Hypogeous Fungi (p. 616)

Because they are mostly underground, these fungi are not commonly collected. Most species in this group must be excavated, although species of *Rhizopogon* and *Zelleromyces* are sometimes found partially buried or wholly aboveground. They are nearly round or lobed, and their smooth or roughened to warted outer rind-like surface is often thickened. Although they sometimes resemble puffballs or earthballs, their interior is usually chambered, marbled, or somewhat hollow.

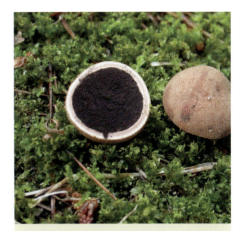

Elaphomyces species (p. 620)

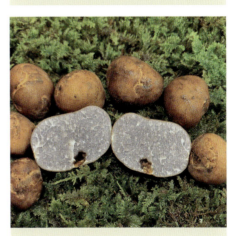

Tuber canaliculatum (p. 619)

Species Descriptions & Illustrations

BIRD'S-NEST FUNGI AND THE SPHERE THROWER

Bird's-nest fungi are small cone- to vase-shaped or barrel-like fruit bodies that contain numerous tiny egg-like sacs of spores called peridioles. They grow on wood chips, mulch, branches, leaves, dung, and other organic matter. The Sphere Thrower, *Sphaerobolus stellatus*, is very small, up to 3 mm wide. It has a puffball-like peridium that splits open when mature to form a miniature, star-shaped structure surrounding a single, tiny round peridiole. When light and moisture conditions are correct the peridiole is forcibly thrown up to 10 feet away. Like the bird's nests, it grows on woody substrates, dung, and other decaying matter.

Cyathus stercoreus (Schwein.) De Toni

= *Nidularia stercorea* Schwein.

COMMON NAME: Dung-loving Bird's Nest
MACROSCOPIC FEATURES: fruit body 5–15 mm high and 4–8 mm wide, consisting of a cone- to vase-shaped peridium containing egg-like peridioles that are splashed out by raindrops. **outer surface** covered with long, stiff, pale ocher to light brown hairs that separate at the apex to expose a white membrane, which also soon ruptures to reveal the peridioles inside. **inner surface** smooth, not vertically lined, grayish to blackish. **peridioles** 1–2 mm wide, egg-like to lens-shaped, gray to black, containing spores.
MICROSCOPIC FEATURES: Spores 18–35 × 15–35 μm, subglobose, smooth, thick-walled, hyaline.
HABIT, HABITAT, AND SEASON: In groups or clusters on decaying wood debris, sawdust piles, mulch, manured soil, and dung and in burned places; summer–early winter.
EDIBILITY: Inedible.

COMMENTS: The epithet *stercoreus* means "growing on dung." It is derived from Sterculius, the Roman god of manure. Although this species grows on dung, it is often found on other substrates as described above. *Cyathus striatus* (see Color Key) is similar, but the interior surface of the peridium is distinctly vertically lined, the exterior surface is reddish brown to grayish brown, and the 1.5–3 mm wide peridioles are vaguely triangular and dark gray. Molecular analysis has shown that the name *Cyathus striatus* is actually a group of several species, including *Cyathus annulatus* (not illustrated), which also occurs in Georgia. It has an inner brown ring on the lip of the peridia. They are sometimes parasitized by *Hypocrea latizonata* (not illustrated), a mold-like fungus that forms a white band around the peridium. The exterior surface of the Common Bird's Nest or White-egg Bird's Nest, *Crucibulum laeve* (see Color Key), is yellowish orange. The inner surface is smooth and whitish and contains 1.5–2 mm wide, lens-shaped, whitish peridioles.

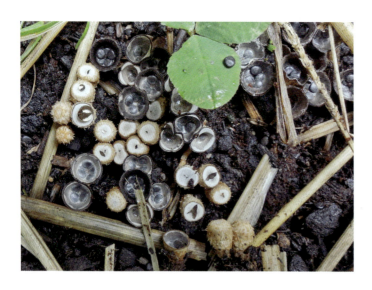

Sphaerobolus stellatus Tode

= *Sphaerobolus dentatus* (With.) W. G. Sm.

COMMON NAMES: Cannon Fungus, Sphere Thrower

MACROSCOPIC FEATURES: fruit body consisting of a peridium and a single egg-like peridiole. **peridium** 1.5–3 mm wide, nearly round, white to yellow-orange, splitting at maturity into 4–9 star-shaped to teeth-like rays that expose the peridiole. **peridiole** 1.5–2.5 mm wide, whitish to dull yellow or reddish brown to dark brown.

MICROSCOPIC FEATURES: Spores 7–10 × 3.5–5 μm, oblong, smooth, hyaline.

HABIT, HABITAT, AND SEASON: Solitary or in groups on decaying wood, sawdust, compost, or dung; spring–fall.

EDIBILITY: Inedible.

COMMENTS: *Sphaerobolus stellatus* means "star-shaped sphere thrower." The peridiole is forcibly ejected in response to moisture and light. When colonies fruit near walls, vehicles, or windows, the sticky peridioles often appear as dark spots on those surfaces and require some scrubbing to remove. *Helicogloea compressa* = *Pleurocolla compressa* (not illustrated) has a small, 1.5–5 mm, gelatinous to rubbery, stalkless, cushion-shaped fruit body that is whitish at first and becomes yellowish to orange-yellow at maturity. It grows in dense clusters on decaying wood. These structures never rupture, instead producing asexual spores on the surface.

BOLETES

Boletes are fleshy mushrooms with a cap, a stalk, and a sponge-like undersurface composed of vertically arranged tubes, each of which terminates in an opening called a pore. The tube layer is often easy to separate from the cap tissue. Boletes typically grow on the ground and form mycorrhizal relationships with trees.

Stalk ornamentation is one of the most important macroscopic features used in bolete identification. The different types are distinctive and fairly easy to recognize once one understands the terms used to describe them. Some of the most common terms used to describe various stalk features are:

Ring: remnants of a partial veil that remains attached to the stalk after the veil ruptures.

Ring zone: faint remnants of a partial veil, usually composed of tiny fibers, attached to the stalk.

Reticulation: raised, net-like ridges resembling stretched pore openings covering part or almost all of a stalk, or a net-like pattern seen on the spores of some fungi.

Resinous dots and smears: small marks or patches of sticky resin.

Scabers: small, stiff, granular projections on the stalk.

Punctae: tiny dots or spots not as above.

These terms are part of the "language" of mycology. Taking the time to look them and other unfamiliar words up in the glossary will greatly increase your chances of identifying your bolete.

If you cannot identify your unknown mushroom in this section, try comparing it to species of *Albatrellus* in the Polypore group.

In the following key, genus and species names that are fully described and illustrated are set in boldface italic. Partially described species, including those illustrated in the Color Key, are set in italic.

Key to the Boletes

1a Stalk with a ring, a ring zone, or resinous dots and smears, or both 2
1b Stalk lacking a ring, a ring zone, or resinous dots and smears 3

2a Stalk lacking resinous dots and smears; cap margin fringed with cottony pieces of white, grayish, or tan partial veil; flesh white, quickly staining orange to orange-red, then slowly blackish:
 Strobilomyces confusus
 Strobilomyces dryophilus
 Strobilomyces strobilaceus
 Suillus spraguei

2b Stalk with resinous dots and smears, at least on mature specimens, or if lacking, a ring zone is present; flesh not staining orange to orange-red, then slowly blackish:
 Suillus acidus
 Suillus americanus
 Suillus brevipes
 Suillus cothurnatus
 Suillus decipens
 Suillus granulatus
 Suillus hiemalis
 Suillus hirtellus
 Suillus luteus
 Suillus placidus
 Suillus spraguei
 Suillus tomentosus
 Suillus weaverae

3a Stalk covered with conspicuous, pointed, white, brown, purple-brown, or black scabers or dark brown punctae:
 Boletellus chrysenteroides
 Hemileccinum rubropunctum
 Leccinum albellum
 Leccinum chalybaeum
 Leccinum crocipodium
 Leccinum roseoscabrum
 Leccinum rugosiceps
 Leccinum scabrum
 Sutorius eximius

3b Stalk not as above; may be smooth, reticulate, pseudoreticulate, or coated with tiny punctae that are not dark brown 4

4a Pore surface markedly elongated with gill-like ridges and crosswalls or gill-like, strongly decurrent:
 Boletinellus merulioides
 Phylloporopsis boletinoides
 Phylloporus foliiporus
 Phylloporus leucomycelinus
 Phylloporus rhodoxanthus

4b Pore surface not as above; pores round, angular, irregular, or somewhat elongated but not gill-like 5

5a Stalk with fine to coarse reticulation 6
5b Stalk lacking reticulation 8

6a Pore surface some shade of orange or red:
 Boletus carminiporus
 Boletus flammans
 Butyriboletus floridanus
 Caloboletus firmus
 Exsudoporus frostii
 Suillellus luridus

6b Pore surface white, creamy white, yellow, or pinkish brown to olive brown 7

7a Pore surface white to creamy white at first, becoming grayish pink, then pinkish brown at maturity:
 Austroboletus subflavidus
 Tylopilus appalachiensis
 Tylopilus atronicotianus
 Tylopilus balloui
 Tylopilus felleus
 Tylopilus ferrugineus
 Tylopilus griseocarneus
 Tylopilus indecisus
 Tylopilus minor
 Tylopilus plumbeoviolaceus
 Tylopilus porphyrosporus
 Tylopilus rhoadsiae
 Tylopilus rubrobrunneus
 Tylopilus variobrunneus
 Tylopilus violatinctus
 Tylopilus williamsii
 Veloporphyrellus conicus

7b Pore surface white to creamy white, yellow, or olive brown to yellow-brown, lacking pinkish tones:
 Alessioporus rubriflavus
 Aureoboletus auriflammeus
 Aureoboletus betula
 Aureoboletus projectellus
 Aureoboletus russellii
 Boletus albisulphureus
 Boletus aurantiosplendens
 Boletus aureissimus
 Boletus auripes
 Boletus edulis
 Boletus luridellus
 Boletus nobilis
 Boletus oliveisporus
 Boletus pseudopinophilus
 Boletus rubissimus
 Boletus sensibilis
 Boletus separans
 Boletus variipes
 Bothia castanella
 Buchwaldoboletus lignicola
 Butyriboletus roseopurpureus
 Caloboletus inedulis
 Caloboletus peckii
 Hemileccinum hortonii
 Pulchroboletus rubricitrinus
 Pulchroboletus sclerotiorum
 Retiboletus fuscus group
 Retiboletus griseus
 Retiboletus ornatipes
 Retiboletus vinaceipes
 Tylopilus tabacinus
 Xanthoconium affine
 Xerocomus illudens/tenax group

8a Pore surface white to creamy white at first, becoming grayish pink, then pinkish brown at maturity:
 Austroboletus gracilis
 Porphyrellus sordidus
 Tylopilus alboater
 Tylopilus appalachiensis

 Tylopilus atronicotianus
 Tylopilus badiceps
 Tylopilus ferrugineus
 Tylopilus indecisus
 Tylopilus peralbidus
 Tylopilus plumbeoviolaceus
 Tylopilus porphyrosporus
 Tylopilus rhodoconius
 Tylopilus rubrobrunneus
 Tylopilus violatinctus
 Tylopilus williamsii
 Veloporphyrellus conicus

8b Pore surface differently colored, or if white, not pinkish brown at maturity 9

9a Pore surface staining greenish or blue to blackish blue when bruised, sometimes slowly 10

9b Pore surface not staining greenish or blue to blackish blue when bruised 11

10a Cap some shade of pink or red:
 Baorangia bicolor group
 Boletellus ananas
 Boletus miniato-olivaceus
 Boletus rufomaculatus
 Boletus sensibilis
 Boletus subluridellus
 Hortiboletus campestris
 Hortiboletus harrisonii
 Hortiboletus rubellus group
 Lanmaoa pallidorosea
 Pulchroboletus rubricitrinus
 Pulchroboletus sclerotiorum
 Suillellus subluridus
 Suillellus subvelutipes

10b Cap whitish, buff, yellow, orange, or some shade of brown:
 Boletellus chrysenteroides
 Boletinellus merulioides
 Boletus ochraceoluteus
 Boletus oliveisporus
 Boletus patrioticus
 Boletus subgraveolens
 Buchwaldoboletus lignicola
 Buchwaldoboletus sphaerocephalus
 Caloboletus firmus
 Chalciporus piperatoides
 Chalciporus piperatus
 Cyanoboletus cyaneitinctus
 Gyroporus cyanescens
 Hemileccinum hortonii
 Imleria badia
 Imleria floridana
 Imleria pallida
 Neoboletus luridiformis
 Pulveroboletus ravenelii
 Suillellus hypocarycinus
 Xerocomus hypoxanthus
 Xerocomus illudens/tenax group

11a Stalk stuffed with soft pith, developing cavities or becoming hollow in age:
 Gyroporus borealis
 Gyroporus phaeocyanescens
 Gyroporus purpurinus
 Gyroporus smithii
 Gyroporus subalbellus
 Gyroporus unbrinisquamosus

11b Stalk solid, not stuffed with pith, and not hollow in age 12

12a Cap white, whitish to straw, yellow, or pink to rose and sometimes fading to pinkish tan or yellowish:
 Aureoboletus pseudoauriporus
 Buchwaldoboletus hemichrysus
 Chalciporus rubinellus
 Harrya chromapes
 Pulveroboletus curtisii
 Xanthoconium stramineum

12b Cap differently colored, often some shade of brown but sometimes orange to brownish orange, or red:
 Aureoboletus auriporus
 Aureoboletus innixus
 Aureoboletus russellii
 Boletus abruptibulbus
 Boletus projectelloides
 Boletus roodyi
 Chalciporus piperatus
 Chalciporus rubinellus
 Hemileccinum hortonii
 Hemileccinum subglabripes
 Leccinum longicurvipes
 Pseudoboletus parasiticus
 Suillus brevipes
 Xanthoconium affine
 Xanthoconium purpureum
 Xerocomus illudens/tenax group
 Xerocomus morrisii

Alessioporus rubriflavus J. L. Frank, A. R. Bessette, & Bessette

MACROSCOPIC FEATURES: cap 5–21 cm wide, convex to broadly convex, sticky or dry, slightly velvety, sometimes very finely cracked, initially dark wine red or occasionally entirely yellow when young, becoming yellow overall and splashed with wine red, red-brown, ocher, or a combination of these colors that persists well into maturity, readily bruising greenish blue to bluish black; margin sterile. **pore surface** yellow at first, becoming pale orange-yellow, then olive brown, deeply depressed at the stalk when mature, quickly bruising blue, stained areas slowly turning reddish brown; **tubes** 8–25 mm deep. **stalk** enlarged downward, centrally swollen, or club-shaped, typically with a pinched base, solid, dry, reticulate over the upper half or on the upper portion, or sometimes lacking, bright yellow near the apex or nearly overall, with dark wine red to red-brown splashes below, especially near the base, quickly bruising blue, then slowly brownish; reticulation yellow toward the apex, yellow-brown below, darkening when handled; mycelium whitish. **flesh** firm, bright yellow, quickly staining dark blue when exposed, usually dark wine red near the base; odor not distinctive, taste astringent or not distinctive.

MICROSCOPIC FEATURES: Spores 13–19 × 4–6 μm, subellipsoid to subfusiform, smooth, pale brownish yellow.

SPORE PRINT: Olive brown.

HABIT, HABITAT, AND SEASON: Solitary, scattered, or in groups on the ground in mixed pine and oak woods or adjacent grassy areas; summer–fall.

EDIBILITY: Edible.

COMMENTS: The epithet *rubriflavus* means "red and yellow." Red portions of the cuticle immediately stain amber with KOH, and the flesh immediately stains orange with KOH. The European *Neoboletus pseudosulphureus* (not illustrated) has been reported from eastern North America but may have been misidentified because of the morphological variability expressed by *Alessioporus rubriflavus*. Molecular analysis of European and American collections is needed to resolve this issue.

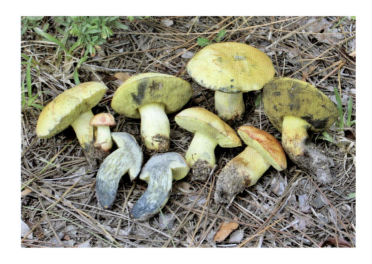

Aureoboletus auriflammeus (Berk. & M. A. Curtis) G. Wu & Zhu L. Yang

= *Boletus auriflammeus* Berk. & M. A. Curtis
= *Pulveroboletus auriflammeus* (Berk. & M. A. Curtis) Singer

COMMON NAME: Flaming Gold Bolete
MACROSCOPIC FEATURES: cap 4–9 cm wide, convex to broadly convex, dry, velvety, bright orange-yellow to golden yellow, or brownish orange; margin even. **pore surface** bright yellow to yellow-orange, sometimes tinged reddish, not bluing; **tubes** 6–15 mm deep. **stalk** nearly equal, solid, dry, reticulate on the upper portion or overall, frequently lacking reticulation when young, often longitudinally striate, basal mycelium white or yellow. **flesh** white to pale yellow, unchanging; odor not distinctive, taste acidic or not distinctive.
MICROSCOPIC FEATURES: Spores 8–12 × 3–5 µm, subellipsoid to subfusiform, smooth, hyaline.
SPORE PRINT: Ochraceous brown.
HABIT, HABITAT, AND SEASON: Solitary or in groups in broadleaf or mixed woods, especially with oaks; summer–fall.
EDIBILITY: Unknown.
COMMENTS: The Showy Orange Bolete, *Boletus aurantiosplendens* (not illustrated), edibility unknown, has a darker orange to brownish orange cap, a yellow to apricot stalk with tawny streaks over the mid-portion, obscure to distinct reticulation, and yellow flesh that darkens or becomes bright orange when exposed. It grows with beeches, oaks, hickories, and pines. *Pulveroboletus curtisii* (not illustrated), edibility unknown, has a sticky yellow to orange-yellow cap with an incurved margin. The pore surface is yellow to yellow-orange. The stalk is sticky and yellow and lacks reticulation. It grows in conifer or mixed woods, often with pines. Ravenel's Bolete, *Pulveroboletus ravenelii* (see Color Key), edible, has a bright yellow cap that becomes reddish orange on the disc. The cap surface may be dry or tacky, and the margin is sometimes fringed with veil remnants. The flesh stains pale blue, then brownish, sometimes with a fragrant odor. The pore surface bruises blue and is covered with a bright yellow, partial veil when young.

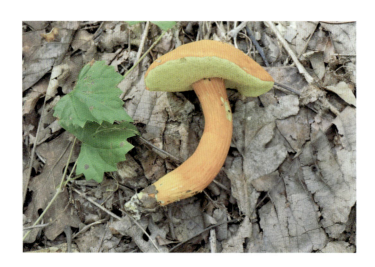

Aureoboletus betula (Schwein.)
M. Kuo & B. Ortiz

= *Austroboletus betula* (Schweinitz) E. Horak
= *Frostiella betula* (Schwein.) Murrill
= *Heimioporus betula* (Schwein.) E. Horak

COMMON NAME: Shaggy-stalked Bolete
MACROSCOPIC FEATURES: cap 3–9 cm wide, rounded to convex and remaining so well into maturity, bald, sticky, and shiny when moist, bright to dark red, orange, a blend of red and orange or orange and yellow, often yellow at the sterile margin or in age. **pore surface** bright to pale yellow or greenish yellow, unchanging, depressed around the stalk; **tubes** 1–1.5 cm deep. **stalk** thin, slender, often curved near the base, solid and firm, dry, coarsely reticulate-shaggy, yellow when young, becoming reddish to yellow, with a massive pad of cottony white basal mycelium. The reticulation is strongly raised, yellow or sometimes reddish. **flesh** soft, pale yellow, occasionally tinged orange beneath the cap cuticle, unchanging; odor not distinctive, taste sour or acidic.

MICROSCOPIC FEATURES: Spores 15–19 × 6–10 μm, narrowly elliptic, ornamented with a loose reticulum and scattered minute pits, typically with a distinct apical pore, pale brown.
SPORE PRINT: Olive brown.
HABIT, HABITAT, AND SEASON: Solitary or scattered in mixed broadleaf and pine woodlands; summer–fall.
EDIBILITY: Edible.
COMMENTS: *Betula* refers to the genus of birch trees, many of which bear shaggy bark. *Aureoboletus russellii* is reddish brown overall with a dry, scaly cap lacking bright red, orange, or yellow tones. The spores are not pitted. Pine associate *Aureoboletus projectellus* (not illustrated), edible, has a 4–20 cm wide, reddish brown to cinnamon brown cap with a sterile margin, and a stalk up to 24 cm long prominently reticulated overall or at least on the upper portion. The pore surface is yellow and unchanging. Flesh is white, and the spores are large, measuring 18–33 × 7.5–12 μm.

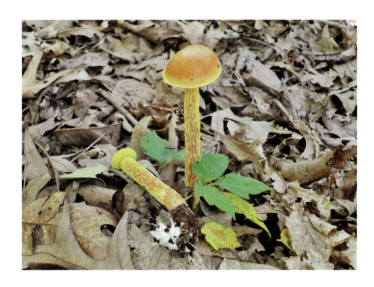

Aureoboletus innixus (Frost) Halling, A. R. Bessette, & Bessette

= *Boletus innixus* Frost
= *Boletus caespitosus* Peck

COMMON NAME: Clustered Brown Bolete
MACROSCOPIC FEATURES: cap 3–7.5 cm wide, convex when young, becoming broadly convex to nearly flat when mature, dry, slightly velvety, often cracked in age, dull reddish brown to dull cinnamon or yellow-brown, typically purplish or reddish near the margin; margin sterile. **pore surface** bright yellow when young, dull yellow in age, unchanging when bruised; **tubes** 3–10 mm deep. **stalk** stout, solid, often club-shaped or swollen in the midportion, with a tapered base, dry or slightly sticky near the base, smooth or finely fibrillose, yellowish streaked with brown, staining brownish when handled, often with yellow basal mycelium. **flesh** white to pale yellow, sometimes tinged vinaceous beneath the cuticle; odor pungent or reminiscent of witch hazel, taste lemony or not distinctive.
MICROSCOPIC FEATURES: Spores 8–11 × 3–5 μm, elliptic, smooth, pale brown.
SPORE PRINT: Olive brown.
HABIT, HABITAT, AND SEASON: Solitary, scattered, or often in caespitose clusters in broadleaf woods, especially with oaks; late spring–fall.
EDIBILITY: Edible, but not highly regarded.
COMMENTS: *Innixus* means "reclining," referring to its habit of often leaning, especially when in tight clusters. The cap surface stains mahogany red to reddish brown with KOH. Addition of NH_4OH to the cap surface produces a green flash and then stains dull orange-red. *Aureoboletus auriporus* has a sticky cap with a peelable cuticle that tastes acidic and flesh lacking a distinctive odor.

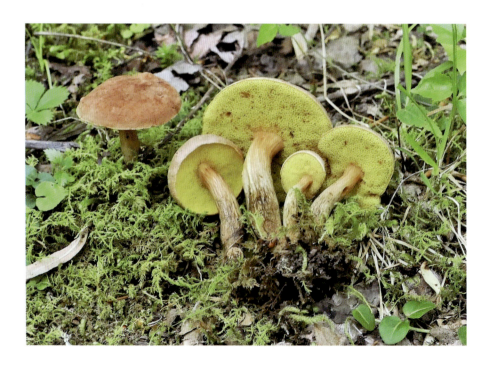

Aureoboletus pseudoauriporus
J. A. Bolin, A. R. Bessette, Bessette, L. Kudzma, J. L. Frank, & A. Farid

MACROSCOPIC FEATURES: cap 5–8.5 cm wide, convex to broadly convex; surface bald, moist, sticky, and shiny when fresh, color variable, pinkish to pinkish red or pinkish tan, unchanging when bruised; cuticle tastes acidic; margin incurved, even or narrowly sterile. **pore surface** bright yellow, becoming darker yellow, then dingy yellow in age, not staining; **tubes** 4–12 mm deep. **stalk** typically equal or slightly enlarged downward, sometimes with a pinched base, dry but sticky when wet, usually longitudinally striate for one-third or more of its length, whitish, sometimes with pale pink tones, not staining, with white basal mycelium. **flesh** white, unchanging or faintly and slowly turning pink or light yellow near the tubes, firm and slightly woody near the base; odor and taste not distinctive.

MICROSCOPIC FEATURES: Spores (14–)15–17(–18) × 5–6.5 μm, elliptic, smooth, thick-walled.

SPORE PRINT: Brown.

HABIT, HABITAT, AND SEASON: Solitary or scattered on sandy soil in broadleaf or mixed woods with oaks; late spring–fall.

EDIBILITY: Edible.

COMMENTS: The epithet *pseudoauriporus* means "false *auriporus*." The cap surface of *Aureoboletus pseudoauriporus* stains pale blue-green, fading quickly or slowly with NH_4OH. The very similar but molecularly distinct *Aureoboletus auriporus* (not illustrated), edible, has a darker pinkish cinnamon to dull reddish brown cap staining dark red with NH_4OH, lacks longitudinal stalk striations, and has slightly smaller spores, 11–16 × 4–6 μm. The Abruptly Bulbous Sand Bolete, *Boletus abruptibulbus* (see Color Key), edible, has a 3–8 cm wide, reddish brown cap. The pore surface is yellow to yellowish olive. It has a bulbous stalk base and whitish, unchanging flesh. Spores are dextrinoid and measure 13.5–19.8 (–22.5) × 5–7.2 μm. It grows in oak and pine woods during winter and spring.

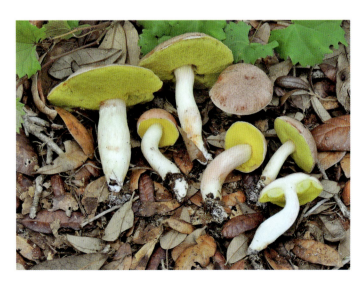

Aureoboletus russellii (Frost)
G. Wu & Zhu L. Yang

= *Boletellus russellii* (Frost) E.-J. Gilbert
= *Frostiella russellii* (Frost) Murrill

COMMON NAME: Russell's Bolete
MACROSCOPIC FEATURES: cap 3–13 cm wide, initially rounded to convex, becoming broadly convex, dry, velvety, forming cracks or scale-like patches when mature, yellow-brown, reddish brown, to cinnamon brown or olive gray; margin even, strongly incurved. **pore surface** yellow to greenish yellow, not bruising blue but sometimes brighter yellow when cut or rubbed, usually depressed around the stalk in age; **tubes** up to 2 cm deep. **stalk** equal or enlarging slightly downward, solid, typically curved at the base, dry, frequently sticky at the base when moist, reddish brown to pinkish tan, deeply grooved and ridged over most or all of its length, the ridges branched or torn to create a honeycomb or shaggy bark effect resembling coarse reticulation. **flesh** pale yellow to yellow, usually brownish around larval tunnels, not staining blue when cut or bruised but may slowly stain brown; odor and taste not distinctive.
MICROSCOPIC FEATURES: Spores 15–20 × 7–11 μm, elliptic, longitudinally striate with deep grooves or wrinkled with a cleft in the wall at the apex, pale brown.
SPORE PRINT: Dark olive to olive brown.
HABIT, HABITAT, AND SEASON: Solitary or scattered with oaks or pines; summer–fall.
EDIBILITY: Edible.
COMMENTS: The epithet *russellii* honors American botanist John Lewis Russell. The cap surface stains reddish with NH_4OH and olive gray with $FeSO_4$. The flesh stains reddish with KOH and blackish blue with $FeSO_4$. *Aureoboletus betula* and *Aureoboletus projectellus* (not illustrated) are potential sources of diagnostic confusion and are both discussed in the description of *Aureoboletus betula*.

Austroboletus subflavidus (Murrill) Wolfe

= *Tylopilus subflavidus* Murrill
= *Porphyrellus subflavidus* (Murrill) Singer

COMMON NAME: White Coarsely-ribbed Bolete

MACROSCOPIC FEATURES: cap 3–10 cm wide, convex, becoming nearly flat, usually somewhat depressed in age, dry, finely velvety and becoming cracked, initially white, darkening to buff or very pale yellowish to grayish yellow in age, sometimes with a pale ochraceous salmon tinge; margin even. **pore surface** white to grayish at first, pinkish to pinkish brown at maturity, unchanging; **tubes** 1–2 cm deep. **stalk** nearly equal, tapered downward, or enlarged at the base, solid, dry, colored like the cap, having thick, raised, coarsely ribbed reticulation that may create a pitted appearance. **flesh** white above, yellow in the base, not staining when cut or bruised; odor somewhat fruity, taste bitter.

MICROSCOPIC FEATURES: Spores 15–20 × 6–9 μm, fusoid, minutely pitted, pale brown.

SPORE PRINT: Reddish brown.

HABIT, HABITAT, AND SEASON: Scattered or in groups with oaks and pines; late spring–fall.

EDIBILITY: Edible but sometimes bitter.

COMMENTS: *Subflavidus* means "nearly yellow." *Tylopilus rhoadsiae* has a club-shaped stalk with a pinched base, prominent white reticulation that darkens to brown in age, and smaller, smooth spores measuring 11–13.5 × 3.5–4.5 μm. The Graceful Bolete, *Austroboletus gracilis* (see Color Key), edible, has a maroon to reddish brown or cinnamon cap and a white pore surface that becomes pinkish to pinkish brown, and it bruises brownish. The stalk is long and slender in proportion to cap diameter, colored like the cap or paler, with elevated, anastomosing, rib-like lines sometimes forming an obscure reticulation overall or on the upper half. The basal mycelium is white. Flesh is white or pale pinkish and unchanging. The spore deposit is pinkish to reddish brown. It grows on the ground or decaying wood in conifer or broadleaf forests.

Baorangia bicolor group (Kuntze) G. Wu, Halling, & Zhu L. Yang

= *Boletus bicolor* Peck
= *Boletus bicolor* var. *subreticulatus* A. H. Sm. & Thiers

COMMON NAME: Red and Yellow Bolete, Two-colored Bolete

MACROSCOPIC FEATURES: cap 5–12.5 cm wide, convex, becoming nearly flat, dry, somewhat velvety, usually developing cracks in dry weather or when mature, dark red to rose red, fading to pale brownish orange-yellow or tan in age; margin initially incurved. **pore surface** bright yellow when young, olive yellow in age, quickly bruising blue; **tubes** 3–10 mm deep. **stalk** nearly equal or enlarged downward, solid, dry, smooth, rarely reticulate on the upper portion, yellow at the apex, red or rose red lower down, unchanging or slowly bluing when bruised or cut. **flesh** yellow, deeper bright yellow in the stalk, unchanging or slowly and erratically staining blue when cut; odor and taste not distinctive.

MICROSCOPIC FEATURES: Spores 8–12 × 3.5–5 μm, oblong to slightly ventricose, smooth, pale brown.

SPORE PRINT: Olive brown.

HABIT, HABITAT, AND SEASON: Solitary, scattered, or in groups associated with oaks; summer–fall.

EDIBILITY: Edible.

COMMENTS: *Bicolor* means "having two colors." *Boletus sensibilis* quickly bruises blue on all parts. The flesh smells of fenugreek or curry. The Pale Rose Bolete, *Lanmaoa pallidorosea* (see Color Key), edible, smells like beef bouillon. The pinkish to purplish red cap stains crimson, then dark olive with NH_4OH. The stalk is yellow, sometimes reticulate at the apex, with pinkish to reddish tones downward. The yellow pores stain blue; tubes are 4–8 mm deep. Both the whitish cap flesh and yellow stalk flesh can slowly stain blue. The beech associate *Boletus rufomaculatus* (not illustrated), edibility unknown, has a mottled brick red to brownish red cap with a sterile margin and paler yellow stalk flesh. All parts stain blue, though slowly and weakly in the cap flesh.

Boletellus ananas (M. A. Curtis) Murrill

= *Boletus ananas* M. A. Curtis

COMMON NAME: Pineapple Bolete

MACROSCOPIC FEATURES: cap 3–10 cm wide, convex to broadly convex, dry, coated with coarse, overlapping, purplish red to dark red scales that become dull pinkish tan to dingy yellow and extend beyond the margin in age; margin fringed with whitish partial veil fragments. **pore surface** yellow when young, tinged reddish brown at maturity, bruising blue, initially covered by a whitish partial veil; **tubes** 9–16 mm deep. **stalk** enlarged downward or nearly equal, dry, slightly fibrillose, white to pale tan, at times with a reddish zone near the apex, usually lacking a ring. **flesh** whitish on exposure, quickly yellowing, then blue and finally bluish gray; odor and taste not distinctive.

MICROSCOPIC FEATURES: Spores 15–24 × 7–11 μm, fusoid, with longitudinally ridged and spirally arranged wings, pale brown.

SPORE PRINT: Dark rusty brown to dark brown.

HABIT, HABITAT, AND SEASON: Scattered or in groups, typically on the bases of oaks or pines but occasionally on the ground; spring–fall or year-round during mild winters.

EDIBILITY: Edible.

COMMENTS: *Ananas* is the genus name for pineapple. *Boletellus chrysenteroides* (not illustrated), edible, has a 3–6 cm wide cap that is initially dark brown and velvety, then chestnut brown and often cracked in age with whitish exposed flesh. The pore surface is pale yellow when young and darker yellow to greenish yellow in age, and it quickly stains blue when cut or bruised. The stalk is reddish to blackish brown, decorated with dark brown punctae, and stains blue, then slowly reddish when bruised. The whitish to pale yellow flesh stains blue, often slowly, when exposed. It grows on decaying wood, especially oaks, at the base of standing trunks or sometimes on the ground. See also *Suillus spraguei*, which only grows with White Pine.

Boletinellus merulioides (Schwein.) Murrill

= *Gyrodon merulioides* (Schwein.) Singer

COMMON NAME: Ash Tree Bolete
MACROSCOPIC FEATURES: cap 4–12.5 cm wide, initially convex with an incurved margin, becoming depressed at the center to nearly funnel-shaped in age, often kidney-shaped, slightly velvety when young, somewhat sticky and shiny when moist, smooth, yellow to olive or reddish brown. **pore surface** decurrent, elongated and radially arranged with gill-like ridges and crosswalls, yellow, dull golden yellow, or olive, usually slowly bruising greenish blue; **tubes** 3–6 mm deep, not easily separated from the cap flesh. **stalk** short, solid, eccentric to nearly lateral but occasionally central, often curved and pinched at the base, dry, colored on the upper portion like the pore surface, brownish to blackish at the base, sometimes mottled with reddish brown and bruising reddish brown. **flesh** thick in the center, thinning toward the cap margin, yellow, typically unchanging but sometimes staining bluish when exposed, usually reddish brown around larval tunnels and at the stalk base; odor musty and unpleasant or not distinctive, taste described as resembling raw potatoes or not distinctive.
MICROSCOPIC FEATURES: Spores 7–11 × 6–7.5 μm, broadly elliptic to nearly globose, smooth, pale yellow in water mounts, ochraceous in KOH.
SPORE PRINT: Olive brown.
HABIT, HABITAT, AND SEASON: Solitary or in groups on the ground, sometimes on wood, near or under ash trees; summer–fall.
EDIBILITY: Edible.
COMMENTS: Although the Ash Tree Bolete occurs with ash trees it is not mycorrhizal with them. Instead, it has evolved a relationship with parasitic aphids that shelter in underground knots of fungal tissue called sclerotia. The fungus benefits from aphid rent paid in the form of nutritious honeydew. Additional information about this bolete and its relationship with the aphids can be found in Brundrett and Kendrick (1987).

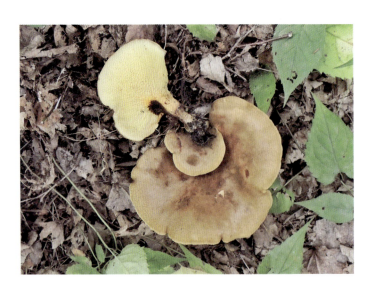

Boletus aureissimus (Murrill) Murrill

= *Boletus auripes* var. *aureissimus* (Murrill) Singer
= *Ceriomyces aureissimus* Murrill

COMMON NAMES: Golden Yellow Bolete, Southern Gold

MACROSCOPIC FEATURES: cap 4–14 cm wide, obtuse when young, becoming broadly convex to nearly flat, dry, bald, honey yellow to bright yellow or yellow-ocher, often duller when mature. **pore surface** pale yellow to yellow, olive yellow at maturity, frequently depressed at the stalk in age, unchanging when bruised; **tubes** 1–2.5 cm deep. **stalk** typically bulbous to club-shaped when young, nearly equal in age, solid, dry, yellow to bright yellow, fine yellow reticulation common on the upper portion but not always present. **flesh** yellow, unchanging; odor and taste not distinctive.

MICROSCOPIC FEATURES: Spores 10–14 × 3–5 μm, ellipsoid-cylindric to subfusoid, smooth, yellowish.

SPORE PRINT: Yellow-brown to olive brown.
HABIT, HABITAT, AND SEASON: Solitary, scattered, or in groups with oaks; summer–fall.
EDIBILITY: Edible.
COMMENTS: The epithet *aureissimus* means "golden yellow." *Boletus auripes* is similar, but the darker cap ranges from yellowish to chestnut brown, purplish brown, or grayish brown above a golden yellow stalk and yellow reticulation. *Retiboletus ornatipes* has a darker yellow or gray cap, prominent and coarse reticulation over most of the length of the stalk, and bitter-tasting flesh. *Boletus ochraceoluteus* (see Color Key), edibility unknown, has a 2–7 cm wide, ochraceous yellow to orange-ocher cap, bright yellow flesh that stains reddish, then bluish green, and a bright yellow pore surface. The cap surface stains bluish green with NH_4OH. It grows in mixed oak and pine woods from summer to fall.

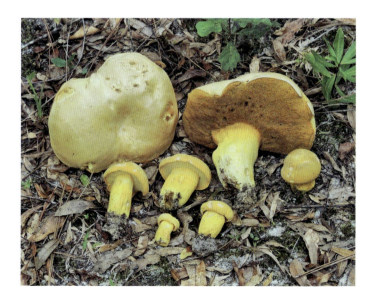

Boletus auripes Peck

COMMON NAME: Butter Foot Bolete
MACROSCOPIC FEATURES: cap 4–13 cm wide, initially cushion-shaped, broadly convex to nearly flat at maturity, dry, finely velvety to nearly bald, yellowish brown to chestnut or grayish brown, becoming paler in age; margin even. **pore surface** light yellow to yellow, maturing to olive yellow, not bluing when bruised, often depressed around the stalk; **tubes** 1–2.5 cm deep. **stalk** typically bulbous to club-shaped when young, club-shaped to nearly equal in age, solid, dry, golden yellow with yellow reticulation on at least the upper portion. **flesh** bright yellow, intensifying when rubbed or bruised, not staining blue when exposed; odor and taste not distinctive.
MICROSCOPIC FEATURES: Spores 10–14 × 3–5 μm, ellipsoid-cylindric to subfusoid, smooth, yellowish.
SPORE PRINT: Yellow-brown to olive brown.
HABIT, HABITAT, AND SEASON: Solitary, scattered, or in groups in broadleaf forests, especially with oaks and beeches, sometimes in grassy areas; summer–fall.
EDIBILITY: Edible.
COMMENTS: *Auripes* means "golden yellow foot." *Boletus aureissimus* is very similar but has a honey yellow to bright yellow or yellow-ocher cap and finer reticulation on the stalk.

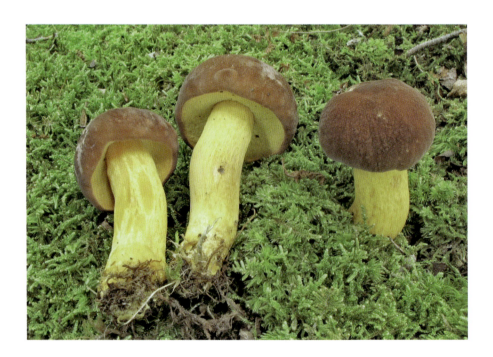

Boletus luridellus (Murrill) Murrill

= *Boletus subsensibilis* (Murrill) Murrill

MACROSCOPIC FEATURES: cap 4–12 cm wide, cushion-shaped, becoming broadly convex, dry, sometimes cracked, velvety to nearly bald, initially yellow-brown to amber brown, or streaked dull brown over a yellow ground color, at maturity ochraceous tawny to hazel; margin sterile. **pore surface** initially yellow, becoming greenish to olive yellow, depressed around the stalk at maturity, quickly staining blue when bruised; **tubes** 8–16 mm deep. **stalk** nearly equal or tapered in either direction, at times swollen near the middle, solid, dry, covered with brown reticulation on the upper portion or at least apically, yellow on the upper portion or nearly overall, often with tiny brownish punctae and streaks, dark red to brownish red near the base, quickly staining blue when bruised. **flesh** yellow above red in the stalk base, quickly staining blue when cut; odor and taste not distinctive.

MICROSCOPIC FEATURES: Spores 12–17 × 4–6 μm, fusoid, smooth, pale yellow-brown.
SPORE PRINT: Olive brown.
HABIT, HABITAT, AND SEASON: Scattered or in groups in oak and pine woods or adjacent grassy areas; summer–fall.
EDIBILITY: Edible.
COMMENTS: *Luridellus* means "dirty brownish." The Patriotic Bolete, *Boletus patrioticus* (see Color Key), edible, has a 3–13 cm wide, dry cap that is olive when very young but soon turns pinkish red to pale reddish brown, often with a darker margin. Pores are yellow and stain blue. The stalk is dry, nonreticulated, usually rosy red over a yellowish ground color on the upper portion or nearly overall and olive toward the base. The acidic-tasting flesh is whitish, pinkish red under the cuticle, bruising blue-green or reddish elsewhere. Spores measure 10–13 × 4–5.5 μm. It grows in grassy areas or woodlands with oaks. Also compare with *Boletus miniato-olivaceus* (not illustrated); see Comments under *Boletus sensibilis*.

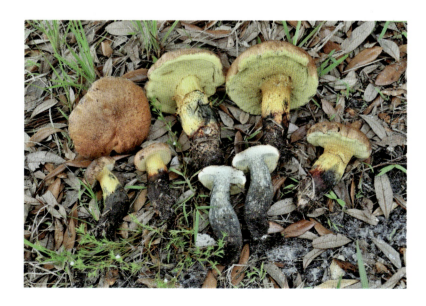

Boletus nobilis Peck

COMMON NAME: Noble Bolete

MACROSCOPIC FEATURES: cap 7–20 cm wide, convex, becoming broadly convex to nearly flat, dry, smooth, bald, yellowish or reddish brown at first, later ochraceous to olive ochraceous or reddish ochraceous; margin even. **pore surface** initially white, then yellow to pale ochraceous or brownish yellow, usually slightly depressed around the stalk in age; **tubes** 8–25 mm deep. **stalk** variably equal, centrally swollen, or enlarged near the base, solid, dry, white to pale tan, finely reticulate near the apex or on the upper half and bald below, rarely bald overall. **flesh** white, becoming yellowish near the tubes, unchanging; odor and taste not distinctive.

MICROSCOPIC FEATURES: Spores 11–16 × 4–5 μm, subfusiform, smooth, pale olivaceous.

SPORE PRINT: Dull ocher-brown to dull rusty brown.

HABIT, HABITAT, AND SEASON: Solitary, scattered, or in groups with broadleaf trees, especially oaks and beeches; summer–fall.

EDIBILITY: Edible.

COMMENTS: *Nobilis* means "noble or grand." *Boletus variipes* has a darker cap and prominent reticulation usually covering most of the stalk.

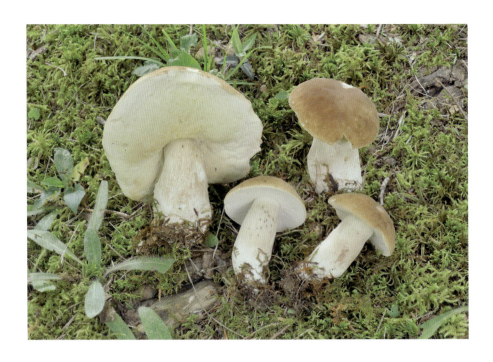

Boletus oliveisporus (Murrill) Murrill

= *Ceriomyces oliveisporus* Murrill

MACROSCOPIC FEATURES: cap 5–18 cm wide, convex, becoming broadly convex to nearly flat, dry, slightly velvety, usually finely cracked in age, reddish orange overall, may be paler yellow-orange near the margin when young, later dark fulvous-tinged with bay or cinnamon to dull brown, somewhat shiny in age, rapidly staining blue-black when bruised; the margin sterile. **pore surface** yellow to greenish yellow, becoming olive yellow, then olive brown, depressed around the stalk in age, rapidly staining blue when bruised; **tubes** 5–20 mm deep. **stalk** tapered in either direction or nearly equal, solid, dry, covered with distinct brown punctae nearly overall or sometimes nearly bald, at first yellow with reddish tinges, turning olive brown from the base upward in maturity, rapidly staining blue-black when bruised, with or without reticulation on the upper portion, conspicuously longitudinally striate. **flesh** yellow, reddish brown at the very base and around larval tunnels, staining blue when cut, sometimes slowly; odor and taste not distinctive.

MICROSCOPIC FEATURES: Spores 11–17 × 4–6 μm, fusoid, smooth, ochraceous.

SPORE PRINT: Olive brown.

HABIT, HABITAT, AND SEASON: Solitary, scattered, or in groups on the ground or on pine stumps; summer–fall.

EDIBILITY: Unknown.

COMMENTS: *Oliveisporus* means "olive-colored spores." All parts of this bolete instantly stain dark blue when handled or bruised. *Cyanoboletus cyaneitinctus* has a smaller, darker brown cap, raised longitudinal ridges on the stalk, and a cap surface that displays a green flash with NH_4OH.

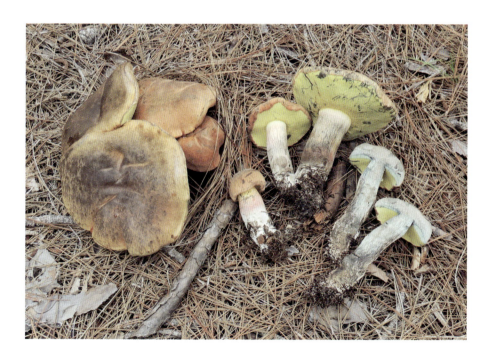

Boletus projectelloides B. Ortiz, Both, Halling, & T. J. Baroni

COMMON NAME: Long-legged White Foot
MACROSCOPIC FEATURES: cap 4–16 cm wide, cushion-shaped to convex-depressed, becoming broadly convex to nearly flat, sticky when fresh, shiny when dry, densely matted and woolly, pinkish brown to reddish tan, retaining these colors well into maturity; margin incurved when young, even. **pore surface** yellow at first, becoming olive yellow and finally dark olive in age, staining dull reddish brown when bruised, not bluing, depressed around the stalk, pores angular, 1–2 per mm; **tubes** 1–2.6 cm deep. **stalk** solid, nearly equal or slightly enlarged in either direction, with a pinched base, typically curved near the base, longitudinally striate, lacking reticulation, colored like the cap, and covered nearly overall with fine pinkish brown punctae, the base coated with white mycelium extending upward as much as 3 cm. **flesh** whitish to pale yellow, reddish under the cuticle, slowly staining pinkish red, then brownish when exposed or bruised, not bluing; odor and taste not distinctive.
MICROSCOPIC FEATURES: Spores 12–17 × 7–8 μm, thin-walled and fragile, oblong-elliptic, brownish.
SPORE PRINT: Olive brown.
HABIT, HABITAT, AND SEASON: Solitary or scattered on the ground under pine or in mixed oak and pine woods; summer–early winter.
EDIBILITY: Edible.
COMMENTS: The cap surface stains dark maroon to reddish brown with KOH, is very dark olive with NH_4OH, and is negative with $FeSO_4$; the flesh exhibits an olive flash, then becomes dark amber with KOH, stains very pale blue with NH_4OH, and is faintly grayish olive with $FeSO_4$. The epithet *projectelloides* means "resembling *Aureoboletus projectellus*" (not illustrated), edible, which has similar colors and a long stalk, but the stalk is reticulated rather than longitudinally lined, and the cap margin projects conspicuously beyond the tube layer as a sterile margin. Spores are huge, measuring 18–33 × 7.5–12 μm.

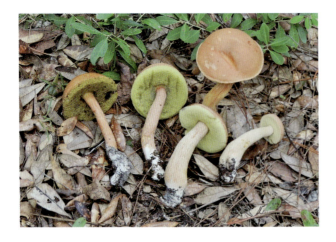

Boletus pseudopinophilus
A. R. Bessette, Bessette, J. Craine, & J. L. Frank

= *Boletus edulis* f. *pinicola* (Vittad.) Vassilkov
= *Boletus pinicola* (Vittad.) A. Venturi

COMMON NAME: Pine-loving King Bolete
MACROSCOPIC FEATURES: cap 5–15 cm wide, initially convex, becoming broadly convex to nearly flat, dry, usually wrinkled or shallowly pitted, reddish to dark rusty brown; margin incurved at first, sterile or nearly even. **pore surface** whitish when young, turning yellow to olive or brownish yellow by maturity, bruising rusty brown, depressed around the stalk in age; **tubes** 8–25 mm deep. **stalk** enlarged downward, occasionally bulbous, solid, dry, white to pale yellow near the apex, pale brown to brown below, darkening when handled or bruised, reticulate overall or at least the upper two-thirds, reticulum whitish near the apex, brownish below, darkening when handled. **flesh** pinkish brown under the cuticle, whitish elsewhere, unchanging when cut or exposed; odor spicy or not distinctive, taste not distinctive.
MICROSCOPIC FEATURES: Spores 15–20 × 4–6 μm, fusoid to cylindric, smooth, yellowish.
SPORE PRINT: Dark olive to olive brown.
HABIT, HABITAT, AND SEASON: Solitary, scattered, or in groups with conifers, especially pines, sometimes buried in duff; spring–fall.
EDIBILITY: Edible.
COMMENTS: *Pseudopinophilus* means "false *pinophilus*," a reference to the European *Boletus pinophilus*. The King Bolete, *Boletus edulis* (not illustrated), edible, has a 4–20 cm wide, brown to rusty red or tan cap. Its pore surface is white at first, then brownish yellow to brown and rarely stains blue when bruised. The stalk is enlarged downward, sometimes bulbous, covered with a fine white reticulum overall or at least on the upper third. The flesh is white and does not stain blue when exposed. King Boletes grow on the ground with conifers, especially Norway spruce; summer–fall.

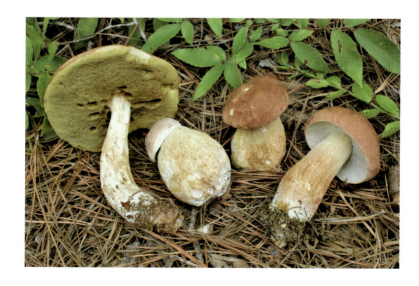

Boletus rubissimus A. H. Sm.

MACROSCOPIC FEATURES: cap 4–9 cm wide, broadly convex, dry, unpolished, pinkish red to rose red, sometimes with a yellow or ochraceous margin, covered with a hoary sheen when very fresh; the margin even. **pore surface** yellow, dingy brownish yellow in age, staining blue when bruised; **tubes** 2–4 mm deep. **stalk** nearly equal above a tapered base, solid, dry, yellow, usually with reddish tints toward the base, reticulate on the upper portion or nearly overall, showing white to pale yellow basal mycelium. **flesh** pale yellow, not staining or sometimes erratically and weakly bluing; odor and taste not distinctive.

MICROSCOPIC FEATURES: Spores 9–11 × 3–4.5 μm, oblong to narrowly ellipsoid, hyaline to yellowish.

SPORE PRINT: Olive brown.

HABIT, HABITAT, AND SEASON: In groups on the ground in grassy areas near oaks or pines; summer–fall.

EDIBILITY: Unknown.

COMMENTS: *Rubissimus* means "pinkish red." Pinkish areas of the cuticle slowly stain yellow with KOH. *Butyriboletus roseopurpureus* (not illustrated), edible, has a pinkish purple to dark purplish red cap with a golden to lemon yellow pore surface that matures to yellowish olive and instantly stains dark blue to greenish blue when bruised. The stalk is reticulate overall or at least the upper two-thirds, bright yellow, occasionally with red areas near a base covered in white mycelium. The pale yellow flesh instantly stains dark blue. Ordinarily terrestrial, it can rarely occur on decayed wood and is associated with oaks. Roody's Bolete, *Boletus roodyi* (not illustrated), edible, has a pinkish red or darker red cap, very pale yellow flesh, a bright yellow to pale golden yellow pore surface aging to greenish yellow, and a yellow stalk with red tints on the lower portion. The stalk is not reticulate, and no part of the fruit body stains blue when bruised.

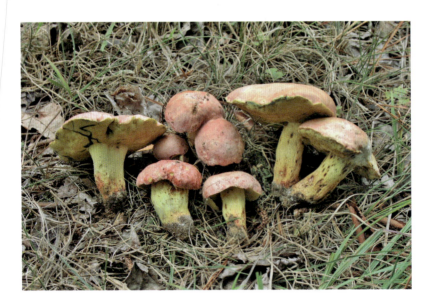

Boletus sensibilis Peck

= *Boletus miniato-olivaceus* var. *sensibilis* (Peck) Peck

= *Boletus sensibilis* var. *subviscidus* A. H. Sm. & Thiers

COMMON NAME: Sensitive Bolete

MACROSCOPIC FEATURES: **cap** 5–16 cm wide, convex at first, becoming broadly convex, dry, velvety when young, nearly smooth when mature, pale to dark brick red, in age dull rose, dingy cinnamon, or pale brown, quickly bruising blue; margin even. **pore surface** yellow at first, duller or browner in age, immediately staining blue when bruised; **tubes** 8–12 mm deep. **stalk** equal or slightly enlarged downward, solid, dry, mostly yellow but often tinged pink or red toward the base, sometimes finely reticulate at the apex, quickly staining blue when bruised or handled. **flesh** pale yellow, brighter yellow in the stalk, quickly staining blue when exposed; odor faintly fruity or sweet like maple syrup, fenugreek, curry, or licorice, taste not distinctive.

MICROSCOPIC FEATURES: Spores 10–13 × 3.5–4.5 µm, suboblong to slightly ventricose, smooth, pale brown.

SPORE PRINT: Olive brown.

HABIT, HABITAT, AND SEASON: Scattered or in groups, usually in broadleaf forests; summer–fall.

EDIBILITY: Edible; previously considered toxic, now known to be safely consumed if thoroughly cooked.

COMMENTS: *Sensibilis* means "sensitive," referring to the fact that all parts of this bolete stain blue when bruised. The cap surface stains yellow with KOH or NH_4OH and greenish gray with $FeSO_4$. The Red and Olive Velvet-cap, *Boletus miniato-olivaceus* (not illustrated), has a velvety, red to rose red cap that soon develops olive tones and stains dark blue. Pores are yellow to olive yellow and quickly stain blue. The yellow stalk is ornamented with delicate reddish punctae and sometimes apical reticulation. Flesh is dull white to pale yellow, slowly staining blue and lacking a distinctive odor. Spores are large, measuring 10–15(–18) × 4–6(–7) µm.

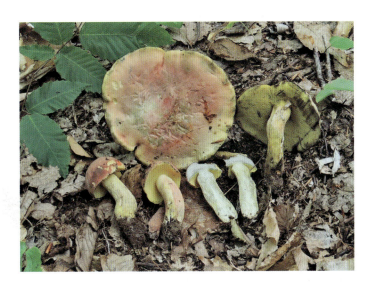

Boletus separans Peck

= *Boletus pseudoseparans* Grand & A. H. Sm.
= *Xanthoconium separans* (Peck) Halling & Both

COMMON NAME: Eastern King, Lilac Bolete
MACROSCOPIC FEATURES: cap 5–15 cm wide, convex when young, becoming broadly convex, dry, bald or somewhat velvety, typically pitted, wrinkled, or lumpy and uneven, creamy white tinged with lilac, to pinkish brown, lilac brown, or reddish brown, occasionally even dark purple, aging to yellowish brown or nearly bronze, usually paler near the margin; margin even. **pore surface** initially white, becoming yellowish to ocher-brown and unchanging when bruised; **tubes** 1–3 cm deep. **stalk** equal or enlarged downward, solid, dry, colored like the cap or paler, usually with lilac in the midportion, sometimes purplish overall, covered with a fine white reticulum over most of its length or at least on the upper half. **flesh** white, unchanging; odor not distinctive, taste sweet and nutty or not distinctive.
MICROSCOPIC FEATURES: Spores 12–16 × 3.5–5 μm, narrowly subfusiform, smooth, pale brown.
SPORE PRINT: Brownish ocher to pale reddish brown.
HABIT, HABITAT, AND SEASON: Solitary, scattered, or in clusters in mixed woods, oak woods, or sometimes with pines; summer–winter.
EDIBILITY: Edible.
COMMENTS: *Separans* means "separating," referring to the tube layer that sometimes pulls away from the stalk as the cap expands. Lilac areas of the cap and stalk stain aquamarine to deep blue with NH_4OH. *Xanthoconium purpureum* (see Color Key and Comments under *Xanthoconium affine*), edible, has a darker cap and stalk without lilac tones. Its pore surface stains yellow-brown to brown when bruised.

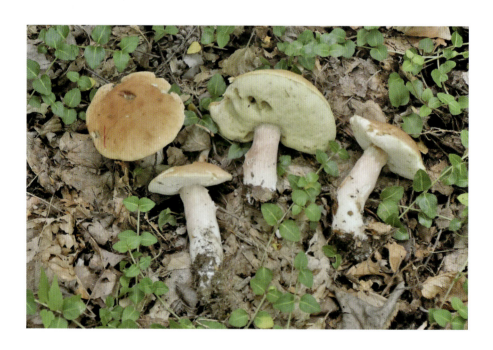

Boletus subgraveolens A. H. Sm. & Thiers

MACROSCOPIC FEATURES: cap 4–15 cm wide, initially convex, then broadly convex to flat, dry or slightly sticky, smooth but often cracked when the weather is hot and dry, dull yellow-brown, sometimes mottled with darker or paler shades of yellow or brown, when fresh typically staining dark blue that slowly changes to brown; margin even and initially incurved. **pore surface** brownish yellow when very young, maturing to bright yellow-brown and paler in age, depressed near the stalk, bruising dark blue, then slowly brown; **tubes** 6–13 mm deep. **stalk** tapered downward, usually pinched or pointed at the base, solid, dry, bright yellow at the apex, dull pale yellow and pruinose below, dark vinaceous red to maroon at the base, developing yellowish brown tints from the base upward in age or when handled, sometimes bruising bluish. **flesh** whitish to pale yellow, staining blue when exposed, eventually becoming orange-brown to reddish brown, darker in the stalk; odor disagreeably pungent, taste not distinctive.

MICROSCOPIC FEATURES: Spores 9–13 × 3.5–4.5 µm, subfusiform, smooth, yellowish brown.

SPORE PRINT: Olive brown.

HABIT, HABITAT, AND SEASON: Solitary, scattered, or in groups under broadleaf trees, especially aspens and oaks; summer–early winter.

EDIBILITY: Unknown.

COMMENTS: *Subgraveolens* means "somewhat strong-smelling." Dried specimens of this bolete have a distinctly unpleasant aroma. The cap surface displays a blue flash, then slowly stains vinaceous with NH_4OH. Both *Boletus vermiculosoides* (not illustrated), edibility unknown, and *Boletus vermiculosus* (not illustrated), edibility unknown, are similar but lack the bright yellow at the stalk apex and the reddish coloration at the base. These two are best separated microscopically. *Boletus vermiculosoides* has spores measuring 9–12 × 3–4 µm. The spores of *Boletus vermiculosus* are larger, 11–15 × 4–5 µm.

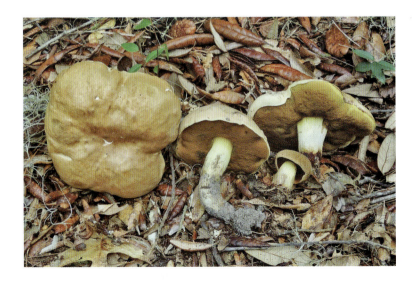

Boletus subluridellus A. H. Sm. & Thiers

MACROSCOPIC FEATURES: cap 5–12 cm wide, convex becoming broadly convex, dry, somewhat velvety, color variable, ranging from pinkish red to orange-red, purplish red, or brownish red, instantly staining blackish blue when bruised; margin sterile. **pore surface** pinkish red, rosy red, or dark red at first, becoming orange-red in age, quickly staining blue when bruised; **tubes** 6–10 mm deep. **stalk** nearly equal, solid, dry, pale yellow, darkening from the base upward in age or where handled, usually faintly pruinose or scurfy, often staining faintly gray-blue where handled. **flesh** bright yellow, quickly staining dark blue upon exposure; odor and taste not distinctive.

MICROSCOPIC FEATURES: Spores 11–15 × 4–6 μm, subfusoid with a minute apical pore, smooth, dull yellowish.

SPORE PRINT: Olive brown.

HABIT, HABITAT, AND SEASON: Scattered or in groups on the ground with broadleaf trees, especially oaks, or in mixed woods with oaks present; summer–early winter.

EDIBILITY: Unknown.

COMMENTS: *Suillellus subvelutipes* has a more orange to brownish cap and often has bristle-like red or yellow hairs on its stalk base that are especially visible upon drying. *Suillellus subluridus* (not illustrated), edibility unknown, has a cap ranging from orange-yellow to orange with purple stains or entirely purplish red. The stalk is yellow near the apex, minutely punctate and reddish below, lacking basal hairs. Flesh is yellow, staining blue when exposed, as do the purple-red to dark red pores. It is found with oaks and pines during summer and fall. *Boletus flammans* (not illustrated), edibility unknown, has a rosy red to dark red cap, yellowish flesh without a distinctive odor, a bright red to orange-red pore surface that is sometimes yellow at the apex, and a rosy red to dark red stalk that is finely reticulate. All parts stain blue. It grows on the ground with conifers.

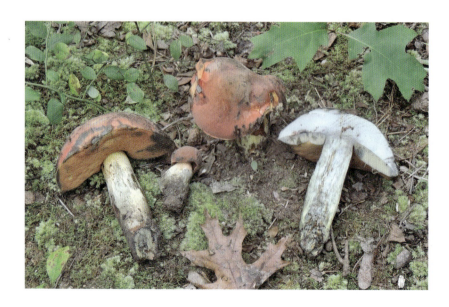

Boletus variipes Peck

= *Boletus variipes* var. *fagicola* A. H. Sm. & Thiers
= *Boletus variipes* var. *variipes* Peck

COMMON NAME: Variable-stalk Bolete
MACROSCOPIC FEATURES: **cap** 6–20 cm wide, convex, becoming broadly convex or flattening, dry, somewhat velvety to nearly smooth, creamy tan to yellowish tan, yellow-brown to grayish brown, or dark brown, usually cracked in age; margin even. **pore surface** white at first, becoming yellowish to yellowish olive in age, unchanging when bruised; **tubes** 1–3 cm deep. **stalk** equal or enlarged downward, solid, dry, whitish to yellow-brown or grayish brown, usually with white or brown reticulation that might not be obvious. **flesh** white, unchanging when exposed; odor and taste not distinctive.
MICROSCOPIC FEATURES: Spores 12–18 × 4–6 μm, subfusoid, smooth, yellow.
SPORE PRINT: Olive brown.
HABIT, HABITAT, AND SEASON: Scattered or in groups associated with broadleaf trees such as oaks, beeches, or aspens, sometimes with conifers, especially pines; spring–fall.
EDIBILITY: Edible.
COMMENTS: *Variipes* means "variable foot," referring to the color, shape, and amount of reticulation on its stalk. The cap of the Bitter Bolete, *Tylopilus felleus* (not illustrated), is initially pinkish brown, then eventually some shade of brown or tan. The young white pores become pinkish brown in age. Its mostly brown stalk is reticulated over at least the upper half, and the flesh tastes bitter. It fruits predominantly under conifers. *Boletus nobilis* has a taller stature, a paler and often pitted cap, a white to pale tan stalk, and reticulation that is delicate and normally limited to the upper portion of the stalk. Another look-similar with a pitted brown cap is *Hemileccinum hortonii*, which initially has a yellow pore surface.

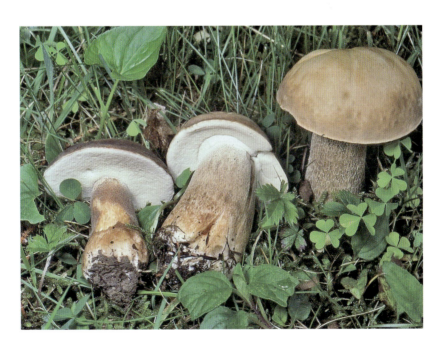

Buchwaldoboletus hemichrysus (Berk. & M. A. Curtis) Pilát

= *Boletus hemichrysus* Berk. & M. A. Curtis
= *Pulveroboletus hemichrysus* (Berk. & M. A. Curtis) Singer

COMMON NAME: Half Yellow Powdery Bolete
MACROSCOPIC FEATURES: cap 3–8 cm wide, obtuse to convex, broadly convex in age, dry, floccose-scaly to velvety, often cracked when mature, bright yellow to golden yellow, coated with yellow powder; margin even, incurved at first and remaining so into maturity. **pore surface** yellow when very young, soon reddish brown, attached or subdecurrent at the stalk, staining dark blue when bruised; **tubes** up to 1 cm deep. **stalk** equal or tapered in either direction, often with a narrowed base, solid, dry, yellow like the cap or tinged reddish brown, often showing yellowish basal mycelium. **flesh** yellow, unchanging or staining blue, sometimes slowly; odor not distinctive, taste slightly acidic or not distinctive.
MICROSCOPIC FEATURES: Spores 6–9 × 2.5–4 μm, ellipsoid to subfusoid, smooth, yellowish.
SPORE PRINT: Olive brown.
HABIT, HABITAT, AND SEASON: Solitary or scattered on pine wood, often at the base of trunks or on the ground attached to buried roots; late spring–early winter.
EDIBILITY: Unknown.
COMMENTS: *Hemichrysus* means "half yellow." The cap surface stains dark amber with KOH or NH_4OH and yellow-brown to gold with $FeSO_4$. Its flesh stains olive to olive gray with a darker ring with KOH, olive yellow, then soon fading with NH_4OH, and slowly pale gray with $FeSO_4$. *Buchwaldoboletus lignicola* has a scaly or velvety and suede-like yellowish brown to reddish brown cap and a more persistently yellow pore surface. *Buchwaldoboletus sphaerocephalus* (not illustrated), edibility unknown, commonly fruits on pine sawdust, also on pine wood. The cap is sulfur yellow, pale yellow to whitish in age, slightly sticky, and bald. Its yellow pore surface matures to dull or brownish yellow. The yellow stalk lacks reddish or brown tones.

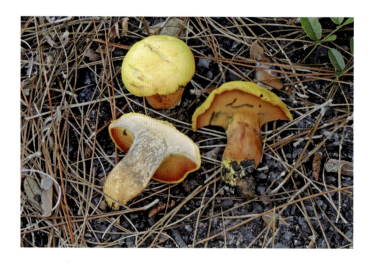

Buchwaldoboletus lignicola (Kallenb.) Pilát

= *Boletus lignicola* Kallenb.
= *Pulveroboletus lignicola* (Kallenb.) E. A. Dick and Snell

MACROSCOPIC FEATURES: cap 2.5–12 cm wide, convex when young, later broadly convex, dry, velvety and suede-like, at times finely cracked in age, reddish to yellow-brown or rusty golden yellow, often darker brown at the margin, sometimes staining darker brown when bruised; margin sterile and wavy, inrolled when young and remaining so well into maturity. **pore surface** initially yellow, becoming golden yellow to brownish yellow when mature, subdecurrent, bruising dark greenish blue to blackish blue, then fading to reddish brown; **tubes** 3–12 mm deep. **stalk** equal or tapered in either direction, typically narrowed at the base, often eccentric, solid, dry, somewhat velvety, golden mustard yellow at the apex and reddish brown to yellow-brown below, staining darker brown when bruised, often with a fine reddish reticulum at the apex; basal mycelium yellow. **flesh** firm, pale yellow, quickly or slowly staining blue when cut, rusty toward the base; odor sweet, somewhat minty or citrus-like, taste weakly acidic or not distinctive.

MICROSCOPIC FEATURES: Spores 6–10 × 3–4 μm, ellipsoid, smooth, yellowish.

SPORE PRINT: Olive brown.

HABIT, HABITAT, AND SEASON: Solitary or scattered with pines, usually at the base of the tree or on stumps or roots, in pine or mixed oak and pine woods; late spring–early winter.

EDIBILITY: Unknown.

COMMENTS: *Lignicola* means "growing on wood." The cap surface immediately stains intense black with NH_4OH and is negative with $FeSO_4$. *Phaeolus schweinitzii* is a polypore that often fruits with this bolete. Microscopic studies have shown *Buchwaldoboletus lignicola* to be parasitic on *Phaeolus schweinitzii* (Nuhn et al. 2013). *Buchwaldoboletus hemichrysus* is similar, but it has a brighter yellow to golden yellow, very powdery cap and a reddish brown pore surface.

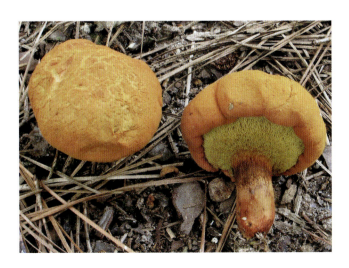

Caloboletus inedulis (Murrill) Vizzini

= *Boletus inedulis* (Murrill) Murrill
= *Ceriomyces inedulis* (Murrill)

COMMON NAME: Rosy-footed Oak Bolete
MACROSCOPIC FEATURES: cap 4–12 cm wide, convex, becoming broadly convex, dry, initially coated with tiny, cottony, matted fibers, whitish to pale pinkish gray, darkening to olivaceous brown or grayish brown, cracking in age; margin sterile, incurved to inrolled and remaining so well into maturity. **pore surface** pale yellow, turning olive yellow, staining dark blue, then brownish when bruised; **tubes** 8–16 mm deep. **stalk** nearly equal, solid, dry, pale yellow to yellow, sometimes with a pinkish to pinkish red zone at the apex or downward, especially near the base, with yellow, reddish, or brownish reticulation at least on the upper portion, staining blue when bruised. **flesh** whitish to yellowish, staining blue when exposed; odor not distinctive, taste bitter.
MICROSCOPIC FEATURES: Spores 9–13 × 3.3–4.5 μm, subfusoid, smooth, ochraceous.
SPORE PRINT: Olive brown.
HABIT, HABITAT, AND SEASON: Scattered or in groups in broadleaf or mixed woods, especially with oaks; summer–fall.
EDIBILITY: Inedible because of the bitter taste.
COMMENTS: *Inedulis* means "inedible." *Caloboletus firmus* (not illustrated), inedible, has a whitish, pale grayish olive, light gray, or tan cap, whitish flesh that blues upon exposure, and a pinkish red to red-orange pore surface that also bruises blue. The stalk is colored like the cap and ornamented with fine red reticulation near the apex or nearly overall; it stains olive to brownish when handled. It grows with broadleaf trees, spring–fall. *Caloboletus peckii* (not illustrated), edibility unknown, has a somewhat velvety rose to deep red cap that turns brownish red in age, whitish flesh that lightly stains blue, a yellow pore surface staining blue, then brownish. The red stalk is typically reticulate overall.

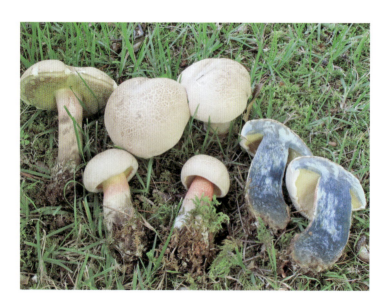

Chalciporus piperatoides (A. H. Sm. & Thiers) T. J. Baroni & Both

= *Boletus piperatoides* A. H. Sm.

COMMON NAME: Blue-staining Peppery Bolete

MACROSCOPIC FEATURES: **cap** 3–8 cm wide, convex, then broadly convex, sticky when wet, velvety and streaked with tiny fibers and scales when young, becoming smooth or cracked in age, color variable from dull orange to cinnamon, buff, yellow-brown, or reddish brown; margin inrolled at first, with a narrow sterile zone. **pore surface** reddish brown to cinnamon brown or yellowish brown, staining dark blue; the angular pores may appear to radiate from the stalk; **tubes** 4–10 mm deep. **stalk** nearly equal, solid, scurfy, colored like the cap or paler with bright yellow basal mycelium. **flesh** pinkish buff to brown, staining dark blue above the tube layer; odor not distinctive, taste slowly acrid.

MICROSCOPIC FEATURES: Spores 7–9 × 3–4 μm, subfusiform, smooth, pale brown.

SPORE PRINT: Dark olive, drying cinnamon.

HABIT, HABITAT, AND SEASON: Solitary or in groups with conifers or broadleaf trees or in grassy woodland margins; spring–fall.

EDIBILITY: Inedible.

COMMENTS: The epithet *piperatoides* means "resembling *Chalciporus piperatus*." The Peppery Bolete, *Chalciporus piperatus* (not illustrated), inedible, is nearly identical but does not stain blue and has larger spores, 9–12 × 4–5 μm. Studies of Australian specimens indicate it may be a mycoparasite of *Amanita muscaria* (Nuhn et al. 2013). *Chalciporus rubinellus* (not illustrated), edibility unknown, has a pinkish to rose red cap that fades toward yellow in age. The rose red pore surface turns dull reddish to pinkish brown by maturity and doesn't stain blue when bruised. Its stalk is red or red mixed with yellow and lacks yellow basal mycelium. The bright yellow flesh doesn't stain blue. Spores are slightly larger, 12–15 × 3–5 μm. It grows in conifer or mixed woods during summer and fall.

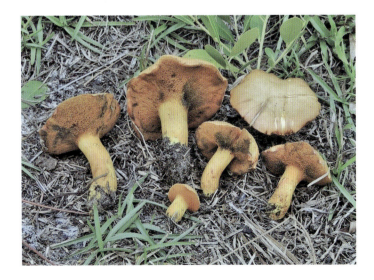

Cyanoboletus cyaneitinctus A. Farid, A. R. Franck, & J. A. Bolin

= *Ceriomyces cyaneitinctus* Murrill

MACROSCOPIC FEATURES: cap 4–12.5 cm wide, convex, becoming broadly convex, dry, dusty or powdery and slightly velvety at first, balding and often shiny in age, dark yellow-brown to blackish brown, dark cinnamon brown, or rarely brick red, instantly staining blackish blue when handled or bruised. **pore surface** yellow at first, golden yellow to brownish yellow in age, instantly bruising dark blue, then dull brown; **tubes** 6–12 mm deep. **stalk** nearly equal or enlarged downward, solid, dry, pruinose at the apex, yellow above and darker orange-yellow below, usually reddish brown and pruinose toward the base, not reticulate but often with raised longitudinal ridges, quickly staining dark blue, then slowly dull brown when handled or bruised. **flesh** yellow with reddish brown in the base, quickly staining blue when exposed; odor and taste not distinctive.

MICROSCOPIC FEATURES: Spores 11–15 × 4–6 μm, fusoid to elliptic, smooth, yellowish.

SPORE PRINT: Dark olive to olive brown.

HABIT, HABITAT, AND SEASON: Scattered or in groups with conifers or broadleaf trees; summer–fall.

EDIBILITY: Edible.

COMMENTS: The epithet *cyaneitinctus* means "dyed or colored dark blue," a reference to the intense staining reaction this bolete produces when bruised. The cap surface displays a green flash with NH_4OH. American collections have traditionally been called *Cyanoboletus pulverulentus*, but molecular analysis has shown that it is a European species. *Boletus oliveisporus* is typically larger, and its fulvous to cinnamon brown cap does not produce a green flash reaction with NH_4OH.

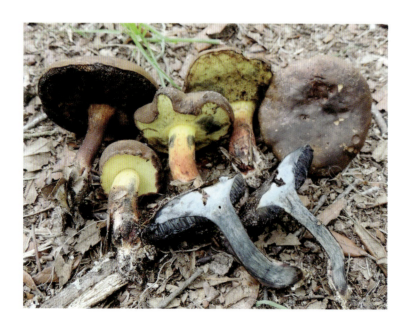

Exsudoporus floridanus (Singer) Vizzini, Simonini, & Gelardi

= *Boletus floridanus* (Singer) Murrill
= *Butyriboletus floridanus* (Singer) G. Wu, Kuan Zhao, & Zhu L. Yang
= *Suillellus floridanus* (Singer) Murrill

MACROSCOPIC FEATURES: **cap** 4–15 cm wide, convex, becoming broadly convex or flat, dry, somewhat velvety, rose red to pinkish red, purplish red, or brownish red, typically yellowing or whitening at the margin, which is even and initially incurved. **pore surface** reddish orange to pinkish red, at times with yellowish tints, or yellow overall with red tints, usually beaded with yellow droplets when young and fresh, often depressed around the stalk in age; **tubes** 6–12 mm deep. **stalk** commonly bulbous when young, usually club-shaped or nearly equal in age, solid, dry, yellow at the apex and red below or red overall, with conspicuous and elongated red reticulation over at least the upper half. **flesh** pale to bright yellow, quickly staining dark blue when exposed; odor and taste not distinctive.

MICROSCOPIC FEATURES: Spores 13–18 × 4–5 µm, ellipsoid to fusoid, smooth, pale yellow-brown.

SPORE PRINT: Olive brown.

HABIT, HABITAT, AND SEASON: Scattered or in groups with oaks or pines; summer–winter.

EDIBILITY: Edible.

COMMENTS: The epithet *floridanus* means "Florida," referring to where the type collection was found. The cap surface stains olive black with the application of NH_4OH. The Lurid Bolete, *Suillellus luridus* (not illustrated), reportedly poisonous, has a brownish orange or reddish cap, a dark red to orange-red or brownish orange pore surface, a stalk that is yellow above, apically or more, and red below, sometimes only at the base. It has reddish reticulation nearly overall or at least on the upper portion and yellowish to reddish flesh. All parts quickly stain blue. It grows in broadleaf or mixed woods. The spores measure 11–17 × 5–7 µm.

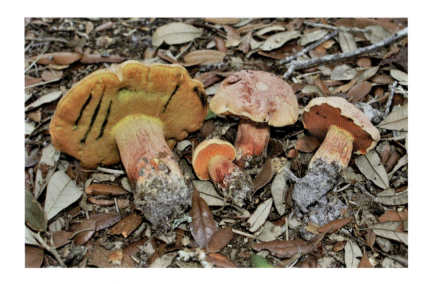

Exsudoporus frostii (J. L. Russell) Vizzini, Simonini, & Gelardi

= *Boletus frostii* J. L. Russell
= *Butyriboletus frostii* (J. L. Russell) Vizzini, Simonini, & Gelardi

COMMON NAME: Frost's Bolete

MACROSCOPIC FEATURES: **cap** 5–15 cm wide, rounded to convex when young, then broadly convex, smooth, shiny, dry, tacky when moist, blood red to candy apple red, sometimes developing yellowish areas in age, the margin frequently banded with yellow. **pore surface** dark red, paler in age, often exuding golden droplets when young, eventually depressed around the stalk, instantly bruising blackish blue; **tubes** 6–15 mm deep. **stalk** enlarged downward or nearly equal, solid, dry, dark red to pinkish red or yellow-orange with a whitened or yellow base, staining blackish blue when bruised; coarsely and deeply reticulated overall in shades of red or yellow or a combination of these. **flesh** pale yellow to whitish, quickly staining blue when cut; odor not distinctive, taste acidic.

MICROSCOPIC FEATURES: Spores 11–17 × 4–5 μm, elliptic, smooth, pale brown.

SPORE PRINT: Olive brown.

HABIT, HABITAT, AND SEASON: Solitary or in groups in broadleaf or mixed woods, commonly with oaks; summer–fall.

EDIBILITY: Edible.

COMMENTS: The epithet *frostii* honors Vermont mycologist Charles C. Frost (1805–1880), who first described this species. *Suillellus subluridus* (not illustrated), edibility unknown, has a variably colored cap, ranging from orange-pink to orange-yellow with vinaceous tints or red to purplish red and developing more brownish tones in age. It has a blue staining and a red pore surface that becomes reddish orange to orange-yellow with maturity. The nonreticulated stalk is yellow near the apex, reddish and minutely punctate lower down, and often longitudinally striate, and it lacks yellow or reddish hairs at the base. The yellow flesh stains blue when exposed. It grows with oaks or pines. Its spores measure 9–14 × 4–6 μm.

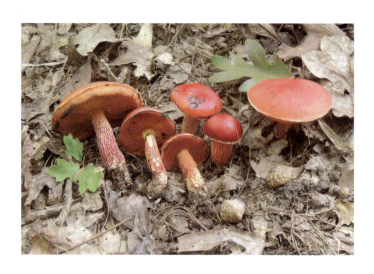

Gyroporus phaeocyanescens Singer & M. H. Ivory

MACROSCOPIC FEATURES: cap 4–12 cm wide, convex at first, broadly convex in age, dry, coated with a thick mat of hairs that become appressed-fibrillose to fibrillose-scaly in age, fulvous to yellow-brown or grayish brown; margin incurved when young, even. **pore surface** initially whitish, then pale yellow and darkening further in age, depressed at the stalk when mature, not bluing when bruised; **tubes** 5–15 mm deep. **stalk** enlarged downward or nearly equal, solid, hollow and brittle when mature, dry, coated with tiny fibrils, buff to pale straw yellow, darkening with age or when handled, especially near the base. **flesh** whitish with a dark brown zone beneath the cuticle, staining indigo blue when exposed, sometimes erratically, and slowly fading to creamy buff; odor and taste not distinctive.

MICROSCOPIC FEATURES: Spores 9–15 × 5–7 μm, ellipsoid, smooth, pale yellow.

SPORE PRINT: Pale yellow.

HABIT, HABITAT, AND SEASON: Scattered or in groups with oaks; summer–fall.

EDIBILITY: Unknown.

COMMENTS: *Phaeocyanescens* means "dark blue," referring to the indigo blue staining of the exposed flesh. Waterlogged specimens sometimes do not bruise blue. The cap surface stains amber to orange-brown with KOH and reddish brown with NH_4OH, and it is negative with FeSO4. The flesh stains bright yellow with KOH, yellow with NH4OH, and pale yellow with $FeSO_4$. The Staining Blue Bolete, *Gyroporus cyanescens* (see Color Key), edible, has a tan to brown cap and bruises greenish blue to dark blue on all parts when handled or bruised. *Gyroporus umbrinisquamosus* (not illustrated), edibility unknown, has a yellow-ocher cap with prominent, yellow-brown, fibrillose scales and white, nonstaining flesh with a mild taste. The pore surface is white to pale yellowish. Its stalk is enlarged downward, pinkish on the upper portion and pale yellow-brown below.

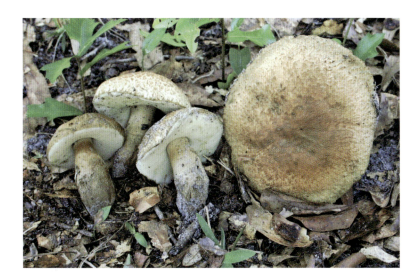

Gyroporus smithii Davoodian

MACROSCOPIC FEATURES: cap 2–6.5 cm wide, convex to broadly convex, nearly smooth, dry, yellow-orange to orange or cinnamon orange; margin entire, sometimes split. **pore surface** whitish becoming buff, then yellowish in age, not bruising; **tubes** 5–8 mm deep. **stalk** enlarged downward or nearly equal, usually with a pinched base, often curved, brittle, stuffed with a soft pith, developing several cavities or becoming hollow when mature, dry, uneven, colored like the cap but paler and duller, basal mycelium white. **flesh** brittle, white, unchanging; odor faintly pungent or not distinctive, taste not distinctive.
MICROSCOPIC FEATURES: Spores 6–10 × 4–5 μm, ellipsoid to ovoid, smooth, hyaline.
SPORE PRINT: Pale yellow.
HABIT, HABITAT, AND SEASON: Solitary, scattered, or in groups, usually associated with broadleaf trees, especially oaks, or in mixed oak and pine woods; summer–winter.
EDIBILITY: Edible.

COMMENTS: The epithet *smithii* honors American mycologist Alexander H. Smith (1904–1986). The Chestnut Bolete, *Gyroporus borealis* (not illustrated), edible, is very similar. Its cap diameter can be slightly larger, up to 8 cm wide, and it is typically darker colored, with orange-brown to reddish brown tones. Its spores are slightly larger, measuring 8–13 × 5–6 μm. The Red Gyroporus, *Gyroporus purpurinus* (not illustrated), edible, is very similar, but the cap and stalk are vinaceous to burgundy-colored. The Graceful Bolete, *Austroboletus gracilis* (see Color Key), edible, has a maroon to reddish brown or cinnamon cap and a white pore surface that becomes pinkish to pinkish brown and bruises brownish. The stalk is long and slender in proportion to cap diameter and is colored like the cap or paler. It has a pinkish to reddish brown spore print and grows on the ground or on decaying wood in conifer or broadleaf forests. *Gyroporus castaneus* (not illustrated), edible, is a European species.

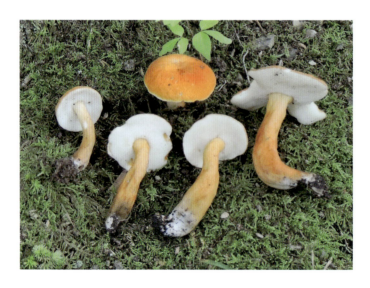

Gyroporus subalbellus Murrill

= *Suillus subalbellus* (Murrill) Sacc. & Trotter

MACROSCOPIC FEATURES: **cap** 2.5–12 cm wide, convex at first, later broadly convex and often shallowly depressed in age, dry, nearly smooth, some shade of buff, cinnamon, pale yellow, or even whitish, browning in age or when handled. **pore surface** whitish, turning pale yellow and maturing to dull yellow, at times deeply depressed around the stalk, unchanging or slowly staining pinkish cinnamon when bruised or old; **tubes** 3–8 mm deep. **stalk** usually enlarged downward to a swollen and sometimes pinched base, brittle, chambered or hollow by maturity, dry, smooth, whitish at first, flushing with pink to salmon-orange as it matures, especially toward the base, often staining cinnamon to brownish or olivaceous. **flesh** white, unchanging; odor and taste not distinctive.

MICROSCOPIC FEATURES: Spores 8–14 × 4–6 µm, ellipsoid to ovoid, smooth, hyaline.

SPORE PRINT: Yellowish buff.

HABIT, HABITAT, AND SEASON: Scattered or in groups in oak and pine woods; summer–fall.

EDIBILITY: Edible.

COMMENTS: The epithet *subalbellus* means "somewhat whitish," referring to the colors of this pale bolete. *Tylopilus peralbidus* has similar colors, but the flesh is bitter-tasting, and it has a pinkish brown, not yellowish buff, spore print.

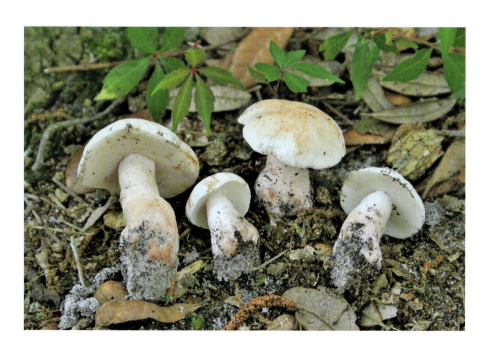

Harrya chromapes (Frost) Halling, Nuhn, Osm., & Manfr. Binder

= *Boletus chromapes* Frost
= *Leccinum chromapes* (Frost) Singer
= *Tylopilus chromapes* (Frost) A. H. Sm. & Thiers

COMMON NAMES: Chrome-footed Bolete, Yellowfoot Bolete

MACROSCOPIC FEATURES: **cap** 3–15 cm wide, convex, becoming broadly convex and sometimes slightly depressed, dry or slightly sticky when moist, pink to rose-colored at first, fading to pinkish tan or dingy brown in age. **pore surface** white, then pinkish to dingy pinkish tan, unchanging when bruised; **tubes** 8–14 mm deep. **stalk** equal or tapered in either direction, often crooked at the base, solid, dry, white to pinkish and covered with pink, reddish, or whitish scabers above a bright chrome yellow base. **flesh** white, becoming chrome yellow at the stalk base, unchanging; odor not distinctive, taste lemony or not distinctive.

MICROSCOPIC FEATURES: Spores 11–17 × 4–5.5 μm, nearly oblong to narrowly oval, smooth, hyaline to pale brown.

SPORE PRINT: Pinkish brown to reddish brown.

HABIT, HABITAT, AND SEASON: Solitary or in small groups with broadleaf or conifer trees; summer–fall.

EDIBILITY: Edible.

COMMENTS: *Chromapes* means "chrome yellow foot," referring to this bolete's distinctive chrome yellow stalk base. *Harrya* honors American mycologist Harry D. Thiers (1919–2000). It is a small genus, with only two species known worldwide to date. *Harrya chromapes* is the only *Harrya* species reported to occur in eastern North America. *Retiboletus griseus* (not illustrated) also has a yellow foot but is duller grayish brown elsewhere and has a reticulated stalk.

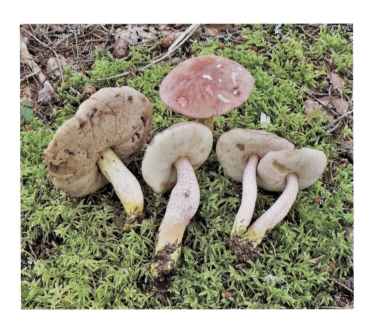

Hemileccinum hortonii (A. H. Sm. & Thiers) M. Kuo & B. Ortiz

= *Boletus hortonii* A. H. Sm. & Thiers
= *Xerocomus hortonii* (A. H. Sm. & Thiers) Manfr. Binder & Besl

COMMON NAME: Corrugated Bolete, Horton's Bolete

MACROSCOPIC FEATURES: cap 4–10 cm wide, convex to broadly convex, dry to somewhat sticky, deeply pitted and corrugated, tan to reddish tan or ocher-brown to reddish brown; margin even. **pore surface** yellow at first, becoming olive yellow with age, unchanging or rarely and slowly staining blue when bruised; **tubes** 5–10 mm deep. **stalk** enlarged downward or nearly equal, solid, dry, smooth to lightly pruinose or occasionally with delicate reticulation on the upper half, pale yellow to tan, sometimes reddish at the base. **flesh** whitish to pale lemon yellow, unchanging when exposed; odor and taste not distinctive.

MICROSCOPIC FEATURES: Spores 12–15 × 3.5–4.5 μm, somewhat boat-shaped, smooth, yellow.

SPORE PRINT: Olive brown.

HABIT, HABITAT, AND SEASON: Solitary, scattered, or in groups under broadleaf trees or in mixed woods, especially with oaks, hickories, beeches, and hemlocks; late spring–fall.

EDIBILITY: Edible and very good.

COMMENTS: *Hemileccinum subglabripes* is similar but has a smooth to slightly wrinkled cap, a smooth stalk, and somewhat larger spores. *Boletus separans* is also similar and has a wrinkled to pitted cap. The pore surface is white when young and becomes yellow as it matures. The stalk is colored like the cap, usually with lilac in the midportion, and is covered with a fine white reticulum. *Leccinum crocipodium* (not illustrated), edible, has a dark brown cap, 4–15 cm wide, that is wrinkled and pitted when young, coarsely cracked and pale yellow-brown in age. Pores are pale to dingy yellow. The pale yellow stalk has brown scabers that darken to blackish brown in age. It grows with oaks or other broadleaf trees.

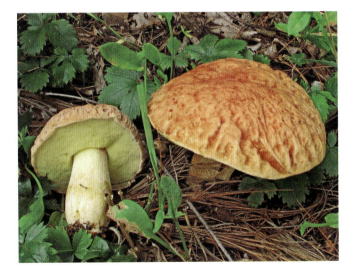

Hemileccinum subglabripes (Peck)
Šutara

= *Boletus subglabripes* Peck
= *Leccinum subglabripes* (Peck) Singer

COMMON NAME: Smoothish-stemmed Boletus

MACROSCOPIC FEATURES: cap 4.5–12 cm wide, convex when young, broadly convex to nearly flat in age, sometimes with a broad umbo, smooth to slightly wrinkled, chestnut brown, ocher, cinnamon, or reddish brown to bay brown. **pore surface** yellow to bright yellow when fresh, duller or greenish yellow at maturity, unchanging when bruised; **tubes** 5–16 mm deep. **stalk** nearly equal, solid, sometimes stout, dry, minutely scurfy and sprinkled with tiny yellow scabers over a yellow ground color often tinged reddish or reddish brown here and there, especially on the lower portion. **flesh** pale yellow to yellow, reddish toward the stalk base, unchanging or, rarely, staining slightly blue; odor not distinctive, taste of the cap cuticle very tart, otherwise slightly acidic or not distinctive.

MICROSCOPIC FEATURES: Spores 11–17 (–21) × 3–5 (–7) µm, narrowly fusoid, smooth, pale brown.

SPORE PRINT: Olive brown.

HABIT, HABITAT, AND SEASON: Solitary or scattered with broadleaf trees, especially birches and oaks, occasionally with conifers; summer–fall.

EDIBILITY: Edible.

COMMENTS: *Subglabripes* means "having a nearly smooth foot," referring to its stalk. The cap surface stains pale amber, and cap flesh stains pale gray with the application of NH_4OH. *Hemileccinum hortonii*, edible, is similar but has a notably pitted cap and a stalk variably smooth, pruinose, or reticulated. *Leccinum longicurvipes* has a sticky yellow-orange to brownish orange or ochraceous cap, yellow pores that do not bruise blue, and a long, curved stalk with fine whitish to yellowish scabers that darken in age. The cap surface stains cherry red to reddish orange with NH_4OH and bright cherry red with KOH.

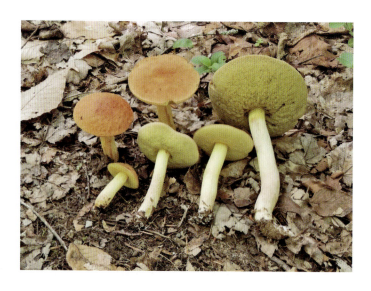

Hortiboletus rubellus group (Krombh.) Simonini, Vizzini, & Gelardi

= *Boletus fraternus* Peck
= *Boletus rubellus* Krombholz

COMMON NAME: Ruby Bolete

MACROSCOPIC FEATURES: cap 2–8 cm wide, convex, becoming nearly flat, dry, somewhat velvety, often finely cracked when mature, dark red fading to brick red or olivaceous brown. **pore surface** yellow, staining blue-green when bruised, typically depressed at the stalk in age; **tubes** 6–10 mm deep. **stalk** nearly equal, enlarged, or tapered downward, often with a narrowed base, solid, dry, sometimes pruinose, yellow at the apex with dull reddish orange punctae, darkening to brown where handled. **flesh** pale yellow, slowly staining blue-green on exposure, reddish orange toward the stalk base; odor and taste not distinctive.

MICROSCOPIC FEATURES: Spores 10–13 × 4–5 μm, ellipsoid, smooth, pale brown.

SPORE PRINT: Olive brown.

HABIT, HABITAT, AND SEASON: Solitary, scattered, or in groups in grassy areas, parks, gardens, and flower beds, on disturbed roadsides, along paths, or in broadleaf or mixed woods, especially under oaks and beeches; summer–fall.

EDIBILITY: Unknown.

COMMENTS: *Rubellus* means "reddish." The flesh stains dull orange with KOH and olive green with $FeSO_4$. Historically, there has been much confusion about distinguishing this bolete from others that look very similar. *Hortiboletus campestris* (not illustrated), reportedly edible, has bright yellow stalk flesh throughout and larger spores that measure 11–15 × 4.5–7 μm. The flesh stains orange with KOH and dull orange with $FeSO_4$. *Boletus harrisonii* (not illustrated), edibility unknown, has a brick red to ocher-red cap that becomes finely cracked in age and a smooth stalk lacking punctae or pruinosity. The yellow flesh is streaked with brown. Microscopically, the last 3–4 cells of the cuticle hyphae are short and inflated. It typically grows under oaks.

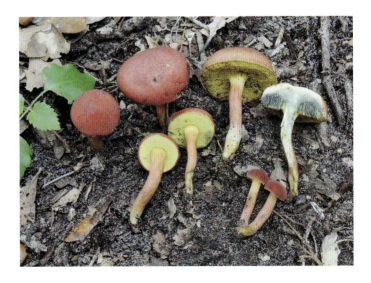

Imleria floridana A. Farid, A. R. Franck, & J. Bolin

MACROSCOPIC FEATURES: cap 7–12 cm wide, hemispherical at first, broadening to convex, then nearly flat, smooth, slightly woolly, dry or sticky, usually not cracking with age, dull reddish brown to chocolate or chestnut brown; margin staining dark blue when bruised. **pore surface** dull to bright yellow, staining blue, then slowly brown when bruised; **tubes** 3–11 mm long, eventually depressed around the stalk. **stalk** sometimes bent, nearly equal above a narrowed base, solid, often fibrillose, somewhat shiny, streaked brownish red and golden yellow with minute reddish brown or yellow punctae that are especially evident near the stalk apex on young specimens. **flesh** cream-colored except beneath the cap and stalk cuticles, where it is brownish red, faintly staining blue above the tubes and slowly pink elsewhere, especially near the apex, brown in the stalk base; odor and taste not distinctive.

MICROSCOPIC FEATURES: Spores 11–13.5 (–15) × 3.5–6(–7) μm, fusoid to subfusoid with a pronounced apiculus and 1–3 oil drops, hyaline, inamyloid.
SPORE PRINT: Olive brown.
HABIT, HABITAT, AND SEASON: Solitary, scattered, or in groups with oaks and pines; year-round.
EDIBILITY: Unknown.
COMMENTS: The epithet *floridana* means "Florida," a reference to the type locality. The cap stains dark orange to dark brown with KOH. With NH_4OH a green flash is followed by orange to brown staining ringed in green. The Bay Bolete, *Imleria badia* (not illustrated), edible, is a very similar and more northern species growing on the ground or decaying conifer stumps. The stalk is nearly equal or enlarged downward, based in white mycelium. *Xanthoconium affine* has a dark brown to chestnut brown or ocher-brown cap. The white pores become yellowish to dingy yellow-brown and stain brownish, not blue, when bruised.

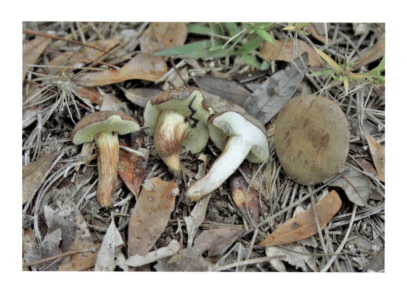

Imleria pallida (Frost ex Peck) A. Farid, A. R. Franck, & J. Bolin

= *Boletus pallidus* Frost ex Peck

COMMON NAME: Pallid Bolete

MACROSCOPIC FEATURES: cap 4.5–15 cm wide, convex with an incurved margin, maturing to broadly convex or slightly depressed, dry, smooth, bald or nearly so, often cracked in age, whitish to buff or pale brownish when young, becoming dingy brown with rose tints. **pore surface** whitish to pale yellow at first, later yellow to greenish yellow, rapidly staining greenish blue, then grayish brown when bruised; **tubes** 1–2 cm deep. **stalk** enlarged downward or nearly equal, solid, dry, smooth or with slight apical reticulation, whitish when young, sometimes yellow at the apex, usually developing brownish streaks or reddish flushes most pronounced toward the base, frequently bruising slightly blue, often with white basal mycelium. **flesh** thick, whitish or pale yellow, sometimes slowly staining bluish or pinkish when cut; odor not distinctive, taste not distinctive or slightly bitter.

MICROSCOPIC FEATURES: Spores 9–15 × 3–5 μm, narrowly oval to subfusoid, smooth, pale brown.

SPORE PRINT: Olive to olive brown.

HABIT, HABITAT, AND SEASON: Solitary, scattered, in groups, or clustered in broadleaf forests or in mixed woods under oaks; summer–fall.

EDIBILITY: Edible.

COMMENTS: The epithet *pallidus* means "pale." The flesh stains pale rusty orange with the application of KOH, blue-green with NH_4OH, and bluish green to grayish with $FeSO_4$. *Tylopilus rhoadsiae* is similar, but its pore surface turns dull pinkish in age; the stalk is prominently reticulate nearly overall or at least on the upper half, and the flesh tastes bitter.

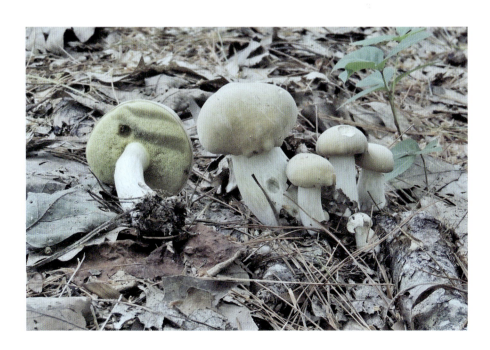

Leccinum chalybaeum Singer

MACROSCOPIC FEATURES: cap 4–9 cm wide, roundish at first, becoming convex to broadly convex, sticky, somewhat shiny when dry, smooth to velvety, sometimes finely cracked when mature, initially buff to pinkish buff, dingy yellow-brown in age, usually with grayish green to blue-gray tints, especially near the margin. **pore surface** whitish to beige, typically staining dingy olive or brownish when bruised, deeply depressed around the stalk in age; **tubes** up to 16 mm deep. **stalk** typically short and thick, equal or enlarged downward, solid, almost woody, dry, whitish, covered with dingy white scabers that darken to brown in age. **flesh** stains pinkish, then slowly pinkish brown to purplish gray and blackish when cut or exposed; odor and taste not distinctive.

MICROSCOPIC FEATURES: Spores 16–18 × 5–6 μm, fusoid, smooth, brownish; caulocystidia fusoid to fusoid-ampullaceous.
SPORE PRINT: Olive brown.
HABIT, HABITAT, AND SEASON: Scattered or in groups under oaks or in mixed woods with oaks and pines; summer–fall.
EDIBILITY: Edible.
COMMENTS: The epithet *chalybaeum* means "steel gray," referring to the grayish green to blue-gray tints on the cap. The cap flesh stains yellow with KOH, slowly pale greenish blue with NH_4OH, and greenish blue with $FeSO_4$. Compare with *Leccinum albellum* (see Color Key) and *Leccinum scabrum*.

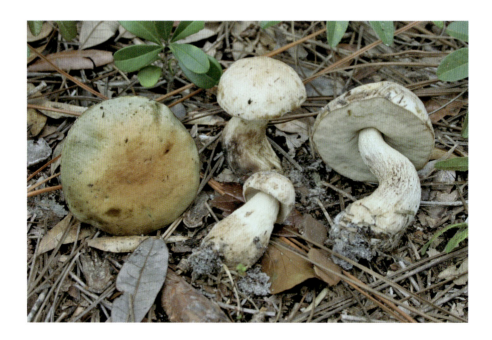

Leccinum longicurvipes (Snell & A. H. Sm.) M. Kuo & B. Ortiz

= *Boletus longicurvipes* Snell & A. H. Sm.
= *Boletus viscidocorrugis* Both

MACROSCOPIC FEATURES: **cap** 2.5–11 cm wide, convex, then broadly convex, smooth or slightly wrinkled or pitted, sticky to slimy, shiny, yellow-orange to brownish orange or ochraceous, often developing green tones in wet weather or age. **pore surface** pale yellow at first, later greenish yellow to greenish gray, sometimes staining yellow or brownish when bruised; **tubes** 8–12 mm deep. **stalk** enlarged downward or nearly equal, typically curved on the lower portion, dry, whitish to yellowish with fine, similarly colored scabers that usually darken to reddish brown in age; basal mycelium white. **flesh** white to pale yellow, unchanging or staining pinkish to brick red, then dingy slate, sometimes staining light blue in the stalk base or erratically throughout the stalk; odor and taste not distinctive.

MICROSCOPIC FEATURES: Spores 13–17 × 4–5 μm, oblong, smooth, pale brown.
SPORE PRINT: Olive brown.
HABIT, HABITAT, AND SEASON: Solitary or scattered with oaks or in mixed broadleaf and pine woods; summer–fall.
EDIBILITY: Edible.
COMMENTS: *Longicurvipes* refers to the long, curved stalk. Its cap surface stains bright cherry red with KOH and red to reddish orange with NH_4OH. The Ashtray Bolete, *Hemileccinum rubropunctum* = *Leccinum rubropunctum* (see Color Key), edible but unpleasant-tasting, has a 2–9 cm wide, bay red to reddish brown, convex cap. Its pore surface is bright yellow to brownish yellow and does not stain blue. The stalk is covered with reddish punctae on a yellow ground color above a base covered by white to pale yellow mycelium. Flesh is yellowish and unchanging when bruised. The odor and taste are unpleasant, reminiscent of stale cigarette butts. It grows in broadleaf or conifer woods, year-round.

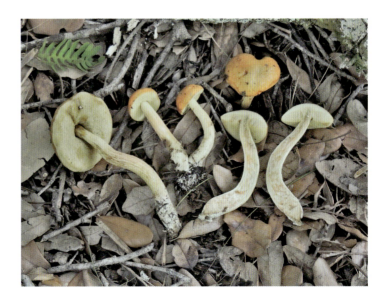

Leccinum roseoscabrum Singer & R. Williams

MACROSCOPIC FEATURES: **cap** 2–7 cm wide, rounded to convex when young, broadly convex at maturity, dry or slightly sticky, smooth to somewhat wrinkled or with shallow pits, dark brown to chestnut brown, fading in age, often with paler spots; margin sterile. **pore surface** white to whitish at first, becoming yellowish or grayish with a dull orange tint, usually depressed around the stalk in age, staining brownish when bruised; **tubes** up to 13 mm deep. **stalk** enlarged downward, often curved, at times swollen near the middle, frequently with a pinched base, solid, dry, white on the upper portion, pinkish below and sometimes green or yellow at the base, covered with coarse rosy pink scabers that turn brown or dark brown in age or when bruised or handled, basal mycelium sparse and white. **flesh** firm, white, unchanging; odor not distinctive, taste slightly bitter or not distinctive.

MICROSCOPIC FEATURES: Spores 12–18 × 3.5–6 μm, fusoid to cylindric, smooth, pale ochraceous brown.
SPORE PRINT: Yellowish brown.
HABIT, HABITAT, AND SEASON: Scattered or in groups with broadleaf trees, especially oaks; summer–early winter.
EDIBILITY: Edible.
COMMENTS: The epithet *roseoscabrum* means "having rosy pink scabers." The cap surface stains brown with KOH and is negative with both $FeSO_4$ and NH_4OH. The flesh stains blue-green with $FeSO_4$ and pale orange with NH_4OH and is negative with KOH. The Wrinkled Leccinum, *Leccinum rugosiceps* (not illustrated), edible, has a 5–15 cm wide, distinctly wrinkled and shallowly pitted orange-yellow cap that ages to yellow-brown. The flesh is white or pale yellow and slowly stains reddish or burgundy when exposed. Its pore surface is dingy yellow. The stalk is pale yellow with pale brown scabers darkening in age. It grows on the ground with oaks.

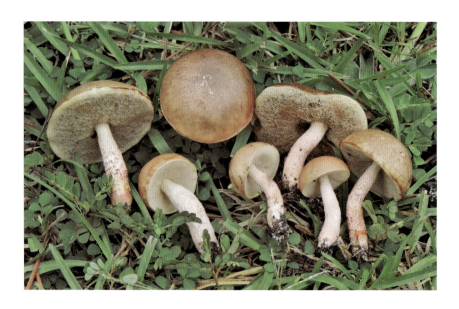

Leccinum scabrum group (Bull.) Gray

COMMON NAMES: Brown Birch Bolete, Common Scaber Stalk

MACROSCOPIC FEATURES: **cap** 4–12 cm wide, obtuse to broadly convex, dry or moist, smooth, bald or with matted fibrils breaking up into tiny flattened scales, often distinctly cracked at maturity, grayish brown to yellow-brown. **pore surface** grayish white, very slowly staining brownish or grayish when bruised, depressed at the stalk when mature; **tubes** 7–18 mm deep. **stalk** enlarged downward or nearly equal, solid, dry, whitish to grayish, covered with dark brown to blackish scabers, occasionally with red or blue to greenish blue stains near the base. **flesh** white, unchanging, slowly staining reddish, or sometimes with patchy yellow or light blue stains when exposed; odor and taste not distinctive.

MICROSCOPIC FEATURES: Spores 15–19 × 4.5–7 µm, fusiform, smooth, pale ochraceous brown.

SPORE PRINT: Brown.

HABIT, HABITAT, AND SEASON: Solitary, scattered, or in groups on the ground under broadleaf trees, commonly birches or oaks.

EDIBILITY: Edible.

COMMENTS: The epithet *scabrum* means "rough or covered with scabers." This is a group of several morphologically similar species with variable staining reactions. Molecular analysis is needed to separate the species within this group. *Leccinum albellum* is very similar, but the caps are typically damp, soft, and commonly pitted by maturity. Also compare with *Leccinum chalybaeum*, which has a sticky or shiny, pinkish buff cap that ages to dingy yellow-brown, often tinted with grayish green to bluish gray, especially near the margin. It grows on the ground with oaks.

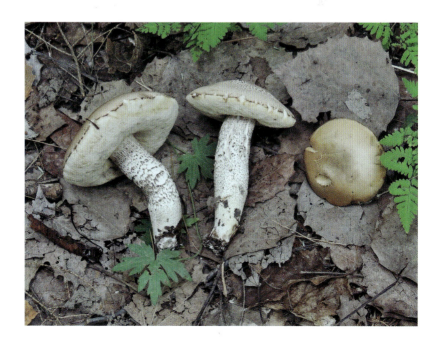

Phylloporopsis boletinoides

(A. H. Sm. & Thiers) Vizzini, Angelini, A. Farid, Gelardi, Costanzo, & M. E. Smith

= *Phylloporus boletinoides* A. H. Sm. & Thiers

MACROSCOPIC FEATURES: cap 2–10 cm wide, broadly convex at first, becoming nearly flat, occasionally shallowly depressed in age, dry, somewhat velvety to minutely scaly when young, nearly smooth in age, cinnamon to dark pinkish brown fading to dull yellow-brown; margin sterile, strongly incurved and remaining so into maturity. **pore surface** deeply decurrent, radially arranged and gill-like with numerous crossveins, pale olive buff at first and dark olive buff in age, at times with a bluish green tinge near the margin, typically not staining but occasionally slowly staining bluish green to dark blue when bruised; **tubes** 3–5 mm deep. **stalk** tapered downward or nearly equal, solid or hollow in the base, dry, smooth, pale yellow at the apex, pale cinnamon below with a sparse layer of white basal mycelium. **flesh** white to whitish, sometimes darker cinnamon toward the stalk base, slowly staining bluish gray to gray when exposed; odor not distinctive, taste slightly acidic or not distinctive.

MICROSCOPIC FEATURES: Spores 11–16 × 5–6.5 μm, subcylindric to narrowly oval, smooth, pale brown.

SPORE PRINT: Olive brown.

HABIT, HABITAT, AND SEASON: Solitary or scattered in mixed oak-pine woods; summer–early winter.

EDIBILITY: Unknown.

COMMENTS: *Boletinoides* means "having radially arranged and elongated pores." The cap surface stains reddish to red-brown with NH_4OH and is negative with $FeSO_4$. *Phylloporus leucomycelinus* and *Phylloporus rhodoxanthus* have redder caps and a yellow to golden yellow pore surface.

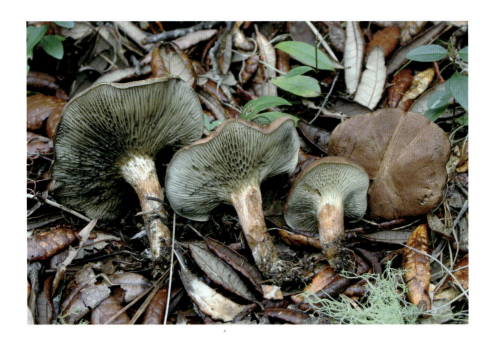

Phylloporus foliiporus (Murrill) Singer

= *Gomphidius foliiporus* Murrill
= *Phylloporus rhodoxanthus* ssp. *foliiporus* (Murrill) Singer

MACROSCOPIC FEATURES: **cap** 5–7.5 cm wide, convex at first and nearly flat in age, sometimes slightly depressed, dry, finely velvety to nearly smooth, often spotted or streaked, pinkish brown, reddish brown, or grayish brown; margin incurved when young, entire. **pore surface** yellow to golden yellow, occasionally poroid and radially arranged but usually gill-like, widely spaced, decurrent, sometimes forked and crossveined, easily separated from the cap, bruising greenish blue to dark blue, then slowly dark brown; **tubes** 6–15 mm deep. **stalk** tapered downward, longitudinally striate nearly overall or at least on the upper portion, sometimes reticulate near the apex, reddish pink to pale pinkish brown with white basal mycelium. **flesh** whitish to pale yellow, slightly bluing when bruised; odor and taste not distinctive.
MICROSCOPIC FEATURES: Spores 11–15 × 4.5–6 μm, ellipsoid to fusoid, smooth, hyaline to yellowish.
SPORE PRINT: Reddish brown.
HABIT, HABITAT, AND SEASON: Solitary or in groups on the ground or at the base of oak or pine tree trunks; summer–early winter.
EDIBILITY: Unknown.
COMMENTS: The epithet *foliiporus* means "having leaf-like or gill-like pores." The cap surface and stalk stain light orange-brown with KOH. The pore surface stains dark brown with KOH. *Phylloporus leucomycelinus* is very similar, but no part of its fruit body stains blue. The basal mycelium of *Phylloporus rhodoxanthus* (see Comments under *Phylloporus leucomycelinus*) is yellow, not white.

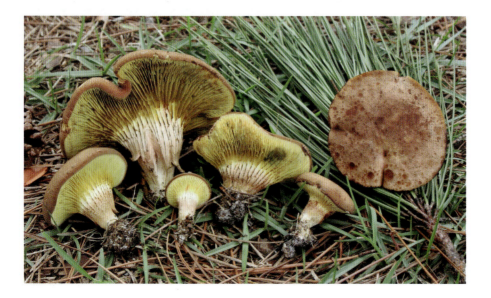

Phylloporus leucomycelinus Singer

= *Phylloporus rhodoxanthus* ssp. *albomycelinus* Snell & Dick

MACROSCOPIC FEATURES: **cap** 4–8 cm wide, rounded to convex when young, nearly flat and at times slightly depressed in age, dry, slightly velvety, sometimes finely cracked when mature, dark red or reddish brown to chestnut, fading and paler over the disc in age; margin incurved at first, usually sterile. **pore surface** yellow to golden yellow, occasionally poroid and radially arranged but typically gill-like and decurrent, widely spaced, sometimes forked and crossveined, easily separable from the cap, unchanging when bruised; **tubes** 8–16 mm deep. **stalk** equal or pinched at the base, firm, solid, dry, usually with conspicuous ribs near the apex, yellow with reddish tints, covered overall with reddish brown punctae, basal mycelium white to whitish. **flesh** whitish to pale yellow, not bluing when exposed; odor and taste not distinctive.

MICROSCOPIC FEATURES: Spores 8–14 × 3–5 μm, ellipsoid to fusoid, smooth, pale yellowish.

SPORE PRINT: Yellowish ochraceous.

HABIT, HABITAT, AND SEASON: Scattered or in groups under broadleaf trees, especially beeches and oaks; summer–fall.

EDIBILITY: Edible.

COMMENTS: The epithet *leucomycelinus* means "having white mycelium," one of the most distinctive field characteristics of this mushroom. *Phylloporus foliiporus* is nearly identical, but its flesh and pore surface stain blue. The Gilled Bolete, *Phylloporus rhodoxanthus* (not illustrated), edible, is also nearly identical but has yellow basal mycelium.

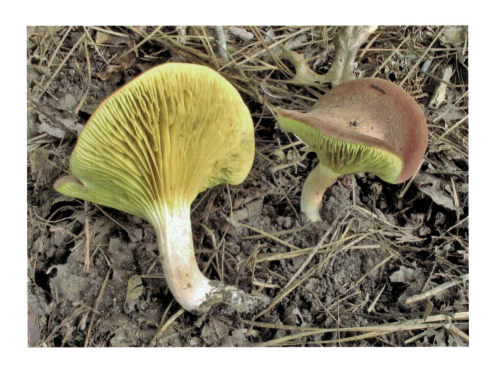

Porphyrellus sordidus (Frost) Snell

= *Boletus sordidus* Frost
= *Tylopilus sordidus* (Frost) A. H. Sm. & Thiers

MACROSCOPIC FEATURES: **cap** 4.5–13 cm wide, convex, becoming broadly convex, dry, bald or velvety, cracked in age, gray-brown to olive brown, often with dark greenish or bluish tints along the margin; margin sterile when young. **pore surface** whitish to grayish buff at first, later reddish brown, staining dark blue, then dark brownish red when bruised; **tubes** 6–20 mm deep. **stalk** slightly enlarged downward or nearly equal, solid, dry, scurfy, brownish with darker longitudinal streaks, typically paler in the upper portion with bluish green tints near the apex, and whitish at the base. **flesh** whitish, staining blue-green when exposed, sometimes with reddish tints; odor slightly pungent or not distinctive, taste tinny or not distinctive.

MICROSCOPIC FEATURES: Spores 10–14 × 4–6 µm, subellipsoid, smooth, pale brown.

SPORE PRINT: Reddish brown.

HABIT, HABITAT, AND SEASON: Solitary, scattered, or in groups with oaks or other broadleaf trees, also under conifers; summer–fall.

EDIBILITY: Unknown.

COMMENTS: The epithet *sordidus* means "dirty or smoky," referring to the overall colors of this bolete. When wrapped in waxed paper for several minutes, the exposed flesh of this bolete stains the paper dark blue-green. The Dark Bolete, *Tylopilus porphyrosporus* (not illustrated), edibility unknown, has a 5–15 cm wide, dry, dark brown to olive brown cap. The pore surface is pinkish brown to dark reddish brown and bruises darker brown or sometimes dark greenish blue. The stalk is sometimes reticulate at the apex, colored like the cap, and has a whitish base. Flesh is white, rapidly or slowly staining blue when exposed. The odor is unpleasant and the taste weakly bitter to unpleasant or not distinctive. It grows in broadleaf or conifer woods. The spores measure 12–18 × 6–7.5 µm.

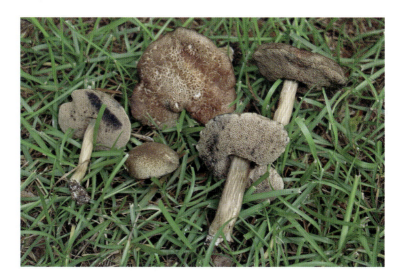

Pseudoboletus parasiticus (Bull.) Šutara

= *Boletus parasiticus* Bull.
= *Xerocomus parasiticus* (Bull.) Quél.

COMMON NAME: Parasitic Bolete

MACROSCOPIC FEATURES: cap 2.5–6 cm wide, rounded with an incurved margin at first, becoming convex as it matures, dry, somewhat velvety, nearly bald and shiny in age, ocher-brown to tawny olive or tarnished brass. **pore surface** yellow, turning olivaceous in age, sometimes with reddish or rusty stains, unchanging or staining very slightly bluish when bruised; **tubes** 3–6 mm deep. **stalk** nearly equal, usually curved, solid, dry, matted-fibrillose, colored like the cap or paler with white to very pale yellow basal mycelium. **flesh** pale yellow, unchanging when exposed; odor and taste not distinctive.

MICROSCOPIC FEATURES: Spores 12–18.5 × 3.5–5 μm, ellipsoid, smooth, pale brown.

SPORE PRINT: Olive brown.

HABIT, HABITAT, AND SEASON: Solitary, in small groups, or in clusters attached at the base of the Poison Pigskin Puffball, *Scleroderma citrinum*; summer–fall.

EDIBILITY: Edible.

COMMENTS: This bolete is parasitic on the host fungus.

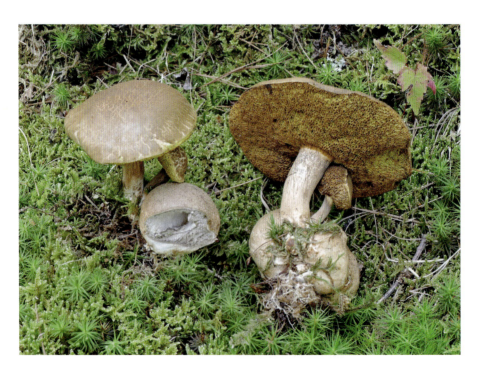

Pulchroboletus rubricitrinus (Murrill) A. Farid & A. R. Franck

= *Boletus rubricitrinus* (Murrill) Murrill
= *Ceriomyces rubricitrinus* Murrill

COMMON NAME: Rubies

MACROSCOPIC FEATURES: cap 3–15 cm wide, convex at first, nearly flat and sometimes slightly depressed in age, dry, bald to somewhat velvety, color varying from dull rose red to dull brick red, reddish brown, or tawny cinnamon when young and fresh, fading to tawny olive or dull brown when mature, sometimes with yellow tints, typically bruising blue-black; cuticle tart- or acidic-tasting; margin initially incurved, sterile. **pore surface** yellow, becoming dull yellow to olive yellow, depressed around the stalk in age, staining blue when bruised; **tubes** 8–20 mm deep. **stalk** equal or tapered in either direction, sometimes swollen near the base, solid, dry, yellow, usually with dull reddish to red-brown streaks and punctae most notable toward the base, quickly staining blue-green to blue-black when handled or bruised, not reticulate or weakly so only at the very apex, typically longitudinal striate nearly overall. **flesh** pale yellow to yellow, instantly staining blue when cut or exposed; odor not distinctive, taste slightly tart to acidic.

MICROSCOPIC FEATURES: Spores 13–19 × 5–8 μm, fusoid to subfusoid-ellipsoid, smooth, yellowish.

SPORE PRINT: Olive brown.

HABIT, HABITAT, AND SEASON: Solitary, scattered, or in groups with oaks or pines, often in grassy areas; year-round.

EDIBILITY: Edible.

COMMENTS: *Butyriboletus roseopurpureus* (not illustrated), edible, has a pinkish purple to dark purplish red cap with a golden to lemon yellow pore surface that becomes yellowish olive and instantly stains blue when bruised. The stalk is bright yellow, occasionally red near the base, reticulate overall or at least over the upper two-thirds, with white basal mycelium. The pale yellow flesh instantly stains blue. It grows on the ground or rarely on decayed wood, usually near oaks.

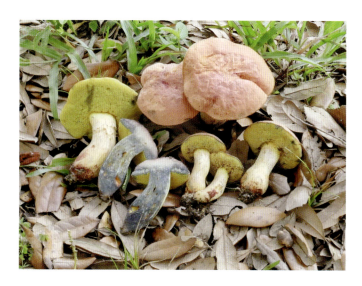

Pulchroboletus sclerotiorum
M. E. Sm., Bessette, & A. R. Bessette

MACROSCOPIC FEATURES: **cap** 4–10 cm wide, hemispherical at first, convex to broadly convex at maturity, dry, dull or somewhat shiny, finely matted, colors range from pinkish red, rose red, to purplish red, sometimes with olive tints, dull rose pink to brownish pink in age, slowly staining blackish blue when bruised; margin bright yellow, often persistent, incurved at first with a narrow band of sterile tissue; cuticle tastes slightly acidic. **pore surface** initially bright yellow, becoming dull to brownish yellow, staining blue when bruised; **tubes** 6–15 mm deep. **stalk** enlarged downward or nearly equal, solid, dry, longitudinally striate, yellow at the apex, red on the lower portion, with conspicuous red to reddish brown punctae over a yellow ground color, staining blue when handled or bruised, sometimes slowly, lacking reticulation or reticulate on the upper portion, with white basal mycelium and yellow rhizomorphs sometimes connected to subterranean orange sclerotia. **flesh** pale yellow, occasionally with a pinkish tinge under the cuticle, brighter and deeper yellow in the stalk, sometimes weakly and erratically staining blue when exposed; odor not distinctive, taste acidic.

MICROSCOPIC FEATURES: Spores 14–18 × 4–6 μm, subfusoid to fusiform, smooth, hyaline to pale brownish yellow.

SPORE PRINT: Olive brown.

HABIT, HABITAT, AND SEASON: Scattered or in groups, often on sandy soil with oaks; summer–early winter.

EDIBILITY: Edible.

COMMENTS: The epithet *sclerotiorum* refers to the subterranean orange sclerotia formed by this species. The cap surface stains gray, then orange with KOH, weakly orange with NH_4OH, and olive gray with $FeSO_4$.

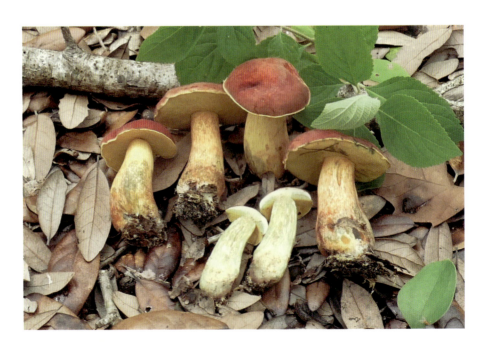

Retiboletus fuscus group (Hongo) N. K. Zeng & Zhu L. Yang

= *Retiboletus griseus* var. *fuscus* Hongo

MACROSCOPIC FEATURES: **cap** 5–14 cm wide, convex, becoming broadly convex to nearly flat or slightly depressed, dry, bald and smooth or slightly flattened-fibrillose, dark gray or brownish gray when young, paler gray in age; margin even. **pore surface** whitish to grayish or dingy gray-brown, not yellow at any stage, unchanging or staining brownish to gray when bruised; **tubes** 8–20 mm deep. **stalk** nearly equal, enlarged downward or tapered downward, often curved near the base, solid, whitish or grayish when young, usually developing reddish tints from the base upward as it matures, not staining yellow, covered overall with a coarse brownish to grayish reticulum that darkens in age; basal mycelium whitish. **flesh** white to yellowish, slowly reddening when cut or bruised; odor and taste not distinctive.

MICROSCOPIC FEATURES: Spores 11–17 × 4–6 µm, fusoid to oblong, smooth, pale brown.
SPORE PRINT: Olive brown.
HABIT, HABITAT, AND SEASON: Solitary or scattered with pines or in mixed woods with oaks and pines; summer–fall.
EDIBILITY: Edible.
COMMENTS: The epithet *fuscus* means "dark brownish gray to brownish black," with or without a tinge of purple, a reference to the cap color. We have included "group" after the epithet because molecular analysis of American and Asian specimens has not been compared. It is possible that American specimens are an undescribed species. The more common Gray Bolete, *Retiboletus griseus* (not illustrated), has a paler gray cap with whitish flesh that yellows toward the stalk base. The stalk develops yellow tones from the base upward as it matures. Gray Boletes grow under mixed broadleaf trees, especially oaks, and have smaller spores that measure 9–13 × 3–5 µm.

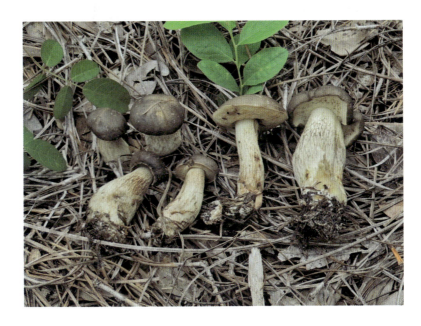

Retiboletus ornatipes (Peck) Manfr. Binder & Bresinsky

= *Boletus ornatipes* Peck

COMMON NAME: Ornate-stalked Bolete

MACROSCOPIC FEATURES: cap 4–20 cm wide, convex, broadly convex or slightly depressed, dull, somewhat powdery or slightly velvety, smooth and bald, color ranges from yellow to mustard yellow, olive yellow, yellow-brown, or gray. **pore surface** bright lemon yellow to deep rich yellow, becoming dingy brownish yellow in age, staining yellow-orange to orange-brown when bruised; **tubes** 4–15 mm deep. **stalk** varying from nearly equal to swollen in the middle, tapered toward the base, or with a club-shaped base, solid, dry, coarsely reticulate usually over the entire length, yellow to somewhat brownish, staining darker when bruised or handled. **flesh** thick, yellow, unchanging or rarely staining bluish at the stalk base; odor not distinctive, taste usually bitter.

MICROSCOPIC FEATURES: Spores 9–13 × 3–4 μm, oblong to slightly ventricose with an obtuse apex, smooth, pale brown.

SPORE PRINT: Olive brown to dark yellow-brown.

HABIT, HABITAT, AND SEASON: Solitary, in groups, or in conjoined clusters in broadleaf or mixed woods, typically under oaks or beeches but sometimes pines; late spring–fall.

EDIBILITY: Some collections are mild-tasting and edible, but most collections are intensely bitter.

COMMENTS: The epithet *ornatipes* means "ornate foot," a reference to the coarsely reticulated stalk. The cap surface stains orangish to pale orange-brown with KOH or NH_4OH and is negative with $FeSO_4$. Handling this bolete will stain fingers yellow. Gray-capped forms of *Retiboletus ornatipes* bear a strong resemblance to *Retiboletus griseus*, which has mild-tasting flesh and is typically yellow only on the lower portion of the stalk. Both species often appear in the same habitat at the same time. Some authors recognize *Retiboletus retipes* as a distinct species that is similar to *Retiboletus ornatipes* but with a cap up to 5 cm wide and slightly larger spores.

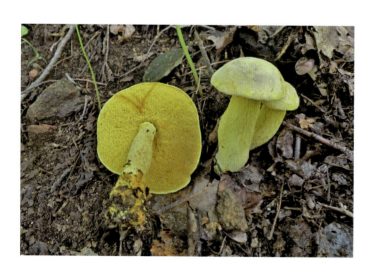

Retiboletus vinaceipes B. Ortiz, Lodge, & T. J. Baroni

MACROSCOPIC FEATURES: cap 3–8 cm wide, broadly convex, minutely pubescent, felty, or appressed tomentose, dry, color highly variable, whitish when very young, becoming dull brown to brownish gray or grayish to dark gray when mature; margin even. **pore surface** whitish at first, soon buff to pale dull yellow, then darkening in age to sordid yellow or cinnamon drab, staining brown when bruised; **tubes** 6–15 mm deep. **stalk** nearly equal down to a tapered base, whitish when very young, becoming off-white to buff or pale gray and rhubarb red to wine red at the base, with prominent brownish to gray reticulation over the upper two-thirds; basal mycelium white. **flesh** whitish and not staining in the cap and upper stalk, developing dull yellow or reddish stains near the stalk base, sometimes erratically staining weakly blue in the stalk; odor pungent or not distinctive, taste sweet, acidic, or slightly bitter.

MICROSCOPIC FEATURES: Spores 9.6–16 × 4–4.8 μm, fusiform, smooth, greenish yellow in KOH.

SPORE PRINT: Olive brown.

HABIT, HABITAT, AND SEASON: Scattered or in groups on the ground with oaks and pines; summer–early winter.

EDIBILITY: Unknown.

COMMENTS: The epithet *vinaceipes* means "wine foot," a reference to the wine red stalk base. The stalk is often riddled with larvae. The similar *Retiboletus griseus* (not illustrated) also has prominent reticulation but has yellow rather than wine red coloration on the stalk base.

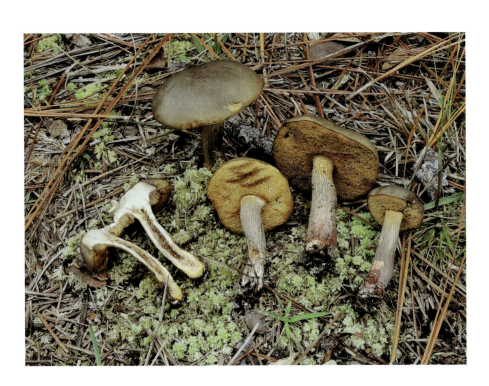

Strobilomyces dryophilus Cibula & N. S. Weber

MACROSCOPIC FEATURES: cap 3–12 cm wide, convex, becoming broadly convex to nearly flat in age, dry, with a whitish ground color covered by coarse, woolly or cottony, flattened or erect, grayish pink to pinkish tan or pinkish brown scales; margin fringed with cottony fragments of whitish to tan partial veil. **pore surface** white when young, soon gray and eventually black, staining reddish orange or brick red, then black when bruised, initially protected by a cottony or woolly partial veil that is whitish to pale pinkish tan; **tubes** 10–17 mm deep. **stalk** nearly equal or enlarged at the base, with an often shaggy ring zone, dry, solid, pinkish tan to brownish, ridged or reticulate above the ring, shaggy to woolly below. **flesh** whitish, quickly staining orange to orange-red, then slowly blackish when cut or bruised; odor and taste not distinctive.

MICROSCOPIC FEATURES: Spores 9–12 × 7–9 μm, subglobose to short-ellipsoid, covered by a distinct and complete reticulum, grayish.
SPORE PRINT: Blackish brown to black.
HABIT, HABITAT, AND SEASON: Solitary, scattered, or in groups under oaks; summer–winter.
EDIBILITY: Edible.
COMMENTS: The epithet *dryophilus* means "oak-loving," referring to its association with oak trees. The cap surface stains brown with NH_4OH or $FeSO_4$ and dark reddish brown with KOH. *Strobilomyces strobilaceus* has a darker purplish gray to blackish cap and stalk. So does the equally edible *Strobilomyces confusus* (not illustrated), which has smaller, more erect, stiffly pointed scales and a darker stalk. Its spores are ornamented with irregular projections and short ridges that do not form a complete reticulum.

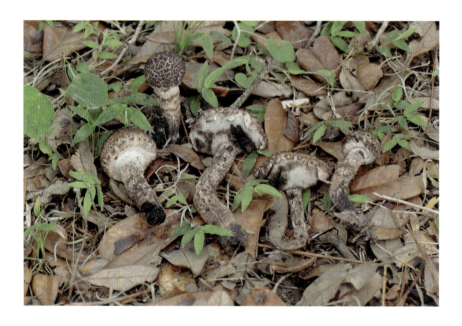

Strobilomyces strobilaceus (Scop.) Berk.

= *Strobilomyces floccopus* (Vahl) P. Karst.

COMMON NAMES: Old Man of the Woods, Pine Cone Bolete

MACROSCOPIC FEATURES: **cap** 3–16 cm wide, becoming broadly convex to nearly flat in age, dry, with a whitish to grayish ground color covered by coarse woolly or cottony, flattened or erect, and sometimes overlapping gray to purplish gray or blackish scales; margin fringed with cottony pieces of grayish partial veil. **pore surface** white when young, soon gray and finally black in age, staining reddish to brownish, then black if bruised, covered when young by a cottony or woolly partial veil; **tubes** 10–15 mm deep. **stalk** nearly equal or enlarged at the base, solid, usually with a distinct and shaggy ring zone, dry, grayish or colored like the cap, reticulate above the ring zone, shaggy to woolly below. **flesh** whitish, quickly staining orange to orange-red and then black when cut or bruised; odor and taste not distinctive.

MICROSCOPIC FEATURES: Spores 9.5–15 × 8.5–12, short-ellipsoid to globose, covered by a complete reticulum, grayish.

SPORE PRINT: Blackish brown to black.

HABIT, HABITAT, AND SEASON: Solitary, scattered, or in groups with pines or oaks; summer–fall.

EDIBILITY: Edible.

COMMENTS: The epithet *strobilaceus* means "resembling a pine cone." *Strobilomyces confusus* (not illustrated), edible, is very similar but has slightly smaller spores, 10–12.5 × 9.5–10.5 μm, ornamented with irregular projections and short ridges that sometimes link to form a partial reticulum. *Strobilomyces dryophilus* has a dull grayish pink to pinkish tan cap that becomes darker brown in age. Its spores have a complete reticulum.

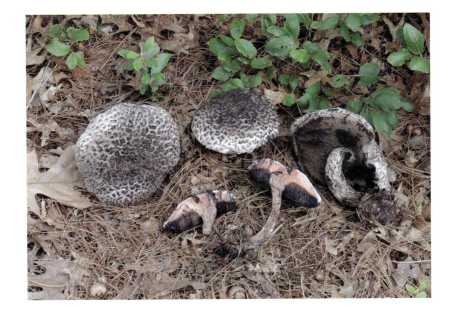

Suillellus hypocarycinus (Singer) Murrill

= *Boletus hypocarycinus* Singer

MACROSCOPIC FEATURES: cap 4–12 cm wide, rounded when young, becoming broadly convex, dry, somewhat velvety, brown to yellow-brown, sometimes with olive or cinnamon tones; margin incurved when young, usually sterile. **pore surface** red to orange-red or dull orange, staining blue when bruised, often depressed around the stalk in age; **tubes** 8–16 mm deep. **stalk** slightly enlarged downward or nearly equal, solid, dry, whitish to yellowish with a yellow apex and red punctae on at least the lower portion, not reticulate, lacking tiny tufts of yellow or reddish hairs at the base, basal mycelium white. **flesh** yellow, staining blue when cut; odor and taste not distinctive.

MICROSCOPIC FEATURES: Spores 8–12 × 3–4 µm, subfusoid to ellipsoid, smooth, brownish yellow.

SPORE PRINT: Olive brown.

HABIT, HABITAT, AND SEASON: Solitary, scattered, or in groups on the ground, especially in river bottomlands, associated with oaks and hickories; summer–fall.

EDIBILITY: Unknown.

COMMENTS: The epithet *hypocarycinus* means "under hickory." *Boletus carminiporus* (not illustrated), edibility unknown, has a dull red cap that becomes pinkish red to orange-red. The pore surface is dark red to orange-red and stains bluish green when bruised. It has a rose pink to dark red stalk that is sometimes yellow at the apex, reticulate overall or on the upper portion, and stains brownish red or slowly olive green to olive yellow when bruised. The flesh is whitish to pale yellow, turning darker yellow when exposed but not staining blue. It grows with broadleaf trees or in mixed oak and pine woods. The spores measure 8–11 × 3–4 µm.

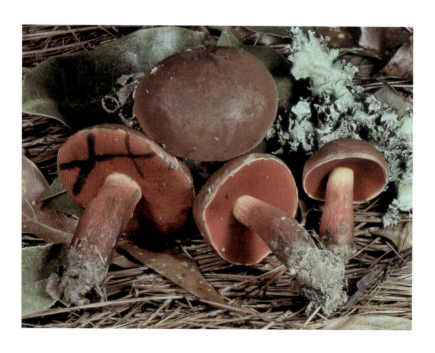

Suillellus subvelutipes (Peck) Murrill

= *Boletus subvelutipes* Peck

COMMON NAME: Red-mouth Bolete

MACROSCOPIC FEATURES: cap 6–13 cm wide, convex, becoming broadly convex, dry, velvety or smooth, color ranging from cinnamon brown to yellow-brown, reddish brown, or reddish orange to orange-yellow, often yellow near the margin, staining bluish black; margin sometimes sterile. **pore surface** red, brownish red, or red-orange, duller in age, staining dark blue to blackish when bruised; **tubes** 8–26 mm deep. **stalk** equal, solid, dry, scurfy, flushed red and yellow, usually yellow at the apex, staining dark blue to blackish, not reticulate, usually having tufts of very short, stiff hairs at the base that are yellow at first but mature to dark red. **flesh** bright yellow, staining dark blue, then whitish; odor not distinctive, taste slightly acidic or not distinctive.

MICROSCOPIC FEATURES: Spores 13–18 × 5–6.5 μm, fusoid-subventricose, smooth, pale brown.

SPORE PRINT: Dark olive brown.

HABIT, HABITAT, AND SEASON: Solitary, scattered, or in groups with broadleaf trees, especially oaks, but sometimes under conifers; summer–fall.

EDIBILITY: Traditionally considered poisonous. However, we have had several recent reports of individuals who ate this bolete without ill effects. Although one of the authors has personally consumed it without incident, we advise caution.

COMMENTS: The Slender Red-pored Bolete, *Neoboletus luridiformis* (not illustrated), edibility unknown, has a somewhat velvety, dark brown cap when young that ages to olive brown, develops red tones, or becomes dull yellow and stains dark blue to blackish brown when bruised. The pore surface is orange-red and stains blackish blue. The stalk has reddish to orange cinnamon punctae over a yellow ground color or is reddish overall, stains blue, is not reticulate, and lacks basal yellow or reddish hairs. The flesh is yellow, instantly staining blue. Spores measure 12–16 × 4.5–6 μm.

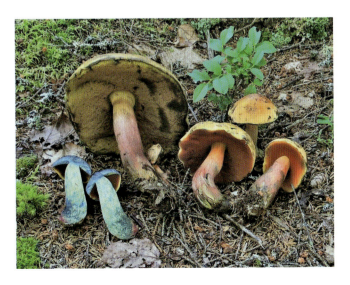

Suillus americanus (Peck) Snell

= *Boletus americanus* Peck

COMMON NAMES: American Slippery Jack, Chicken-fat Suillus

MACROSCOPIC FEATURES: cap 3–13 cm wide, initially rounded, becoming broadly convex, occasionally with a broad umbo, sticky to slimy and shiny when moist, bright yellow to ocher-yellow with cinnamon to reddish patches or streaks; margin incurved when young, hung with white to yellow or pale brown veil tissue. **pore surface** yellow, slowly staining reddish brown when bruised; **pores** angular, sometimes elongated and radially arranged; **tubes** 7–10 mm deep. **stalk** nearly equal, solid at first, developing cavities or hollowing in age, yellow with reddish brown resinous dots and smears. **flesh** yellow, staining pinkish gray to purplish brown when exposed; odor and taste not distinctive.

MICROSCOPIC FEATURES: Spores 8–11 × 3–4 μm, subfusiform, smooth, pale brown.

SPORE PRINT: Brown.

HABIT, HABITAT, AND SEASON: Sometimes solitary but usually in groups or clusters with white pines, often in grassy areas in parks; summer–fall.

EDIBILITY: Edible.

COMMENTS: This bolete stains fingers brownish when handled. The Blue-staining Slippery Jack, *Suillus tomentosus* (see Color Key), edible, has a dry, fibrillose-scaly cap when young that becomes nearly bald and shiny or slippery in age. The cap is yellow to orange-yellow, with grayish, yellow-ocher, dark olive yellow, or reddish scales and fibers. The pore surface is initially brown to vinaceous brown or dingy cinnamon, ages to dingy yellow or olive yellow, and bruises blue. Its tubes are 8–15 mm deep (distinguishing it from the shallow-tubed and occasionally bluing *Suillus hirtellus*). The stalk is yellow to dull orange-yellow with darker orange to brownish resinous dots and smears. The flesh is yellow and bruises blue erratically and often slowly. It grows with conifers. The spores measure 7–12 × 3–5 μm.

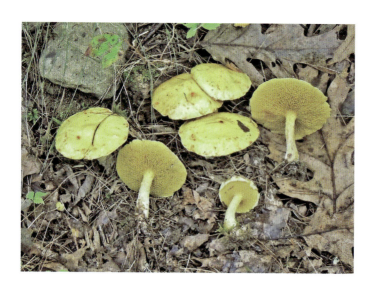

Suillus cothurnatus Singer

= *Boletus luteus* var. *cothurnatus* (Singer) Murrill

COMMON NAMES: Baggy-veiled Suillus, Booted Suillus

MACROSCOPIC FEATURES: cap 1.5–6 cm wide, obtuse to broadly convex, sometimes with a low umbo, smooth, bald, sticky, color variable, yellow-brown or olive brown to grayish brown or dark brown; margin usually hung with whitish veil fragments. **pore surface** pale yellow to orange-yellow, aging to brownish yellow, unchanging when bruised; **pores** irregular to radially elongated, covered initially by a thick, rubbery, baggy, slimy, whitish to grayish partial veil that eventually tears and leaves a ring on the stalk; **tubes** up to 5 mm deep. **stalk** equal or tapered downward, dry, solid, whitish to yellowish, brownish when mature, with brownish resinous dots on the upper portion or overall; ring median to superior, membranous, band-like, whitish to grayish, collapsed, the lower edge sometimes flaring. **flesh** with orange-buff and pale yellow marbling; odor fragrant or not distinctive, taste not distinctive.

MICROSCOPIC FEATURES: Spores 8–10 × 2.5–3.5 μm, ellipsoid-oblong to subcylindric, smooth, honey brown.

SPORE PRINT: Brown.

HABIT, HABITAT, AND SEASON: Scattered or in groups with pines, sometimes on moss-covered trunks or stumps; year-round.

EDIBILITY: Edible.

COMMENTS: The epithet *cothurnatus* means "high boot," referring to the baggy partial veil that covers the pores and part of the stalk. *Suillus hiemalis* is similar but much larger and more orange and has unpleasant-tasting flesh. Its ring is median, collapsed, membranous, band-like, and grayish, and the lower edge does not flare. The Slippery Jack, *Suillus luteus* (not illustrated), edible, has a sticky to slimy brown cap and a pale yellow to brownish yellow pore surface, and it is covered when young by a white partial veil with a purple band on the undersurface.

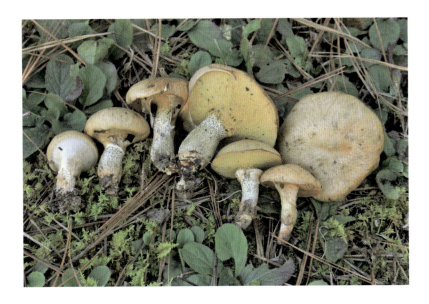

Suillus decipiens (Peck) Kuntze

= *Boletinus decipiens* Berk. & M. A. Curtis
= *Boletus decipiens* Peck

MACROSCOPIC FEATURES: **cap** 4–9 cm wide, convex to nearly flat, dry, fibrillose, sometimes with small, flattened scales, may be bald in places, orange to dull yellow, tan, or pale reddish brown, staining grayish to blackish when bruised, sometimes slowly; margin strongly incurved and typically fringed with whitish, yellowish, or grayish fragments of veil tissue. **pore surface** orange-yellow to yellow, aging to brownish yellow, bruising brownish, initially covered by a fibrillose, whitish, yellowish, or grayish partial veil that entirely disappears or leaves a thin, fragile ring zone on the upper stalk; **pores** angular, elongated and radially arranged; **tubes** up to 8 mm deep. **stalk** usually enlarged downward, solid, dry, somewhat velvety or fibrillose, orange to dull yellow, often bright yellow-orange above the ring zone. **flesh** pale yellow to pinkish buff, unchanging or slowly reddening or darkening after exposure, bright yellow in the stalk, orange in the base; odor and taste not distinctive.

MICROSCOPIC FEATURES: Spores 9–12 × 3.5–4 µm, cylindric to subellipsoid, smooth, hyaline to pale ochraceous.

SPORE PRINT: Pale brown.

HABIT, HABITAT, AND SEASON: Scattered or in groups in mixed oak and pine woods; summer–fall.

EDIBILITY: Edible.

COMMENTS: The epithet *decipiens* means "deceiving," referring to its resemblance to other species. The cap surface stains pale gray to greenish gray with KOH. Both's Bolete, *Bothia castanella* (see Color Key), edibility unknown, has a dry, yellow-brown to reddish brown cap and a decurrent, brownish yellow to yellow-brown pore surface that bruises brown and features angular, elongated, radially arranged pores. The stalk is short, often narrowed downward, and colored like the cap. Flesh is whitish and seldom stains when exposed. It grows in oak woods and has spores that measure 8–11 × 4.5–5.5 µm.

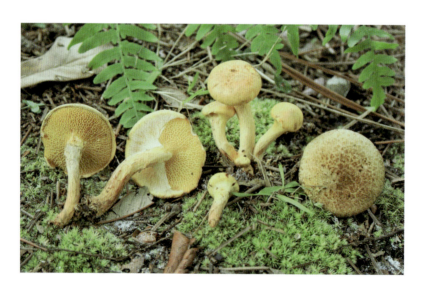

Suillus hiemalis (Singer) Farid, A. R. Franck, J. Bolin, W. C. Roody, Bessette, & A. R. Bessette comb. prov.

= *Suillus cothurnatus* ssp. *hiemalis* Singer

COMMON NAME: Chunky Monkey

MACROSCOPIC FEATURES: **cap** 4–11.5 cm broad, convex, becoming broadly convex to nearly flat, sometimes with a depressed center, bald, sticky when wet, slightly tacky when dry, dull orange at first, then developing brownish tones, dull tan in age, unchanging when bruised; cuticle tastes mild to strongly acidic; margin entire, hung with partial veil fragments that remain well into maturity. **pore surface** initially yellow, then bright orange, darkening in age to dark orange-brown, not staining when bruised; covered when young by a thick, baggy, rubbery, slimy, grayish partial veil that tears and leaves a ring on the stalk when mature; **tubes** 2–10 mm deep. **stalk** nearly equal, tapered downward or sometimes with an enlarged and pinched base, often with a rhizomorph that extends into the soil, yellow-orange with a bright yellow apical zone, covered overall with prominent red-orange resinous dots that darken to brown, then black in age; ring median, collapsed, membranous, band-like, grayish. **flesh** orange in young specimens, becoming yellow, then creamy white with age, bright orange in the stalk base, unchanging when exposed; odor not distinctive, taste very unpleasant or rarely not distinctive.

MICROSCOPIC FEATURES: Spores 9–13 × 3–4 µm, subcylindric to ellipsoid-oblong, smooth, pale grayish brown.

SPORE PRINT: Light brown.

HABIT, HABITAT, AND SEASON: Solitary, scattered, or in groups along the Coastal Plain in the sandy soil of mixed oak-pine woods; fall–winter.

EDIBILITY: Edible but usually very unpleasant-tasting.

COMMENTS: The epithet *hiemalis* means "occurring in winter." *Suillus cothurnatus* is similar but smaller with a much thinner stalk, a partial veil that sometimes has a flaring lower edge, and marbled, mild-tasting flesh.

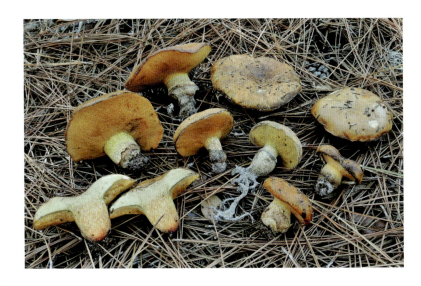

Suillus hirtellus (Peck) Snell

= *Boletus hirtellus* Peck

MACROSCOPIC FEATURES: cap 5–12 cm wide, convex to nearly flat, dry to slightly tacky, yellow, covered with scattered tufts of reddish, brownish, or grayish fibrils and scales, balding in age; the young margin is decorated with fragments of tissue. **pore surface** initially pale yellow, sometimes with whitish to pinkish droplets, aging to dull yellow or dingy orange-buff, unchanging or bruising vinaceous brown or rarely bluish green; **tubes** 3–8 mm deep. **stalk** equal or enlarged downward, often curved, solid; dry, bald, pale yellow with prominent yellowish resinous dots and smears that become brown or blackish brown in age, sometimes with reddish tints chiefly toward the base, usually with white basal mycelium. **flesh** yellow, unchanging or bruising weakly and erratically blue; odor and taste not distinctive.

MICROSCOPIC FEATURES: Spores 7–11(–13) × 3–3.5 μm, nearly oblong, smooth, pale ochraceous.

SPORE PRINT: Ochraceous brown to dull cinnamon.

HABIT, HABITAT, AND SEASON: Scattered or in groups with conifers, especially pines; summer–winter.

EDIBILITY: Edible.

COMMENTS: The epithet *hirtellus* means "hairy or shaggy," referring to the cap fibers and scales. The Sour-cap Suillus, *Suillus acidus* (not illustrated), edible, has a sticky yellowish to pinkish cinnamon cap often hung with marginal veil fragments, a yellow to dingy yellow pore surface sometimes beaded with white to pinkish droplets, and a yellow to ocher-yellow stalk with reddish resinous dots and an apical, gelatinous, band-like ring. Flesh is whitish to yellow. It grows with pines. The White Suillus, *Suillus placidus* (not illustrated), edible, lacks a partial veil. The cap is sticky whitish to yellowish. Pores are whitish, then pale ocher-yellow, often beaded with pinkish droplets. The stalk is whitish to yellowish with pinkish brown resinous dots and smears. Flesh is white to yellowish. It grows with white pines.

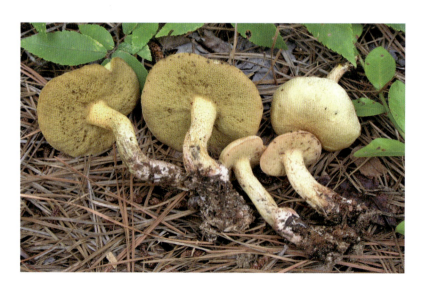

Suillus spraguei (Berk. & M. A. Curtis) Kuntze

= *Boletinus pictus* Peck
= *Boletus pictus* Peck
= *Suillus pictus* (Peck) A. H. Sm. & Thiers

COMMON NAMES: Painted Bolete, Painted Suillus

MACROSCOPIC FEATURES: cap 4–12 cm wide, convex, becoming nearly flat in age, with or without a low, broad umbo, dry, covered with fibrils and soft, more or less flattened scales that are red to purplish red or rose red at first but fade to ochraceous or buff over a yellow to dirty white ground color; margin incurved when young, often fringed with pieces of whitish partial veil. **pore surface** yellow, turning dingy yellow to ochraceous in age, staining reddish to brownish when bruised, initially covered by a whitish cottony or web-like partial veil; **pores** angular, elongated and radially arranged; **tubes** 4–8 mm deep. **stalk** nearly equal or with an enlarged or tapered base, colored like the cap, lacking resinous dots and smears, cottony or scaly, sometimes appearing concentrically banded from the base up to the subapical cottony, flaring or collapsed, whitish to grayish ring. **flesh** yellow, sometimes staining slightly reddish, then very slowly brownish black; odor and taste not distinctive.

MICROSCOPIC FEATURES: Spores 8–12 × 3.5–5 μm, ellipsoid, smooth, pale brown.
SPORE PRINT: Olive brown.
HABIT, HABITAT, AND SEASON: Scattered or in groups with white pines; spring–late fall.
EDIBILITY: Edible.
COMMENTS: The epithet *spraguei* honors Charles James Sprague (1823–1903), who first collected this bolete in 1865. The cap surface stains blackish with KOH, NH_4OH, or $FeSO_4$. It is sometimes attacked by a parasitic mold, *Hypomyces completus*, which covers the cap, stalk, and pore surface of this species with a dense coating of mycelium. It is white at first, then yellowish to brownish, and finally blackish.

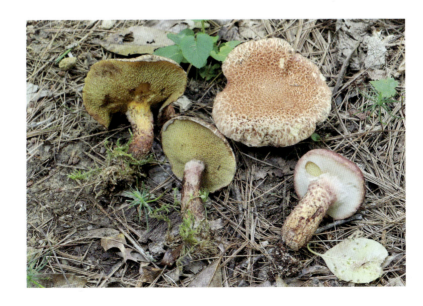

Suillus weaverae (A. H. Sm. & Schaffer) H. Engel & Klofac

= *Suillus lactifluus* (With.) A. H. Sm. & Thiers

COMMON NAMES: Butterball, Granulated Slippery Jack

MACROSCOPIC FEATURES: cap 5–12 cm wide, broadly convex, sticky to slimy, often streaked or mottled in a vaguely checkered pattern, color some shade of tan, brown, cinnamon, or orange-cinnamon, rarely yellowish; margin even. **pore surface** whitish to pinkish buff at first, becoming dull yellow, sometimes with pinkish cinnamon moisture drops, staining dull brown; **tubes** 4–10 mm deep. **stalk** nearly equal, solid, dry, whitish or yellowish with conspicuous pinkish brown resinous dots and smears. **flesh** white to pale yellow, not staining when exposed; odor and taste not distinctive.

MICROSCOPIC FEATURES: Spores 7–10 × 2.5–3.5 µm, oblong or obovate, smooth, pale brown.

SPORE PRINT: Brown.

HABIT, HABITAT, AND SEASON: Scattered or in groups with pines; summer–early winter.

EDIBILITY: Edible.

COMMENTS: North American field guide authors historically identified *Suillus weaverae* as *Suillus granulatus*, a European sister-species. *Suillus placidus* (not illustrated, briefly described in Comments for *Suillus hirtellus*) is similar but paler. The Short-stemmed Slippery Jack, *Suillus brevipes* (not illustrated), edible, is similar as well but usually has a darker brown cap and shorter stalk that may develop inconspicuous resinous dots in age. The edible Slippery Jack, *Suillus luteus* (not illustrated), has a sticky to slimy brown cap often decorated on the margin with veil fragments. Its pore surface is pale yellow to brownish yellow, does not stain when bruised, and is initially covered by a white partial veil banded with purple on the undersurface. The generally whitish stalk has a pale yellow apex and is decorated, at least above the ring zone, with resinous dots and smears. The flesh is white to pale yellow, not staining when exposed. It grows with conifers, especially pines. Spores measure 7–9 × 2.5–3 µm.

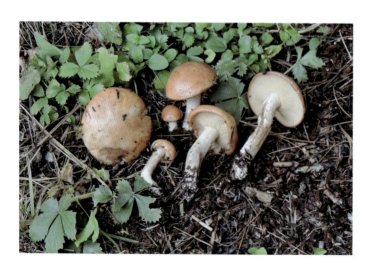

Sutorius eximius (Peck) Halling, Nuhn, & Osmundson

= *Boletus eximius* Peck
= *Leccinum eximium* (Peck) Singer
= *Tylopilus eximius* (Peck) Singer

COMMON NAME: Lilac-brown Bolete
MACROSCOPIC FEATURES: **cap** 5–12 cm wide, hemispherical to nearly flat, dry, bald or finely velvety, purplish brown to grayish brown, usually with a whitish bloom at first; margin initially incurved. **pore surface** dark purple-brown to brown when young, aging to reddish brown; **tubes** 9–22 mm deep. **stalk** stout, equal or sometimes enlarged downward, solid, dry, pale purplish gray, densely covered with purple-brown scabers. **flesh** whitish, grayish, reddish, or brownish lilac; odor slightly pungent or not distinctive, taste mildly bitter or not distinctive.
MICROSCOPIC FEATURES: Spores 11–17 × 3.5–5 μm, narrowly subfusoid, smooth, hyaline to pale brown.
SPORE PRINT: Pinkish brown.
HABIT, HABITAT, AND SEASON: Scattered or in groups with conifers or in mixed woods with oaks; summer–fall.
EDIBILITY: Avoid. Although historically considered edible, cases of gastrointestinal toxicity requiring hospitalization are reported.
COMMENTS: The epithet *eximius* means "distinguished or excellent in size or beauty." This bolete might be confused with species of *Leccinum* because of the small scabers on its stalk. *Leccinum* species are differentiated by typically having paler fruit bodies and yellow-brown spore prints. *Tylopilus plumbeoviolaceus* is similar but has a smooth stalk and intensely bitter flesh. *Tylopilus griseocarneus* is also similar but has a reticulated rather than scabered stalk.

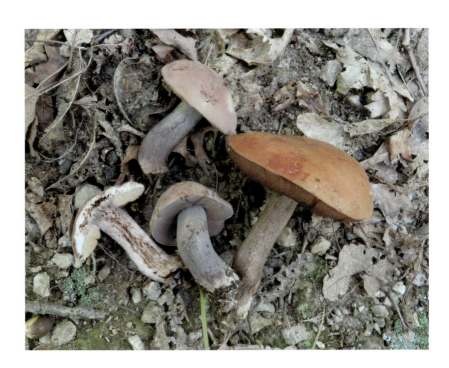

Tylopilus alboater (Schwein.) Murrill

= *Boletus alboater* Schwein.

COMMON NAME: Black Velvet Bolete
MACROSCOPIC FEATURES: cap 3–15 cm wide, convex to nearly flat, dry, velvety, occasionally developing fine cracks in age, deep violet to dark grayish brown or nearly black, usually with a thin whitish bloom when young. **pore surface** white or with a gray tinge at first, becoming dull pinkish brown, usually bruising reddish, then slowly black; **tubes** 5–10 mm deep. **stalk** equal or enlarged downward, solid, dry, colored like the cap or paler near the apex, often covered with a thin whitish bloom, slowly staining blackish, not reticulate or only slightly so at the apex. **flesh** white or tinged gray, staining pinkish to reddish gray when exposed and eventually blackening; odor and taste not distinctive.
MICROSCOPIC FEATURES: Spores 7–11 × 3.5–5 μm, narrowly oval, smooth, hyaline.
SPORE PRINT: Pinkish brown.
HABIT, HABITAT, AND SEASON: Solitary to scattered with broadleaf trees, especially oaks; late spring–fall.

EDIBILITY: Although edible for some individuals, it causes significant gastrointestinal upset for others.
COMMENTS: The epithet *alboater* means "white and black." The cap surface stains amber orange with KOH and is negative with $FeSO_4$ or NH_4OH. The False Black Velvet Bolete, *Tylopilus atronicotianus* (not illustrated), edibility unknown, is very similar but has an olive brown, bronze brown, or grayish brown cap that fades to pale brown in age. The flesh is white, slowly stains pink to reddish vinaceous, then blackish, and has a musty or disagreeable odor. *Tylopilus williamsii* (not illustrated), inedible, is also similar but has a pale yellow to grayish stalk often streaked with beige and grayish orange. Its flesh tastes bitter. The edible Burnt Orange Bolete, *Tylopilus balloui* (see Color Key), has white flesh that stains pinkish tan to violet-brown when exposed. It grows with broadleaf trees, especially oaks, but sometimes with pines as well. The spores measure 5–11 × 3–5 μm.

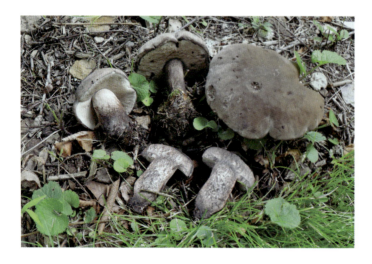

Tylopilus griseocarneus Wolfe & Halling

MACROSCOPIC FEATURES: **cap** 4–11 cm wide, convex to nearly flat, dry, velvety when young, sometimes cracking in age, color ranges from dull reddish brown to brown, dark olive brown, dark gray to brownish gray or blackish; margin incurved and remaining so well into maturity. **pore surface** initially blackish, aging to gray, staining grayish orange or a darker gray when mature; **tubes** 3–11 mm deep. **stalk** equal or tapered in either direction, solid, dry, blackish brown to gray, sometimes paler at the apex, with prominent reticulation on the upper one-third or nearly overall, often darkly pruinose. **flesh** grayish, bruising orangish to orange-red and then black; odor and taste not distinctive.

MICROSCOPIC FEATURES: Spores 8–14 × 3–5 μm, fusiform to ellipsoid, smooth, hyaline.
SPORE PRINT: Pinkish to pinkish gray.
HABIT, HABITAT, AND SEASON: Scattered or in groups with oaks or pines; summer–winter.
EDIBILITY: Reportedly poisonous.
COMMENTS: The epithet *griseocarneus* means "gray flesh." The cap surface stains vinaceous black with KOH. The cap flesh stains vinaceous pink with KOH and is negative with NH_4OH or $FeSO_4$. The stalk flesh stains reddish orange with KOH and gray-blue with $FeSO_4$ and is negative with NH_4OH. *Tylopilus alboater* has white or whitish pores and lacks prominent reticulation on the stalk.

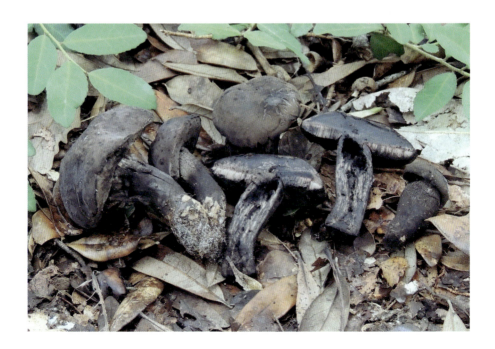

Tylopilus indecisus (Peck) Murrill

= *Boletus indecisus* Peck
= *Tylopilus subpunctipes* (Peck) A. H. Sm. & Thiers

MACROSCOPIC FEATURES: cap 4–12 cm wide, convex at first, becoming broadly convex to nearly flat in age, dry, velvety to nearly smooth, ochraceous brown to light brown, sometimes with reddish brown tints; margin even. **pore surface** whitish when young, aging to pinkish or pinkish brown, staining brown when bruised; **tubes** 6–15 mm deep. **stalk** nearly equal to slightly enlarged downward, solid, dry, whitish but turning pale brown on the lower portion by maturity, lacking violaceous tones, staining brown when bruised, typically finely reticulate near the apex; basal mycelium white. **flesh** white, unchanging or slowly staining pinkish to brownish when exposed; odor and taste not distinctive.

MICROSCOPIC FEATURES: Spores 10–15 × 3–5 μm, narrowly subfusiform, smooth, hyaline to yellowish.

SPORE PRINT: Pinkish brown to reddish brown.

HABIT, HABITAT, AND SEASON: Scattered or in groups with broadleaf trees, especially oaks; summer–fall.

EDIBILITY: Edible.

COMMENTS: *Tylopilus ferrugineus* (not illustrated) also has mild-tasting flesh and is edible. It differs by having a rusty brown to darker brown cap and a dull brown to rusty brown stalk. The smaller Beveled-cap Bolete, *Tylopilus badiceps* (not illustrated), edible and mild-tasting, has a 4–8 cm cap, maroon to purplish brown or dark brown, with a beveled to folded margin and violaceous tones on the stalk. The bitter *Tylopilus rubrobrunneus* resembles *Tylopilus indecisus* as well, usually having a white stalk when young, but it turns brown and slowly develops bright olive or olive brown stains from the base upward when handled or in age. Although some macrochemical test results have been reported for each of these species, we have omitted them here because the data presented in various sources differ dramatically.

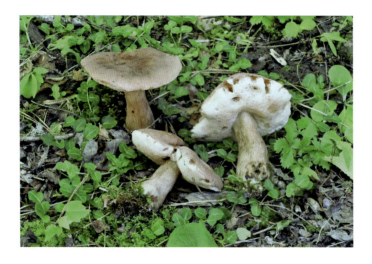

Tylopilus minor Singer

= *Boletus minor* (Singer) Murrill

COMMON NAME: Little Bitter Bolete
MACROSCOPIC FEATURES: cap 3–8(–15) cm wide, convex, becoming broadly convex in age, dry, bald to finely velvety, pale brown to brown or sometimes dull whitish, often with pinkish tones; margin even. **pore surface** white at first, pale brownish pink and often depressed at the stalk in age, not staining when bruised; **tubes** 4–12(–18) mm deep. **stalk** nearly equal or slightly enlarged downward, usually with an abruptly narrowed base, solid, dry, with pale to brownish reticulation near the apex, sometimes extending to the midportion or lacking, white to whitish at first, becoming brownish to cinnamon, apex and base whitish, basal mycelium white. **flesh** white, unchanging when exposed; odor not distinctive, taste bitter.
MICROSCOPIC FEATURES: Spores 9–15 × 3–5 μm, fusoid, smooth, yellowish to hyaline.
SPORE PRINT: Pinkish brown.
HABIT, HABITAT, AND SEASON: Solitary, scattered, or in groups in broadleaf or mixed woods with oaks; late spring–fall.
EDIBILITY: Inedible due to bitterness.
COMMENTS: The Bitter Bolete, *Tylopilus felleus* (not illustrated), inedible, is similar but larger, 5–30 cm wide. Its stalk is enlarged downward, is often bulbous at the base, and has prominent reticulation over the upper third or more. It grows in association with conifers, especially pines. The Variable Brown-net Bolete, *Tylopilus variobrunneus* (see Color Key), is edible if not too bitter. The young cap is greenish brown to dark olive brown or blackish brown, turning dull medium brown to chestnut brown when mature. The stout and often stubby stalk is typically 2-toned, whitish above and brown below, featuring dark brown reticulation that may be white at the stalk apex. The flesh is mild or slightly bitter-tasting. It grows in broadleaf or mixed woods with oaks. Spores measure 9–13 × 3–4.5 μm.

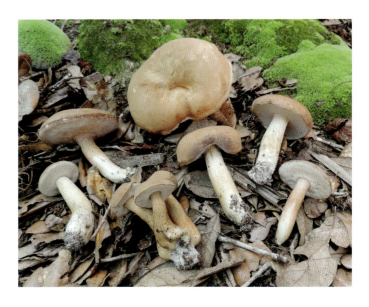

Tylopilus peralbidus (Snell & Beardslee) Murrill

= *Boletus peralbidus* Snell & Beardslee

MACROSCOPIC FEATURES: cap 4.5–13 cm wide, convex to nearly flat, often depressed over the disc when mature, dry, bald to velvety, developing fine cracks in age, initially white, becoming ochraceous tan to chamois and finally brownish, bruising cinnamon to brown; margin even. **pore surface** initially whitish, buff or tinged pinkish in age, bruising brown; **tubes** 6–10 mm deep. **stalk** equal or tapered in either direction, often with a pointed base, solid, dry, smooth, white to brownish or colored like the cap, bruising brown. **flesh** white, sometimes slowly bruising pale pinkish brown or buff; odor bleach-like or unpleasant, taste bitter.
MICROSCOPIC FEATURES: Spores 7–12 × 2.3–3.5 µm, cylindric or cylindric-subclavate, smooth, pale honey yellow.
SPORE PRINT: Pinkish brown.
HABIT, HABITAT, AND SEASON: Solitary, scattered, or in groups on lawns, along roads, or in oak or pine woods; spring–fall.
EDIBILITY: Unknown.
COMMENTS: The epithet *peralbidus* means "whitish throughout," referring to the youthful color. The cap surface stains yellow with KOH and dark blue-green with $FeSO_4$ and is negative with NH_4OH. The flesh immediately stains dark bluish gray with $FeSO_4$ and pale yellow with KOH or NH_4OH. *Tylopilus rhoadsiae* is similar but has a reticulated stalk. The Appalachian Yellow-brown Bolete, *Tylopilus appalachiensis* (see Color Key), edibility unknown, has a dry, velvety, chamois to brownish yellow cap that typically becomes darker brown and may crack in age. The white flesh slowly stains pinkish, then pale brown and has an unpleasant odor and a bitter taste. The pore surface is whitish at first and pinkish brown in age and stains brown when bruised. The stalk is colored like the cap or paler and lacks reticulation or is reticulate only at the apex. It grows under broadleaf trees, especially oaks. Spores measure 9–12 × 3–3.5 µm.

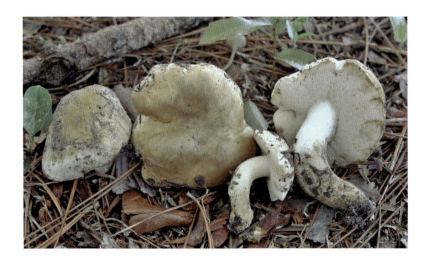

Tylopilus plumbeoviolaceus (Snell & Dick) Singer

= *Boletus plumbeoviolaceus* Snell & Dick

COMMON NAME: Violet-gray Bolete
MACROSCOPIC FEATURES: **cap** 4–15 cm wide, convex to broadly convex and nearly flat in age, smooth, shiny, cracked at times, brownish to grayish brown or dull cinnamon, sometimes tinged purplish especially toward the margin, sometimes entirely purple when young; margin narrowly sterile. **pore surface** dull white, becoming very pale brown to pinkish tan with age, not staining when bruised or bruising light pinkish brown, depressed around the stalk at maturity; **tubes** 4–18 mm deep. **stalk** nearly equal or enlarged downward, solid, dry, smooth and bald except for a narrow zone of apical reticulation, purple at first, then grayish purple to purplish brown, with white basal mycelium. **flesh** firm when fresh, white, not staining when cut or bruised; odor slightly pungent or not distinctive, taste very bitter.
MICROSCOPIC FEATURES: Spores 10–13 × 3–4 μm, ellipsoid, smooth, pale brown.
SPORE PRINT: Purplish brown.
HABIT, HABITAT, AND SEASON: Solitary or in small groups in broadleaf woods with oak; early summer–late fall.
EDIBILITY: Inedible due to bitterness.
COMMENTS: The epithet *plumbeoviolaceus* means "grayish violaceous," referring to the overall colors. The Pale Violet Bitter Bolete, *Tylopilus violatinctus* (not illustrated), inedible, is similar. Its cap is paler grayish lilac to pinkish lilac. The pore surface is white to pale dull pink at first, browning slightly with maturity, and unchanging when bruised. The stalk is white at the apex and colored like the cap below and either lacks reticulation or is inconspicuously reticulate at the apex. It grows with broadleaf or conifer trees and has smaller spores, measuring 7–10 × 3–4 μm.

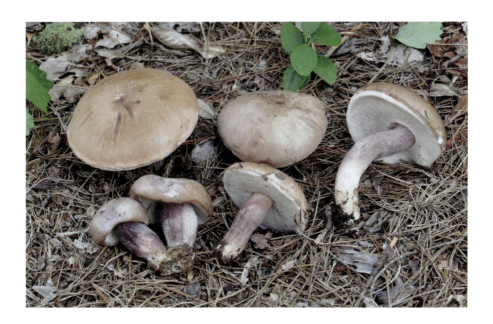

Tylopilus rhoadsiae (Murrill) Murrill

= *Boletus rhoadsiae* (Murrill) Murrill
= *Gyroporus rhoadsiae* Murrill

COMMON NAME: Pale Bitter Bolete
MACROSCOPIC FEATURES: cap 6–15 cm wide, convex to nearly flat, dry, bald or velvety, at first white to whitish tinged with buff, grayish buff, pinkish, or pinkish tan, aging to tan, pinkish brown, or golden brown. **pore surface** white, becoming dull pinkish with maturity, unchanging; **tubes** 9–20 mm deep. **stalk** equal or enlarged downward above a pinched base, solid, dry, white or colored like the cap with prominent white or brown reticulation on the upper half or nearly overall, basal mycelium white. **flesh** white, unchanging; odor not distinctive, taste bitter.
MICROSCOPIC FEATURES: Spores 11–13.5 × 3.5–4.5 µm, oblong to elliptic, smooth, hyaline to pale yellow.
SPORE PRINT: Pinkish to brownish vinaceous.
HABIT, HABITAT, AND SEASON: Scattered or in groups with pines or oaks; summer–winter.
EDIBILITY: Inedible due to bitterness.
COMMENTS: The epithet *rhoadsiae* honors Louise and Arthur S. Rhoads, who first collected this bolete in Putnam County, Florida. The cap surface stains pale yellow with KOH or NH_4OH and gray with $FeSO_4$. *Retiboletus griseus* (not illustrated) is not bitter and has a prominently reticulated stalk that yellows from the base upward. *Tylopilus peralbidus* is another look-similar but lacks reticulation on the stalk. *Tylopilus rhodoconius* has a darker brown cap, a stalk that bruises brown, and white to creamy white flesh with translucent marbling. *Imleria pallida* can resemble an older *Tylopilus rhoadsiae* as well, but the pores yellow in age and stain blue, and the stalk lacks prominent reticulation.

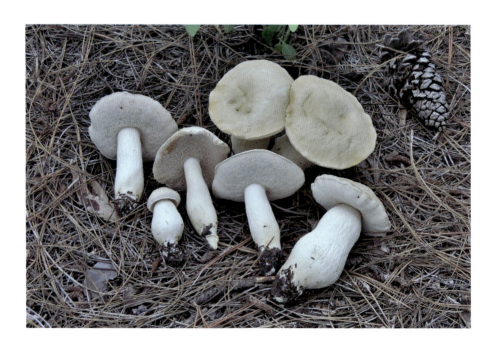

Tylopilus rhodoconius T. J. Baroni, Both, & Bessette

MACROSCOPIC FEATURES: cap 4–14 cm wide, hemispheric at first, broadly convex to nearly flat in age, matted and woolly, developing fine cracks in age, initially pale ochraceous to brownish orange, then pale brown and finally darker brown, remaining paler toward the margin, bruising dark brown; margin sterile. **pore surface** whitish with a faint flush of pink when young, later pinkish buff, and finally vinaceous fawn, staining dull brown, then dark cinnamon brown to tobacco brown when bruised; **tubes** 6–10 mm deep. **stalk** equal or bulging in the midsection, tapered to a point at the base, often with a short, root-like projection, dry, solid, finely pruinose, white near the apex, below that yellow-brown to reddish brown or colored like the cap, bruising dark cinnamon brown to tobacco brown when handled, basal mycelium white and often coated with sand. **flesh** soft, white to pale creamy white with translucent marbling, slowly staining pale pinkish and finally a dingy, Caucasian flesh color when exposed; odor faintly of chlorine or not distinctive, taste mild or initially mild, then very bitter.

MICROSCOPIC FEATURES: Spores 8.4–13 × 2–3.5 μm, cylindric, smooth, hyaline.

SPORE PRINT: Pink to reddish gray.

HABIT, HABITAT, AND SEASON: Scattered or in groups on the ground in sandy woods under oaks, pines, or beeches; summer–fall.

EDIBILITY: Unknown.

COMMENTS: The epithet *rhodoconius* refers to the pinkish to reddish gray color of the accumulated spore deposit of this bolete. The cap surface slowly stains pale yellow-brown with KOH or NH_4OH and bluish green to bluish gray with $FeSO_4$. *Tylopilus peralbidus* is similar but differs by having a paler cap and stalk, not readily bruising brown when handled, lacking translucent marbling in the flesh, and having slightly smaller spores.

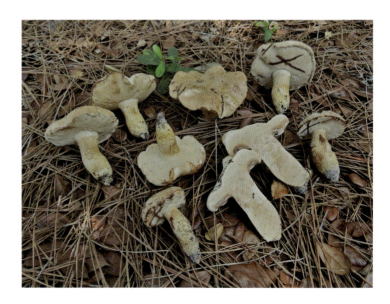

Tylopilus rubrobrunneus Mazzer & A. H. Sm.

COMMON NAME: Reddish-brown Bitter Bolete

MACROSCOPIC FEATURES: **cap** 8–30 cm wide, broadly convex to nearly flat or slightly depressed in age, dry, bald, sometimes cracking, pinkish purple to dark purple with subtle brown tones at first, becoming purple-brown, dark reddish brown, dull brown, or cinnamon when mature; margin initially incurved to inrolled. **pore surface** whitish to very pale brown when young, aging to dingy pinkish brown, bruising brown; **tubes** 8–20 mm deep. **stalk** equal or enlarged downward, solid, dry, bald or with fine apical reticulation, white when young, then browning and slowly developing olive or olive brown stains from the base upward when handled or in age. **flesh** white, unchanging or slowly bruising brown; odor not distinctive, taste very bitter.

MICROSCOPIC FEATURES: Spores 10–14 × 3–4.5 μm, suboblong to nearly fusoid, smooth, pale brown.

SPORE PRINT: Reddish brown to dull pinkish brown.

HABIT, HABITAT, AND SEASON: Scattered, in groups, or clustered in broadleaf forests, especially with beeches or oaks, also in mixed oak-pine woods; summer–fall.

EDIBILITY: Inedible due to its bitter taste.

COMMENTS: The epithet *rubrobrunneus* means "reddish brown." The purple areas of the cap surface bleach pinkish brown with KOH or NH_4OH and are negative with $FeSO_4$. *Tylopilus violatinctus* (not illustrated), inedible, is similar but has a pale purplish to grayish violet or pale brown cap and does not develop olive brown stains on the stalk. The stalk of the Bitter Bolete, *Tylopilus felleus* (not illustrated), inedible, has more prominent reticulation and lacks olive stains, and the cap lacks purple tones when mature. *Tylopilus plumbeoviolaceus* lacks olive stains on the stalk.

Tylopilus tabacinus (Peck) Singer

= *Tylopilus tabacinus* var. *amarus* Singer

COMMON NAME: Tobacco-brown Tylopilus

MACROSCOPIC FEATURES: **cap** 4.5–18 cm wide, roundish when young, then broadly convex to nearly flat, dry, smooth, slightly velvety, finely cracked in age, yellow-brown to orange-brown or tobacco brown; margin even and wavy. **pore surface** at first whitish or pale brown, maturing to light brown or yellow-brown with darker brown patches and stains, usually depressed at the stalk in age; **tubes** 1–1.5 cm deep. **stalk** initially enlarged to bulbous, nearly equal when mature, solid, dry, colored like the cap or paler, lightest at the apex, prominently reticulate over at least the upper portion and smooth near the base. **flesh** white, usually slowly staining purplish buff or pinkish buff when exposed, often brown at maturity, sometimes burgundy brown near the stalk base; odor variously described as fruity, fishy, pungent, or not distinctive, taste slightly bitter or not distinctive.

MICROSCOPIC FEATURES: Spores 10–14 (–17) × 3.5–4.5 μm, fusoid to ellipsoid, smooth, hyaline to pale honey yellow.

SPORE PRINT: Pinkish brown to reddish brown.

HABIT, HABITAT, AND SEASON: Scattered or in groups in woods, woodland edges, or lawns near trees, usually oaks or pines; summer–fall.

EDIBILITY: Unknown.

COMMENTS: The epithet *tabacinus* means "color of tobacco." The cap surface stains rusty brown to dark maroon with KOH, vinaceous with NH_4OH, and pale olive gray with $FeSO_4$. Specimens with bitter-tasting flesh were previously identified as var. *amarus*. *Tylopilus felleus* (not illustrated), inedible, is similar, but its youthful white pores turn pinkish, vinaceous, or pinkish tan in age, and it has very bitter-tasting flesh.

Veloporphyrellus conicus (Ravenel) B. Ortiz, Yan C. Li, & Zhu L. Yang

= *Fistulinella conica* var. *conica* (Ravenel) Pegler & T. W. K. Young
= *Fistulinella conica* var. *reticulata* (Wolfe) Singer
= *Mucilopilus conicus* (Ravenel) Wolfe
= *Tylopilus conicus* (Ravenel) Beardslee

COMMON NAME: Conical Shaggy-capped Bolete.

MACROSCOPIC FEATURES: cap 2.5–9.5 cm wide, bluntly conical at first, convex in age, dry, shaggy or scaly when young and often developing a network of ridges and small depressions, pinkish tan to golden yellow, yellow-brown, or salmon-tinged, with white flesh showing between the scales or beneath the ridges; the young cap margin is fringed with thin flaps of membranous veil tissue. **pore surface** initially white, becoming grayish pink to pinkish brown; **tubes** 8–14 mm deep. **stalk** slender, nearly equal, often curved, solid, dry, smooth or minutely wrinkled, occasionally reticulate, white or yellow, sometimes with pinkish tones, especially toward the midportion. **flesh** white, unchanging; odor fruity or not distinctive, taste not distinctive.

MICROSCOPIC FEATURES: Spores 14–21 × 4–6 µm, elongate-fusoid, smooth, hyaline to honey yellow, pseudoamyloid in Melzer's.

SPORE PRINT: Pinkish brown to reddish brown.

HABIT, HABITAT, AND SEASON: Solitary or scattered under pines and in mixed woods, often in bottomlands along streams; summer–fall.

EDIBILITY: Edible.

COMMENTS: The epithet *conica* means "cone-shaped," a reference to the shape of the young caps. *Suillus spraguei* grows exclusively under white pines and has a shaggy cap, but the scales are a shade of red before browning in age. Both the pore surface and flesh are yellow.

Xanthoconium affine (Peck) Singer

= *Boletus affinis* Peck
= *Boletus affinis* var. *maculosus* Peck

MACROSCOPIC FEATURES: cap 4–11.5 cm wide, convex to broadly convex and nearly flat in age, dry, velvety, smooth or wrinkled, dark brown to chestnut brown or ocherbrown, sometimes with white to pale yellow spots or patches; margin even. **pore surface** white at first, then yellowish or dingy yellow-brown, bruising dull yellow to brownish, depressed at the stalk in age; **tubes** 6–20 mm deep. **stalk** nearly equal or tapered in either direction, solid, smooth or with sparse to conspicuous brown reticulation, dry, whitish, often with brownish streaks on the middle portion or base. **flesh** white, unchanging; odor and taste not distinctive.

MICROSCOPIC FEATURES: Spores (9–)12–16 × 3–5 μm, narrowly ventricose to nearly cylindric, smooth, yellowish.

SPORE PRINT: Bright yellow-brown to rusty ochraceous.

HABIT, HABITAT, AND SEASON: Scattered or more usually in groups, sometimes clustered, in broadleaf woods, especially with oaks or beeches but also under pines; spring–fall.

EDIBILITY: Edible, flavor varying from good to mediocre or unpleasant.

COMMENTS: The cap surface stains reddish brown with NH_4OH and is negative with KOH or $FeSO_4$. The similarly edible *Xanthoconium purpureum* (see Color Key) has a cap that stains blue-green with NH_4OH. It is 3–12 cm wide, dark red to purple-red or maroon, sometimes tinged brown. The pore surface is whitish at first, then ochraceous to dingy brownish yellow and stains brownish when bruised. The stalk is whitish, sometimes reticulate at the apex or upper portion, typically with reddish brown streaks down to a whitish, pinched base. It has whitish, unchanging flesh and grows in broadleaf woods with oaks or in mixed woods with oaks and pines. The spores measure 8–14 × 3–4 μm.

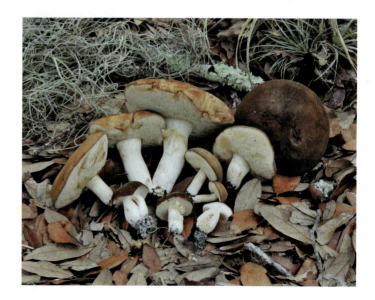

Xanthoconium stramineum (Murrill) Singer

= *Boletus stramineus* (Murrill) Murrill

MACROSCOPIC FEATURES: cap 4–9 cm wide, convex, then broadly convex to nearly flat, dry, bald and smooth when young, sometimes cracking and uneven in age, white at first, becoming whitish to pale straw-colored or tinged brownish; the immature margin is incurved and sterile. **pore surface** white to whitish, eventually turning buff to yellowish buff or pale yellow-brown, unchanging when bruised; **tubes** 3–10 mm deep. **stalk** enlarged downward or nearly equal above an often swollen base, solid, dry, bald, white to whitish, not staining when bruised, lacking reticulation. **flesh** white, unchanging or slowly staining pinkish brown when exposed; odor variously described as slightly fruity, unpleasant, or not distinctive, taste somewhat bitter or not distinctive.

MICROSCOPIC FEATURES: Spores 10–15 × 2.5–4 µm, cylindric, smooth, yellowish to hyaline.
SPORE PRINT: Brownish yellow to yellowish rusty brown.
HABIT, HABITAT, AND SEASON: Solitary, scattered, or in groups on sandy soil or in grassy areas under oaks and pines; summer–fall.
EDIBILITY: Purportedly edible, but in our experience, it has a sour or bitter and unpleasant taste.
COMMENTS: The epithet *stramineum* means "straw-colored," referring to the cap color. The cap stains bluish gray with $FeSO_4$, stains quickly salmon pink with KOH before fading on dark areas, and is negative with NH_4OH. The Chalk-white Bolete, *Boletus albisulphureus* (not illustrated), edible, is very similar but has a reticulate stalk apex. *Gyroporus subalbellus* has a brittle stalk that hollows with maturity.

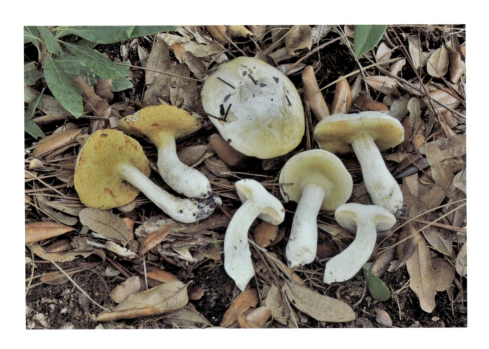

Xerocomus morrisii (Peck) M. Zang

= *Boletus morrisii* Peck

COMMON NAME: Red-speckled Bolete
MACROSCOPIC FEATURES: cap 3–9 cm wide, convex to broadly convex, dry, velvety at first, balding in age, olive brown to reddish brown with a margin that is often yellow to olive gold, the margin banded by a narrow flap of sterile tissue. **pore surface** yellow to orange-yellow or tinged reddish near the stalk, becoming orange to brownish orange in age, depressed at the stalk when mature; **tubes** 6–12 mm deep. **stalk** nearly equal or enlarged downward, solid, yellow dotted with reddish or reddish brown punctae; basal mycelium yellow. **flesh** pale yellow, slowly staining reddish when exposed; odor and taste not distinctive.
MICROSCOPIC FEATURES: Spores 10–16 × 4–6 µm, ellipsoid to fusiform, smooth, yellowish.
SPORE PRINT: Olive brown.
HABIT, HABITAT, AND SEASON: Solitary or in small groups in sandy soil, usually with pines; summer–fall.
EDIBILITY: Reportedly edible.
COMMENTS: This species was named for Boston mycologist and artist George Edward Morris (1853–1916), collector of the type specimen. *Hemileccinum rubropunctum* (see Color Key), edible but unpleasant, has yellowish flesh that does not stain when exposed and an odor reminiscent of stale cigarette butts or a dirty ashtray. The edible *Xerocomus illudens / tenax* group (see Color Key) has a 3–9 cm wide cap, a yellow pore surface that does not blue, and a very hard, yellowish stalk typically featuring longitudinal rib-like lines that form a partial reticulum. It grows under oaks or pines, and the spores measure 10–14 × 4–5 µm. *Xerocomus hypoxanthus* (not illustrated), edibility unknown, has a 2.5–7 cm wide, tawny brown to orange-brown cap, yellowish flesh that sometimes weakly stains blue, a yellow pore surface that usually stains bluish, and large, elongated pores. It grows with oaks. Spores measure 8–14 × 4–5 µm.

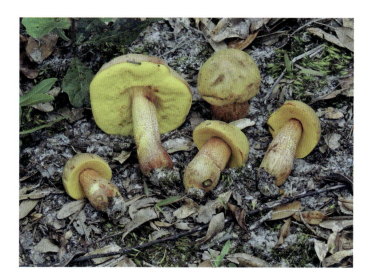

CARBON FUNGI

Fruit bodies of carbon fungi are hard, black, cinder-like, and variously shaped. Some are flat and spreading; others are erect and cylindric to club-shaped or antler-like. The fertile surface is roughened like sandpaper (use a hand lens) due to the presence of partially submerged clusters (perithecia) of spore-producing cells. These species grow on living or decayed wood, leaves, nuts, cones, or fruit.

Apiosporina morbosa (Schwein.) Arx

= *Dibotryon morbosum* (Schwein.) Theiss & Syd.

COMMON NAME: Black Knot

MACROSCOPIC FEATURES: **fruit body** 3–15 cm long and 1–3 cm thick, club- to spindle-shaped or irregularly elongated. **exterior** hard, roughened with nipple-like bumps, often furrowed and cracked, dark olive, becoming black. **interior** brittle, white at first, black when mature, with perithecia embedded in a single layer near the surface.

MICROSCOPIC FEATURES: Spores 13–19 × 4–7.5 μm, narrowly elliptic to clavate, 1–3-septate, smooth; pale yellowish brown.

HABIT, HABITAT, AND SEASON: Solitary or in groups, clasping and enveloping twigs and branches of cherry and plum trees; year-round.

EDIBILITY: Inedible.

COMMENTS: The epithet *morbosa* means "diseased." It is a highly destructive pathogen of cherry and plum trees.

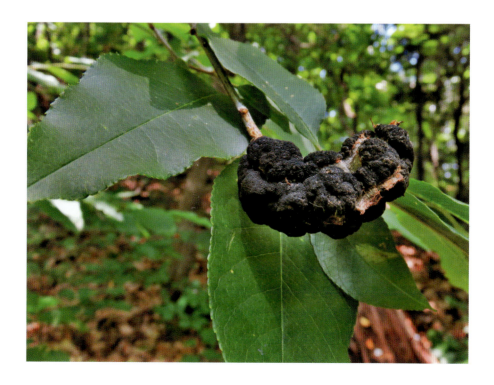

Daldinia childiae J. D. Rogers & Y. M. Ju

COMMON NAMES: Carbon Balls, Crampballs, King Alfred's Cakes

MACROSCOPIC FEATURES: **fruit body** 0.5–5 cm wide, cushion-shaped to nearly round or irregular, stalkless or sometimes with a stout, rudimentary stalk. **surface** furrowed, finely roughened, somewhat shiny, often with minute pores (use a hand lens), reddish brown to grayish or black. **interior** fibrous or powdery and carbon-like, concentrically zoned when cut vertically, dark purplish brown alternating with darker or sometimes whitish zones, with blackish perithecia embedded in a single layer near the surface.

MICROSCOPIC FEATURES: Ascospores 12–16 × 5.5–7.5 μm, irregularly elliptic with one side flattened, with a straight, spore-length germ slit, smooth, dark brown.

HABIT, HABITAT, AND SEASON: Solitary or in clusters on decaying broadleaf logs, stumps, and trees; year-round.

EDIBILITY: Inedible.

COMMENTS: Carbon Balls have honey-colored to amber or cinnamon pigments that can be extracted when a portion of the fruit body is partially pulverized in 10% KOH. Nearly all American mushroom field guides that include a description and illustration of Carbon Balls call it *Daldinia concentrica*. However, this is a European species typically found on branches and logs of *Fraxinus* (ash); it contains a purple, KOH-extractable pigment. The Dog's Nose Fungus or Split-skin Carbon Cushion, *Camarops petersii* (see Color Key), has a 2–6 cm wide, stalkless, cushion-shaped, oval or irregular fruit body that grows on decaying broadleaf wood. The yellowish brown to grayish brown outer surface of young fruit bodies splits open to leave a ragged collar around a shiny black sandpaper-like inner surface. This is covered with black slime when actively exuding spores.

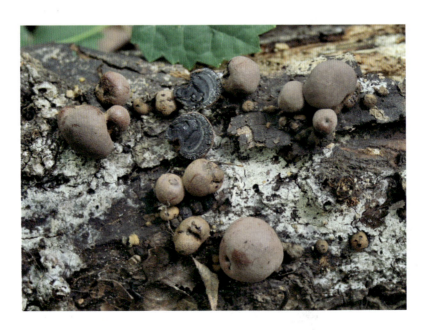

Diatrype stigma (Hoffm.) Fr.

MACROSCOPIC FEATURES: **fruit body** up to 20 cm or more long and 1–2 mm thick, a spreading crust that is highly variable in shape and size. **exterior** shiny or dull, finely roughened or nearly smooth, sometimes minutely cracked, brownish purple to reddish brown when young, becoming blackish brown to black when mature. **interior** fibrous or brittle, whitish to brownish, with perithecia embedded just below the surface in a single layer.

MICROSCOPIC FEATURES: Spores 6–12 × 1.5–2 μm, allantoid, smooth, with 1 or 2 oil drops at each end, hyaline.

HABIT, HABITAT, AND SEASON: On decaying broadleaf branches and logs; year-round.

EDIBILITY: Inedible.

COMMENTS: The epithet *stigma* means a "point" or a "mark," a reference to the roughened surface. Similar brownish black to black spreading crust fungi tend to have more coarsely roughened surfaces and produce dark brown spores. Microscopic examination may be required for positive identification. The mature fruit body of *Kretzschmaria deusta* is thicker: a black, blistered-looking, spreading crust that forms irregularly shaped patches up to 40 cm long and 10 cm wide. These resemble burnt wood. *Rhytisma americanum* forms raised black spots on red, silver, or sugar maple leaves.

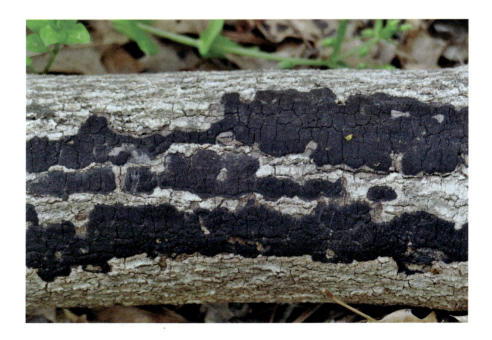

Kretzschmaria deusta (Hoffm.) P. M. D. Martin

= *Ustulina deusta* (Hoffm.) Lind

COMMON NAME: Carbon Cushion

MACROSCOPIC FEATURES: fruit body up to 40 cm or more long, 10 cm wide, and 3–6 mm thick when mature, a thick, spreading crust forming irregularly shaped patches. **immature stage** (asexual stage) is soft, lobed, powdery, and grayish white with a white interior. **mature stage** (sexual stage) is black throughout with a finely roughened, conspicuously furrowed surface resembling burnt wood. The perithecia are embedded beneath the surface in a single layer.

MICROSCOPIC FEATURES: Spores 28–36 × 7–10 μm, irregularly elliptic with one side flattened, smooth, dark brown.

HABIT, HABITAT, AND SEASON: On broadleaf stumps and roots; year-round.

EDIBILITY: Inedible.

COMMENTS: The epithet *deusta* means "burned up," a reference to the black mature stage. Compare with *Diatrype stigma*, which has a much more even and often somewhat shiny surface along with smaller spores.

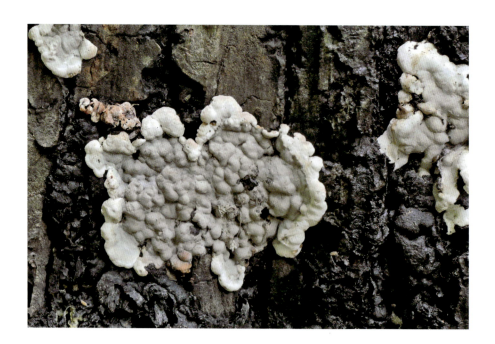

Rhytisma americanum Hudler & Banik

COMMON NAME: Tar Spot of Maple
MACROSCOPIC FEATURES: fruit body 5–12 mm wide, typically circular, a slightly raised tar-like cushion on maple leaves, sometimes coalescing into spots up to 4 cm wide. The fruit bodies are often surrounded by a narrow yellow to orange or reddish border. **surface** dry, somewhat shiny or dull, black, uneven, marked by a serpentine pattern of alternating shallow ridges and depressions (use a hand lens). **interior** containing embedded perithecia, black.
MICROSCOPIC FEATURES: Ascospores 50–88 × 1.5–2.5 μm, filiform, smooth, aseptate, hyaline.
HABIT, HABITAT, AND SEASON: Solitary, scattered, or in groups, sometimes coalescing, on leaves of red or silver maple; fall–winter.
EDIBILITY: Inedible.
COMMENTS: The epithet *americanum* means "American." In spring the infection appears as a yellow spot on the leaf. These spots turn brownish black over the summer and then black in the fall. Willow Tar Spot, *Rhytisma salicinum* (not illustrated), is very similar and occurs on leaves of coastal willow trees. It has filiform, smooth, hyaline ascospores that measure 60–90 × 1.5–3 μm.

Xylaria allantoidea (Berk.) Fr.

MACROSCOPIC FEATURES: fruit body erect, consisting of two stages, asexual and sexual, growing on wood. **immature stage** (asexual stage) is an erect, up to 9 cm high and 0.7–2.5 cm wide, highly variable, wavy and lobed, pale grayish mass covered with whitish to pale gray powder. **mature stage** (sexual stage) is cylindric-allantoid to club- or tongue-shaped or irregular, typically with a pointed apex and a rudimentary stalk, rounded to somewhat flattened. It is smooth or nearly so, bald, tan to dull brown at first, becoming blackish and somewhat roughened with age. **flesh** firm, flexible, white at first, then blackish as the perithecia develop and mature; odor not distinctive.

MICROSCOPIC FEATURES: Conidia 3–7 × 1.5–4 µm, obovate to ellipsoid, smooth, hyaline. Ascospores (8.5–)10–12 × (3–)3.5–4.5 µm, ellipsoid-inequilateral, single-celled, with a conspicuous straight germ slit usually less than the full length of the spore, brown.

HABIT, HABITAT, AND SEASON: Solitary or in groups or clusters on decaying broadleaf wood; year-round.

EDIBILITY: Inedible.

COMMENTS: *Allantoidea* means "sausage-shaped," a reference to the sexual stage fruit body of this fungus.

Xylaria liquidambar J. D. Rogers, Y. M. Ju, & F. San Martín

COMMON NAME: Sweetgum Xylaria
MACROSCOPIC FEATURES: fruit body up to 6 cm high and 1–3 mm wide, filamentous to spindle-shaped, elongated and tapered upward, typically unbranched, with a stalk-like base. **exterior** covered with whitish to grayish, powdery, asexual spores when immature, becoming black and roughened from the base upward and covered with sexual spores as it ages. **interior** white and soft at first, becoming blackish and tough with embedded perithecia when mature.
MICROSCOPIC FEATURES: Spores 10–16 × 4–6.5 μm, elliptic-inequilateral to somewhat crescent-shaped, with a spiraling germ slit, smooth, brown.
HABIT, HABITAT, AND SEASON: Sometimes solitary or in groups on fallen fruits of American Sweetgum; fall–early winter.
EDIBILITY: Inedible.
COMMENTS: The epithet *liquidambar* is the genus name of the host organism, *Liquidambar styraciflua*. *Xylaria oxyacanthae* (not illustrated) grows on buried fruits of hawthorns, hickories, or pecans. It has elliptic-inequilateral, smooth, blackish spores, 8–14 × 4.5–6 μm, with a straight germ slit. *Xylaria persicaria* (not illustrated) was described from peach pits when wild peaches colonized the Southeast. According to Jack Rogers, it is extinct or basically so. The ascospores of *Xylaria persicaria* are nearly identical to those of *Xylaria liquidambar*, but the germ slits are straight, as seen on limited and immature museum specimens.

Xylaria longipes Nitschke

COMMON NAME: Dead Moll's Fingers
MACROSCOPIC FEATURES: fruit body 4–9 cm high and 3–10 mm wide, consisting of a fertile head and sterile stalk. **head** 3–6 cm long and 3–10 mm thick, cylindric to slightly club-shaped, unbranched, sometimes bent, uneven and roughened like sandpaper, dark gray to black. **stalk** 1–3 cm long and 2–6 mm thick, cylindric, nearly equal or tapered downward to an enlarged base, smooth, grayish to dark brown or black. **flesh** fibrous-tough, white at first, becoming blackish as the embedded perithecia mature; odor not distinctive.
MICROSCOPIC FEATURES: Ascospores 13–16 × 5–7.5 μm, elliptic-inequilateral, with 1 or 2 oil drops, smooth, blackish, with a curved germ slit.
HABIT, HABITAT, AND SEASON: Usually in groups, sometimes solitary, on decaying broadleaf wood or on the ground attached to buried wood; year-round.
EDIBILITY: Inedible.
COMMENTS: The epithet *longipes* means "having a long stalk." The cylindric to club-shaped, copper-colored to dark brown or blackish fruit body of *Xylaria cubensis* (not illustrated) is 3–7(–10) cm high and 0.5–1(–2.5) cm thick. The spores are 7–10.5(–13) × 3.5–6 μm and lack an obvious germ slit. Dead Man's Fingers, *Xylaria polymorpha* (not illustrated), has broadly club- to spindle-shaped or sometimes flattened fruit bodies that are stalkless or have a rudimentary stalk. The almond- to spindle-shaped or irregularly elliptic spores with a long, straight germ slit are much larger, 22–30 × 5–9 μm. *Xylaria poitei* (not illustrated) is very similar to *Xylaria polymorpha* but much larger, sometimes twice as large or more, and has smaller spores that measure 14–18 × 5.5–7.5 μm, with a straight germ slit.

Xylaria magnoliae J. D. Rogers

COMMON NAMES: Cone Flickers, Magnolia-cone Xylaria

MACROSCOPIC FEATURES: fruit body 2.5–7.5 cm high and up to 2 mm thick, upright, slender, filamentous to spindle-shaped, sometimes branched, tough. **exterior** covered with white, powdery, asexual spores when immature, becoming black and roughened at maturity and covered with sexual spores that are produced in embedded perithecia. **interior** firm, whitish at first, becoming blackish as the perithecia develop.

MICROSCOPIC FEATURES: Ascospores 11–17 × 3–6 μm, spindle-shaped or irregularly elliptic, smooth, yellowish.

HABIT, HABITAT, AND SEASON: Gregarious on decaying magnolia cones; spring–fall.

EDIBILITY: Inedible.

COMMENTS: This fungus is easy to identify because of its exclusive association with magnolia cones. The fruit body of the Candlesnuff Fungus, *Xylaria hypoxylon* (see Color Key), is up to 10 cm high, erect, tough, antler-like, and often flattened on the upper portion. When immature it is whitish to grayish and powdery on the upper portion and eventually becomes roughened and blackish overall as it matures. It grows singly or in groups on decaying broadleaf branches, logs, and stumps and has elliptic-inequilateral, smooth, blackish spores, 12–15 × 4.5–6 μm, with 1 or 2 oil drops and a straight germ slit.

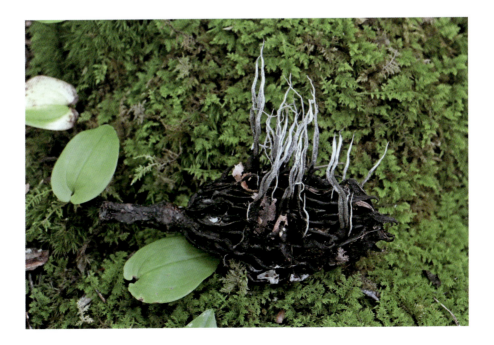

CHANTERELLES AND SIMILAR FUNGI

Fruit bodies typically with a cap and stalk, sometimes funnel-shaped. Undersurface of the cap with blunt, gill-like ridges that are often forked and crossveined or nearly smooth. They usually grow on the ground.

Cantharellus altipes Buyck & V. Hofst.

= *Cantharellus septentrionalis* A. H. Sm.

MACROSCOPIC FEATURES: **cap** 1–5.5 cm wide, relatively flat at first with an inrolled and often irregularly lobed margin, typically uplifted or funnel-shaped by maturity, bright yellow to orange-yellow, occasionally with a very faint tinge of green. Smooth to the naked eye but covered with a felt-like mat of fibers at 10×, the felt sometimes breaks up or becomes minutely scaly. **fertile surface** decurrent ridges that are prominently raised and variably branched and/or crossveined, colors generally paler than the cap or pinkening. **stalk** 4.5–5 cm long and 4–7 mm wide, equal or narrowing downward, solid, colored like the cap or paler with a whitened base, sometimes bruises rusty brown. **flesh** tough, whitish before eventually yellowing, may bruise rusty brown; odor of apricots, taste not distinctive.

MICROSCOPIC FEATURES: Spores 7–12 × 4.5–5.5 μm, somewhat kidney-shaped, smooth, hyaline.

SPORE PRINT: Unknown.

HABIT, HABITAT, AND SEASON: Solitary or in groups, known mainly from mixed oak-pine woods in sandy soil; summer.

EDIBILITY: Edible.

COMMENTS: This slender chanterelle is often taller than it is wide. The relationship between it and *Cantharellus septentrionalis*, a genetically very similar species described from Michigan, remains unsettled. *Cantharellus iuventateviridis* and *Cantharellus appalachiensis* resemble *Cantharellus altipes*, but their yellows are distinctly mixed with green, gray, or brown. *Cantharellus persicinus* (not illustrated) is a smaller yellowish species with a pink fertile surface. Cap diameters rarely exceed 30 mm. Spores measure 9.5–11 × 6–7 μm. *Cantharellus minor* (not illustrated) is smaller still. Caps are 5–20 mm wide, yellow or yellow-orange, with a fertile surface colored like the cap.

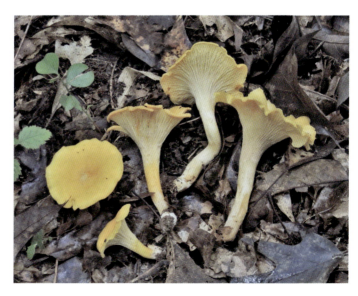

Cantharellus appalachiensis
R. H. Petersen

COMMON NAME: Appalachian Chanterelle
MACROSCOPIC FEATURES: cap 1–5 cm wide, broadly convex at first, soon with a depressed center and an elevated wavy or crimped margin, yellowish brown, darkest over the center, in age a dingy shade of yellow to yellow-orange. Covered with tiny matted fibers when young, later smooth to the unaided eye. **fertile surface** decurrent ridges that are prominently raised, forking and often crossveined, pale yellow to orange-yellow. **stalk** 1.5–6 cm long and up to 1.3 cm wide, equal or narrowing downward, hollowing, pale yellowish brown, often with hints of orange. **flesh** relatively thin, brittle or soft, pale yellowish brown to buff, not changing when bruised; odor like apricots or not distinctive, taste not distinctive.

MICROSCOPIC FEATURES: Spores 6–10 × 4–6 μm, elliptic to oblong, smooth, hyaline.
SPORE PRINT: Yellowish salmon.
HABIT, HABITAT, AND SEASON: Scattered or in loose groups on the ground under mixed or broadleaf woods in the southern Appalachians; summer–fall.
EDIBILITY: Edible.
COMMENTS: The cap color separates *Cantharellus appalachiensis* from *Cantharellus altipes*, *Cantharellus iuventateviridis*, and large examples of the reddish orange to cinnabar red Cinnabar Chanterelle, *Cantharellus cinnabarinus* (see Color Key). The hollowing stalk of *Cantharellus appalachiensis* can, however, lead to confusion with *Craterellus tubaeformis*. It has paper-thin flesh and a differently colored fertile surface. *Cantharellus appalachiensis* is the only Georgia chanterelle that stains persistently red when tested with a drop of $FeSO_4$ solution.

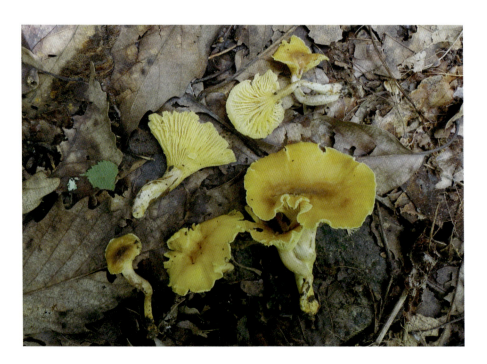

Cantharellus iuventateviridis Buyck, Looney, Harsch, & V. Hofst.

MACROSCOPIC FEATURES: cap 1.2–4.7 cm wide, convex at first with an inrolled and often scalloped margin, soon centrally depressed or funnel-shaped, some shade of grayish yellow with an olive green margin in youth, turning olive yellow to brownish yellow in age. Smooth or minutely hairy over most of the surface, hairs longer at the cap margin. **fertile surface** decurrent ridges that are prominently raised, forking and sometimes crossveined, initially pale yellow but deepening to peach yellow or orange-yellow. **stalk** 1–4 cm long and 3–11 mm thick, equal or narrowing downward, often curved in the lower half, usually paler than the cap color, sometimes off-white. **flesh** relatively thick, brownish gray and off-white streaks intermingling, bruises faintly yellow; odor described as weakly fruity-nutty when cut, taste not distinctive.

MICROSCOPIC FEATURES: Spores 8–9 × 5–6 μm, elliptic to egg-shaped, smooth.
SPORE PRINT: Pale cream.
HABIT, HABITAT, AND SEASON: Known from nearly bare soil or maritime woods in wet or muddy places with water oaks and other broadleaf trees; summer.
EDIBILITY: Unknown.
COMMENTS: This recently described species is not widely known. Its jawbreaker of an epithet derives from *iuventas*, "juvenile," and *viridis*, "green." The green cap margin of young specimens and the muddy habitat should help distinguish it from other Georgia chanterelles. Additionally, the stalk stains gray-green with a drop of $FeSO_4$ solution. *Gerronema strombodes* is a gilled mushroom somewhat resembling a thin-fleshed and greenish yellow chanterelle, but it grows on dead wood.

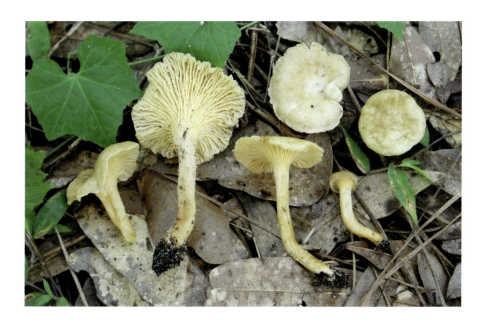

Cantharellus lateritius (Berk.) Singer

= *Craterellus lateritius* Berk.

COMMON NAME: Smooth Chanterelle

MACROSCOPIC FEATURES: cap 3–12 cm wide, convex to nearly flat or slightly depressed at first, perhaps with a low umbo, then thinning out to become vase- or funnel-shaped at maturity, often lobed and wavy, yellow to yellow-orange, nearly smooth to minutely fuzzy, the fuzz not breaking into wave-like ripples. **fertile surface** decurrent, nearly smooth or with low, blunted ridges and crossveins as though they'd been sanded down, pale yellow to light orange. **stalk** 2–8 cm long and 7–25 mm thick, narrowing downward, solid or beginning to hollow in age, colored like the cap or paler. **flesh** thick and somewhat fibrous but not tough, white; odor of apricots or not distinctive, taste not distinctive.

MICROSCOPIC FEATURES: Spores 7.5–12 × 4.5–6.5 μm, elliptic, smooth, hyaline.

SPORE PRINT: Pale pinkish yellow.

HABIT, HABITAT, AND SEASON: Scattered, in loose groups, or sometimes conjoined at the base in twos or threes on the ground in woods, particularly near oaks; summer–fall.

EDIBILITY: Edible.

COMMENTS: Three species of "smooth" chanterelles occur in the Southeast. The fuzz on the cap of the smooth form of *Cantharellus velutinus* breaks up into wave-like ripples. *Cantharellus flavolateritius* (not illustrated) lacks the rippling fuzz, tends to have a chunkier build than *Cantharellus lateritius*, and has a pinkening fertile surface by maturity, and the spores are slightly smaller, 7–8.5 × 4–5 μm. The Fragrant Chanterelle, *Craterellus odoratus* = *Cantharellus odoratus* (see Color Key), resembles a dense clump of small yellow trumpets with a smooth fertile surface. All of these species are edible.

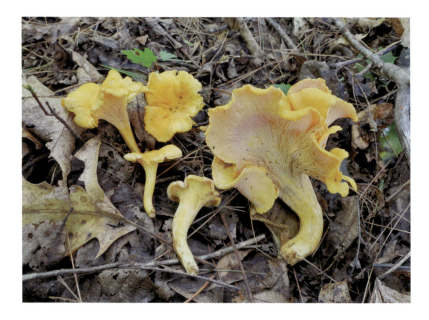

Cantharellus tenuithrix Buyck & V. Hofst.

COMMON NAMES: Chanterelle, Golden Chanterelle

MACROSCOPIC FEATURES: cap 4–14 cm wide, convex at first with an inrolled margin that is often lobed, then flattening and continuing to uplift at the margin, orange-yellow to orange, smooth to the eye but minutely fuzzy at 10×, the fuzz not breaking into wave-like ripples. **fertile surface** decurrent raised ridges that are blunt-edged and variously elaborated with forks and crossveins in colors ranging from yellow to whitish at first. **stalk** 1.5–7.5 cm long and 0.5–2.5 cm thick, equal or narrowing downward, solid, whitish to pale yellow, bruising rusty orange. **flesh** thick, white, slowly staining rusty orange; odor of apricots or not distinctive, taste not distinctive.

MICROSCOPIC FEATURES: Spores 7–8.5 × 4–4.5 μm, elliptic or peanut-shaped, smooth, hyaline.

SPORE PRINT: Pale cream.

HABIT, HABITAT, AND SEASON: Solitary to loosely grouped in or near woods; late spring–early winter.

EDIBILITY: Edible.

COMMENTS: The European Golden Chanterelle, *Cantharellus cibarius*, doesn't occur in North America. The relation between *Cantharellus tenuithrix* and three other recently proposed golden chanterelles thought to occur in the Southeast, *Cantharellus flavus*, *Cantharellus phasmatis*, and *Cantharellus deceptivus* (none illustrated), is sufficient to support their designation as separate species but not enough to determine whether they can be reliably distinguished from each other without molecular analysis. Differences in the color of the fertile surface proposed in the original species descriptions appear unreliable. The cibarioid form of *Cantharellus velutinus* is separable from other golden chanterelles by virtue of the cap fuzz breaking into wave-like ripples or scales. The smaller *Cantharellus altipes* typically differs from golden chanterelles by being taller than it is wide. Taxonomic fragmentation aside, these are all choice edibles. But beware confusing chanterelles with poisonous Jack O'Lanterns such as *Omphalotus subilludens*, which has gills.

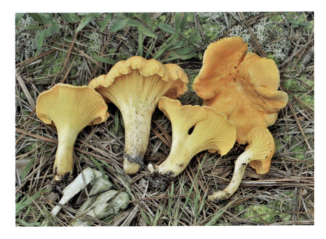

Cantharellus velutinus Buyck & V. Hofstetter

COMMON NAME: Peach Chanterelle (pink form only)

MACROSCOPIC FEATURES: cap to 8 cm wide, initially broadly convex with an inrolled and often lobed margin, becoming uplifted or funnel-shaped with a wavy margin. Color ranges from clear yellow to orange or pink. The surface is fuzzy at 10×, with the fuzz whitening and breaking up at places into concentric ripples or scales. **fertile surface** decurrent with ridges nearly absent to well-defined, often showing forks and crossveins, pale yellow, yellow, or pink. **stalk** to 8 cm long and 1.5 cm thick, usually narrowing downward, solid, colored like the cap or paler, with a whitened base, bruises dirty brown. **flesh** thick, solid, generally whitish, sometimes orange-yellow in the cap, bruising slowly yellowish; odor of apricots or not distinctive, taste not distinctive.

MICROSCOPIC FEATURES: Spores 7–8.5 × 4–5 μm, ellipsoid, smooth, hyaline.

SPORE PRINT: White when fresh, drying to pale yellow.

HABIT, HABITAT, AND SEASON: Scattered under mixed or broadleaf woods with oaks; summer–fall.

EDIBILITY: Edible.

COMMENTS: The three visually dissimilar forms of this recently described species share the trait of rippling fuzz patterns on the cap surface, a feature absent in look-alikes. The cibarioid form strongly resembles other golden chanterelles. The smooth form looks a lot like *Cantharellus lateritius* or *Cantharellus flavolateritius* (not illustrated). The pink form, commonly known as the Peach Chanterelle, was misidentified for years in guidebooks as *Cantharellus persicinus* (not illustrated), a much smaller species with larger spores. See Comments under *Cantharellus altipes* for additional details.

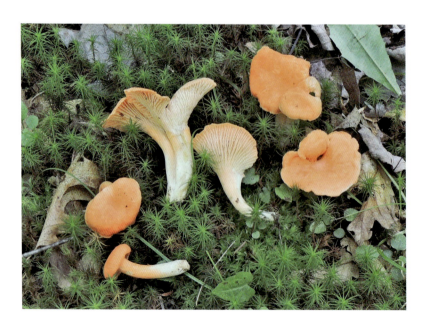

Craterellus fallax A. H. Sm.

COMMON NAME: Black Trumpet
MACROSCOPIC FEATURES: fruit body 2–8 cm wide and 4–10 cm tall, trumpet-shaped and hollow, the margin inrolled at first, then flaring, wavy, and often splitting in age. **upper surface** gray to dark brown or almost black, roughened by tiny fibers or scales. **fertile surface** decurrent, smooth or with very shallow vein-like ridges, color varying from dusty pinkish orange to dull gray, or very dark gray, bruising black. **stalk** a hollow tube not clearly distinguishable from the lower margin of the fertile surface, dull gray to dark brown or black, whitened with mycelium at the base. **flesh** paper thin and somewhat brittle; odor faintly floral or not distinctive, taste not distinctive.

MICROSCOPIC FEATURES: Spores 10–14 × 7–9 μm, broadly elliptic, smooth, hyaline.
SPORE PRINT: Pale pinkish orange.
HABIT, HABITAT, AND SEASON: Hiding in scattered groups or small clusters in woodland moss banks or leaf litter on soil, commonly near oaks; summer–fall.
EDIBILITY: Edible.
COMMENTS: Older field guides may refer to this species as *Craterellus cornucopioides*, a white-spored trumpet that apparently doesn't occur in North America. For many mushroom hunters, the ability to spot black trumpets is a rite of passage. Success at long last is customarily celebrated by feasting on the harvest.

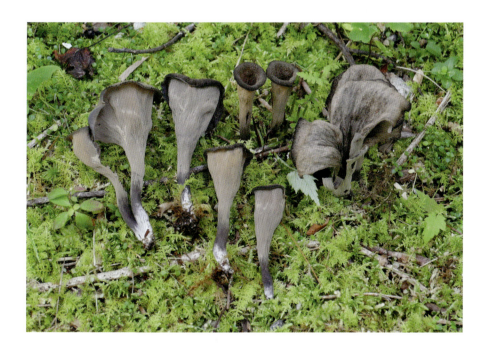

Craterellus ignicolor (R. H. Petersen) Dahlman, Danell, & Spatafora

COMMON NAME: Flame Chanterelle
MACROSCOPIC FEATURES: fruit body 1–8 cm wide, initially convex with an inrolled margin and central depression that perforates smoothly into the hollow stalk. The wavy margin uplifts, often rendering the cap vase-shaped at maturity. **upper surface** bright yellow or orange-yellow, fading in age to brownish yellow, almost smooth but roughened near the margin by tiny scales or erect hairs best seen with a hand lens. **fertile surface** slightly decurrent and well demarcated from the stalk, false gill ridges prominently raised, forking and crossveined, yellow to orange-yellow at first, becoming pinkish lavender. **stalk** 2–6 cm long and 3–12 mm thick, equal, sometimes laterally compressed, hollow, yellow or orange-yellow even after the fertile surface changes color. **flesh** paper thin, colored like the stalk, not changing when bruised; odor and taste not distinctive.
MICROSCOPIC FEATURES: Spores 7.5–12 × 4.5–6.5 μm, elliptic, smooth, hyaline.
SPORE PRINT: Pale pinkish yellow.
HABIT, HABITAT, AND SEASON: Scattered or in small groups in woods with nearby oaks, beeches, or other broadleaf trees, often near moss or rotting wood, and occasionally fruiting on well-rotted wood; summer–fall.
EDIBILITY: Edible.
COMMENTS: The epithet *ignicolor* means "having the colors of flames." The paper-thin flesh and hollow fruit body of *Craterellus ignicolor* distinguish it from *Cantharellus* species other than *Cantharellus appalachiensis*, which has a browner, thicker-fleshed cap and a fertile surface not maturing to pink or lavender. *Craterellus tubaeformis* has paper-thin flesh, but the cap color and admixture of gray in the fertile surface sets it apart.

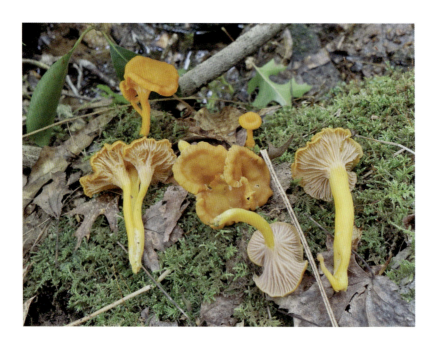

Craterellus tubaeformis (Fr.) Quél.

= *Cantharellus tubaeformis* Fr.
= *Cantharellus infundibuliformis* (Scop.) Fr.

COMMON NAME: Trumpet Chanterelle
MACROSCOPIC FEATURES: fruit body 1–7.5 cm wide, initially convex with an inrolled margin and central depression that perforates into the hollow stalk. The margin becomes uplifted and wavy, sometimes vase-like. **upper surface** yellowish brown, often very dark centrally and lightening toward the cap margin, fading in age to a more uniform yellowish brown, smooth or minutely scaly. **fertile surface** slightly decurrent and well demarcated from the stalk, false gill ridges prominently raised, forking and crossveined, yellowish gray at first, maturing to violet-gray. **stalk** 1.5–10 cm long and 3–12 mm thick, equal or narrowing downward, sometimes laterally compressed, hollow, yellow-brown to brownish yellow, darkest at the apex, yellow tones predominating below. **flesh** paper thin, colored like the stalk, not changing when bruised; odor and taste not distinctive.
MICROSCOPIC FEATURES: Spores 8–13 × 5.5–10 µm, broadly elliptic, smooth, hyaline.
SPORE PRINT: White to creamy or pale pinkish buff.
HABIT, HABITAT, AND SEASON: Solitary or scattered on the ground, in moss, or on well-rotted logs in conifer or mixed woods, often in boggy areas; summer–late fall.
EDIBILITY: Edible for some; use caution.
COMMENTS: Genetic analysis has established that *Cantharellus infundibuliformis* is a white-spored form of *Cantharellus tubaeformis*. Look-alikes include *Cantharellus appalachiensis*, which has thicker flesh and a differently colored fertile surface, and *Craterellus ignicolor*. The latter begins to brown only in age and has a fertile surface maturing to pinkish lavender. *Craterellus tubaeformis* is a cause of gastrointestinal distress for some people.

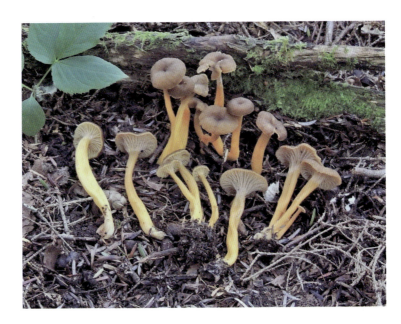

Turbinellus floccosus (Schwein.) Earle ex Giachini & Castellano

= *Cantharellus floccosus* Schwein.
= *Gomphus floccosus* (Schwein.) Singer

COMMON NAME: Scaly Vase Chanterelle
MACROSCOPIC FEATURES: fruit body 6–18 cm high and 4–16 cm wide, shaped like an ice cream sugar cone, centrally depressed with a margin that is thin, wavy-edged, and sometimes lobed. **upper surface** concave, featuring coarse orange to reddish orange scales over a paler orange ground color, aging to orange-brown. **fertile surface** strongly decurrent, vein-like ridges fork freely and often extend nearly to ground level, creamy white to pale yellow, tinted with brown by maturity. **stalk** often not separable from the fertile surface, narrowing smoothly downward. **flesh** whitish, solid and fibrous but not tough, unchanging or staining brown when bruised; odor not distinctive, taste variously described as sweet, sour, or not distinctive.

MICROSCOPIC FEATURES: Spores 11–15 × 7–8 μm, elliptic, warted, hyaline.
SPORE PRINT: Brownish yellow.
HABIT, HABITAT, AND SEASON: Solitary or in small groups on the ground, associated with a variety of woodland conifers; summer–fall.
EDIBILITY: Edible for some but not recommended.
COMMENTS: A related species, *Turbinellus kauffmanii* (not illustrated), differs by virtue of the replacement of orange shades with medium to light browns. It can also be larger and have coarser scales on the upper surface. Genetic analysis places *Turbinellus* species far from the true chanterelles. Closer relatives include the Fairy Club, *Clavariadelphus americanus*, and certain clustered corals. Although some people consume *Turbinellus* mushrooms without ill effects, gastrointestinal upset is not uncommon.

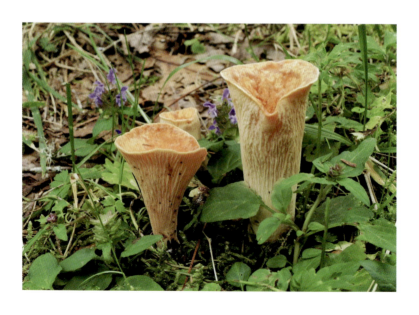

CORALS AND CAULIFLOWERS

Fruit bodies in this group are of three types: bundles of simple, erect, worm-like branches often fused at their bases; or erect coral-like, repeatedly forking branches; or a rounded, lettuce-like or cauliflower-like cluster of flattened branches attached to a partially buried stalk-like base. Most members of this group grow on the ground, sometimes at the base of trees. A few grow on wood.

Artomyces pyxidatus (Pers.) Jülich

= *Clavicorona pyxidata* (Pers.) Doty

COMMON NAME: Crown-tipped Coral
MACROSCOPIC FEATURES: fruit body up to 13 cm high and 10 cm wide, erect, coral-like, repeatedly forking, arising from a short, velvety, whitish to brownish, stalk-like base. **branches** 2–5 mm thick, erect, crowded, smooth, whitish to yellowish or tan. **branch tips** have multiple crown-like points (use a hand lens) and are colored like the branches. **flesh** tough or brittle, whitish; odor not distinctive, taste somewhat peppery or not distinctive.
SPORE PRINT: White.
MICROSCOPIC FEATURES: Spores 4–5 × 2–3 μm, elliptic, smooth, hyaline, amyloid.
HABIT, HABITAT, AND SEASON: Solitary, scattered, or in groups on decaying broadleaf wood; spring–fall.
EDIBILITY: Edible.

COMMENTS: The epithet *pyxidatus* means "resembling a small box," a reference to the appearance of the branch tips. The crown-like branch tips and growth on decaying wood are the important field identification features. *Ramaria stricta* also grows on decaying wood. Its erect, parallel, yellowish to pinkish buff branches often have forked but not crown-like tips. The flesh has a distinctive spicy odor and bitter or metallic taste. The White Green-algae Coral, *Multiclavula mucida* = *Clavaria mucida* (not illustrated), fruits on damp, rotting logs covered with green algae and is actually a basidiomycete lichen. The tiny fusiform to cylindric or tine-like fruit bodies are up to 15 mm high, white to creamy white, tough and waxy. They arise singly from the algae but often in considerable numbers.

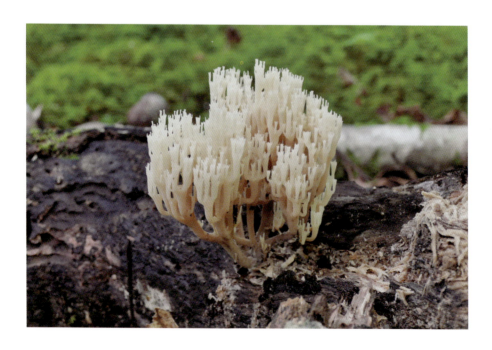

Clavaria fragilis Holmsk.

= *Clavaria cylindrica* Gray
= *Clavaria vermicularis* Sw.

COMMON NAME: White Worm Coral
MACROSCOPIC FEATURES: fruit body consisting of erect branches, 3–12 cm high and 2–5 mm thick. **branches** tapered downward, worm-like to fusiform cylinders, typically not forking, white overall or sometimes with yellowish to yellow-brown tips. **flesh** thin, brittle, white; odor and taste not distinctive.
SPORE PRINT: White.
MICROSCOPIC FEATURES: Spores 4–7 × 3–5 μm, elliptic, smooth, hyaline.
HABIT, HABITAT, AND SEASON: In clusters on the ground in woodlands or sometimes grassy areas; summer–early winter.
EDIBILITY: Edible.
COMMENTS: The epithet *fragilis* refers to the brittle flesh. More brightly colored simple corals include Spindle-shaped Yellow Coral, *Clavulinopsis fusiformis*. It forms dense clusters of erect, cylindric to worm-like fruit bodies that are bright to dull yellow. The very similar Orange Spindle Coral, *Clavulinopsis aurantiocinnabarina* (see Color Key), is distinguishable by color. Its clusters of erect, cylindric to worm-like fruit bodies are reddish orange to pale orange with yellow to whitish bases. Both species are edible and grow on the ground in woodlands or grassy areas.

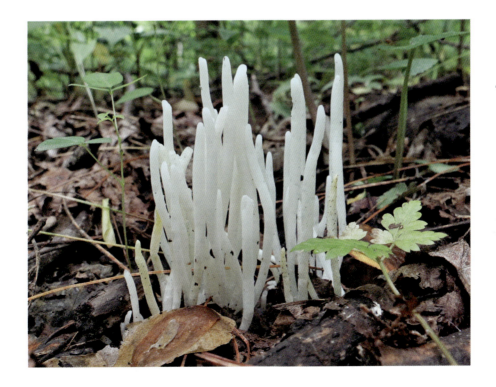

Clavaria zollingeri Lév.

= *Clavaria lavandula* Peck

COMMON NAME: Magenta Coral

MACROSCOPIC FEATURES: fruit body up to 10 cm high, coral-like, repeatedly forking, arising from a smooth, whitish to pinkish purple stalk-like base. **branches** erect, crowded, typically rounded, smooth, color variable, pinkish purple, violet, or pale to dark purple. **branch tips** rounded to bluntly pointed, colored like the branches but typically darker. **flesh** brittle, reddish purple; odor not distinctive, taste somewhat radish-like.

MICROSCOPIC FEATURES: Spores 5–7.5 × 3–4.5 μm, elliptic to oval, smooth, hyaline.

SPORE PRINT: White.

HABIT, HABITAT, AND SEASON: Solitary, scattered, or in groups on the ground in mixed woods; summer–fall.

EDIBILITY: Edible.

COMMENTS: *Clavaria amethystina* = *Clavulina amethystina* is sometimes listed as a similar species in American field guides, but it is a European species that does not occur in North America. *Clavulina amethystinoides* (not illustrated) is a faded lilac look-alike that might be found in northeastern Georgia. Branches appear more crowded, and the spores are larger, 7.5–8.5 × 6–7.5 μm.

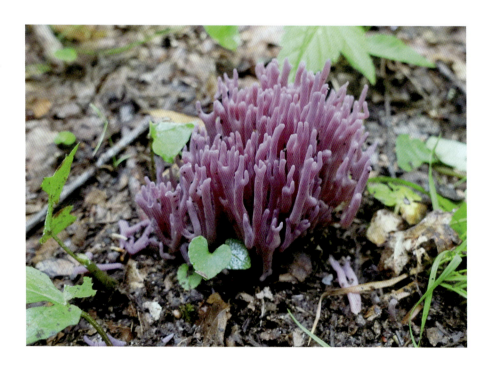

Clavulina cinerea (Bull.) J. Schröt.

= *Clavaria cinerea* Bull.

COMMON NAME: Gray Coral

MACROSCOPIC FEATURES: fruit body up to 11 cm high, coral-like, repeatedly forking, arising from an inconspicuous stalk-like base. **branches** erect, crowded, rounded to somewhat flattened, often curved, smooth or wrinkled, sometimes longitudinally grooved, whitish at first, becoming ashy gray, sometimes blackened from the base upward. **branch tips** pointed or blunt but not crested, colored like the branches. **flesh** tough or brittle, white; odor and taste not distinctive.

MICROSCOPIC FEATURES: Spores 6.5–11 × 5–10 μm, oval to subglobose, smooth, hyaline.

SPORE PRINT: White.

HABIT, HABITAT, AND SEASON: Solitary, scattered, or in groups on the ground in conifer or mixed woods; late spring–fall.

EDIBILITY: Edible.

COMMENTS: The Crested Coral, *Clavulina coralloides* = *Clavulina cristata* (not illustrated), has a white to yellowish or pale pinkish brown fruit body. It is extremely variable in shape and sparingly forked, except near the tips. Some branch tips are crested with a line of jagged, teeth-like, or fairly blunt points resembling a rooster's comb. The fruit bodies of both the Gray Coral and the Crested Coral may blacken from the base upward when attacked by *Helminthosphaeria clavariarum* (not illustrated), a parasitic fungus. *Clavulina rugosa* (not illustrated) has an erect, compressed, and conspicuously wrinkled white fruit body that is either unforked or notched at the apex. See also *Lentaria byssiseda*, *Lentaria micheneri*, and their associated Comments.

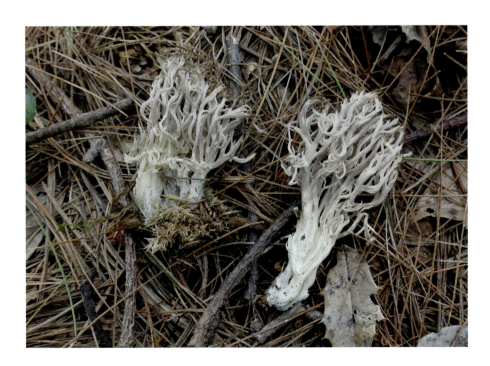

Clavulinopsis corniculata (Schaeff.) Corner

= *Clavaria corniculata* Schaeff.
= *Ramariopsis corniculata* (Schaeff.) R. H. Petersen

COMMON NAMES: Forked Clavaria, Yellow Antler Coral

MACROSCOPIC FEATURES: fruit body 2–8 cm high and wide, a cluster of branches arising from a common stalk-like base. **branches** erect, loosely spaced or crowded, repeatedly forked, mostly rounded but sometimes slightly flattened with a shallow longitudinal groove, occasionally with a perforated axil, smooth, fragile, pale dull yellow to orange-yellow or brownish yellow, paler toward the tips. **branch tips** slightly blunt, antler-like, usually elongated, but may be short. **stalk-like base** up to 2.5 cm long and 3 mm thick, rooting, smooth, and colored like the branches on the upper portion, scurfy and white below. **flesh** firm, fairly tough or brittle, whitish to pale yellow; odor not distinctive, taste bitter or not distinctive.

MICROSCOPIC FEATURES: Spores 5–7 × 4–7 μm, subglobose to globose with a prominent apiculus, smooth, hyaline, inamyloid.

SPORE PRINT: White.

HABIT, HABITAT, AND SEASON: Solitary or in groups on the ground or among mosses in broadleaf or mixed woodlands; summer–fall.

EDIBILITY: Reportedly edible.

COMMENTS: The epithet *corniculata* means "having horn-like appendages." The branches stain olive green with $FeSO_4$. *Clavaria muscoides* as described and illustrated by Coker in *The Club and Coral Mushrooms (Clavarias) of the United States and Canada* and by Hesler in *Mushrooms of the Great Smokies* is most likely *Clavulinopsis corniculata*. However, according to Dr. Ronald H. Petersen, *Clavaria muscoides* is "one of those names that no one knows what it means anymore." *Ramaria* species are more highly branched and thicker-fleshed, and they have a much thicker stalk-like base.

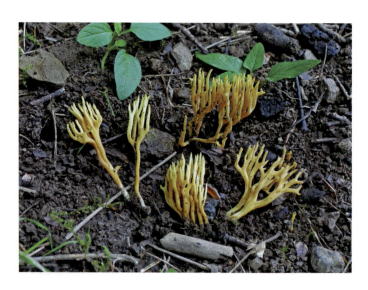

Clavulinopsis fusiformis (Sowerby) Corner

= *Clavaria fusiformis* Sowerby

COMMON NAME: Spindle-shaped Yellow Coral
MACROSCOPIC FEATURES: fruit body up to 14 cm high and 1.5–7 mm thick, spindle-shaped to worm-like, sometimes slightly flattened, often with a shallow longitudinal groove, unforked or occasionally forked once, with a pointed or rounded apex. **surface** smooth or wrinkled, bright to dull yellow, not changing with KOH. **flesh** thin, fibrous or brittle, yellowish; odor not distinctive, taste bitter.
MICROSCOPIC FEATURES: Spores 5–9 × 4–9 μm, broadly oval to globose, smooth, hyaline.
SPORE PRINT: White to pale yellow.
HABIT, HABITAT, AND SEASON: In dense clusters on soil in woodlands or fields; late spring–fall.
EDIBILITY: Edible.
COMMENTS: The epithet *fusiformis* means "spindle-shaped." Orange Spindle Coral, *Clavulinopsis aurantiocinnabarina* (see Color Key), is very similar and also edible. It forms clusters of erect, cylindric to worm-like, reddish orange to pale orange fruit bodies that are yellow to whitish near the base and grow on the ground in woodlands and grassy areas. Fruit bodies of the Golden Fairy Club, *Clavulinopsis laeticolor* = *Clavaria pulchra* (not illustrated), are also small, to about 6 cm tall, erect, cylindric to somewhat flattened, deep golden yellow, and unbranched. They stain greenish yellow with KOH. Stalk bases are white. The ellipsoid to subglobose spores measure 4.5–7 × 3.5–5.5 μm. It grows in small groups, not dense clusters, on the ground in conifer or broadleaf woods.

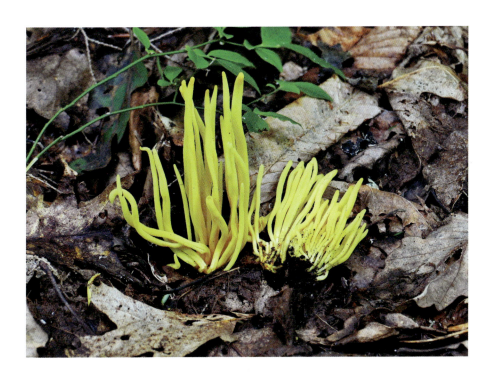

Lentaria byssiseda Corner

MACROSCOPIC FEATURES: fruit body 1–6 cm high and wide, a cluster of branches arising from a short common stalk. **branches** erect, crowded, repeatedly forked, smooth, tough, pliable, pinkish tan to brown, whitish toward the tips. **branch tips** short and acute or elongated, often forked, white. **stalk** 3–18 mm long and 1–5 mm thick, tapered downward or nearly equal, whitish or colored like the branches, attached to a white, spreading, mycelial mat, which often has slender white rhizomorphs. **flesh** tough, flexible, whitish or pale ochraceous, sometimes staining brown when cut or bruised, greening with FeSO4; odor not distinctive, taste bitter or not distinctive.

MICROSCOPIC FEATURES: Spores 12–14 (–18) × 3–4(–6) μm, cylindric-oblong, smooth, hyaline.

SPORE PRINT: White.

HABIT, HABITAT, AND SEASON: Scattered or in groups on leaves, cones, twigs, and rotting broadleaf or conifer wood; summer–early winter.

EDIBILITY: Unknown.

COMMENTS: *Lentaria micheneri* is almost identical but has a pale orange to pale pinkish orange or pale orange-buff fruit body with similarly colored branch tips and smaller spores. The White Coral, *Ramariopsis kunzei* (not illustrated), grows on soil. Its erect, coral-like fruit body grows up to 8 cm high and has a short stalk. The white branches are repeatedly forked and usually develop a pinkish to pale apricot tinge in age. Surfaces and flesh do not stain green with the application of $FeSO_4$.

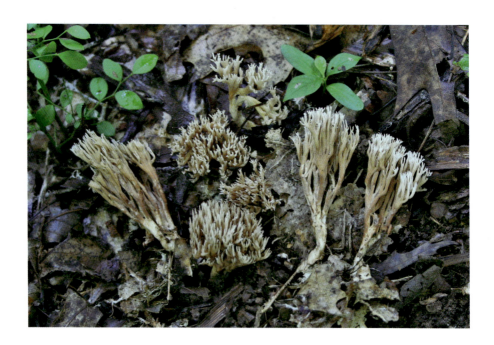

Lentaria micheneri (Berk. & M. A. Curtis) Corner

= *Clavaria micheneri* (Berk. & M. A. Curtis) R. H. Petersen

MACROSCOPIC FEATURES: fruit body up to 4 cm high and 1–2.5 cm wide, a cluster of branches arising from a common stalk. **branches** erect, crowded, repeatedly forked, smooth or with velvety patches, pale orange to pale pinkish orange or pale orange-buff. **branch tips** pointed, often forked, colored like the branches. **stalk** smooth or velvety, colored like the branches, with a conspicuous mat of white basal mycelium. **flesh** tough, whitish, staining green with $FeSO_4$; odor not distinctive, taste bitter.
MICROSCOPIC FEATURES: Spores 7–9 × 2.3–4.5 μm, narrowly elliptic, smooth, hyaline.
SPORE PRINT: White.
HABIT, HABITAT, AND SEASON: Solitary, scattered, or in groups on leaf litter and duff under oaks, beeches, or pines; summer–fall.
EDIBILITY: Unknown.

COMMENTS: The epithet *micheneri* honors Pennsylvania physician and mycologist Ezra Michener (1794–1887), who contributed hundreds of specimens to the Schweinitz Herbarium in Pennsylvania. *Lentaria byssiseda* is very similar but has a pinkish tan fruit body with creamy white branch tips and larger spores. *Scytinopogon angulisporus* = *Clavaria angulispora* = *Clavulina connata* (see Color Key) is another look-similar. There is no general agreement on its proper name and even serious doubt that, despite the coral body plan, it should be classified in the Clavariaceae (Birkebak et al. 2013). In any event, it knows what it looks like. The fruit body is 3–5 cm high and wide, pure white, soft and flexible with a mass of slender, repeatedly forked and almost curly branches. These arise from slender stalks and terminate in short, flattened, pointed tips. The habitat is leaf litter or humus, often adjacent to rotting wood. Spores are angular to warted, 5–7 × 3–3.5 μm. The odor has been variously described as resembling old ham or a pleasantly scented cleaning product.

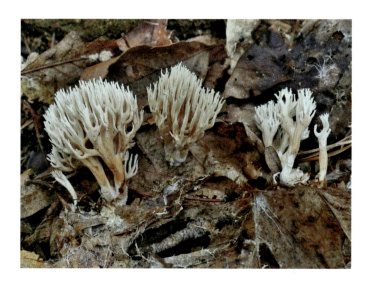

Ramaria formosa (Pers.) Quél.

= *Clavaria formosa* Pers.

COMMON NAME: Yellow-tipped Coral
MACROSCOPIC FEATURES: fruit body up to 20 cm high and 5–15 cm wide, consisting of a cluster of branches arising from a common stalk. **branches** erect, crowded, rounded, repeatedly forked, smooth or wrinkled, coral pink to pale salmon, becoming brownish in age. **branch tips** typically forked and blunt, pale yellow when young and fresh, later brownish. **stalk** short, thick, pinkish or whitish. **flesh** fibrous or brittle, colored like the stalk; odor not distinctive, taste bitter.
SPORE PRINT: Pale brownish yellow.
MICROSCOPIC FEATURES: Spores 8–15 × 4–6 μm, elliptic, finely warted, hyaline.
HABIT, HABITAT, AND SEASON: Solitary, scattered, or in groups on the ground in a variety of woodland types; summer–fall.
EDIBILITY: Poisonous, causing gastrointestinal distress.
COMMENTS: Addition of $FeSO_4$ to the branches produces a green stain. *Ramaria subbotrytis* is very similar, but branch tips are not yellow. *Ramaria stricta* has yellowish branch tips but grows from wood. Branches are thinner, straighter, and densely packed. The *Ramaria aurea* group (see Color Key) has fruit bodies up to 12 cm high and 10–15 cm wide, with clusters of golden yellow to golden orange branches that are repeatedly forked and arise from a white common stalk. The fruit body of *Ramaria conjunctipes* (not illustrated) has yellow tips and salmon orange to yellow-orange branches. These arise from slender bases that touch each other but are not fused. Unfortunately, identification of *Ramaria* species is often complicated by their tendency to rapidly lose distinctive coloration and fade to dull shades of tan.

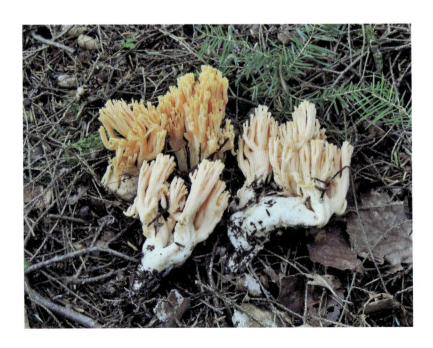

Ramaria stricta (Pers.) Quél.

= *Clavaria stricta* Pers.

COMMON NAME: Straight-branched Coral

MACROSCOPIC FEATURES: fruit body up to 14 cm high and 5–12 cm wide, a cluster of branches arising from a short base. **branches** erect and nearly parallel, slender, crowded, rounded or somewhat flattened, repeatedly forked, smooth, pale yellow to orange-buff or pinkish buff, bruising brown. **branch tips** typically forked and pointed, pale yellow, browning with age. **stalk base** whitish on the lower portion, colored like the branches above. **flesh** tough, whitish; odor fragrant or not distinctive, taste bitter.

MICROSCOPIC FEATURES: Spores 7–10 × 3.5–5.5 μm, ellipsoid, minutely roughened, hyaline to pale yellow.

SPORE PRINT: Yellowish.

HABIT, HABITAT, AND SEASON: Solitary, scattered, or in groups on fallen branches, logs, and stumps of conifer or broadleaf trees or at their base; summer–fall.

EDIBILITY: Unknown.

COMMENTS: The epithet *stricta* means "straight." Addition of $FeSO_4$ to the branches produces a green stain. *Ramaria concolor* (not illustrated) is nearly identical, but both the branches and branch tips are yellowish tan to pale cinnamon. It grows on well-decayed wood or on the ground in conifer or broadleaf forests.

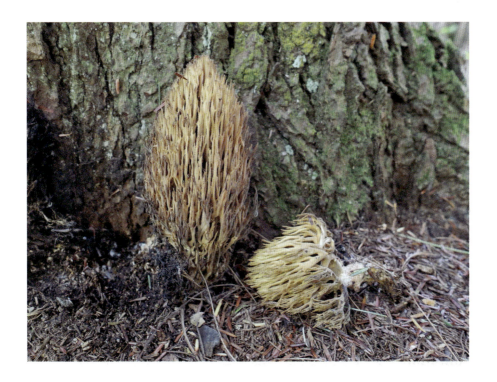

Ramaria subbotrytis (Coker) Corner

= *Clavaria subbotrytis* Coker

COMMON NAME: Rose Coral
MACROSCOPIC FEATURES: **fruit body** up to 15 cm high, erect and coral-like with numerous branches arising from a distinct central stalk. **branches** rounded, fleshy to somewhat brittle, rose coral to salmon pink at first, fading to creamy ochraceous at maturity. **branch tips** bluntly rounded, rose coral to salmon orange when young, becoming salmon pink to creamy ochraceous in age. **stalk** up to 3 cm long and 2 cm thick, nearly equal or somewhat enlarged downward, usually with a pointed base, colored like the branches or whitish. **flesh** thick, somewhat brittle, pinkish or white, often marbled with watery areas at the stalk base; odor and taste faintly reminiscent of sauerkraut or not distinctive.

SPORE PRINT: Yellowish.
MICROSCOPIC FEATURES: Spores 8–11 × 3–4 μm, elliptic, minutely roughened, yellowish.
HABIT, HABITAT, AND SEASON: Solitary, scattered, or in groups on the ground in broadleaf and mixed woods; summer–fall.
EDIBILITY: Edible.
COMMENTS: *Ramaria botrytis* (not illustrated) is similar, but when young it has a thick, whitish to pale pink base and stubby branches that terminate in strongly contrasting rosy red to purplish branch tips. Spores are larger, minutely roughened, and faintly longitudinally twisted-striate, measuring 11–20 × 4–6 μm. Although *Ramaria formosa* is also pink, the branch tips are at first yellow.

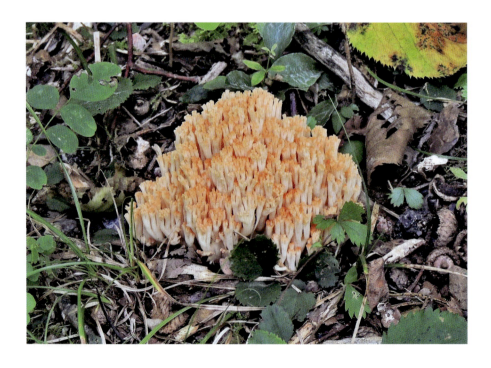

Sebacina schweinitzii (Peck) Oberw.

= *Tremellodendron schweinitzii* (Peck) G. F. Atk.
= *Tremellodendron pallidum* Burt

COMMON NAMES: False Coral Mushroom, Jellied False Coral

MACROSCOPIC FEATURES: fruit body up to 10 cm high and 14 cm wide, tough, coral-like, densely clustered and compact, consisting of numerous erect and forked branches that are broadly flattened to somewhat rounded. **branches** leathery to fibrous-tough, white to buff, fused together at their bases and sometimes on the upper portions. **flesh** very tough, whitish; odor not distinctive, taste slightly bitter to rancid or not distinctive.

SPORE PRINT: White.

MICROSCOPIC FEATURES: Spores 7.5–12 × 4–6.5 μm, ovoid to allantoid, smooth, hyaline.

HABIT, HABITAT, AND SEASON: Solitary, scattered, or in groups on the ground in broadleaf woods, often on or alongside trails, tolerant of foot traffic; summer–fall.

EDIBILITY: Edible.

COMMENTS: The epithet *schweinitzii* honors American clergyman and mycologist Lewis David de Schweinitz (1780–1834), the father of North American mycology. False Coral's very tough, stoutly branched fruit body and growth on the ground are good field identification marks. When young it could be mistaken for a very young *Thelephora vialis*, but the odor of that fiber fan is distinct. *Tremellodendropsis semivestita* = *Lachnocladium semivestitum* (not illustrated) is smaller and more delicate than these. It has nonfused branches and larger, hyaline, subelliptic to amygdaliform spores measuring 12–18 × 6–7 μm. Other look-similars include species discussed in the descriptions of *Clavulina cinera*, *Lentaria byssiseda*, and *Lentaria micheneri*. All of them have comparatively slender, more fragile branches. Unlike False Coral, when stomped they remain stomped.

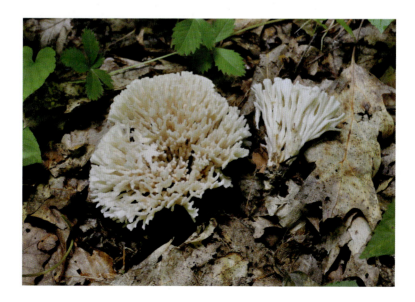

Sparassis spathulata (Schwein.) Fr.

= *Sparassis herbstii* Peck

COMMON NAME: Cauliflower Mushroom
MACROSCOPIC FEATURES: fruit body up to 40 cm high and 45 cm wide, a dense lettuce-like cluster of branches arising from a buried, stalk-like base. **branches** wavy, flattened, zonate, spatula-shaped and widening upward, somewhat flexible, whitish to yellowish buff with darker bands. **branch tips** broad and commonly paler than the branch zonation. **flesh** fairly tough, white; odor and taste not distinctive.
MICROSCOPIC FEATURES: Spores 5.5–8 × 4.5–6 μm, elliptic, smooth, hyaline.
SPORE PRINT: White.
HABIT, HABITAT, AND SEASON: Solitary on the ground at the base of an oak or occasionally a different broadleaf tree; summer–early winter.
EDIBILITY: Edible.
COMMENTS: This is a parasite on broadleaf trees, especially oaks. The edible American Cauliflower Mushroom, *Sparassis americana* (see Color Key), has a 15–30 cm high and wide fruit body consisting of densely clustered, lettuce-like branches attached to a common, rooting base. The branches are smaller, flattened and flexible, crinkled to curly, azonate, creamy white to pale yellow, pinkish, or tan. It grows on ground adjacent to or sometimes on rotting conifer logs and stumps. Spores are oval and smooth, 5–7 × 3–4 μm.

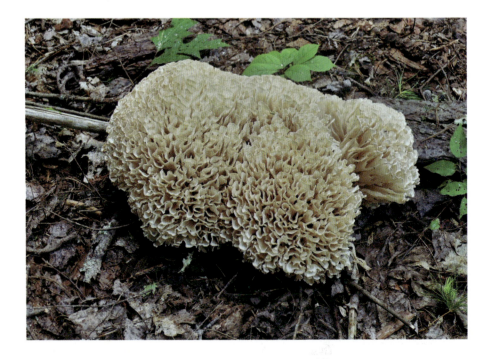

CORDYCEPS AND SIMILAR FUNGI

Members of this group are parasitic. Some infect hypogeous (truffle-like) fungi. Others prefer the larvae, pupae, or adults of arthropods. Fruit bodies often have a distinct stalk and head with a fertile surface roughened like sandpaper, but a few species cover their hosts with mycelium, causing them to appear furry or mummified.

Akanthomyces aculeatus Lebert

COMMON NAME: Moth Akanthomyces
MACROSCOPIC FEATURES: **fruit body** a coating of white to yellowish mycelium and thin, rod-like projections up to 8 mm long on the adult host. The extensions may have expanded, club-like tips. The result is what appears to be a mummified moth studded with fungal pins and often stuck to whatever surface it died on.
MICROSCOPIC FEATURES: Spores are conidia, 3–6 × 2–3 μm, broadly elliptic or ovoid, smooth, hyaline.
HABIT, HABITAT, AND SEASON: Parasitic on moths attached to leaves, branches, or tree trunks; summer–early winter.
EDIBILITY: Unknown, but of no culinary interest.
COMMENTS: The epithet *aculeatus* means "having spines or needles," a reference to the tiny rod-like extensions. An unidentified parasitic fungus, most likely a species of *Ophiocordyceps*, attacks the Carolina Leaf Roller Cricket, *Camptonotus carolinensis* (see Color Key). The fungus forms numerous thin, brownish gray, rod-like structures up to 2 cm long and nearly 1 mm thick, which arise from a white mycelium that partially or completely covers the body of the dead host. *Cordyceps olivascens* (see Color Key) consists of a head and stalk that is attached to the remains of a buried or partially buried, often unidentified insect. The head is 2.5–3 cm high and 4–6 mm wide, very light green to olive buff, and roughened like sandpaper. The stalk is 2–3 cm long, 1.5–4 mm thick, and colored like the head or slightly darker olive, and it typically has a whitish base. It has hyaline, inamyloid, filiform, multiseptate spores that soon break up into oblong fragments, 3.5–6 × 1–1.5 μm.

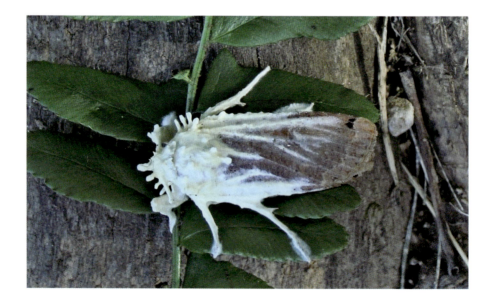

Cordyceps militaris (L.) Fr.

COMMON NAME: Trooping Cordyceps
MACROSCOPIC FEATURES: **fruit body** up to 8 cm high and 6–10 mm wide, consisting of a head and stalk. **head** cylindric to spindle- or club-shaped, finely roughened, reddish orange. **stalk** 0.5–3 cm long, up to 6 mm wide, rounded, tapering downward, often curved, smooth, orange. **flesh** thin, pale orange; odor and taste not distinctive.
MICROSCOPIC FEATURES: Spores filiform, breaking into barrel-shaped spores, 2.5–6 × 1–1.5 μm, smooth, hyaline.
HABIT, HABITAT, AND SEASON: Solitary or in groups on larvae and pupae of moths and butterflies shallowly buried in soil or mosses; summer–fall.
EDIBILITY: Unknown.
COMMENTS: The epithet *militaris* means "soldier or war-like," a reference to killing larvae and pupae. Bee, wasp, hornet, or bumblebee corpses that sprout one or more 2–8 mm long, yellow-knobbed stalks likely fell victim to the inelegantly named Yellow-headed Hymenoptera Cordyceps, *Ophiocordyceps sphecocephala* (not illustrated). The Beetle Cordyceps, *Ophiocordyceps melolonthae* (see Color Key), is much larger, up to 8 cm tall and 1 cm thick, and grows on underground beetle grubs. It too has a yellowish or whitish, oval or spindle-shaped head and yellowish stalk. Subterranean spiders are the target of *Purpureocillium atypicola* = *Nomuraea atypicola* (not illustrated). The cylindric to spindle-shaped fruit body consists of a scurfy to powdery, grayish tan to light gray-purple head and a grayish tan stalk. The curved head measures 1.5–3 cm high and 2.5–5 mm thick. The stalk is 2–3 cm long and 2.5–3.5 mm thick. The connection to a buried spider and the color of the fruit body distinguish it from slender xylarias such as *Xylaria hypoxylon* (see Color Key and Comments under *Xylaria magnoliae*). *Beauveria bassiana* (not illustrated) causes white muscardine disease in a variety of arthropods and is used as a bioinsecticide. The disease presents as white, cottony, spore-producing mold erupting from joints of the deceased's exoskeleton.

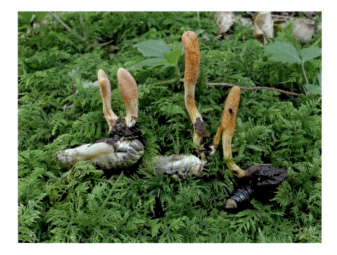

Tolypocladium ophioglossoides
(J. F. Gmel) C. A. Quandt, Kepler, & Spatafora

= *Cordyceps ophioglossoides* (J. F. Gmel) Link
= *Elaphocordyceps ophioglossoides* (J. F. Gmel) G. H. Sung, J. M. Sung, & Spatafora

COMMON NAMES: Adder's Tongue, Golden-thread Cordyceps
MACROSCOPIC FEATURES: fruit body consisting of a head and stalk. **head** 2–2.5 cm high and 1–1.6 cm wide, spindle-shaped to oval or club-shaped, finely roughened like sandpaper, yellowish brown to dark reddish brown, becoming olive black at maturity. **stalk** 2.5–14 cm high and 1.5–10 mm thick, equal or nearly so, smooth, yellow to olive black, with long rope-like rhizomorphs of golden hyphae connecting it to the host (excavate carefully to preserve the thread). **flesh** thick, firm, whitish; odor and taste not distinctive.
MICROSCOPIC FEATURES: Spores 2–5 × 1.5–2 μm, cylindric, smooth, hyaline.
HABIT, HABITAT, AND SEASON: Solitary or in groups in mixed woods on buried, walnut-shaped, reddish brown fruit bodies of False Truffles, *Elaphomyces* species; summer–fall.
EDIBILITY: Unknown.
COMMENTS: The epithet *ophioglossoides* means "snake tongue." The Round-headed Cordyceps, *Tolypocladium capitatum* (see Color Key), is very similar but has an irregularly rounded head. Although it also parasitizes Deer Truffles, the stalk is directly attached to the host and lacks the long, rope-like rhizomorphs of golden hyphae. *Ophiocordyceps gracilioides* (not illustrated) attacks beetle larvae and forms a fruit body consisting of a head and stalk that emerges from the parasitized larva. The nearly globose fertile head is up to 5.7 mm wide. The outer surface is roughened by embedded perithecia and pale yellowish brown to pale reddish brown. The stalk is similarly colored and up to 30 mm long and 3.5 mm wide. Cylindric ascospores are 5.5–9 × 1.4–2 μm. Earth Tongues such as *Trichoglossum farlowii* are similar as well, but they grow from woodland soil, not the body of an insect or truffle host. Again, careful excavation is the key to identifying many of these species.

Torrubiella arachnophila var. *leiopus*
(J. R. Johnst.) Mains

= *Cordyceps arachnophila* J. R. Johnst.

COMMON NAME: Spider Cordyceps

MACROSCOPIC FEATURES: **fruit body** of the asexual (anamorphic) stage of this fungus, *Gibellula leiopus*, shown in the photograph, covers the host spider with white to yellowish mycelium, resulting in what appears to be a mummified spider. The sexual (teliomorphic) stage eventually arises from the mycelium and consists of numerous, thin, rod-like extensions, up to 7 mm long, that are white to yellowish or pale pinkish.

MICROSCOPIC FEATURES: Spores produced by the anamorph are conidia, $2.5–6 \times 1.5–2.5$ μm, fusoid-elliptic, smooth, hyaline. The teleomorph produces ascospores, $450–650 \times 1.5–2$ μm, thread-like, segmented, smooth, hyaline.

HABIT, HABITAT, AND SEASON: Parasitic on spiders that usually die attached to the underside of a leaf; summer–fall.

EDIBILITY: Unknown, but of no culinary interest.

COMMENTS: The epithet *arachnophila* means "loving arachnids."

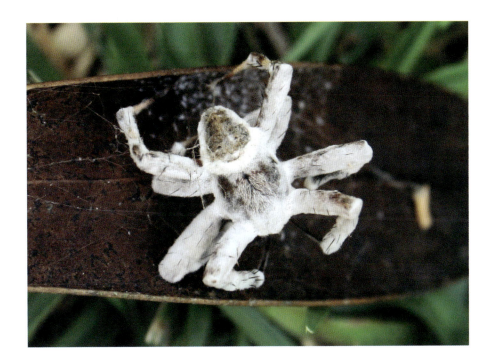

CRUST, CUSHION, AND PARCHMENT FUNGI

Fungi in this mixed bag of basidiomycetes and ascomycetes can be crust-like and spreading, cushion-shaped, or parchment-like. Shapes are extremely variable, often mimicking those commonly seen in other major groups. Fertile surfaces may be smooth, roughened, warty, wrinkled, cracked, toothed, or poroid. Although many grow on wood, some occur on other substrates. If you are unable to find a match here, try the Polypores, Carbon Fungi, and Tooth Fungi groups.

Biscogniauxia atropunctata (Schwein.) Pouzar

= *Diatrype atropunctata* (Schwein.) Berk.
= *Hypoxylon atropunctatum* (Schwein.) Cooke

COMMON NAME: Hypoxylon Canker of Oak
MACROSCOPIC FEATURES: fruit body a spreading crust, up to 50 cm or more long and 25 cm or more wide, tightly adhering to the substrate. **outer surface** thin, pale blue-gray at first, then white punctuated by tiny black openings, blackening overall in age. **interior** hard and blackened, with embedded perithecia; odor not distinctive.
MICROSCOPIC FEATURES: Ascospores 20–30 × 11.5–14.5 μm, elliptic with rounded ends, smooth with a straight, spore-length germ slit, brown.
HABIT, HABITAT, AND SEASON: On trunks and logs of oaks and other broadleaf trees; year-round.
EDIBILITY: Inedible.

COMMENTS: The epithet *atropunctata* means "having dark dots," a reference to the tiny black openings (ostioles) dotting the white outer surface. *Perenniporia subacida* (see Color Key) is an ivory white to buff, perennial, spreading crust with a whitish margin. It has 4–6 rounded pores per mm and grows on decaying stumps and trunks of conifers or sometimes broadleaf trees. The hyphae are distinctly dextrinoid, and the ovoid spores are weakly dextrinoid and measure 4.5–6 × 3.5–4.5 μm. *Annulohypoxylon cohaerens* = *Hypoxylon cohaerens* (see Color Key) grows on beech logs and stumps. It has 1.5–8 mm wide, cushion-shaped to rounded, hard, blackish fruit bodies with tiny nipple-like bumps. *Annulohypoxylon annulatum* (not illustrated) is very similar to *Annulohypoxylon cohaerens*, but the tiny nipple-like bumps are surrounded by small depressions. It grows on oaks. *Diatripe stigma* is blackish throughout its developmental cycle.

Ceriporia purpurea (Fr.) Donk

= *Gloeoporus purpureus* (Fr.) Zmitr. & Spirin
= *Merulioporia purpurea* (Fr.) Bondartsev & Singer

MACROSCOPIC FEATURES: fruit body annual, resupinate, tightly attached to the substrate, forming poroid patches several centimeters or more long, soft and wax-like when young, hard and brittle when dry; margin distinctly demarcated, sterile and white when immature. **fertile surface** whitish when very young, soon pink or salmon, becoming purple to purple-violet as it ages or when bruised, purple-brown to wine red when dry. **pores** rounded to oblong or elongated, 3–5 per mm. **tubes** 2–4 mm long.
MICROSCOPIC FEATURES: Spores 6–7 × 2–2.5 μm, allantoid, smooth, hyaline, inamyloid, often with several small oil drops.
HABIT, HABITAT, AND SEASON: On branches, logs, or trunks of fallen broadleaf trees; year-round.
EDIBILITY: Inedible.
COMMENTS: The epithet *purpurea* means "purple." Compare with *Skeletocutis lilacina*, which is similarly colored but has 5–6 pores per mm and smaller spores. Also compare with *Phlebiopsis crassa*, which is similarly colored but lacks pores. When young, the broadleaf tree pathogen *Chondrostereum purpureum* (see Color Key) is a rubbery, peelable, pinkish to purple crust with an irregularly wrinkled or almost poroid surface. It is discussed in the Comments for *Terana coerulea*. *Chondrostereum* causes silver leaf disease and can be a serious problem in fruit trees.

Cymatoderma caperatum
(Berk. & Mont.) D. A. Reid

= *Stereum caperatum* (Berk. & Mont.) Berk.
= *Thelephora caperata* Berk. & Mont.

COMMON NAME: Goblet Fungus

MACROSCOPIC FEATURES: **fruit body** 2–10 cm wide, wrinkled to folded, vase- to bowl-shaped, attached to wood by a short stalk. **inner surface** conspicuously longitudinally ribbed, bald and shiny when moist and fresh, color highly variable, a mixture of whitish to pinkish, lavender, or purple, darkest toward the margin when fresh, often browner below, in age becoming yellowish to whitish; margin divided into slightly concave, somewhat zonate, rounded or pointed teeth-like lobes with finely torn edges. **outer surface** convex, wavy, uneven, bald, colors similar to the interior. **stalk** 1–3.5 cm long and 3–12 mm thick, nearly equal down to an enlarged base, solid, whitish with yellow or brownish tints. **flesh** thin, papery to somewhat cartilaginous, whitish; odor not distinctive.

MICROSCOPIC FEATURES: Spores 8–11 × 3–4 µm, subcylindric, smooth, hyaline.

SPORE PRINT: White.

HABIT, HABITAT, AND SEASON: Solitary, scattered, or in groups on decaying hardwood logs and branches; summer–early winter.

EDIBILITY: Inedible.

COMMENTS: *Cymatoderma* means "wavy skin." The epithet *caperatum* means "wrinkled or folded." *Cotylidia diaphana* (not illustrated) has a similar fluted or goblet shape and often paler or whitish colors, and it grows on the ground in woodland litter. The fruit body including stalk is 1.5–4.5 cm tall and 0.5–3 cm wide at the radially wrinkled rim. The stalk is up to 3.5 mm wide and partially covered by white tomentum. Spores are 4–6 × 2.5–4 µm, broadly ellipsoid, smooth, and hyaline.

Hydnoporia olivacea (Schwein.) Teixeira

= *Hydnochaete olivacea* (Schwein.) Banker
= *Hymenochaetopsis olivacea* (Schwein.) S. H. He & Jiao Yang
= *Irpex cinnamomeus* Fr.

COMMON NAME: Brown-toothed Crust
MACROSCOPIC FEATURES: **fruit body** a resupinate to slightly effused-reflexed crust extending up to 30 cm or more on wood. **fertile surface** dry and leathery, consisting of dull yellowish brown to reddish brown, flattened to cylindric, jagged teeth-like projections up to 2 mm long. **flesh** up to 3 mm thick, leathery, brown; odor and taste not distinctive.
MICROSCOPIC FEATURES: Spores 4.5–7 × 1.2–1.5 μm, allantoid, smooth, hyaline; setae on the teeth are 30–150 × 9–14 μm, sharp and tapered at both ends, thick-walled, reddish brown.

HABIT, HABITAT, AND SEASON: A spreading crust on the underside of fallen broadleaf branches, especially oaks; year-round.
EDIBILITY: Inedible.
COMMENTS: The epithet *olivacea* means "olive colored." Compare with the Milk-white Toothed Polypore, *Irpex lacteus* (see Color Key), an effused-reflexed crust with small, overlapping, fused, white to creamy white caps on decaying wood. The fertile surface is mainly covered with jagged, teeth-like, eroded pores and tubes, often with a few intact pores near the cap margin. It has white to pale tan flesh. Also consider Asian Beauty, *Radulomyces copelandii* = *Radulodon copelandii* (not illustrated), which is discussed in the Comments for *Xylodon paradoxus*.

Hydnoporia tabacina (Sowerby) Spirin, Miettinen, & K. H. Larss.

= *Hymenochaete tabacina* (Sowerby) Lév.
= *Hymenochaetopsis tabacina* (Sowerby) S. H. He & Jiao Yang
= *Stereum tabacinum* (Sowerby) Fr.

COMMON NAME: Willow Glue

MACROSCOPIC FEATURES: **fruit body** annual or sometimes perennial, a thin spreading crust with small, shelf-like, semicircular to fan-shaped caps, growing on wood. **cap** 1–2 cm wide, often laterally fused and extending 20–30 cm or more, projecting 6–10 mm, leathery, flexible, able to be torn. **upper surface** dry, densely matted and woolly, becoming nearly bald in age, concentrically zonate with bands of yellowish brown to orange-brown and dark brown; margin orange-yellow to bright golden yellow, stalkless. **fertile surface** smooth or uneven, often cracked when dry, dull brown, dotted with tiny dark brown spines or setae (use a hand lens). **flesh** thin, fibrous-tough, dull brown; odor and taste not distinctive.

MICROSCOPIC FEATURES: Spores 4.5–7 × 2–3 µm, allantoid to nearly cylindric, smooth, hyaline, inamyloid; setae 60–92 × 6–12 µm, awl-shaped, thick-walled, reddish brown, sometimes finely encrusted toward the apex.

HABIT, HABITAT, AND SEASON: In overlapping clusters on decaying broadleaf trees; year-round.

EDIBILITY: Inedible.

COMMENTS: Saprotrophic on broadleaf trees. The epithet *tabacina* means "colored like tobacco." The cap surface immediately stains black with KOH. The fruit body of *Hydnoporia corrugata* (see Color Key) forms resupinate crusty patches up to several centimeters wide that are tightly attached to decaying wood. The reddish brown to grayish brown fertile surface is hard, brittle, azonate, uneven, rough, warted, and conspicuously cracked. It has bristle-like spines or setae visible when viewed with a hand lens.

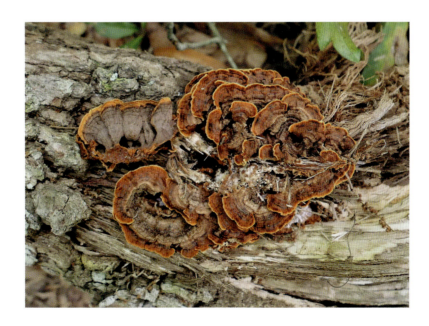

Hypoxylon howeianum Peck

= *Hypoxylon multiforme* var. *australe* (Fr.) Cooke

MACROSCOPIC FEATURES: fruit body 2–11(–20) mm wide, hemispherical to nearly spherical, sometimes fusing. **upper surface** smooth to slightly roughened, with ostioles below or at the same level, fulvous to rusty orange or dark brick red. **flesh** hard, black, with embedded spherical to obovoid perithecia that are covered by white tissue while immature; odor not distinctive.

MICROSCOPIC FEATURES: Spores 7–10 × 3–4.5 µm, ellipsoid-inequilateral with narrowly rounded ends, brown to dark brown, with a slightly spiral spore-length germ slit.

HABIT, HABITAT, AND SEASON: Scattered, in groups, or clustered on the bark of decaying broadleaf wood; summer–early winter.

EDIBILITY: Inedible.

COMMENTS: *Hypoxylon* means "beneath wood." The epithet *howeianum* honors American botanist Elliot C. Howe (1828–1899), who discovered this species. The Red Carbon Cushion, *Hypoxylon fragiforme* (not illustrated), forms cushion-shaped or round fruit bodies 2–16 mm wide with a hard, dry, conspicuously roughened exterior with raised dots. The fruit bodies are grayish white at first, become salmon pink, then cinnamon to brick red when mature, and finally blacken in age. It grows on a wide variety of broadleaf branches and logs and has elliptic ascospores that measure 10–15 × 5–8 µm. The ascospores are smooth, dark brown, and flattened on one side, and they have a spore-length germ slit.

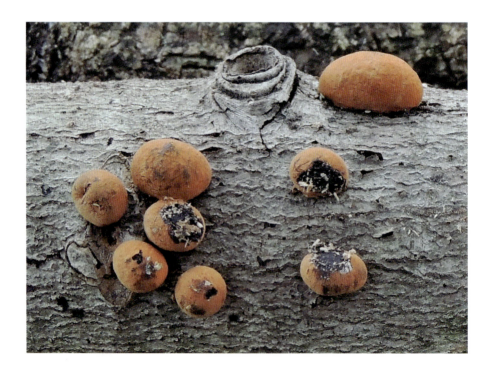

Nectria peziza (Tode) Fr.

= *Hydropisphaera peziza* (Tode) Dumort.

COMMON NAMES: Orange Spot, Yellow Spot

MACROSCOPIC FEATURES: **fruit body** a large spreading aggregation of tiny cushion-like, oval to spherical perithecia, 0.2–0.4 mm wide, adhering to the substrate. **outer surface** slightly roughened to nearly smooth, often with a small papilla, developing a tiny central depression and becoming somewhat cup-shaped on drying, slightly rubbery, yellow to orange. The perithecia are sometimes adorned with short, whitish to yellowish orange hairs on the surface that occasionally form triangular fascicles. **interior** soft or somewhat rubbery, colored like the exterior or paler; odor not distinctive.

MICROSCOPIC FEATURES: Ascospores (9–)12–17 × (4–)5–7 μm, oblong-elliptic, 2-celled, longitudinally striate, inamyloid, hyaline to pale yellow.

HABIT, HABITAT, AND SEASON: In clusters or groups on decaying fruit bodies of *Polyporus squamosus* or *Trametes versicolor*, as well as on decaying wood, bark, or dung.

EDIBILITY: Unknown, but too small to be of culinary interest.

COMMENTS: The epithet *peziza* means "sessile or lacking a stalk." The perithecial wall does not change color in KOH. Other similarly colored species such as *Bisporella citrina* and *Scutellinia scutellata* are larger and distinctly cup- to saucer-shaped.

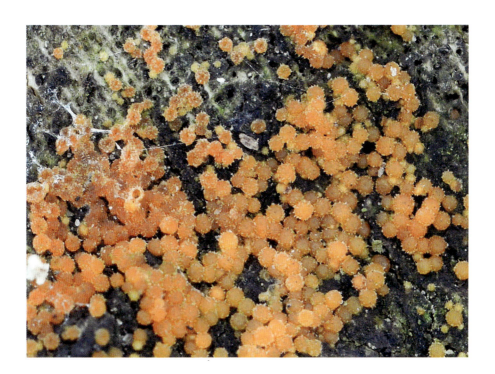

Phlebia incarnata (Schwein.) Nakasone & Burds.

= *Byssomerulius incarnatus* (Schwein.) Gilb.
= *Merulius incarnatus* Schwein.

COMMON NAME: Coral-pink Merulius
MACROSCOPIC FEATURES: fruit body consisting of stalkless caps, 3–8 cm long and 2–4 cm wide, semicircular to fan-shaped, somewhat leathery to cartilaginous. **upper surface** moist or dry, nearly bald or covered with short, soft, downy hairs, coral pink when young and fresh, becoming salmon buff in age. **lower surface** a network of radiating branched folds that resemble broad pores, pinkish ocher to salmon buff. **flesh** 2–4 mm thick, spongy to leathery, whitish to buff; odor not distinctive.
MICROSCOPIC FEATURES: Spores 4–5 × 2–3 μm, elliptic, smooth, hyaline.
SPORE PRINT: White.

HABIT, HABITAT, AND SEASON: In overlapping clusters on logs and stumps of broadleaf trees, often interspersed with old fruit bodies of the *Stereum ostrea* group or other *Stereum* species; summer–winter.
EDIBILITY: Unknown.
COMMENTS: Recent reports suggest that Coral-pink Merulius may be parasitic on species of *Stereum*. The Trembling Merulius, *Phlebia tremellosa* (see Color Key), is a spreading, often coalescing crust that usually makes small attempts at cap formation. Upper surfaces are hairy to woolly, white to pale yellow. The lower surface consists of reticulate ridges and shallow pits that are yellowish to brownish orange or pinkish orange and become dark orange in age. Spores are allantoid, smooth, and hyaline and measure 3–4 × 0.5–1.5 μm.

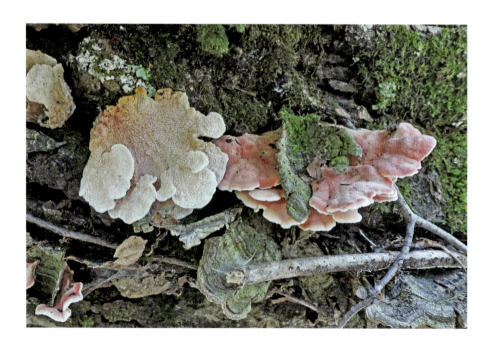

Phlebiopsis crassa (Lév.) Floudas & Hibbett

= *Hjortstamia crassa* (Lév.) Boidin & Gilles
= *Laxitextum crassum* (Lév.) Lentz
= *Phanerochaete crassa* (Lév.) Burds.
= *Porostereum crassum* (Lév.) Hjortstam & Ryvarden

MACROSCOPIC FEATURES: fruit body annual, a resupinate to effused-reflexed, spreading crust. **upper surface** velvety to matted and woolly, sometimes warted and uneven or cracking in age, lacking pores, brownish with purplish tints, bright purple to dark violet near the growing margin; the margin is often partially reflexed and whitish during active growth. **flesh** thin, brown.
MICROSCOPIC FEATURES: Spores 5.5–7.5 × 3–4 μm, ellipsoid, smooth, hyaline, inamyloid. Cystidia 50–120 × 8–20 μm, cylindric with a subulate apex, smooth to strongly encrusted, thick-walled, hyaline to pale brown.
HABIT, HABITAT, AND SEASON: Closely attached and spreading on decaying broadleaf branches and logs; fall–early spring.
EDIBILITY: Inedible.
COMMENTS: The epithet *crassa* means "thick or heavy." The color of the upper surface is highly variable and frequently changes as it ages. Compare with *Ceriporia purpurea* and *Skeletocutis lilacina*, which are similarly colored but have pores. *Terana coerulea* is typically bright blue and found on the underside of oak branches or logs. Another look-similar, *Chondrostereum purpureum* (see Color Key), is discussed in the Comments under *Terana coerulea*.

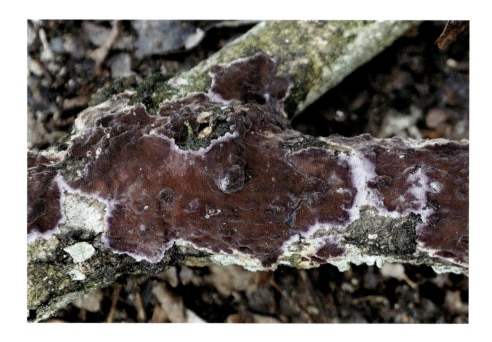

Scorias spongiosa (Schwein.) Fr.

COMMON NAME: Honeydew Eater

MACROSCOPIC FEATURES: fruit body up to 6 cm high and 15 cm or more wide. At first a loosely stranded or tangled cobwebby mat, cream to buff, adhering to leaves and twigs. It eventually thickens into a brownish yellow mass resembling a gelatinous sponge and produces asexual spores. Months later, the mass darkens to brown or black and generates sexual ascospores.

MICROSCOPIC FEATURES: Ascospores 1.2–5 × 2.5–3 μm, cylindric to elliptic, 3-septate, smooth, yellowish hyaline.

HABIT, HABITAT, AND SEASON: Beneath colonies of the Beech Blight or Boogie Woogie Aphid, *Grylloprociphilus imbricator*, infesting leaves, twigs, and branches of American Beech trees. The asexual stage of the fungus appears in late summer below an infested branch and persists through the winter. The sexual stage follows in spring.

EDIBILITY: Inedible.

COMMENTS: This sooty mold feeds on aphid honeydew. Unlike the aphid, it does not attack the tree. The photograph on the upper left shows aphids congregating on branches and an immature hyphal mass of *Scorias spongiosa*. The second photograph shows a stroma containing the embedded reproductive structures of the fungus.

Sebacina incrustans (Pers.) Tul. & C. Tul.

= *Corticium incrustans* Pers.

MACROSCOPIC FEATURES: **fruit body** up to 16 cm wide and occasionally larger, a thin, irregularly shaped, tough, and waxy to leathery crust with small lateral projections from the margins, whitish to pale tan.

MICROSCOPIC FEATURES: Spores 11.5–15 × 6–8 μm, elliptic to ovoid, flattened to slightly depressed on one side, smooth, hyaline.

HABIT, HABITAT, AND SEASON: On the ground, spreading and enveloping leaves, cones, twigs, plant stems, and debris; spring–fall.

EDIBILITY: Inedible.

COMMENTS: The epithet *incrustans* means "covered with a crust-like layer." Compare with *Helvellosebacina concrescens*, which is also pale in color, grows on the ground, and clasps or envelops plant stems and leaves. It has a soft, rubbery to gelatinous fruit body. *Sebacina schweinitzii* is a tough, coral-like mass of flattened and fused whitish fingers that grow erect on the ground, not engulfing parts of plants.

Skeletocutis lilacina A. David & Jean Keller

MACROSCOPIC FEATURES: fruit body annual, resupinate, tightly attached to the substrate, forming irregular poroid patches up to 6 cm or more long and 1 mm thick, elastic and soft when fresh, hard and brittle when dry; margin distinctly demarcated, sterile, white during active growth. **fertile surface** lilac with a grayish tint. **pores** rounded-angular, 5–6 per mm. **tubes** 0.5–1 mm long.

MICROSCOPIC FEATURES: Spores 3–4 × 0.8–1 μm, strongly allantoid, smooth, hyaline, inamyloid.

HABIT, HABITAT, AND SEASON: On decaying broadleaf trunks and branches; year-round.

EDIBILITY: Inedible.

COMMENTS: The epithet *lilacina* means "lilac." Compare with *Ceriporia purpurea*, which is similarly colored but has 3–5 pores per mm and larger spores. Also compare with *Phlebiopsis crassa*, which lacks pores. A third look-similar, *Chondrostereum purpureum* (see Color Key), is discussed in the Comments under *Terana coerulea*.

Stereum complicatum group (Fr.) Fr.

COMMON NAME: Crowded Parchment
MACROSCOPIC FEATURES: fruit body a spreading crust of caps that are sometimes laterally fused. **cap** up to 3 cm wide, fan-shaped. **upper surface** dry, with fine, silky hairs near the margin and stiff hairs at the base, concentrically zoned and variously colored from orange to grayish orange or reddish brown, sometimes with shallow radial grooves. The margin is usually paler, often wavy or crimped, and sometimes folded back over itself. **lower surface** smooth, pale orange to tan or grayish, exuding a red juice if cut when fresh and moist. **flesh** very thin, fibrous; odor and taste not distinctive.
MICROSCOPIC FEATURES: Spores 5–6.5 × 2–2.5 μm, nearly cylindric, smooth, hyaline.
SPORE PRINT: White.
HABIT, HABITAT, AND SEASON: In groups or dense overlapping clusters on twigs and branches of conifers and broadleaf trees, especially oaks; year-round.
EDIBILITY: Inedible.
COMMENTS: The epithet *complicatum* means "folded back over itself," a reference to the cap margin. The relationship between this species and *Stereum hirsutum* (not illustrated) remains unclear. Classically, *Stereum hirsutum* is larger and slightly thicker, has a dense coating of stiff hairs on the entirety of its upper surface, and never shows reddening or red juice when injured. However, both are highly variable in appearance, and intermediate forms do occur. The upper surface of *Stereum gausapatum* (not illustrated) is appressed-matted, woolly to nearly bald, and rusty brown to dark brown, sometimes with greenish tints when coated with algae. It has a white margin when actively growing, and its lower surface stains dark red when cut or bruised. The spores measure 6.5–9 × 3–4 μm. Red staining or bruising may not be evident in this group except when caps are young and actively growing.

Stereum ostrea group (Blume & T. Nees) Fr.

COMMON NAME: False Turkey-tail

MACROSCOPIC FEATURES: fruit bodies in this group of three or more species are fan- to oystershell-shaped, up to 8 cm wide, thin, overlapping or laterally fused. **upper surface** covered with silky gray hairs, concentrically zoned, often with bald bands of reddish brown, gray, yellow, or orange and a whitened margin. **lower surface** smooth or slightly lumpy but not pored, reddish brown to reddish buff or buff, often staining yellow when bruised during active growth or when rehydrated. **flesh** thin, leathery, tough, whitish to buff; odor and taste not distinctive.

MICROSCOPIC FEATURES: Spores 5–7.5 × 2–3 μm, cylindric, smooth, hyaline.

SPORE PRINT: White.

HABIT, HABITAT, AND SEASON: In gregarious groups on decaying broadleaf branches, logs, and stumps; year-round.

EDIBILITY: Inedible.

COMMENTS: False Turkey-tails have been collectively known as *Stereum ostrea*, a Javanese species that does not stain yellow and might not occur in North America. Here, fresh specimens often bruise yellow. When cap hairiness is woolly and exposed bands of red and brown are irregular and uneven, the correct identification is Yellowing Curtain Crust, *Stereum subtomentosum* (not illustrated). Short-haired specimens that bruise yellow and show wide, bald bands of color are currently called *Stereum lobatum* (not illustrated). Those with short hair, few bald bands, and no bruising reaction are most likely *Stereum fasciatum*. Further work on the group is needed. Silky Parchment, *Stereum striatum* (see Color Key), forms a spreading array of fan- to shell-shaped caps that are often laterally fused. Caps are up to 1.5 cm wide, shiny, pale gray to silvery or buff, with radiating silky fibers. They grow in groups or clusters on decaying broadleaf twigs and branches, especially American hornbeam; year-round. All of these species are often confused with the polypore *Trametes versicolor*.

Terana coerulea (Lam.) Kuntze

= *Terana coerulea* (Lam.) Kuntze
= *Pulcherricium coeruleum* (Lam.) Parmasto
= *Corticum coeruleum* (Lam.) Fr.

COMMON NAME: Velvet Blue Crust
MACROSCOPIC FEATURES: fruit body thin, rounded to irregular crusts up to 2 cm wide that become confluent and spread to form patches up to 16 cm or more wide. **surface** dry, velvety, dark blue to blackish blue with a paler margin.
MICROSCOPIC FEATURES: Spores 6–10 × 4–5 µm, elliptic, smooth, hyaline.
SPORE PRINT: White.
HABIT, HABITAT, AND SEASON: In fused clusters, usually on the underside of decaying broadleaf logs and branches, especially oaks; summer–winter.
EDIBILITY: Inedible.
COMMENTS: Velvet Blue Crust is easy to identify because of its distinctive velvety surface and blue color. *Chondrostereum purpureum* (see Color Key) causes silver leaf disease in fruit and other deciduous trees, rarely conifers, or grows on dead wood. Fruit bodies are initially pinkish to purple, resupinate or effused-reflexed, coalescing to form a spreading crust-like mass up to 10 cm or more long. Effused-reflexed portions may project 2 cm or more. Upper surfaces are matted and woolly, indistinctly zonate, grayish with a whitish margin. The fertile surface is smooth to somewhat wrinkled, bright pink-violet to dark violet, aging to lighter shades of violet-brown or brown. Spores are elliptic to cylindric, smooth, and hyaline and measure 6.5–8 × 2.5–3.5 µm. Giraffe Spots, *Dendrophora albobadia* = *Peniophora albobadia* (see Color Key), has a reddish brown fertile surface with a sharply contrasting white margin. It is typically resupinate, often fuses, and grows on fallen branches of numerous species of broadleaf trees. Spores are cylindric, often curved, hyaline, smooth, and thin-walled and measure 7–11 × 2.5–4 µm.

Trichoderma peltatum (Berk.) Samuels, Jaklitsch, & Voglmayr

= *Hypocrea peltata* Berk.

MACROSCOPIC FEATURES: fruit body up to 8 cm wide, cushion-shaped to brain-like, often intricately folded, attached to the woody substrate at a central point; margin incurved, wavy and lobed. **upper surface** fleshy or leathery, light tan, covered with tiny slightly raised dots (use a hand lens). **lower surface** smooth except for shallow ridges radiating from the rudimentary point of attachment, pale tan. **perithecia** numerous, crowded, immersed, and inconspicuous. **flesh** leathery, whitish; odor not distinctive.

MICROSCOPIC FEATURES: Spores 2–6.5 × 2–5 μm, subglobose, covered with tiny spines, hyaline.

HABIT, HABITAT, AND SEASON: Solitary, in groups, or in fused clusters on broadleaf logs, stumps, and branches, rarely on pines; year-round.

EDIBILITY: Unknown.

COMMENTS: The cushion-shaped fruit body with radial ridges on the lower surface is distinctive and resembles a parasitized gilled mushroom growing on wood. *Entonaema liquescens* (not illustrated) has a 1–13 cm wide, stalkless, cushion-shaped to rounded fruit body that is often convoluted and brain-like. The exterior is powdery, bright sulfur brown to olive or dull yellow, sometimes with orange tones, and it may stain greenish when bruised. It has a darker inner surface that is roughened like sandpaper and surrounds a fluid-filled cavity. It grows on decaying wood and has elliptic-inequilateral to rectangular spores with blunt ends with or without a straight, spore-length germ slit. Spores are pale to dark brown, typically have 2 oil drops, and measure 8–13 × 4–7.5 μm.

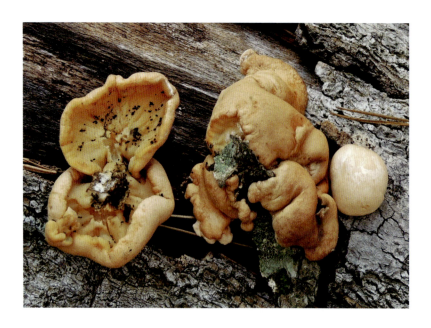

Xylobolus subpileatus (Berk. & M. A. Curtis) Boidin

= *Stereum frustulatum* var. *subpileatum* (Berk. & M. A. Curtis) A. L. Welden

COMMON NAME: Bacon of the Woods
MACROSCOPIC FEATURES: **fruit body** 1–6 cm broad and up to 1.5 mm thick, corky to very hard, drying rigid, resupinate to effused-reflexed, often laterally fused. **upper surface** typically wavy, somewhat zonate, sometimes with concentric grooves and ridges, matted and woolly, grayish orange to pale brown at first, becoming reddish brown to dark cinnamon brown in age; margin even, whitish or brownish. **lower surface** smooth or slightly velvety, often deeply cracked in age, whitish to pale orange, light buff, or pinkish buff. **flesh** pale orange; odor not distinctive.
MICROSCOPIC FEATURES: Spores 4–5 × 2.5–3 μm, cylindric, smooth, hyaline.
HABIT, HABITAT, AND SEASON: On logs and trunks of broadleaf trees, especially oaks, often covering large areas; year-round.
EDIBILITY: Inedible.
COMMENTS: The epithet *subpileatus* means "having a partially developed cap." The contrasting pale lower surface and dark upper surface help to identify this species. Fire Crust, *Rhizina undulata* (not illustrated), has a 2–6 cm wide crust-like or cushion-shaped fruit body attached to burned ground, well-decayed wood, or forest debris by a mass of thin, root-like filaments. The outer surface is smooth, reddish brown to dark brown or blackish, with a creamy white margin. It has spindle-shaped, smooth spores measuring 22–40 × 8–11 μm. The fruit body of Ceramic Parchment, *Xylobolus frustulatus* (see Color Key), consists of a crust-like layer of small, many-sided plates that are whitish to grayish tan or brownish and aggregate into irregular patches resembling a dull mosaic of ceramic tiles. It grows year-round on barkless broadleaf stumps and logs and is especially visible on sawed ends.

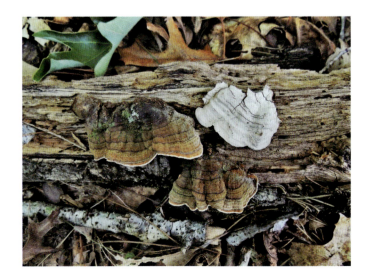

Xylocoremium flabelliforme (Schwein.) J. D. Rogers

COMMON NAMES: Bubble Gum Fungus, Powdery Xylaria

MACROSCOPIC FEATURES: fruit body 5–35 mm, an erect, convoluted, fan-shaped to tree-like or brain-shaped fertile head, attached to the woody substrate by a short stalk. **head** 2–15 mm wide, a fascicle of spore-bearing conidiophores that are whitish, yellowish, pinkish, or even orange. They are usually covered with powdery conidia ready to disperse in a smoky puff when touched. **stalk** up to 2 cm long and 2–5 mm thick, composed of a bundle of closely adhering, long, shaggy hairs, black overall or at the base.

MICROSCOPIC FEATURES: Conidia 3–7 × 1.5–4 μm, obovate to elliptic, smooth, hyaline.

HABIT, HABITAT, AND SEASON: Solitary, in groups, or in clusters on decaying branches, logs, and stumps of broadleaf trees; year-round.

EDIBILITY: Inedible.

COMMENTS: The epithet *flabelliforme* means "small fan." *Xylocoremium flabelliforme* is the anamorphic stage of *Xylaria cubensis* (not illustrated). That teliomorph also grows on decaying broadleaf wood. It is tough and much larger: 2–8 cm long by 2–20 mm thick, more or less club-shaped, brownish when young, blackish at maturity. Its surface is roughened and sandpaper-like due to embedded, flask-shaped perithecia. The ascospores are elliptic to irregular, smooth, and brown and measure 7–13 × 3.5–6 μm. Interestingly, the piece of wood hosting the anamorph might not produce the teleomorph later in the season.

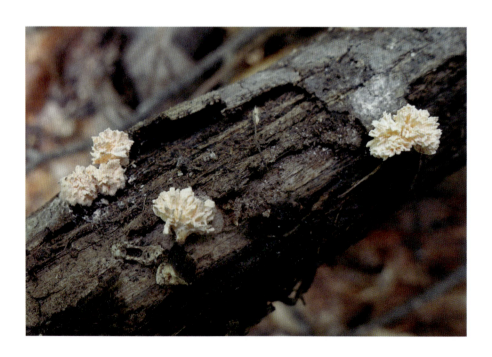

CUP FUNGI

Fruit bodies in this group resemble small cups or plates and often have thin, brittle flesh. Some have stalks; others are stalkless. They grow on the ground, on wood, or sometimes on other substrates.

Aleuria aurantia (Pers.) Fuckel

= *Peziza aurantia* Pers.

COMMON NAME: Orange Peel

MACROSCOPIC FEATURES: fruit body 1–10 cm wide, cup- to saucer-shaped or somewhat variable; margin occasionally torn at maturity, stalkless. **inner surface** smooth, bright orange to yellow-orange. **outer surface** pale orange, downy at first, becoming bald in age. **flesh** thin, brittle, pale orange; odor and taste not distinctive.

MICROSCOPIC FEATURES: Spores 17–24 × 9–11 μm, elliptic, coarsely warted and reticulate, usually with projecting spines at one or both ends, typically containing 2 oil drops, hyaline.

HABIT, HABITAT, AND SEASON: Solitary, scattered, or in groups or clusters, commonly on disturbed soil such as roadsides, waste areas, or gardens or under trees; year-round.

EDIBILITY: Edible but tasteless.

COMMENTS: The epithet *aurantia* means "orange." The Brown Otidea, *Otidea unicisa* = *Sowerbyella unicisa* (see Color Key), has a 1–4 cm wide, cup-shaped fruit body that is split down to the base on one side. It has a pinkish buff to yellowish brown inner surface that is often wrinkled and a yellowish brown outer surface, and it grows singly or clustered on the ground under broadleaf or mixed broadleaf and conifer trees. The spores are long-elliptic to slightly fusoid and finely roughened and measure 14–17 × 6–7 μm. Yellow Fairy Cups, *Bisporella citrina* (see Color Key), have very small, 1–3 mm wide, saucer-shaped, bright yellow fruit bodies that grow in groups or clusters on decaying wood. They have elliptic, 0–1-septate, smooth, hyaline spores, 9–14 × 3–5 μm, with oil drops.

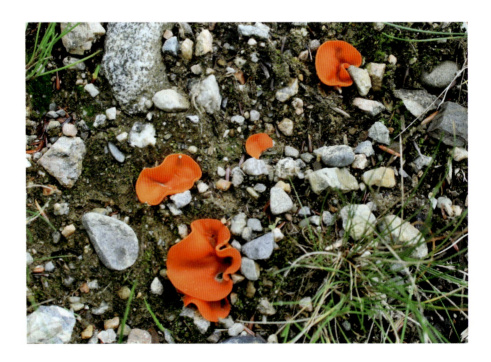

Ascocoryne cylichnium (Tul.) Korf

= *Peziza cylichnium* Tul.

COMMON NAME: Purple Jelly Drops

MACROSCOPIC FEATURES: fruit body 3–10 mm wide and 3–20 mm tall, shape highly variable, from stubby columns to shallow cups or puffy cushions with dimpled centers, often somewhat wrinkled; margin lobed or wavy, stalkless. **inner surface** and **outer surface** pinkish to reddish purple, bald, smooth or wrinkled. A rudimentary stalk may be present. **flesh** violet-pink, rubbery-gelatinous; odor and taste not distinctive.

MICROSCOPIC FEATURES: Spores 18–30 × 4–6 μm, elliptic, smooth; mature spores divided by several internal septa; paraphyses filiform and unbranched, hyaline.

HABIT, HABITAT, AND SEASON: In dense clusters on damp logs and stumps of broadleaf trees, especially beeches; fall–early winter.

EDIBILITY: Unknown.

COMMENTS: *Ascocoryne sarcoides*, also called Purple Jelly Drops (not illustrated), is nearly identical but typically more regularly cup-shaped. It has smaller spores, 11–18 × 3.5–5 μm, with a single septum, and its paraphyses are branched. Look-alikes on wood include *Exidia crenata* and similar jelly fungi, which typically have larger fruit bodies and differently colored flesh. The same is true for Black Jelly Drops, *Bulgaria inquinans*.

Chlorencoelia versiformis (Pers.) J. R. Dixon

= *Chlorociboria versiformis* (Pers.) Seaver
= *Chlorosplenium versiforme* (Pers.) P. Karst.

MACROSCOPIC FEATURES: fruit body 6–30 mm wide, shallowly cup- to saucer-shaped, with a short stalk. **inner surface** olive green to olive brown or orange-brown. **outer surface** velvety, dull reddish brown. **stalk** 3–6 mm long, tapered downward, dull reddish brown.

MICROSCOPIC FEATURES: Spores 9–16 × 2–4 μm, cylindric to allantoid or fusiform, smooth, with 0 to 4 oil drops, hyaline.

HABIT, HABITAT, AND SEASON: Scattered or in groups on decaying wood; summer–early winter.

EDIBILITY: Unknown.

COMMENTS: The epithet *versiformis* means "changing form." *Chlorosplenium chlora* (not illustrated) also grows in groups or clusters on decaying wood. It has a 1–3 mm wide, saucer-shaped, stalkless fruit body with a bright yellow outer surface. The inner surface is also yellow when young, aging to yellowish green. The spores are narrowly elliptic to fusiform and smooth, and they measure 7–9 × 1.5–2 μm. Yellow Fairy Cups, *Bisporella citrina* (see Color Key), is another grouped or clustered look-alike on decaying wood. It is discussed in the Comments for *Aleuria aurantia*.

Chlorociboria aeruginascens (Nyl.) Kanouse ex C. S. Ramamurthi, Korf, and L. R. Batra

= *Chlorociboria aeruginascens* (Nyl.) Kanouse
= *Chlorosplenium aeruginascens* (Nyl.) P. Karst.

COMMON NAMES: Blue-stain Fungus, Green-stain Fungus
MACROSCOPIC FEATURES: fruit body 3–8 mm wide, shallowly cup-shaped to nearly flat, often asymmetrical. **inner surface** smooth or wrinkled, blue-green, sometimes with yellow tints. **outer surface** finely roughened, blue-green. **stalk** 3–6 mm long, frequently eccentric, tapered downward, blue-green. **flesh** very thin, blue-green; odor not distinctive.
MICROSCOPIC FEATURES: Spores 5–7(–10) × 1–2.5 μm, elliptic to irregularly fusiform, with 2 oil drops, 1 at each end, smooth, hyaline.
HABIT, HABITAT, AND SEASON: In groups or clusters on decaying broadleaf wood; spring–fall. The blue-green mycelial stain in wood is visible year-round.
EDIBILITY: Unknown.
COMMENTS: The epithet *aeruginascens* means "blue-green." Pigments in the hyphal threads of this fungus stain wood blue-green. *Chlorociboria aeruginosa* (not illustrated) is nearly identical, but the stalk is generally central, producing a more symmetrical cup. It has larger spores, 8–15 × 2–4 μm. The Stalked Hairy Fairy Cup, *Lachnum virgineum* = *Dasyscyphus virgineus* (not illustrated), has a 1.5–4 mm wide, cup-shaped, distinctly stalked fruit body with a white outer surface densely covered with white hairs. The inner surface is bald, white to cream colored. It grows on decaying cones, stems, branches, and other woody debris. Spores are fusiform to clavate, smooth, and hyaline, and they measure 6–10 × 1.5–2.5 μm.

Galiella rufa (Schwein.) Nannf. & Korf

= *Bulgaria rufa* Schwein.

COMMON NAMES: Hairy Rubber Cup, Peanut Butter Cup Fungus

MACROSCOPIC FEATURES: fruit body cup-shaped, up to 3 cm high and 1–3 cm wide. **inner surface** smooth, orange to reddish orange or reddish brown. **outer surface** covered with a dense layer of matted, woolly hairs, tough, brown to blackish brown; margin finely toothed. **flesh** nearly black and rubbery-gelatinous.

MICROSCOPIC FEATURES: Spores 18–20 × 8–10 μm, elliptic with narrow ends, finely roughened, hyaline.

HABIT, HABITAT, AND SEASON: In groups or clusters on decaying broadleaf wood; summer–fall.

EDIBILITY: Unknown.

COMMENTS: The epithet *rufa* means "reddish orange," referring to the color of the inner surface. *Wolfina aurantiopsis* (not illustrated) may occur in Georgia, although it has not been formally recorded. It is similar but sometimes larger, with the shallow cups up to 7 cm wide. The inner surface is pale yellow to ochraceous, and the tough, yellowish flesh becomes corky on drying. Spores are much larger and broadly elliptic, 27–33 × 16–18 μm. It grows on decaying wood, wood chips, or nearby soil. Black Jelly Drops, *Bulgaria inquinans*, have rounded to top-shaped, rubbery-gelatinous, black fruit bodies that are 2–4 cm wide and up to 3.5 cm tall. These are scurfy, blackish to dark brown when young, becoming shallowly cup-shaped with age. They are stalkless or have rudimentary stalks and grow on decaying oak wood. The brown spores are apt to stain an enquiring finger brown.

Paragalactinia michelii (Boud.) Van Vooren

= *Galactinia michelii* Boud.
= *Peziza michelii* (Boud.) Dennis

COMMON NAME: Milking Lilac Cup
MACROSCOPIC FEATURES: fruit body 2–5 cm wide, cup- to saucer-shaped, stalkless or with a rudimentary stalk; margin distinctly curved upward. **inner surface** smooth, reddish brown with a lilac tint, exuding a clear or whitish liquid if broken or cut. **outer surface** scurfy to granular, dull yellow to yellow-orange, very slowly yellowing further when bruised. **flesh** thin, brittle, brownish; odor and taste not distinctive.
MICROSCOPIC FEATURES: Spores 15–17.5 × 8–9 μm, elliptic, finely warted when mature, hyaline, often with 2 oil drops. Asci 8-spored, amyloid. Paraphyses cylindric, septate, with slightly club-shaped tips.
HABIT, HABITAT, AND SEASON: Solitary or in groups on the ground in broadleaf or mixed woodlands; summer–fall.
EDIBILITY: Unknown.
COMMENTS: The larger Yellow Sap Cup, *Peziza succosa* (not illustrated), edibility unknown, also grows on the ground from late spring to fall. The shallowly cup-shaped fruit body is 2–5 cm wide, pale grayish brown on the smooth inner surface and scurfy, whitish to grayish or yellowish on the outer surface. The whitish flesh exudes yellow sap when broken or cut, coloring the flesh. Spores are elliptic and coarsely ornamented and measure 16–22 × 8–12 μm. The Bladder Cup, *Peziza vesiculosa* (not illustrated), has a 2–8 cm wide, stalkless, often distorted, cup-shaped fruit body with a yellowish brown to pale reddish brown inner surface that may be smooth or centrally textured by small blister-like bumps. The outer surface is paler and often textured with wart-like bumps, especially near the margin. It grows singly, in groups, or clustered on sawdust, wood chips, or manure piles. Spores are elliptic, smooth, and hyaline and measure 19–23 × 11–14 μm.

Peziza phyllogena Cooke

= *Peziza badioconfusa* Korf

COMMON NAME: Common Brown Cup
MACROSCOPIC FEATURES: fruit body 3–15 cm wide, cup-shaped, flattening with age, stalkless. **inner surface** smooth, brown, with hints of pink, purple, or olive. **outer surface** scurfy or granular, pale reddish brown to purple-brown. **flesh** thin, brittle, brownish; odor and taste not distinctive.
MICROSCOPIC FEATURES: Spores 16–21 × 8–10 μm, elliptic, finely warted, with 2 oil drops, hyaline.
HABIT, HABITAT, AND SEASON: Scattered or clustered on rich soil or decaying wood; spring–fall.
EDIBILITY: Reportedly edible.
COMMENTS: The Palamino Cup or Recurved Cup, *Peziza varia* = *Peziza repanda* (see Color Key), edibility unknown, has a 5–11.5 cm wide cup- to saucer-shaped fruit body that is often split at the margin and rolled outward (recurved). The inner surface is smooth, usually with a puckered center, pale yellow-brown to dark brown. The outer surface is finely fuzzy, whitish, with a small, central point of attachment or rudimentary stalk. The elliptic spores measure 14–17 × 8–10 μm and lack oil drops. They grow on decaying broadleaf wood or the ground nearby.

Sarcoscypha occidentalis (Schwein.) Sacc.

= *Peziza occidentalis* Schwein.

COMMON NAME: Stalked Scarlet Cup
MACROSCOPIC FEATURES: fruit body up to 4.5 cm high and 5–16 mm wide, shallowly cup-shaped with a distinct stalk. **inner surface** smooth, shiny, bright red. **outer surface** smooth to finely roughened, pinkish red to pinkish orange. **stalk** 1–3 cm long, 1.5–3 mm thick, nearly equal, smooth, white. **flesh** very thin, brittle, whitish to pinkish; odor and taste not distinctive.
MICROSCOPIC FEATURES: Spores 18–22 × 10–12 µm, elliptic, with several oil drops, smooth, hyaline.
HABIT, HABITAT, AND SEASON: Scattered, in groups, or in clusters on decaying broadleaf twigs or sticks; late winter–summer.
EDIBILITY: Unknown.
COMMENTS: The epithet *occidentalis* means "occurring in the western part of the world." The Scarlet Cup, *Sarcoscypha austriaca* (not illustrated), grows on branches from early spring to early summer. It also has a bright and shiny red inner surface complemented by a pinkish red to pinkish orange outer surface. It is larger, up to 5 cm wide, and either stalkless or with a short, thick stalk colored like the outer surface. The spores are elongated elliptic with flattish ends, plus or minus a bit of adherent external tissue. They measure 20–38 × 9–16 µm and contain several small oil drops. *Sarcoscypha dudleyi* (not illustrated) is macroscopically indistinguishable from Scarlet Cup but has spores with 2 large oil drops and a complete coating of rumpled, adherent tissue when observed in a water mount.

Scutellinia scutellata (L.) Lambotte

= *Peziza scutellata* L.

COMMON NAME: Eyelash Cup
MACROSCOPIC FEATURES: fruit body a stalkless shallow cup 3–20 mm wide. **inner surface** smooth, shiny, orange-red to bright orange. **outer surface** orange; margin covered with long, stiff, brown hairs. **flesh** thin, brittle, reddish; odor and taste not distinctive.
MICROSCOPIC FEATURES: Spores 16–21 × 10–14 µm, elliptic, finely roughened, sometimes with oil drops, hyaline.
HABIT, HABITAT, AND SEASON: Scattered, in groups, or in clusters on decaying wood or nearby soil; late spring–fall.
EDIBILITY: Unknown.
COMMENTS: The Orange Eyelash Cup, *Scutellinia erinaceus* (not illustrated), is very similar but smaller, up to 5 mm wide. It has a pale orange-yellow to orange inner surface and a dull brownish orange outer surface, grows on wood from spring through fall, and has nearly identical spores. The fruit body of *Scutellinia setosa* (not illustrated) is also small, up to 2.5 mm wide, but is orange-red. It also has similar spores. The Brown-haired White Cup, *Humaria hemisphaerica* (see Color Key), has a 1–3 cm wide cup-shaped fruit body with a smooth, whitish to grayish inner surface and a brownish yellow outer surface covered by a dense layer of brownish hairs that project from the margin over part of the inner surface. It grows on soil, among mosses, and on decaying wood from summer through early winter. Molecular data indicate that this "species" may be a group of several closely related taxa. *Humaria hemisphaerica* is sometimes attacked by *Hypomyces stephanomatis* (not illustrated), initially a white parasitic fungus that covers all or some portion of the fruit body, causing it to appear mummified. The white cottony growth soon develops oblong to ellipsoid, hyaline conidia that measure 8–13 × 3–4.6 µm, which gives the white cottony growth a tan, powdery aspect. Eventually, unicellular, boat- to slipper-shaped, hyaline ascospores, 7.8–12.3 × 2–4.6 µm, are produced.

Tatraea macrospora (Peck) Baral

= *Helotium macrosporum* Peck
= *Rutstroemia macrospora* (Peck) Kanouse

COMMON NAME: Gray Stalked Cup
MACROSCOPIC FEATURES: fruit body 5–15 mm wide, up to 1.5 cm high, convex at first, soon becoming shallowly cup- to saucer-shaped, with a short stalk as it matures; margin acute. **inner surface** dingy white to grayish, sometimes with yellowish tints, smooth, dry. **outer surface** finely scurfy, colored like the inner surface or more yellowish. **stalk** 4–15 mm long and up to 1.5 mm thick, central, smooth or finely scurfy, tapered toward the base, dry, colored like the outer surface or brownish. **flesh** very thin, whitish to grayish; odor and taste not distinctive.
MICROSCOPIC FEATURES: Spores 22–34 × 6–8 μm, narrowly oblong-fusoid, typically flattened on one side, smooth, hyaline, sometimes with a row of 4–8 large oil drops that are eventually separated by septa.
HABIT, HABITAT, AND SEASON: Solitary, in groups, or in clusters on decaying logs and stumps of broadleaf or conifer wood; summer–fall.
EDIBILITY: Unknown, but too small to be of culinary interest.
COMMENTS: The epithet *macrospora* means "having large spores." It is a decomposer of wood. The Stalked Hairy Fairy Cup, *Lachnum virgineum* = *Dasyscyphus virgineus* (not illustrated), is somewhat similar. It has a 1.5–4 mm wide, cup-shaped, distinctly stalked fruit body with a white outer surface densely covered with white hairs. The inner surface is bald, white to cream colored. It grows on decaying cones, stems, branches, and other woody debris. Spores are fusiform to clavate, smooth, and hyaline and measure 6–10 × 1.5–2.5 μm.

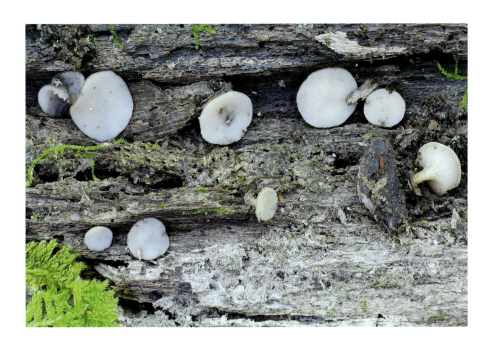

Urnula craterium (Schwein.) Fr.

= *Peziza craterium* Schwein.

COMMON NAME: Devil's Urn

MACROSCOPIC FEATURES: fruit body 2–7 cm wide and 4.5–11 cm tall, goblet-shaped, initially with a narrow mouth that expands with age as the rim splits and peels back. **inner surface** black and smooth. **outer surface** woolly when young, dark brown to black. **stalk** 2–4 cm long and 5–10 mm thick, black. **flesh** thin, leathery; odor and taste not distinctive.

MICROSCOPIC FEATURES: Spores 25–35 × 10–15 μm, broadly elliptic, smooth, lacking oil drops, hyaline.

HABIT, HABITAT, AND SEASON: In groups adjacent to fallen decaying branches, to which they are attached; early spring.

EDIBILITY: Unknown.

COMMENTS: The epithet *craterium* means "having a crater-like cup." It is a harbinger of spring and begins to appear shortly after morels do.

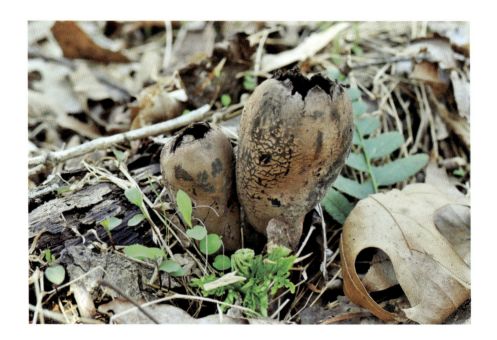

EARTH TONGUES AND CLUB FUNGI

Species in this heterogeneous group resemble erect tongues or clubs with heads ranging in shape from rounded to oval, spatula, spindle-like, or cylindric. Although these fungi may occur in groups, the stalk bases are not fused, and they are typically unbranched. Fertile surfaces may be smooth, wrinkled, or minutely bristly, but with the exception of *Trichoderma alutaceum*, these fungi are not roughened like sandpaper. They grow on the ground, wood, or decaying leaves.

Clavariadelphus americanus (Corner) Methven

COMMON NAME: Fairy Club
MACROSCOPIC FEATURES: fruit body 3–15 cm high and 1–3 cm wide in the upper portion, cylindric when young, becoming broadly club-shaped, usually unbranched, tapered downward to a whitish stalk-like base that is sometimes curved. **surface** dry, smooth to longitudinally wrinkled, orange-buff to orange-brown or reddish brown, slowly bruising brownish. **flesh** thick, firm or spongy, whitish, slowly bruising brownish when cut; odor not distinctive, taste bitter to unpleasant or not distinctive.
MICROSCOPIC FEATURES: Spores 8–12 × 4–6 µm, broadly ovoid, smooth, hyaline.
SPORE PRINT: White.
HABIT, HABITAT, AND SEASON: Scattered or in groups with oaks and pines; summer–fall.
EDIBILITY: Edible.
COMMENTS: The epithet *americanus* means "American." *Clavariadelphus pistillaris* (not illustrated) is nearly identical but grows exclusively with beech trees. *Clavariadelphus truncatus* (not illustrated) is also similar, up to 15 cm high and 3–7 cm wide. It is typically shaped like a club or top with a flattened to slightly depressed apex.

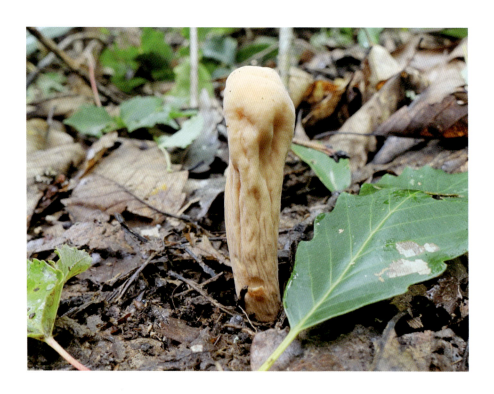

Leotia lubrica (Scop.) Pers.

COMMON NAMES: Jelly Babies, Ocher Jelly Club

MACROSCOPIC FEATURES: fruit body consisting of a gelatinous head and stalk. **head** 6–30 mm wide, irregularly rounded and flattened, smooth to distinctly furrowed or brain-like; margin strongly inrolled. **surface** moist, smooth, slippery, pale dull yellow to orange-yellow, sometimes with a greenish tint. **stalk** 2–5 cm long, 6–10 mm thick, enlarged downward, moist, smooth, slippery, pale dull yellow to orange-yellow. **flesh** soft, gelatinous, yellowish; odor and taste not distinctive.

MICROSCOPIC FEATURES: Spores 18–25 × 4–6 μm, cylindric-oblong to fusiform, often curved, multiseptate at maturity, smooth, hyaline.

HABIT, HABITAT, AND SEASON: In groups or clusters on the ground or well-decayed logs in woods or sandy waste areas; year-round.

EDIBILITY: Unknown.

COMMENTS: The epithet *lubrica* means "smooth or slippery." *Leotia atrovirens* (not illustrated) has a pea green to bluish green cap that darkens in age and a pale green to whitish stalk. The Green-capped Jelly Baby, *Leotia viscosa* (see Color Key), is similar but has a dark green head and pale greenish yellow to orange-yellow stalk. The Swamp Beacon, *Mitrula elegans* (not illustrated), is an uncommon species sometimes encountered in wet areas on decaying leaves and twigs in woodlands and bogs. The fruit body is 2–5 cm high, consisting of a head and stalk. Head 6–20 mm high, 3–12 mm wide, spindle- to pear-shaped, elliptic, or irregularly rounded. It is shiny, smooth to wrinkled, and translucent yellow to orange. Stalks are 2–4 cm long, 1.5–3 mm thick, white to pale translucent gray, sometimes with a pinkish tint. The elliptic, smooth, hyaline spores measure 11–18 × 1.5–3 μm. *Mitrula lunulatospora* (not illustrated) is very similar and occurs in the same habitats, but it has a pale pink head.

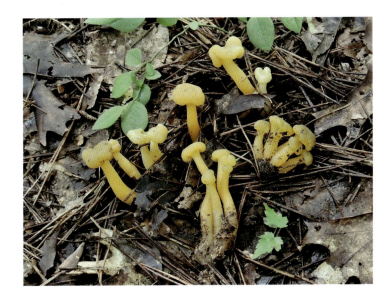

Microglossum rufum (Schwein.) Underw.

COMMON NAME: Orange Earth Tongue
MACROSCOPIC FEATURES: fruit body consisting of a head and stalk. **head** 3–16 mm wide and 1–3.5 cm high, tongue- to spoon-shaped or cylindric, smooth, dull or shiny, often longitudinally furrowed or compressed, yellow-orange to orange. **stalk** 1.5–4.5 cm long and 1.5–5 mm thick, equal or tapered downward, often longitudinally furrowed, granular or finely scaly, yellow to orange-yellow. **flesh** firm, yellowish; odor and taste not distinctive.
MICROSCOPIC FEATURES: Spores 18–38 × 4–6 μm, allantoid to fusiform, aseptate when young, 5–10-septate in age, smooth, hyaline.
HABIT, HABITAT, AND SEASON: Scattered, in groups, or clustered on the ground, among mosses, or on decaying wood; summer–fall.
EDIBILITY: Unknown.
COMMENTS: The epithet *rufum* means "reddish," not a very accurate descriptor for the actual color of the fruit body. The Irregular Earth Tongue, *Neolecta irregularis* (see Color Key), has a 2–8 cm high fruit body consisting of a head and stalk-like base. Heads may be broadly club- to spoon-shaped or lobed and sometimes branched. They can be smooth, furrowed, folded, irregularly contorted, or flattened and are bright yellow to orange-yellow. They grow on the ground or among mosses in conifer woods. Spores measure 5.5–10 × 3.5–5 μm. *Neolecta vitellina* (not illustrated) is very similar but typically forms narrower, club-shaped fruit bodies. Its spores measure 5.5–9 × 3–4 μm.

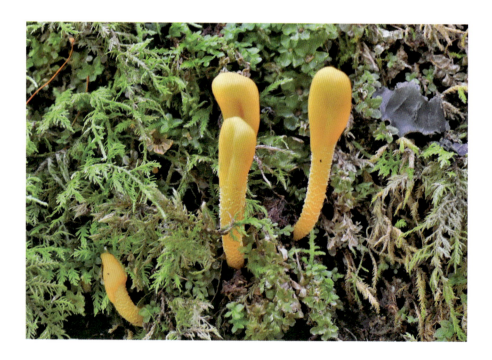

Spathulariopsis velutipes (Cooke & Farl.) Maas Geest.

= *Spathularia velutipes* Cooke & Farl.

COMMON NAME: Velvety Fairy Fan

MACROSCOPIC FEATURES: fruit body up to 7 cm high, consisting of a head and stalk. **head** 1–4 cm high and 1–3 cm wide, flattened. Surface wrinkled to folded, fan- to spoon-shaped, yellowish to brownish yellow. **stalk** 2–4 cm long and 6–15 mm thick, equal or tapered downward, solid, velvety, reddish brown, the base densely covered with orange mycelium. **flesh** thin, yellowish; odor and taste not distinctive.

MICROSCOPIC FEATURES: Spores 30–45 × 1.5–2 µm, needle-like, multiseptate, hyaline.

HABIT, HABITAT, AND SEASON: In groups or clusters on decaying broadleaf wood, sometimes on mossy soil; summer–fall.

EDIBILITY: Unknown.

COMMENTS: The epithet *velutipes* means "velvety stalk." *Spathularia flavida* (not illustrated) is similar but has a pale yellow to brownish yellow or yellow-orange head and a whitish stalk without orange mycelium at the base. The head of *Microglossum rufum* is less flattened, and the stalk is colored like the head.

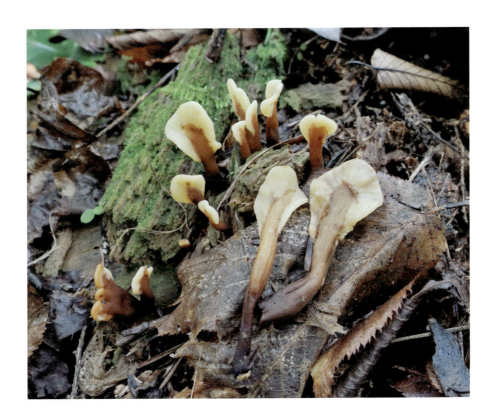

Trichoderma alutaceum Jaklitsch

= *Hypocrea alutacea* (Pers.) Ces. & De Not.
= *Podostroma alutaceum* (Pers.) G. F. Atk.

MACROSCOPIC FEATURES: **fruit body** up to 5 cm high and 1 cm wide, club- to spindle-shaped or irregular, consisting of an obscure head and a stalk. Head 1–3 cm high and 6–10 mm wide, not sharply delimited from the stalk, finely roughened, whitish at first, becoming yellowish to yellow-orange and finally brownish orange or brown in age. Stalk 1–2 cm long, 3–8 mm wide, smooth or somewhat wrinkled, hollow, whitish, then developing yellowish to brownish tints as it ages. Flesh thin, tough, white; odor and taste not distinctive.

MICROSCOPIC FEATURES: Spores long-ellipsoid, multiseptate, breaking up into smaller, finely roughened, hyaline, globose to subglobose, aseptate part-spores, 3.5–4.5 × 3–4 μm.

HABIT, HABITAT, AND SEASON: Solitary or in small groups on the ground among leaves or on decaying wood, usually with broad-leaf trees; summer–fall.

EDIBILITY: Unknown.

COMMENTS: This rare fungus is easily confused with *Cordyceps* and similar species but is not parasitic or attached to a hypogeous host organism. The White Green-algae Coral, *Multiclavula mucida* (not illustrated), forms tiny, 3–15 mm high and 1–1.5 mm wide, erect, spindle-shaped to cylindric or tine-like fruit bodies with a narrow apex. They are tough, waxy, smooth or longitudinally wrinkled, and white to creamy white, sometimes with a brownish tint. The fruit bodies are scattered or occur in groups on algae-covered, wet, decaying wood or algae-covered wet soil. The elliptic, smooth, hyaline spores measure 5–7.5 × 2–3 μm. *Clavaria phycophila* (not illustrated) forms very tiny, 3–10 mm high and 1–1.5 mm wide, erect, club-shaped to tine-like fruit bodies. They are tough, waxy, smooth or longitudinally wrinkled, and yellow-orange to orange and translucent. The fruit bodies occur on algae-covered soil, and they have elliptic to allantoid spores that measure 6.5–10 × 2–3.5 μm.

Trichoglossum walteri (Berk.) E. J. Durand

= *Geoglossum walteri* Berk.

COMMON NAME: Black Earth Tongue
MACROSCOPIC FEATURES: fruit body up to 8 cm high, consisting of a head and stalk. **head** 1.2–3 cm high and 3–10 mm wide, hollow, elliptic to oval or spindle-shaped, often flattened with a longitudinal furrow, dry, minutely velvety to spiny (use a hand lens), blackish brown to black. **stalk** 2–6 cm long, 2–5 mm thick, nearly equal, slightly compressed, often curved, densely velvety, blackish brown to black. **flesh** thin, tough, dark brown; odor and taste not distinctive.
MICROSCOPIC FEATURES: Spores 60–125 × 5–7 μm, needle-like to cylindric, mostly 7-septate, smooth, grayish or brownish; setae more than 150 μm long, pointed, brown.
HABIT, HABITAT, AND SEASON: Solitary, in groups, or clustered on the ground or among mosses; summer–early winter.
EDIBILITY: Unknown.
COMMENTS: The Rough Black Earth Tongue, *Trichoglossum farlowii* (not illustrated), has needle-like to cylindric spores that are 0–6-septate, mostly 3-septate, and measure 45–85 × 6–7 μm. It has setae that are more than 150 μm. The Smooth Black Earth Tongue, *Geoglossum difforme* (not illustrated), has a bald, shiny surface and spores with 12–15 septa, and it lacks setae. Several *Trichoglossum* and *Geoglossum* species are very similar macroscopically, requiring microscopic examination of spores and setae (if present) for positive identification. *Trichoglossum* species have tiny velvety or hair-like setae on their fertile surface, whereas *Geoglossum* species lack them. If you have access to a microscope, the following key can assist with identifying *Geoglossum* and *Trichoglossum* to species level.

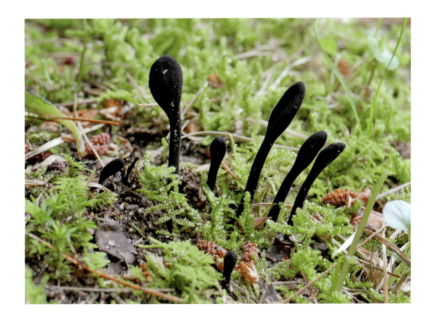

Key to Species of *Geoglossum* and *Trichoglossum*

(Requires microscopic examination)

1a Surface of the head minutely spiny when examined with a hand lens; when examined microscopically, brown setae present among the asci. Fruit body growing on soil, on decaying wood, or among mosses 2
1b Surface of the head smooth, not minutely spiny when examined with a hand lens; setae absent among the asci when examined microscopically ... 7

2a Spores 8–17-septate 3
2b Spores 0–7-septate 6

3a Asci 4-spored or sometimes fewer; spores 115–145 × 6–7 µm, 0–17-septate but mostly 15-septate: *Trichoglossum tetrasporum*
3b Not as above 4

4a Asci 4-spored; spores 95–150 × 6–7 µm, usually 7–11-septate: *Trichoglossum velutipes*
4b Not as above 5

5a Asci 8-spored; spores 80–200 × 5–7 µm, mostly 15-septate: *Trichoglossum hirsutum*
5b Asci 8-spored; spores 80–150 × 4.5–6 µm, 4–16-septate, mostly 10–14-septate: *Trichoglossum variabile*

6a Spores 45–85 × 6–7 µm, 0–6-septate, mostly 3-septate: *Trichoglossum farlowii*
6b Spores 60–125 × 5–7 µm, mostly 7-septate: *Trichoglossum walteri*

7a Fruit body producing both hyaline and brownish needle-like spores; fruit body growing on soil, humus, or decaying wood 8
7b Fruit body with only brownish needle-like spores; fruit body growing on soil, on decaying wood, or among mosses 10

8a Spores 50–105 × 5–7 µm; hyaline spores aseptate; brownish spores 0–12-septate: *Geoglossum fallax*
8b Not as above 9

9a Spores 45–75 × 5.5–6 µm; hyaline spores 0–6-septate; brownish spores 7–12-septate: *Geoglossum intermedium*
9b Spores 55–95 × 4–5 µm; hyaline spores 0–15-septate; brownish spores 8–15-septate: *Geoglossum alveolatum*

10a Spores 3–7-septate 11
10b Spores 10–16-septate 15

11a Spores 55–102 × 5–6 µm; 0–3-septate or more typically 7-septate: *Geoglossum glutinosum*
11b Not as above 12

12a Spores 45–60 × 5–6 μm; mostly 7-septate: *Geoglossum affine*
12b Not as above 13

13a Spores 65–80 × 5–6 μm; mostly 7–8-septate: *Geoglossum umbratile*
13b Not as above 14

14a Spores 50–105 × 7–9 μm; mostly 7-septate; distal cells of paraphyses enlarged and rounded to obovoid: *Geoglossum glabrum*
14b Spores 60–102 × 6–9 μm; mostly 7-septate; paraphyses with many barrel-shaped, 2-celled segments: *Geoglossum simile*

15a Spores 75–125 × 6–7 μm; mostly 12-septate: *Geoglossum difforme*
15b Spores 120–175 × 6–7 μm; mostly 12–15-septate: *Geoglossum pygmaceum*

FIBER FANS

Fan- or vase-shaped fruit bodies that are leathery to fibrous-tough, sometimes with split or torn margins. They are typically some shade of brown or gray, with or without a whitish margin. Their fertile undersurfaces may be smooth or wrinkled and warted but lack pores (use a hand lens). They usually grow on the ground.

Thelephora vialis Schwein.

COMMON NAME: Vase Thelephore
MACROSCOPIC FEATURES: fruit body up to 10 cm high and 5–13 cm wide, erect, variable, typically a rosette of ascending lobe-like caps arising from a common central stalk. **cap** spoon- to funnel-shaped or fused and somewhat vase-shaped. **upper surface** striate or minutely scaly, whitish to yellowish. **lower surface** wrinkled, dingy yellow, becoming grayish brown. **flesh** thick, leathery, whitish to grayish; odor usually disagreeable and intensifying with dehydration, taste not distinctive. **stalk** erect, enlarged downward, solid, whitish to grayish, with short, soft, downy hairs.
MICROSCOPIC FEATURES: Spores $4.5–8 \times 4.5–6.5$ μm, angular, warted and minutely spiny, olive buff.
SPORE PRINT: Brown.
HABIT, HABITAT, AND SEASON: Solitary, scattered, or in groups on the ground in broadleaf woods, especially with oaks; summer–winter.
EDIBILITY: Inedible.

COMMENTS: This is sometimes collected to dye wool and silk. The Common Fiber Vase or Earth Fan, *Thelephora terrestris* (see Color Key), is 2–5 cm high, partially erect, and spreading. It consists of circular to fan-shaped, stalkless, brown caps in overlapping whorls and often laterally fused. The margin is typically tattered. Fruit bodies are terrestrial or attached to roots, branches, seedlings, or mosses in conifer or mixed conifer and broadleaf woods. Spores are angularly oval to elliptic, nearly smooth to warted or spiny, and purplish and measure $8–12 \times 6–9$ μm. The odor is moldy. *Thelephora terrestris* f. *concrescens* (see Color Key) forms overlapping clusters that envelop and clasp the stems of woody plants. *Thelephora palmata* (see Color Key) has a coral-like fruit body with numerous flattened, spoon- to fan-shaped, brown branches with whitish tips, and the odor of its flesh is intensely fetid and disagreeable. *Thelephora anthocephala* (see Color Key) has a coral-like fruit body with numerous flattened brown branches and whitish tips. The odor is not distinctive.

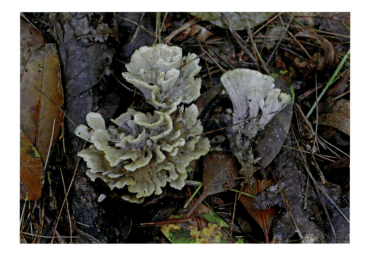

GILLED MUSHROOMS

The undersurface of the cap has knife-blade-like, thin gills that radiate from a stalk or, on stalkless species, from the point of attachment to a woody substrate. Species in this group grow on a variety of substrates. Because species included in this book are organized using macroscopic features, some polypores with distinctive gill-like pores are included in this section. A few species with gill-like undersurfaces may also be found in the Boletes, Chanterelles and Similar Fungi, and Polypores groups.

Key to the Gilled Mushrooms

In the following key, genus and species names that are fully described and illustrated are set in boldface italic. Partially described species, including those illustrated in the Color Key, are set in italic.

1a Spore print green to grayish green:
 Chlorophyllum molybdites
1b Spore print some other color 2

2a Spore print white, cream, yellow, ocher-orange, grayish, or lilac 3
2b Spore print some other color 11

3a Mushroom with warts or patches on the cap or with a volva at the stalk base:
 Amanita abrupta
 Amanita albocreata
 Amanita amerivirosa
 Amanita arkansana
 Amanita atkinsoniana
 Amanita baningiana
 Amanita bisporigera
 Amanita brunnescens
 Amanita brunnescens var. *pallida*
 Amanita chlorinosma
 Amanita cinereoconia
 Amanita cinereopannosa
 Amanita cokeri
 Amanita daucipes
 Amanita farinosa
 Amanita flavoconia
 Amanita flavorubens
 Amanita frostiana
 Amanita fulva group
 Amanita hesleri
 Amanita jacksonii
 Amanita lavendula group
 Amanita levistriata
 Amanita longipes
 Amanita microlepis
 Amanita multisquamosa
 Amanita muscaria* var. *guessowii
 Amanita mutabilis
 Amanita onusta
 Amanita parcivolvata
 Amanita peckiana
 Amanita pelioma
 Amanita persicina
 Amanita polypyramis
 Amanita praecox
 Amanita pseudovolvata nom. prov.
 Amanita ravenelii
 Amanita rhacopus
 Amanita rhoadsiae
 Amanita rhopalopus
 Amanita roseitincta
 Amanita rubescens group
 Amanita rubescens var. *alba*
 Amanita russuloides group
 Amanita species ARB1328
 Amanita spreta
 Amanita subcokeri
 Amanita submaculata
 Amanita tephrea
 Amanita vaginata group
 Amanita velatipes
 Amanita volvata group
 Amanita whetstoneae
 Amanita williamsiae
3b Mushroom lacking warts, patches, or a volva, but cap may have scales or other features 4

4a Mushroom growing on the ground, gills exuding a milk-like latex when cut or bruised:
 Lactarius alachuanus
 Lactarius areolatus
 Lactarius argillaceifolius
 Lactarius atroviridis
 Lactarius camphoratus
 Lactarius chelidonium
 Lactarius chrysorrheus
 Lactarius croceus
 Lactarius delicatus
 Lactarius deterrimus
 Lactarius gerardii
 Lactarius gerardii var. *subrubescens*
 Lactarius imperceptus
 Lactarius indigo var. indigo
 Lactarius lignyotus
 Lactarius maculatipes
 Lactarius mutabilis
 Lactarius oculatus
 Lactarius paradoxus
 Lactarius peckii
 Lactarius peckii var. *glaucescens*
 Lactarius proximellus
 Lactarius psammicola
 Lactarius pseudodeliciosus
 Lactarius purpureoechinatus
 Lactarius quietus
 Lactarius rimosellus
 Lactarius salmonius
 Lactarius speciosus
 Lactarius subpalustris
 Lactarius subplinthogalus
 Lactarius subpurpureus
 Lactarius subserifluus
 Lactarius subvernalis var. cokeri
 Lactarius tomentosomarginatus
 Lactarius vinaceorufescens
 Lactarius yazooensis
 Lactifluus allardii
 Lactifluus corrugis
 Lactifluus deceptivus
 Lactifluus glaucescens
 Lactifluus hygrophoroides
 Lactifluus luteolus
 Lactifluus petersenii
 Lactifluus piperatus
 Lactifluus rugatus
 Lactifluus subvellereus
 Lactifluus volemus var. *flavus*
 Lactifluus volemus var. volemus
 Multifurca furcata

4b Mushroom growing on the ground or on wood but not exuding a milk-like latex when cut or bruised 5

5a Mushroom growing on the ground, cap and stalk brittle and easily crumbled:
 Russula aeruginea
 Russula albidula
 Russula albonigra
 Russula atropurpurea
 Russula ballouii
 Russula brevipes
 Russula compacta
 Russula crustosa
 Russula dissimulans
 Russula earlei
 Russula flavida
 Russula flavisiccans
 Russula foetentula
 Russula fragrantissima
 Russula grata
 Russula hixsonii
 Russula mariae
 Russula mutabilis

Russula ochroleucoides
Russula parvovirescens
Russula peckii
Russula perlactea
Russula redolens
Russula rugulosa
Russula sericeonitans
Russula subalbidula
Russula subfragiliformis
Russula subsericeonitans
Russula variata
Russula virescens
Russula xerampelina

5b Mushroom growing on the ground or on wood, but cap and stalk not brittle and easily crumbled 6

6a Mushroom growing on the ground; cap and gills with a waxy consistency like soft candle wax when rubbed and crushed between thumb and fingers; cap brightly colored or sometimes dull:
Cuphophyllus colemannianus
Cuphophyllus lacmus
Cuphophyllus pratensis
Cuphophyllus virgineus
Gliophorus irrigatus
Gliophorus laetus
Gliophorus perplexus
Gliophorus psittacinus
Humidicutis marginata var. *concolor*
Humidicutis marginata var. marginata
Humidicutis marginata var. *olivacea*
Hygrocybe acutoconica
Hygrocybe caespitosa
Hygrocybe cantharellus
Hygrocybe coccinea

Hygrocybe conica
Hygrocybe conicoides
Hygrocybe flavescens
Hygrocybe miniata
Hygrocybe punicea
Hygrophorus hypothejus
Hygrophorus russula
Hygrophorus subsordidus
Hygrophorus tennesseensis
Neohygrocybe nitrata
Neohygrocybe ovina
Neohygrocybe subovina
Russula earlei

6b Mushroom growing on the ground or on wood; cap and gills not waxy when rubbed and crushed between thumb and fingers 7

7a Mushroom stalkless or with a rudimentary or short lateral stalk:
Anthracophyllum lateritium
Hohenbuehelia angustata
Hohenbuehelia mastrucata
Hohenbuehelia petaloides
Lentinellus angustifolius
Lentinellus subaustralis
Lentinellus ursinus
Lentinellus vulpinus
Pleurocybella porrigens
Pleurotus ostreatus
Pleurotus pulmonarius
Resupinatus alboniger
Resupinatus applicatus
Resupinatus trichotis
Sarcomyxa serotina

7b Mushroom with a conspicuous stalk that is usually central 8

8a	Mushroom with a small stature; stalk 1–6 mm thick 9		*Ripartitella brasiliensis*
8b	Mushroom stature larger; stalk more than 6 mm thick 10		**Tetrapyrgos nigripes**
			Tricholomopsis aurea
			Xeromphalina campanella
			Xeromphalina kauffmanii
9a	Growing on wood:		*Xeromphalina tenuipes*

9a Growing on wood:
 Arrhenia epichysium
 Clitocybe peralbida
 Connopus acervatus
 Crinipellis zonata
 Cyptotrama asprata
 Gerronema strombodes
 Gymnopus biformis
 Gymnopus dichrous
 Gymnopus dryophilus
 Gymnopus dysodes
 Gymnopus foetidus
 Gymnopus semihirtipes
 Gymnopus subnudus
 Lentinellus micheneri
 Lentinus berteroi
 Lentinus crinitus
 Marasmiellus candidus
 Marasmiellus praeacutis
 Marasmius cohaerens
 Marasmius rotula
 Marasmius siccus
 Mycena galericulata
 Mycena haematopus
 Mycena inclinata
 Mycena leptocephala
 Mycena pseudoinclinata
 Mycena semivestipes
 Mycena subcaerulea
 Mycetinus opacus
 Panellus stipticus
 Pseudoarmillariella ectypoides
 Pseudoclitocybe cyathiformis
 Rhizomarasmius pyrrhocephalus

9b Growing on the ground, on leaf litter, cones, or nuts, among mosses, or on other mushrooms:
 Asterophora lycoperdoides
 Asterophora parasitica
 Baeospora myosura
 Cantharellula umbonata
 Clitocybe rivulosa
 Connopus acervatus
 Gymnopus confluens
 Gymnopus dryophilus
 Gymnopus iocephalus
 Gymnopus semihirtipes
 Gymnopus spongiosus
 Gymnopus subnudus
 Gymnopus subsulphureus
 Lepiota cristata
 Leucocoprinus birnbaumii
 Leucocoprinus cepistipes
 Leucocoprinus fragilissimus
 Leucopaxillus gracillimus
 Marasmiellus praeacutis
 Marasmius bellipes
 Marasmius capillaris
 Marasmius cohaerens
 Marasmius delectans
 Marasmius fulvoferrugineus
 Marasmius graminum
 Marasmius oreades
 Marasmius pulcherripes
 Marasmius siccus
 Marasmius sullivantii
 Marasmius vagus

Mycena epipterygia* var. *viscosa
Mycena leptocephala
Mycena pura
Mycena subcaerulea
Mycetinus scorodonius
Pseudoclitocybe cyathiformis
Rhizomarasmius pyrrhocephalus
Rickenella fibula
Strobilurus conigenoides
Tetrapyrgos nigripes
Xeromphalina cauticinalis* ssp. *pubescentipes

10a Growing on wood:
 Armillaria gallica
 Armillaria gemina
 Armillaria mellea
 Callistosporium luteo-olivaceum
 Callistosporium purpureomarginatum
 Flammulina velutipes
 Gymnopus luxurians
 Hygrophoropsis aurantiaca
 Hypsizygus ulmarius
 Lentinula boryana
 Lentinula raphanica
 Lentinus tigrinus
 Lepiota mucrocystis
 Leucoagaricus americanus
 Leucopholiota decorosa
 Marasmiellus luxurians
 Marasmius strictipes
 Megacollybia rodmanii
 Mycena epipterygia* var. *lignicola
 Mycena epipterygia* var. *viscosa
 Neolentinus lepideus
 Omphalotus subilludens
 Oudemansiella canarii
 Panus lecomtei

Pleurotus dryinus
Pleurotus levis
Pleurotus ostreatus
Pleurotus pulmonarius
Pseudoclitocybe cyathiformis
Tricholomopsis decora
Tricholomopsis formosa
Tricholomopsis rutilans

10b Growing on the ground:
 Ampulloclitocybe clavipes
 Armillaria gallica
 Cantharellula umbonata
 Chlorophyllum hortense
 Chlorophyllum rhacodes
 Chlorophyllum subrhacodes
 Clitocybe odora
 Cystoderma amianthinum
 Desarmillaria caespitosa
 Echinoderma asperum
 Hygrophoropsis aurantiaca
 Hygrophorus russula
 Hygrophorus subsordidus
 Hymenopellis furfuracea
 Hymenopellis incognita
 Hymenopellis megalospora
 Hymenopellis rubrobrunnescens
 Infundibulicybe gibba
 Infundibulicybe squamulosa
 Laccaria amethystina
 Laccaria laccata var. *decurrens*
 Laccaria laccata* var. *pallidifolia
 Laccaria ochropurpurea
 Laccaria trichodermophora
 Laccaria trullisata
 Lepiota mucrocystis
 Leucoagaricus americanus
 Leucoagaricus leucothites
 Leucoagaricus meleagris
 Leucoagaricus rubrotinctus

Leucopaxillus albissimus
Leucopaxillus laterarius
Limacella glischra
Limacella illinita
Lyophyllum decastes
Macrocybe titans
Macrolepiota procera
Marasmius nigrodiscus
Marasmius strictipes
Megacollybia rodmanii
Melanoleuca alboflavida
Omphalotus illudens
Omphalotus subilludens
Pseudoclitocybe cyathiformis
Rhodocollybia butyracea
Rhodocollybia maculata
Tricholoma aurantium
Tricholoma caligatum
Tricholoma equestre
Tricholoma intermedium
Tricholoma odorum
Tricholoma portentosum
Tricholoma saponaceum
Tricholoma subluteum
Tricholoma subresplendens
Tricholoma subsejunctum
Tricholoma sulphurescens
Tricholoma sulphureum
Zhuliangomyces illinitus

Pluteus atromarginatus
Pluteus cervinus group
Pluteus chrysophlebius
Pluteus flavofuligineus
Pluteus granularis
Pluteus hongoi
Pluteus longistriatus
Pluteus pellitus
Pluteus petasatus
Pluteus thomsonii
Pluteus umbrosus
Volvariella bombycina

12b Growing on the ground:
Clitocybe odora
Clitopilus prunulus
Entoloma abortivum
Entoloma conicum
Entoloma incanum
Entoloma luteum
Entoloma murrayi
Entoloma quadratum
Entoloma rhodopolium group
Entoloma serrulatum
Entoloma strictius
Entoloma subsinuatum
Entoloma velutinum
Entoloma vernum
Lepista nuda
Lepista sordida
Lepista subconnexa
Pluteus thomsonii

11a Spore print pink, salmon, pinkish buff to pinkish tan or brownish pink .. 12
11b Spore print some shade of brown or black 13

12a Growing on wood:
Entoloma conicum
Phyllotopsis nidulans

13a Spore print rusty brown, yellowish brown, brown or dark brown 14
13b Spore print purplish brown to dark purple-brown, blackish brown, or black 16

14a Growing on wood:
Agrocybe firma
Bolbitius titubans
Crepidotus applanatus
Crepidotus cinnabarinus
Crepidotus croceitinctus
Crepidotus crocophyllus
Crepidotus herbarum
Crepidotus malachius
Crepidotus mollis
Crepidotus nyssicola
Crepidotus stipitatus
Crepidotus versutus
Flammulaster erinaceellus
Galerina marginata
Gymnopilus armillatus
Gymnopilus junonius
Gymnopilus lepidotus
Gymnopilus liquiritiae
Gymnopilus luteofolius
Gymnopilus luteus
Gymnopilus penetrans
Gymnopilus sapineus
Pholiota aurivella
Pholiota polychroa
Pholiota squarrosa
Pholiota squarrosoides
Pseudomerulius curtisii
Simocybe centunculus
Tapinella atrotomentosa
Tapinella panuoides

14b Growing on the ground, on dung or manure, on compost, on manured sawdust, among grasses or mosses 15

15a Partial veil web-like, leaving a fibrillose annular zone or sometimes evanescent:
Agrocybe molesta
Agrocybe pediades
Cortinarius albidus
Cortinarius alboviolaceus
Cortinarius argentatus
Cortinarius armillatus
Cortinarius atrotomentosus
Cortinarius bolaris
Cortinarius camphoratus
Cortinarius caperatus
Cortinarius collinitus
Cortinarius corrugatus
Cortinarius cyanites
Cortinarius distans
Cortinarius hesleri
Cortinarius iodeoides
Cortinarius iodes
Cortinarius lewisii
Cortinarius limonius
Cortinarius marylandensis
Cortinarius mucosus
Cortinarius obliquus
Cortinarius pyriodorus
Cortinarius sanguineus
Cortinarius semisanguineus
Cortinarius sphaerosporus
Cortinarius squamulosus
Cortinarius traganus
Cortinarius vibratilis
Cortinarius violaceus
Inocybe geophylla
Inocybe hystrix
Inocybe lacera
Inocybe lanatodisca
Inocybe lilacina
Inocybe rimosa
Inocybe tahquamenonensis

Inosperma calamistratum
Inosperma rimosoides
Pholiota castanea
Pholiota highlandensis
Pholiota squarrosa
Pholiota squarrosoides
Pseudosperma sororium

15b Partial veil not web-like, sometimes membranous and often leaving a ring on the stalk, or partial veil absent:
 Agaricus abruptibulbus
 Agaricus campestris
 Agaricus placomyces
 Agaricus pocillator
 Agaricus xanthodermus
 Agrocybe pediades
 Conocybe apala
 Conocybe tenera group
 Gymnopilus junonius
 Hebeloma crustuliniforme
 Hebeloma mesophaeum
 Hebeloma sinapizans
 Pholiota squarrosa

16a Mature gills liquefying and forming a black inky fluid:
 Coprinellus domesticus
 Coprinellus micaceus
 Coprinellus radians
 Coprinellus truncorum
 Coprinopsis lagopus
 Coprinopsis variegata
 Coprinus comatus
 Coprinus sterquilinus

16b Mature gills not liquefying 17

17a Growing on wood:
 Coprinellus disseminatus
 Hypholoma capnoides
 Hypholoma fasciculare
 Hypholoma lateritium
 Hypholoma subviride
 Lacrymaria lacrymabunda
 Pholiota polychroa
 Psathyrella delineata
 Psathyrella piluliformis
 Psathyrella septentrionalis
 Psilocybe ovoideocystidiata
 Stropharia hardii
 Stropharia rugosoannulata

17b Growing on the ground, among mosses, on dung or manure:
 Chroogomphus ochraceus
 Chroogomphus vinicolor
 Coprinopsis atramentaria
 Lacrymaria lacrymabunda
 Panaeolina foenisecii
 Panaeolus cinctulus
 Panaeolus cyanescens
 Panaeolus papilionaceus
 Panaeolus semiovatus
 Panaeolus solidipes
 Parasola auricoma
 Parasola plicatilis
 Psathyrella candolleana
 Psathyrella pennata
 Psilocybe caerulescens
 Psilocybe cubensis
 Psilocybe ovoideocystidiata
 Psilocybe weilii
 Stropharia hardii
 Stropharia rugosoannulata

Agaricus campestris L.

COMMON NAMES: Meadow Mushroom, Pink Bottom

MACROSCOPIC FEATURES: cap 3–11 cm wide, lumpily subspherical at button stage, broadly convex to almost flat at maturity, white at first but developing brownish tinges, dry, smooth or with a scattering of fibrils or small scales that may be slightly darker than the cap color. **gills** free, very close or crowded, pink in youth, maturing to dark brown. **stalk** 2.5–6 cm long and 1–1.5 cm thick, equal, white but may discolor pink, solid. The base is blunt or tapered, not staining yellow when cut. Partial veil superior, membranous, thin, dangling or disappearing, white. **flesh** white but may discolor pink in damp conditions; odor mushroomy, taste not distinctive.

MICROSCOPIC FEATURES: Spores 6–9 × 4–6 μm, elliptic, smooth, brown; cheilocystidia absent.

SPORE PRINT: Chocolate brown.

HABIT, HABITAT, AND SEASON: Solitary to gregarious in grassy areas, including lawns and horse or cow pastures; fruiting peaks in late spring and again in early fall.

EDIBILITY: Choice, with caution.

COMMENTS: Molecular mycology has raised uncertainty about the taxonomic unity of *Agaricus campestris* (see Kerrigan 2016). Of greater consequence to most mushroom hunters is distinguishing it from look-alikes. *Agrocybe molesta* has attached gills that are whitish before turning brown and a cap that often cracks in dry weather. Its brown spores measure 10–14 × 6.5–8 μm. The poisonous *Agaricus xanthodermus* has pallid gills at first, a base bruising bright yellow when cut, and an unpleasant smell. Remember that the deadly poisonous *Amanita bisporigera* is also white.

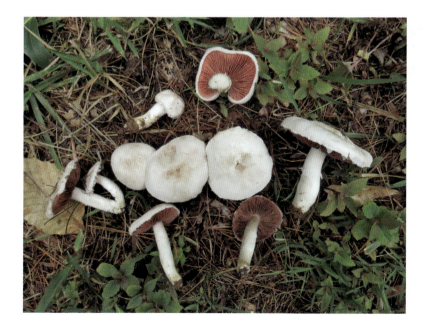

Agaricus placomyces Peck

COMMON NAME: Flat-cap Agaric
MACROSCOPIC FEATURES: cap 5–13 cm wide, convex, becoming broadly convex or flattish, perhaps with a slight umbo, white to pale silver-gray, briefly bruising yellow when rubbed, dry, decorated with small dark gray-brown or brown scales that are most dense centrally. **gills** free, close, pale gray in the button, then briefly pink before turning chocolate brown. **stalk** 6–15 cm long and 4–15 mm wide, nearly equal above the bulb, white, hollowing, often slowly bruising yellow or brownish. The bulb is small and rounded, not abrupt, white, staining bright yellow when cut. The partial veil is superior, membranous, dangling, white, sometimes with brown droplets on the underside. **flesh** white, staining yellow when cut or rubbed, especially the bulb; odor phenolic, variously interpreted as resembling creosote or library paste, taste not distinctive or unpleasant.
MICROSCOPIC FEATURES: Spores 4.5–6 × 3–4.5 μm, oval to broadly ellipsoid, smooth, brown.
SPORE PRINT: Chocolate brown.
HABIT, HABITAT, AND SEASON: Scattered on the ground in a variety of woodlands or adjacent grassy areas; summer–fall.
EDIBILITY: Poisonous.
COMMENTS: *Agaricus pocillator* (not illustrated) is very similar but has an abruptly bulbous base and slender build. The cap scales in both of these toxic species are small and dense, like flakes of black pepper, and are notably dense centrally, with the cap margin almost clear.

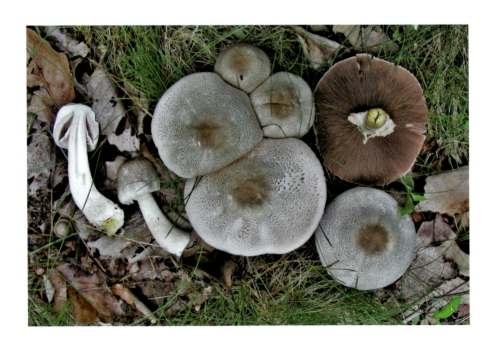

Agaricus xanthodermus Genev.

COMMON NAME: Yellow Stainer

MACROSCOPIC FEATURES: cap 6–20 cm wide, dry, lumpily subspherical at first, broadly convex or nearly flat at maturity, white at first, bruising yellow and often developing brownish tinges most notable centrally, smooth or with a scattering of pale scales. **gills** free, close, pallid at first, then sometimes briefly pink before maturing to dark brown. **stalk** 5–18 cm long and 1–2 cm thick at the upper stalk, equal or club-shaped, white, bruising yellow, hollowing. Base blunt or bulbous with a diameter to 3 cm, white. The membranous partial veil is superior, flaring, thick, white, sometimes showing a cogwheel pattern on the underside that may brown over time. **flesh** white, bruising bright yellow in the bulb when cut; odor phenolic, resembling creosote or library paste, taste not distinctive.

MICROSCOPIC FEATURES: Spores 4.5–6 × 3–4.5 µm, oval, smooth, brown.

SPORE PRINT: Chocolate brown.

HABIT, HABITAT, AND SEASON: Single to scattered in a variety of thin woodland, grassy, or otherwise disturbed areas; summer–early fall.

EDIBILITY: Poisonous.

COMMENTS: Mushrooms classically identified as *Agaricus abruptibulbus* (see Color Key) and probably constituting multiple species are slender woodland relatives found near rotting wood. It is whitish and yellowing slightly in age, smells of anise, and has a small, abrupt bulb that does not stain bright yellow when cut. Spores measure 6–8 × 4–5 µm. It is edible, but virtually identical mushrooms can have a phenolic odor and should be avoided. Any *Agaricus* species with the phenolic smell is generally considered poisonous, although some people do consume *Agaricus xanthodermus* without ill effects.

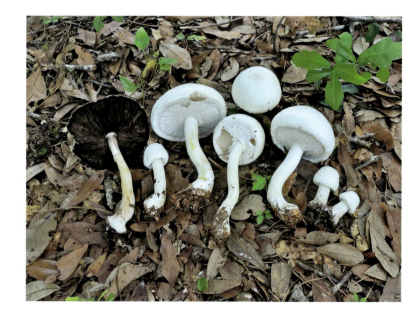

Agrocybe firma (Peck) Singer

MACROSCOPIC FEATURES: cap 2–8 cm wide, convex, then flattening with a low umbo, dry, dark brown, fading toward yellow-brown at maturity, smooth. Cap margin inrolled at first. **gills** attached, close, a light shade of brown. **stalk** 3–8 cm long and 0.5–1 cm thick, equal, brown underneath a layer of pale granules and fibrils that form longitudinal lines, turn brown in age, and tend to wear off, especially below. The base is encased in ropy white mycelium. No partial veil or ring zone. **flesh** white and unchanging; odor and taste faintly farinaceous or not distinctive.

MICROSCOPIC FEATURES: Spores 6–9 × 4–5 μm, ellipsoid, smooth with an apical pore, brown.

SPORE PRINT: Cinnamon brown.

HABIT, HABITAT, AND SEASON: Scattered or clustered on decaying hardwood, hardwood mulch, or similar debris; fruiting peaks in late spring and early fall.

EDIBILITY: Unknown.

COMMENTS: *Agrocybe firma* distinguishes itself from other members of the genus with a dark cap, lack of a partial veil or ring zone, and prolific fruiting on rotting hardwood debris. *Agrocybe smithii* (not illustrated) is of a similar size, lacks a veil, and fruits on rotting wood chips. The cap is yellow-brown and develops deep cracks in dry weather. Spores are larger as well, at 11–13.5 × 6–8 μm. Young specimens of *Pluteus cervinus* have the same general colors as *Agrocybe firma*, fruit on dead hardwood, and lack a partial veil. But *Pluteus* species have free gills that pinken by maturity to produce a pink spore print.

Agrocybe molesta (Lasch) Singer

= *Agrocybe dura* (Bolton) Singer

MACROSCOPIC FEATURES: cap 3–9 cm wide, convex to flat in age, dry or sticky when moist, whitish to pale yellowish tan, smooth but readily cracking in dry weather. The young cap margin is usually decorated with white remnants of partial veil. **gills** attached, close to subdistant, white at first, turning brown. **stalk** 3–10 cm long and 0.5–1.5 cm thick, equal, whitish. The base is often attached to white rhizomorphs. The flimsy membranous partial veil is superior, commonly leaving remnants on the cap margin and a ring zone on the stalk. **flesh** white and unchanging; odor and taste not distinctive.

MICROSCOPIC FEATURES: Spores 10–14 × 6.5–8 μm, ellipsoid, smooth with an apical pore, brown.

SPORE PRINT: Dark brown.

HABIT, HABITAT, AND SEASON: Scattered or clustered in grass; spring–early summer.

EDIBILITY: Edible.

COMMENTS: *Agrocybe* is a small genus of brown-spored recyclers that has yet to be definitively sorted out. *Agrocybe molesta* is a member of the larger *Agrocybe praecox* group, composed of three or more species, most of which recycle wood rather than dead grass. *Agrocybe pediades* (see Color Key) isn't a member of that group but is another grass recycler. It differs from *Agrocybe molesta* by virtue of a smaller, 1–4 cm, yellow-brown cap, fringed at first with wisps of white partial veil, and a thinner stalk, typically 3–8 mm, but sometimes up to 12 mm wide. The spores are slightly smaller as well, measuring 9–13 × 6.5–8 μm.

Amanita abrupta Peck

COMMON NAME: American Abrupt-bulbed Lepidella

MACROSCOPIC FEATURES: cap 3.5–10 cm wide, globose buttons open to become convex and then flatten or become centrally depressed, shiny white, dry, densely covered with white pyramidal warts that may age to tan but might also wash off. Cap margin not striate, appendiculate when young. **gills** narrowly attached or free, close or somewhat distant, white, then pale yellow in age. **stalk** 6–12 cm long and 5–15 mm wide, enlarging downward, white but eventually yellowing a bit, solid or stuffed, white volval remnants are common at the bulb junction. The base is an oversized and abrupt bulb measuring 1.5–3 cm, roundish and slightly rooting, white, often displaying a few raised rings on the upper part and longitudinal cracks that do not redden. The partial veil is superior, membranous and substantial, persistent, white. **flesh** white, not reddening at injuries; odor not distinctive at first but developing the Lepidella scent of rotting meat or chlorine.

MICROSCOPIC FEATURES: Spores 6.5–9.5 × 5.5–8.5 μm, globose to elliptic, smooth, hyaline, amyloid.

SPORE PRINT: White.

HABIT, HABITAT, AND SEASON: Scattered on soil in mixed or broadleaf forests; late spring–fall.

EDIBILITY: Unknown.

COMMENTS: This modestly sized, white Lepidella most closely resembles the larger *Amanita cokeri* and *Amanita polypyramis*, neither of which has the same style of bulb. *Amanita ravenelii* and *Amanita rhopalopus* are larger and whitish as well. White examples of *Amanita brunnescens* lack pyramidal cap warts, stain brownish in old wounds, and smell like raw potato.

Amanita albocreata (G. F. Atk.) E.-J. Gilbert

= *Amanitopsis albocreata* G. F. Atk.

COMMON NAME: Ringless Panther
MACROSCOPIC FEATURES: cap 2.5–8 cm wide, convex at first but flattening, whitish with a pale yellow or tan center, sticky when moist, sprinkled with small fluffy patches of white volval material that commonly wash off. Cap margin strongly striate, not appendiculate. **gills** free or narrowly attached, crowded, white. **stalk** 5–15 cm long and 5–13 mm wide, expanding slightly downward, white, solid or stuffed, typically with a rolled collar or fringe of white volval material attached at the bulb junction. Bulb is abrupt, round to oval, 15–22 × 12–20 mm, white. Partial veil absent. **flesh** white; odor not distinctive.
MICROSCOPIC FEATURES: Spores 7–9.5 × 6–9 µm, subglobose to globose, smooth, hyaline, inamyloid.
SPORE PRINT: White.
HABIT, HABITAT, AND SEASON: Solitary to scattered on soil in mixed or broadleaf forests; late spring–fall.
EDIBILITY: Presumed poisonous.
COMMENTS: *Ocreate* refers to a rolled collar of tissue atop the bulb. *Albo* means "white." This species is one of several small "pantherine" Amanitas, the junior panther brigade, sharing a slender build (with or without a partial veil) and a collared bulb. All members are presumed to contain the toxins ibotenic acid and muscimol. *Amanita multisquamosa* has a partial veil. *Amanita praecox* nom. prov. (see Color Key) doesn't, but the cap is more uniformly tan to yellowish. Differentiating pantherine Amanitas from the unrelated *Amanita russuloides* group and *Amanita lavendula* group, neither of which has a striated cap margin unless desiccated, can require a second look.

Amanita banningiana Tulloss nom. prov.

COMMON NAMES: Mary Banning Slender Caesar, Yellow Caesar

MACROSCOPIC FEATURES: cap 4–11.5 cm wide, egg-shaped, then flattening with a retained umbo, orange-yellow at first, the color deepening centrally toward bronze or reddish brown by maturity, smooth and often shiny, sticky when moist, volval patches typically absent. Cap margin striate for 25%–40% of the cap radius, not appendiculate. **gills** free or slightly attached, close to crowded, pale yellow. **stalk** 8–22 cm long and 6–15 mm thick, nearly equal or slightly enlarging downward, pale yellow to nearly white, stuffed but hollowing by maturity. The bulbless base is grounded in a thick, white, and often lobed volval sac. The membranous partial veil is superior, persistent, white to yellowed, typically darker underneath. **flesh** whitish, not changing when bruised; odor not distinctive.

MICROSCOPIC FEATURES: Spores 8.5–12 × 6–8 μm, elliptic, smooth, hyaline, inamyloid.

SPORE PRINT: White.

HABIT, HABITAT, AND SEASON: Single or scattered on soil in broadleaf or mixed forests; fruiting peaks in summer.

EDIBILITY: Unknown.

COMMENTS: Mary Elizabeth Banning (1822–1903) was a pioneering female mycologist and illustrator. The bronzing cap center readily distinguishes *Amanita banningiana* from *Amanita jacksonii* but not from *Amanita arkansana* (not illustrated). That larger look-alike has brownish tones in the cap from the beginning. Cap diameters are to 15 cm, stalks to 17.5 cm long and 3 cm thick. *Amanita spreta* has a grayish to dirty brown cap, often partially covered with white patches of volva.

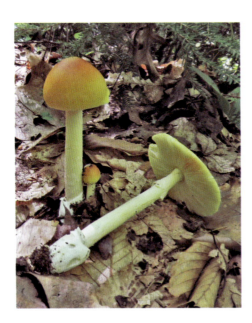

Amanita bisporigera G. F. Atk.

= *Amanita virosa* Bertill.

COMMON NAME: Eastern Destroying Angel
MACROSCOPIC FEATURES: cap 2.5–10 cm wide, oval at first, then broadly convex or nearly flat, white or tinged pale yellow or pinkish, especially centrally. Tacky when moist, volval remnants on the cap are rare. Cap margin is neither striate nor appendiculate. **gills** free or slightly attached, crowded, white. **stalk** 5.5–14 cm long and 0.5–2 cm thick, expanding downward, white, solid or densely stuffed, often fibrillose to floccose-scaly. The base is a small, rounded bulb encased in a thin, lobed, saccate volva that often clings to the stalk, white. The membranous partial veil is superior, thin but persistent, dangling, white. **flesh** white or slightly yellowed; odor not distinctive to sickly sweet.
MICROSCOPIC FEATURES: Spores 7–10 × 6.5–9 µm, globose to broadly elliptic, smooth, hyaline, amyloid. Basidia 2-spored early in the season.
SPORE PRINT: White.
HABIT, HABITAT, AND SEASON: Single to scattered, typically under oaks or pines or in nearby grassy areas; spring–fall.
EDIBILITY: Deadly poisonous.
COMMENTS: Eastern Destroying Angels were once known as *Amanita virosa*, a consistently 4-spored European species. The naming consensus shifted to *Amanita bisporigera* when it became apparent that 2-spored specimens are commonly found early in the season. Recent work has shown that this name has also become a multi-species catchall. *Amanita amerivirosa* (not illustrated) is genetically distinct and consistently 4-spored. It is larger (cap diameter 10.5–14.3 cm) and has slightly larger spores (9–11 × 8–10 µm). Both species are stained yellow by a drop of 5%–10% KOH. Some other Destroying Angels lack this reaction. All Destroying Angels are deadly due to amatoxin. *Leucoagaricus leucothites* (see Color Key) is similar in overall appearance but lacks the saccate volva.

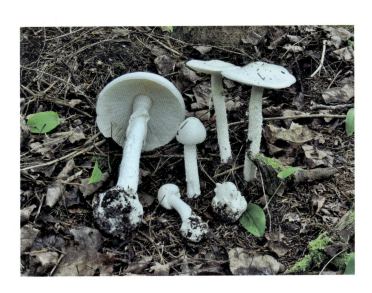

Amanita brunnescens G. F. Atk.

COMMON NAME: Cleft-foot Amanita

MACROSCOPIC FEATURES: cap 3–12 cm wide, convex at first but flattening, color variable from brown to greenish yellow to nearly white, darkest centrally, with colored caps showing innate radial color streaks, white blotches, and sometimes brown stains. Caps may be whitish on one side and brown on the other. Sticky when moist, occasionally decorated with small, pale warts. Cap margin typically not striate, not appendiculate. **gills** free or narrowly attached, close, white, staining reddish. **stalk** 6–14 cm long, 6–20 mm wide, slightly enlarging downward, creamy white and staining orange-brown to reddish, stuffed. The basal bulb is abrupt and rimmed, nearly globose, usually displaying one or more vertical cracks. Partial veil is membranous, apical, large, dangling, then collapsing against the stalk, white. **flesh** whitish, staining slowly brown or orange-brown; odor of raw potato.

MICROSCOPIC FEATURES: Spores 8–9 × 7–8.5 μm, globose to subglobose, smooth, hyaline, amyloid.

SPORE PRINT: White.

HABIT, HABITAT, AND SEASON: Scattered on the ground under conifers or broadleaf trees; spring–early winter.

EDIBILITY: Unknown.

COMMENTS: The cap color of *Amanita brunnescens* is highly variable. White specimens have been designated by some as *Amanita brunnescens* var. *pallida*. All color schemes smell of raw potato. *Amanita submaculata* (not illustrated) has a similar streaky cap and partial veil, but the small bulb is a rimless oval. Spores are narrower, 7–10 × 5–6.5 μm, and the variable odor possibilities don't include raw potato.

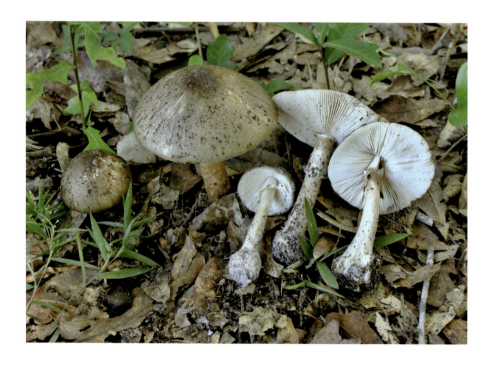

Amanita cokeri (E.-J. Gilbert & Kühner) E.-J. Gilbert

COMMON NAME: Coker's Lepidella
MACROSCOPIC FEATURES: **cap** 8–15 cm wide, hemispheric at first, becoming convex to almost flat, white, sticky when moist, and at least initially covered with white to brownish pyramidal warts that shrink toward the margin. Cap margin appendiculate when young, not striate. **gills** free to narrowly attached, crowded, white or tinged with pink or yellow. **stalk** 10–20 cm long and 1–2.3 cm thick, equal or enlarged downward, white, solid or stuffed. The base is a shallowly rooting white bulb crowned by rings of white to brownish recurved scales. Partial veil is substantial, white, dangling, and often doubled. **flesh** white; odor not distinctive.
MICROSCOPIC FEATURES: Spores 11–13 × 6.5–8.5 μm, elliptic, smooth, hyaline, amyloid.
SPORE PRINT: White.
HABIT, HABITAT, AND SEASON: Solitary or scattered on soil, typically in mixed oak-pine forests; summer–fall.
EDIBILITY: Unknown.
COMMENTS: Named in honor of North Carolina mycologist William Chambers Coker (1872–1953). A similar species, *Amanita subcokeri* nom. prov. (see Color Key), develops pink to reddish staining, especially on the lower portion of the fruit body, and is more common northward. *Amanita abrupta* is smaller, with an abrupt bulb lacking recurved scales. The bulb of *Amanita polypyramis* also lacks those scales and typically smells of chlorine or rotting meat.

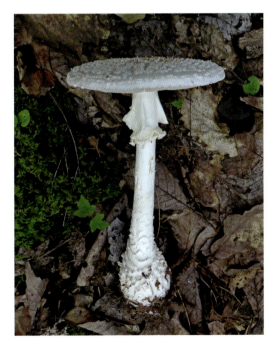

Amanita daucipes (Sacc.) Lloyd

COMMON NAME: Carrot-foot Amanita

MACROSCOPIC FEATURES: cap 6–29 cm wide, the globose button opens to become flat at maturity, dry. The button is initially dull white, with the ground color remaining so or darkening centrally to beige, covered with warts shaped like pieces of dirt. These are soon pinkish to orange-brown at least centrally. Cap margin not striate, appendiculate when young. **gills** usually free, close or very close, pale yellow to cream. **stalk** 6–20 cm long (excluding bulb) and 1–3 cm thick, nearly equal, whitish underneath pinkish to clay-colored areas of volval fluff, solid, sometimes with a ring of fluff lying atop the bulb. The massive bulb is typically carrot- or turnip-shaped, 6–20 × 3–8 cm, often longitudinally cracked, whitish with pinkish brown areas and reddish stains in old wounds. The partial veil is apical, membranous, whitish overall, often falling down the stalk by maturity. **flesh** white to pale yellow, staining reddish in old wounds; odor resembles old ham with a hint of chlorine.

MICROSCOPIC FEATURES: Spores 8–11.5 × 5–7 μm, elliptic, smooth, hyaline, amyloid.

SPORE PRINT: White.

HABIT, HABITAT, AND SEASON: Solitary to grouped under oaks in a variety of forest types; summer–fall.

EDIBILITY: Unknown.

COMMENTS: *Daucipes* refers to a carrot-shaped stalk. Compare with *Amanita ravenelii* and *Amanita rhopalopus*. Confusion could also arise with *Amanita muscaria* var. *guessowii* or *Amanita persicina*. These have shinier caps underneath flaky warts and much smaller bulbs, and they lack the odor of old ham.

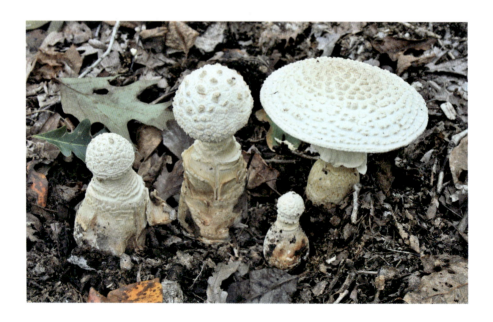

Amanita farinosa Schwein.

COMMON NAME: Powder-cap Amanita
MACROSCOPIC FEATURES: cap 2.5–6.5 cm wide, convex, then flattening without an umbo, brownish gray, darkest centrally, dry, sprinkled with brownish gray powder. Cap margin strongly striate, not appendiculate. **gills** narrowly attached, close to very close, occasionally forking, white or off-white. **stalk** 3–6.5 cm long, 3–9 mm thick, expanding slightly downward, whitish to light gray, stuffed or hollowing, sprinkled with brownish gray powder, especially at ground level. The base is a minimalist oval bulb, whitish. Partial veil absent. **flesh** thin, white; odor and taste not distinctive.
MICROSCOPIC FEATURES: Spores 6.5–9 × 5.5–7 µm, subglobose, smooth, hyaline, inamyloid.
SPORE PRINT: White.
HABIT, HABITAT, AND SEASON: Solitary or scattered on the ground in mixed or broadleaf woods; summer–fall.
EDIBILITY: Unknown.
COMMENTS: The epithet *farinosa* refers to the floury character of the volval remnants. Although common, this diminutive *Amanita* is easy to overlook. Look-similars tend to be larger in size. *Amanita vaginata* is gray with a striate cap margin but rises from a volval sac and lacks the cap powder. *Amanita cinereoconia* (not illustrated) has a cap frosted with fluffy gray volval material. However, the cap margin lacks striations and is appendiculate when young. The bulb is also more pronounced. Bigger bulbs also typify *Amanita onusta* and *Amanita hesleri*, which have clumpier cap warts as well.

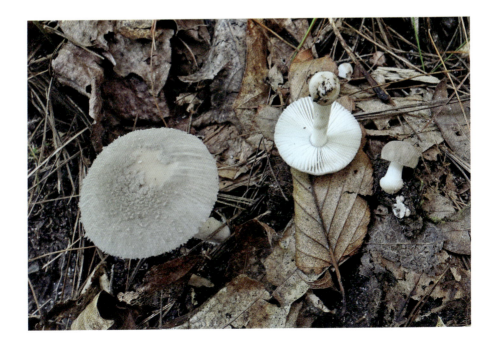

Amanita flavoconia G. F. Atk.

COMMON NAME: Yellow Patches

MACROSCOPIC FEATURES: cap 3–9 cm wide, bell-shaped at first, then convex and flattening without an umbo, orange-red centrally, usually transitioning to bright yellow at the margin, sticky when damp, decorated with small yellow patches of volval material that routinely wash off. The margin is not appendiculate and not usually striate. **gills** free or narrowly attached, close to very close, white, perhaps with a yellow edge. **stalk** 4.5–10.5 cm long, 3–15 mm thick, expanding downward, entirely yellow or partly white, hollow or stuffed. The basal bulb is oval to turnip-shaped but not rooting, smooth or scaly, white to orange-yellow, with yellow flakes of volval material littering the soil around it. The apical partial veil is membranous, pale yellow, browning in age. **flesh** white or yellowed in places, not staining; odor not distinctive.

MICROSCOPIC FEATURES: Spores 6.5–9 × 5–7 μm, elliptic, smooth, hyaline, amyloid.

SPORE PRINT: White, can appear yellow if gill edges are yellow and they touch the test paper.

HABIT, HABITAT, AND SEASON: Solitary, scattered, or in small groups on the ground, common in a variety of forest types; spring–early winter.

EDIBILITY: Unknown.

COMMENTS: *Amanita flavoconia* is very easy to confuse with the nearly identical *Amanita frostiana* (not illustrated). That species typically has a striate cap margin and a roll of tissue ringing the top of the small bulb. The spores are inamyloid and globose to subglobose, measuring 8.5–10.5 × 8–10 μm. *Amanita parcivolvata* also has a striate cap margin but lacks a partial veil. *Amanita flavorubens* (see Color Key) doesn't have a striate cap margin, but reddish stains develop at injuries.

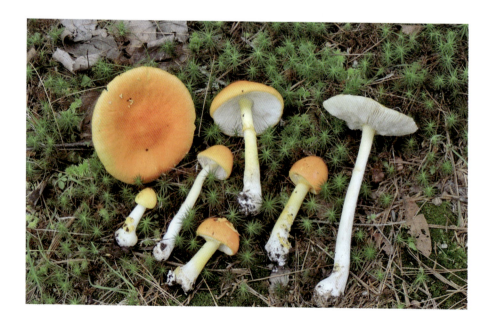

Amanita fulva group Fr.

= *Amanita amerifulva* Tulloss nom. prov.

COMMON NAME: Tawny Grisette

MACROSCOPIC FEATURES: cap 4–10 cm wide, bell-shaped at first, flattening but for a low umbo, tawny to reddish brown, darkest centrally, sticky when damp, volval patches or warts on cap very rare. Cap margin striate for 33%–50% of the cap radius, not appendiculate. **gills** typically free, crowded or nearly so, white to pale yellowish cream. **stalk** 7–15.5 cm long, 5–15 mm thick, enlarging slightly downward, white or tinged pale yellow to brownish, hollow. The bulbless base is encased in a tall white volval sac that often collapses against the stalk and may turn orange-brown in age. Partial veil absent. **flesh** whitish; odor not distinctive.

MICROSCOPIC FEATURES: Spores 9–12 × 9–11 μm, globose to subglobose, smooth, hyaline, inamyloid.

SPORE PRINT: White.

HABIT, HABITAT, AND SEASON: Single to scattered on the ground in mixed or broadleaf woods; spring–late fall.

EDIBILITY: Edible but not recommended.

COMMENTS: *Amanita fulva* is a catchall (European) species designation for several brownish American grisettes. *Amanita* expert Rod Tulloss has popularized the name *Amanita amerifulva* for a common American type, but the name had not been validly published at this writing. Grisette variations include the predominantly gray *Amanita vaginata* and *Amanita rhacopus*. The latter often has gray volval patches on the cap and prominent dark fibrils on the stalk. *Amanita praecox* nom. prov. resembles a pale and puny tawny grisette but has a bulb with a rolled collar, not a saccate volva. The stocky *Amanita spreta* has a partial veil.

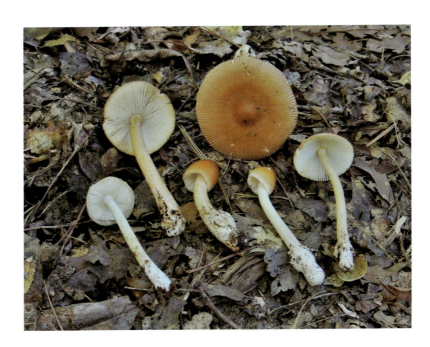

Amanita hesleri Bas

COMMON NAME: Hesler's Amanita
MACROSCOPIC FEATURES: cap 5–11.5 cm wide, convex, then flattening, white, usually dry, covered with concentrically arranged, brownish gray pyramidal warts. Young cap margin appendiculate, not striate, but may become weakly so at maturity. **gills** attached, crowded, white, sometimes pinkening. **stalk** 4–14 cm long (including bulb) and 8–15 mm thick, enlarging downward, white, solid. Bits of semiorganized white to gray volval remnants are sometimes seen near the base. The base is a club-shaped or tubular bulb up to 3 cm wide, white. Partial veil typically absent. **flesh** white and unchanging; odor often not distinctive.
MICROSCOPIC FEATURES: Spores 9.5–12.5 × 5–6.5 μm, elliptic, smooth, hyaline, amyloid.
SPORE PRINT: White.
HABIT, HABITAT, AND SEASON: Single to scattered on soil in forests with oaks and/or pines; spring–fall.
EDIBILITY: Unknown.
COMMENTS: The epithet honors the mid-20th-century American mycologist L. R. Hesler (1888–1977). Several members of the Lepidella section of genus *Amanita* are whitish with brown to gray warts or powders on the cap. Among the look-alikes is the slightly smaller *Amanita onusta*, which has well-organized gray warts or recurved scales covering the upper surface of the rooting bulb and smells of chlorine or rotting meat. This smell is shared by *Amanita cinereopannosa* (not illustrated). It's a larger species with cap diameters ranging from 7 to 15 cm. There is a flimsy, apical partial veil, and the lower stalk is distinctly gray.

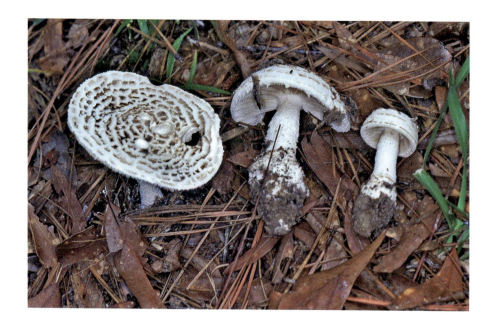

Amanita jacksonii Pomerl.

= *Amanita umbonata* Pomerl.

COMMON NAME: American Caesar

MACROSCOPIC FEATURES: cap 7–14 cm wide, egg-shaped, then flattening but for an umbo, sticky when damp and often shiny, bright red-orange, retaining that color centrally as it yellows from the periphery, typically lacking patches of volva on the cap. Margin striate for 40%–50% of the radius, not appendiculate. **gills** free or narrowly attached, very close or crowded, pale yellow to orange-yellow. **stalk** 9–15 cm long, 10–16 mm wide, equal or enlarging slightly downward, yellow and partly overlaid with orange fibrils often arranged in chevrons or bands, stuffed or hollow, no bulb. The base arises from a thick, white, and often lobed volval sac. The partial veil is membranous, superior, persistent, yellow-orange. **flesh** white and unchanging; odor not distinctive.

MICROSCOPIC FEATURES: Spores 8–10 × 6–7.5 μm, elliptic, smooth, hyaline, inamyloid.

SPORE PRINT: White.

HABIT, HABITAT, AND SEASON: Solitary or scattered on soil usually under oaks or pines; late spring–fall.

EDIBILITY: Edible with caution.

COMMENTS: *Jacksonii* recognizes the Canadian illustrator and amateur mycologist Henry Alexander Carmichael Jackson (1877–1961). *Amanita banningiana* and *Amanita arkansana* (not illustrated) have bronzed rather than red-orange cap centers. *Amanita* species ARB1328 (see Color Key) is a pale variation on the *Amanita jacksonii* theme that also grows under oaks and pines or in nearby grassy areas. The partial veil is white, the bright white stalk lacks prominent orange fibrils, and the volval sac is smaller and thinner. At the time of writing this book, this species is undescribed, as confirmed by *Amanita* expert Rod Tulloss. *Amanita flavoconia* and *Amanita frostiana* (not illustrated) have stalks terminating in bulbs rather than volval sacs. *Amanita parcivolvata* lacks a partial veil as well. None of these look-alikes is known to be edible.

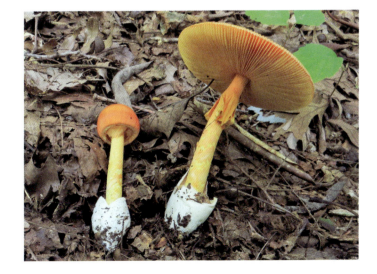

Amanita lavendula group (Coker) Tulloss, K. W. Hughes, Rodrig. Cayc., & Kudzma

= *Amanita citrina* f. *lavendula* (Coker) Veselý
= *Amanita citrina* var. *lavendula* (Coker) Sartory & Maire
= *Amanita mappa* var. *lavendula* Coker

COMMON NAMES: Citron Amanita, Coker's Lavender Staining Amanita

MACROSCOPIC FEATURES: cap 4–13 cm wide, convex, then flattening, pale greenish yellow most notable centrally, shiny and sticky when moist, decorated with patches of whitish to lavender volval material that often wash off. Margin typically not striate and not appendiculate. **gills** free or narrowly attached, crowded, whitish to cream. **stalk** 6–14 cm long, 6–20 mm wide, equal or enlarging slightly downward, whitish, hollow or stuffed. The small basal bulb is oval and slightly rimmed, often crowned by a thin, free rim of attached volva, off-white. Partial veil apical, membranous, thin but persisting, pale yellow. **flesh** off-white with all parts and surfaces prone to rusty stains; odor of raw potato or radish.

MICROSCOPIC FEATURES: Spores 6–9 μm, globose or subglobose, smooth, hyaline, amyloid.

SPORE PRINT: White.

HABIT, HABITAT, AND SEASON: Scattered on soil, often under pine or in mixed woods; late summer–early winter.

EDIBILITY: Unknown.

COMMENTS: Until recently this mushroom was mistakenly assigned to the European species *Amanita citrina*. Several similar species live in Georgia. Along the coast consider *Amanita levistriata* (not illustrated). It differs by having yellowish green cap warts and a consistently but weakly striate cap margin. Small pantherine species with partial veils, such as *Amanita multisquamosa*, have consistently striate cap margins and lack the potato smell. Members of the *Amanita russuloides* group lack the striate margin and often have partial veils but don't smell of potato either.

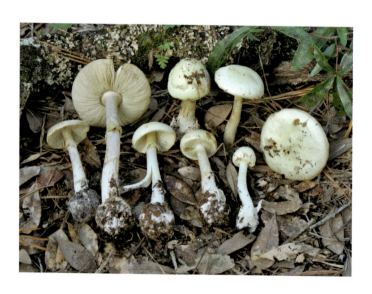

Amanita longipes Bas ex Tulloss & D. T. Jenkins

COMMON NAME: Dog-legged Lepidella
MACROSCOPIC FEATURES: **cap** 2.5–10 cm wide, hemispheric at first, then broadly convex, whitish with a grayish center, dry, covered with fine, white powder and fluffy volval remnants that may darken centrally and form loose warts. All of this readily washes off. Cap margin appendiculate, not striate. **gills** more or less attached, close, whitish. **stalk** 5–15 cm long (excluding bulb) and 5–20 mm wide, enlarging downward, white, solid or firmly stuffed, covered with fluffy and persistently white volval material. The base is a naked, club-shaped to more deeply rooting bulb, 22–72 × 8.5–27 mm, sometimes featuring a dog-leg bend, white or with reddish stains. The partial veil is flimsily fibrous or fluffy and soon disintegrates. **flesh** white; odor not distinctive or pleasantly like a disinfectant.
MICROSCOPIC FEATURES: Spores 10–14 × 4.5–6 µm with much larger outliers sometimes seen, elliptic, smooth, hyaline, amyloid.
SPORE PRINT: White.
HABIT, HABITAT, AND SEASON: Solitary or scattered on soil in mixed woods, especially with oaks or pines; summer–early winter.
EDIBILITY: Unknown.
COMMENTS: The bulb of the long-stalked *Amanita longipes* is frequently shorter and more turnip-like than one might expect. Fluffy cap coverings aren't unique to this species. *Amanita rhoadsii* (not illustrated) has an odor resembling ham and narrower spores measuring 10–14.5 × 4–5 µm. In *Amanita tephrea* (not illustrated) the fluff turns gray, darkest on the stalk. It is odorless or pleasant-smelling. Spores are 10–12.5 × 5.5–7 µm. The fluff on *Amanita chlorinosma* (not illustrated) may gray or not. Cap diameters are 7–10 cm. Spores measure 8–11 × 4.5–6.5 µm. It has the chlorine or old ham smell.

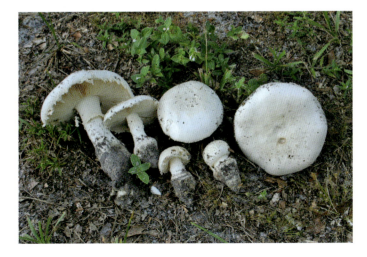

Amanita multisquamosa Peck

= *Amanita pantherina* var. *multisquamosa* (Peck) D. T. Jenkins
= *Amanita cothurnata* G. F. Atk.

COMMON NAME: Small Funnel-veiled Amanita

MACROSCOPIC FEATURES: cap 3–13 cm wide, convex, then flattening, off-white peripherally transitioning to a tan or dirty brown center, sticky when damp, covered with pale, flat warts often lost to rains. Cap margin consistently but weakly striate, not appendiculate. **gills** free to narrowly attached, crowded, white. **stalk** 3.5–15 cm long, 3–12 mm thick, enlarging slightly downward, white, stuffed or hollow, typically with a rolled collar of volval material at the bulb junction. The smallish bulb is ovoid, white. Partial veil membranous, persistent, superior on the stalk, often but not always pulled upward like a funnel, white. **flesh** white, not staining when bruised; no distinct smell.

MICROSCOPIC FEATURES: Spores 7–11 × 5.5–8.5 μm, subglobose to ellipsoid, smooth, hyaline, inamyloid.

SPORE PRINT: White.

HABIT, HABITAT, AND SEASON: Solitary to loosely scattered on the soil in broad-leaf or mixed woods, often near oaks; summer–fall.

EDIBILITY: Poisonous.

COMMENTS: *Multisquamosa* refers to the large number of cap warts. This species is one of several similar small "pantherine" Amanitas with a collared bulb and shared toxicity profile. (See *Amanita albocreata* for further information.) When it is large, *Amanita multisquamosa* can be confused with a small *Amanita velatipes*. That species is stockier and has a dull yellow to yellow-tan cap. When warts are missing, *Amanita multisquamosa* resembles pale forms of *Amanita brunnescens*. In that species the partial veil is apical and dangling. The flesh develops orange-brown stains. The bulb and odor are different too.

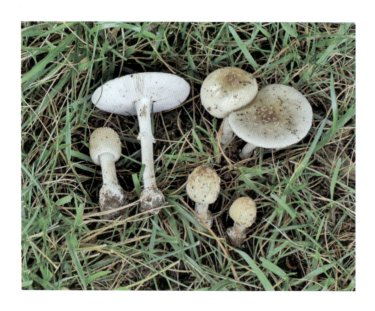

Amanita muscaria var. *guessowii*
Veselý

= *Amanita muscaria* var. *formosa* Pers.

COMMON NAME: Yellow Fly Agaric

MACROSCOPIC FEATURES: cap 5–20 cm wide, convex, then flattening, yellow-orange at first, paling peripherally toward a shade of yellow, slightly sticky when damp, covered with cream-colored warts that may wash off. Margin not appendiculate, sometimes weakly striate at maturity. **gills** narrowly attached or free, crowded, white to cream. **stalk** 6–15 cm long, up to 3 cm thick, equal or enlarging downward, whitish or tan-tinged, stuffed, lower stalk shows multiple rings or partial rings of volval material. The base is an ovoid bulb not much wider than the stalk. The partial veil is membranous, superior, dangling, usually persistent. **flesh** white, bruising pale yellow-brown; odor not distinctive.

MICROSCOPIC FEATURES: Spores 9–12 × 6.5–8.5 μm, elliptic, smooth, hyaline, inamyloid.

SPORE PRINT: White.

HABIT, HABITAT, AND SEASON: Single to scattered on soil in broadleaf or mixed woods or in adjacent grass; summer–early winter.

EDIBILITY: Poisonous.

COMMENTS: This is the yellowish, eastern North American form of the Alice in Wonderland Fly Agaric. *Amanita muscaria* var. *guessowii* has a more northerly geographic distribution than *Amanita persicina*, but the two overlap in Georgia. See the Comments under the latter species for differential features and a note on toxicity. *Amanita parcivolvata* resembles a miniature red Fly Agaric, but it has a strongly striate cap margin and lacks a partial veil.

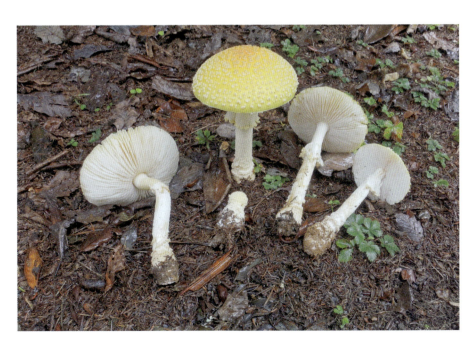

Amanita mutabilis Beardslee

COMMON NAME: Anise and Raspberry Limbed-Lepidella
MACROSCOPIC FEATURES: cap 4.5–11 cm wide, broadly convex, then flattening, whitish to creamy tan but rapidly bruising pink to magenta when injured, slightly sticky when damp, partially covered by a large whitish patch of membranous volva. The cap margin is slightly appendiculate, not striate. **gills** free or narrowly attached, close, pale cream, bruising pink. **stalk** 6–11.5 cm long and 1–2 cm wide, enlarging downward, white but bruising like the cap, solid. The base is a roundish, somewhat rimmed bulb crowned by a short edging of membranous volva. The partial veil is membranous, almost apical, white but bruising pink. **flesh** white, quickly staining bright pink to magenta; odor often of anise.
MICROSCOPIC FEATURES: Spores 10–14.5 × 5.5–9 μm, elliptic, smooth, hyaline, amyloid.
SPORE PRINT: White.
HABIT, HABITAT, AND SEASON: Gregarious in sandy soil, usually under pines or oaks; summer–early winter.
EDIBILITY: Unknown.
COMMENTS: *Mutabilis* refers to the mutability of the color in this species, readily changing from white to bright shades of pink or red when bruised. *Amanita rubescens* var. *alba* (not illustrated) is similar but has chunky cap warts and changes color more slowly. *Amanita volvata* and *Amanita peckiana* (not illustrated) can have a dull pink or pinkish brown bruising reaction, but they have a saccate volva. None of these look-alikes smells like anise.

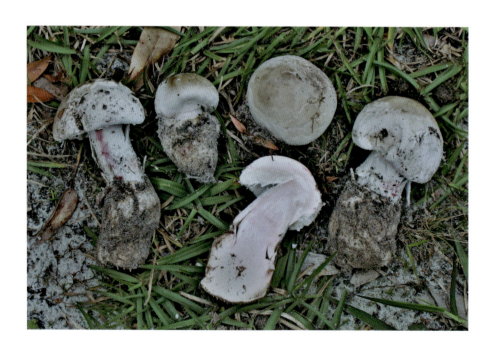

Amanita onusta (Howe) Sacc.

COMMON NAME: Gunpowder Lepidella
MACROSCOPIC FEATURES: cap 3–8 cm wide, convex, then flattening, sometimes depressed and possibly showing a low umbo, pale gray, dry, covered with powdery to granular brownish gray volval material. The cap margin is appendiculate, not striate. **gills** free or narrowly attached, crowded, white but yellowing, and looking waterlogged at maturity. **stalk** 4–15 cm long (including bulb) by 6–15 mm thick, equal or expanding slightly downward, whitish above, darkening to brownish gray near the base, solid. The base is a small rooting bulb, white below a few rings of well-organized gray warts or recurved scales on the upper surfaces. The partial veil is apical, a flimsy whitish to creamy skirt that often disintegrates. **flesh** whitish to dirty cream, not reddening at injuries; odor typically of chlorine or spoiling meat.
MICROSCOPIC FEATURES: Spores 8–11 × 5.5–7 μm, elliptic, smooth, hyaline, amyloid.
SPORE PRINT: White.
HABIT, HABITAT, AND SEASON: Scattered or in groups on the ground, commonly under oaks or pines; spring–fall.
EDIBILITY: Unknown.
COMMENTS: Look-similars for *Amanita onusta* are several. In addition to *Amanita hesleri*, consider also the larger *Amanita atkinsoniana* (see Color Key). Concentric rings of warts on the bulb cover most of its surface, and injured flesh turns reddish brown. *Amanita cinereoconia* (not illustrated) is about the same size as *Amanita onusta*. The gray volval material on the cap is fluffier, less well organized into discrete warts. The stalk base remains whiter, lacking gray warts. *Amanita onusta*, *Amanita atkinsoniana*, and *Amanita cinereoconia* usually smell of chlorine or rotting meat.

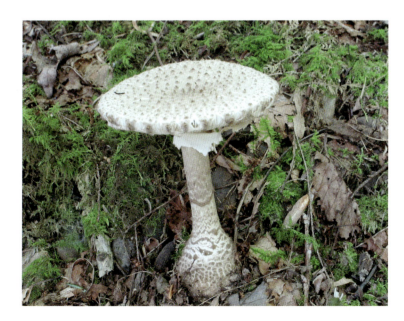

Amanita parcivolvata (Peck) E.-J. Gilbert

COMMON NAME: Ringless False Fly Agaric
MACROSCOPIC FEATURES: cap 3–12 cm wide, convex, then flattening but often retaining a low umbo, scarlet to crimson but fading from the periphery with age, sticky when moist, covered with chunky yellow-tan warts that easily wash off. Margin strongly striate, not appendiculate. **gills** free, close, white to pale yellow. **stalk** 3–10 cm long, 5–15 mm wide, nearly equal, yellowish or white, stuffed or partially hollow, may have flakes of volval material or a raised ridge of it at the top of the basal bulb. The small bulb is usually rounded but can be slightly rooting. No partial veil. **flesh** white; odor vaguely unpleasant or not distinctive.
MICROSCOPIC FEATURES: Spores 9–14 × 6–8 µm, elliptic to cylindric, smooth, hyaline, inamyloid.
SPORE PRINT: White.
HABIT, HABITAT, AND SEASON: Single or scattered on the ground in woods or adjacent grassy borders; summer–fall.
EDIBILITY: Unknown.
COMMENTS: The common name notes a resemblance to the much larger Fly Agaric, *Amanita muscaria* var. *muscaria*, the classic red form of which is not known from Georgia. Other misidentification opportunities present themselves when cap warts have gone missing. *Amanita frostiana* (not illustrated) has a partial veil. The veil is also present in *Amanita flavoconia*. It usually lacks cap striations as well. *Amanita jacksonii* is a larger species with an apical partial veil. At the base is a white volval sac.

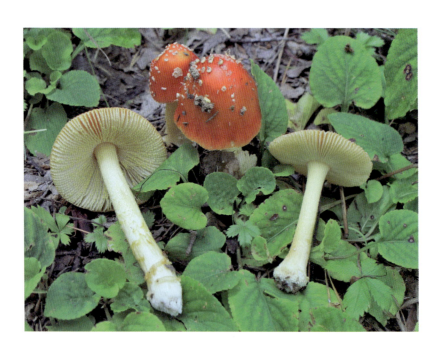

Amanita pelioma Bas

COMMON NAME: Bruising Lepidella
MACROSCOPIC FEATURES: cap 4–9 cm wide, convex, then almost flat, shiny off-white to light gray or buff, tacky when moist, covered with powdery volval material that sometimes includes greenish bits. Cap margin not striate, appendiculate when young. **gills** free, crowded, creamy at first but soon café au lait or olive buff; lavender notes are also recorded for this species. **stalk** 9–15 cm long and 6–15 mm thick, enlarging slightly downward, colored and powdery like the cap but typically stained blue-green at ground level, solid. The base is a small turnip-shaped bulb, blue-green above and colored like the cap below. Partial veil is semimembranous, superior to subapical on the stalk but quickly lost, white. **flesh** pale buff, not changing when bruised; odor not distinctive or chlorine and stale ham.

MICROSCOPIC FEATURES: Spores 9–14 × 5–10 µm, elliptic to long-elliptic, smooth, hyaline, amyloid.
SPORE PRINT: Grayish buff, buff, or white.
HABIT, HABITAT, AND SEASON: Usually solitary on the ground in woods near oaks or pines; summer–fall.
EDIBILITY: Unknown.
COMMENTS: This is the only *Amanita* in Georgia known to bruise blue-green. There is, however, a species with café au lait gills that lacks the blue-green staining. *Amanita microlepis* (not illustrated) is of similar size, color (minus blue-green areas), overall shape, and smell. The tannish cap is covered with tiny, spiky cap warts that might wash off. The apical partial veil is relatively persistent and tan to café au lait in color. Spores measure 9–11 × 6–8 µm. In *Amanita pelioma* blue-green staining does not indicate psychoactive potential.

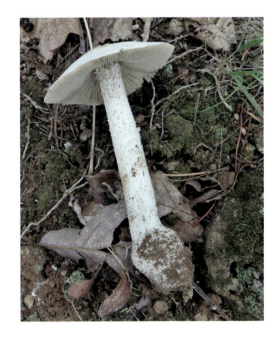

Amanita persicina (D. T. Jenkins) Tulloss & Geml

= *Amanita muscaria* var. *persicina* D. T. Jenkins

COMMON NAME: Peach-colored Fly Agaric
MACROSCOPIC FEATURES: cap 4–20 cm wide, convex, then flattening, red-orange at first but lightening to melon or pale orange by maturity, darkest centrally, slightly sticky when damp, covered with yellow warts that fade in age to tan and often wash off. The cap margin is often weakly striate by maturity, not appendiculate. **gills** are free, crowded, cream-colored or tinged with pink. **stalk** 4–25 cm long, up to 3 cm thick, equal or enlarging downward, yellowed at the apex but otherwise whitish, densely stuffed, often with a few remnants of fluffy volval material partially ringing the lower stalk. The base is an ovoid bulb measuring 20–45 × 15–35 mm. The partial veil at midstalk is membranous with a thickened margin but fragile and often lost, white above and pale yellow below. **flesh** white; odor not distinctive.
MICROSCOPIC FEATURES: Spores 9–13 × 6.5–8.5 μm, elliptic, smooth, hyaline, inamyloid.
SPORE PRINT: White.
HABIT, HABITAT, AND SEASON: Single to scattered on the ground, often under oaks in woodlands or adjacent grass; fall–winter.
EDIBILITY: Poisonous.
COMMENTS: The epithet *persicina* refers to the peachy color of the cap. The very similar *Amanita muscaria* var. *guessowii* generally has a yellower cap and more pronounced rings of volval tissue at the base of the stalk. *Amanita persicina* along with other Fly Agarics and "pantherine" Amanitas such as *Amanita velatipes* contain ibotenic acid and muscimol, toxins with psychoactive properties.

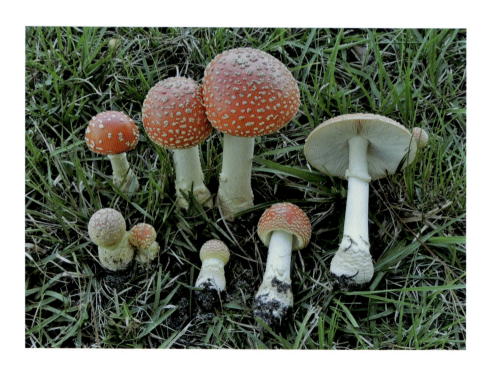

Amanita polypyramis (Berk. & M. A. Curtis) Sacc.

COMMON NAME: Plate Full of Pyramids

MACROSCOPIC FEATURES: cap 7.5–21 cm wide, convex, then flattening, semi-shiny, white, dry, covered with enough white pyramidal warts and granular volval material to keep Egyptologists busy for years, but warts and Egyptologists readily wash off. The cap margin is not striate, appendiculate when young. **gills** free or narrowly attached, crowded to subdistant, white but darkening to dirty cream at maturity. **stalk** 7–20 cm long and 1–3.5 cm wide, enlarging slightly downward, white, solid. The base is a rounded to short club-shaped white bulb that may have a smooth or almost marginate shoulder, vertical splits not common. The partial veil is apical, thick, and white and often falls off. **flesh** white and unchanging; odor of chlorine.

MICROSCOPIC FEATURES: Spores 9–14 × 5–10 µm, elliptic, smooth, hyaline, amyloid.

SPORE PRINT: White.

HABIT, HABITAT, AND SEASON: Scattered or in groups on soil, typically near pines; late summer–fall.

EDIBILITY: Unknown.

COMMENTS: *Polypyramis* references the many pyramidal warts on the cap. This species is larger and more slenderly built than *Amanita abrupta*, which often develops vertical splits in the bulb. *Amanita chlorinosma* (not illustrated) is also smaller. The cap is decorated with more fluff and fewer pyramids. Its spiderwebby partial veil quickly vanishes, and spores are slightly smaller as well, measuring 8–11 × 5–7 µm.

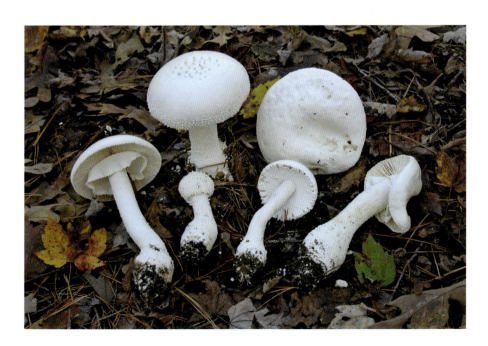

Amanita ravenelii (Berk. & M. A. Curtis) Sacc.

COMMON NAME: Pine Cone Lepidella
MACROSCOPIC FEATURES: cap 8–20 cm wide, buttons globose, then convex and flattening, whitish, dry, covered with concentric rings of scales resembling those of conifer cones. These scales radially stretch the underlying surface (use hand lens) and darken from white through tan to reddish brown. Cap margin not striate, young margin appendiculate. **gills** free or narrowly attached, crowded, creamy to yellowish cream. **stalk** 8–12 cm long (excluding bulb) and 1–3 cm thick, equal or expanding slightly downward, white at first but aging to yellowish or rusty brown, solid, volval fluff may form loose rings above the bulb. The massive bulb is 7–20 cm long and 3–6 cm thick, shape variable from rounded to deeply rooting and bent, often longitudinally cracked, whitish with rusty stains in old wounds. The partial veil is thick and felt-like, superior, white, tends to fall off. **flesh** whitish, turning rusty where injured; odor of chlorine usually predominates over notes of ham bone.
MICROSCOPIC FEATURES: Spores 8–12 × 5–7.5 μm, elliptic, smooth, hyaline, amyloid.
SPORE PRINT: White.
HABIT, HABITAT, AND SEASON: Solitary to scattered on soil in mixed or broadleaf forests, usually near oaks or pines; late summer–fall.
EDIBILITY: Unknown.
COMMENTS: *Ravenelii* honors South Carolina mycologist Henry William Ravenel (1814–1887). The resemblance of the cap warts to whorled pine cone scales is sufficient to distinguish *Amanita ravenelii* from other large Lepidellas found in Georgia. *Amanita pseudovolvata* nom. prov. (see Color Key) is much smaller and lacks a bulbous base and the characteristic odor.

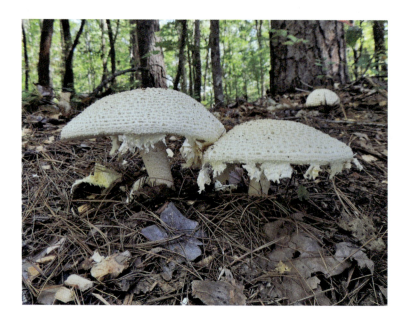

Amanita rhacopus Y. Lamoureux

= *Amanita ceciliae* (Berk. & Broome) Bas

COMMON NAME: Snakeskin Grisette

MACROSCOPIC FEATURES: cap 5.5–12 cm wide, convex, then flattening, sticky when damp, brown to grayish brown, darkest centrally, may show warts or patches of gray volval material. Cap margin striate for 25%–40% of the cap radius, not appendiculate. **gills** free, close to crowded, whitish to grayish white in age. **stalk** 12–16 × 0.8–1.4 cm wide, enlarging downward, hollow or partially so, whitish to light gray and covered with darker fibrils that often organize into chevrons. Fluffy gray remnants of the volva often present around the bulbless base. Partial veil absent. **flesh** white; odor not distinctive.

MICROSCOPIC FEATURES: Spores 9.5–12 × 9–11.5 μm, globose to subglobose, smooth, hyaline, inamyloid.

SPORE PRINT: White.

HABIT, HABITAT, AND SEASON: Scattered on soil in mixed or broadleaf woods; fruiting peaks during summer.

EDIBILITY: Unknown.

COMMENTS: This is one of several North American species historically lumped together as *Amanita ceciliae*, a European species not occurring here. Further work will be necessary to separate them all. Meanwhile, *Amanita rhacopus* differs from *Amanita vaginata* by lacking a saccate volva. *Amanita farinosa* is smaller with gray powder on the cap and on soil at the base. Dark variants of *Amanita brunnescens* may be radially streaked with dark fibrils but don't tend to be radially grooved. They also have partial veils.

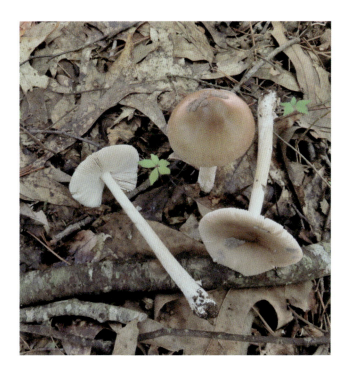

Amanita rhopalopus Bas

= *Amanita radicata* Peck
= *Amanita rhopalopus* f. *turbinata* Bas

COMMON NAME: American Club-footed Lepidella

MACROSCOPIC FEATURES: **cap** 5–18 cm wide, convex, then flattening or slightly depressed with a low umbo, whitish, dry, covered with an irregular scattering of white to tan or brown warts that are irregularly chunky to pyramidal in shape, tallest centrally. Cap margin not striate, appendiculate when young. **gills** free or narrowly attached, crowded or nearly so, white to pale cream. **stalk** 6–20 cm long (above the bulb) and 1–2.5 cm wide, expanding downward, white, with fluffy white to tannish warts or partial rings often seen above the bulb. The bulb is typically not much wider than the stalk but can be very long, cylindric or root-shaped, terminating in false rootlets, white to tan. The partial veil is subapical, thin and felt-like, dingy white, frequently lost. **flesh** whitish, not reddening at injuries; strong odor of chlorine or rotting meat.

MICROSCOPIC FEATURES: Spores 8–11 × 5–7 μm, elliptic to long-elliptic, smooth, hyaline, amyloid.

SPORE PRINT: White.

HABIT, HABITAT, AND SEASON: Solitary to loosely grouped on the ground in broadleaf or mixed woods, usually near oaks; summer–fall.

EDIBILITY: Unknown.

COMMENTS: *Rhopalopus* is an English spelling for the Greek ροπαλου πούς, which can be loosely translated as "billy club foot." This large Lepidella is distinguished from *Amanita ravenelii* by the different style of cap warts and failure to redden at wounds—the club doesn't bleed. *Amanita daucipes* typically has pinkish or orange-tinted warts and other volval remnants, a much fatter bulb, and reddish staining around wounds.

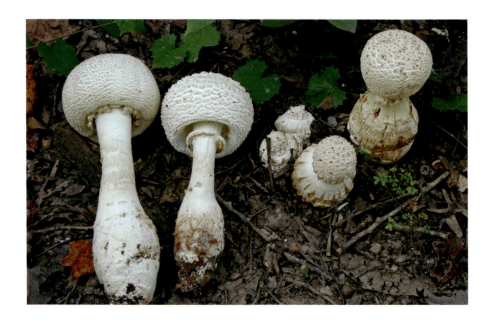

Amanita roseitincta (Murrill) Murrill

= *Amanita komarekensis* D. T. Jenkins and Vinopal

COMMON NAME: Rose-tinted Amanita

MACROSCOPIC FEATURES: **cap** 3–7.5 cm wide, convex, then flattening with a low umbo, white under a layer of pinkish brown powder that fades toward beige, sticky when damp, gray pyramidal warts are sometimes present. The cap margin is striate, not appendiculate. **gills** free, crowded, pale cream or white. **stalk** 3–15 cm long and 5–20 mm thick, enlarging slightly downward, whitish, hollow or nearly so, covered with pinkish powder near the apex. The base is an oval to turnip-shaped bulb sprinkled with pink to beige volval remnants. The partial veil is membranous, apical, pink at first, at least underneath. **flesh** whitish, not staining; odor described variously as fruity, like clover, or like ham.

MICROSCOPIC FEATURES: Spores 8–12 × 6–9 μm, elliptic, smooth, hyaline, inamyloid.

SPORE PRINT: White.

HABIT, HABITAT, AND SEASON: Solitary or scattered on the ground under oaks or pines; spring–fall.

EDIBILITY: Unknown.

COMMENTS: The pink coloration makes *Amanita roseitincta* easy to distinguish from other Amanitas when young and in pristine condition, but the pinks soon turn beige. *Amanita peckiana* (not illustrated) has membranous pink volval patches on the cap and a saccate volva. *Leucoagaricus rubrotinctus* (not illustrated) has a 3–6 cm cap that is uniformly pinkish brown to reddish brown at first. The colored layer breaks up into rings of reddish brown scales over a white ground layer. The partial veil is white and superior on the stalk, not apical. It has a central white stalk, 3–10 mm thick. Spores are white and inamyloid but smaller (6–9 × 4–5 μm).

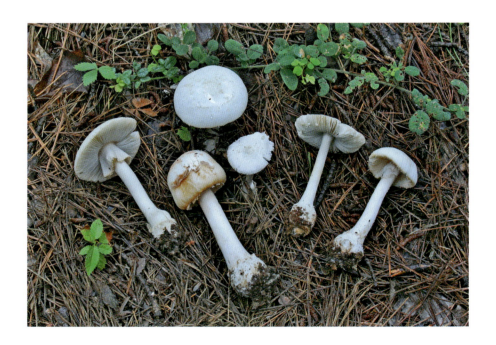

Amanita rubescens group Pers.

COMMON NAME: Blusher

MACROSCOPIC FEATURES: cap 4–20 cm wide, convex, then flattening with a slight umbo, moist, tan to reddish brown, often with blotchy red stains, covered with flat, pinkish tan to yellowish tan warts that also bruise red and easily wash off. Cap margin rarely striate, not appendiculate. **gills** free or narrowly attached, very close, creamy white and bruising red. **stalk** 5–25 cm long, 7–40 mm thick, equal or enlarging downward with a smooth transition to a slight bulb, whitish and staining like the cap, solid to stuffed or hollowing. The bulb may crack vertically. The partial veil is apical, membranous, thin but usually persistent. **flesh** white, staining reddish; odor and taste not distinctive.

MICROSCOPIC FEATURES: Spores 7–9.5 × 6–7 μm, subglobose to broadly ellipsoid, smooth, hyaline, amyloid.

SPORE PRINT: White.

HABIT, HABITAT, AND SEASON: Solitary or in small groups on soil in a variety of forest types; spring–fall.

EDIBILITY: Edible but not recommended; see below.

COMMENTS: The epithet *rubescens* refers to the reddish staining reaction. According to *Amanita* expert Rod Tulloss, the *rubescens* group may contain up to nine or more species. Most of these are best identified using molecular analysis. The Golden Underskirt Blusher, *Amanita aureosubucula* (not illustrated), is similar, but the underside or both sides of the hanging partial veil are golden yellow. Blushers with whitish caps are known as *Amanita rubescens* var. *alba* (not illustrated). The Yellow Blusher, *Amanita flavorubens* (see Color Key), has a golden yellow cap and warts. Both share the red blushing reaction. Although edible, blushers contain rubescenslysin, a toxin that destroys blood cells. Cooking or stomach acid inactivates it. Also be advised that some poisonous Amanitas can superficially resemble the Blusher. Be careful.

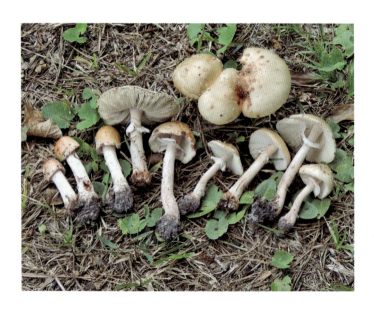

Amanita russuloides group (Peck) Sacc.

= *Amanita gemmata* (Fr.) Bertillon in DeChambre

COMMON NAME: Russula-like Amanita

MACROSCOPIC FEATURES: cap 2.5–12 cm wide, convex and flattening with age, pale yellow to amber, darkest centrally, sticky when moist, dotted with whitish warts that often wash off. The cap margin is striate, not appendiculate. **gills** free or narrowly attached, crowded, white to cream-colored. **stalk** 3.5–12 cm long and 0.5–2 cm thick, expanding slightly downward, white to pale cream, hollow or stuffed. The base is a small oval bulb colored like the stalk, usually topped by a low ring or fringe of whitish volval tissue. Partial veil present or absent, membranous if present, persistent, dangling, variably located from superior to below midlevel on the stalk, white. **flesh** white; no distinctive odor.

MICROSCOPIC FEATURES: Spores 8.5–10 × 6.5–7 μm, elliptic, smooth, hyaline, inamyloid.

SPORE PRINT: White.

HABIT, HABITAT, AND SEASON: Scattered or loosely grouped on the ground in a variety of forest types or adjacent grassy areas; late spring–fall.

EDIBILITY: Unknown, but probably poisonous.

COMMENTS: Once upon a time, *Amanita gemmata* was a catchall name applied to any small American *Amanita* matching this general description. More recently, it has become clear that in eastern North America, whatever these mushrooms are, *Amanita gemmata* they are not. It is suspected that a variety of species are now lumped together as *Amanita russuloides*. Look-alikes include the more slenderly built *Amanita albocreata* and *Amanita praecox* nom. prov. (see Color Key). Neither species has a partial veil. *Amanita multisquamosa* and *Amanita lavendula* group both do, but the latter smells like raw potato or radish.

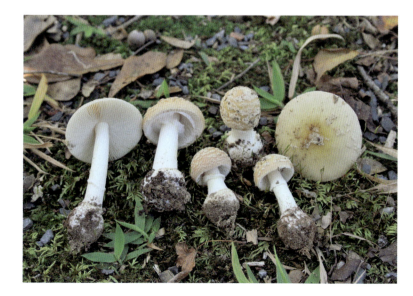

Amanita spreta (Peck) Sacc.

COMMON NAME: Hated Caesar

MACROSCOPIC FEATURES: cap 5–15 cm wide, broadly convex to flat with a low umbo, sticky when moist, pale at first but quickly darkening to brown or grayish brown, especially centrally, and often appearing radially streaked or speckled. One or more large patches of white volva might adhere to the cap. Cap margin striate for 5%–20% of the radius, not appendiculate. **gills** free, crowded, white to off-white. **stalk** 5–19 cm long and 8–20 mm wide, thick, enlarging slightly downward, hollowing, whitish with darkening fibrils below the partial veil. The bulbless base rises from a thin, white volval sac with free edges that may flare away from the stalk. The membranous and persistent partial veil is superior, white to off-white. **flesh** pale cream; odor not distinctive.

MICROSCOPIC FEATURES: Spores 9.5–13 × 6–8 μm, elliptic to elongate, smooth, hyaline, inamyloid.

SPORE PRINT: White.

HABIT, HABITAT, AND SEASON: Single or in loose groups under broadleaf trees or conifers or in nearby grass; summer–fall.

EDIBILITY: Historically, considered poisonous.

COMMENTS: The general stockiness and partial veil distinguish *Amanita spreta* from the typically smaller and leggier *Amanita fulva*. The bases of *Amanita brunnescens* and *Amanita submaculata* (not illustrated) are bulbous. Their caps normally lack a striate cap margin. Although conventional wisdom lists *Amanita spreta* as poisonous, Woehrel and Light (2017) were unable to track down any actual cases. Still, better safe than sorry.

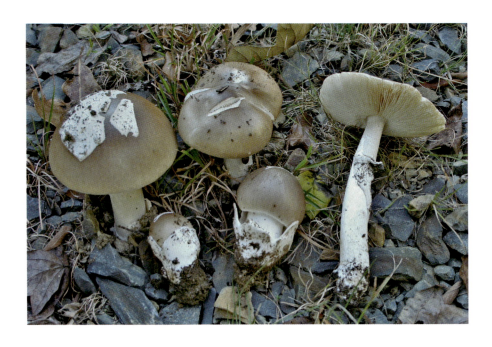

Amanita vaginata group (Bull.) Lam.

COMMON NAME: Grisette

MACROSCOPIC FEATURES: cap 4–9.5 cm, convex, then flattening with a low umbo, usually gray or gray-brown, darkest centrally, sticky when damp. Cap warts or patches of white volval material are uncommon. Margin strongly striate, not appendiculate. **gills** free or narrowly attached, close or crowded, white to pale gray. **stalk** 7–18 cm long and 5–20 mm wide, nearly equal or enlarging downward, whitish, hollowing. The bulbless base rises from a flimsy white volval sac that collapses against the stalk and may darken with age. No partial veil. **flesh** white; odor not distinctive.

MICROSCOPIC FEATURES: Spores 8–12 μm, globose, smooth, hyaline, inamyloid.

SPORE PRINT: White.

HABIT, HABITAT, AND SEASON: Single or scattered on the ground in mixed or broadleaf woods or adjacent disturbed areas; spring–fall.

EDIBILITY: Not recommended due to species uncertainty.

COMMENTS: *Amanita vaginata* is a European species currently used as a catchall to cover what are probably several species of gray or grayish grisettes. For now, in Georgia, the distinction from *Amanita fulva* might most reliably depend on the presence of orangish or reddish tones in the cap. A white grisette is often referred to, probably imprecisely, as *Amanita vaginata* var. *alba*. The smaller *Amanita farinosa*, which isn't a grisette, is gray and has a striate cap margin, but the cap is topped at first with gray powder. It terminates in a slight bulb rather than a saccate volva.

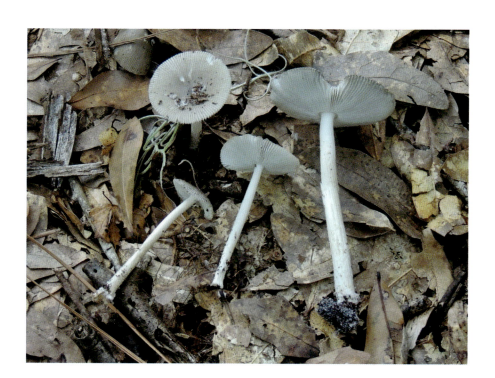

Amanita velatipes G. F. Atk.

= *Amanita pantherina* var. *velatipes* (G. F. Atk.) D. T. Jenkins

COMMON NAMES: Great Funnel-veil Amanita, Eastern Panther

MACROSCOPIC FEATURES: cap 5–18 cm wide, bell-shaped at first, then convex and flattening at maturity, creamy yellow to shades of tan, darkest centrally, sticky when moist, decorated with pale, flat warts often in concentric circles but tending to wash off. Cap margin striate, not appendiculate. **gills** free or narrowly attached, crowded, white to pale cream. **stalk** 5–20 cm long, up to 2 cm wide, expanding slightly downward, white to creamy, hollow or stuffed, with a rolled collar of volval tissue and occasionally other partial rings of it at the bulb junction. The small bulb is often slightly rooting. Partial veil is membranous and persistent, white, midlevel or lower on the stalk, initially funneling upward but then collapsing. **flesh** whitish; no distinct odor.

MICROSCOPIC FEATURES: Spores 8–13 × 6.5–8 µm, elliptic, smooth, hyaline, inamyloid.

SPORE PRINT: White.

HABIT, HABITAT, AND SEASON: Single or in small groups on the ground in mixed or broadleaf woods or adjacent grass; late spring–fall.

EDIBILITY: Poisonous.

COMMENTS: This is the largest "pantherine" *Amanita* found in Georgia. (See *Amanita albocreata* for an overview of smaller pantherine relatives.) *Amanita muscaria* var. *guessowii* is similar, but the cap is more brightly colored, the partial veil is superior, and there are usually multiple rings of volval material at the stalk base. *Amanita velatipes* contains the toxins ibotenic acid and muscimol.

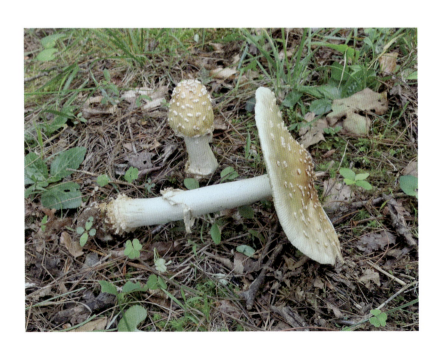

Amanita volvata group (Peck) Lloyd

COMMON NAME: American Amidella
MACROSCOPIC FEATURES: cap 3.5–5.5 cm wide, convex, then broadly convex, moist, smooth, white or with a brownish center, slowly bruises pinkish brown after handling, sometimes decorated with soft patches of randomly arranged white to brownish volval tissue. Young cap margin appendiculate, smooth or faintly striate. **gills** free, crowded, white or pale cream. **stalk** 4.5–7 cm long, 5–11 mm thick, enlarging slightly downward, white, bruising like the cap, covered with tiny fluffy scales, stuffed. The small basal bulb rises from a tough white volval sac that is lobed and rounded or elliptic on side view. Partial veil absent. **flesh** white, not staining with exposure; odor not distinctive.
MICROSCOPIC FEATURES: Spores 8.5–12 × 5–7 μm, ellipsoid to elongate, smooth, hyaline, amyloid.
SPORE PRINT: White.
HABIT, HABITAT, AND SEASON: Solitary or scattered on soil, often in damp areas of mixed woods or broadleaf river bottoms; summer–fall.
EDIBILITY: Unknown.
COMMENTS: *Amanita volvata* remains a catchall undoubtedly covering several species and accounting for some of the descriptive variation among field guides. Here, we adopt the Tulloss concept. Among the few other members of the Amidella section of the genus that might be identifiable without resort to molecular study is *Amanita peckiana* (not illustrated). It has pinkish to cream-colored pieces of volva on the cap, a weak pinkish brown staining reaction, a thin partial veil when young, and spores measuring 12–16 × 5–7 μm. *Amanita whetstoneae* nom. prov. (not illustrated) also has a weak staining reaction. The cap turns tan in age, and the stalk is longish. Spores measure 9–12 × 5–6.5 μm. *Amanita pseudovolvata* nom. prov. (see Color Key) is comparatively small and squat. The cap displays concentrically arranged brown scales composed of flat volval material and short striations at the cap margin when young. Spores measure 8–11 × 4.5–6 μm.

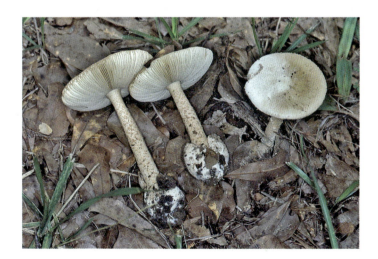

Amanita williamsiae Tulloss nom. prov.

COMMON NAME: Williams' Great Ringless Amanita
MACROSCOPIC FEATURES: cap 8.5 cm wide, bell-shaped at first, nearly flattening by maturity but retaining a prominent and broad umbo, pale yellow with a browning center, no volval patches or warts on cap. Cap margin striate for 40% of the cap radius, not appendiculate. **gills** free or nearly so, close, short gills ending abruptly (truncate), very pale yellow. **stalk** 16 cm long, 5–11.5 mm thick, enlarging downward, white at first with white fibrils that gray toward maturity, stuffed or hollow. The rounded base is encased by a large and tall, leathery, white volval sac. Partial veil absent. **flesh** white; odor and taste unknown.
MICROSCOPIC FEATURES: Spores 12–15 × 10–12.5 μm, subglobose to broadly ellipsoid, smooth, hyaline, inamyloid.
SPORE PRINT: White.
HABIT, HABITAT, AND SEASON: Single to scattered or in small groups and often deeply inserted into the sandy soils of the Atlantic Coastal Plain, usually in mixed woods with pines and oaks; spring–summer.
EDIBILITY: Unknown.
COMMENTS: This large and uncommon grisette was named in honor of Mrs. E. M. Williams, who spotted it growing around Washington, D.C., early in the 20th century. Like many other members of *Amanita* section Vaginatae it remains only partially characterized and provisionally named. *Amanita banningiana* has a darker, orange-yellow cap with a bronzed center and a membranous partial veil on the stalk. *Amanita fulva* group lacks a partial veil, as does *Amanita williamsiae*, but its cap is tawny to reddish brown rather than pale yellow.

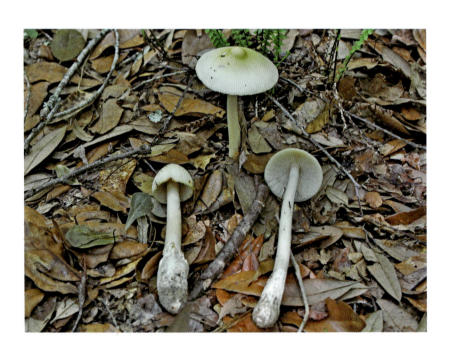

Ampulloclitocybe clavipes (Pers.)
Redhead, Lutzoni, Moncalvo, & Vilgalys

= *Clitocybe clavipes* (Pers.) P. Kumm.

COMMON NAME: Club-footed Clitocybe
MACROSCOPIC FEATURES: cap 2–9 cm wide, flattish, often developing a central depression and uplifted margin, but not nearly as vase-shaped as it might appear, moist at first, then drying, a dingy shade of grayish brown to olive brown. The margin is slightly inrolled at first. **gills** decurrent, close or nearly distant, whitish to creamy. **stalk** 3.5–6 cm long and 4–12 mm thick, sometimes nearly equal above the bulb but usually club-shaped, dry, colored lighter than the cap, stuffed. The spongy basal bulb can have a diameter to 3 cm or more. No partial veil. **flesh** white; odor fruity or reminiscent of almond, taste not distinctive.
MICROSCOPIC FEATURES: Spores 6–8.5 × 3.5–5 μm, ovoid to irregularly elliptic, smooth, hyaline, inamyloid.

SPORE PRINT: White.
HABIT, HABITAT, AND SEASON: Scattered on the ground in woodlands, usually under conifers; summer–fall.
EDIBILITY: Edible, but adverse reactions with alcohol intake have been reported.
COMMENTS: The similar *Infundibulicybe squamulosa* (not illustrated) is also found on the ground under conifers. The distinctly vase-shaped cap and stalk are yellow- to orange-brown, and there is no basal bulb. The stalk is 3–10 mm thick. Milk mushrooms, such as *Lactarius gerardii*, could also cause confusion, but they also lack a bulb and when damaged exude a latex juice. Adverse reactions reported after the combined consumption of *Ampulloclitocybe clavipes* and alcohol consist of headache, flushing, and rash.

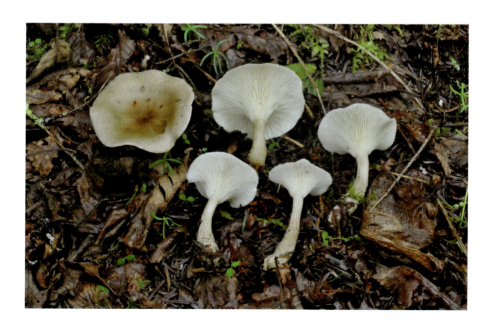

Armillaria gallica Marxm. & Romagn.

COMMON NAME: Bulbous Honey Mushroom
MACROSCOPIC FEATURES: cap 2–7 cm wide, convex, then broadly convex, slightly sticky or dry, tan to reddish brown, covered with small, erect, yellow to brown hairs or scales that may wash off. The cap margin often retains bits of partial veil. **gills** usually subdecurrent, almost distant, whitish, staining pinkish or brown. **stalk** 4–10 cm long and 5–12 mm thick, enlarging downward or frankly club-shaped, dry, whitish. The swollen base is attached to black rhizomorphs and tends to stain yellow. The partial veil is a flimsy white membrane that often leaves tags on the cap margin and a yellowed ring on the upper stalk. **flesh** white; odor sweet or not distinctive, taste not distinctive or mildly bitter.
MICROSCOPIC FEATURES: Spores 7–9.5 × 4.5–6 μm, ellipsoid, smooth, hyaline, inamyloid.
SPORE PRINT: White.
HABIT, HABITAT, AND SEASON: Usually scattered or in small groups on or adjacent to rotting hardwood, occasionally on conifers; late summer–fall.
EDIBILITY: Edible when thoroughly cooked.
COMMENTS: *Armillaria gallica* is typically found on dead wood and is generally considered more of a recycler than a parasite. The flimsy partial veil and swollen rather than tapering base help distinguish it from other honey mushroom species. *Armillaria gemina* (not illustrated) is very similar but has a more persistent partial veil rimmed by brown dots on the stalk. The Deadly Galerina, *Galerina marginata* (see Color Key), and a host of other brown mushrooms also create opportunities for confusion. Double check your identification, including spore color, before cooking.

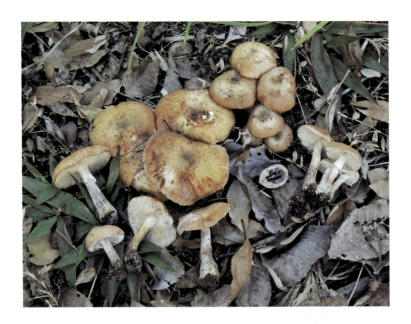

Armillaria mellea (Vahl) P. Kumm.

COMMON NAMES: Bootlace Fungus, Honey Mushroom

MACROSCOPIC FEATURES: cap 3–15 cm wide, initially convex with a slight umbo, then flattening or centrally depressed, moist to sticky when damp, more or less honey yellow, darkest centrally, and often displaying a few erect central scales. **gills** attached or subdecurrent, close, white but developing reddish brown stains. **stalk** 5–15 cm long and 6–15 mm wide, nearly equal or tapering downward, moist, white above and yellowish gray below, bruising darker, covered below the veil with white cottony fibrils or scales. The base is often pinched due to clustered growth. The partial veil is a superior, cottony membrane remaining on the stalk, white or pale yellow. **flesh** white; odor and taste not distinctive.

MICROSCOPIC FEATURES: Spores 7–9 × 6–7 µm, broadly elliptic to oval, smooth, hyaline, inamyloid.

SPORE PRINT: Pale cream.

HABIT, HABITAT, AND SEASON: Commonly in groups or clumps rising from a common base near the roots or on the wood of living or dead trees; fall, occasionally late spring.

EDIBILITY: Edible when thoroughly cooked.

COMMENTS: This pathogen kills the trees it attacks at root level and under the bark, where a lacework of thick black rhizomorphs is commonly seen. The well-developed partial veil distinguishes *Armillaria mellea* from the other honey mushrooms treated here. Match all diagnostic features, including spore color, to rule out look-similars such as the brown-spored *Pholiota squarrosa*. *Armillaria* species are themselves attacked by *Entoloma abortivum*, giving rise to so-called Aborted Entolomas.

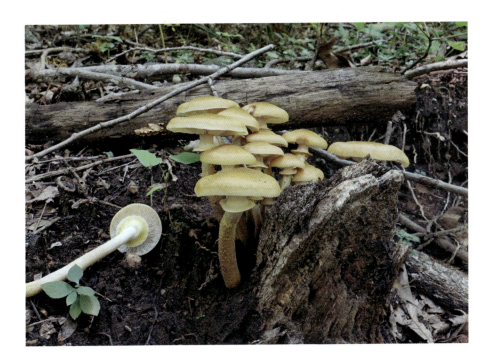

Asterophora lycoperdoides (Bull.) Ditmar

COMMON NAMES: Star-bearing Powder Cap, Wolf Asterophora

MACROSCOPIC FEATURES: cap 1–2.5 cm wide, rounded to convex, dry, white and cottony at first, then thickly coated with brown powder as asexual chlamydospores mature on the surface. **gills** usually present, attached, distant, thick and deformed, often forked, white, pale gray, or beige. **stalk** 2–5 cm long and 3–10 mm thick, equal, white to pale brownish, smooth or silky. No partial veil. **flesh** white; odor and taste farinaceous.

MICROSCOPIC FEATURES: Basidiospores, if present, 5–6 × 3–4 μm, ellipsoid, smooth, hyaline, inamyloid. Chlamydospores are 12–20 μm, globose, excluding the knobby projections, brown, inamyloid.

SPORE PRINT: White, if obtainable.

HABIT, HABITAT, AND SEASON: Clustered on rotting mushroom caps, especially *Russula* and *Lactarius* species; summer–fall.

EDIBILITY: Unknown.

COMMENTS: The chlamydospores in this species resemble microscopic stars, hence the common name. A closely related species, *Asterophora parasitica* (not illustrated), fruits on the same rotting hosts and is of a similar size. The gray to brownish gray cap and stalk are silky, not powdery, from chlamydospore production. Gills tend to be less deformed and do produce chlamydospores. These are smoothly spindle-shaped to ovoid, measuring 12–17 × 9–10 μm. Basidiospores measure 5–6 × 3–4 μm. Another minimushroom with an unusual host, old pine cones, is *Baeospora myosura* (see Color Key). The yellowish brown to cinnamon brown cap ranges from 5 to 20 mm wide. Gills are attached, crowded, and white. The stalk is 1–5 cm long but only 1–2 mm wide. Spores are white, ellipsoid, and 3–4.5 × 1–2.5 μm.

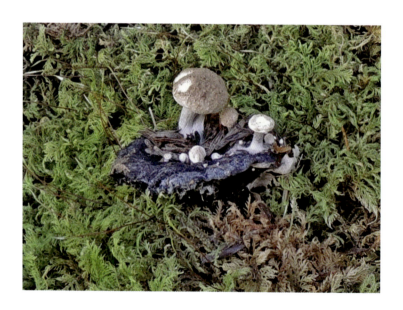

Bolbitius titubans (Bull.) Fr.

= *Bolbitius variicolor* G. F. Atk.
= *Bolbitius vitellinus* (Pers.) Fr.

COMMON NAME: Yellow Bolbitius
MACROSCOPIC FEATURES: cap 1.5–5 cm wide, initially conical or bell-shaped, opening to flat with a small umbo, sticky-slimy, lemon yellow to greenish yellow before fading to grayish tan or pale tan, but often retaining a yellower center, bald. The cap margin is striate nearly to the center of the cap. **gills** free or narrowly attached, close, whitish to pale yellow before browning. **stalk** 3–12 cm long and 3–8 mm thick, equal, sticky if moist, pale yellow, scurfy, hollow. **flesh** yellowish and fragile; odor and taste not distinctive.
MICROSCOPIC FEATURES: Spores 11–15 × 6–8 μm, elliptic with an apical pore, smooth, brownish.
SPORE PRINT: Rusty brown.
HABIT, HABITAT, AND SEASON: Solitary to loosely grouped in lawns, compost, or wood chips or on dung; spring–late fall.
EDIBILITY: Edible.
COMMENTS: *Titubans* translates to "fragile," an apt descriptor of this evanescent species. It can come and go in a day. The White Dunce Cap, *Conocybe apala* (see Color Key), is similarly sized, short-lived, and brown-spored. The conical cap is lined but dry, with colors ranging from whitish to pale tan. Spores are 10–14 × 6–9 μm, ellipsoid, with a truncated end and apical pore. It is very common in irrigated lawns and usually withers by noontime. Brown Dunce Caps, the *Conocybe tenera* group (not illustrated), fruit in rich woods, gardens, and grassy areas. The brown caps are 1–3 cm wide, conical to bell-shaped, dry, hygrophanous, and striate. Stalks are up to 9 cm long and 7 mm thick, white or brownish. Spores are reddish brown, 10–14 × 5–6 μm. In grassy areas, also consider the Lawnmower's Mushroom, *Panaeolina foenisecii*.

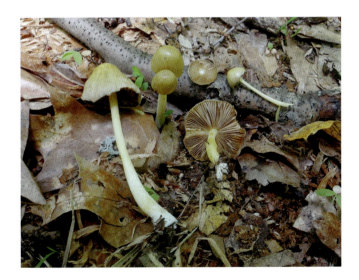

Callistosporium luteo-olivaceum
(Berk. & M. A. Curtis) Singer

= *Callistosporium luteofuscum* Singer
= *Collybia luteo-olivacea* (Berk. & M. A. Curtis) Sacc.

MACROSCOPIC FEATURES: **cap** 1–6 cm wide, broadly convex to flat, moist or dry, light yellow at first, becoming olive brown or reddish brown, fading toward yellow at maturity, minutely hairy at first but soon smooth. **gills** attached, close, yellow progressing to golden yellow. **stalk** 3–6 cm long and 2–4 mm wide, enlarging downward, sometimes longitudinally flattened, moist or dry, colored like the cap under a frosting of whitish fibrils that diminish in age, hollow. The base is coated with white tomentum. No partial veil. **flesh** colored like the cap or paler; odor fruity or not distinctive, taste bitter or not distinctive.

MICROSCOPIC FEATURES: Spores 5–8 × 3–4.5 µm, broadly ellipsoid, smooth, hyaline often with reddish dots, inamyloid. KOH mounts turn spores purple.

SPORE PRINT: White.

HABIT, HABITAT, AND SEASON: Scattered or loosely grouped on rotten conifer logs and stumps, rarely on broadleaf wood; spring–fall.

EDIBILITY: Unknown.

COMMENTS: A drop of KOH on the cap produces a vivid purplish red stain. The intensity of this response helps to separate *Callistosporium luteo-olivaceum* from a larger look-alike, *Tricholomopsis decora* (see Color Key), reportedly poisonous, which also fruits on conifer wood. It has a yellowish to greenish yellow cap with blackish fibers and scales. A drop of KOH typically produces a pale reddish to pale dull amber stain. *Gymnopilus sapineus* (see Color Key) is another conifer recycler that stains red with KOH. It has a brown spore print. See Comments under *Gymnopilus liquiritiae* for further details.

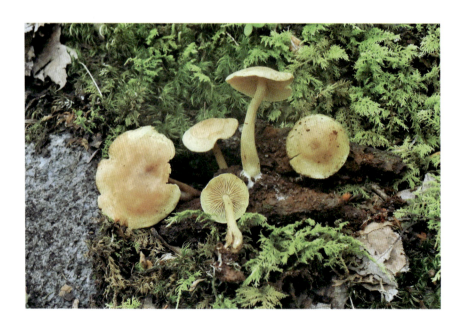

Callistosporium purpureomarginatum
Fatto and Bessette

MACROSCOPIC FEATURES: cap 1.5–4 cm wide, convex before flattening or developing a central depression, moist or dry, hygrophanous, purplish red to brownish violet when moist, fading to pinkish tan. The margin is sometimes striate and retains a dusky blue or purple band of color as the cap fades. **gills** are attached, close, yellowish pink with a purple tinge and reddish purple edges. **stalk** 2–4 cm long and 1.5–4 mm thick, equal, colored like the cap and yellowing toward the base, hollow. No partial veil. **flesh** yellowish; odor not distinctive, taste not distinctive or slowly bitter and metallic.

MICROSCOPIC FEATURES: Spores 4–6 × 2–4 µm, ellipsoid, smooth, hyaline, inamyloid, with many staining vinaceous in KOH mounts.

SPORE PRINT: White.

HABIT, HABITAT, AND SEASON: A rare species occurring scattered or in loose groups on decaying hardwood, especially oaks, or occasionally on conifers; summer–fall.

EDIBILITY: Unknown.

COMMENTS: The genus name *Callistosporium* roughly translates to "beautiful spore producer," and the epithet *purpureomarginatum* refers to the reddish purple gill edges. Red or reddish purple look-alikes fruiting on rotten hardwood lack marginate gills and are more commonly encountered. *Gymnopilus liquiritiae* has brown spores. So does *Pholiota polychroa* (see Color Key), but a drop of KOH on its cap very slowly produces a yellow-green, not red, stain. See Comments under *Gymnopilus liquiritiae* for additional details.

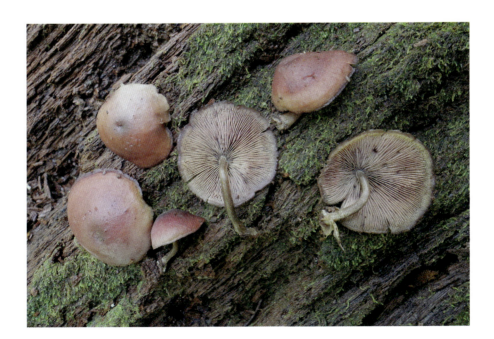

Cantharellula umbonata (J. F. Gmel) Singer

= *Cantharellus umbonatus* (J. F. Gmel) Pers.

COMMON NAME: Grayling

MACROSCOPIC FEATURES: cap 1–5 cm wide, convex at first, then flattening or becoming slightly funnel-shaped, with or without a pointed umbo, moist or dry, silver gray to brownish gray, minutely hairy. The cap margin is initially inrolled, later uplifted. **gills** decurrent, crowded, narrow and repeatedly forking, whitish, typically developing reddish stains. **stalk** 2.5–12.5 cm long and 3–7 mm thick, equal, dry, white or similar to the cap, smooth to silky, stuffed. The base is attached to substrate moss by white mycelium. No partial veil. **flesh** white, perhaps bruising reddish; odor and taste not distinctive.

MICROSCOPIC FEATURES: Spores 7–11 × 3–4.5 μm, spindle-shaped, smooth, hyaline, amyloid.

SPORE PRINT: White.

HABIT, HABITAT, AND SEASON: Gregarious, sometimes in fairy rings, on Haircap Moss (*Polytrichum* spp.); late summer–fall.

EDIBILITY: Edible.

COMMENTS: The Grayling looks a lot like a gray chanterelle and was at one time assigned to that genus. But *Cantharellus iuventateviridis* is the closest look-similar known from Georgia. It has a yellowish fertile surface and prefers mudflats to *Polytrichum* mossbanks. *Pseudoclitocybe cyathiformis* (not illustrated) occurs on or near dead wood. The vase-shaped cap, 1.5–7 cm wide, is depressed and brown and lacks an umbo. Gills are decurrent and pale brown. It has a 4–9 mm thick stalk and a white spore print. Spores are 7.5–10 × 5–6.5 μm, ellipsoid, hyaline, amyloid. *Ampulloclitocybe clavipes* is chunkier, less gregarious, and not limited to mossbanks.

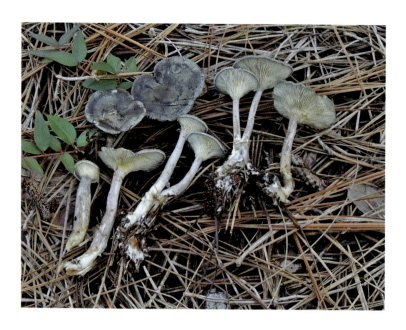

Chlorophyllum hortense (Murrill) Vellinga

= *Chlorophyllum humei* (Murrill) Vellinga
= *Leucoagaricus hortensis* (Murrill) Pegler

MACROSCOPIC FEATURES: cap 4–10 cm wide, egg-shaped at first, then broadly convex or nearly flat with an umbo, dry, initially yellowish or light yellow-brown but soon breaking into a central patch and roughly concentric rings of colored scales that may wash off over a white and fibrillose background. The cap margin is striate, often splitting, not shaggy. **gills** attached when young, free at maturity, crowded, white, becoming yellowish, then vinaceous brown in age. **stalk** 4–7 cm long and 3–6 mm thick, nearly equal above a swollen base, dry, white above the ring, browner and fibrillose below it, hollowing, developing vinaceous brown stains as it ages. The partial veil is a thick, double-edged ring, moveable on the stalk. **flesh** whitish, staining red or vinaceous brown on exposure; odor and taste not distinctive.

MICROSCOPIC FEATURES: Spores 8–10 × 6–7 μm, ellipsoid, smooth, hyaline, dextrinoid.

SPORE PRINT: White.

HABIT, HABITAT, AND SEASON: Scattered or in groups or fairy rings on lawns and in gardens, manure, or open spaces in oak-pine woods; summer–early winter.

EDIBILITY: Unknown.

COMMENTS: This lesser-known species may be more common than generally thought. *Leucoagaricus americanus* tends to be larger, has reddish brown cap scales, and usually fruits on wood chips. Two other red stainers, the Shaggy Parasol, *Chlorophyllum rhacodes* (not illustrated), and *Chlorophyllum subrhacodes* (see Color Key), also have darker cap scales and are described in Comments under *Chlorophyllum molybdites*. That poisonous species has greening gills and a gray-green spore print. The edible Parasol, *Macrolepiota procera*, has nonstaining flesh.

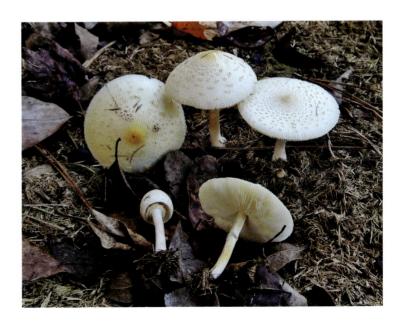

Chlorophyllum molybdites (G. Mey.) Massee

= *Lepiota molybdites* (G. Mey.) Sacc.

COMMON NAME: Green-spored Lepiota

MACROSCOPIC FEATURES: cap 7–40 cm wide, egg-shaped, then broadly convex with or without an umbo, dry, smooth and white at first but developing a pinkish brown to cinnamon central patch and large scales over a white background. Young cap margins retain wisps of partial veil. **gills** free, close, white, bruising brownish, eventually turning dingy green. **stalk** 5–25 cm long and 1–2.5 cm wide, equal, dry, white before darkening to grayish brown, sometimes staining reddish brown, hollow. The thick partial veil is double-edged and moveable on the stalk, white, or brownish underneath. **flesh** white, may bruise reddish brown; odor and taste not distinctive.

MICROSCOPIC FEATURES: Spores 9–13 × 6–9 μm, broadly ellipsoid with an apical pore, smooth, hyaline, dextrinoid.

SPORE PRINT: Gray-green.

HABIT, HABITAT, AND SEASON: Scattered, in groups or fairy rings in grassy areas; summer–early winter.

EDIBILITY: Poisonous.

COMMENTS: This species is a big reason why beginning mushroom hunters shouldn't gamble on cooking what they think is *Macrolepiota procera*. Other look-alikes include *Chlorophyllum subrhacodes* (see Color Key), a woodland species with cap diameters of 7–10 cm. Cap scales are reddish brown and flattened. The white gills eventually turn light brown. The flesh stains pinkish orange. Spores are white, 7–11 × 5–8 μm. The Shaggy Parasol, *Chlorophyllum rhacodes* (not illustrated), strongly resembles *Chlorophyllum subrhacodes* but typically fruits in grassy or disturbed areas, wood chips, or conifer needles. Caps are 5–20 cm with raised scales and notably shaggy margins. Spores are white, 6–13 × 5–9 μm. The ingestion of *Chlorophyllum molybdites* often causes gastrointestinal distress severe enough to require rehydration in a hospital.

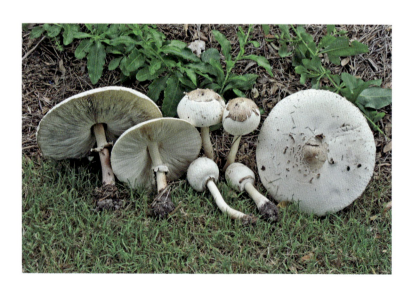

Chroogomphus vinicolor (Peck) O. K. Mill.

= *Gomphidius vinicolor* Peck

COMMON NAME: Wine-cap Chroogomphus

MACROSCOPIC FEATURES: cap 2–8 cm wide, convex or obtuse, sometimes with a small umbo, smooth, sticky when fresh, shiny when dry, colors range from vinaceous red to orange-red or yellow-brown, often aging to dark vinaceous red; the margin is incurved well into maturity. **gills** decurrent, subdistant to distant, at first buff to pale orange, becoming dull ochraceous, then smoky brown. **stalk** 5–10 cm long and 6–20 mm thick, tapered downward, dry, nearly smooth, pale ochraceous to orange-buff or vinaceous red; partial veil fibrillose, pale ochraceous, sometimes leaving a thin layer of fibrils on the upper portion of the stalk. **flesh** initially orange, fading to ochraceous buff or pale salmon in age; odor and taste not distinctive.

MICROSCOPIC FEATURES: Spores 17–23 × 4.5–7.5 μm, subfusiform, smooth, smoky brown; cystidia cylindric with thickened walls.

SPORE PRINT: Smoky gray to blackish.

HABIT, HABITAT, AND SEASON: Scattered or in groups on the ground or among mosses under conifers, especially pines; fall–early winter.

EDIBILITY: Edible.

COMMENTS: The epithet *vinicolor* means "having wine red color." The Brownish Chroogomphus, *Chroogomphus ochraceus* (see Color Key), edible, grows in the same habitat and can be macroscopically indistinguishable. Its sticky cap is 2–10 cm wide, obtuse to convex, with or without a small umbo, dull orange- to ochraceous brown. Gills are decurrent, close or subdistant, pale ocher aging to pale cinnamon brown. The stalk tapers downward and is ochraceous buff to tawny orange, sometimes with a thin layer of fibrils on the upper portion. Flesh is pale salmon to pale ochraceous. Spores measure 14–22 × 6–7.5 μm, and the cystidia are cylindric with thin, not thickened, walls. In some older American mushroom guides, *Chroogomphus rutilus*, a European species, is used instead of *Chroogomphus ochraceus*.

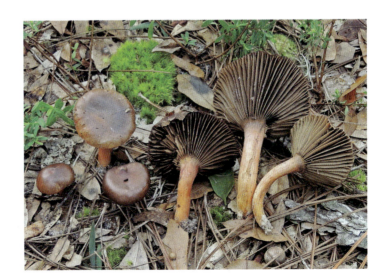

Clitocybe peralbida Murrill

MACROSCOPIC FEATURES: cap 2–5.5 cm wide, convex to depressed or funnel-shaped, dry, milk white, finely powdery. The cap margin is incurved at first but soon uplifted and often wavy. **gills** decurrent, distant, forking, edges fimbriate, white but yellowish when dry. **stalk** 2–3 cm long and 2–6 mm thick, equal, dry and smooth, white or slightly yellowed. The base is directly inserted into substrate wood. No partial veil. **flesh** white and unchanging; odor not distinctive, taste sweet but becoming bitter and mawkish.
MICROSCOPIC FEATURES: Spores 4–6 × 2–4 μm, ellipsoid, smooth, hyaline.
SPORE PRINT: White.
HABIT, HABITAT, AND SEASON: Loosely grouped on decaying broadleaf wood; summer.
EDIBILITY: Unknown.
COMMENTS: The epithet *peralbida* means "white throughout." This is an uncommon or often overlooked species in southern Georgia. According to Bigelow (1982), it may be the only *Clitocybe* with toothed gill edges, a feature caused by prominent cheilocystidia rather than gill erosion. Since these "teeth" are very small, a better term for this sort of fringed edge is "fimbriate." *Clitocybe peralbida* also differs from many other Clitocybes by fruiting directly on logs. It could be confused with the smaller *Marasmiellus candidus* (not illustrated), which fruits gregariously on sticks. The thin, white caps are 6–35 mm wide, flat to depressed, dry and finely hairy. Gills are attached to subdecurrent, distant and crossveined. The stalks are 4–20 mm long and about 1 mm thick, white and smooth at first but browning and becoming hairy from the base upward. Spores are white, 10–19 × 3.5–6 μm, long-ellipsoid, with a stretched apicular end, smooth, hyaline, and inamyloid.

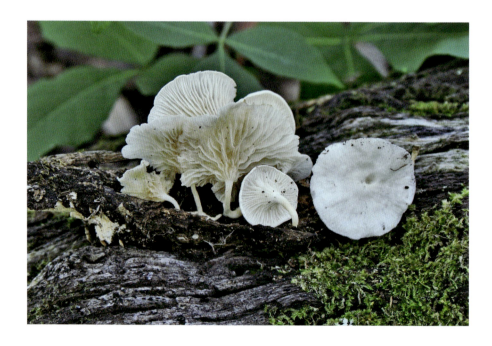

Clitopilus prunulus (Scop.) P. Kumm.

COMMON NAMES: Sweetbread Mushroom, The Miller

MACROSCOPIC FEATURES: cap 3–12 cm wide, convex to nearly flat, often centrally depressed; surface dry and suede-like, whitish to pale gray. The young margin is inrolled and typically becomes wavy and irregular by maturity. **gills** decurrent, close, white, then pinkening. **stalk** 2.5–7.5 cm long and 3–15 mm wide, often eccentrically located, equal or enlarging downward, dry, colored like the cap, solid. No partial veil. **flesh** white and unchanging; odor and taste farinaceous.

MICROSCOPIC FEATURES: Spores 9–12 × 4–7 µm, elliptic with longitudinal ridges in end view that give a 6-angled appearance, hyaline, inamyloid.

SPORE PRINT: Salmon pink.

HABIT, HABITAT, AND SEASON: Solitary to loosely grouped on the ground in open woods or grassy verges; summer–fall.

EDIBILITY: Edible with caution.

COMMENTS: Here's a species best avoided by inexperienced mushroom cooks. The dangerously poisonous *Entoloma subsinuatum* (not illustrated), like its highly toxic European counterpart, *Entoloma sinuatum*, has a strongly farinaceous odor. It looks similar except for the satiny cap texture and attached, not decurrent, yellowish gills, which soon develop a pinkish cast. Spores are 7–8.5 × 6.5–8 µm and 5–7-angled. The edible Anise-scented Clitocybe, *Clitocybe odora* (see Color Key), often fades to pale gray, and the pleasant anise scent may dissipate. The white gills are attached or subdecurrent. Spores are cream to pale pink and smoothly ellipsoid, measuring 5–9 × 3.5–5 µm. See also *Entoloma abortivum*, another pink-spored look-similar.

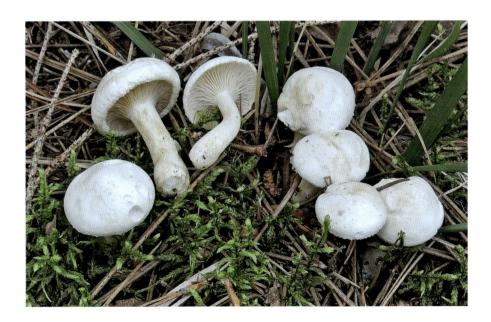

Connopus acervatus (Fr.) K. W. Hughes, Mather, & R. H. Petersen

= *Collybia acervata* (Fr.) P. Kumm.
= *Gymnopus acervatus* (Fr.) Murrill

COMMON NAME: Clustered Collybia
MACROSCOPIC FEATURES: **cap** 1–5 cm wide, convex, then flattening, often with a broad umbo, moist or dry, purplish brown to reddish brown or chestnut brown when moist, hygrophanous, becoming buff from the margin inward. The cap margin may be pale early on and is usually lined. **gills** attached, crowded, white to pinkish. **stalk** 2–12 cm long and 2–6 mm thick, equal, dry, colored like the cap, smooth, hollow. The base is a fused mass of stalks coated with whitish mycelium. No partial veil. **flesh** white, brittle; odor and taste not distinctive.
MICROSCOPIC FEATURES: Spores 5.5–7 × 2.5–3 μm, elliptic, smooth, hyaline, inamyloid.
SPORE PRINT: White to cream.
HABIT, HABITAT, AND SEASON: Densely clustered on conifer wood, which may be buried, or with sphagnum mosses in bogs; summer–fall.
EDIBILITY: Unknown.
COMMENTS: The massively fused base is a useful means of winnowing out other diagnostic possibilities among small mushroom species that fruit prolifically on dead conifer wood. *Xeromphalina campanella* is smaller and has a dimpled cap. *Mycena inclinata* is sticky and fruits on hardwoods.

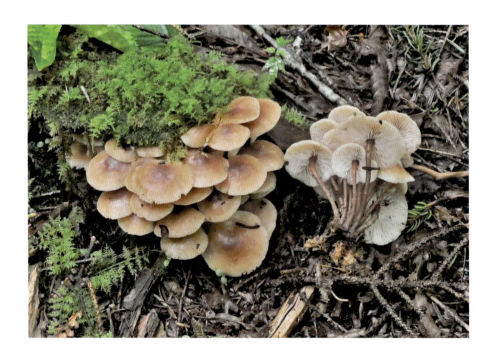

Coprinellus micaceus (Bull.) Vilgalys, Hopple, & Jacq. Johnson

= *Coprinus micaceus* (Bull.) Fr.

COMMON NAME: Mica Cap

MACROSCOPIC FEATURES: cap 2–6 cm wide, egg-shaped, then more convex, dry, tawny to honey-colored, darkest centrally, sprinkled with shiny granules that often wash off. The cap margin is striate at least halfway to the center and dissolves into inky goo with the underlying gills. **gills** attached or free, crowded, whitish before blackening and deliquescing. **stalk** 2–8 cm long and 2–6 mm thick, equal, dry and smooth or finely granular, white, hollow. No partial veil. **flesh** white; odor and taste not distinctive.

MICROSCOPIC FEATURES: Spores 7–11 × 4–7 μm, elliptic in one view, in the other, a truncated end gives a bishop's mitre appearance, apical pore present, blackish.

SPORE PRINT: Black ink.

HABIT, HABITAT, AND SEASON: Clustered on dead wood, which may be buried; early spring–fall.

EDIBILITY: Edible.

COMMENTS: This may be genetically the same as *Coprinellus truncorum* (not illustrated), which has plain elliptic spores. Two look-alike household horrors, *Coprinellus domesticus* (not illustrated) and *Coprinellus radians* (not illustrated), differ from each other in spore dimensions: 6–9 × 3.5–5 μm in the former and 8.5–12 × 5.5–7 μm in the latter. Both have yellowish, deeply grooved caps 2–3 cm wide, initially sprinkled with white to brownish warts, not shiny granules. They fruit on decaying hardwood and arise from a fuzzy orange mat or ozonium. The Fairy Bonnet, *Coprinellus disseminatus* (see Color Key), fruits, often massively, on decaying broadleaf wood. Caps are only to 2 cm, bell-shaped to convex, initially white but graying, and grooved almost to the center. Gills and caps don't deliquesce. Spores are ellipsoid, 6.5–10 × 4–6 μm.

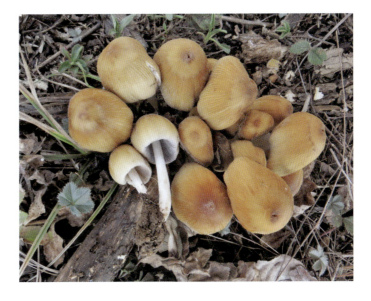

Coprinopsis variegata (Peck) Redhead, Vilgalys, & Moncalvo

= *Coprinus variegatus* Peck

COMMON NAME: Scaly Inkcap

MACROSCOPIC FEATURES: cap 2–7.5 cm wide and 5–8 cm tall, egg-shaped, becoming bell-shaped, dry, gray or brownish gray beneath a flaking coat of whitish to yellow-buff scales. Cap margin usually unlined but tatters and blackens as it deliquesces with the underlying gills. **gills** free, crowded, white before dissolving into black goo. **stalk** 4–12 cm long and 5–10 mm thick, equal, white, woolly below the ring, hollow. The base attaches to brown rhizomorphs. A woolly partial veil often leaves a ring low on the stalk. **flesh** tan; odor and taste not distinctive or unpleasant.

MICROSCOPIC FEATURES: Spores 7.5–10 × 4–5.5 μm, elliptic, smooth, with an apical pore, blackish.

SPORE PRINT: Black ink.

HABIT, HABITAT, AND SEASON: Clustered on or around decaying hardwood; late spring–fall.

EDIBILITY: Edible with caution.

COMMENTS: This species can cause skin flushing, headache, difficulty breathing, and nausea if alcohol is consumed at the same time or up to two days later. The culprit is coprine, which has effects similar to those of the alcohol deterrent drug disulfiram. The Alcohol Inky, *Coprinopsis atramentaria* (see Color Key), more commonly causes the same unpleasantness. Caps are brownish gray to gray, with few if any scales and a variably lined margin. Fruitings usually occur in grass near stumps or buried wood. *Coprinopsis lagopus* (not illustrated) also fruits on woody debris and has mature cap diameters only to 4 cm. The striate, gray to blackish caps are covered with silvery hairs that flake off in patches as the cap matures from bell-shaped to flat. Gills deliquesce. Spores are larger at 10–14 × 6–8.5 μm.

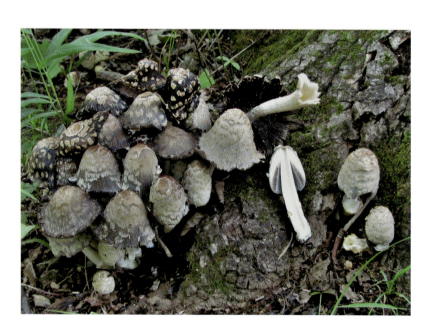

Coprinus comatus (O. F. Müll.) Pers.

COMMON NAME: Shaggy Mane

MACROSCOPIC FEATURES: cap 3–4.5 cm wide when young and up to 15 cm tall, cylindric at first, becoming much wider when deliquescing, conic to nearly flat, dry, whitish, covered with shaggy, white to pale brown scales. The cap margin blackens and deliquesces toward the center with the gills. **gills** free, crowded, white before dissolving into an inky mess. **stalk** 5–12.5 cm long and 1–2 cm wide, equal and smooth above a swollen base, white, hollow. The partial veil is a thin, white ring on the lower stalk. **flesh** white; odor and taste not distinctive.

MICROSCOPIC FEATURES: Spores 9–14 × 6–9 µm, ellipsoid, truncate, with an apical pore, smooth, purple-brown.

SPORE PRINT: Black ink.

HABIT, HABITAT, AND SEASON: Solitary to clustered on disturbed ground such as lawns, roadsides, or landscape wood chips; late spring–fall.

EDIBILITY: Edible if collected and cooked before it deliquesces.

COMMENTS: Fresh Shaggy Mane has a flavor resembling asparagus when steamed, but this rapidly deteriorates with the onset of deliquescence. *Coprinus sterquilinus* (not illustrated) resembles a miniature Shaggy Mane growing on manure, horse stall muck, or similar substrates. The young, cylindric caps reach a maximum height of 6 cm and a width up to 7 cm when deliquescing. Cap scales are smaller too. The stalk grays with age. Spores measure 16–22 × 10–13 µm and have a slightly eccentric, not central, apical pore.

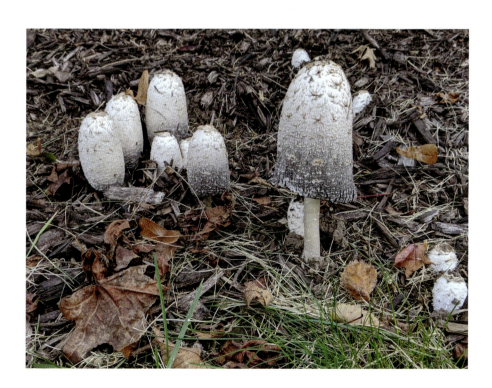

Cortinarius albidus Peck

= *Phlegmacium albidum* (Peck) M. M. Moser

MACROSCOPIC FEATURES: cap 5–11 cm wide, convex before almost flattening, sticky when moist, white underneath a layer of yellowish slime, smooth and shiny when dry. **gills** attached, close, white at first, passing through a cinnamon pink stage before turning rusty. **stalk** 4–8 cm long and 8–20 mm thick near the apex, expanding downward to a bulb, dry, white, solid. The bulb has a diameter to 3 cm, is usually set at a cockeyed angle to the stalk and vertically flattened, upper surface sometimes depressed and almost rimmed. The partial veil is a white cortina that sometimes leaves a few rusty fibers on the stalk. **flesh** white, firm, unchanging; odor and taste not distinctive or sweet-tasting.

MICROSCOPIC FEATURES: Spores 9–12 × 5–7 μm, elliptic, roughened, brown.
SPORE PRINT: Rusty brown.
HABIT, HABITAT, AND SEASON: Scattered, loosely grouped, or in clumps on the ground, usually under oaks or beeches; late summer–early winter.
EDIBILITY: Unknown.
COMMENTS: *Cortinarius* refers to the cobweb style of partial veil found in most mushrooms of this genus. *Albidus* means "white." Chunky white mushrooms are common under hardwoods. White-spored look-similars include *Leucopaxillus laterarius*, which rises from a dense mycelial mat rather than a bulb. White *Russula* species and milk mushrooms have relatively hard but crumbly flesh and lack a bulb. The edible *Hygrophorus subsordidus* (see Color Key) brings the slime but also misses the basal bulb.

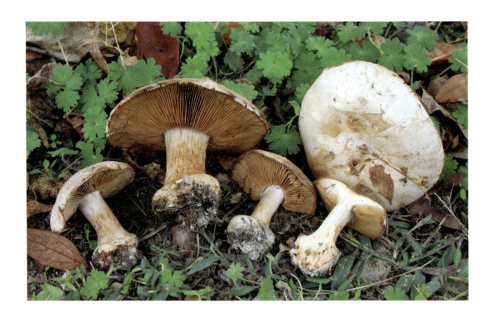

Cortinarius alboviolaceus (Pers.) Fr.

COMMON NAME: Silvery-violet Cort

MACROSCOPIC FEATURES: **cap** 3–9.5 cm wide, bell-shaped at first, then broadly convex, usually with a low umbo, dry, pale violet with a satin sheen due to a superficial layer of silvery fibrils that are remnants of a universal veil. The young cap margin is incurved for a long time. **gills** attached, close, initially violet, turning rusty. **stalk** 4–9 cm long and 0.5–1 cm thick near the apex, usually club-shaped, dry, pale violet, at first sheathed from base to cortina by a silvery layer of universal veil. The base is typically swollen with a diameter to 2 cm but not notably bulbous. Partial veil is a white cortina that usually leaves a few fibers hanging on the stalk to collect rusty spores. **flesh** pale violet; odor and taste not distinctive.

MICROSCOPIC FEATURES: Spores 7–10 × 4–6 µm, variably ellipsoid, roughened, brown.

SPORE PRINT: Rusty brown.

HABIT, HABITAT, AND SEASON: Solitary to gregarious on the ground under hardwoods, frequently birches; late summer–fall.

EDIBILITY: Reportedly edible, but not recommended.

COMMENTS: Many species of mushrooms with purplish gills occur in Georgia. Determining which is which requires assessment of multiple characteristics. *Cortinarius obliquus* (not illustrated) has an abrupt, flattened bulb set at a cockeyed angle to the stalk. *Cortinarius argentatus* has a bigger bulb. *Cortinarius camphoratus* and *Cortinarius pyriodorus* are mycorrhizal with conifers, not hardwoods, and have distinctive odors. The edible Blewit, *Lepista nuda*, is also similar but has a pinkish tan spore print.

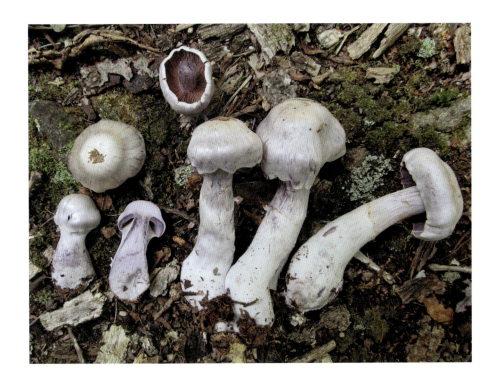

Cortinarius argentatus (Pers.) Fr.

MACROSCOPIC FEATURES: cap 5–9 cm wide, bell-shaped at first, then broadly convex, dry, silver violet and often tinged with brown in age, silky smooth. The cap margin is initially inrolled. **gills** attached, close, purple when immature, turning rusty. **stalk** 5–8 cm long and up to 1 cm thick near the apex, dry, club-shaped, pale violet, lacking a sheath below the ring zone, but may retain a coating of universal veil on the bulb. Partial veil a whitish cortina that usually leaves a rusty ring zone. **flesh** pale violet, unchanging when exposed; odor often not distinctive but radish-like on occasion, taste not distinctive.

MICROSCOPIC FEATURES: 7–9.5 × 5–6 μm, elliptic, roughened, brown.

SPORE PRINT: Rusty brown.

HABIT, HABITAT, AND SEASON: Solitary to scattered under hardwoods, especially oaks; summer–fall.

EDIBILITY: Unknown.

COMMENTS: In addition to the look-alikes mentioned in the Comments section of *Cortinarius alboviolaceus*, also consider the possibility of *Cortinarius cyanites* (not illustrated). It is distinguished by a darker and browner shade of purple and flesh that slowly stains a vinaceous shade of red when cut. Spores are longer at 9–11.5 × 5–6.5 μm. *Cortinarius violaceus* is a still darker shade of violet in youth and has a scruffy cap. If the cap and stalk fade toward white but the gills remain purple, it could be the white-spored *Laccaria ochropurpurea* (see Color Key), which lacks a partial veil and has spiny, globose spores measuring 7–9 μm.

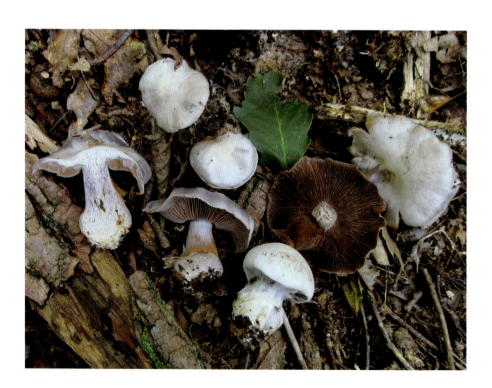

Cortinarius armillatus (Fr.) Fr.

COMMON NAME: Bracelet Cort

MACROSCOPIC FEATURES: cap 5–15 cm wide, bell-shaped, then broadly convex, dry or moist without stickiness, burnt orange to reddish brown with some radial streaking, nearly smooth to faintly hairy or scaly, especially at the center. **gills** attached, close or almost distant, dull and dirty yellowish to pale brown, then turning rusty. **stalk** 5–15 cm long and 1–2.5 cm thick, dry, typically club-shaped or nearly equal above a small bulb, silky white to pale brown overlain by a few irregular bands of reddish universal veil tissue. The partial veil is a white cortina usually leaving a rusty ring around the upper stalk. **flesh** white to brownish, unchanging when bruised; odor not distinctive or like radish, taste not distinctive or slightly bitter.

MICROSCOPIC FEATURES: Spores 7–12 × 5–7 μm, ellipsoid to amygdaliform, roughened, brown.

SPORE PRINT: Rusty brown.

HABIT, HABITAT, AND SEASON: Single to scattered, often with birches; summer–fall.

EDIBILITY: Edible but poorly regarded.

COMMENTS: The epithet *armillatus* translates helpfully to "bracelets." The cap of the smaller *Cortinarius bolaris* (see Color Key) is covered with orange scales over a lighter background, and the stalk features a denser arrangement of orange chevrons or irregular orange rings over a whitish background. A drop of KOH on the cap of *Cortinarius armillatus* causes a black reaction, but orange areas on the stalk turn purple.

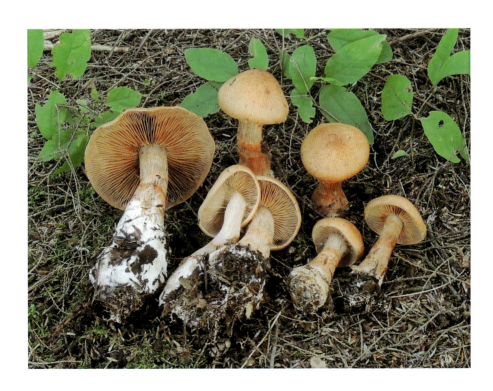

Cortinarius camphoratus (Fries) Fries

MACROSCOPIC FEATURES: **cap** 3–10 cm across, hemispheric at first, then becoming broadly convex to flat, sometimes with a low umbo, dry and smooth, pale lilac with a silvery fibrillose sheen in youth but soon developing golden tones that spread from the center. The cap margin is initially inrolled. **gills** are attached, close or subdistant, initially violet, then shades of dull brown to cinnamon brown. **stalk** 4–10 cm long and 1–2.5 cm thick, usually club-shaped, dry, pale lilac, then yellowish, sheathed from base to cortina with white fibrils of universal veil. The partial veil is a white cortina leaving a thin ring zone on the stalk. **flesh** lilac when young, especially in the cap, yellowing upward from the base; odor distinct and unpleasant but variably described as goat cheese, rotting vegetables, or raw potatoes, taste unpleasant.

MICROSCOPIC FEATURES: Spores 8.5–11.5 × 5–6.5 µm, amygdaliform to elliptic, roughened, brown.

SPORE PRINT: Rusty brown.

HABIT, HABITAT, AND SEASON: Uncommon in Georgia, typically associated with spruces or firs; late summer–fall.

EDIBILITY: Allegedly edible but not recommended.

COMMENTS: In Europe this widespread inhabitant of conifer forests is known as the Goat Cheese Webcap. In Georgia it resembles *Cortinarius pyriodorus* and *Cortinarius traganus* (not illustrated), both of which—if they are different—occur with conifers and have distinctive odors. *Cortinarius traganus* is said to smell like acetylene and has yellowish flesh from the beginning and slightly smaller spores at 7.5–10 × 5–6 µm.

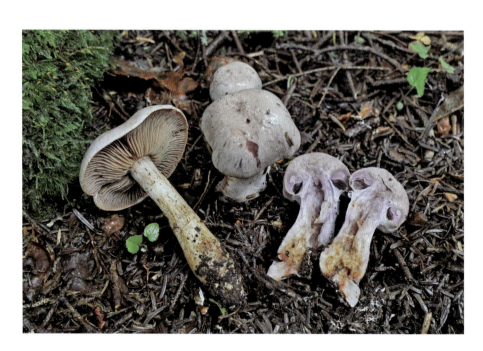

Cortinarius caperatus (Pers.) Fr.

= *Rozites caperatus* (Pers.) P. Karst.

COMMON NAME: Gypsy

MACROSCOPIC FEATURES: cap 5–15 cm wide, egg-shaped in the button, then broadly convex with a low umbo, moist or dry but not sticky, yellowish brown, often slightly wrinkled, covered initially with a thin, white membrane or powder of universal veil that persists longest centrally. **gills** attached, close, off-white becoming rusty at maturity. **stalk** 5–13 cm long and 1–2.5 cm thick, nearly equal above a base that may be swollen, dry, off-white to light tan, solid. The thick partial veil is membranous, white, and persisting at midlevel on the stalk. **flesh** white and not changing; odor and taste not distinctive.

MICROSCOPIC FEATURES: 10–15 × 7–10 μm, amygdaloid, roughened, brown.

SPORE PRINT: Rusty brown.

HABIT, HABITAT, AND SEASON: Scattered or in loose and sometimes large groups on the ground, more commonly under conifers than broadleaf trees; late summer–fall.

EDIBILITY: Edible with caution.

COMMENTS: Other southeastern corts with similar cap and stalk colors lack the distinctive partial veil. *Cortinarius mucosus* (see Color Key) is smaller and slimy and has narrower spores, 11–17 × 5–7.5 μm. *Cortinarius sphaerosporus* = *Cortinarius delibutus* (not illustrated) is also smaller and sticky. It has lilac gills at first and small subglobose spores, 6–7.5 × 5–6.5 μm. *Cortinarius vibratilis* is intensely bitter. Of equal concern for misidentification are species with membranous veils in other genera, such as *Amanita spreta*. Be very certain of the ID before firing up a skillet.

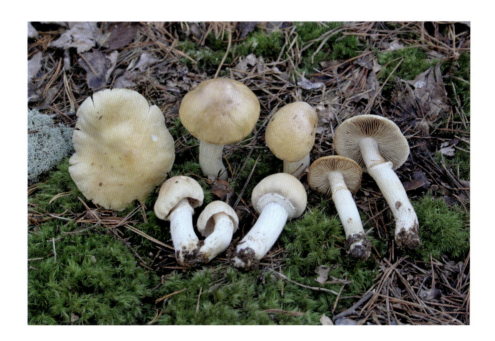

Cortinarius corrugatus Peck

COMMON NAME: Wrinkled Cort
MACROSCOPIC FEATURES: cap 3–10 cm wide, initially conical to bell-shaped but becoming broadly convex, usually with a small umbo, slimy at first, later sticky when moist, some shade of yellowish brown, orange-brown, or reddish brown, strongly radially wrinkled almost to the center. **gills** attached, close, pale lilac gray, becoming rusty. **stalk** 5–12 cm long and 6–20 mm thick, equal above the bulb, whitish to pale yellowish brown and staining rusty brown, hollowing. The bulb is small and abrupt, often coated with slime. Partial veil is a thin cortina leaving little or no trace on the stalk. **flesh** white, staining yellowish when exposed; odor and taste not distinctive.
MICROSCOPIC FEATURES: Spores 10–15 × 7–10 µm, ellipsoid to amygdaliform, roughened, brown.
SPORE PRINT: Rusty brown.
HABIT, HABITAT, AND SEASON: Scattered or in groups on the ground under hardwoods such as oaks or beeches; summer–fall.
EDIBILITY: Unknown.
COMMENTS: *Psathyrella delineata* (see Color Key) looks much the same but grows on decaying hardwood. It has smooth spores, measuring 6.5–9 × 4.5–5.5 µm, and unusual pleurocystidia that contain 1 or 2 large oil drops. These microscopic features have led some mycologists to synonymize it with the European *Typhrasa gossypina* (not illustrated). However, that species lacks a strongly wrinkled cap and has not been compared molecularly to our *Psathyrella delineata*. *Typhrasa delineata* group has recently been proposed as a new name for *Psathyrella delineata*. Another potential source of confusion is *Cortinarius distans* (see Color Key). The cap is moist but not sticky, with a finely scaly rather than wrinkled cap. Gills are distantly spaced, and the base is not abruptly bulbous. Spores are smaller as well, at 7–9 × 5–6 µm. The odor is slightly of radish or peanut butter or not distinctive.

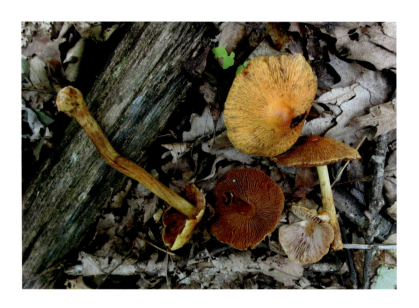

Cortinarius iodeoides Kauffman

COMMON NAME: Bitter Spotted Cort
MACROSCOPIC FEATURES: cap 2–5 cm wide, convex at first, then broadly convex, slimy and smooth, deep lilac to purple, usually with irregular yellow blemishes, yellower overall at maturity. **gills** attached, close, initially purple, then rusty brown. **stalk** 2–6.5 cm long and up to 1 cm thick, club-shaped, white under a purplish coat of slime. The partial veil is a pale purplish cortina that often leaves a rusty ring on the stalk. **flesh** pale purple to whitish; odor radish-like or not distinctive, cap slime bitter.
MICROSCOPIC FEATURES: Spores 7–8 × 4–5 μm, ellipsoid, roughened, brown.
SPORE PRINT: Rusty brown.
HABIT, HABITAT, AND SEASON: Scattered on the ground under oaks or other hardwoods, often in damp woods; late summer–fall.
EDIBILITY: Unknown.
COMMENTS: The more familiar Spotted Cort, *Cortinarius iodes* (not illustrated), is macroscopically identical except for the mild-tasting cap slime. It has larger spores, 8–10 × 5–6.5 μm. *Cortinarius collinitus* (not illustrated) shares the thick coat of purple slime but has a brown cap. The spores are still larger at 12–16.5 × 6.5–8 μm. *Inocybe lilacina* is a merely sticky look-alike with a spermatic odor. *Mycena pura* often smells like radish. The cap may be moist but isn't sticky, tends more toward pink than purple, has white gills, and produces white spores. *Laccaria amethystina* is smaller, dry, usually centrally dimpled, and white-spored.

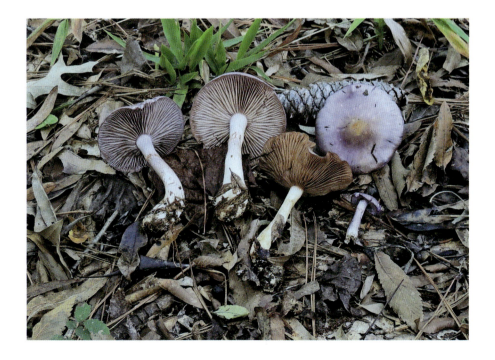

Cortinarius lewisii O. K. Miller

= *Cortinarius alboluteus* Lebeuf, Andre Paul, Liimat., Niskanen, & Ammirati

MACROSCOPIC FEATURES: cap 2.5–7.5 cm wide, becoming widely convex to nearly plane at maturity, with a broad umbo when mature; surface dry, with tiny appressed scales, bright orange-yellow to yellow; margin incurved at first, yellow to apricot yellow. **gills** notched to narrowly attached, close, narrow, whitish at first, becoming yellowish and finally rusty brown at maturity. **stalk** 4–10 cm long and 3–12 mm wide, nearly equal or somewhat enlarged downward, solid or hollow, dry, fibrillose, white to creamy white, with white basal mycelium; partial veil dense, white in the button stage but soon yellow, leaving a bright yellow ring near the apex that typically becomes 1 to several partial or complete, yellow, annular ring zones on the stalk of mature specimens. **flesh** firm, deep buff; odor musky to radish-like, taste not distinctive.

MICROSCOPIC FEATURES: Spores 6–7.5 × 5–6 μm, subglobose to globose, warted, pale brown.

SPORE PRINT: Rusty brown.

HABIT, HABITAT, AND SEASON: Scattered or in groups in mixed pine and hardwood forests, usually near baygall communities; spring–fall.

EDIBILITY: Unknown.

COMMENTS: The dry, minutely squamulose, yellowish cap and whitish stalk with yellow ring zones are good field identification characters. It was named for Texas mycologist David Lewis, who discovered it in the 1970s.

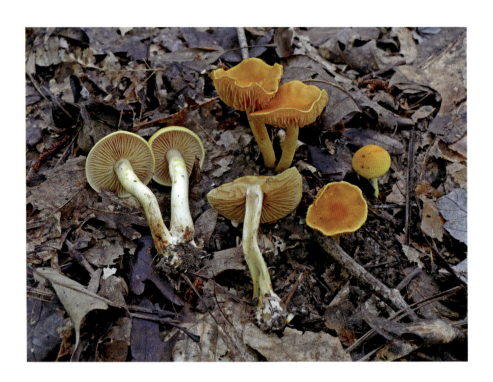

Cortinarius marylandensis (Ammirati)
Ammirati, Niskanen, & Liimat.

= *Dermocybe marylandensis* Ammirati

MACROSCOPIC FEATURES: **cap** 1–6 cm wide, bell-shaped at first, then flattening with a low umbo, dry, orange-red to brownish red, smooth or finely hairy. **gills** are attached, subdistant, cinnabar red, turning rusty at maturity. **stalk** 2–7 cm long and up to 1.5 cm thick, nearly equal, dry, colored like the cap at the apex, yellower near the base, hollow. No basal bulb. The partial veil is a reddish cortina sometimes leaving a ring on the stalk. **flesh** yellowish above, reddening near the base of the stalk; odor and taste radish-like or not distinctive.

MICROSCOPIC FEATURES: 6.5–9 × 4–5 μm, ellipsoid, slightly roughened, brown.

SPORE PRINT: Rusty brown.

HABIT, HABITAT, AND SEASON: Single or scattered on the ground under hardwoods, typically oaks or beeches; summer–fall.

EDIBILITY: Unknown.

COMMENTS: This is one of several small corts prized by fabric dyers. A drop of KOH on the cap produces a rose-colored stain that soon turns purple. *Cortinarius sanguineus* (not illustrated) is almost identical but associates with conifers. It has a redder reaction to KOH and roughened spores measuring 7–9 × 4–6 μm. The Red-gilled Cort, *Cortinarius semisanguineus* (not illustrated), has a silky to finely scaly, yellow-brown to cinnamon brown cap, sometimes with a prominent umbo. The usually crowded gills are blood red before turning rusty. The stalk is dull yellowish with a reddened base. It grows on the ground with conifers or in mixed woods. The ellipsoid spores are roughened and measure 5–9 × 3–6 μm. *Cortinarius hesleri* (see Color Key) is orange top to bottom in its prime. The KOH reaction is purple to blackish, and the coarsely roughened spores are slightly larger at 7.5–10 × 5–6.5 μm.

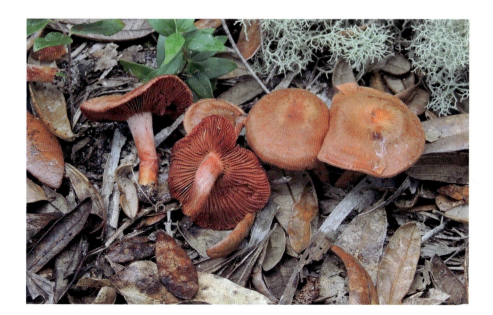

Cortinarius olearioides Rob. Henry

= *Cortinarius subfulgens* P. D. Orton

MACROSCOPIC FEATURES: cap 5–15 cm wide, convex at first, becoming broadly convex to nearly flat, sticky, smooth or finely hairy, bright yellow when young and fresh, becoming yellowish brown to orange-brown as it ages. **gills** are attached, close, bright yellow at first, turning rusty, then rusty brown at maturity. **stalk** 4–10 cm long and 1–2.3 cm thick on the upper portion, enlarged downward to a swollen basal bulb, dry, smooth or finely hairy, whitish to pale yellow when young, becoming darker yellow and discoloring brownish in age, typically coated with rusty fibrils as the spores mature. The partial veil is a dense, whitish cortina that sometimes leaves a ring zone on the stalk. **flesh** whitish to pale yellow; odor variously described as potato-like, slightly fruity or not distinctive, taste not distinctive.

MICROSCOPIC FEATURES: Spores 9–12 × 5–7 μm, lemon-shaped, coarsely warted, brown.

SPORE PRINT: Rusty brown.

HABIT, HABITAT, AND SEASON: Solitary, scattered, or in groups on the ground under hardwoods, typically oaks or beeches; summer–fall.

EDIBILITY: Unknown.

COMMENTS: The epithet *olearioides* means "resembling the color of olive oil," a reference to the color of the gills. Application of KOH to the cap surface gives a red reaction.

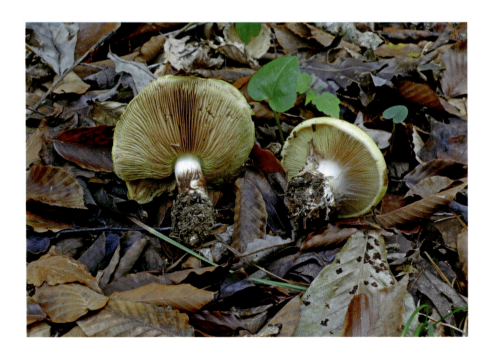

Cortinarius pyriodorus Kauffman

MACROSCOPIC FEATURES: cap 4–12 cm wide, bell-shaped at first, then broadly convex to nearly flat, sometimes with a low umbo, dry, pale violet with a satin sheen due to a superficial layer of silvery fibrils, soon fading toward buff. The young cap margin is incurved. **gills** attached, close or subdistant, initially violet, passing through a yellowish phase, then rusty. **stalk** 4–12.5 cm long and 1–1.2 cm wide near the apex, club-shaped or abruptly bulbous, dry, colored like the cap, browning when handled, solid. The base is slightly to abruptly bulbous with a diameter to 2.5 cm. The partial veil is a white cortina usually leaving a thin, rusty ring on the stalk. **flesh** in young specimens is lilac in the cap and upper stalk and yellowish below, yellowing further with maturity; odor of ripe pears, taste not distinctive or slightly bitter.

MICROSCOPIC FEATURES: Spores 7–10 × 4–6 μm, ellipsoid, roughened, brown.

SPORE PRINT: Rusty brown.

HABIT, HABITAT, AND SEASON: Solitary or scattered on the ground under conifers; late summer–fall.

EDIBILITY: Unknown.

COMMENTS: The status of *Cortinarius pyriodorus* is debated. Some mycologists lump it with the European species *Cortinarius traganus* (not illustrated), which is nearly identical in most respects. However, according to Brietenbach and Kränzlin (1984–1995), the European *Cortinarius traganus* has yellow gills at first, is yellow-fleshed throughout, and smells like acetylene, a gas with a garlicky odor at commercial grade. The original description of *Cortinarius pyriodorus* (Kauffman 1932) specifies lilac gills in youth, lilac flesh in the upper parts, and an odor of pear. Pending molecular analysis, the situation remains unresolved. Also consider the similar and unpleasantly odoriferous *Cortinarius camphoratus*.

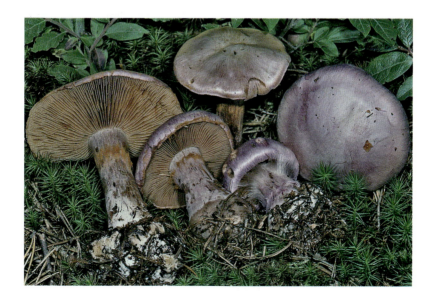

Cortinarius vibratilis (Fr.) Fr.

COMMON NAME: Slimy-bitter Cort
MACROSCOPIC FEATURES: cap 1.5–5 cm wide, hemispheric, then broadly convex, slimy to sticky, a shade of yellowish orange with a whiter cap margin, smooth. The young cap margin is not notably inrolled. **gills** attached, close, whitish or pale yellow, then rusty. **stalk** 3–7 cm long and 3–10 mm thick, nearly equal or club-shaped, white, slimy at first but drying. The base is often slightly bulbous but tapers on occasion. The partial veil is a white cortina often leaving a ring zone or rusty fibrils on the stalk. **flesh** white; odor not distinctive, slime or flesh intensely bitter.
MICROSCOPIC FEATURES: Spores 6–8.5 × 4–5.5 μm, ellipsoid, slightly roughened, brown.
SPORE PRINT: Rusty brown.
HABIT, HABITAT, AND SEASON: Single or scattered on the ground in a variety of damp woodland settings; late summer–fall.
EDIBILITY: Unknown.
COMMENTS: *Cortinarius vibratilis* may be a catchall for multiple species sharing the same general appearance and bitter taste. *Cortinarius limonius* = *Cortinarius luteus* (not illustrated) has a 3–8 cm wide, moist or dry, orange-brown to yellow cap, often with an obtuse umbo. The nearly equal orange-yellow stalk is longitudinally brownish fibrillose, indistinctly banded, solid when young, and hollow in age and often has whitish basal mycelium. It has close, yellow gills that become orange-yellow, then orange-brown as they mature and mild-tasting flesh. The elliptic to subglobose spores are finely warted and measure 7–9 × 5–6.5 μm. Also compare with *Cortinarius lewisii*.

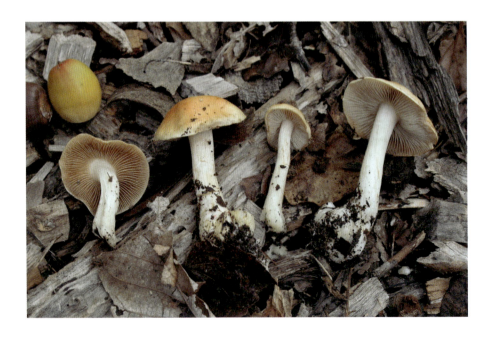

Cortinarius violaceus (L.) Gray

COMMON NAME: Violet Cort

MACROSCOPIC FEATURES: cap 4–12 cm broad, convex at first, opening to broadly convex or nearly flat, sometimes with a small umbo, dry, dark violet when young but transitioning to dark brown in age, covered with erect tufts of fibrils or scales that are colored like the background. The young cap margin is inrolled. **gills** attached, nearly distant, deep violet at first, darkening to almost black before turning rusty. **stalk** 6–16 cm long and 1–2.5 cm thick, enlarging slightly downward or club-shaped, dry, colored like the cap and covered with matted fibrils, solid before hollowing. The partial veil is a violet cortina that leaves a thin ring on the stalk. **flesh** dark violet to grayish violet, not changing when exposed; odor and taste not distinctive.

MICROSCOPIC FEATURES: Spores 12–17 × 8–10 μm, ellipsoid, roughened, brown.

SPORE PRINT: Rusty brown.

HABIT, HABITAT, AND SEASON: Solitary to loosely grouped on the ground under conifers; late summer–fall.

EDIBILITY: Reportedly edible, but not recommended.

COMMENTS: Collectors in southern Georgia should also be aware of *Cortinarius atrotomentosus* (not illustrated), a very similar species fruiting near Live Oaks. The stalk is olive brown to brownish gray with mauve flesh. Spores measure 10.5–13 × 7–8 μm. KOH stains the caps of both these species red. The cap of *Cortinarius cyanites* (not illustrated) is also brownish purple but thinly decorated with flattened scales or fibrils. Its violet flesh slowly develops vinaceous stains after exposure. Cap scales of the reddish brown to purplish brown *Cortinarius squamulosus* (see Color Key) are erect, but it has a large basal bulb and subglobose spores, 6–8 × 5–7 μm.

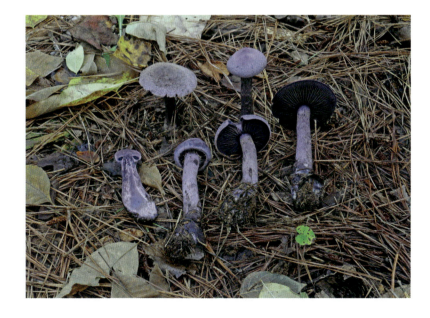

Crepidotus applanatus (Pers.) P. Kumm.

COMMON NAME: Flat Crep

MACROSCOPIC FEATURES: cap 1–4 cm wide, fan-shaped or like a flattish clamshell, moist or dry, white at first, becoming pale brown, hygrophanous, usually finely hairy at the point of attachment but otherwise bald. Young cap margins often translucent-striate. **gills** attached, close or crowded, radiating from the point of attachment, narrow, white, maturing to light brown. Stalkless. **flesh** brownish and squishy-watery; odor and taste not distinctive.

MICROSCOPIC FEATURES: Spores 4–5.5 μm, globose, minutely spiny, brown.

SPORE PRINT: Brown.

HABIT, HABITAT, AND SEASON: In groups or overlapping clusters on decaying broadleaf wood or rarely on conifers; summer–early winter.

EDIBILITY: Unknown.

COMMENTS: *Applanatus* means "flat." Combinations of characteristics are usually required to distinguish one *Crepidotus* from another. *Crepidotus malachius* (not illustrated) is white and bald except at the attachment point but has broad gills, looks humped or peaked rather than flat, and has larger globose spores at 5–7.5 μm. *Crepidotus croceitinctus* (not illustrated) is relatively flat and hairy only near the point of attachment, but it is pale honey yellow and has broadly elliptic spores 5–6.5 × 4–5.5 μm. *Hohenbuehelia angustata* (not illustrated) is whitish to beige in color and fan- or shoehorn-shaped and has rubbery rather than squishy flesh. Its spores are white and subglobose and measure 3–5.5 μm. *Pleurotus pulmonarius* and related oyster mushrooms are larger and have a distinctive odor.

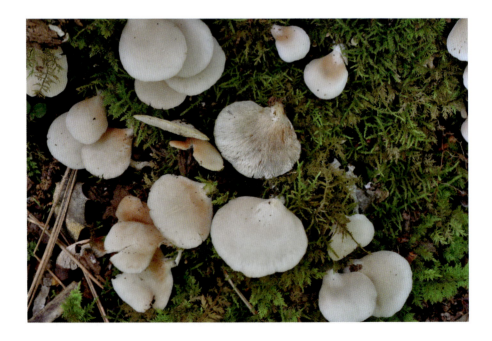

Crepidotus cinnabarinus Peck

COMMON NAME: Cinnabar Oysterling

MACROSCOPIC FEATURES: cap 5–15 mm wide, shell- to fan- or kidney-shaped, convex and flattening at maturity, dry, usually hairy but may be smooth, bright red. **gills** attached, fairly distant and broad, radiating from a narrow attachment point, gill edges red, faces yellow to red, browning with age. Stalkless. **flesh** thin, pale; odor and taste not distinctive.

MICROSCOPIC FEATURES: Spores 6–10 × 5–6 μm, ovoid, punctate or finely warted, pale brown.

SPORE PRINT: Brown.

HABIT, HABITAT, AND SEASON: Solitary or in small groups on decaying broadleaf wood; summer–early fall.

EDIBILITY: Unknown.

COMMENTS: The epithet *cinnabarinus* means "having red pigment." *Crepidotus nyssicola* (not illustrated), edibility unknown, has a 3–6 cm wide, smooth or finely hairy, whitish or pale purple cap with dark purple lines. It is deeply depressed with an arched margin when young and becomes simply depressed or vase-shaped as it ages. The cap sometimes bruises reddish brown, and the margin is faintly striate when moist. Gills are decurrent, close, and white before browning at maturity. The stalk is central or eccentric, white to pallid, and covered with short downy hairs or fine scales. It has subglobose to globose, minutely spiny, brown spores that measure 5–7 × 5–6 μm and grows on rotting broadleaf or conifer logs. *Hohenbuehelia petaloides* (not illustrated), edible, is similar to *Crepidotus nyssicola* and may appear to be vase-shaped but usually takes the form of a rolled shoehorn with a lateral stalk. It often fruits on the ground adjacent to rotting wood. The beige to pale brownish caps have diameters to 7 cm. Gills are decurrent, close or crowded, whitish before yellowing. Stalks blend imperceptibly into the lower cap. The flesh is rubbery and farinaceous. Spores are white, 5–9 × 3–5 μm.

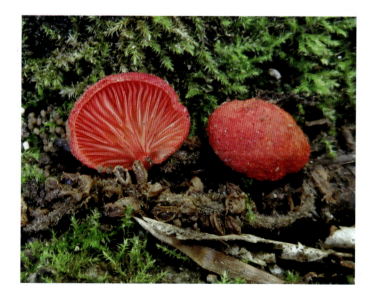

Crepidotus mollis (Schaeff.) Staude

COMMON NAME: Jelly Crep

MACROSCOPIC FEATURES: cap 1–5 cm wide, semicircular to fan-shaped, moist or dry, whitish under a coat of tan to orange-brown hairs or tiny scales but occasionally nearly bald, hygrophanous. The cap margin is faintly striate. **gills** decurrent, close or crowded, of variable width, radiating from the attachment point, whitish before browning. **stalk** stubby to absent. **flesh** whitish and squishy-watery; odor not distinctive, taste not distinctive or bitter.

MICROSCOPIC FEATURES: Spores 7–10 × 4.5–6 µm, ellipsoid, smooth, brown.

SPORE PRINT: Yellowish brown.

HABIT, HABITAT, AND SEASON: Scattered or in overlapping clusters on decaying broadleaf wood, including branches; summer–fall.

EDIBILITY: Generally considered inedible for unknown reasons.

COMMENTS: Hairy species of *Crepidotus* are numerous. *Crepidotus crocophyllus* (not illustrated) could be a Jelly Crep but for the yellow to orange gills in youth and globose spores at 4.5–8 µm. The smaller, 5–15 mm, bright red, hairy, and stalkless cap of *Crepidotus cinnabarinus* is diagnostic, even before noticing the distant pink gills with bright red edges. Only slightly larger, with caps to 25 mm wide, is the reddish brown but blackening *Anthracophyllum lateritium* (see Color Key). Caps are nearly bald but often wrinkled. Gills are reddish brown and blacken in age. The white spores measure 9.5–15 × 5.5–8 µm. It grows grouped or clustered on hardwood, especially oaks, and occurs year-round. *Hohenbuehelia mastrucata* is gray, rubbery, and covered in gelatinous spines.

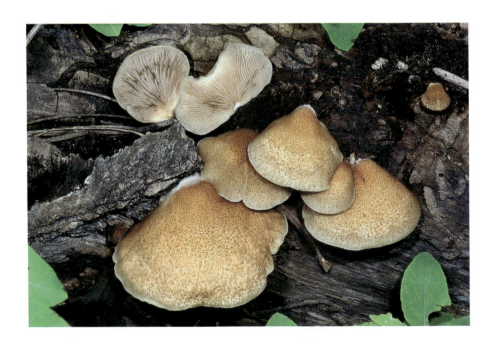

Crepidotus versutus (Pk.) Sacc.

COMMON NAME: Evasive Agaric
MACROSCOPIC FEATURES: cap 5–25 mm wide, flat against the substrate at first, then reflexing to develop a kidney-, fan-, or roundish-shaped cap attached dorsally or laterally to the substrate, dry, white or pale gray, finely but densely covered with downy, white hairs. The cap margin is incurved. **gills** radiate from the point of attachment, nearly distant, white before browning at maturity. Stalkless or a tubercle attached eccentrically or laterally to the cap. **flesh** white and squishy-watery; odor and taste not distinctive.
MICROSCOPIC FEATURES: Spores 7–11 × 4.5–6 μm, ellipsoid, minutely speckled, yellowish to yellowish brown.
SPORE PRINT: Cinnamon brown.
HABIT, HABITAT, AND SEASON: Scattered or loosely clustered on the bark of fallen broadleaf branches or logs, often on the underside; late spring–fall.
EDIBILITY: Unknown.
COMMENTS: The epithet *versutus* means "clever," referring to the ability of this species to devise a properly oriented mushroom regardless of the angle of its food source. Charles Peck, who originally described the species, also dubbed it Evasive Agaric. The closely related *Crepidotus herbarum* (not illustrated) looks similar and sometimes occurs on stems of herbaceous plants. The spores are pale yellowish brown, pip-shaped to lanceolate, measuring 6–8 × 3–3.5 μm.

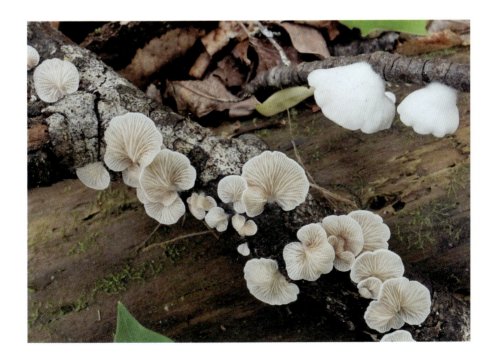

Cuphophyllus lacmus (Schumach.) Bon

= *Hygrocybe lacmus* (Schumach.)
 P. D. Orton & Watling
= *Hygrocybe subviolacea* (Peck)
 P. D. Orton & Watling

MACROSCOPIC FEATURES: cap 2–6 cm wide, broadly conical before flattening, with or without an umbo or central depression, slippery when wet, some shade of ashy gray to bluish gray to violet-gray, browner at the center, hygrophanous, smooth. The damp cap margin is translucent-striate. **gills** decurrent, distant, occasionally forked and commonly crossveined, pale gray to gray-violet. **stalk** 3–7 cm long and 4–12 mm thick, equal or tapering downward, often curved near the base, smooth and dry, not slippery, whitish or colored like the cap but paler, solid, then hollowing. Partial veil absent. **flesh** waxy, colored like the cap or paler; odor unpleasant, taste not distinctive at first but eventually bitter or acrid.

MICROSCOPIC FEATURES: Spores 6–8.5 × 4–7 μm, broadly elliptic to subglobose, smooth, hyaline, inamyloid.
SPORE PRINT: White.
HABIT, HABITAT, AND SEASON: Scattered or in loose groups on the soil, typically in damp woodlands or adjacent grass; summer–fall.
EDIBILITY: Unknown.
COMMENTS: *Cuphophyllus* refers to the curving, decurrent gills of mushrooms in this genus. *Lacmus* means "dark violet-blue." *Cuphophyllus colemannianus* (see Color Key) is of a similar size, build, cap slickness, spore size, and habitat, but reddish brown tones replace the blues and violets. Odor and taste are not distinctive. *Cantharellula umbonata* has crowded white gills that stain red. It also tastes better than *Cuphophyllus lacmus*.

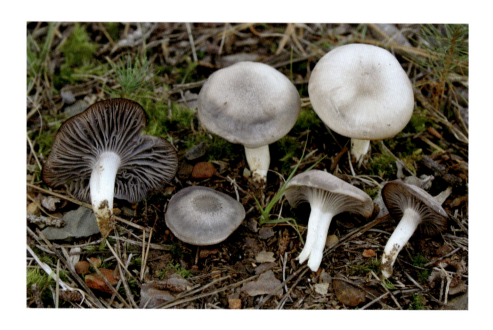

Cuphophyllus pratensis (Fr.) Bon

= *Hygrocybe pratensis* var. *pratensis* (Fr.) Murrill
= *Hygrophorus pratensis* (Fr.) Fr.

COMMON NAMES: Meadow Waxcap, Salmon Waxcap

MACROSCOPIC FEATURES: cap 2–7 cm wide, convex, becoming broadly convex, usually retaining a low umbo, moist or dry, a shade of orange, eventually fading to orange-yellow or tan, smooth or centrally cracked at maturity. The youthful cap margin is incurved and translucent-striate when wet. **gills** decurrent, subdistant or distant, commonly crossveined, whitish to pale orange. **stalk** 3–8 cm long and 5–20 mm thick, equal or tapering downward, often curved near the base, smooth and dry, whitish to pale salmon buff. Partial veil absent. **flesh** brittle for a waxcap, whitish to pale cinnamon; odor and taste not distinctive.

MICROSCOPIC FEATURES: Spores 5–8 × 3–5 μm, ellipsoid to subglobose, smooth, hyaline, inamyloid.

SPORE PRINT: White.

HABIT, HABITAT, AND SEASON: Solitary or in loose groups on the ground in damp woodland humus or grassy areas; late spring–fall.

EDIBILITY: Edible.

COMMENTS: A trio of similar miscreants, including the Salmon Waxcap, pretend membership in some other genus. The brittle flesh of *Cuphophyllus pratensis* is reminiscent of a *Russula*. *Russula earlei* has the thick, distant gills of a waxcap and appears to be crafted of slightly lumpy beeswax. The Russula-like Waxcap, *Hygrophorus russula*, has crowded, not distant, gills and a Russula-like pink, not orange, cap.

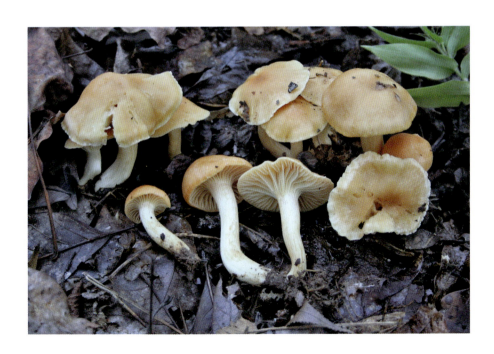

Cuphophyllus virgineus (Wulfen) Kovalenko

= *Hygrocybe virginea* (Wulfen) P. D. Orton & Watling

COMMON NAME: Snowy Waxcap
MACROSCOPIC FEATURES: cap 1–7 cm wide, initially convex, then flattening, often with a low umbo or central depression, moist or dry, white to pale cream-colored, smooth. The young cap margin is incurved and usually translucent-striate halfway to the center. **gills** decurrent, nearly distant, occasionally forking, white. **stalk** 2–12 cm long and 2–10 mm thick, nearly equal or tapering downward, round or laterally compressed, dry, white, smooth. No partial veil. **flesh** waxy, white; odor and taste not distinctive.
MICROSCOPIC FEATURES: Spores 6–9 × 4–6 µm, elliptic, smooth, hyaline, inamyloid.
SPORE PRINT: White.

HABIT, HABITAT, AND SEASON: Scattered or in groups on the ground in woodlands, on moss banks, or in grassy areas; summer–early winter.
EDIBILITY: Edible.
COMMENTS: The combination of macroscopic and habitat features is enough to separate the Snowy Waxcap from most other white mushrooms of modest size. *Clitocybe peralbida*, for instance, grows on wood. *Lactarius subvernalis* var. *cokeri* has close or crowded gills. Although *Cuphophyllus virgineus* is edible, there isn't much flesh on those slender bones. Compare with the larger, meatier, and notably sticky Dirty Southern Waxcap, *Hygrophorus subsordidus* (see Color Key). Caps are up to 10 cm wide, flat or depressed, sticky and usually encrusted with debris. The gills are white or tinged pinkish to pinkish orange, and the white spores measure 5.5–8 × 3–4 µm. It's a tasty species if you have the patience to clean it.

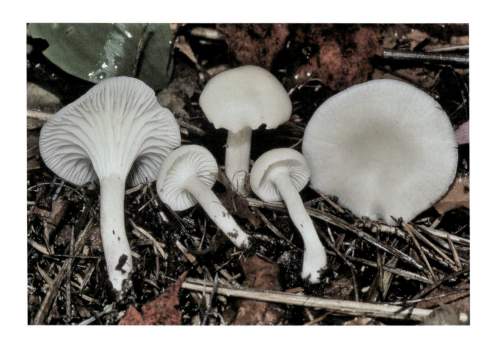

Cyptotrama asprata (Berk.) Redhead & Ginns

= *Cyptotrama chrysopepla* (Berk. & M. A. Curtis) Singer
= *Lepiota asprata* (Berk.) Sacc.

COMMON NAME: Golden Scruffy Collybia
MACROSCOPIC FEATURES: cap 5–25 mm wide, broadly convex at maturity, dry, golden to bright yellow, covered with similarly colored fine scales or granules and often wrinkling in age. The cap margin is sometimes translucent-striate. **gills** attached, becoming slightly decurrent, distant, white. **stalk** 1–5 cm long and 1–3 mm thick, equal above a swollen base, dry, yellow, decorated with golden granules or scales, solid. No partial veil. **flesh** relatively tough, yellowish; odor and taste not distinctive.
MICROSCOPIC FEATURES: Spores 8–12 × 6–7.5 µm, ovoid to lemon-shaped, smooth, hyaline, inamyloid.
SPORE PRINT: White.
HABIT, HABITAT, AND SEASON: Solitary to loosely grouped on decomposing branches, stumps, or logs, often oaks; summer–fall.
EDIBILITY: Unknown.
COMMENTS: These beautiful little mushrooms have yellow-capped look-similars that also occur on rotting hardwood. *Pluteus chrysophlebius* (see Color Key) has a smooth, yellow to greenish yellow cap and stalk. The initially white gills pinken and produce pink spores, 5–7 × 4.5–6 µm. *Pluteus flavofuligineus* (see Color Key) is slightly larger, with smooth, yellow or yellow-brown caps up to 7 cm wide. The stalk is white. Once again, the gills pinken and drop pink spores measuring 6–7 × 4.5–5.5 µm. The reportedly poisonous *Tricholomopsis decora* (see Color Key) decomposes conifer wood. See Comments under *Tricholomopsis formosa* for additional details.

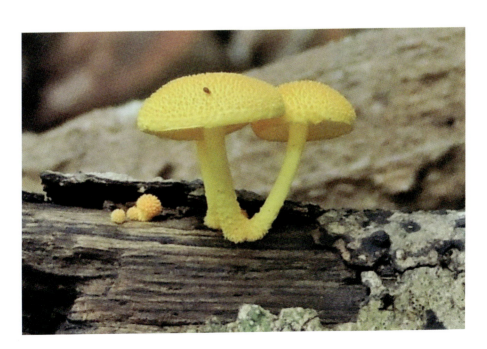

Desarmillaria caespitosa (Berk.) Antonin, J. E. Stewart, & Medel

COMMON NAME: Ringless Honey Mushroom
MACROSCOPIC FEATURES: cap 1–10 cm wide, convex becoming broadly convex, dry, some shade of yellow-brown or reddish brown, rarely yellow, scruffy with dark hairs or small scales that may be erect or flattened. **gills** subdecurrent, nearly distant, whitish but developing pinkish brown stains. **stalk** 5–20 cm long and 5–15 mm thick, tapering downward, dry, dirty white above, darkening toward cap color below, hairy near the base. The base is typically pinched due to clustered growth. No partial veil. **flesh** white to pale brown; odor not distinctive, taste not distinctive to bitter.
MICROSCOPIC FEATURES: Spores 8–10 × 5–7 μm, ellipsoid, smooth, hyaline, inamyloid.
SPORE PRINT: White to cream.

HABIT, HABITAT, AND SEASON: Usually clustered at or near the base of infected hardwoods, often oaks; summer–fall.
EDIBILITY: Edible if thoroughly cooked.
COMMENTS: Authors of most North American field guides have labeled illustrations of this species as *Desarmillaria tabescens* or *Armillaria tabescens*, a European species. The Ringless Honey Mushroom is a tree pathogen. The complete lack of a partial veil distinguishes it from *Armillaria* species found in Georgia. Since the woods are full of brown mushrooms, some of them catastrophically poisonous, match all characteristics, including spore color, before cooking. Although honey mushrooms are rated edible and enjoyed by many, some people suffer hours of rip-roaring intestinal distress after ingestion. Thorough cooking or parboiling before final cooking and disposing of the parboiling water reduce the frequency and severity of this unpleasantness.

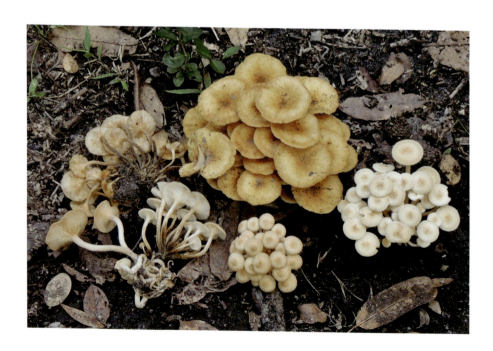

Entoloma abortivum (Berk. & M. A. Curtis) Donk

= *Clitopilus abortivus* (Berk. & M. A. Curtis) Sacc.
= *Pleuropus abortivus* (Berk. & M. A. Curtis) Murrill
= *Rhodophyllus abortivus* (Berk. & M. A. Curtis) Singer

COMMON NAME: Abortive Entoloma

MACROSCOPIC FEATURES: cap 3–10 cm broad, convex, with or without a low umbo or slight central depression, dry, pale gray or brownish gray, radially silky, fibrous or smooth in age. The cap margin is at first inrolled. **gills** attached to subdecurrent, close or crowded, pale gray before turning pink. **stalk** 2.5–10 cm long and 0.5–2 cm thick, nearly equal above a usually swollen base, dry, smooth to finely hairy, whitish or colored like the cap, solid. The base is typically coated with white mycelium. Partial veil absent. **flesh** white; odor and taste farinaceous.

MICROSCOPIC FEATURES: Spores 8–10 × 4.5–6.5 μm, mostly 6-angled, smooth, hyaline, inamyloid.

SPORE PRINT: Salmon pink.

HABIT, HABITAT, AND SEASON: Solitary to grouped on the ground, often near rotting stumps or wood; summer–fall.

EDIBILITY: Edible with caution due to potential confusion with poisonous *Entoloma* species.

COMMENTS: *Entoloma abortivum* fruits at the same time as honey mushrooms in the genera *Armillaria* and *Desarmillaria*, distorting them into edible bald, white to grayish irregular blobs. Known as "Shrimp of the Woods," they measure up to 10 cm in diameter and have streaky white and pinkish interiors and a pleasant farinaceous odor. The poisonous *Entoloma subsinuatum* (not illustrated) has a satiny, whitish or grayish cap up to 15 cm wide. Gills are pale yellow before pinkening. The odor is farinaceous. Spores measure 7–8.5 × 6.5–8 μm and are 5–7-angled.

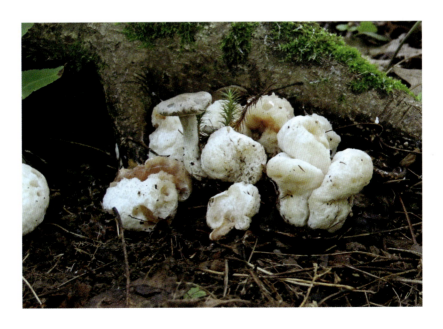

Entoloma conicum (Sacc.) Hesler

= *Nolanea conica* Sacc.

MACROSCOPIC FEATURES: cap 5–20 mm wide, conical with a small and rounded umbo, moist or dry, pale cinnamon to pinkish buff or grayish, whitened over the umbo, hygrophanous, covered with fibrils that may impart a silvery sheen. The cap margin extends slightly beyond the gills and is faintly translucent-striate when moist. **gills** nearly free, close or subdistant, whitish before pinkening. **stalk** 4–6 cm long and 1–2 mm wide, straight, equal, dry, chocolate brown with a smattering of white fibrils and white basal mycelium, hollow. Partial veil absent. **flesh** brittle, brownish; odor and taste farinaceous or not distinctive.

MICROSCOPIC FEATURES: Spores 8–11 × 6–8 μm, 4–5-angled, smooth, hyaline, inamyloid.

SPORE PRINT: Salmon pink.

HABIT, HABITAT, AND SEASON: Solitary to clustered in rich woodland humus or on moss banks, rarely on rotted wood; summer–early fall.

EDIBILITY: Unknown.

COMMENTS: Look-similars include larger and poisonous Entolomas. The Springtime Entoloma, *Entoloma vernum* (not illustrated), has a darker brown to gray-brown conical or bell-shaped cap measuring 2.5–6.5 cm wide. Spores differ mainly by being 5–7-angled. *Entoloma strictius* (see Color Key) is much like *Entoloma vernum* but fruits later and has larger spores at 10–13 × 7–9 μm, 5–6-angled. The longitudinal grooves on the stalks of these two species usually differ as well. The grooves in *Entoloma strictius* tend to spiral all the way up, while those in *Entoloma vernum* are relatively straight until just below the apex.

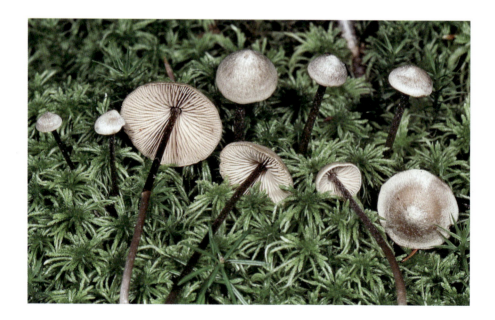

Entoloma quadratum (Berk. & M. A. Curtis) E. Horak

= *Inocephalus quadratus* (Berk. & M. A. Curtis) T. J. Baroni
= *Nolanea salmonea* (Peck) Pomerl.
= *Nolanea quadrata* (Berk. & M. A. Curtis) Sacc.

COMMON NAME: Salomon Unicorn Entoloma

MACROSCOPIC FEATURES: cap 1–5 cm wide, conical to bell-shaped with a pointed or nipple-like umbo, moist and slightly sticky or dry, salmon orange, yellowing somewhat with age and often developing greenish discolorations, smooth and shiny. The fresh cap margin is translucent-striate and sometimes scalloped. **gills** attached, nearly distant, salmon orange before pinkening. **stalk** 4–10 cm long and 2–6 mm thick, equal, dry, colored like the cap, with or without green tinges, smooth or cloaked in inconspicuous fibrils. The basal mycelium is white to pale orange. No partial veil. **flesh** brittle, orange; odor and taste not distinctive.

MICROSCOPIC FEATURES: Spores 8–12 µm, square, 4-angled, smooth, hyaline, inamyloid.

SPORE PRINT: Salmon pink.

HABIT, HABITAT, AND SEASON: Scattered to clustered in rich and often damp woodland soil; summer–fall.

EDIBILITY: Unknown.

COMMENTS: Salmon Unicorn Entoloma is abundantly blessed with Latin names that vary from author to author and change frequently. The same can be said of the Yellow Unicorn, *Entoloma murrayi* = *Inocephalus murrayi* = *Nolanea murrayi* (see Color Key). It is bright yellow throughout and has a nipple-like umbo. *Entoloma luteum* = *Inocephalus luteus* (not illustrated) has a merely conical, dull yellow-brown cap sometimes tinged with green. Its gills are initially whitish. The larger *Humidicutis marginata* var. *marginata* is orange and has orange gills. The flesh is waxy-watery, and spores are white.

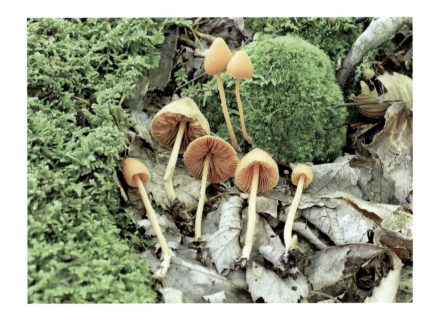

Entoloma serrulatum (Fr.) Hesler

= *Leptonia serrulata* (Fr.) P. Kumm.

COMMON NAME: Blue-toothed Entoloma

MACROSCOPIC FEATURES: cap 1–4 cm wide, convex with a central depression, dry, finely scaly at least centrally, dark blue to almost black, fading to pale violet-gray. The cap margin is sometimes striate nearly to the center. **gills** attached or subdecurrent, close, whitish to pale blue before pinkening, the edges are notably darker blue than the faces and minutely serrated at 10×. **stalk** 4–8 cm long and 2–3 mm thick, dry, equal or enlarging downward, sometimes flattened, the apex clothed with flattened fibers, smooth below, colored like the cap but whitened with mycelium at the base, hollow. No partial veil. **flesh** pale blue; odor and taste farinaceous or not distinctive.

MICROSCOPIC FEATURES: Spores 9–12 × 6–8 μm, 5–7-angled, smooth, hyaline, inamyloid.

SPORE PRINT: Salmon pink.

HABIT, HABITAT, AND SEASON: Solitary to gregarious on rich woodland soil, rotten wood, or mosses; summer–early fall.

EDIBILITY: Unknown.

COMMENTS: Interesting gill edges distinguish the Blue-toothed Entoloma and the slightly larger, velvet-capped *Entoloma velutinum* from a grab bag of other Entolomas with blue or purplish brown caps. *Mycena subcaerulea* (not illustrated) is a smaller wood rotter with a smooth and slippery robin's egg blue cap that browns in age and has a striate margin. Its gills are almost free, white to pale gray, without darker or serrated edges. The basal mycelium is blue when fresh. Spores are white, smooth, and subglobose, 6–8 μm.

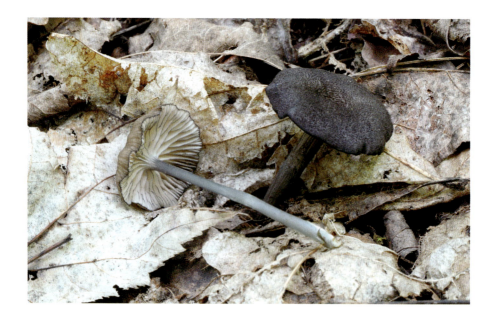

Entoloma velutinum Hesler

= *Leptonia velutina* (Hesler) Largent

MACROSCOPIC FEATURES: cap 3–8 cm wide, initially convex but uplifting and often vase-like or splitting by maturity, dry, velvety, at first royal blue to sooty gray or black, fading uniformly toward slate gray, the margin smooth. **gills** variably attached from free to slightly decurrent, close, pale violet-gray but pinkening, the edges dark blue and minutely serrated at 10×. **stalk** 4–9 cm long and 2–8 mm thick, dry, equal or enlarging downward, sometimes flattened, variably covered with flattened fibers, colored like the cap but with a white mycelial base, hollow. No partial veil. **flesh** pale blue; odor and taste farinaceous, tinny, or not distinctive.

MICROSCOPIC FEATURES: Spores 8–11 × 6–8 μm, 5–6-angled, smooth, hyaline, inamyloid.

SPORE PRINT: Salmon pink.

HABIT, HABITAT, AND SEASON: Solitary to gregarious on rich soil in deciduous or mixed woods or in grass at their edge; summer–early fall.

EDIBILITY: Unknown.

COMMENTS: This often spectacular *Entoloma* has been confused with the Blue-toothed Entoloma, *Entoloma serrulatum*, in some field guides, including our own, but the cap of that species is scaly near the center rather than a uniform field of velvet. *Entoloma velutinum* is known from the mountains of eastern Tennessee, western North Carolina, and the north central portion of Georgia. *Entoloma velutinum* was originally described by the renowned American mycologist L. R. Hesler (1888–1977) of the University of Tennessee, Knoxville.

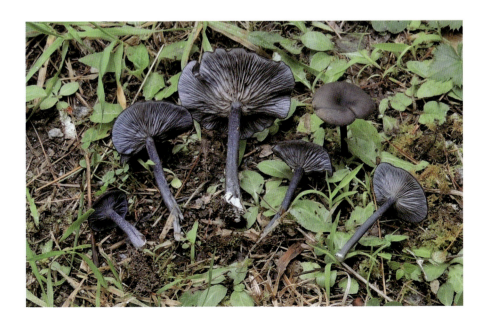

Flammulaster erinaceellus (Peck) Watling

= *Phaeomarasmius erinaceellus* (Peck) Singer
= *Pholiota erinaceella* (Peck) Peck

COMMON NAME: Powder-scale Pholiota
MACROSCOPIC FEATURES: cap 1–4 cm wide, convex before flattening, dry, yellow-orange under a coating of rusty brown granules or scales that fade toward yellow-brown in age. The young cap margin is hung with bits of white partial veil. **gills** attached, close or crowded, pale yellow at first, rusty at maturity. **stalk** 3–4 cm long and 2–5 mm thick, equal, dry, colored and scaly like the cap, but the scales may disappear by maturity. The partial veil is fibrous, white, briefly leaving a thin ring on the stalk. **flesh** yellow; odor not distinctive, taste vaguely bitter or metallic.
MICROSCOPIC FEATURES: Spores 6–8 × 4–4.5 µm, ellipsoid, smooth, brown, inamyloid.
SPORE PRINT: Cinnamon brown.
HABIT, HABITAT, AND SEASON: Solitary to gregarious on rotting hardwood; spring–fall.
EDIBILITY: Unknown.
COMMENTS: A drop of KOH on the cap produces a reddish stain. *Xeromphalina tenuipes* (see Color Key) has a similar KOH response, occurs in similar situations, and has a similarly colored, granular cap, diameter 2–7 cm, and yellow gills. The stalk is darker brown and hairy and lacks a partial veil. Spores are white. *Crinipellis zonata* (not illustrated) is smaller. The dimpled cap and stalk are densely covered by brown hairs. Gills and spores are white. The Decorated Pholiota, *Leucopholiota decorosa* (not illustrated), recycles both broadleaf and conifer wood. The 2.5–7 cm cap and stalk are dry and pale brown under darker brown scales. Gills and spores are white. The partial veil leaves a prominent ring on the stalk.

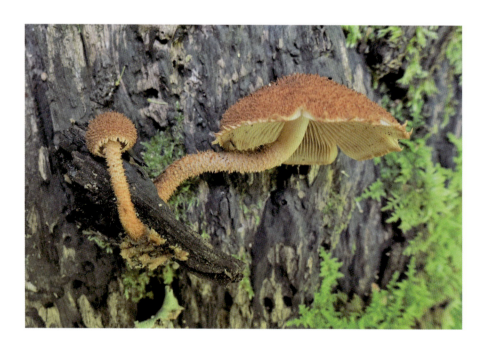

Flammulina velutipes (Curtis) Singer

COMMON NAME: Velvet Foot
MACROSCOPIC FEATURES: cap 1–7 cm wide, convex at first, then flattening, smooth and slimy or sticky, yellowish brown to orange-brown. The young cap margin is incurved and striate. **gills** attached or nearly free, close, whitish to pale yellow. **stalk** 2–11 cm long and 3–5 mm thick, equal or enlarging downward, occasionally with a long "taproot" extending into a crack or other gap in the substrate, dry, pale yellow and smooth above, transitioning to dark reddish brown and furry below, fibrous and very tough. No partial veil. **flesh** yellowish; odor and taste not distinctive.
MICROSCOPIC FEATURES: Spores 7–9 × 3–6 μm, elliptic, smooth, hyaline, inamyloid.
SPORE PRINT: White.

HABIT, HABITAT, AND SEASON: Scattered to clustered on dead broadleaf logs and stumps; fall–spring.
EDIBILITY: Cap edible. Stalks inedibly tough.
COMMENTS: A drop of KOH on the cap produces a red stain. Velvet Foot is the same mushroom as Enoke or Enotake. The vastly different appearance of the commercially produced product results from intentionally unnatural growing conditions. The truly deadly Deadly Galerina or Funeral Bell, *Galerina marginata* (see Color Key), is a potentially catastrophic look-alike. It also has a brown cap and a stalk that darkens below, and it fruits in cool weather, sometimes on the same logs. It usually retains a collapsed ring on the stalk and has brown spores. In other words, Velvet Foot is a dangerous edible for any but experienced hands, and they should inspect every mushroom individually before cooking.

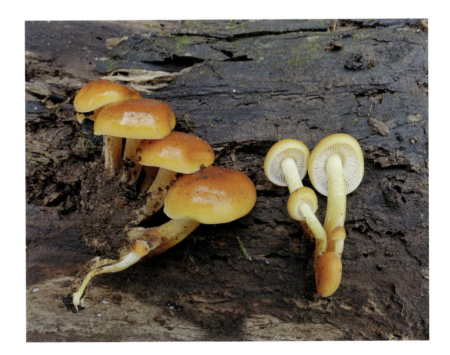

Gerronema strombodes (Berk. and Mont.) Singer

= *Chrysomphalina strombodes* (Berk. and Mont.) Clémençon
= *Omphalia strombodes* (Berk. and Mont.) Sacc.
= *Omphalina strombodes* (Berk. and Mont.) Murrill

MACROSCOPIC FEATURES: **cap** 2–10 cm broad, initially convex with an umbilicate center, soon funnel-shaped, tacky or dry, yellow or greenish yellow underneath a dense layer of brown to gray-brown radial fibers, paler toward the margin. The cap margin is incurved at first, later flaring and often ragged. **gills** decurrent, subdistant, pale yellow or greenish yellow. **stalk** 2–6.5 cm long and 3–8 mm wide, nearly equal, dry, paler than the cap, covered with white matted fibrils, hollow. Partial veil absent. **flesh** pale yellow; odor not distinctive, taste not distinctive or weakly bitter.

MICROSCOPIC FEATURES: Spores 7–9 × 4–5.5 µm, elliptic, smooth, hyaline, inamyloid.
SPORE PRINT: White.
HABIT, HABITAT, AND SEASON: In groups or clusters on rotting conifer or broadleaf wood; late spring–fall.
EDIBILITY: Edible.
COMMENTS: In colors ranging from gray-brown to pale lemon yellow, *Gerronema strombodes* can cause diagnostic headaches. The keys to separating it from *Pseudoarmillariella ectypoides* are the latter's scaly rather than flattened fibrillose cap surface and its growth on decaying conifer wood. *Lentinellus micheneri* has saw-toothed gills and usually doesn't become funnel-shaped. *Craterellus ignicolor* and other chanterelles seldom fruit on wood at all, let alone in numbers.

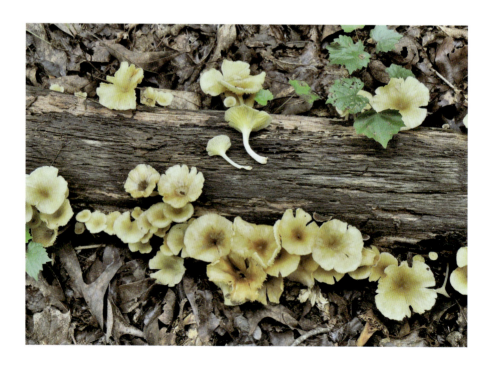

Gliophorus laetus (Pers.) Herink

= *Hygrocybe laeta* (Pers.) P. Kumm.
= *Hygrophorus laetus* (Pers.) Fr.

MACROSCOPIC FEATURES: **cap** 1–5 cm wide, initially convex but flattening or with a slightly depressed center at maturity, slimy smooth or dry and shiny, color highly variable, from shell pink to various oranges, reddish brown, violet-gray, or green-tinged, changing over the course of development. The cap margin is faintly translucent-striate. **gills** attached to subdecurrent, nearly distant, color usually paler than the cap, possibly a little pinker or more vinaceous. **stalk** 1.5–12 cm long and 1.5–6 mm thick, equal, slimy and smooth, colored like the cap or paler, hollow. No partial veil. **flesh** tough, colored like the cap; odor not distinctive or unpleasantly of burned rubber or fish, taste not distinctive.

MICROSCOPIC FEATURES: Spores 5–8 × 3–5 μm, ellipsoid, smooth, hyaline, inamyloid.
SPORE PRINT: White.
HABIT, HABITAT, AND SEASON: Scattered or more commonly clumped on wet ground or moss banks in *Sphagnum* bogs and broadleaf or mixed woods; summer–early winter.
EDIBILITY: Allegedly edible.
COMMENTS: Waxcaps in the genus *Gliophorus* are so slimy that collecting them usually requires picking up the soil at the base. Fortunately, these guys are tougher than they appear. *Gliophorus perplexus* (not illustrated) is more consistently yellow to orange-brown with few if any greenish areas. The cap is not centrally depressed. Gills are pale pink at first, becoming yellow-orange. It associates with broadleaf trees, especially beeches, and likes drier woodland, mossy, or grassy situations.

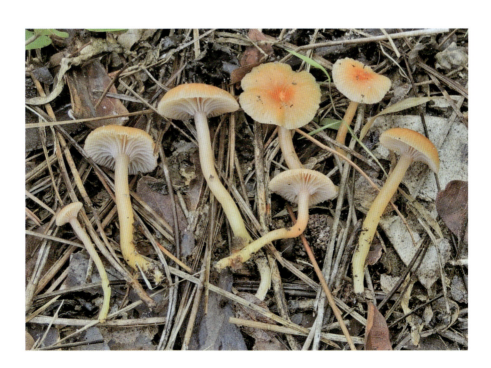

Gliophorus psittacinus (Schaeff.) Herink

= *Hygrocybe psittacina* (Schaeff.) P. Kumm.
= *Hygrophorus psittacinus* (Schaeff.) Fr.

COMMON NAME: Parrot Waxcap
MACROSCOPIC FEATURES: cap 1–3 cm wide, conical when young, then flattening, often with a low umbo, slimy and sticky smooth when fresh, initially green, changing to shades of yellow, orange, or pink beginning at the margin, often preserving a green center. The young cap margin is translucent-striate. **gills** attached, nearly distant, pale green, becoming yellow or reddish. **stalk** 3–7 cm long and 2–5 mm thick, nearly equal, slimy and smooth, green or green above and yellowish, pinkish, or whitish below, hollow. **flesh** colored like the cap; odor and taste not distinctive.
MICROSCOPIC FEATURES: Spores 6.5–10 × 4–6 μm, elliptic, smooth, hyaline, inamyloid.
SPORE PRINT: White.
HABIT, HABITAT, AND SEASON: Scattered or in groups on soil or humus in the woods or adjacent grass; summer–early winter.
EDIBILITY: Edible.
COMMENTS: Parrots are classified in order Psittaciformes. *Gliophorus laetus* and *Gliophorus perplexus* (not illustrated) are not uniformly green when young and don't tend to have green cap centers and upper stalks at maturity. The color of young Parrot Waxcaps can make them very hard to find without the assistance of a guide-child. *Gliophorus irrigatus* (not illustrated) is equally slimy and may be even harder to spot in the woods due to its dark gray or gray-brown caps and stalks. The gills are white or pale gray. *Entoloma incanum* (not illustrated) is colored like the Parrot Waxcap, but the cap is dry, spores are salmon pink, and the odor of older caps resembles mouse urine.

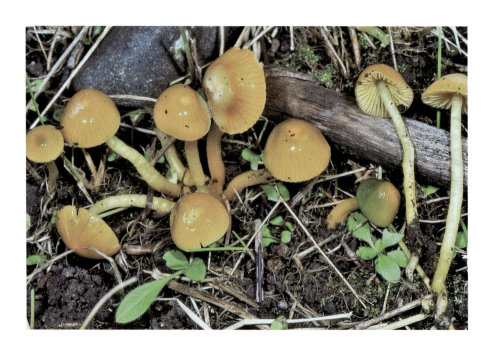

Gymnopilus junonius (Fr.) P. D. Orton

= *Gymnopilus spectabilis* sensu A. H. Smith
= *Gymnopilus spectabilis* var. *junonius* (Fr.) Kühner & Romagn.

COMMON NAME: Big Laughing Gym
MACROSCOPIC FEATURES: cap 3–20 cm wide, initially convex but flattening, dry, sometimes buff at first but commonly dull yellow to yellow-orange, silky when young, nearly smooth. **gills** attached to decurrent, close or crowded, colored like the cap before turning rusty. **stalk** 3–20 cm long and 1–3 cm thick, dry, equal or enlarging downward above an often pinched base, colored like the cap or with white longitudinal streaks below the partial veil, solid. The partial veil is a flimsy yellow membrane leaving a ring on the stalk. **flesh** firm and pale yellow; odor like anise, taste bitter.
MICROSCOPIC FEATURES: Spores 7–10 × 4.5–6 μm, elliptic, roughened, brown, dextrinoid.
SPORE PRINT: Rusty brown.

HABIT, HABITAT, AND SEASON: Typically clustered from a shared base on logs, stumps, or buried wood; summer–early winter.
EDIBILITY: Variably hallucinogenic, illegal to possess.
COMMENTS: Big Laughing Gym is the largest of our ringed and often difficult to distinguish *Gymnopilus* species. A drop of KOH on the cap is said to produce a red stain promptly turning black. The reaction on the cap of the slender and yellower broadleaf recycler, *Gymnopilus luteus* (not illustrated), is persistently red. The gills are notched, and it has an odor of anise. *Gymnopilus armillatus* (see Color Key) has sinuate gills with a decurrent tooth and inamyloid spores, and it is reported on sweet gums. The Yellow-gilled Gymnopilus, *Gymnopilus luteofolius* (see Color Key), has a yellowish cap that can stain green, covered with purplish red to dark red or reddish brown scales. The whitish flesh stains purplish pink. The KOH reaction on the cap is black. It fruits on conifer wood.

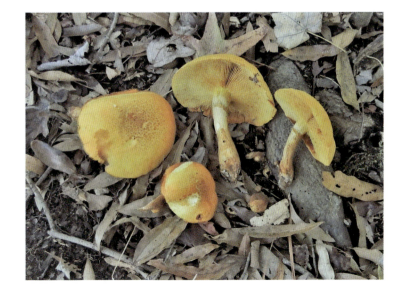

Gymnopilus liquiritiae (Persoon) Karst.

= *Flammula liquiritiae* (Pers. ex Fr.) Kumm.

MACROSCOPIC FEATURES: cap 2–8 cm wide, convex to flat, dry or moist but not sticky, smooth, rusty to orange-brown. The cap margin is faintly striate at maturity. **gills** attached but often pulling away at maturity, close or crowded, yellowish at first, then orange, sometimes developing reddish brown spots. **stalk** 3–7 cm long and 3–10 mm thick, nearly equal, dry, dull orange but whiter toward the apex, smooth or finely hairy with rusty or yellowish basal mycelium. No partial veil. **flesh** pale yellow or orange; odor varies from raw potato to fragrant or not distinctive, taste distinctly bitter.

MICROSCOPIC FEATURES: Spores 7–10 × 4–6 µm, ellipsoid, finely spiny, pale brown, dextrinoid.

SPORE PRINT: Rusty brown.

HABIT, HABITAT, AND SEASON: Scattered to gregarious on rotting conifer wood, on sawdust, occasionally on rotting broadleaf wood; summer–early winter.

EDIBILITY: Unknown.

COMMENTS: The cap surface is important to distinguishing this species from *Gymnopilus sapineus* (see Color Key), which has a finely scaly cap, and *Gymnopilus penetrans* (not illustrated), which has a finely hairy cap and might or might not be genetically distinct from *Gymnopilus sapineus*. They both have an evanescent, fibrillose partial veil. *Gymnopilus lepidotus* (see Color Key) has cap diameters to 8 cm. It has erect cap scales, fruits on rotting Sweetgum, and has spores measuring 5.5–7.5 × 4.5–5 µm. The caps of *Gymnopilus liquiritiae*, *Gymnopilus sapineus*, and *Gymnopilus penetrans* stain dark red with KOH. The effect of KOH on the cap color of *Gymnopilus lepidotus* is unclear.

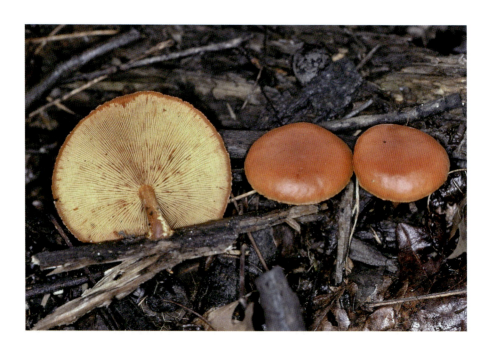

Gymnopus biformis (Peck) Halling

= *Collybia biformis* (Peck) Singer
= *Marasmius biformis* Peck

MACROSCOPIC FEATURES: **cap** 1–2.5 cm wide, convex at first, then flattening or with a depressed to umbilicate center, with or without a tiny umbo, dry, reddish brown at first, slowly fading toward tan, often radially wrinkled and finely bumpy. The cap margin is initially incurved. **gills** attached, close, whitish. **stalk** 1.5–5 cm long and 1–4 mm thick, equal, dry, white above, transitioning to cap color below, densely velvety or hairy from apex to base, hollow. Partial veil absent. **flesh** tough, whitish; odor and taste not distinctive.
MICROSCOPIC FEATURES: Spores 6.5–8.5 × 3–4.5 µm, lacrimoid to ellipsoid, smooth, hyaline, inamyloid.
SPORE PRINT: White to cream.
HABIT, HABITAT, AND SEASON: Scattered to loosely grouped on woodland soil, occasionally on leaf litter, pine needles, or downed twigs; summer–fall.
EDIBILITY: Unknown.
COMMENTS: Thin, ground-dwelling *Gymnopus* species are distinguishable, but it can take a second look. *Gymnopus subnudus* (not illustrated) has cap diameters to 3.5 cm, more widely spaced gills that pinken in age, a stalk hairy only in the lower half, and longer spores, 8–11 × 3.5–4 µm. *Gymnopus spongiosus* has a shaggy stalk that is swollen and soft toward the base. *Gymnopus confluens* grows in clumps. The Violet Collybia, *Gymnopus iocephalus* (see Color Key), smells like garlic and has a purplish cap fading toward gray. *Gymnopus dichrous* (see Color Key) fruits on decaying hardwood but otherwise strongly resembles *Gymnopus subnudus*. It has a small basal knob and spores measuring 10–12 × 3–4.5 µm. *Collybiopsis dichroa* has been recently proposed as a name change based on molecular studies.

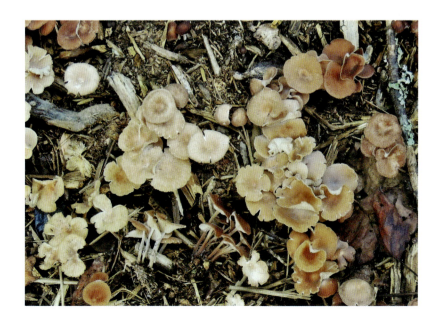

Gymnopus confluens (Pers.) Antonín, Halling, & Noordel

= *Collybia confluens* (Pers.) P. Kumm.

COMMON NAME: Tufted Collybia
MACROSCOPIC FEATURES: cap 1–6 cm wide, initially convex but flattening, moist or dry, cinnamon when young, fading through yellow-brown toward pale tan, smooth or minutely hairy. The young cap margin can be faintly striate. **gills** narrowly attached or free, crowded, pinkish buff, fading to cream or whitish. **stalk** 2.5–10 cm long and 1.5–5 mm thick, equal, dry, colored like the cap, covered end to end by a dense coat of fine white to grayish hairs, hollow. Base shows white mycelium. No partial veil. **flesh** white; odor and taste not distinctive.
MICROSCOPIC FEATURES: Spores 7–10 × 3.5–5 μm, lacrimoid to ellipsoid, smooth, hyaline, inamyloid.
SPORE PRINT: White.
HABIT, HABITAT, AND SEASON: Gregarious to clustered on woodland leaf litter or humus; summer–fall.
EDIBILITY: Edible.
COMMENTS: The epithet *confluens* means "joined," which often describes the stalk bases of Tufted Collybia. The stalk is frequently much longer than the cap diameter. *Marasmius cohaerens* typically fruits in small clumps joined at the base and booted with dense white mycelium. *Connopus acervatus* is darker, often purple-tinged. *Lyophyllum decastes* is larger and more heavily built.

Gymnopus dryophilus (Bull.) Murrill

= *Collybia dryophila* (Bull.) P. Kumm.

COMMON NAME: Oak-loving Collybia

MACROSCOPIC FEATURES: cap 1–7 cm wide, convex before flattening, moist or dry, smooth, reddish brown to orange-brown, fading toward yellowish tan but retaining a darker center, hygrophanous, smooth. The cap margin is incurved at first, uplifted in age. **gills** attached or free, crowded, white, eventually slightly pinkish or yellowish. **stalk** 3–10 cm long and 2–8 mm thick, equal or enlarging downward, smooth and dry, white at the apex, colored like the cap below, hollow. The base is attached to white rhizomorphs. No partial veil. **flesh** whitish; odor and taste not distinctive.

MICROSCOPIC FEATURES: Spores 5–7 × 2.5–3.5 μm, lacrimoid to ellipsoid, smooth, hyaline, inamyloid.

SPORE PRINT: White or creamy.

HABIT, HABITAT, AND SEASON: Scattered to gregarious on the ground in the woods, less commonly on rotting logs or stumps; late spring–early winter.

EDIBILITY: Edible.

COMMENTS: Despite the epithet *dryophilus*, which means "oak-loving," this species sometimes fruits on rotting pine. The yellower *Gymnopus subsulphureus* (see Color Key) has pale yellow gills and pink basal rhizomorphs. *Marasmius cohaerens* has a reddish brown cap, but the blackening bases of its often fused stalks are booted in white mycelium. *Rhodocollybia butyracea* (see Color Key) specializes in conifer recycling. It has a reddish brown cap, a stockier stalk that expands downward, and faintly pinkish spores measuring 6–10.5 × 3.5–5 μm. Another conifer recycler, *Rhodocollybia maculata* (see Color Key), is fractionally larger. The whitish cap and stalk develop rusty spots. It has globose spores, 4–6 μm. *Gymnopus dryophilus* is parasitized by Collybia Jelly, *Syzygospora mycetophila* (not illustrated). Infected mushrooms develop unsightly tan blobs on the cap or stalk.

Gymnopus dysodes (Halling) Halling

= *Collybia dysodes* (Halling)

MACROSCOPIC FEATURES: cap 0.6–6 cm wide, bell-shaped or convex and flattening, moist or dry, dark reddish brown fading in age to cinnamon brown and eventually buff to whitish, especially toward the margin, bald but conspicuously pleated at maturity. The young cap margin is striate and incurved. **gills** attached, distant, light brown before fading to pale pinkish buff. **stalk** 1.5–4 cm long and 2–5 mm thick, equal or enlarging downward, round or compressed, colored like the cap, eventually vinaceous buff, minutely pruinose, although the apex can be nearly smooth, hollowing. **flesh** tough when young, later brittle, white; odor of old onions, garlic, or potato, taste resembling onion or unpleasant to slightly bitter.

MICROSCOPIC FEATURES: 8–9 × 3.5–4 µm, ovoid to lacrimoid, smooth, hyaline, inamyloid.

SPORE PRINT: White.

HABIT, HABITAT, AND SEASON: Gregarious to clustered from a common base on wood chips; summer–fall.

EDIBILITY: Unknown.

COMMENTS: *Dysodes* means "stinking or unpleasant." A name change to *Collybiopsis dysodes* has recently been proposed based on molecular studies. *Gymnopus foetidus* is a similar stinker. It has subdecurrent and subdistant gills, a much darker stalk, and pinkish flesh. *Marasmiellus luxurians* = *Gymnopus luxurians* (see Color Key) also clusters on wood chips or buried wood. Caps are larger, to 8 cm, reddish brown, sometimes radially streaked but not striate. The whitish to pinkish gills are close or crowded. Stalks are as much as 13 mm thick, usually with twisting, longitudinal grooves under a coating of fine, white hairs that readily detach. Odor and taste are not distinctive or at least not oniony.

Gymnopus foetidus (Sowerby)
J. L. Mata & R. H. Petersen

= *Marasmius foetidus* (Sowerby) Fr.
= *Micromphale foetidum* (Sowerby) Singer

COMMON NAME: Fetid Marasmius

MACROSCOPIC FEATURES: cap 1.5–3.5 cm wide, broadly convex and flattening, often with a depressed center, moist or dry, reddish brown and darkest on the disc, fading as it ages, bald but conspicuously pleated from the center to the margin. The young cap margin is incurved. **gills** subdecurrent, subdistant, pinkish buff. **stalk** 1.5–2.5 cm long and 1.5–2.5 mm thick, nearly equal or slightly enlarged at the apex or base, sometimes compressed, dry, solid, then hollowing in age, pinkish brown at the apex, dark brown below, with minute, short, white hairs especially toward the base (use a hand lens). Partial veil lacking. **flesh** very thin, soft, pinkish; odor variously described as rotting cabbage, strongly disagreeable, or stinking, taste unpleasant or strongly disagreeable.

MICROSCOPIC FEATURES: Spores 7–10 × 2.6–3.2 μm, narrowly elliptic, smooth, hyaline, inamyloid.

SPORE PRINT: White.

HABIT, HABITAT, AND SEASON: Gregarious on decaying broadleaf logs, branches, stumps, or woody debris; summer–fall.

EDIBILITY: Inedible.

COMMENTS: The epithet *foetidus* means "foul-smelling or stinking." *Gymnopus dysodes* is very similar, but the gills are not decurrent. *Ripartitella brasiliensis* (see Color Key) has a 1–7 cm wide dry cap that is matted-woolly and reddish brown when young. The cap surface breaks up and forms small, concentric to scattered, reddish brown scales on a buff ground color. The margin of young specimens often has patches of torn partial veil. It has attached, close, white gills, white flesh, a dry, fibrillose stalk with tiny brownish scales on a whitish to buff ground color, and white, cottony, basal mycelium. It fruits in groups or clusters on decaying broadleaf wood, especially oaks. The spores are broadly elliptic to subglobose, finely spiny, and hyaline, and they measure 4.5–6 × 3.5–4.5 μm.

Gymnopus spongiosus (Berk. & M. A. Curtis) Halling

= *Collybia spongiosa* (Berk. & M. A. Curtis) Singer
= *Marasmius spongiosus* Berk & M. A. Curtis

COMMON NAME: Hairy-stalked Collybia
MACROSCOPIC FEATURES: **cap** 1–3.5 cm wide, convex before flattening, sometimes with a slight umbo, dry and smooth, reddish brown fading toward grayish orange with a whitened margin. The cap margin often wrinkles in age. **gills** attached, close or crowded, whitish. **stalk** 2–6 cm long and 1–4 mm thick at the apex, expanding below and often twisted, dry, whitish and relatively hairless above, reddish brown and prominently covered with long, reddish brown hairs below. The base is expanded, spongy, and soft. **flesh** white; odor and taste not distinctive.
MICROSCOPIC FEATURES: Spores 6–8.5 × 3.5–4 μm, lacrimoid to ellipsoid, smooth, hyaline, inamyloid.
SPORE PRINT: White.
HABIT, HABITAT, AND SEASON: Solitary to clustered on woodland leaf or needle litter or on well-rotted wood; summer–winter.
EDIBILITY: Unknown.
COMMENTS: The spongy, shaggy base helps distinguish Hairy-stalked Collybia. Field guides often make a point of noting a green or gray-green reaction to a drop of KOH or NH_4OH in one or another *Gymnopus* species. Although those reactions are more consistent in some species than in others, a green response is of limited diagnostic use within *Gymnopus*. It serves mainly to rule out candidates from genera with a red reaction to KOH, such as *Xeromphalina tenuipes* (see Color Key). Additional details are available in Comments under *Flammulaster erinaceellus*.

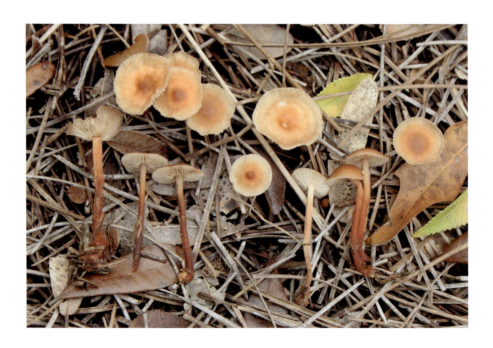

Hebeloma crustuliniforme (Bull.) Quél.

COMMON NAME: Poison Pie

MACROSCOPIC FEATURES: cap 3–11 cm wide, convex, then flattening, sometimes with a low umbo, sticky and smooth, whitish to buff or tan. The young cap margin is inrolled, later uplifted. **gills** attached, close or crowded, whitish at first and spotted with clear droplets that dry to brown stains, becoming gray-brown overall, edges white and minutely fringed at 10×. **stalk** 3–13 cm long and 0.5–1.5 cm thick, equal or enlarging downward to a swollen base, white to buff, with small flakes near the apex, often with white basal mycelium, hollow without a central stalactite of cap flesh protruding into the cavity. No partial veil. **flesh** white; odor of radish, taste similar or bitter.

MICROSCOPIC FEATURES: Spores 9–13 × 5–7.5 μm, amygdaliform or ellipsoid, roughened, pale brown, dextrinoid.

SPORE PRINT: Brown.

HABIT, HABITAT, AND SEASON: Scattered or making fairy rings on woodland or grassy soil near trees or shrubs; summer–early winter.

EDIBILITY: Poisonous.

COMMENTS: The Scaly-stalked Hebeloma, *Hebeloma sinapizans* (see Color Key), is fractionally larger and stouter, has a scalier apical stalk, and shows a dangling cone of cap flesh protruding into the stalk cavity. A slender cousin, *Hebeloma mesophaeum* (not illustrated), grows under conifers. The sticky and smooth reddish brown caps have pale margins that sometimes retain bits of fibrous partial veil. Cap diameters are to 7 cm. The gills may be pink-tinged at first, are white-fringed, and don't develop brown spots. Stalks are whitish but browning from the bottom up and may show a faint ring zone. *Hebeloma* species produce severe gastrointestinal distress if eaten.

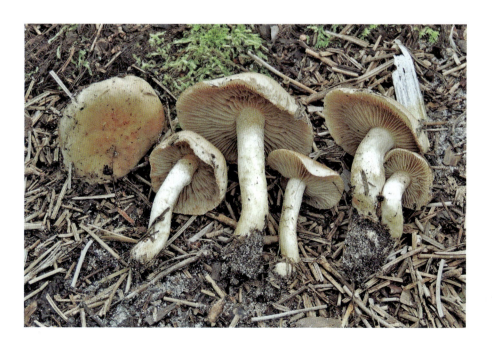

Hohenbuehelia mastrucata (Fr.) Singer

COMMON NAME: Woolly Oyster
MACROSCOPIC FEATURES: cap 2–7 cm wide, shaped like a clamshell, moist, pale bluish gray to brownish gray, fading in age, covered with coarse, gelatinous hair. The cap margin is inrolled. **gills** arise from the point of attachment, close to nearly distant, whitish or pale gray. **stalk** none or minimal. No partial veil. **flesh** rubbery, colored like the cap; odor mushroomy or farinaceous, taste not distinctive or vaguely unpleasant.
MICROSCOPIC FEATURES: Spores 6–9 × 5–6 μm, elliptic, smooth, hyaline, inamyloid.
SPORE PRINT: White.
HABIT, HABITAT, AND SEASON: Solitary or scattered on rotting wood, usually maples; summer–fall.
EDIBILITY: Unknown.
COMMENTS: The genus honors an early Austrian mycologist named Ludwig Samuel Joseph David Alexander Freiherr Heufler zu Rasen und Perdonegg von Hohenbühel (1817–1885). *Mastrucata* means "woolly." Stalkless gilled mushrooms fruiting on wood are commonly encountered, but the Woolly Oyster has a distinctive set of features. The flesh of *Crepidotus mollis* and others of that genus is squishy, not rubbery, and the spore print is brown. *Lentinellus vulpinus* has serrated gills. *Pleurotus pulmonarius* is larger and hairless. Seemingly innocuous wood recyclers often supplement their diets with nematode worms they capture in the substrate. Some set constricting snares. Others secrete droplets of immobilizing poison. The mycelium of *Hohenbuehelia mastrucata* is studded with sticky spots. Nematodes thus detained are speared and digested from the inside out.

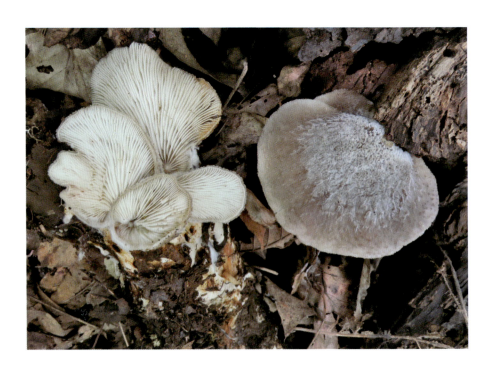

Humidicutis marginata var. *marginata*
(Peck) Singer

= *Hygrocybe marginata* (Peck) Murrill
= *Hygrophorus marginatus* Peck

COMMON NAME: Orange-gilled Waxcap
MACROSCOPIC FEATURES: cap 1–5 cm wide, broadly conical at first, then convex or nearly flat with a low umbo, smooth and slippery, orange or yellow-orange, hygrophanous, becoming pale yellow. The young cap margin is incurved, sometimes faintly striate, uplifted in age. **gills** attached, nearly distant, bright orange and remaining so, especially the edges, after the cap yellows. **stalk** 4–10 cm long and 3–6 mm thick, equal or widest in the middle, round or laterally compressed, dry, smooth, usually paler than the cap, hollow. No partial veil. **flesh** splits easily, colored like the cap, unchanging when bruised; odor and taste not distinctive.
MICROSCOPIC FEATURES: Spores 7–10 × 4–6 µm, broadly ellipsoid to ellipsoid, smooth, hyaline, inamyloid.
SPORE PRINT: White.
HABIT, HABITAT, AND SEASON: Solitary to clustered on woodland humus or leaf litter; summer–fall.
EDIBILITY: Edible.
COMMENTS: Three varieties of the Orange-gilled Waxcap are recognized. In *Humidicutis marginata* var. *marginata* the emerging color difference between the dehydrating cap and bright orange gills sets it apart from *Humidicutis marginata* var. *concolor* (not illustrated), which is often a bit yellower and shows more uniform fading of cap and gills. *Humidicutis marginata* var. *olivacea* (not illustrated) has greenish areas absent in the other varieties. Compare it with the smaller *Entoloma quadratum*. The Golden Waxcap, *Hygrocybe flavescens* (see Color Key), lacks an umbo. The bright yellow to yellow-orange cap contrasts with pale yellow gills when fresh.

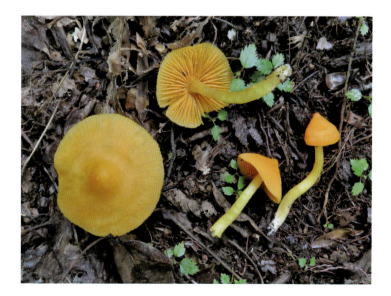

Hygrocybe acutoconica (Clem.) Singer

= *Hygrocybe persistens* (Britzelm.) Singer
= *Hygrophorus acutoconicus* (Clem.) A. H. Sm.

MACROSCOPIC FEATURES: cap 2–10 cm wide, acutely conical at first, becoming bell-shaped to nearly flat but retaining the umbo, smooth and slimy or sticky, orange to red-orange. The cap margin frequently uplifts and may split. **gills** initially attached, often becoming free, close or nearly distant, yellow, the edges smooth or serrated in age. **stalk** 6–12 cm long and 3–12 mm thick, equal or enlarging downward, often longitudinally twisted or fibrillose, smooth, not sticky, commonly paler than the cap and with a whitened base, hollowing. No partial veil. **flesh** yellow, unchanging when bruised; odor and taste not distinctive.

MICROSCOPIC FEATURES: Spores 9–15 × 5–9 μm, elliptic, smooth, hyaline, inamyloid.
SPORE PRINT: White.
HABIT, HABITAT, AND SEASON: Scattered to loosely grouped on the ground in habitats ranging from woodlands to grassy, disturbed areas; early summer–late fall.
EDIBILITY: Reportedly edible.
COMMENTS: The epithet *acutoconica* means "sharply conical," an apt description for the sticky cap of this brightly colored waxcap. It closely resembles *Hygrocybe conica* but fails to bruise black after collection. *Hygrocybe coccinea* is also similar but redder, not acutely conical, sticky, or bruising black. The hygrophanous cap in varieties of *Humidicutis marginata* is yellow-orange to orange, lacking red components and stickiness.

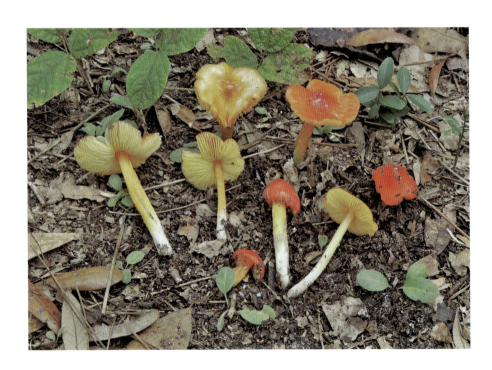

Hygrocybe caespitosa Murrill

= *Hygrophorus caespitosus* (Murrill) Murrill

COMMON NAME: Clustered Waxcap

MACROSCOPIC FEATURES: cap 1–6 cm wide, broadly convex or flattening, sometimes centrally depressed, moist or dry, pale yellow to honey yellow under a dusting of olive brown scales with darker tips. The cap margin often uplifts and tears at maturity. **gills** attached or subdecurrent, more or less distant, occasionally forking, whitish to pale yellow. **stalk** 2–5 cm long and 3–7 mm thick, equal or tapering downward, smooth, dry, pale yellow, darkening or becoming green-tinged toward the base, hollow. No partial veil. **flesh** yellowish; odor not distinctive, taste not distinctive or resembling raw potato.

MICROSCOPIC FEATURES: Spores 6.5–10 × 4–7 μm, ellipsoid, smooth, hyaline, inamyloid.

SPORE PRINT: White.

HABIT, HABITAT, AND SEASON: Scattered or more commonly clustered on the ground in the woods or adjacent grass; summer–fall.

EDIBILITY: Unknown.

COMMENTS: *Hygrocybe* translates more or less to damp head, referring to the moist, waxy texture of crushed waxcap flesh and gills. The epithet *caespitosa* or *caespitose* is the mycological term for fruiting in clumps, typically with stalks joined at the base. Don't confuse Clustered Waxcap for Honey Mushroom, *Armillaria mellea*. That much larger species has a yellowish, scaly cap and grows in clumps, but it is tougher and has close or crowded gills and an obvious partial veil.

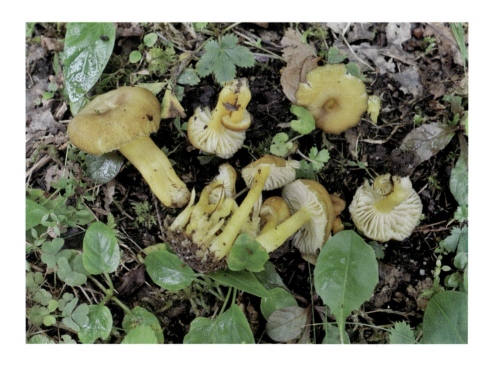

Hygrocybe coccinea (Schaeff.) P. Kumm.

= *Hygrophorus coccineus* (Schaeff.) Fr.

COMMON NAME: Scarlet Waxcap
MACROSCOPIC FEATURES: cap 2–7 cm wide, conical at first but not sharply so, then convex or nearly flat with a broad umbo or central depression at maturity, moist or dry, smooth, bright red, fading to orange-red. The cap margin is initially incurved, later uplifted. **gills** attached, nearly distant, yellowish to reddish orange, frequently yellow-edged. **stalk** 2–8 cm long and 0.5–1 cm thick, equal, often laterally compressed, dry, smooth and lacking longitudinal lines, yellow-orange to orange-red with a yellower base covered in white mycelium, hollow. No partial veil. **flesh** colored like the cap; odor and taste not distinctive.
MICROSCOPIC FEATURES: Spores 7–11 × 4–5 µm, ellipsoid, smooth, hyaline, inamyloid.
SPORE PRINT: White.

HABIT, HABITAT, AND SEASON: Solitary to loosely grouped on the ground under conifers or broadleaf trees; summer–fall.
EDIBILITY: Reportedly edible.
COMMENTS: The closely related *Hygrocybe punicea* (not illustrated) has a darker red cap up to 12 cm wide and is slippery to sticky when fresh. Stalks are longitudinally striate or fibrillose, not smooth. That said, *Hygrocybe coccinea* and *Hygrocybe punicea* can be difficult to distinguish. The smaller *Hygrocybe miniata* (not illustrated) is initially scarlet, fading to orange or yellow. Cap diameters top out at 4 cm. These are dry, lack an umbo, and often become depressed and scaly in age. Gills are attached or slightly decurrent, close to almost distant. Stalks are 2.5–5 cm in length. *Hygrocybe cantharellus* (see Color Key) differs from *Hygrocybe miniata* by having distant and typically decurrent gills. Stalks are longer too, averaging 3–9 cm.

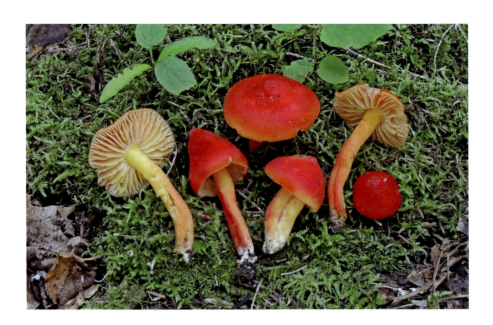

Hygrocybe conica (Schaeff.) P. Kumm.

= *Hygrophorus conicus* (Schaeff.) Fr.

COMMON NAME: Witch's Hat

MACROSCOPIC FEATURES: cap 2–9 cm wide, acutely conical to bell-shaped, rarely flattish, typically retaining an umbo, sticky when moist, later dry, smooth or finely hairy, orange to red or occasionally yellow, darkest at the center, frequently with olive areas, bruising or aging black. **gills** nearly free or free, close, pale yellow to greenish orange, staining black. **stalk** 2–10 cm long and 3–10 mm thick, equal, round, striate or twisted-striate, colored like the cap but often paler, whitened near the base, staining black, hollowing. No partial veil. **flesh** colored like the cap, bruising and aging black; odor and taste not distinctive.

MICROSCOPIC FEATURES: Spores 8–10 × 5–6.5 µm, ellipsoid, smooth, hyaline, inamyloid.

SPORE PRINT: White.

HABIT, HABITAT, AND SEASON: Solitary to gregarious on woodland soil or in grassy areas; late spring–late fall.

EDIBILITY: Allegedly poisonous.

COMMENTS: One other black-staining waxcap with a red cap is known from coastal Georgia. The Dune Witch's Hat, *Hygrocybe conicoides* (not illustrated), fruits in sand dunes, often with only the cap protruding above the sand. The gills have a redder or salmon tinge, longer spores at 10–14 × 4–6 µm, and a fall–early winter fruiting season. The poisonous reputation of Witch's Hat seems to rest on thin evidence, but really, what's so appetizing about a sticky black mess?

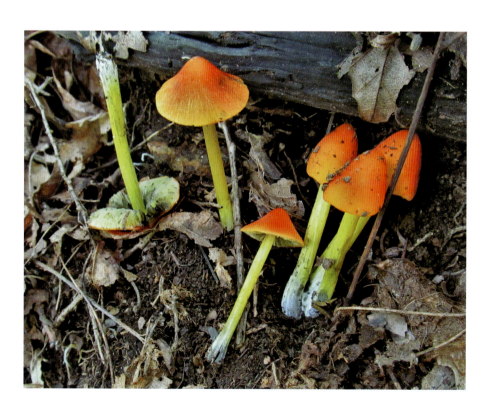

Hygrophorus russula (Schaeff. ex Fr.) Kauffman

= *Tricholoma russula* (Schaeff. ex Fr.) Gillet

COMMON NAME: Russula-like Waxcap
MACROSCOPIC FEATURES: cap 5–12 cm wide, convex, then flattening or centrally depressed, sticky or dry, smooth or finely hairy to scaly, mottled brownish pink to purplish pink, often bruising yellow, especially peripherally. The young cap margin is cottony and inrolled, not striate. **gills** attached or subdecurrent, crowded to close, white, developing purplish red spots or flushes. **stalk** 3–8 cm long and 1.5–3.5 cm thick, equal, dry, powdery near the apex and smooth below, white at first but becoming streaked like the cap, solid. No partial veil. **flesh** firm, white to pinkish, often bruising yellow; odor not distinctive, taste not distinctive or bitter.
MICROSCOPIC FEATURES: Spores 6–8 × 3–5 μm, elliptic, smooth, hyaline, inamyloid.
SPORE PRINT: White.
HABIT, HABITAT, AND SEASON: Solitary to gregarious on soil in or near broadleaf woods, usually near oaks; summer–fall.
EDIBILITY: Edible.
COMMENTS: The Russula-like Waxcap is easily mistaken for a *Russula*, but the flesh is relatively tough, not crumbly. *Hygrophorus tennesseensis* (see Color Key) is of a similar size but associates with conifers. The convex to flattened or centrally depressed cap is sticky when damp, tawny at the center and creamy toward the periphery. Spores are fractionally larger, 6–10 × 4.5–6 μm. *Hygrophorus hypothejus* (not illustrated) has sticky-slimy caps with diameters only to 6 cm. They are olive brown to reddish brown, fading and yellowing near the margins at maturity. Gills are decurrent, nearly distant, pale yellow. It usually fruits under 2-needle pines from late summer to fall.

Hymenopellis furfuracea (Peck) R. H. Petersen

= *Oudemansiella furfuracea* (Peck) Zhu L. Yang, G. M. Muell, G. Kost, & Rexer
= *Xerula furfuracea* (Peck) Redhead, Ginns, & Shoemaker

COMMON NAME: Rooted Collybia

MACROSCOPIC FEATURES: cap 2–14 cm wide, bell-shaped, convex, or nearly flat, typically with an umbo and radial wrinkling, occasionally smooth, greasy and rubbery or dry, dark grayish brown or yellow-brown, sometimes fading to buff. **gills** attached, close or subdistant, white. **stalk** 7–30 cm long aboveground and 0.5–2 cm thick, ramrod straight, enlarging slightly downward, dry, whitish beneath a flat coating of gray-brown fibers that often form chevrons, solid. The swollen base is connected to a "taproot" rivaling the length of the stalk. **flesh** relatively hard and brittle, white, unchanging or staining slightly brown; odor and taste not distinctive.

MICROSCOPIC FEATURES: Spores 14–17 × 9.5–12 μm, ovoid to ellipsoid, smooth, hyaline, inamyloid.

SPORE PRINT: White.

HABIT, HABITAT, AND SEASON: Solitary or scattered in woods on soil or thoroughly rotted wood; spring–fall.

EDIBILITY: Edible.

COMMENTS: *Furfuracea* means "flaky" rather than "furry," which is too bad. The obviously hairy stalk helps distinguish this species from its rooted cousins. *Hymenopellis rubrobrunnescens* (not illustrated) shares the same coloration and body plan, minus stalk hair, but readily stains reddish brown. The 2–7 cm cap of *Hymenopellis incognita* (not illustrated) is initially slimy-sticky, usually dark brown over the umbo and yellowish brown peripherally. The stalk is smooth or finely silky. *Hymenopellis megalospora* (not illustrated) has cap diameters to 8 cm. These are greasy at first and whitish to pale gray-brown. Stalks are typically smooth, often with a comparatively short rooting section. Spores are longer at 18–23 × 10–14 μm.

Hypholoma capnoides (Fr.) P. Kumm.

= *Naematoloma capnoides* (Fr.) P. Karst.

COMMON NAME: Smoky-gilled Hypholoma
MACROSCOPIC FEATURES: cap 2–7.5 cm wide, convex, then flattening at maturity, smooth and dry, orange cinnamon to reddish cinnamon paling to yellow-orange or dull yellowish near the margin. The young cap margin is inrolled and usually displays remnants of a whitish partial veil. **gills** attached, close or crowded, white at first but soon smoky gray and then purple-brown. **stalk** 5–10 cm long and 4–10 mm thick, equal or tapering downward, smooth or finely fibrillose, especially near the base, dry, pale yellow, browning from the bottom up. The partial veil is a whitish cortina, usually leaving a ring zone on the stalk and tags on the cap margin. **flesh** whitish to cream; odor and taste not distinctive.

MICROSCOPIC FEATURES: Spores 6–7.5 × 3.5–4.5 µm, ellipsoid with a small apical pore, smooth, pale brown, inamyloid.
SPORE PRINT: Dark purplish brown.
HABIT, HABITAT, AND SEASON: Clumped from a common base on rotting conifer wood; fall and sometimes late spring.
EDIBILITY: Edible with caution.
COMMENTS: Here's another culinary opportunity that can severely punish a mistaken identification. The closest look-alike is a poisonous cousin, *Hypholoma fasciculare*, which can also fruit in clumps on rotting conifer wood and have an orangey cap. However, the developing gills pass through a green-tinged phase. The edible *Hypholoma lateritium* is also similar but fruits exclusively on rotting broadleaf wood. Look-similars include Deadly Galerina, *Galerina marginata*. It has rusty brown spores, as do *Gymnopilus* species.

Hypholoma fasciculare (Huds.) P. Kumm.

= *Hypholoma subviride* (Berk. & M. A. Curtis) Dennis
= *Naematoloma fasciculare* (Huds.) P. Karst.

COMMON NAME: Sulfur Tuft
MACROSCOPIC FEATURES: cap 2–8 cm wide, convex but flattening, occasionally with a broad umbo, smooth, dry, brownish orange to orange centrally and yellower peripherally, often green-tinged near the margin. The young cap margin is frequently wispy with veil fragments. **gills** attached, close, pale yellow progressing through greenish yellow to shades of gray and finally purple-brown. **stalk** 5–12 cm long and 3–10 mm thick, nearly equal or tapering downward, dry, fibrillose below the ring zone, yellow but turning orange-brown from the base upward. The partial veil is a thin, whitish cortina often leaving a ring zone on the stalk. **flesh** pale yellow, sometimes bruising brownish; odor not distinctive, taste bitter.
MICROSCOPIC FEATURES: Spores 6.5–8 × 3.5–4 µm, elliptic with an apical pore, smooth, pale brown.
SPORE PRINT: Dark purplish brown.
HABIT, HABITAT, AND SEASON: Gregarious to clustered on conifer or broadleaf logs, stumps, chips, or surrounding soil; spring–fall.
EDIBILITY: Poisonous.
COMMENTS: *Hypholoma subviride* (see Color Key), a petite form with caps less than 3 cm wide, is sometimes recognized as a distinct species, although it is otherwise indistinguishable macroscopically and microscopically from Sulfur Tuft. Don't mistake Sulfur Tuft for the edible *Hypholoma capnoides* or *Hypholoma lateritium*, which can fruit on the same logs. Gastrointestinal symptoms predominate in Sulfur Tuft poisonings, according to Benjamin (1995), but symptom onset may be delayed for 5–10 hours and persist for days.

Hypholoma lateritium (Schaeff.) P. Kumm.

= *Hypholoma sublateritium* (Fr.) Quél.
= *Naematoloma sublateritium* (Fr.) P. Karst.

COMMON NAME: Brick Cap
MACROSCOPIC FEATURES: cap 2–10 cm wide, convex at first but eventually almost flat, smooth, dry, brick red centrally shading toward pinkish yellow or pale yellow at the margin. The young cap margin may show yellowish remnants of partial veil. **gills** attached, close, whitish progressing through gray to purplish gray. **stalk** 5–12 cm long and 0.5–1.5 cm thick, equal, creamy and nearly smooth above the ring zone, browner and covered with reddish brown fibrils below. The partial veil is a pale yellow cortina usually leaving a thin ring zone. **flesh** dull yellow, occasionally bruising yellower; odor not distinctive, taste not distinctive or slightly bitter.
MICROSCOPIC FEATURES: Spores 6–7 × 3.5–4.5 μm, ellipsoid with an apical pore, smooth, pale brown.
SPORE PRINT: Dark purplish brown.
HABIT, HABITAT, AND SEASON: Usually clustered on hardwood logs; summer–early winter.
EDIBILITY: Edible.
COMMENTS: Brick Cap is often cultivated and sold for food. The commercial product has at least two potential advantages over foraged collections. The latter are often gritty with detritus and might accidentally contain Sulfur Tuft, *Hypholoma fasciculare*, a poisonous look-alike. Any Brick Caps with green-tinged gills should be presumed to be Sulfur Tuft and discarded. Another look-alike, *Hypholoma capnoides*, fruits on conifer wood.

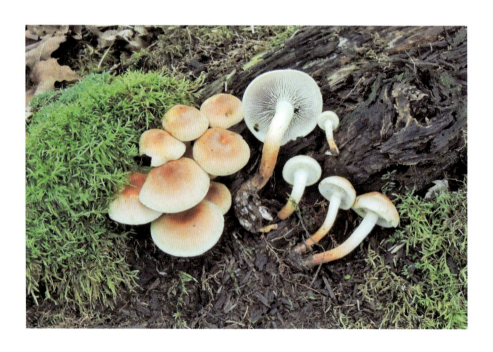

Infundibulicybe gibba (Pers.) Harmaja

= *Clitocybe gibba* (Pers.) P. Kumm.

COMMON NAMES: Common Funnel Cap, Forest Funnelcap

MACROSCOPIC FEATURES: cap 3–9 cm wide, flat to centrally depressed at first but quickly funnel-shaped, slightly sticky or dry, tan to pinkish cinnamon, smooth or with inconspicuous central scales. The cap margin is often wavy in maturity. **gills** decurrent, close or crowded, sometimes forked, whitish. **stalk** 3–8 cm long and 3–12 mm thick, equal or enlarging downward, dry and smooth, white or at least paler than the cap, hollowing. The base is covered with white mycelium. No partial veil. **flesh** white; odor somewhat fragrant or not distinctive, taste not distinctive.

MICROSCOPIC FEATURES: Spores 5–9 × 3.5–6 µm, elliptic, smooth, hyaline, inamyloid.

SPORE PRINT: White.

HABIT, HABITAT, AND SEASON: Single to loosely grouped on the ground under broadleaf trees, rarely under conifers; summer–fall.

EDIBILITY: Edible.

COMMENTS: The very similar *Infundibulicybe squamulosa* = *Clitocybe squamulosa* (not illustrated) grows under conifers. The cap surface and stalk are both a warm shade of orange-brown to cinnamon brown, separated by white gills. Its spores are fractionally smaller at 5–7.5 × 3–4.5 µm. *Ampulloclitocybe clavipes* usually fruits under conifers, is grayer, and has a frankly bulbous base. *Lepista subconnexa* = *Clitocybe subconnexa* (see Color Key) grows in clumps in woodland leaf or needle debris. The dry, white to buff caps have a diameter of 3–9 cm. Gills are subdecurrent, crowded, and buff in color. Odor and taste are not distinctive or fragrant. The pale pink spores are finely warted and elliptic, 4.5–6 × 3–3.5 µm.

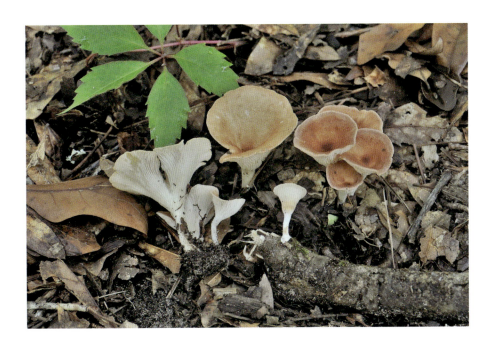

Inocybe hystrix (Fr.) P. Karst.

COMMON NAME: Porcupine Inocybe
MACROSCOPIC FEATURES: cap 1–4 cm wide, hemispherical when young, becoming broadly convex, sometimes with a low, broad umbo, densely covered with erect, pointed, brown scales; margin incurved and remaining so well into maturity, minutely fringed. **gills** broadly attached, close to subdistant, whitish at first, becoming brown as they mature, edges white-fringed. **stalk** 3–6 cm long and 4–8 mm thick, nearly equal to a slightly enlarged base, solid, then hollow in age, densely covered with erect, pointed, brown scales over a whitish ground color, sometimes with an apical zone, smooth above it. **flesh** thin, whitish; odor slightly unpleasant or not distinctive, taste not distinctive.
MICROSCOPIC FEATURES: Spores 8–12.5 × 5.5–7 μm, elliptic to amygdaliform, thick-walled, smooth, yellow-brown. Cheilocystidia 45–77 × 10–19 μm, fusiform to ventricose, thick-walled, lightly encrusted apically.
SPORE PRINT: Brown.

HABIT, HABITAT, AND SEASON: Solitary or in groups on the ground or among mosses in broadleaf or conifer woods; summer–fall.
EDIBILITY: Unknown.
COMMENTS: The epithet *hystrix* means "hedgehog or porcupine," a reference to the pointed scales. It is mycorrhizal with broadleaf trees. The Green-foot Inocybe, *Inosperma calamistratum* = *Inocybe calamistrata* (see Color Key), poisonous, has a chocolate brown to reddish brown cap, 1–4 cm wide, covered with appressed to recurved brown scales. Its stalk is similarly colored and has recurved scales, but the base of mature stalks is blue-green, not indicating psychoactive potential. The thick-walled, elliptic, smooth spores measure 9–13 × 4.7–6.5 μm. *Inocybe tahquamenonensis* (not illustrated), edibility unknown, is a very similar species with a brown cap and stalk that are covered with erect, pointed scales. It has brown, angular, warted spores that measure 6–8.5 × 5–6 μm and is a more northern species that occurs in Tennessee and North Carolina northward.

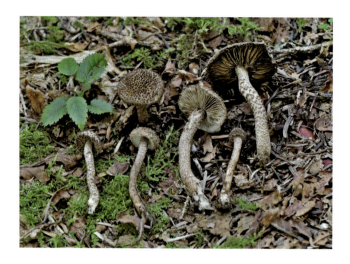

Inocybe lanatodisca Kauffman

MACROSCOPIC FEATURES: cap 2–8 cm wide, broadly bell-shaped and then nearly flat, usually with a wide umbo, dry, tawny to orange-brown, initially covered by a grayish, silky, universal veil that cracks apart into a central patch and semiconcentric remnants scattered across the cap. The cap margin is initially incurved and later uplifted. **gills** attached, close, whitish before browning, edges white-fringed. **stalk** 3–5 cm long and 4–6 mm thick, equal or expanding slightly downward, dry, white, and powdery to finely scaly near the apex, smoother below, transitioning to cap color near the base, solid. No basal bulb. No evident partial veil. **flesh** white; odor variously described as nauseating, aromatic with a green-corn component, or not distinctive. Taste not distinctive.

MICROSCOPIC FEATURES: Spores 9–10.5 × 5–7 µm, ellipsoid to almost kidney-shaped, smooth, pale brown.

SPORE PRINT: Dull brown.

HABIT, HABITAT, AND SEASON: Gregarious to clumped on the ground in broadleaf or mixed woods, leaf mulch, or grass clippings; summer–early winter.

EDIBILITY: Unknown, but probably poisonous.

COMMENTS: *Inocybe* means "fiber head," and *lanatodisca* translates to "woolly cap center." The caps and stalks of several *Inocybe* species are more than woolly; they are scaly. Perhaps the easiest of that group to identify is the poisonous Green-foot Inocybe, *Inosperma calamistratum* = *Inocybe calamistrata* (see Color Key). The Green-foot has a chocolate brown to reddish brown cap, 1–4 cm wide, covered with erect, brown scales. The stalk is similarly colored and has recurved scales, but the base of mature stalks is blue-green. The Green-foot often smells fishy.

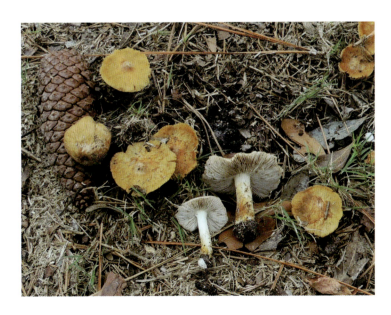

Inocybe lilacina (Peck) Kauffman

= *Agaricus geophyllus* var. *lilacinus* Peck
= *Inocybe geophylla* var. *lilacina* (Peck) Gillet [as *lilacinus*]

COMMON NAME: Lilac Fiber Head
MACROSCOPIC FEATURES: cap 8–18 mm wide, bluntly conical at first but flattening with a small umbo, tacky, initially dark purple or violet overall and remaining so centrally as peripheral areas whiten under purplish radial fibers. The young cap margin is incurved, later uplifted. **gills** attached, close, light gray transitioning to brown with paler and finely fringed edges. **stalk** 20–30 mm long and 2–3 mm thick, even, tacky, colored and streaked like the cap, whitened at the base. The base is swollen or a slight, rounded bulb. The partial veil is a purple-and-white cortina that sometimes leaves a ring zone on the stalk. **flesh** white, not changing; odor strongly spermatic.

MICROSCOPIC FEATURES: Spores 24–30 × 8–9 μm, elliptic with a small apical pore, smooth, brown, inamyloid.
SPORE PRINT: Brown.
HABIT, HABITAT, AND SEASON: Scattered or in small clusters on soil in a variety of forest types; late summer–fall.
EDIBILITY: Poisonous.
COMMENTS: Lilac varieties of the larger *Inocybe geophylla* group were reviewed by Matheny and Swenie (2018). The version found in the Southeast is the true *Inocybe lilacina*. White Fibercap, *Inocybe geophylla* (not illustrated), is whitish without purple elements but otherwise very similar. The Violet Collybia, *Gymnopus iocephalus* (see Color Key), has reddish purple gills, white spores, and an odor of garlic. *Mycena pura* is pinker and white-spored and smells like radish. *Laccaria amethystina* is odorless, lacks an umbo, and has purple gills and white spores. *Cortinarius iodeoides* has a slimy cap and rusty spores.

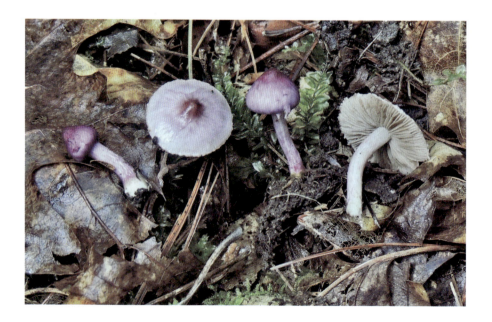

Inocybe rimosa (Bull.) P. Kumm.

= *Inocybe fastigiata* (Schaeff.) Quél.

COMMON NAME: Straw-colored Fiber Head
MACROSCOPIC FEATURES: cap 2–9 cm wide, broadly conical at first, becoming broadly convex to nearly flat with a conical umbo, slippery if wet but usually dry and silky, yellowish to yellow-brown, darkest centrally, covered with slightly darker radial fibers that separate from each other to reveal a paler background. The young cap margin is incurved, later splitting almost to the center in multiple locations. **gills** attached, close, initially whitish, then passing through pale gray to coffee brown with white-fringed edges. **stalk** 3–10 cm long and 3–12 mm thick, nearly equal, dry, longitudinally fibrillose and striate, whitish to pale yellow. No basal bulb. No evident partial veil. **flesh** whitish; odor spermatic or not distinctive, taste not distinctive.

MICROSCOPIC FEATURES: Spores 9–15 × 6–8 μm, ellipsoid, smooth, pale brown.
SPORE PRINT: Brown.
HABIT, HABITAT, AND SEASON: Solitary to loosely grouped on soil or mosses in a variety of woodlands; summer–winter.
EDIBILITY: Poisonous.
COMMENTS: *Inocybe rimosa* is a catchall name for multiple species yet to be fully characterized. *Rimosa* means "cracked or fissured," referring to the radially split caps common in Inocybes. The browner and smaller *Inocybe lacera* (see Color Key) is odorless and has cap diameters only to 4 cm. Its spores are narrower, 12–17 × 4.5–6 μm. In the autumnal conifer woods, brown, pointed caps could also belong to Pine Spikes, species of *Chroogomphus* such as *Chroogomphus vinicolor* and *Chroogomphus ochraceus* (see Color Key). *Cystoderma amianthinum* (see Color Key) has a partial veil, a white spore print, and corn silk odor.

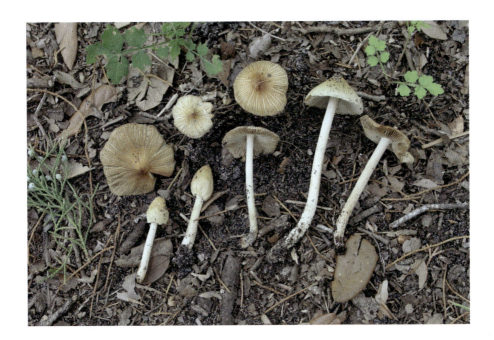

Laccaria amethystina Cooke

= *Clitocybe amethystina* (Cooke) Peck
= *Collybia amethystina* (Cooke) Quél.

COMMON NAME: Amethyst Laccaria
MACROSCOPIC FEATURES: **cap** 0.5–5 cm wide, convex at first, becoming flat or centrally depressed, moist or dry, initially grayish purple to bright purple, hygrophanous, fading toward pale purplish gray or light tan, nearly smooth to finely fibrillose or scaly. The young cap margin is sometimes inrolled and rarely translucent-striate. **gills** attached or subcurrent, distant or nearly so, colored like the young cap. **stalk** 2–7.5 cm long and 1–8 mm thick, equal or slender club-shaped, dry, longitudinally striate and fibrillose, colored and fading like the cap, with lilac basal mycelium that whitens in age. **flesh** colored like the cap; odor and taste not distinctive.
MICROSCOPIC FEATURES: Spores 7–10 μm excluding spines, globose, hyaline, inamyloid, studded with 1.5–3 μm spines.

SPORE PRINT: White.
HABIT, HABITAT, AND SEASON: Solitary to gregarious on wet or mossy ground in the woods, usually near oaks or beeches; summer–fall.
EDIBILITY: Unknown.
COMMENTS: This is Georgia's smallest *Laccaria* with distinctly purple gills. Sandy Laccaria, *Laccaria trullisata* (see Color Key), is found in sandy soil under pines. Cap diameter ranges from 2 to 7.5 cm. At first grayish purple, cap and stalk both develop brown or reddish brown tones at maturity. Spores are 14–22 × 5.5–8 μm and bumpy but not spiny. The edible Purple-gilled Laccaria, *Laccaria ochropurpurea* (see Color Key), is larger still and fruits in relatively open areas under oaks, beeches, or white pines. Caps are up to 12 cm wide. They and the stalks are a light shade of grayish violet or brownish violet. Spores are globose, 6–9 μm excluding the 1–2 μm long spines.

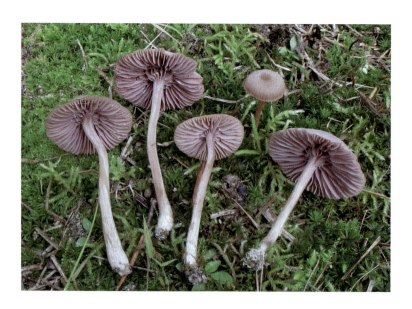

Laccaria laccata var. *pallidifolia* (Peck) Peck

COMMON NAMES: Deceiver, Waxy Laccaria
MACROSCOPIC FEATURES: cap 1–5 cm wide, convex at first, then flattening and often developing a central depression or perforation, dry, orange-brown to yellowish brown or buff, hygrophanous, smooth to finely fibrillose or scaly. The cap margin is striate or not and often uplifts at maturity. **gills** attached, close to nearly distant, faintly pinkish to the pink of Caucasian skin. **stalk** 2–7.5 cm long and 2–6 mm thick, nearly equal or tapering downward, occasionally slightly bulbous, dry, smooth to finely hairy, with or without longitudinal striations, colored like the cap, stuffed and hollowing. Fresh basal mycelium is white. No partial veil. **flesh** colored like the cap; odor and taste not distinctive.
MICROSCOPIC FEATURES: Spores 7–10 μm excluding spines, globose to subglobose, hyaline, inamyloid, with spines 1–2 μm long.
SPORE PRINT: White.
HABIT, HABITAT, AND SEASON: Scattered to loosely grouped on the ground in many woodland ecosystems, especially damp ones; spring–fall.
EDIBILITY: Edible but poor.
COMMENTS: The variability of *Laccaria laccata* (Scop.) Cooke accounts for the common name, Deceiver. The form presented here has gills that are simply attached, not decurrent, and pale in color. *Laccaria laccata* var. *decurrens* (not illustrated) has deeper pink or slightly purplish, decurrent gills. The basal mycelium of *Laccaria laccata*, all varieties, is white when fresh. The otherwise indistinguishable *Laccaria trichodermophora* (see Color Key) has purplish basal mycelium that quickly fades to white. Unless you're writing a thesis on this murky group of ho-hum mycological weeds you are forgiven for glazing over at this point.

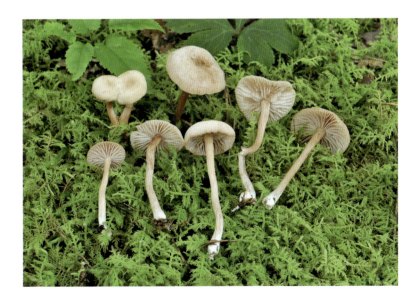

Lactarius areolatus Hesler & A. H. Sm.

MACROSCOPIC FEATURES: cap 2–7 cm wide, convex, becoming nearly flat with a depressed center or with a low umbo, dry or moist, bald, finely cracked in a somewhat concentric pattern, especially toward the margin, brown to orange-brown; margin curved downward, even. **gills** decurrent, close, yellowish at first, developing vinaceous spots, then becoming vinaceous brown overall in age. **stalk** 2–8 cm long and 3–15 mm thick, nearly equal, dry, bald, hollow in age, colored like the cap or paler, often whitish at the base. **flesh** thin, brittle, colored like the cap or paler; odor fragrant or sweet, taste not distinctive or sometimes faintly acrid. **latex** white to whey-like on exposure, unchanging, not staining tissues, taste not distinctive.
MICROSCOPIC FEATURES: Spores 6.5–9 × 6–7 μm, subglobose to broadly ellipsoid, ornamented with warts and ridges that do not form a reticulum, hyaline, amyloid.
SPORE PRINT: Whitish.
HABIT, HABITAT, AND SEASON: Scattered to clustered, terrestrial with oaks; summer–early winter.
EDIBILITY: Unknown.
COMMENTS: The epithet *areolatus* means "finely cracked." *Lactarius rimosellus* (not illustrated), edibility unknown, has a 2–8 cm wide, dull ferruginous to rusty brown or pinkish cinnamon cap that is finely cracked, especially toward the margin. Gills are decurrent, close, sometimes forked, whitish to ochraceous or colored like the cap. The stalk is also colored like the cap. Latex is white to whey-like, flesh is unchanging and mild-tasting, and the spores typically lack ridges. It is terrestrial in conifer woods. Similarly colored species lacking the concentric cracks include *Lactarius oculatus* and *Lactarius quietus*.

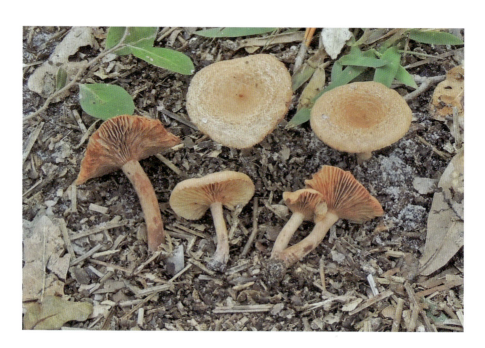

Lactarius chelidonium Peck

COMMON NAME: Celandine Lactarius
MACROSCOPIC FEATURES: cap 5–8 cm wide, convex, becoming broadly convex to nearly flat with a depressed center, slightly sticky, bald, grayish green to grayish yellow or yellow-brown with bluish green tints in age, sometimes weakly zonate toward the margin. **gills** attached to slightly decurrent, narrow, close, forked and wavy near the stalk, grayish yellow. **stalk** 2.5–4 cm long and 7–20 mm thick, nearly equal, dry, bald, hollow in age, colored like the cap. **flesh** yellow at first, becoming blue overall, staining green where bruised; odor not distinctive, taste mild or slowly and slightly acrid. **latex** scant, yellow on exposure, slowly changing to dingy yellowish brown and staining gills green, taste mild.
MICROSCOPIC FEATURES: Spores 8–10 × 6–7 μm, ellipsoid, ornamented with warts and ridges that form a partial reticulum, prominences up to 0.5 μm high, hyaline, amyloid.
SPORE PRINT: Yellowish.
HABIT, HABITAT, AND SEASON: Scattered or in groups on sandy soil under pines; summer–fall.
EDIBILITY: Edible.
COMMENTS: The cap of the edible Silver-blue Milky, *Lactarius paradoxus* (see Color Key), is zoned with bands of grayish blue, grayish purple, green, and blue; it stains green when bruised. Latex is scanty, dark vinaceous brown on exposure, staining tissues green. The stalk is colored like the cap at first, then develops pinkish to purplish tones. It inhabits a variety of woodland types. The Variegated Milky, *Lactarius subpurpureus* (see Color Key), edibility unknown, grows under conifers, often pines, or in mixed woods. It has a reddish pink to vinaceous pink cap that is spotted or zonate and sometimes stained emerald green. Stalk and gills are colored like the cap, with the stalk adding dark red pits. Latex is scant and wine red; flesh is mild-tasting.

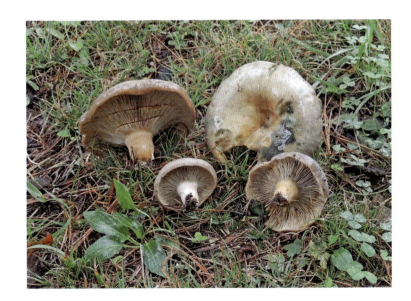

Lactarius chrysorrheus Fr.

COMMON NAME: Gold Drop Milk Cap
MACROSCOPIC FEATURES: cap 3–9 cm wide, convex, becoming depressed over the disc, then broadly funnel-shaped, initially moist or slippery but soon dry, bald with a dusting of white, azonate or with watery spots loosely arranged in zones, whitish to pale yellowish cinnamon with darker spots when young, fading in age to nearly whitish overall; margin even. **gills** attached to subcurrent, narrow, close, sometimes forking near the stalk, whitish to pale orange-buff, not discoloring or with vinaceous to brown spots. **stalk** 3–8 cm long and 1–2 cm thick, nearly equal, moist or dry, bald, hollowing, whitish, sometimes flushed orange-buff in age, sometimes coarsely hairy at the base. **flesh** thin, whitish, yellowing when cut; odor not distinctive, taste distinctly acrid, sometimes slowly. **latex** copious, white on exposure, quickly changing to yellow, not staining tissues, taste acrid, sometimes slowly.
MICROSCOPIC FEATURES: Spores 6–9 × 5.5–6.5 μm, broadly ellipsoid, ornamented with warts and ridges that may form a partial reticulum, prominences up to 0.5 μm high, hyaline, amyloid.
SPORE PRINT: Pale yellow.
HABIT, HABITAT, AND SEASON: Solitary, scattered, or in groups in broadleaf and mixed woods, especially with oaks; summer–fall.
EDIBILITY: Unknown.
COMMENTS: The very similar *Lactarius vinaceorufescens* (not illustrated), reportedly poisonous, has pinkish tones and fruits under pine. *Lactarius proximellus* (see Color Key), edibility unknown, has a depressed, zonate, tawny to brownish orange cap. The stalk typically stains pale bluish green when bruised. Flesh tastes very acrid, and latex is scant, white, unchanging. It is terrestrial with oaks or pines. *Lactarius psammicola* (see Color Key), edibility unknown, has a deeply depressed, sticky, coarsely fibrillose, ochraceous orange cap with a bearded margin when young. The stalk is often pitted. Latex is white, and the flesh is acrid. This species usually grows with oaks.

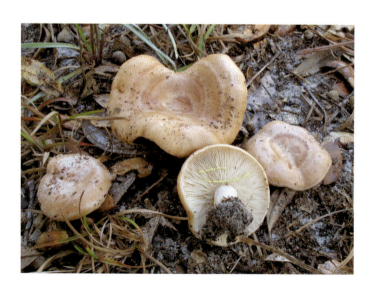

Lactarius croceus Burl.

MACROSCOPIC FEATURES: cap 5–10 cm wide, broadly convex to nearly flat with a depressed center, bald, slimy when wet, shiny when dry, initially bright orange to saffron yellow, fading to paler yellow-orange or yellowish tan, azonate or zoned with darker orange bands; margin curved downward. **gills** attached or slightly decurrent, close to subdistant, creamy buff to pale yellow-tan, staining sulfur yellow. **stalk** 3–6 cm long and 1–2 cm thick, nearly equal, bald, colored like the cap or paler, sometimes spotted brownish, becoming hollow. **flesh** thick, whitish, staining sulfur yellow before the latex changes color; odor not distinctive, taste bitter or acrid. **latex** white on exposure, soon changing to sulfur yellow, staining gills and flesh sulfur yellow, taste bitter or acrid.

MICROSCOPIC FEATURES: Spores 7.5–10 × 5.5–7.5 μm, elliptic, ornamented with warts and ridges that form a partial reticulum, prominences up to 0.6 μm high, hyaline, weakly amyloid.

SPORE PRINT: Yellowish.

HABIT, HABITAT, AND SEASON: Solitary or scattered in broadleaf woods, especially with oaks; summer–fall.

EDIBILITY: Unknown.

COMMENTS: The epithet *croceus* means "saffron-colored," a reference to the color of its cap and stalk. *Lactarius salmoneus* (not illustrated), edibility unknown, has an azonate cap that is initially white, then becomes orange nearly overall; it stains orange and rarely bluish green when bruised. The white stalk turns orange as the white layer wears away. Flesh tastes slightly acrid or not distinctive. The latex is scant and dark orange. It typically grows with pines. *Lactarius pseudodeliciosus* (see Color Key), edibility unknown, has a depressed, azonate, whitish to buff cap that becomes yellowish in age. Gills are honey yellow with orange tones; the yellowish flesh turns grayish green when cut, and the scant orange latex tastes slowly acrid. It grows on sandy soil with oaks and pines.

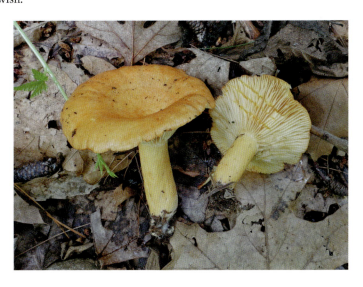

Lactarius delicatus Burl.

MACROSCOPIC FEATURES: cap 6–12 cm wide, convex with a depressed center, becoming funnel-shaped when mature, sticky to slimy, bald, zonate, pale orange-yellow with yellowish salmon tints over the disc; margin inrolled and bearded at first with coarse, short hairs. **gills** attached or subdecurrent, narrow, close, sometimes forked near the stalk, whitish becoming pale buff to pale orange-yellow. **stalk** 1.5–5 cm long and 1.5–2.3 cm thick, nearly equal or tapered downward, sticky, bald, stuffed to hollow, pitted, colored like the cap. **flesh** firm, white; odor pungent or not distinctive, taste acrid. **latex** scant, white on exposure, soon changing to sulfur yellow, taste acrid.

MICROSCOPIC FEATURES: Spores 7–9.5 × 6–7 μm, broadly ellipsoid, ornamented with isolated warts and ridges that form a partial reticulum, prominences up to 0.5 μm high, hyaline, amyloid.

SPORE PRINT: Whitish with a yellowish salmon tint.

HABIT, HABITAT, AND SEASON: Scattered or in groups in hardwoods, usually with oaks; summer–fall.

EDIBILITY: Unknown.

COMMENTS: *Lactarius maculatipes* (see Color Key), edibility unknown, has a similarly colored cap and stalk, but the latex is white and unchanging and stains tissues yellowish. The flesh slowly tastes acrid. It grows with oaks. The cap of *Lactarius yazooensis* (see Color Key), edibility unknown, has conspicuous orange to rusty orange or dull orange-red zones alternating with paler zones. The flesh tastes exceedingly acrid. It grows with broadleaf trees, especially oaks.

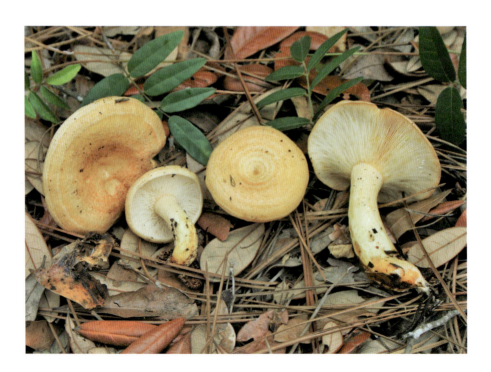

Lactarius deterrimus Gröger

= *Lactarius deliciosus* var. *deterrimus* (Gröger) Hesler & A. H. Sm.

COMMON NAME: False Saffron Milkcap

MACROSCOPIC FEATURES: cap 3–12 cm wide, convex, becoming broadly convex to nearly flat with a depressed center or broadly funnel-shaped, bald, azonate to obscurely zonate, light orange, fading in age and developing green spots; margin even. **gills** attached to slightly decurrent, subdistant, not forked, light orange, slowly staining orange-brown to reddish brown, then dull green. **stalk** 2–5 cm long and 6–16 mm thick, equal or tapering downward, dry, stuffed, then hollowing, not pitted, light orange, slowly staining green to grayish green where bruised. **flesh** whitish to pale yellowish orange, slowly staining dull orange to reddish brown when exposed; odor and taste not distinctive. **latex** orange on exposure, unchanging, slowly staining cut surfaces dull orange to reddish brown, taste not distinctive.

MICROSCOPIC FEATURES: Spores 8–11.5 × 6.5–9 μm, broadly ellipsoid, ornamented with warts and ridges that form a partial reticulum, prominences up to 0.5 μm high, hyaline, amyloid.

SPORE PRINT: Pale yellow.

HABIT, HABITAT, AND SEASON: Solitary, scattered, or in groups on the ground in conifer woods; summer–fall.

EDIBILITY: Edible.

COMMENTS: The Orange-latex Milky, *Lactarius deliciosus* (not illustrated), is a group of nearly identical species and varieties in western North America. *Lactarius chelidonium* is also similar but the flesh slowly stains green, not orange or reddish, after exposure. *Lactarius croceus* has a similarly colored cap and stalk but lacks green staining anywhere. The scant white latex soon changes to sulfur yellow. *Lactarius pseudodeliciosus* (see Color Key), edibility unknown, has a depressed, azonate, whitish to buff cap that yellows in age. Gills are honey yellow with orange tones. The yellowish flesh turns grayish green when cut, and the scant orange latex tastes slowly acrid. It grows on sandy soil with oaks and pines.

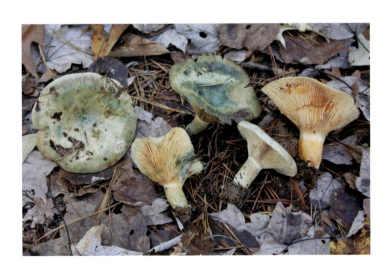

Lactarius dispersus Hesler & A. H. Sm.

MACROSCOPIC FEATURES: cap 4–10 cm wide, convex with a depressed center, expanding and becoming broadly funnel-shaped, slightly sticky, coated with a thin layer of fibrils that agglutinate into distinct tufts near the margin, conspicuously zonate with pale buff to dingy tan zones that alternate with darker brown zones; margin bearded when immature. **gills** decurrent, moderately broad, close to subdistant, dull white to pinkish buff, bruising dingy lilac, then brown. **stalk** 4–6 cm long and 1–1.7 cm thick, nearly equal, dry, solid or hollow, unpolished, pitted, dingy yellow-orange to pale dingy tan or buff. **flesh** whitish to buff, staining lilac from the latex; odor not distinctive, taste not distinctive or slightly bitter. **latex** dingy white on exposure, unchanging, staining tissues dull lilac, taste not distinctive or slightly bitter.

MICROSCOPIC FEATURES: Spores 7.5–10 × 6–7.5 μm, broadly ellipsoid, ornamented with small warts and unconnected ridges that do not form a reticulum, prominences up to 1.5 μm high, hyaline, amyloid.

SPORE PRINT: Yellowish.

HABIT, HABITAT, AND SEASON: Solitary or scattered on the ground in mixed oak and pine woods; summer–fall.

EDIBILITY: Unknown.

COMMENTS: *Lactarius speciosus* (not illustrated), edibility unknown, is very similar but has a white spore print and larger, more reticulate spores that measure 10–13.5 × 9–11 μm. A large and homely lilac-stainer, *Lactarius subpalustris* (not illustrated), edibility unknown, is likely to occur in Georgia. Cap diameters range from 10 to 20 cm. Both cap and stalk are slimy or sticky, bald, colored in dingy shades of pink and ochraceous decorated with yellow-brown to olive brown spots. Caps are azonate to obscurely zonate. The latex is watery buff and stains tissues lilac. Noted mycologist Alexander Smith considered lilac-staining milk mushrooms to be poisonous, and they might be, but case reports for these three species seem lacking.

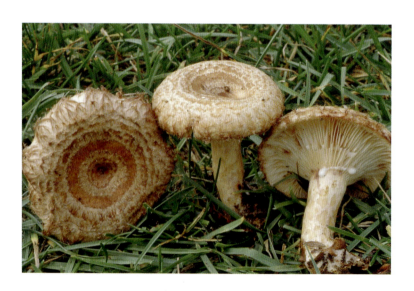

Lactarius gerardii var. *gerardii* Peck

COMMON NAME: Gerard's Milky
MACROSCOPIC FEATURES: cap 3–13 cm wide; convex, becoming broadly convex to flat, wrinkled, with a depressed center in age, with or without an umbo, dry, velvety, azonate, brown to yellow-brown or tan; margin even. **gills** attached to decurrent, broad, subdistant or distant, crossveined, whitish to cream. **stalk** 3.5–8 cm long and 8–20 mm thick, nearly equal or enlarged downward, usually with an abruptly tapered base, stuffed when young, hollow in age, dry, velvety, dark brown to yellow-brown, paler and often grooved at the apex. **flesh** firm, thin, white, not staining; odor not distinctive, taste mild, then slowly, slightly acrid. **latex** white on exposure, unchanging, not staining, taste mild, then slowly, slightly acrid.
MICROSCOPIC FEATURES: Spores 7–10 × 7.5–9 μm, globose to subglobose or broadly ellipsoid, ornamented with warts and ridges that form a reticulum, prominences up to 0.8 μm high, hyaline, amyloid.
SPORE PRINT: White.
HABIT, HABITAT, AND SEASON: Scattered or in groups under hardwoods or conifers; summer–fall.
EDIBILITY: Edible.
COMMENTS: The flesh stains yellow with KOH. *Lactarius gerardii* var. *subrubescens* (not illustrated), edibility unknown, is almost identical, but the flesh stains vinaceous pink when exposed. A look-similar, *Lactarius lignyotus* (not illustrated), edibility unknown, has a blackish brown, velvety cap and white milk that stains tissues pink. *Lactifluus petersenii* is another look-similar. Its latex on exposure is pinkish brown to dingy brown and produces brown stains on the gills.

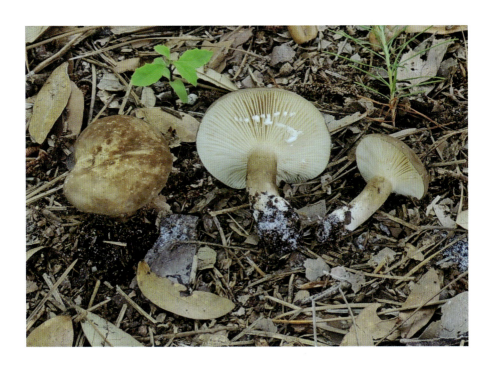

Lactarius imperceptus Beardslee & Burl.

MACROSCOPIC FEATURES: cap 3–9 cm wide, broadly convex to nearly flat, usually slightly depressed on the disc, with a small umbo at maturity, dry, bald, azonate, pale cinnamon to pinkish cinnamon or pale reddish brown, typically pitted and stained with darker flecks of pinkish cinnamon; margin sometimes striate in age. **gills** attached to slightly decurrent, close, whitish to pinkish white, usually staining brownish, occasionally forked at the stalk. **stalk** 3–9 cm long and 6–20 mm thick, tapered downward or nearly equal, solid, dry to moist, pinkish white, darkening in age, bald but for a whitish matted and woolly base. **flesh** whitish, sometimes staining yellow when exposed; odor not distinctive, taste acrid, sometimes slowly. **latex** white to creamy white on exposure, sometimes slowly darkening to yellow, taste bitter, then acrid or acrid only, sometimes slowly.

MICROSCOPIC FEATURES: Spores 8–11 × 7–8.5 μm, broadly ellipsoid, ornamented with heavy bands that do not form a complete reticulum, prominences up to 1.5 μm high, hyaline, amyloid.

SPORE PRINT: White to pale cream.

HABIT, HABITAT, AND SEASON: Solitary, scattered, or in groups on the ground or in needle litter with conifer or broadleaf trees, especially pines or oaks; summer–winter.

EDIBILITY: Unknown.

COMMENTS: The flesh stains pale olive with $FeSO_4$. Staining of the flesh and color change of the latex are variable features, especially if the fruit bodies are soaked following heavy rainfall. *Lactarius alachuanus* (not illustrated), edibility unknown, has an azonate, pale pinkish cinnamon to pale yellowish cinnamon cap when young, turning to pinkish buff in age. It has a pinkish buff stalk dusted with white powder that rubs off. The flesh tastes slightly bitter, then moderately acrid. Latex is white and does not stain gills. This species grows on sandy soil and rotting wood in mixed oak and pine woods.

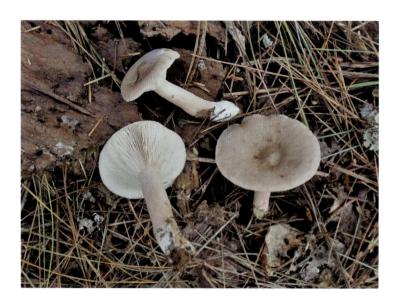

Lactarius indigo var. *indigo* (Schwein.) Fr.

COMMON NAMES: Indigo Milk Cap, Indigo Milky

MACROSCOPIC FEATURES: cap 5–15.5 cm wide, convex to convex-depressed, becoming broadly funnel-shaped, sticky, bald, zonate to nearly azonate, dark blue when fresh, fading to grayish blue, then grayish with a silvery luster, often with dark green areas where bruised; margin inrolled at first. **gills** attached or subdecurrent, broad, close, sometimes forked near the stalk, dark blue at first, paler blue at maturity and developing yellowish tints in age, staining green when bruised. **stalk** 2–8 cm long and 1–2.5 cm thick, nearly equal or tapered downward, hollow in age, sticky but soon dry, colored like the cap, sometimes with a sheen, often pitted. **flesh** thick, firm, whitish, rapidly staining dark blue on exposure, then slowly greenish; odor not distinctive, taste mild, or rarely slightly bitter, becoming slightly acrid. **latex** scant, dark blue on exposure, slowly becoming dark green, taste mild.

MICROSCOPIC FEATURES: Spores 7–9 × 5.5–7.5 μm, broadly ellipsoid to subglobose, ornamented with ridges that form a partial to complete reticulum, prominences up to 0.5 μm high, hyaline, amyloid.

SPORE PRINT: Creamy white.

HABIT, HABITAT, AND SEASON: Solitary, scattered, or in groups on the ground under conifer or broadleaf trees; summer–winter.

EDIBILITY: Edible.

COMMENTS: The epithet *indigo* means "dark blue," a reference to the color of the latex. The cap of *Lactarius atroviridis* (see Color Key), edibility unknown, ranges from dark shades of olive green to grayish green and is usually zonate with concentrically arranged dark green spots. Gills stain greenish gray to brownish. The pitted stalk is colored like the cap. Flesh is acrid, and the latex is white. It is terrestrial in conifer or broadleaf woods.

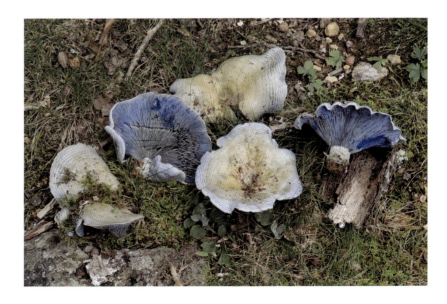

Lactarius oculatus (Peck) Burl.

= *Lactarius subdulcis* var. *oculatus* Peck

COMMON NAME: Eyespot Milky

MACROSCOPIC FEATURES: cap 1–4.5 cm wide, broadly convex, becoming nearly flat when older, with a slightly depressed center and small pointed umbo, sticky when fresh, shiny when dry, azonate, dark reddish brown to orange-brown at the center and paler toward the margin, fading to pale orange-brown except for the umbo, which usually retains its dark color well into maturity and resembles an eyespot; margin even. **gills** attached to slightly decurrent, close to subdistant, cream to pinkish buff, staining light pinkish brown to dull cinnamon with age. **stalk** 2–4.5 cm long and 3–10 mm thick, nearly equal or enlarged slightly downward, hollow, moist but not sticky, dull pinkish brown to pinkish orange, often with whitish basal mycelium. **flesh** thin, fragile, watery, pinkish brown; odor not distinctive, taste very slowly and faintly acrid, then fading. **latex** scant, watery to whey-like on exposure, unchanging, not staining tissues, taste very slowly becoming faintly acrid, then fading.

MICROSCOPIC FEATURES: Spores 7.5–9 × 6–7 µm, elliptic, ornamented with warts and ridges that typically do not form a reticulum, prominences up to 0.6 µm high, hyaline, amyloid.

SPORE PRINT: Pale yellow.

HABIT, HABITAT, AND SEASON: Scattered or in groups on the ground among needles in conifer woods, especially with pines; summer–fall.

EDIBILITY: Edible.

COMMENTS: The Aromatic Milky or Spicy Milk Cap, *Lactarius camphoratus* (not illustrated), edibility unknown, is very similar. The flesh has a fragrant odor, like maple sugar or burnt sugar, and tastes disagreeable to bitter but not acrid. It is terrestrial in conifer woods.

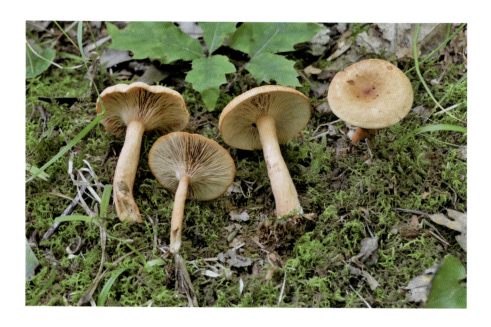

Lactarius quietus (Fr.) Fr.

= *Lactarius quietus* var. *incanus* Hesler & A. H. Sm.

MACROSCOPIC FEATURES: cap 3–11 cm wide, broadly convex with a depressed center, coated with a layer of tiny whitish fibrils when young, soon bald or with scattered small bumps, moist or dry, at times with water spots, typically zonate, dark purplish brown or purplish gray in youth, becoming dark red-brown centrally in age with a paler pinkish brown to pinkish buff margin; margin even. **gills** attached to slightly decurrent, narrow, often forked, close, white to whitish with pink tints, becoming cinnamon, staining orange-cinnamon in age. **stalk** 4–14 cm long and 5–10 mm thick, equal or slightly enlarged at the base, solid, then hollow, dry, covered with a layer of tiny whitish fibrils when young, colored like the cap and darkening progressively toward the apex as it matures. **flesh** pale pinkish buff; odor fragrant, often like burnt sugar or rarely not distinctive, taste mild, then slowly, weakly acrid. **latex** white on exposure in young specimens, soon watery as specimens mature, taste mild, then slowly, weakly acrid.

MICROSCOPIC FEATURES: Spores 6.5–9 × 5–7.5 μm, elliptic, ornamented with warts and ridges that sometimes form a partial reticulum, prominences up to 0.6 μm high, hyaline, amyloid.

SPORE PRINT: Pinkish buff.

HABIT, HABITAT, AND SEASON: Scattered or in groups under oaks; summer, fall–early winter.

EDIBILITY: Unknown.

COMMENTS: *Lactarius mutabilis* (not illustrated), edibility unknown, is similar but has persistently mild-tasting latex and a whitish to dull creamy yellow spore print. It associates with conifers. *Lactarius purpureoechinatus* (not illustrated), edibility unknown, has a dull grayish purple cap covered with erect bundles of dark scales. The flesh taste is not distinctive, and the white latex is unchanging. It grows with oaks. See also the generally smaller *Lactarius areolatus*.

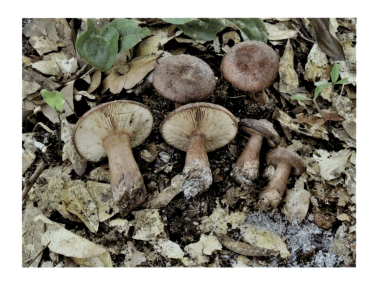

Lactarius subserifluus Longyear

MACROSCOPIC FEATURES: cap 2–7 cm wide, convex-depressed, becoming funnel-shaped in age, usually and often sharply umbonate, dry, bald, orange-brown, paler at maturity; margin often finely scalloped to wavy in age. **gills** decurrent, narrow or broad, subdistant, yellowish, soon stained vinaceous cinnamon, and in age orange-cinnamon or with vinaceous tints overall. **stalk** 5–12 cm long and 3–7 mm thick, nearly equal, moist, hard and tough for a *Lactarius*, bald, orange-cinnamon on the upper portion, dark rusty brown below, base with conspicuous orange-cinnamon hairs. **flesh** thin, yellowish; odor not distinctive, taste mild or faintly acrid. **latex** watery on exposure, unchanging, staining the gills vinaceous cinnamon, taste not distinctive.

MICROSCOPIC FEATURES: Spores 6–7.5 × 6–7 µm, globose to subglobose, ornamented with warts and ridges that form a partial or nearly complete reticulum, prominences up to 1.5 µm high, hyaline, amyloid.

SPORE PRINT: Pinkish buff.

HABIT, HABITAT, AND SEASON: Solitary to scattered or rarely in groups under oaks and hickories; summer–fall.

EDIBILITY: Unknown.

COMMENTS: The distinguishing features include the orange-brown cap, orange-cinnamon to rusty brown stalk, gill details, and small spores. *Lactarius argillaceifolius* (see Color Key), edibility unknown, has a sticky, shiny, lilac brown to lilac gray cap that fades to pale tan and creamy gills that bruise brown. The flesh is white to buff and tastes slowly, slightly acrid or is not distinctive. It has white latex and grows in broadleaf woods, usually with oaks. The cap of *Lactifluus allardii* (see Color Key), edibility unknown, is white when very young, becoming pale pinkish cinnamon, then dull brick red in age. The flesh is white, slowly stains pinkish, then olivaceous, and has an acrid flavor. The white latex turns very slowly greenish olive, then brownish. It is terrestrial in broadleaf or mixed woods.

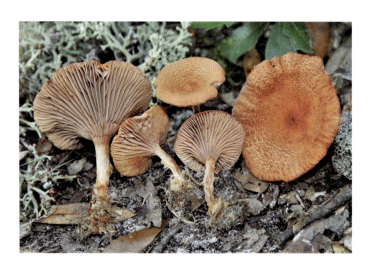

Lactarius subvernalis var. *cokeri*
(A. H. Sm. & Hesler) Hesler and A. H. Sm.

= *Lactarius cokeri* A. H. Sm. & Hesler

MACROSCOPIC FEATURES: **cap** 2–6 cm wide, broadly convex to flat and shallowly depressed when mature, with or without an umbo, dry, unpolished to powdery, bald and finely wrinkled in age, azonate to faintly zonate at the margin, whitish when young becoming buff to pale smoky brownish; margin lobed or wavy. **gills** broadly attached to subdecurrent, crowded, narrow, forking near the stalk, whitish to pinkish buff, spotting pinkish where injured. **stalk** 5–7 cm long and 8–15 mm thick, equal to slightly enlarged at the base, stuffed or hollow, dry, white, covered by a whitish bloom when young, pallid when the bloom is removed, staining pinkish where bruised. **flesh** fairly thick, white, staining pink when cut; odor not distinctive or like coconut suntan lotion, taste acrid. **latex** white, unchanging, staining gills and flesh pinkish where cut, taste acrid.

MICROSCOPIC FEATURES: Spores 7–9 μm, globose to subglobose, ornamented with a complete reticulum of coarse and fine ridges, prominences 0.6–1.5 μm high, hyaline, amyloid.

SPORE PRINT: Yellow.

HABIT, HABITAT, AND SEASON: Scattered or in groups under broadleaf trees; summer–fall.

EDIBILITY: Unknown.

COMMENTS: *Lactarius subplinthogalus* (see Color Key), edibility unknown, has a broadly funnel-shaped, yellowish buff to pale tan or brownish yellow cap with a conspicuously scalloped or pleated margin. It has distant gills and white latex that stains gills and flesh rosy salmon, and it is terrestrial with oaks.

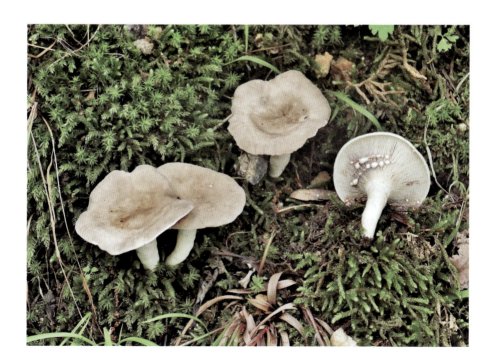

Lactifluus corrugis (Peck) Kuntze

= *Lactarius corrugis* Peck

COMMON NAME: Corrugated-cap Milky

MACROSCOPIC FEATURES: cap 4–20 cm wide; convex, becoming broadly convex to nearly flat with a depressed center in age, velvety, dry, azonate, distinctly wrinkled to finely corrugated, reddish brown to vinaceous brown, paler and sometimes orange-brown on the margin, often with a whitish bloom, especially when young; margin even. **gills** attached, close, occasionally forked, pale cinnamon to pale golden brown, staining darker brown when bruised. **stalk** 5–11 cm long and 1.5–3 cm thick, equal, solid, dry, velvety, pale grayish cinnamon to pale pinkish cinnamon, sometimes with a whitish bloom. **flesh** whitish, staining brown; odor fishy in mature mushrooms, often not distinctive in young specimens, taste not distinctive. **latex** copious, white on exposure, unchanging, staining gills and flesh tawny brown, taste not distinctive.

MICROSCOPIC FEATURES: Spores 9–12 × 8.5–12 μm, subglobose, ornamented with warts and ridges that form a partial reticulum, prominences up to 0.8 μm high, hyaline, amyloid.

SPORE PRINT: White.

HABIT, HABITAT, AND SEASON: Solitary to scattered in broadleaf or mixed woods that include oaks; summer–fall.

EDIBILITY: Edible.

COMMENTS: *Lactifluus volemus* var. *volemus* is very similar, but the dark orange-brown to cinnamon brown cap is less wrinkled and paler orange-brown toward the margin. The edible Buff Fishy Milky, *Lactifluus luteolus* (see Color Key), has a fishy or unpleasant odor resembling spoiled crab. The 2.5–6 cm cap is initially whitish to buff with a white bloom but browns in age. The stalk is colored like the cap. Gills stain yellow-brown. It has copious watery white to white latex and a mild taste. This species also fruits in deciduous or mixed woods, often near oaks.

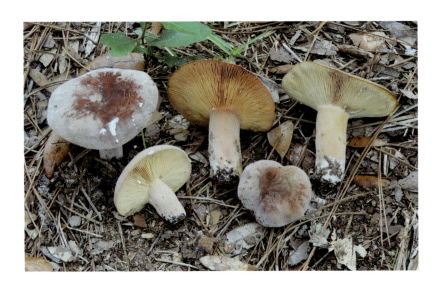

Lactifluus hygrophoroides (Berk. & M. A. Curtis) Kuntze

= *Lactarius hygrophoroides* Berk. & M. A. Curtis

COMMON NAME: Hygrophorus Milky

MACROSCOPIC FEATURES: **cap** 3–10 cm wide, broadly convex, becoming nearly flat with a depressed center or funnel-shaped in age, dry, bald to slightly velvety, sometimes slightly wrinkled toward the margin in age, dull orange to orange-brown or orange-cinnamon; margin even. **gills** attached to slightly decurrent, broad, distant at maturity, crossveined, white to cream or yellowish buff. **stalk** 3–5 cm long and 5–15 mm thick, nearly equal, solid, dry, pale orange-brown to orange-yellow. **flesh** white; odor and taste not distinctive. **latex** white on exposure, unchanging, not staining gills or flesh, taste not distinctive.

MICROSCOPIC FEATURES: Spores 7.5–10.5 × 6–7.5 μm, elliptic, ornamented with warts and ridges, prominences up to 0.4 μm high, hyaline, amyloid.

SPORE PRINT: White.

HABIT, HABITAT, AND SEASON: Solitary, scattered, or in groups in broadleaf woods; summer–early winter.

EDIBILITY: Edible.

COMMENTS: The edible *Lactifluus rugatus* (not illustrated) is very similar but has conspicuous concentric wrinkles near the cap margin and white flesh that stains vinaceous to dull red with $FeSO_4$. It grows in deciduous woods, especially near oaks.

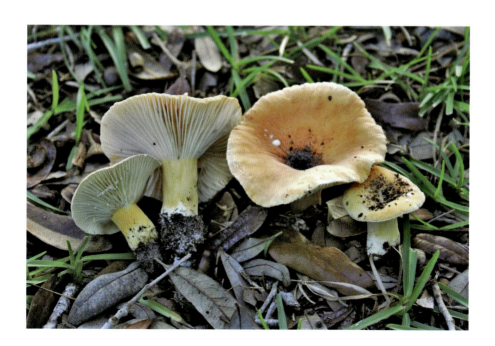

Lactifluus petersenii (Hesler & A. H. Sm.) D. Stubbe

= *Lactarius petersenii* Hesler & A. H. Sm.

MACROSCOPIC FEATURES: cap 3–4.5 cm wide, broadly convex, often with a depressed center, dry, minutely velvety with radiating fine wrinkles, smoky yellowish brown; margin decurved, becoming uplifted in maturity. **gills** attached to decurrent, close, not forked, white to cream, staining brown where bruised. **stalk** 3–4 cm long and 6–10 mm thick, nearly equal, dry, hollow with age, minutely velvety, colored like the cap. **flesh** white, unchanging; odor and taste not distinctive. **latex** pale pinkish brown to dingy brownish on exposure, unchanging, staining gills brownish, taste not distinctive.

MICROSCOPIC FEATURES: Spores 7.5–10 × 6–8 μm, ellipsoid to broadly ellipsoid, ornamented with warts and fine lines that form an obscure reticulum, prominences up to 0.3 μm high, hyaline, amyloid.

SPORE PRINT: White.

HABIT, HABITAT, AND SEASON: Solitary or scattered on the ground in mixed woods, usually with hemlocks present; late spring–fall.

EDIBILITY: Unknown.

COMMENTS: The epithet *petersenii* honors American mycologist Ron Petersen. *Lactarius gerardii* is similar but has white latex on exposure.

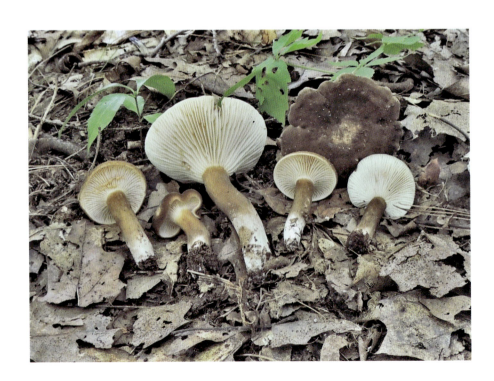

Lactifluus piperatus (L.) Roussel

= *Lactarius piperatus* (L.) Pers.

COMMON NAMES: Peppery Milky, Peppery White Milk Cap

MACROSCOPIC FEATURES: cap 3–15.5 cm wide, convex, becoming nearly flat to depressed and finally funnel-shaped, dry, azonate, bald or finely wrinkled, white when young, then creamy white with ochraceous to dingy tan stains; margin even. **gills** attached to decurrent, narrow, very crowded, often forked one or more times, white at first, pale cream when mature, sometimes staining yellowish. **stalk** 2–8 cm long and 1–2.5 cm thick, nearly equal, dry, firm, solid, white, and powdery. **flesh** white, sometimes slowly staining yellowish; odor not distinctive, taste strongly acrid. **latex** white on exposure, unchanging or sometimes slowly staining the gills yellowish and drying yellow, taste quickly and strongly acrid.

MICROSCOPIC FEATURES: Spores 4.5–7 × 5–5.5 µm, ellipsoid, ornamented with fine lines and isolated particles that do not form a reticulum, prominences up to 0.2 µm high, hyaline, amyloid.

SPORE PRINT: White.

HABIT, HABITAT, AND SEASON: Solitary, scattered, or in groups on the ground under conifers or hardwoods; summer–fall.

EDIBILITY: Edible.

COMMENTS: *Lactifluus glaucescens* (not illustrated), reportedly toxic, is very similar, but the white latex eventually dries bluish green. The edible *Lactifluus subvellereus* (see Color Key) has a white cap and stalk as well. The close to subdistant white gills yellow in age and stain brownish to pinkish where injured. Latex is white, dries creamy yellow, and has a strongly acrid taste. The Deceptive Milky, *Lactifluus deceptivus* (see Color Key), edible, has a conspicuous cottony inrolled margin on young specimens, close or subdistant gills, and a strongly acrid taste. *Lactarius tomentosomarginatus* (not illustrated), unknown edibility, resembles the Deceptive Milky but has a firmer cap margin, crowded gills, and larger spores measuring 9–11 × 7–8.5 µm.

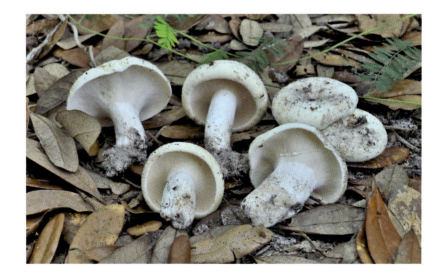

Lactifluus volemus var. *volemus* (Fr.) Kuntze

= *Lactarius volemus* (Fr.) Fr.

COMMON NAMES: Apricot Milk Cap, Bradley, Voluminous-latex Milky

MACROSCOPIC FEATURES: cap 5–10 cm wide, broadly convex, becoming nearly flat with a depressed center, broadly funnel-shaped in age, dry, velvety when young, bald to finely wrinkled at maturity, dark orange-brown to cinnamon brown at the center, fading to pale orange-brown, then honey yellow at the cap margin; margin even. **gills** attached, close, often forked, whitish to cream, slowly bruising brown. **stalk** 5–11.5 cm long and 5–20 mm thick, nearly equal, solid, pale orange-brown to dull orange. **flesh** thick, brittle, white, staining brownish when exposed; odor not distinctive in very young specimens, otherwise fishy, taste mild. **latex** copious, white on exposure, becoming creamy white, brownish, or grayish and staining gills and flesh tawny brown, taste mild.

MICROSCOPIC FEATURES: Spores 7.5–10 × 7.5–9 μm, globose to subglobose, ornamented with warts and ridges that form a complete reticulum, prominences up to 1 μm high, hyaline, amyloid.

SPORE PRINT: White.

HABIT, HABITAT, AND SEASON: Solitary, scattered, or in groups in hardwoods or mixed woods; summer–fall.

EDIBILITY: Edible.

COMMENTS: The flesh instantly stains dark blue-green with $FeSO_4$. *Lactifluus volemus* var. *flavus* (see Color Key), edible, is nearly identical but has a yellow to orange-yellow cap and a cream to pale yellow stalk. Peck's Milky, *Lactarius peckii* (see Color Key), edibility unknown, has a brick red to dull reddish orange or orange-brown cap usually zoned with darker bands and cinnamon buff gills that darken to rusty brown in age. The latex is white on exposure and dries white, and both latex and flesh taste extremely acrid after a few seconds. Terrestrial with oaks. *Lactarius peckii* var. *glaucescens* (not illustrated), edibility unknown, is nearly identical, but the latex dries bluish green.

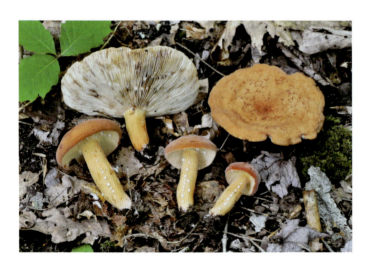

Lentinellus micheneri (Berk. & M. A. Curtis) Pegler

= *Lentinellus omphalodes* (Fr.) P. Karst.

MACROSCOPIC FEATURES: cap 1–5 cm wide, broadly convex to flat, centrally depressed, moist when fresh, hygrophanous, a shade of pinkish brown or light brown at first, bald. The cap margin is not striate. **gills** attached or subdecurrent, distant, pale pink to pinkish brown with saw-toothed edges, not staining when bruised. **stalk** 5–50 mm long and 1–3 mm thick, sometimes eccentrically placed, nearly equal, dry, pinkish brown or reddish brown, bald, often longitudinally grooved, hollow. No partial veil. **flesh** thin but tough, whitish to pale brown, not staining; odor not distinctive, taste eventually acrid.

MICROSCOPIC FEATURES: Spores 4–5 × 3–3.5 µm, ellipsoid, finely roughened, hyaline, amyloid.

SPORE PRINT: Pale buff.

HABIT, HABITAT, AND SEASON: Scattered or in small groups that are not fused at the base on decaying wood or woody debris; summer–fall.

EDIBILITY: Inedible.

COMMENTS: *Lentinellus subaustralis* (not illustrated) has an anesthetic rather than acrid taste but is otherwise nearly indistinguishable in the field or by spore size. *Lentinus tigrinus* has a scaly cap, while *Lentinus crinitis* is hairy. The much larger *Neolentinus lepideus* (see Color Key) has saw-toothed gills too. The 5–12 cm cap is initially whitish but develops brown scales. There is a membranous partial veil and pale, smooth, elliptic spores, 7–15 × 4–6.5 µm. Another group of look-similars has smooth gill edges. These include *Gerronema strombodes*, *Pseudoarmillariella ectypoides*, and *Arrhenia epichysium* (not illustrated). The latter has a bald, brownish gray, translucent-striate cap typically less than 3 cm in diameter, whitish gills, a brownish gray stalk, and smooth, inamyloid spores, 7–9 × 4–5 µm.

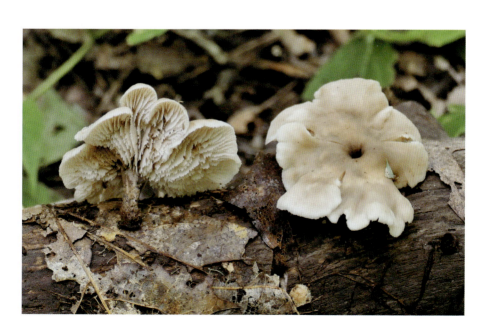

Lentinellus vulpinus (Sowerby) Kühner & Maire
= *Lentinellus ursinus* f. *robustus* (P. Karst.) R. H. Petersen

COMMON NAME: Fox Lentinellus
MACROSCOPIC FEATURES: cap 5–11.5 cm wide, shell-shaped, broadly convex, moist or dry, whitish to yellowish or pinker toward the margin, covered at least near the point of attachment with short, white or pale woolliness. The young cap margin is inrolled, usually developing radial ridges and sometimes raised peripheral scales in age. **gills** subdecurrent, with ridges extending down the stalk, close or crowded, broad, whitish but pinkening and staining brown at maturity, the edges saw-toothed. **stalk** usually less than 5 cm long, stout, eccentric or lateral, tapering downward and typically fused with others, dry, light brown to pinkish brown, fuzzy and ridged. Partial veil absent. **flesh** whitish to pinkish brown; odor not distinctive or of licorice, taste acrid.
MICROSCOPIC FEATURES: Spores 3.5–5 × 2.5–3.5 μm, subglobose, minutely spiny, amyloid.
SPORE PRINT: White.
HABIT, HABITAT, AND SEASON: Usually found in overlapping clusters from a shared base on living or dead deciduous trees; late summer–fall.
EDIBILITY: Inedible.
COMMENTS: The more common and commonly described Bear Lentinellus, *Lentinellus ursinus* (not illustrated), may have a pedicel attachment but is not supposed to have a distinct stalk fused with neighboring caps. Its cap and hairs are classically brownish orange to yellowish brown. The gills are broad but subdistant to close, not crowded. If you must identify an intermediate specimen to species, flip a coin. There's half a chance you'll be correct. *Lentinellus angustifolius* (not illustrated) has a stalkless, yellowish brown, shell-shaped cap 2.5 × 3.5 cm wide or less. The crowded gills are narrow, not broad. Spore details of all three species overlap.

Lentinula raphanica (Murrill) Mata & R. H. Petersen

= *Armillaria raphanica* Murrill

MACROSCOPIC FEATURES: cap 2–9 cm wide, convex, then broadening, perhaps shallowly depressed, moist or dry, suede-like or smooth, hygrophanous, reddish brown fading toward dingy yellow, often developing central wrinkles. The cap margin is a sterile band of tissue often hung with white tatters of partial veil. **gills** free or seceding, crowded, whitish to pale cinnamon brown, edges finely eroded by maturity. **stalk** 2–8 cm long and 3–10 mm thick, nearly equal or enlarging downward, often curved, pinkish buff to yellowish, whiter at the base, scaly. The white partial veil remains as tatters on the cap margin, leaving no ring on the stalk. **flesh** rubbery, whitish, all parts usually bruising brown; odor of garlic, radish, or not distinctive, taste initially mild but becoming garlicky or unpleasantly like cabbage.

MICROSCOPIC FEATURES: Spores $4.5–7 \times 2–3.5$ µm, narrowly ellipsoid, smooth, hyaline. Cheilocystidia usually narrow, mostly clavate, contorted, or knobby.

SPORE PRINT: White.

HABIT, HABITAT, AND SEASON: Probably limited to southern Georgia, scattered to densely gregarious on decaying wood, usually deciduous; summer–early winter.

EDIBILITY: Unknown.

COMMENTS: The rarely collected *Lentinula boryana* = *Lentinula detonsa* (not illustrated) occurs in similar situations and may be macroscopically indistinguishable. It lacks the garlic or radish odor, and the spores are fractionally broader at $5–8 \times 2.5–4$ µm. Cheilocystidia tend to be fatter as well. *Oudemansiella canarii* (see Color Key) occurs on deciduous trunks and branches, often oaks, in southern Georgia. The sticky gray-brown cap, 2–7 cm wide, is convex to flat, radially wrinkled and sometimes cracked, dotted with scale-like tufts that may wash off. Gills are attached, close, white, and smooth-edged. The stalk is 1–7 cm long, whitish with a grayish brown midsection, usually curved. Spores are $19–25 \times 18–23$ µm.

Lentinus berteroi (Fr.) Fr.

= *Lentinus crinitus* var. *berteroi* (Fr.) Pilát

COMMON NAME: Fringed Sawgill

MACROSCOPIC FEATURES: cap 2–7 cm wide, depressed to shallowly funnel-shaped with an incurved margin when young, covered by a dense layer of brown to dark brown hairs and scales that are darkest over the center and intermixed with white hairs most abundantly along the margin. **gills** decurrent, close or crowded, occasionally forked, poroid at the stalk apex, creamy white, becoming dull yellow, then brownish in age, the edges finely toothed (use a hand lens). **stalk** 2–4.5 cm long and 2–6 mm thick, equal or tapered in either direction, dry, with conspicuous hairs or short scales, dark brown to blackish but paler near the apex. No partial veil. **flesh** fibrous, tough, whitish; odor and taste not distinctive.

MICROSCOPIC FEATURES: Spores 5.5–7.5 × 2–2.8 μm, cylindric, smooth, hyaline, inamyloid.

SPORE PRINT: White.

HABIT, HABITAT, AND SEASON: Solitary or more often gregarious to clustered on decaying deciduous wood or tree roots; year-round.

EDIBILITY: Reportedly edible but tough.

COMMENTS: *Lentinus berteroi* is a saprotrophic tropical species found throughout Mexico, Central and South America, the Gulf Coast states, and Georgia. *Lentinus crinitus* is very similar but has yellowish brown to reddish brown hairs over a pale background and a much paler stalk. *Lentinus arcularius* is also similar, but its fertile surface consists of angular to hexagonal pores that are radially arranged like a honeycomb. It is described in the Polypore section. The Zoned Crinipellis, *Crinipellis zonata* (not illustrated), is smaller and usually fruits on decaying deciduous twigs. The cap is convex to broadly convex and only slightly dimpled, 1.2–4 cm in diameter. Rings of stiff orange to orange-brown hairs give it a zonate appearance. Gills are free, white, smooth-edged. The tough brown stalk is shaggy like the cap.

Lentinus crinitus (L.) Fr.

= *Panus crinitus* (L.) Singer

MACROSCOPIC FEATURES: cap 2.5–7.5 cm wide, convex with a broadly depressed and almost funnel-shaped center, dry, with projecting yellowish brown to reddish brown hairs over a pale background. The initially incurved cap margin is not striate, becoming elevated and wavy. **gills** deeply decurrent, close or crowded, whitish to cream, the edges finely toothed (use a hand lens). **stalk** 2–4 cm long and 2–6 mm thick, equal or tapered in either direction, dry, colored like the cap but paler, scurfy. No partial veil. **flesh** fibrous, tough, whitish; odor and taste not distinctive.

MICROSCOPIC FEATURES: Spores 5.5–8 × 2–3 µm, ellipsoid, smooth, hyaline, inamyloid.

SPORE PRINT: White.

HABIT, HABITAT, AND SEASON: Single or more often gregarious to clustered on decaying deciduous wood; year-round.

EDIBILITY: Inedible.

COMMENTS: *Lentinus berteroi* is very similar but has white and dark brown cap hairs and a much darker hairy or scaly stalk. The cap of *Lentinellus micheneri* is bald. *Lentinus tigrinus* has a scaly cap. The Zoned Crinipellis, *Crinipellis zonata* = *Collybia zonata* (not illustrated), is smaller and usually fruits on decaying deciduous twigs. The cap is convex to broadly convex and only slightly dimpled, 1.2–4 cm in diameter. Rings of stiff orange to orange-brown hairs give it a zonate appearance. Gills are free, white, smooth-edged. The tough brown stalk is shaggy like the cap. Odor and taste are not distinctive. Spores are white, 4–6 × 3–5 µm, broadly elliptic, smooth, inamyloid.

Lentinus tigrinus (Bull.) Fr.

MACROSCOPIC FEATURES: cap 1–10 cm wide, convex to broadly convex, commonly with a dimpled center, dry, covered at least centrally by small, grayish brown to blackish brown, fibrillose scales over a buff to pale cinnamon ground color. The cap margin is at first incurved, sometimes striate but typically not. **gills** decurrent, crowded, whitish at first, soon yellowing, sometimes with a pinkish or reddish tint, edges finely serrate. **stalk** 2–8 cm long and 4–8 mm thick, central or eccentric, equal or tapered below, sometimes deeply rooted in rotting host wood, dry, solid, covered nearly overall with small grayish brown scales over a whitish to yellowish ground color. The partial veil is white and fibrillose, sometimes leaving a faint ring zone on the stalk. **flesh** tough, fibrous, white; odor pleasantly resinous, taste not distinctive.

MICROSCOPIC FEATURES: Spores 6.5–10 × 2.5–3.5 μm, narrowly elliptic, smooth, hyaline, inamyloid.
SPORE PRINT: White.
HABIT, HABITAT, AND SEASON: Single to densely clustered from a rooting base on decaying hardwoods; spring–fall.
EDIBILITY: Inedible.
COMMENTS: The dainty *Arrhenia epichysium* (not illustrated) has a bald, translucent-striate cap and smooth gill edges; see Comments under *Lentinellus micheneri*. The genus *Lentinus* provides an excellent example of evolutionary divergence. Although the species presented here are gilled, *Lenzites* is a member of the family Polyporaceae. Two pored cousins, *Lentinus arcularius* and *Lentinus brumalis*, are described in the Polypore section.

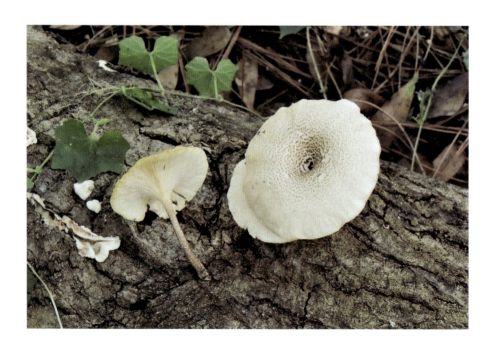

Lepiota mucrocystis Pegler

= *Lepiota besseyi* H. V. Sm. & N. S. Weber

MACROSCOPIC FEATURES: cap 2.5–9 cm wide, buttons are conical to flattened ovals expanding toward flat, dry, smooth and brown at first but soon breaking into concentric rings of cinnamon brown to dark brown scales over a pale background. The youthful margin is incurved, often displays tags of partial veil, and may become faintly striate. **gills** free, close, white to pale buff. **stalk** 3.5–10.5 cm long and 4.5–11 mm thick, enlarging downward to a slightly bulbous base, dry, white and smooth to fibrillose above the partial veil, covered below it with irregular reddish brown or dark brown patches over a light ground color. The base features multiple white rhizomorphs. The partial veil is membranous, median or superior, flaring before collapsing against the stalk or disappearing. **flesh** white to pale buff, all parts bruising orange to reddish, then reddish brown; odor fragrant, taste acidic.

MICROSCOPIC FEATURES: Spores 9–11 × 7–8 μm, ovate to broadly ellipsoid, smooth, hyaline, dextrinoid.

SPORE PRINT: Dark creamy buff.

HABIT, HABITAT, AND SEASON: Scattered to clustered on grassy areas or wood chips; summer–early winter.

EDIBILITY: Probably poisonous.

COMMENTS: This seldom recognized species is one of several reddening Lepiotas; see *Leucoagaricus americanus* for others. *Leucocoprinus cepistipes* (see Color Key) also occurs in wood chips or other disturbed soils. The 2–8 cm cap has a yellow-brown umbo, elsewhere whitish, coated with whitish powder or tiny scales, the margin strongly striate. The crowded gills are whitish, sometimes turning yellowish as they mature. The powdery white stalk bruises yellow and features a small, flaring partial veil. Among the many nonbruising *Lepiota* species, *Lepiota cristata* (see Color Key) resembles *Lepiota mucrocystis* in size and general appearance but has a smooth white stalk and is commonly found in the woods. Spores are smaller at 5–8 × 3–5 μm.

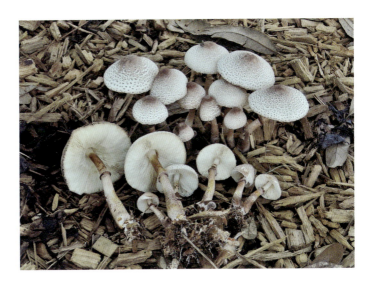

Lepista nuda (Bull.) Cooke

= *Clitocybe nuda* (Bull.) H. E. Bigelow & A. H. Sm.

COMMON NAME: Blewit

MACROSCOPIC FEATURES: cap 4–20 cm wide, convex at first but flattening, tacky when moist, smooth or centrally cracked, hygrophanous, some shade of pinkish lilac or violet fading toward tan, often showing concentric variations in color. The young cap margin is inrolled, not striate, later uplifted and wavy. **gills** notched or free, crowded, violet, fading to dull buff or tan but not rusty brown. **stalk** 3–10 cm long and 1–3 cm thick at the apex, enlarging slightly downward or with a bulbous base, dry, pale lavender to lavender, bruising darker lavender, tannish in age, finely powdery or hairy, lacking coppery threads. No partial veil. **flesh** whitish, lavender, or pale tan; odor fragrant, taste not distinctive or bitter.

MICROSCOPIC FEATURES: Spores 5.5–8 × 3.5–5 μm, elliptic, roughened or smooth, hyaline, inamyloid.

SPORE PRINT: Pinkish buff.

HABIT, HABITAT, AND SEASON: Single or in small groups on the soil in rich woods, landscaped areas, lawns, or compost piles; fall–midwinter.

EDIBILITY: Good if not bitter, but use caution.

COMMENTS: Taxonomists continue to debate the proper genus for Blewits. *Clitocybe* and *Lepista* both have proponents. A preliminary genetic analysis by Alvarado et al. (2015) found that *Lepista nuda* and *Lepista sordida* are more closely related to the type species for genus *Collybia* than to the types for *Clitocybe* or *Lepista*, if *Lepista* is considered distinct from *Clitocybe*. Taxonomy geeks, watch this space. By whatever name, Blewits are easy to confuse with possibly poisonous or inedible silver violet corts such as *Cortinarius alboviolaceus*. All of those have rustier spores, and many display coppery threads of partial veil on their stalks.

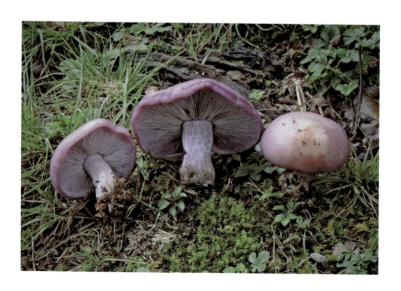

Lepista sordida (Schumach.) Singer

= *Clitocybe tarda* Peck
= *Lepista tarda* (Peck) Murrill

COMMON NAME: Lilac Blewit
MACROSCOPIC FEATURES: cap 1–7 cm wide, initially convex, becoming flat or depressed, sometimes with a broad umbo, moist when fresh, smooth but readily cracking, hygrophanous, some shade of violet brown or vinaceous brown, fading toward pale cinnamon or white. The young cap margin is inrolled, not striate, later uplifted and wavy. **gills** attached and becoming decurrent, close or subdistant, pale pinkish buff to violaceous, sometimes eroded in age. **stalk** 2–8 cm long and 2–8 mm thick at the apex, equal or tapering downward, dry, colored like the cap, usually with some brown streaks and/or longitudinal grooves, finely white fibrillose, often with white to violaceous basal tomentum, solid or hollow. Partial veil absent. **flesh** whitish to pinkish tan; odor and taste not distinctive.
MICROSCOPIC FEATURES: Spores 6–8 × 3–5 μm, elliptic, roughened to almost smooth, hyaline, inamyloid.
SPORE PRINT: Pinkish buff.
HABIT, HABITAT, AND SEASON: Scattered, gregarious, or in caespitose clusters, sometimes forming fairy rings in grass or other disturbed soil enriched with mulch or manure; summer–fall.
EDIBILITY: Said to be edible.
COMMENTS: This is a smaller, thinner variation on *Lepista nuda*. If tempted to eat it, be especially vigilant to exclude other pinkish or violet species. These include corts such as *Cortinarius alboviolaceous* and *Cortinarius iodeoides*, *Laccaria amethystina*, *Inocybe lilacina*, and *Mycena pura*. As with *Lepista nuda*, taxonomic uncertainty plagues *Lepista sordida*.

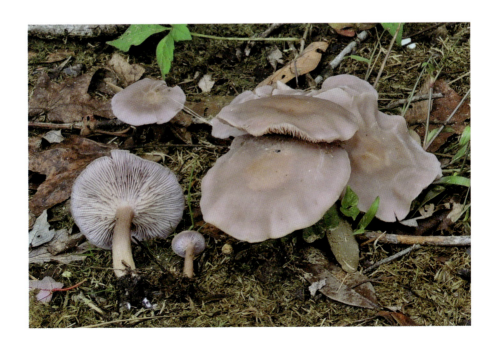

Leucoagaricus americanus (Peck)
Vellinga

= *Agaricus americanus* Peck
= *Lepiota americana* (Peck) Sacc.

COMMON NAME: Reddening Lepiota
MACROSCOPIC FEATURES: cap 3–15 cm wide, initially convex, expanding toward flat, typically with a low umbo, dry, dull reddish brown before the colored layer breaks into concentric rings of scales over a whitish background. The young cap margin is incurved and faintly striate. **gills** free, close, white. **stalk** 5–15 cm long and 6–22 mm thick, equal or enlarging downward with a pinched base, dry, smooth, white, hollowing in age. The partial veil is membranous, superior, white, and double-edged. **flesh** white, all parts bruising yellow, then reddish brown, drying wine red; odor and taste not distinctive.
MICROSCOPIC FEATURES: Spores 8.5–10.5 × 6–7 μm, ellipsoid with a germ pore, smooth, hyaline, dextrinoid.
SPORE PRINT: White.

HABIT, HABITAT, AND SEASON: Scattered to gregarious in grassy areas, wood chips, and compost piles and near rotting stumps, occasionally in the woods; summer–early winter.
EDIBILITY: Edible.
COMMENTS: The so-called reddening Lepiotas are a rather large group of species dispersed among several genera. See Comments under *Chlorophyllum molybdites* for thumbnail descriptions of *Chlorophyllum rhacodes* and *Chlorophyllum subrhacodes*. The stalk of *Lepiota mucrocystis* has brown scales below the partial veil. *Leucoagaricus rubrotinctus* (not illustrated) has a 3–8 cm cap with pinkish brown or coppery brown scales over a light background. The gills don't bruise, but the white stalk sometimes yellows after handling. Spores are narrower, 6–10 × 4–6 μm. *Leucoagaricus meleagris* (not illustrated) is smaller still, with cap diameters of 2–5.5 cm and cinnamon brown to dark brown scales over a light background. The stalk is whitish with tiny brown scales near the base. All parts bruise orange to red, progressing to brown.

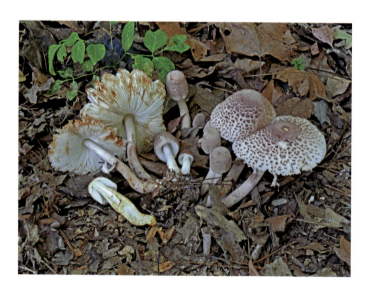

Leucopaxillus laterarius (Peck) Singer & A. H. Sm.

COMMON NAME: White Hardwood Leucopax

MACROSCOPIC FEATURES: cap 4–20 cm wide, convex but flattening or becoming shallowly depressed, dry, smooth or slightly scurfy or cracked in age, dull white, often flushed centrally with pale tan, pinkish brown, or yellow. The cap margin is initially inrolled and frequently striate or grooved. **gills** attached or subdecurrent, crowded, white or pale cream, separable as a layer from the cap flesh. **stalk** 4–11 cm long and 6–20 mm thick, nearly equal or expanding downward, dry, smooth or minutely hairy, whitish, solid, attached to a large mat of myceliated substrate. No partial veil. **flesh** rubbery-tough, white; odor farinaceous or unpleasant like coal tar, taste bitter or not distinctive.

MICROSCOPIC FEATURES: Spores 3.5–5.5 × 3.5–4.5 μm excluding warts, globose to broadly ellipsoid, hyaline with strongly amyloid warts up to 0.5 μm tall.

SPORE PRINT: White.

HABIT, HABITAT, AND SEASON: Solitary to scattered in deciduous woods, attached to leaf litter, debris, or rotten stumps; summer–fall.

EDIBILITY: Unknown.

COMMENTS: A look-alike, *Leucopaxillus albissimus* (not illustrated), occurs on needle duff in conifer woods. The spores are longer and ellipsoid, measuring 4.5–7.5 × 4–4.5 μm excluding amyloid warts to 0.5 μm tall. *Leucopaxillus gracillimus* (not illustrated) is a smaller tropical relative found in southeastern Georgia. The pink to coral red cap is broadly convex, flat, or mildly depressed, often with an umbo. Gills are decurrent, crowded, white. The stalk is 2.5–6 cm long, white, terminating in a dense mat of myceliated litter. Spores are 3–5.5 × 2–4 μm with strongly amyloid warts.

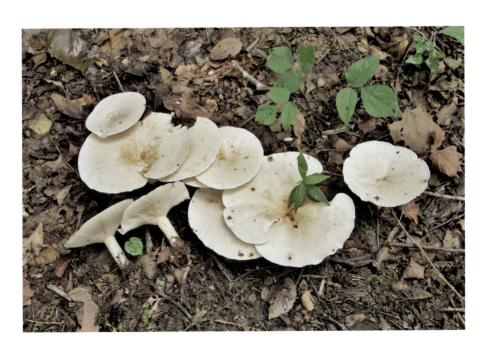

Lyophyllum decastes group (Fr.) Singer

COMMON NAME: Fried Chicken Mushroom
MACROSCOPIC FEATURES: cap 4–12 cm wide, convex at first, becoming nearly flat, moist and slippery when fresh, bald, pale to dark brown, sometimes streaked. The initially inrolled margin uplifts and may become wavy or lobed. **gills** attached or subdecurrent, close, white or developing a yellowish tinge. **stalk** 5–10 cm long and 5–25 mm thick, equal, dry, smooth, often curved, white or with a brownish base, solid. No partial veil. **flesh** white, unchanging when bruised, sometimes rubbery; odor and taste not distinctive.
MICROSCOPIC FEATURES: Spores 4–6 μm, globose to subglobose, smooth, hyaline, inamyloid.
SPORE PRINT: White.
HABIT, HABITAT, AND SEASON: Typically in caespitose clusters on the ground in grassy areas or disturbed soils, usually not in the woods; summer–fall.
EDIBILITY: Edible with caution.
COMMENTS: Fried Chicken Mushroom causes gastrointestinal upset for some people and may be confused with other edible or poisonous species. Check all characteristics, including spore color, before firing up the skillet. *Lepista subconnexa* = *Clitocybe subconnexa* (see Color Key) is a caespitose look-similar that usually fruits in woodland leaf litter and has a whiter cap; see Comments under *Infundibulicybe gibba*. Mushrooms in the *Entoloma rhodopolium* group (not illustrated) are poisonous species usually found in the woods. They have brownish caps, 2–7 cm wide white gills, and white stalks, and they can also fruit in clusters. Spores are pink.

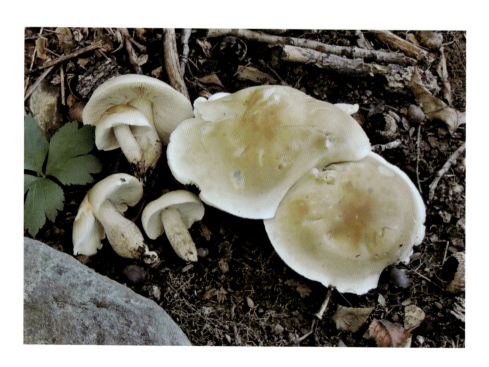

Macrocybe titans (H. E. Bigelow & Kimbr.) Pegler, Lodge, & Nakasone

= *Tricholoma titans* H. E. Bigelow & Kimbr.

COMMON NAME: Giant Gilled Mushroom
MACROSCOPIC FEATURES: **cap** 8–100 cm wide, convex before flattening or becoming shallowly depressed, moist or dry, smooth or with central watery spots or small scales, cracking when dry, pale brownish, buff, or yellowish, darkest centrally, gradually fading toward white. The cap margin is incurved for a long time, later upturning and sometimes wavy. **gills** attached in a sinuate fashion, crowded, grayish shades of pale yellow or buff, sometimes stained brown. **stalk** 6–30 cm long and 1.5–12 cm thick, equal or expanding downward to a club-like or slightly bulbous base, dry, concentrically ringed with dark brown, recurved scales over a whitish to buff background color that darkens when bruised, solid. No partial veil. **flesh** meaty, tough, white; odor variously described as fragrant, mushroomy, like cherries, or unpleasant, taste musty, disagreeable, or not distinctive.
MICROSCOPIC FEATURES: Spores 5.5–8 × 4–5.5 µm, ovoid to broadly ellipsoid, smooth, hyaline, inamyloid.
SPORE PRINT: White to cream.
HABIT, HABITAT, AND SEASON: Single, scattered, or most commonly in caespitose clusters on the ground in grassy, woodland, or disturbed soils; summer–early winter.
EDIBILITY: Edible.
COMMENTS: *Macrocybe titans*, the Western Hemisphere's largest gilled mushroom, is a tropical species moving north for incompletely understood reasons. It has been found in Athens, Georgia, and Durham, North Carolina. Mushroom cultivators see food potential in *Macrocybe titans*. So do the Costa Rican leafcutter ants that farm *Macrocybe titans* mycelium in their nests. The subterranean mycelial gardens are fed prechewed pieces of harvested leaves.

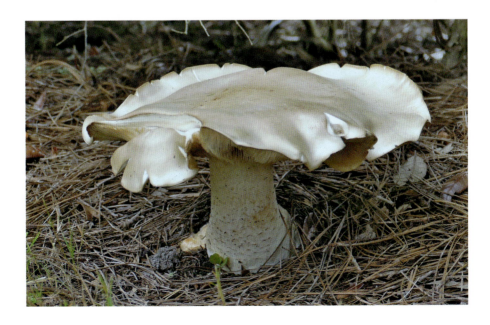

Macrolepiota procera (Scop.) Singer

= *Lepiota procera* (Scop.) Gray

COMMON NAME: Parasol

MACROSCOPIC FEATURES: cap 7–25 cm wide, egg-shaped at first, then bell-shaped to nearly flat in age with a rounded umbo, dry, dark brown or reddish brown in youth with the colored layer breaking up into flat scales over a dirty white ground color. The young cap margin is incurved and shaggy with fibers of partial veil. **gills** free, close, white, developing tan or pinkish tints at maturity. **stalk** 18–34 cm long and 8–13 mm thick, pencil-straight and nearly equal above an enlarged or slightly bulbous base, dry, dirty white beneath irregular rings of tiny brown scales, stuffed or hollow. The thick, 2-edged partial veil forms a moveable grommet on the upper stalk. **flesh** white to reddish gray, not changing when bruised; odor and taste not distinctive.

MICROSCOPIC FEATURES: Spores 12–19 × 8–12 µm, broadly elliptic with an apical pore, smooth, hyaline, dextrinoid.

SPORE PRINT: White.

HABIT, HABITAT, AND SEASON: Solitary or scattered on a variety of woodland, grassy, or roadside soils; summer–early winter.

EDIBILITY: Caps are choice edibles with caution.

COMMENTS: Unwary foragers may confuse the Parasol with reddening Lepiotas (see *Leucoagaricus americanus*) or the poisonous *Chlorophyllum molybdites*, which has white gills in youth. *Echinoderma asperum* = *Lepiota aspera* (not illustrated) is a smaller denizen of rich deciduous woods. The convex to flat cap is 3–11 cm wide, dry, covered at first with soft brown hair that breaks up into erect brown scales over a light ground color. The stalk is 5–11 cm long and up to 1.5 cm thick, equal, hairy, whitish, and sometimes bulbed. The membranous partial veil is thin but persistent. Odor fragrant or not distinctive. Spores are white, 6.5–11 × 2–3.5 µm.

Marasmiellus candidus (Fr.) Singer

= *Marasmiellus albocorticis* Secr. ex Singer
= *Marasmius candidus* Fr.

COMMON NAMES: White Marasmiellus, White Marasmius

MACROSCOPIC FEATURES: cap 1–4 cm wide, convex at first but flattening or centrally depressed at maturity, moist or dry, minutely powdery to smooth, translucent-striate when wet, broadly pleated or wavy when dry, white, sometimes tinged yellow or pinkish in age. The cap margin is not striate or slightly so, sometimes uplifting. **gills** attached or subdecurrent, widely distant, crossveined, white but may develop yellowish or pink spots. **stalk** 1–2 cm long and 1–4 mm thick, central or eccentric and often curved, equal above a slightly expanded base, dry, smooth, initially white, becoming brownish black from the base upward, tough. No partial veil. **flesh** very thin and translucent to whitish; odor and taste not distinctive.

MICROSCOPIC FEATURES: Spores 10–15 × 4–6 µm, elongated lacrimoid to subfusiform, smooth, hyaline, inamyloid.

SPORE PRINT: White.

HABIT, HABITAT, AND SEASON: Gregarious to trooping, often in large numbers, on twigs, stems, berry canes, and small branches; late spring–fall.

EDIBILITY: Unknown.

COMMENTS: The epithet *candidus* means "white." *Tetrapyrgos nigripes* is very similar. It has a white cap with a grayish or brownish disc and a white stalk that blackens in age. The spores are triangular to star-like and multipointed, and they measure 8–9 × 8–9 µm. Several other similar recyclers of woody debris inhabit the Georgia woods. These include *Marasmius delectans* and others mentioned in its Comments section. The White Marasmiellus can be distinguished from them by a combination of characteristics: widely spaced and crossveined gills that are broadly attached or subdecurrent, short stalk without a pinched base, lack of rhizomorphs projecting from the substrate, habitat preference, and spore shape.

Marasmius cohaerens (Pers.) Cooke & Quél.

COMMON NAME: Fused Marasmius
MACROSCOPIC FEATURES: cap 1–4 cm wide, convex to broadly convex or flattening, dry, smooth, a shade of yellowish brown or reddish brown, fading to tan, especially toward the margin. The cap margin may be slightly striate and uplifted in age. **gills** attached or nearly free, subdistant or close, whitish at first, browning toward maturity, sometimes with darker margins. **stalk** 3–8 cm long and 1.5–3 mm thick, equal, dry, smooth, whitish above and darkening to reddish brown from the base upward, hollow, often basally fused with neighbors and densely booted in white mycelium. No partial veil. **flesh** white; odor not distinctive or unpleasant, taste not distinctive or bitter.
MICROSCOPIC FEATURES: Spores 7–10 × 3–5.5 μm, ellipsoid, smooth, hyaline, inamyloid. Gill faces are studded with fusiform setae. Distinctive broom cells on gills and the cuticle are most easily observed on the latter.
SPORE PRINT: White.
HABIT, HABITAT, AND SEASON: Solitary or in small clusters on deciduous leafy or woody debris; spring–fall.
EDIBILITY: Inedible.
COMMENTS: The epithet *cohaerens* means "stuck together." *Marasmius vagus* has a light yellowish orange to brownish orange cap, white gills that remain white in age, and a 3–5.5 cm long white stalk that is typically not fused with others. *Marasmius sullivantii* (not illustrated) is similar and described in the Comments section of *Marasmius vagus*. If the stalk is longer, reddish black below a pale apex, and densely hairy, consider *Rhizomarasmius pyrrhocephalus* (not illustrated). Some species, including *Gymnopus dryophilus*, grow in similar situations and may have hairy stalks but lack the white mycelial boot. Most have crowded or close gills. *Gymnopus semihirtipes* (not illustrated) has subdistant gills. The initially reddish brown cap is hygrophanous, quickly fading to tan, and the lower third of the completely reddish brown stalk is clothed in brown hair.

Marasmius delectans Morgan

COMMON NAME: Charming Marasmius
MACROSCOPIC FEATURES: cap 1–4 cm wide, convex but flattening, dry, smooth or wrinkled, white or faintly yellowish at first, soon whitish with a slightly darker center. The cap margin is often irregular and may show faint marginal striations. **gills** attached or nearly free, usually distant but occasionally close, colored like the cap. **stalk** 1–8 cm long and up to 2 mm thick, nearly equal, dry, shiny, and wiry, whitish at first, darkening to reddish brown or almost black from the base upward, retaining a pale apex, hollow, the base grounded in a white mycelial pad. No partial veil. **flesh** fibrous, whitish; odor strong and foul or not distinctive, taste not distinctive.
MICROSCOPIC FEATURES: Spores 5.5–9 × 3–5 μm, ellipsoid, smooth, hyaline, inamyloid. Gill faces studded with dextrinoid setae. Distinctive dextrinoid broom cells present on the cuticle.
SPORE PRINT: White.
HABIT, HABITAT, AND SEASON: Gregarious or clustered on deciduous leaf litter or debris; summer–fall.
EDIBILITY: Unknown.
COMMENTS: Many smallish white mushrooms decompose woodland litter. *Mycetinus opacus* (see Color Key) favors but isn't limited to rhododendron twigs and leaf ribs. Long brownish rhizomorphs emerge like flyaway hairs from the substrate at a distance from the caps. The Pinwheel Marasmius, *Marasmius rotula* (see Color Key), and *Marasmius capillaris* (not illustrated) have pleated caps and gills attached to a collar encircling the stalk apex. The former fruits on sticks, the latter on deciduous leaf litter. The cap of *Marasmiellus praeacutis* (see Color Key) is briefly brown before whitening. Its stalk terminates in a pinched point attached to the substrate. See also *Tetrapyrgos nigripes*.

Marasmius graminum (Lib.) Berk.

COMMON NAME: Grass Marasmius
MACROSCOPIC FEATURES: cap 1.5–9 mm wide, initially convex and expanding toward flat with a tiny central depression, dry, orange, reddish brown, or brown, fading to yellowish white with a brownish central dot, pleated at maturity. The young cap margin is striate, later pleated and often scalloped. **gills** attached to the stalk or a collar encircling it, distant, white or whitish, lacking short gills. **stalk** 5–30 mm long and 0.1–0.5 mm thick, equal, dry, shiny, yellowish white at the apex, reddish brown below, without a basal pad of mycelium, basal rhizomorphs none or few, brown and short if present. No partial veil. **flesh** present in theory; odor and taste not distinctive.
MICROSCOPIC FEATURES: Spores 7–10.5 × 3–5.5 μm, ellipsoid to amygdaliform, smooth, hyaline, inamyloid.
SPORE PRINT: White.
HABIT, HABITAT, AND SEASON: Solitary to gregarious on dead blades of grass or rarely on sedges, ferns, or hickory leaves; late spring–summer.
EDIBILITY: Inedible.
COMMENTS: Searching for *Marasmius graminum* is occasionally a good use of time. Suppose you've stepped into the backyard to enjoy the sun after a round of spring rain. Not watching your step, you take a tumble, landing facedown on the wet lawn, unhurt but a bit too tipsy to stand just yet. If you're able to focus on the up-close and personal blades of grass, now's your time; Grass Marasmius, where are you? The edible Garlic Mushroom, *Mycetinus scorodonius* = *Marasmius scorodonius* (not illustrated), can also be found on dead grass but is more common on conifer litter in the woods. The cap is slightly larger, pale reddish brown to buff, 0.5–3 cm wide. Its shiny stalk is whitish above, reddish brown below. The odor is garlicky.

Marasmius nigrodiscus (Peck) Halling

= *Collybia nigrodisca* Peck
= *Gymnopus nigrodiscus* (Peck) Murrill

COMMON NAME: Black-eyed Marasmius
MACROSCOPIC FEATURES: cap 3–11 cm wide, convex, becoming broadly convex to nearly flat, with an umbo, dry, typically wrinkled, hygrophanous, pale brown when young, becoming creamy white with a darker brown disc or sometimes pale brown nearly overall, but always with a darker brown disc. The young cap margin is slightly inrolled, later uplifted and wavy. It is weakly striate on young specimens and becomes strongly striate to nearly plicate as the cap ages. **gills** attached, close to subdistant, whitish to creamy white, sometimes with grayish tints. **stalk** 4–10 cm long and 5–10 mm thick, nearly equal or slightly enlarged downward, straight or twisted, dry, smooth or longitudinally striate, stuffed or hollow, white overall or colored like the cap on the upper portion, with white basal mycelium. No partial veil. **flesh** thin, whitish; odor faintly like radishes or bitter almonds or not distinctive, taste slightly bitter or not distinctive.
MICROSCOPIC FEATURES: Spores 6.5–9 × 3–5 μm, ellipsoid, smooth, hyaline, inamyloid.
SPORE PRINT: White.
HABIT, HABITAT, AND SEASON: Solitary, scattered, or in groups on leaf litter or needle duff in broadleaf or conifer woods; summer–fall.
EDIBILITY: Reported to be edible.
COMMENTS: The epithet *nigrodiscus* means "having a dark center." It is an unusually large species for the genus *Marasmius*. Compare with *Marasmius strictipes*, which is also large and grows in the woods but has a differently colored cap. *Marasmius oreades* has a cap similar in color to Black-eyed Marasmius; it grows in grassy areas and commonly makes fairy rings.

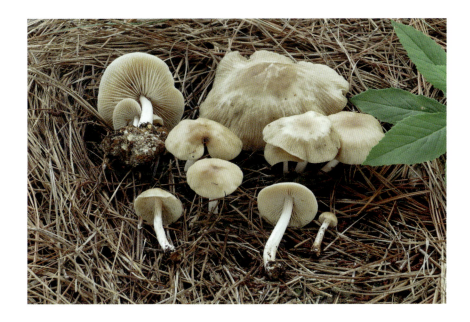

Marasmius oreades (Bolton) Fr.

COMMON NAMES: Fairy-ring Mushroom, Scotch Bonnets

MACROSCOPIC FEATURES: cap 1–5 cm wide, bell-shaped with an umbo at first, then flattening, dry, smooth, hygrophanous, brown in the button, becoming pale yellowish tan or reddish tan and paling toward white as it dries. The young cap margin is slightly inrolled, later uplifted and wavy. **gills** attached, close or subdistant, yellowish white to pale tan. **stalk** 2–8 cm long and 2–6 mm thick, even, dry, tough, pale cream above and yellowish brown to reddish brown below, minutely fibrillose, without a notable mycelial pad at the base. No partial veil. **flesh** white; odor fragrant, faintly of chlorine, or not distinctive, taste not distinctive.

MICROSCOPIC FEATURES: Spores 7–10 × 4–6 μm, asymmetrically narrow ellipsoid, smooth, hyaline, inamyloid.

SPORE PRINT: White.

HABIT, HABITAT, AND SEASON: Scattered, in groups, or making fairy rings in grassy areas; summer–fall.

EDIBILITY: Caps are edible. Stalks too tough.

COMMENTS: The ability to revive from a shriveled state to plumpness after rehydration is common in genus *Marasmius* and can surprise cooks working with dehydrated Scotch Bonnets. The formation of complete or partial fairy rings, the trait for which this species is named, is due to mushrooms sprouting at the frontier of a circular mycelium. But beware; several other species produce fairy rings too. White-spored species found in grass include the poisonous *Clitocybe rivulosa* = *Clitocybe dealbata* (not illustrated). Its blotchy tan or whitish, somewhat funnel-shaped caps measure 2–4 cm wide. Gills are white, crowded, broadly attached or decurrent. Stalks are whitish. Spores are 4–5.5 × 2–4.5 μm, ellipsoid, hyaline, and smooth. The muscarine in this species is more often fatal to pets than people.

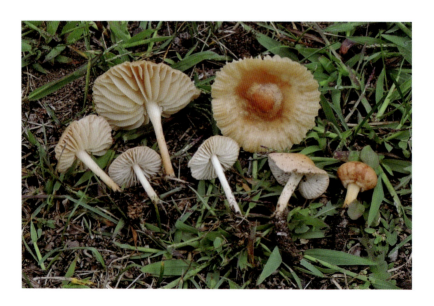

Marasmius pulcherripes Peck

MACROSCOPIC FEATURES: cap 2.5–20 mm wide, conic to convex, often with a small umbo or papilla, dry, nearly smooth, commonly pink or pinkish brown, darker at the center, pleated. The young margin is often striate before becoming pleated and perhaps wavy. **gills** narrowly attached or free, nearly distant, white to yellowish white or pinkish white. **stalk** 2.5–7 cm long and 0.5–1 mm thick, equal, shiny, wiry, often colored like the cap at the apex, darkening to reddish brown below, grounded in a pad of white mycelium. No partial veil. **flesh** insubstantial; odor usually not distinctive, taste not distinctive.

MICROSCOPIC FEATURES: Spores 12–16 × 3.5–5 μm, clavate or subfusiform, asymmetrical or curved, smooth, hyaline, inamyloid. Broom cells present in the cuticle.

SPORE PRINT: White.

HABIT, HABITAT, AND SEASON: Scattered to gregarious on woodland leaf litter or pine duff; summer–fall.

EDIBILITY: Unknown.

COMMENTS: This little pinwheel is pretty in pink. A reddish purple relative, *Marasmius bellipes* (not illustrated), may occur on leaf letter in the northern mountains. It has smaller spores, 8.5–12 × 3–3.5 μm. The Bleeding Mycena, *Mycena haematopus* (see Color Key), is also brownish pink to vinaceous, with 1–4 cm caps that are typically striate but not pleated. It fruits on rotting deciduous logs, not leaves. The stalk contains a drop of brownish or reddish latex.

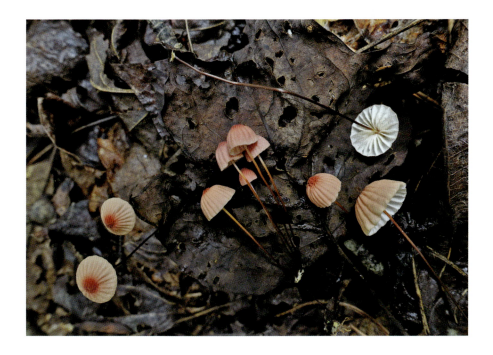

Marasmius siccus (Schwein.) Fr.

COMMON NAME: Orange Pinwheel Marasmius

MACROSCOPIC FEATURES: cap 3–25 mm wide, bell-shaped to convex, often with a slight umbo or central depression, dry, slightly rough, a shade of pale orange, reddish orange, or brownish orange, darkest centrally, pleated by maturity and sometimes wrinkled as well. The cap margin is striate at first and often slightly upturned. **gills** nearly free or free, distant, whitish or faintly yellow. **stalk** 2–7 cm long and 0.2–1 mm thick, nearly equal, smooth and shiny, wiry, pale yellowish above and darker shades of reddish brown below, bedded in a pad of white mycelium. No partial veil. **flesh** white; odor and taste not distinctive.

MICROSCOPIC FEATURES: Spores 15–22 × 3–5 µm, clavate to subfusiform, often curved, smooth, hyaline, inamyloid. Cheilocystidia broom-like, pleurocystidia numerous and cylindric to fusoid.

SPORE PRINT: White.

HABIT, HABITAT, AND SEASON: Scattered to gregarious on leaf litter or rarely on fallen twigs in deciduous or mixed woods; late spring–early winter.

EDIBILITY: Unknown.

COMMENTS: The range of orange cap colors in *Marasmius siccus* overlaps with the typically reddish brown *Marasmius fulvoferrugineus* (see Color Key), which also fruits on deciduous leaf litter. The cap of that species can be larger at 1–4.5 cm wide, and the stalk is apically pale and darker below. Odor and taste are faintly farinaceous or not distinctive. Dust off your microscope for uncertain cases. The gills of *Marasmius fulvoferrugineus* have broom-like cheilocystidia, but pleurocystidia are absent or rare.

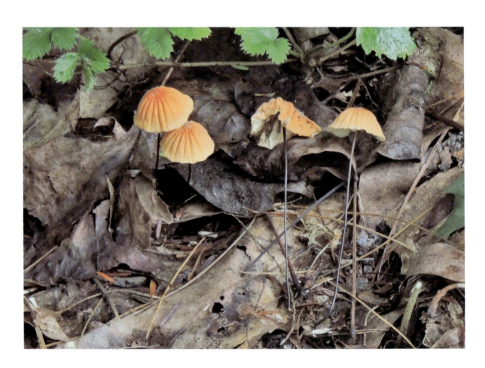

Marasmius strictipes (Peck) Singer

COMMON NAME: Orange-yellow Marasmius
MACROSCOPIC FEATURES: cap 2–7 cm wide, convex to flat with or without a low umbo, moist when fresh, waxy, bald, pale shades of orange or yellow, not fading much in age. The margin is often faintly striate, only rarely uplifting at maturity. **gills** attached or free, close or crowded, white or yellow-tinged. **stalk** 2–9 cm long and 3–10 mm thick, equal and straight, dry, often with a dusty appearance, white at first, then pale yellow, hollow, based in a substantial pad of white mycelium. No partial veil. **flesh** white; odor mildly fragrant or not distinctive, taste radish-like or not distinctive.
MICROSCOPIC FEATURES: Spores 6–11 × 3–4.5 μm, ellipsoid or lacrimoid, smooth, hyaline, inamyloid.
SPORE PRINT: White.
HABIT, HABITAT, AND SEASON: Single to scattered or gregarious on deciduous leaf litter or occasionally well-rotted wood; late spring–fall.
EDIBILITY: Inedible.
COMMENTS: Look-similars include *Gymnopus dryophilus* and *Melanoleuca alboflavida* (not illustrated). The cap of the latter is 3–12 cm wide, convex, then flat or shallowly depressed, slippery when fresh, yellowish to yellow-orange, darkest centrally. Gills are crowded. The rigidly straight stalk is 7–15 cm long and 5–12 mm wide, longitudinally grooved, fibrillose, and solid. Spores are 7–9 × 4–5.5 μm, ellipsoid, with amyloid warts. *Marasmius nigrodiscus* has a browner cap, 3–11 cm wide, with a notably darker and usually umbonate center. Gills are close or subdistant, whitish to creamy white, sometimes with grayish tints. The white stalk is longitudinally striate, sometimes twisted, up to 10 cm long and 1 cm thick, stuffed or hollow.

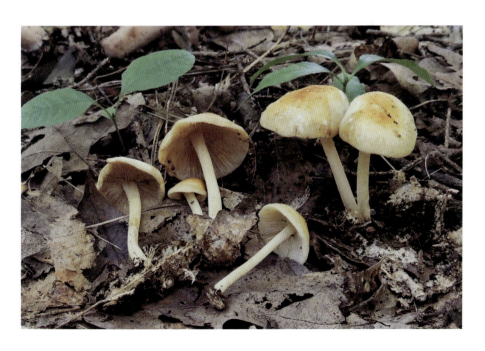

Marasmius vagus Guard, M. D. Barrett, & Farid

MACROSCOPIC FEATURES: cap 1–5 cm wide, hemispherical, becoming convex, then broadly convex, dry, smooth, light yellowish orange to brownish orange; margin even. **gills** attached to nearly free, close to subdistant, white, sometimes with orange edges on young specimens, with 2–3 tiers of short gills. **stalk** 3–5.5 cm long and 3–5 mm thick, dry, smooth, hollow, occasionally longitudinally grooved, white overall, sometimes staining yellowish brown near the base or lower half in age. **flesh** thin, white; odor and taste not distinctive.

MICROSCOPIC FEATURES: Spores 8.5–11.5 × 4.8–6.8 μm, ellipsoid to elongate, slightly curved, hyaline, inamyloid.

SPORE PRINT: White.

HABIT, HABITAT, AND SEASON: Gregarious or caespitose, sometimes in rings, on the ground in grassy areas or leaf litter; year-round.

EDIBILITY: Unknown.

COMMENTS: The epithet *vagus* means "wandering," a reference to its widespread distribution in Australia and the southeastern United States. The similar *Marasmius sullivantii* (not illustrated) has smaller, 5–25 mm, reddish orange to rusty brown caps that are dry, smooth, and occasionally weakly striate. The closely spaced white gills sometimes have pinkish edges when young. Stalks are wiry and finely hairy, up to 4 cm long and 2 mm thick, whitish near the apex, orange-brown in the midsection, darker toward the base, and booted in white basal mycelium. They may be solitary, scattered, or in groups on leaf litter or woody debris in broadleaf woods. The ellipsoid, smooth, hyaline spores measure 7–9 × 3–3.5 μm.

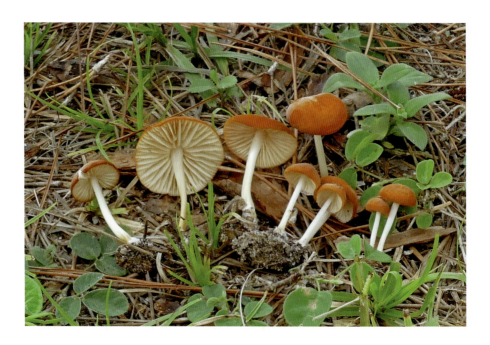

Megacollybia rodmanii R. H. Petersen, K. W. Hughes, & Lickey

= (incorrectly) *Megacollybia platyphylla* (Pers.) Kotl. & Pouzar

COMMON NAMES: Broadgill, Platterful Mushroom

MACROSCOPIC FEATURES: cap 4–20 cm wide, convex at first and expanding toward flat, often with a low umbo, dry, smooth, radially streaked with blackish or dark olive fibers over a light grayish brown background, usually darkest over the center. The young cap margin is not striate. **gills** attached, nearly distant, white, vertically broad (tall). **stalk** 5–12 cm long and 1–2.5 cm thick, equal or enlarging downward, dry, silky but not coarsely fibrillose, white, hollowing when mature, the base typically attached to thick white rhizomorphs. No partial veil. **flesh** whitish; odor and taste not distinctive.

MICROSCOPIC FEATURES: Spores 6–10 × 5–8 μm, ellipsoid, smooth, hyaline, inamyloid.

SPORE PRINT: White.

HABIT, HABITAT, AND SEASON: Solitary or scattered on rotting deciduous logs, stumps, or buried wood; spring–early fall.

EDIBILITY: Edible but mediocre and prone to cause gastrointestinal upset. Cook well.

COMMENTS: Several genetically distinct species of Broadgill occur around the world, but they are otherwise distinguishable mainly by geographic location. *Megacollybia platyphylla* turns out to be European and Russian. Our *Megacollybia rodmanii* takes two recognized forms. The version with a relatively tall and thin stalk, to 12 × 1 cm, is form *rodmanii*. A shorter, stouter stalk, to 9 × 2.5 cm, indicates form *murina*. Young *Pluteus cervinus* mushrooms also grow on rotting wood, but the white gills soon turn pink, matching the spore print. The stalk often shows coarse dark fibrils, and the odor is usually radish-like. *Amanita brunnescens* also has a streaky cap. It grows on soil, has a membranous partial veil and a distinctive basal bulb, and smells like raw potato.

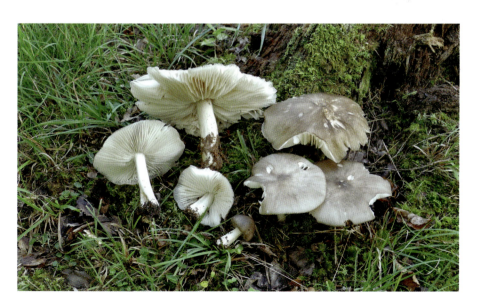

Multifurca furcata (Coker) Buyck & V. Hofst.

= *Lactarius furcatus* Coker

MACROSCOPIC FEATURES: cap 6–10 cm wide, convex to broadly convex, becoming funnel-shaped at maturity, somewhat sticky, matted and woolly, azonate, pale ochraceous; margin even. **gills** decurrent, narrow, crowded, repeatedly forked, ochraceous with a tint of salmon. **stalk** 2–3 cm long and 1–1.5 cm thick, solid, firm, tough, sticky, light yellowish with small ochraceous spots. **flesh** thin, white, with dull ochraceous zones; odor not distinctive, taste acrid. **latex** white on exposure, slowly changing to bluish green, taste moderately acrid.

MICROSCOPIC FEATURES: Spores 3.5–5.5 × 3.5–4 μm, ellipsoid to subglobose, ornamented with a few bands and occasional fine lines that do not form a complete reticulum; prominences only up to 0.2 μm high, hyaline, amyloid.

SPORE PRINT: Pinkish ochraceous.

HABIT, HABITAT, AND SEASON: Solitary, scattered, or in groups under broadleaf or mixed woods; summer–fall.

EDIBILITY: Unknown.

COMMENTS: *Multifurca* means "many forks," a reference to the repeatedly forked gills of species within this genus. *Multifurca furcata* was originally placed in the genus *Lactarius* but was moved to a newly created genus, *Multifurca*, in 2008. *Multifurca* species share macrocharacteristics with species in the genera *Lactarius* and *Lactifluus* but differ from them microscopically and molecularly. *Multifurca furcata* is uncommonly collected. Its crowded, decurrent, repeatedly forked, ochraceous gills and acrid white latex that slowly changes to bluish green are reliable identification features, since the gills of the darker brown *Lactarius peckii* var. *glaucescens* don't fork.

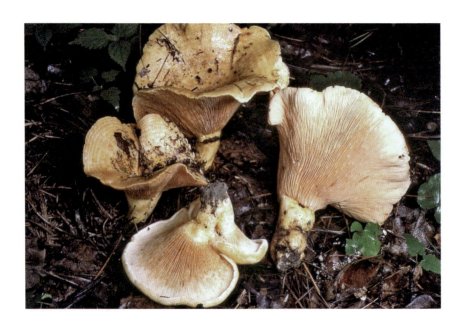

Mycena epipterygia var. *lignicola*
A. H. Sm.

COMMON NAME: Yellow-stalked Mycena
MACROSCOPIC FEATURES: cap 8–20 mm wide, oval at first, developing a conic umbo, slimy or sticky and initially pruinose, with a peelable cuticle, yellow to greenish yellow, paler toward the margin, fading toward white in age. The cap margin is often faintly striate. **gills** barely attached, subdistant to distant, white or pale yellow without reddish spots. **stalk** 4–8 cm long and 0.5–2 mm thick, equal, sticky or slimy, smooth, fragile, colored like the cap or paler. **flesh** insubstantial and yellow; odor and taste more or less farinaceous.
MICROSCOPIC FEATURES: Spores 9–12 × 5.5–8 µm, ellipsoid, smooth, hyaline, amyloid.
SPORE PRINT: White.
HABIT, HABITAT, AND SEASON: Scattered to gregarious on rotted conifer wood or associated mosses; late summer–fall.
EDIBILITY: Inedible.
COMMENTS: *Mycena epipterygia* var. *viscosa* (not illustrated) occurs on soil under conifers or on conifer wood. The cap is typically grayer or slightly brown. Gills often develop reddish brown stains, and the farinaceous odor is usually strong. Small yellow species of *Galerina* (not illustrated) can also have conical caps and grow on mossy conifer wood, but the spores are brown. *Rickenella fibula* fruits on mosses; its cap is centrally dimpled, not umbonate. *Gliophorus perplexus* (not illustrated, see Comments under *Gliophorus laetus*) is orange and slimy. It fruits on soil in deciduous woods. *Baeospora myosura* (see Color Key) grows on pine cones. The moist cinnamon brown or tan caps are 5–20 mm wide. Gills are white and crowded. Spores are white, 4–4.5 × 1–2.5 µm, smooth, amyloid.

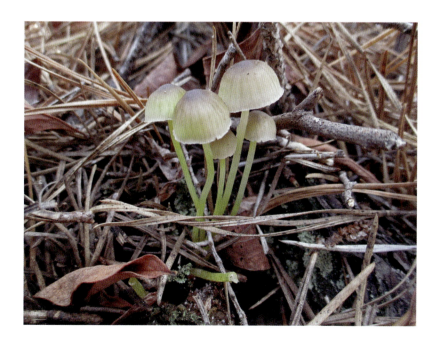

Mycena inclinata (Fr.) Quél.

MACROSCOPIC FEATURES: cap 1–6 cm wide, broadly conical to bell-shaped with a broad umbo, tacky when wet, bald, hygrophanous, brown at the center, paling toward whitish at the margin and eventually overall, translucent-striate or grooved. The young cap margin is also minutely scalloped, often splitting by maturity. **gills** attached, close or subdistant, whitish, but may take on pale yellow or pink tints. **stalk** 5–10 cm long and 1.5–4 mm thick, equal, dry, brittle, finely fibrillose in youth, later smooth, whitish at the apex, yellowing in the midportion, and reddish brown below, hollow, the base coarsely hairy. No partial veil. **flesh** whitish; odor and taste faintly farinaceous.

MICROSCOPIC FEATURES: Spores 7–10 × 5–7 μm, broadly ellipsoid, smooth, hyaline, amyloid.

SPORE PRINT: White.

HABIT, HABITAT, AND SEASON: Gregarious to caespitose on rotting deciduous wood; spring–early winter.

EDIBILITY: Unknown.

COMMENTS: Brown and gray-brown species of *Mycena* are legion and can be very difficult to identify. Among the look-alikes on rotting deciduous wood are three with smooth-edged caps and smooth stalks. *Mycena galericulata* (not illustrated) fails to develop reddish tones near the base and often has a slightly darker brown cap. The stalk of *Mycena pseudoinclinata* (not illustrated) is shorter at 2.5–6 cm. Its narrower spores measure 8–11 × 5–6 μm. *Mycena semivestipes* (not illustrated) smells like chlorine bleach. The cap is 1–3.5 cm wide. Spores are smaller, 4–5 × 2.5–3 μm. *Mycena leptocephala* (not illustrated) also smells like bleach but fruits on or under conifers. Young caps have a frosted appearance. Spores measure 7–10 × 4–6 μm.

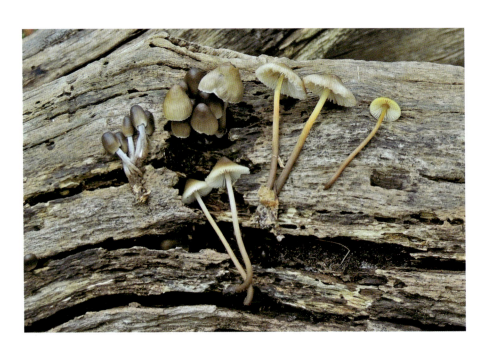

Mycena pura (Pers.) P. Kumm.

COMMON NAMES: Pink Mycena, Lilac Mycena

MACROSCOPIC FEATURES: cap 2–7 cm wide, bell-shaped to convex, becoming almost flat, moist or dry, smooth, hygrophanous, usually some shade of pink or lilac, but reddish or even yellowish specimens also occur. The cap margin is striate. **gills** attached, close or subdistant with several tiers of short gills, eventually crossveined, pale lilac, grayish, pinkish, or almost white. **stalk** 3–10 cm long and 2–6 mm thick, equal or enlarging slightly downward, dry, smooth or nearly so, tough, colored like the cap or paler, hollow. **flesh** pale gray to whitish; odor and taste distinctly of radish.

MICROSCOPIC FEATURES: Spores 6–10 × 3–4 μm, narrowly ellipsoid, smooth, hyaline, amyloid.

SPORE PRINT: White.

HABIT, HABITAT, AND SEASON: Scattered to clustered on rich woodland soils; spring–fall.

EDIBILITY: Reports vary from edible to poisonous.

COMMENTS: Other small, soil-dwelling, purplish mushrooms with white spores include *Laccaria amethystina*, which lacks the radish odor and taste. The Violet Gymnopus, *Gymnopus iocephalus* (see Color Key), is a colorful member of that otherwise drab genus. The cap is flattish, wrinkled, and striate, up to 4 cm wide. Gills are attached, subdistant to distant, reddish purple to violet. The stalk is whitish. Odor is garlicky. The white spores measure 6.5–9 × 3–4.5 μm and are inamyloid. *Inocybe lilacina* has brown spores and a spermatic odor. *Mycena haematopus* (see Color Key and Comments under *Marasmius pulcherripes*) fruits on decaying deciduous wood.

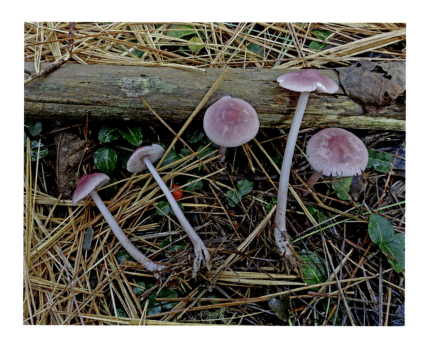

Neohygrocybe subovina (Hesler & A. H. Sm.) Lodge & Padamsee

= *Hygrocybe subovina* (Hesler & A. H. Sm.) Roody
= *Hygrophorus subovinus* Hesler & A. H. Sm.

COMMON NAME: Brown Sugar Waxcap
MACROSCOPIC FEATURES: cap 2–5 cm wide, convex, becoming broadly convex, dry, smooth or with tiny central scales, dark grayish brown to blackish brown. The cap margin lacks striation. **gills** attached, subdistant to distant, thick, pale gray or cream before darkening to deep shades of gray-brown, bruising reddish. **stalk** 3–9 cm long and 4–15 mm thick, equal, dry, brittle, smooth, sometimes compressed or lumpy, colored like the cap or darker, unchanging when bruised, hollow. **flesh** grayish brown, not staining when bruised; odor resembling brown sugar or similar to Black Trumpets, taste unpleasant or not distinctive.
MICROSCOPIC FEATURES: Spores 5–6 × 5–5.7 µm, globose to subglobose, smooth, hyaline, inamyloid. Cystidia present on the gills.
SPORE PRINT: White.
HABIT, HABITAT, AND SEASON: Scattered on the ground in deciduous woods, especially under oaks; summer–fall.
EDIBILITY: Unknown.
COMMENTS: Taxonomic uncertainty remains about whether this species is distinct from *Neohygrocybe ovina* = *Hygrocybe ovina* (not illustrated). Classically, the latter should have a paler brown cap, paler gills, flesh (not only gills) bruising red, an odor with unpleasant notes of ammonia, larger spores at 6–10 × 4.5–7 µm, and no cystidia on the gills. *Hygrocybe deceptiva* = *Camarophyllopsis deceptiva* (not illustrated) is similar in size and preferred habitat but lacks a distinctive odor. The cap is tawny to cinnamon brown, striate when moist. Gills and flesh are unchanging when bruised. Spores measure 3–5 × 3–4 µm. The gills lack cystidia. A similar species that reeks of ammonia or bleach, *Neohygrocybe nitrata* = *Hygrocybe nitrata* (not illustrated), might occur in the mountains. Spores are 7.5–10 × 4.5–6 µm.

Omphalotus subilludens (Murrill) Bigelow

COMMON NAME: Southern Jack O'Lantern
MACROSCOPIC FEATURES: cap 5–15 cm wide, broadly convex, then usually depressed or funnel-shaped by maturity, dry, smooth or slightly wrinkled and innately fibrillose, the fibrils often breaking into brownish streaks or scales over a dull orange to orange-brown background. The initially incurved cap margin uplifts and becomes wavy, sometimes browning in age. **gills** deeply decurrent, close or subdistant, orange-yellow, bioluminescent. **stalk** 3–8 cm long and 1.5–4 cm thick, central or eccentric, equal or tapering downward above a sometimes enlarged base, dry, colored like the cap or paler, solid or hollowing. No partial veil. **flesh** yellowish, unchanging when bruised; odor unpleasant or not distinctive, taste vaguely astringent.
MICROSCOPIC FEATURES: Spores 5.5–8.5 × 3.7–5.3 μm, ellipsoid, smooth, hyaline, inamyloid.
SPORE PRINT: Pale yellow.
HABIT, HABITAT, AND SEASON: In groups or clusters on rotting stumps, saw palmetto trunks, or buried wood; summer–early winter.
EDIBILITY: Presumed poisonous, Benjamin (1995).
COMMENTS: This is a subtropical sibling of the larger and definitely poisonous Jack O'Lantern, *Omphalotus illudens* (see Color Key). That species is brighter orange when fresh and has a longer stalk and 3–5 μm globose spores. It grows in caespitose clusters typically at or around the base of dead or dying oaks. The False Chanterelle, *Hygrophoropsis aurantiaca* (see Color Key), is orange all over but doesn't fruit in dense clusters. It prefers soil with rotting conifer debris. Caps are 2–10 cm wide and become centrally depressed. Gills are decurrent, crowded, repeatedly forking. The stalk is up to 10 cm long and 2 cm thick. Spores are white, 5.5–8 × 2.5–4.5 μm. The gills of all these species are many times taller than they are thick, unlike the short, thick ridges of chanterelles.

Panaeolina foenisecii (Pers.) Maire

= *Panaeolus foenisecii* (Pers.) J. Schröt.

COMMON NAME: Lawnmower's Mushroom

MACROSCOPIC FEATURES: cap 0.5–3 cm wide, conical or bell-shaped, expanding to nearly flat, dry, bald, hygrophanous, reddish brown or dull gray-brown before fading to shades of grayish tan, typically showing concentric rings of varying color, frequently with a dark marginal band. The young margin is often translucent-striate. **gills** attached but seceding, close, pallid at first, brown and mottled at maturity, retaining lighter edges. **stalk** 4–8 cm long and 1.5–3 mm thick, equal or with an expanded base, dry and powdery, brittle, pallid to pale brown, darkening in age, not bluing when bruised or at the base. No partial veil. **flesh** pale brown, unchanging when bruised; odor and taste not distinctive.

MICROSCOPIC FEATURES: Spores 12–17 × 7–9 μm, ellipsoid to subfusoid, roughened, with an apical pore, pale purplish brown, dextrinoid.

SPORE PRINT: Dark brown to purplish brown.

HABIT, HABITAT, AND SEASON: Scattered or gregarious in lawns and other grassy situations; year-round.

EDIBILITY: Usually not psychoactive.

COMMENTS: Stamets (1996) reports that most strains of Lawnmower's Mushroom lack psychoactivity, but there may be weak exceptions. *Panaeolus cinctulus* = *Panaeolus subbalteatus* (not illustrated) is very similar but larger, with cap diameters to 5 cm and a more prominent dark marginal band. It grows on horse manure or manured soil. Spores are black, not dark brown, and gills are blacker at maturity. Although it contains psilocybin, it only occasionally bruises blue, either at the base or after prolonged sun exposure. Most psychoactive relatives, including *Psilocybe ovoideocystidiata*, more readily bruise blue. Additional look-similars for *Panaeolina foenisecii* include the sticky-capped and dark-spored *Bolbitius titubans*. *Conocybe apala* (see Color Key) has a finely striate cap and lighter brown spores. *Agrocybe pediades* (see Color Key and Comments under *Agrocybe molesta*) also has lighter brown spores.

Panaeolus papilionaceus (Bull.) Quél.

COMMON NAME: Petticoat Mottlegill

MACROSCOPIC FEATURES: cap 2–5 cm wide, conical, becoming bell-shaped, dry, bald, sometimes cracked or ridged, pale grayish brown, yellowish brown, or reddish brown. The margin is decorated at first with a regular pattern of white, tooth-like fragments of partial veil. **gills** attached but often seceding, close, mottled shades of gray and dark purplish brown, the edges whitened. **stalk** 4–16 cm long and 1–5 mm thick, equal, dry, wiry and brittle, minutely hairy, striate and whitish near the apex, colored like the cap below. The partial veil is membranous and fragile, leaving fragments on the cap but no ring zone on the stalk. **flesh** insubstantial, not bruising; odor and taste not distinctive.

MICROSCOPIC FEATURES: Spores 15–18 × 10–12 μm, ellipsoid, smooth, thick-walled with an apical pore, dextrinoid.

SPORE PRINT: Black.

HABIT, HABITAT, AND SEASON: Scattered to gregarious on bovine or horse dung; spring or fall.

EDIBILITY: Edible, but seriously, why?

COMMENTS: The combination of ornamented cap margin and dung-dwelling lifestyle distinguishes this common species from *Panaeolina foenisecii* and from the larger and hairier *Lacrymaria lacrymabunda* (see Color Key and Comments under *Psathyrella pennata*) and the brown-spored *Conocybe apala* (see Color Key and Comments under *Bolbitius titubans*). *Panaeolus semiovatus* (not illustrated) fruits on bovine or horse dung and often has some veil remnants on the margin of young caps. The stalk of this larger species should retain a persistent ring zone.

Panaeolus solidipes (Peck) Sacc.

= *Anellaria sepulchralis* (Berk.) Singer
= *Panaeolus sepulchralis* (Berk.) Sacc.

MACROSCOPIC FEATURES: **cap** 4–10 cm wide, convex, becoming broadly convex; surface dry, smooth to wrinkled, often rimose-areolate in dry weather or in age, white to light gray or yellowish buff; margin incurved at first and often remaining so well into maturity. **gills** attached, close, moderately broad, pale gray at first, becoming mottled with black and finally black overall at maturity; edges white. **stalk** 6–18 cm long and 5–15 mm thick, solid; surface dry, longitudinally twisted-striate, sometimes with moisture droplets at the apex when fresh, white to grayish white; partial veil and ring absent. **flesh** moderately thick, whitish; odor and taste not distinctive.

MICROSCOPIC FEATURES: Spores 14–21 × 9–14 µm, ellipsoid, truncate, with an apical pore, smooth, blackish.

SPORE PRINT: Black.

HABIT, HABITAT, AND SEASON: Scattered, in groups or clusters on dung or manure; year-round.

EDIBILITY: Edible, but not recommended.

COMMENTS: The edible Semi-ovate Panaeolus, *Panaeolus semiovatus* (not illustrated), is very similar and also grows on dung or manure, but it has a superior to median ring or ring zone on its stalk. It has a smooth to wrinkled or cracked, brownish buff to ivory white cap. The stalk is hollow in age, and the membranous partial veil is white and delicate, leaving a blackening ring on the stalk. The spores are ellipsoid with a large germ pore, smooth, and dark brown and measure 18.5–21 × 10–11.5 µm. It grows on horse manure from spring through fall.

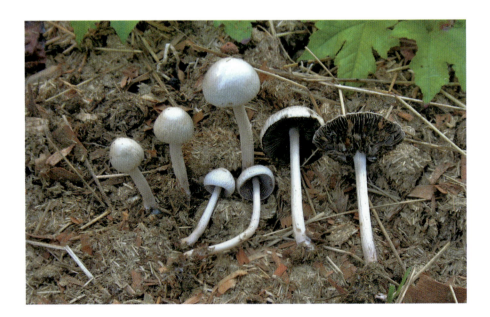

Panellus stipticus (Bull.) P. Karst.

COMMON NAME: Luminescent Panellus
MACROSCOPIC FEATURES: **cap** 5–30 mm wide, shell-like or kidney-shaped, dry, minutely velvety or hairy (use hand lens), pale tan to yellowish brown, often fading toward whitish in age. The cap margin is initially inrolled. **gills** attached at a well-defined line around the stalk, close or crowded, forking, pale brown to pinkish brown, bioluminescent. **stalk** 3–10 mm long and 2–5 mm thick, lateral, equal or tapering downward, pale brown, often coated with white hairs. No partial veil. **flesh** flexible and tough, pale brown; odor not distinctive, taste bitter or occasionally not distinctive.
MICROSCOPIC FEATURES: Spores 3–6 × 2–3 μm, ellipsoid to almost allantoid, smooth, hyaline, amyloid.
SPORE PRINT: White.
HABIT, HABITAT, AND SEASON: Gregarious or clustered on rotting deciduous wood or sticks; year-round.
EDIBILITY: Inedible.
COMMENTS: *Panellus stipticus* in other parts of the world seems to lack bioluminescence. Here, in the eastern United States, the green glow from the gills of fresh specimens can be observed on dark woodland nights or in a very dark room after a few minutes of letting your eyes adapt to the dark. The adaptive function of fungal bioluminescence remains unclear (see Desjardin et al. 2008) but might involve attracting nocturnal insects that inadvertently transport fungal spores to other locations. *Crepidotus stipitatus* (not illustrated) is a white, squishy-fleshed look-alike fruiting gregariously on decaying wood. Caps are shell-like, convex, bald, 1–3 cm across. Gills are close, white before browning with maturing spores. The stalk is 2–4 mm long and 1–1.5 mm thick, eccentric or almost lateral, pruinose, white, hairy at the point of attachment. Spores are brown and globose, 4.5–6.5 μm.

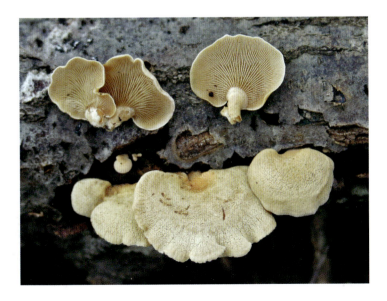

Panus lecomtei (Fr.) Corner 1981

= *Lentinus strigosus* (Fr.)
= *Panus neostrigosus* Drechsler-Santos & Wartchow
= *Panus rudis* Fr.

COMMON NAMES: Hairy Panus, Ruddy Panus
MACROSCOPIC FEATURES: cap 2–10 cm wide, convex at first, soon centrally depressed, becoming fan-, kidney-, or funnel-shaped, dry, densely hairy, a shade of purple, aging to reddish brown or pinkish tan. The young cap margin is strongly inrolled, later sometimes lobed. **gills** decurrent, close or crowded, pale purple progressing to pale tan or whitish, edges even. **stalk**, if present, 1–4 cm long and up to 1 cm thick, central, eccentric, or lateral, dry, colored like the cap or paler. **flesh** tough, white; odor not distinctive, taste not distinctive or bitter.
MICROSCOPIC FEATURES: Spores 4.5–7 × 2–4 μm, ellipsoid, smooth, hyaline, inamyloid.
SPORE PRINT: White.

HABIT, HABITAT, AND SEASON: Solitary to clustered on decaying deciduous logs or stumps; year-round.
EDIBILITY: Edible.
COMMENTS: *Panus conchatus* = *Lentinus torulosus* (see Color Key) is similar and also fruits on rotting wood, which may be buried. But the cap is smooth or scaly, not densely woolly. The stalk is smooth or finely hairy, not densely so. A word about the taxonomic confusion surrounding the Hairy Panus: Latin names are meant to convey family relationships in the tree of life. These concepts change over time as new information emerges. Tree branches and their associated names get rearranged. This means that, in a way, Latin names have their own genealogies and claims to priority based on a factor such as age: the oldest good name and its descendants win. The poor Hairy Panus doesn't quite know who it is because of disagreements about where tree branches fork. Here, we use the name generally favored by molecular mycologists, although it is less commonly seen in field guides.

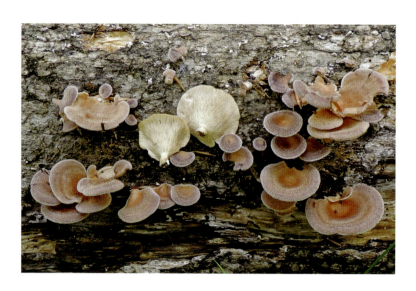

Parasola plicatilis (Curtis) Redhead, Vilgalys, & Hopple

= *Coprinus plicatilis* (Curtis) Fr.

COMMON NAMES: Japanese Umbrella Inky, Pleated Inky Cap

MACROSCOPIC FEATURES: cap 1–3.5 cm wide, ovoid at first, becoming bell-shaped, then flattening, often upturned in age, dry, bald, deeply striate almost to the center, light yellow-brown or orange-brown in youth, turning gray but retaining the brown center. The cap margin is striate. **gills** free, subdistant, very narrow, initially whitish, darkening to black but not liquefying. **stalk** 5–9 cm long and 1–3 mm thick, nearly equal, dry, smooth, fragile, whitish, hollow. No partial veil. **flesh** whitish to pale gray; odor and taste not distinctive.

MICROSCOPIC FEATURES: Spores 10–14 × 7–10 μm, angular-ovoid to lemon-shaped with a conspicuous and eccentric germ pore, smooth, dark brown.

SPORE PRINT: Black.

HABIT, HABITAT, AND SEASON: Solitary to gregarious in grassy areas, compost, or wood mulch; spring–late fall.

EDIBILITY: Reportedly edible.

COMMENTS: The very similar *Parasola auricoma* (see photo) is distinguished by a deeper orange-brown cap when young, fine reddish hairs on the cap (use hand lens), elliptic spores, 10–16 × 6–9 μm, with a central germ pore, and growth in wood chips. Other look-similars include a pair of white-spored species. The very tall and slender woodland leaf recycler, *Leucocoprinus fragilissimus* (see Color Key), has a greenish yellow cap, pleated and granular in texture, 1–4.5 cm wide. Its stalk is up to 16 cm long and features a flaring partial veil. The appropriately named Flowerpot Parasol, *Leucocoprinus birnbaumii* (see Color Key), is bright yellow all over before fading in age. It has a scaly, radially fibrillose cap, diameter to 4 cm, a relatively short stalk, and a flaring veil. These colorful surprises do no harm to houseplants but might give hungry humans a stomachache.

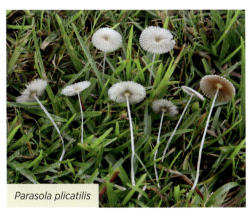

Parasola plicatilis

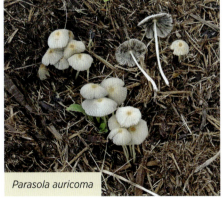

Parasola auricoma

Pholiota castanea A. H. Sm. & Hesler

MACROSCOPIC FEATURES: **cap** 1–5 cm wide, convex to broadly convex, with or without an umbo or central depression, sticky, smooth, chestnut brown to reddish brown or yellowish red, with a cuticle peelable nearly to the center. The margin is even and remains incurved for a long time. **gills** attached or subdecurrent, close or crowded, whitish to yellowish, then browner with darker brown spots, eventually tawny olive or dark brown, the edges often finely serrated. **stalk** 2–6 cm long and 2–6 mm thick, equal or tapering downward, dry, fibrillose, whitish with brown streaks and stains, hollowing in age. The partial veil is a fleeting cortina, sometimes not observed. **flesh** tough or firm, whitish; odor and taste not distinctive.
MICROSCOPIC FEATURES: Spores 6–8 × 3.5–5 μm, ellipsoid to subovate with an indistinct germ pore, smooth, brownish; subpellis hyphae often inflated.
SPORE PRINT: Brown to dark brown.
HABIT, HABITAT, AND SEASON: Gregarious to caespitose on burned soil, charcoal, and other fire debris; year-round.
EDIBILITY: Unknown.
COMMENTS: The Burnsite Pholiota, *Pholiota highlandensis* (not illustrated), is almost identical in form, spore size, and habitat. But it has a slightly smaller, pale brown to brown cap, 0.3–3 cm wide, consistently even gill edges, and no inflated hyphae in the subpellis. See also *Psathyrella pennata*. The Variable Pholiota, *Pholiota polychroa* (see Color Key), often has some red tones in mature caps but fruits gregariously on rotten deciduous or occasionally conifer wood. Caps are 1.5–10 cm wide, broadly convex, sticky, with small cream-colored scales on very young specimens that become pale violet before disintegrating. Cap colors vary: reddish purple, yellow, orange, olive, bluish, or blends of the above. A thin partial veil typically leaves triangular tags on the cap margin and a thin ring on the stalk. Spores are brown or purplish brown.

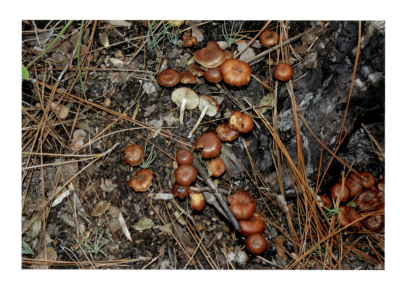

Pholiota squarrosa (Vahl) P. Kumm.

COMMON NAME: Scaly Pholiota

MACROSCOPIC FEATURES: cap 3–12 cm wide, convex expanding toward flat, dry, covered with erect brown to pinkish tan scales over a yellow-brown ground color. The cap margin is incurved at first, decorated with bits of partial veil. **gills** attached, close or crowded, white, developing greenish tints and maturing to rusty brown. **stalk** 4–12 cm long and 4–12 mm thick, equal, dry, pale yellow with yellow-brown scales below the veil. The partial veil is fibrous to membranous, yellowish or tan, leaving a skirt that may disappear. **flesh** pale yellow; odor garlicky or not distinctive, taste not distinctive.

MICROSCOPIC FEATURES: Spores 5–8 × 3.5–4.5 μm, ellipsoid, smooth with an apical pore, pale brown, inamyloid or weakly dextrinoid.

SPORE PRINT: Brown.

HABIT, HABITAT, AND SEASON: Usually caespitose on or at the base of deciduous or conifer trees, logs, or stumps; late summer–fall.

EDIBILITY: May cause gastrointestinal distress.

COMMENTS: *Pholiota squarrosoides* (not illustrated) differs only in the details. The cap surface under the scales is initially slippery or tacky. Its gills never turn greenish. Spores lack an apical pore and measure 4–5.5 × 2.5–3.5 μm. The Golden Pholiota, *Pholiota aurivella* (see Color Key), has a slimy, brownish orange cap, 4–15 cm wide, adorned with flattened brown scales. Gills mature from yellow to rusty brown. The yellowish stalk becomes coarsely scaly below the ring. Spores are 7–11 × 4.5–6 μm. The scaly and white-spored Decorated Pholiota, *Leucopholiota decorosa* (not illustrated), fruits on deciduous wood. Caps are 3–6 cm wide, dry, covered with pointed, reddish brown scales, the margin whitened by fibrous tags of partial veil. Stalks are similarly colored, scaly below the veil. Spores are white, measuring 5.5–7 × 3.5–4 μm, amyloid.

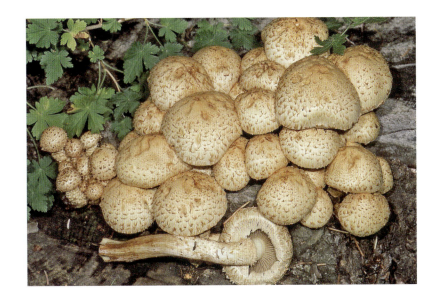

Phyllotopsis nidulans (Pers.) Singer

= *Panus nidulans* (Pers.) Pilát

COMMON NAME: Orange Mock Oyster
MACROSCOPIC FEATURES: cap 2–8 cm wide, convex, semicircular or fan-shaped with a narrowed point of attachment, dry, densely carpeted with short whitish hairs over a yellowish orange to orange background that browns in age. The cap margin is initially inrolled, relaxing somewhat by maturity. **gills** attached, close or crowded, thin, straight, forking, radiating from the point of attachment, colored like the cap, the edges even. **stalk** absent or lateral and rudimentary, dry, colored like the cap. **flesh** orange; odor reminiscent of rotting cabbage or sometimes not distinctive, taste unpleasant or not distinctive.

MICROSCOPIC FEATURES: Spores 6–8 × 3–4 μm, allantoid, smooth, hyaline, inamyloid.
SPORE PRINT: Pale pink or reddish in thick deposits.
HABIT, HABITAT, AND SEASON: Solitary to gregarious on deciduous or conifer wood; year-round.
EDIBILITY: Inedible.
COMMENTS: Here's a mushroom that's easily seen and without any really close look-alikes. *Lentinellus vulpinus* and similar species have saw-toothed gill edges. *Tapinella panuoides* (see Color Key and Comments under *Tapinella atrotomentosa*) is smaller and browner, usually has some crinkled gills, and is restricted to conifer wood. *Gloeophyllum sepiarium* is also restricted to conifer wood or lumber. Its gill-like structures are thick and sometimes maze-like, reflecting its polypore lineage.

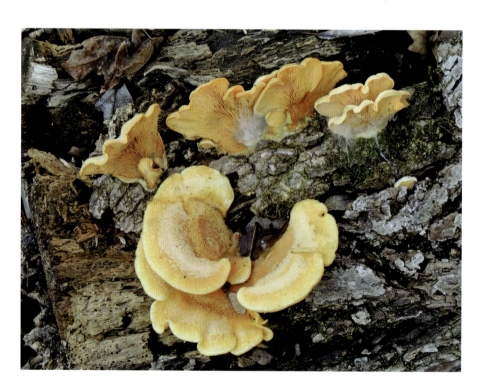

Pleurotus levis (Berk. & M. A. Curtis) Singer

= *Lentinus levis* (Berk. & M. A. Curtis) Murrill

MACROSCOPIC FEATURES: cap 5–21 cm wide, broadly convex, sometimes centrally depressed at maturity, dry, appearing soft and coated with short, matted hairs, whitish when young, developing yellow tinges as it ages. The young cap margin is incurved and may be fringed with fibrillose tufts of veil remnants. **gills** subdecurrent, not extending below the ring or ring zone, close to subdistant, colored like the cap, the edges smooth or irregularly eroded in age. **stalk** 4–15 cm long and 1–4 cm thick, central, enlarging downward, dry, densely hispid from the apex to the base, whitish when young, becoming yellowish to brownish as it ages. **flesh** tough, white, yellowing with age; odor not distinctive, taste not distinctive.
MICROSCOPIC FEATURES: Spores 9–14 × 3–5 µm, ellipsoid, smooth, hyaline, inamyloid.
SPORE PRINT: White.
HABIT, HABITAT, AND SEASON: Solitary or in small groups on living deciduous trees or dead wood, rarely on conifers; summer–fall.
EDIBILITY: Edible for the strong of jaw and empty of belly.
COMMENTS: The similar Veiled Oyster, *Pleurotus dryinus* (not illustrated), also has a partial veil when young that leaves remnants on the cap margin. The cap is whitish when young, develops light beige to pinkish beige tones as it matures, and lacks any yellow tones. The gills are decurrent nearly to the eccentric stalk base. It is often misidentified as *Pleurotus levis*. Youthful specimens of *Neolentinus lepideus* (see Color Key and Comments under *Lentinellus micheneri*) can be all white but aren't densely furred and have serrated gill edges. The Elm Oyster, *Hypsizygus ulmarius* (not illustrated), is also similar but with a bald or slightly scaly, white to tannish cap. It fruits in small groups on living deciduous trees. Spores are globose, 5–6 µm.

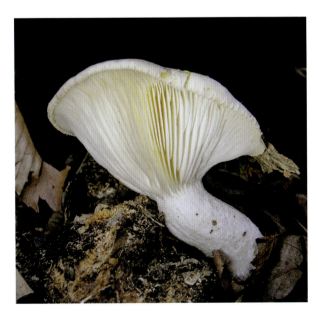

Pleurotus pulmonarius (Fr.) Quél.

COMMON NAME: Summer Oyster
MACROSCOPIC FEATURES: **cap** 2–13 cm wide, initially convex but uplifting to flat or depressed, moist or dry, bald, whitish or tan. The young cap margin is inrolled, later wavy and often slightly striate. KOH on the cap surface produces an orange stain. **gills** long-decurrent, not all terminating at once on the stalk, close or subdistant, whitish, edges even. **stalk** rudimentary or up to 7 cm long and 1.5 cm thick, eccentric or central, moist or dry, bald, whitish. No partial veil. **flesh** whitish; odor distinctive, resembling seafood, taste not distinctive.
MICROSCOPIC FEATURES: Spores 7–10 × 2.5–5 µm, long-ellipsoid to cylindric, smooth, hyaline, inamyloid.
SPORE PRINT: White, pale grayish, or pale lilac.
HABIT, HABITAT, AND SEASON: Usually clustered on dead deciduous wood with the bark still attached; summer–fall.
EDIBILITY: Edible.
COMMENTS: This is a lightly built sibling of the Oyster Mushroom, *Pleurotus ostreatus* (not illustrated), which is equally edible and shares the same odor. That meatier species favors cooler weather. Caps are darker and/or streakier shades of grayish brown, lacking marginal striations, unchanging with KOH. Angel's Wing, *Pleurocybella porrigens* (see Color Key), is a smaller and whiter look-alike occurring on high-elevation conifer logs. Caps are up to 10 cm wide, convex before uplifting, stalkless or nearly so with a narrow point of attachment. No oyster mushroom smell. Spores are white, 6–7 × 5–6 µm. Although often considered edible, it has caused fatal poisonings (see Halford 2011). The Late Autumn Oyster, *Sarcomyxa serotina = Panellus serotinus* (not illustrated), is dark green, yellowish, or brown, sometimes with a purplish tint. Gills yellow; stalk thick and stubby. Spores are whitish, 4–6 × 1.5–2 µm. It fruits on downed logs and is edible if not bitter.

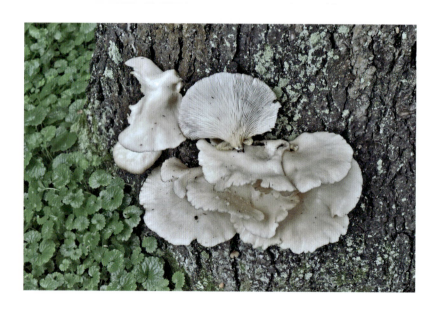

Pluteus cervinus group (Schaeff.) P. Kumm.

COMMON NAMES: Fawn Mushroom, Deer Mushroom

MACROSCOPIC FEATURES: **cap** 2.5–15 cm wide, convex, then expanding to nearly flat with or without a broad umbo, tacky when moist, bald, often wrinkled in youth but smoothing, sometimes radially streaked with darker innate fibers, a shade of tawny brown to grayish brown or rarely pure white. The cap margin is not striate. **gills** free, close or crowded, initially white, then pinkening. **stalk** 4–14 cm long and 5–20 mm thick, nearly equal or with an enlarged base, dry, white, often sparsely overlaid by brownish fibers, solid. No partial veil. **flesh** white; odor and taste usually like radish, occasionally not distinctive.

MICROSCOPIC FEATURES: Spores 6.5–8.5 × 5–7 μm, ellipsoid, smooth, hyaline, inamyloid. Pleurocystidia are corniculate, with 2–6 unbranched hooks.

SPORE PRINT: Pink to brownish pink.

HABIT, HABITAT, AND SEASON: Solitary or scattered on decaying deciduous or conifer wood, sometimes on buried wood or sawdust piles; spring–early winter.

EDIBILITY: Edible.

COMMENTS: Wide variations in form suggest that more than one species might be passing as *Pluteus cervinus*. *Pluteus atromarginatus* (not illustrated) is smaller and has a darker cap, 2.5–12 cm. Gill edges are dark brown to black. Spores measure 6–8.5 × 4–6 μm. Pleurocystidia are corniculate, sometimes with a bifurcated apex, usually 2–5 unbranched hooks. *Pluteus hongoi* (not illustrated) has a brown and streaky or occasionally white cap, 2.5–10 cm wide. Stalks are white, smooth, white floccose, or with a smattering of brown fibrils, 3.5–11 cm long and up to 15 mm thick. Spores are 5.5–9 × 4.5–7 μm. Pleurocystidia are corniculate; hooks are usually forked. *Megacollybia rodmanii* looks similar, but the gills remain white, and the mushroom lacks the odor of radish. Beware confusion with a potentially poisonous species such as *Entoloma subsinuatum* (not illustrated, see Comments under *Entoloma abortivum*).

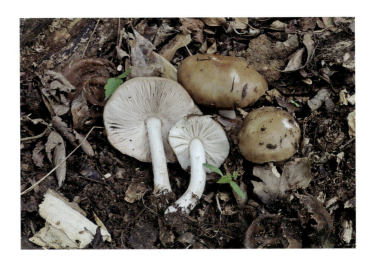

Pluteus longistriatus (Peck) Peck

COMMON NAME: Pleated Pluteus
MACROSCOPIC FEATURES: cap 1–5 cm wide, conical to bell-shaped, opening toward flat with or without a central depression or umbo, dry, granular or minutely scaly, pale gray or gray-brown overall. The cap margin is striate almost to the center, often cracked. **gills** free, close, initially white, then pinkening. **stalk** 2–8 cm long and 1.5–3 mm thick, equal or with an enlarged base, dry, smooth, slightly scurfy or longitudinally fibrillose over a white background. No partial veil. **flesh** fragile, white; odor and taste not distinctive.
MICROSCOPIC FEATURES: Spores 6–7.5 × 5–5.5 μm, subglobose, smooth, hyaline, inamyloid. Pleurocystidia lack hooks.
SPORE PRINT: Salmon pink.
HABIT, HABITAT, AND SEASON: Scattered to gregarious on rotting deciduous logs, branches, or debris; summer–late fall.
EDIBILITY: Edible.
COMMENTS: The epithet *longistriatus* references the long, almost pleated cap striations. The Rib-capped Pluteus, *Pluteus thomsonii* (see Color Key), has a bald, darker brown cap, 1–4 cm wide, that is striate at the margin but centrally textured by vein-like raised and somewhat radial wrinkles. Stalks are pruinose, gray to grayish brown, up to 5 cm long. Pleurocystidia lack hooks. *Pluteus granularis* (not illustrated) has a radially wrinkled cap with a diameter up to 10 cm. The light brown background is sparsely covered by mangy tufts of dark brown granules. Gills are not supposed to have brown margins. The stalk is pale, overlaid with dark brown granules toward the base. Pleurocystidia lack hooks. It is unclear whether mushrooms resembling *Pluteus granularis* but with marginate gills are just a variation or belong to a European species, *Pluteus umbrosus* (not illustrated).

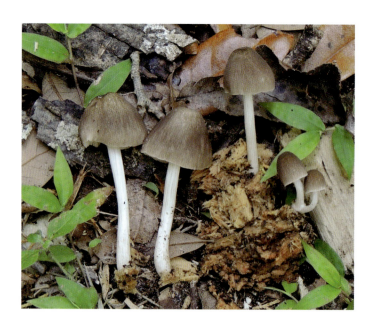

Pluteus petasatus (Fr.) Gillet

= *Agaricus petasatus* Fr.

MACROSCOPIC FEATURES: cap 3–20 cm wide, bell-shaped or convex at first, then broadly convex, with or without a low umbo, tacky when moist, smooth before developing fine central cracks or scales, whitish to pale brown, sometimes showing a radial pattern of pale brown innate fibers. The cap margin sometimes splits in age. **gills** free, close, initially white, then pinkening. **stalk** 3–20 cm long and 5–20 mm thick, nearly equal or with an enlarged base, dry, smooth or longitudinally grooved, white, browning near the base, solid. No partial veil. **flesh** white; odor and taste often unpleasantly sweet or not distinctive but occasionally resemble radish.

MICROSCOPIC FEATURES: Spores 5.5–8 × 3.5–5.5 μm, ellipsoid, smooth, hyaline, inamyloid. Pleurocystidia are corniculate, with 0–3 unbranched hooks.

SPORE PRINT: Dull pink.

HABIT, HABITAT, AND SEASON: Single or in small groups on decaying deciduous wood, wood mulch, or sawdust, often fruiting in residential areas; year-round.

EDIBILITY: Edible.

COMMENTS: This species can be hard to distinguish from pale forms of *Pluteus cervinus*. In questionable cases, a lack of distinct radish odor suggests *Pluteus petasatus*, but smaller spores and some hookless cystidia will confirm it. *Volvariella bombycina* is a look-similar with a neatly barbered hairy cap and a base arising from a papery volva. Although some American field guides describe a species called *Pluteus pellitus*, it is apparently restricted to Eurasia. Consider the possibility of a white *Pluteus hongoi* (not illustrated, see Comments under *Pluteus cervinus*).

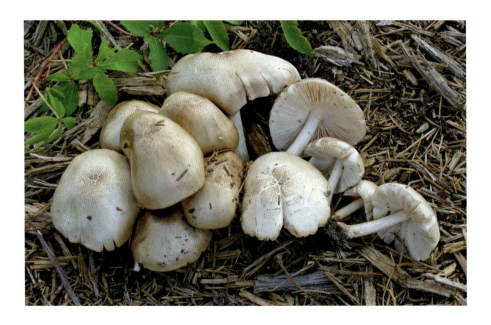

Psathyrella pennata (Fr.) A. Pearson & Dennis

= *Psathyrella carbonicola* A. H. Smith

COMMON NAME: Charcoal Psathyrella

MACROSCOPIC FEATURES: cap 2–6 cm wide, bluntly conical or convex, expanding toward flat, dry, initially covered by white fibrils that fall off to reveal a smooth brown to chocolate brown ground color that fades in age. The young cap margin is festooned with white tags of partial veil. **gills** attached, close, pale brown, darkening evenly to purplish brown. **stalk** 3–7 cm long and 2–5 mm thick, nearly equal, dry, brittle, minutely white fibrillose above the partial veil and shaggier white below, the background color whitish but often browning toward the base. The partial veil is flimsy and cottony and soon disappears, sometimes leaving a fibrillose ring. **flesh** fragile, whitish; odor and taste not distinctive.

MICROSCOPIC FEATURES: 6–8.5 × 3–4.5 μm, ellipsoid, smooth, thick-walled with a small apical pore, inamyloid.

SPORE PRINT: Dark purple-brown.

HABIT, HABITAT, AND SEASON: Gregarious to caespitose on charcoal or burned ground; spring–fall.

EDIBILITY: Inedible.

COMMENTS: Compare with *Pholiota castanea*, which has a smooth and sticky cap with a peeling cuticle. The Velvety Psathyrella or Weeping Widow, *Lacrymaria lacrymabunda* = *Psathyrella velutina* (see Color Key), fruits on unburned soil or woody debris. The cap is 2–12 cm wide, dry, initially covered with darker hairs or small scales over a yellowish brown to reddish brown background. Gills are pale brown at first, maturing to mottled dark brown with whitish edges. The stalk is up to 15 cm long, whitish near the apex, darkening below the veil, and covered with brown fibrils or scales. The partial veil is fibrous and flimsy, often leaving a ring zone. Spores are blackish brown, 8–12 × 5–8 μm, roughened, with a protruding apical pore.

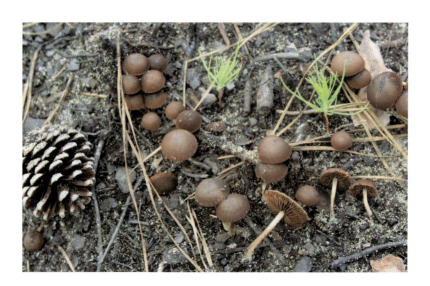

Psathyrella septentrionalis A. H. Sm.

MACROSCOPIC FEATURES: cap 1.5–5 cm wide, convex at first but flattening, moist, smooth under a sparse youthful sprinkling of white fibrils, hygrophanous, a shade of cinnamon or reddish brown, paling most notably at the center. The young cap margin is hung with a tooth-like pattern of partial veil fragments. **gills** attached, close, pale brown, then dark brown at maturity, the edges even. **stalk** 1.5–6 cm long and 1.5–5 mm thick, nearly equal, white, pruinose above the partial veil, smooth or silky fibrillose below, browning from the base upward. The partial veil is fibrillose-membranous, white, flimsy and soon disappearing from the stalk. **flesh** watery, tan; odor and taste not distinctive.

MICROSCOPIC FEATURES: Spores 7–10 × 4.5–5 μm, ellipsoid with an inconspicuous apical pore, smooth, brownish, dextrinoid.

SPORE PRINT: Brownish black.

HABIT, HABITAT, AND SEASON: Gregarious to caespitose on deciduous logs or stumps; summer–fall.

EDIBILITY: Unknown.

COMMENTS: The epithet *septentrionalis* is not a reference to the fruiting season but instead means "northern." The species was originally described from Michigan. *Psathyrella piluliformis* = *Psathyrella hydrophila* (not illustrated) is almost identical to *Psathyrella septentrionalis* but features fewer veil fragments on the cap margin and has spores measuring only 4.5–6 × 3–3.5 μm. Also compare with *Panaeolus papilionaceus*. It has a similar overall appearance, including tooth-like fragments of partial veil hanging from the young cap margin, but is found on dung rather than wood. *Psathyrella candolleana* (see Color Key) has a pale tan or whitish cap and grows on the ground.

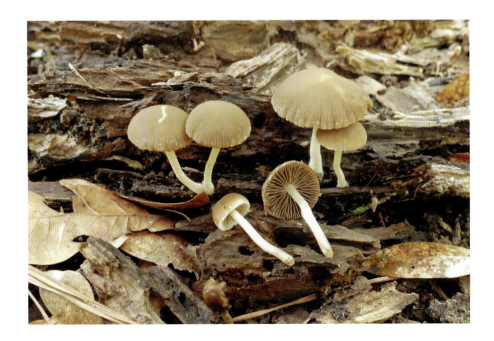

Pseudoarmillariella ectypoides (Peck) Singer

= *Omphalina ectypoides* (Peck) H. E. Bigelow
= *Clitocybe ectypoides* (Peck) Sacc.

COMMON NAME: Wood Clitocybe
MACROSCOPIC FEATURES: **cap** 2–6 cm wide, initially convex with a depressed center, becoming funnel-shaped, moist, hygrophanous, grayish yellow to creamy brown under a radial pattern of small reddish brown to blackish brown scales that may disappear in age. The cap margin is incurved for a long time but eventually uplifts. **gills** decurrent, nearly distant, sometimes forked, pale yellow to yellow, often showing reddish brown stains. **stalk** 2–7 cm long and 3–9 mm thick, equal or enlarging downward, smooth or finely scurfy, colored like the cap or paler, staining brownish when bruised, solid. No partial veil. **flesh** yellowish or colored like the cap; odor and taste not distinctive or slightly sweet.
MICROSCOPIC FEATURES: Spores 6–8 × 3–5 µm, ellipsoid, smooth, hyaline, amyloid.
SPORE PRINT: White.
HABIT, HABITAT, AND SEASON: Scattered or gregarious on decaying conifer wood; late spring–fall.
EDIBILITY: Unknown.
COMMENTS: The Golden-gilled Gerronema, *Chrysomphalina chrysophylla* = *Gerronema chrysophylla* (not illustrated), is a less-common look-alike on conifer wood. It lacks the cap scales and brown bruising reaction. Gills are brighter yellow to yellow-orange, and the spore print is yellowish. Compare both with *Gerronema strombodes*, which usually fruits on deciduous wood and has inamyloid spores. See also *Lentinellus micheneri* and its Comments section for other sources of potential confusion. The Flame Chanterelle, *Craterellus ignicolor*, is hollow, has pinkish lavender ridges, and seldom fruits on wood.

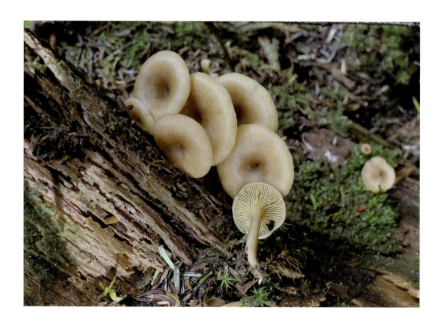

Pseudomerulius curtisii (Berk.) Redhead & Ginns

= *Meiorganum curtisii* (Berk.) Singer, J. Garcia, & L. D. Gomez
= *Paxillus curtisii* Berk.

MACROSCOPIC FEATURES: cap 2–5 cm wide, irregularly fan-shaped and broadly attached, flattening in age, dry, smooth or finely fuzzy, bright yellow or orange-yellow, developing tinges of yellowish brown or olive brown, with or without discrete reddish brown stains. The cap margin is initially inrolled. **gills** radiate from a point of attachment, a semiorganized jumble of close, crinkly, forking, fusing, and crossveined structures, golden yellow at first but closer to olive brown in age, staining darker orange and variably peelable from the cap as a layer. **stalk** absent. **flesh** softly rubbery, yellow; odor pungent, sickly sweet (think rot and cinnamon), but sometimes not distinctive, taste not distinctive or bitter.

MICROSCOPIC FEATURES: Spores 3–3.5 × 1.5–2 μm, broadly ellipsoid, smooth, pale yellow, dextrinoid.
SPORE PRINT: Yellow-brown to slightly olivaceous.
HABIT, HABITAT, AND SEASON: Solitary to clustered on conifer logs and stumps; summer–early winter.
EDIBILITY: Unknown.
COMMENTS: The characteristic "perfume" of this species may be evident from a distance of several feet. *Phylotopsis nidulans* may have a foul but different odor. Its gills are well-behaved, and the spore print is pale pink. *Tapinella panuoides* (see Color Key and Comments under *Tapinella atrotomentosa*) is another stalkless recycler of conifer logs. The colors are duller shades of yellow-brown, and although the gills are usually crinkled near the point of attachment, they straighten toward the periphery. Its gill layer is also dependably peelable from the cap context.

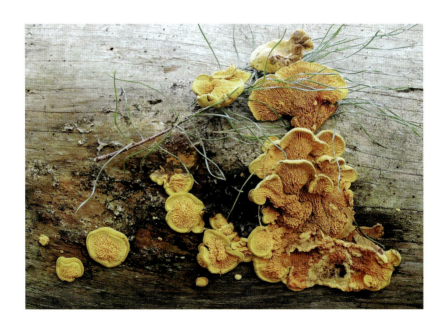

Pseudosperma sororium (Kauffman) Matheny & Esteve-Rav

= *Inocybe sororia* Kauffman

COMMON NAME: Pungent Fiber Head
MACROSCOPIC FEATURES: cap 2–7.5 cm wide, conical, broadening to convex with an umbo, dry, silky, creamy to yellowish brown, darkest over the umbo, radially fibrillose, the fibers separating with cap expansion to reveal a lighter background. The cap margin upturns in age and develops radial tears. **gills** attached, close or crowded, initially white, maturing to yellowish brown with white edges. **stalk** 2.5–10 cm long and 2–6 mm thick, equal, dry, clothed in silky fibers and often scurfy near the apex, whitish, darkening to yellowish brown, solid. The base may be slightly swollen. No evident partial veil. **flesh** white; odor distinctly of green corn, taste not distinctive.
MICROSCOPIC FEATURES: Spores 11–15.5 × 6–8 µm, elliptic, smooth, pale brown.
SPORE PRINT: Brown.
HABIT, HABITAT, AND SEASON: Solitary to loosely grouped in a variety of woodland ecosystems; summer–fall.
EDIBILITY: Poisonous.
COMMENTS: Many Inocybes are strongly scented, and several give off at least a note of raw corn in the husk. The Pungent Fiber Head specializes in that odor. *Inosperma rimosoides* = *Inocybe rimosoides* (not illustrated) smells and looks very much the same but has a smooth stalk and smooth, elliptic spores measuring only 8–10 × 5–6 µm. *Inocybe* toxicity centers on muscarine. Chief symptoms of muscarine poisoning are abbreviated as PSL: perspiration, salivation, and lacrimation. To these we can add constricted pupils, blurred vision, intense need to urinate, slow heartbeat, low blood pressure, nasal and lung congestion, tremor, and gastrointestinal upset. Symptoms appear within an hour or two after ingestion and begin to dissipate a few hours later.

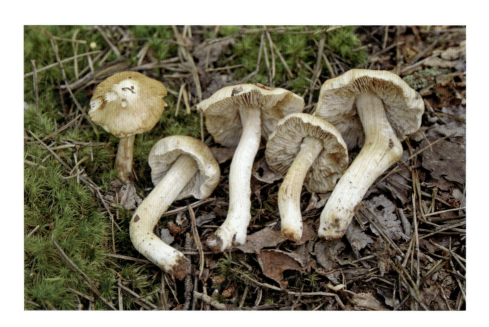

Psilocybe caerulescens Murrill

COMMON NAME: Landslide Mushroom
MACROSCOPIC FEATURES: cap 2–9 cm wide, bell-shaped at first, then broadly convex to almost flat in age, usually with an umbo, slippery to tacky when moist, smooth, hygrophanous, variably dark olive brown to purplish brown or chestnut brown, fading to lighter shades of reddish brown. The young cap margin is inrolled, translucent-striate, and often hung with threads of partial veil. **gills** attached, close, light brown with whiter edges, eventually dark purplish brown. **stalk** 4–12 cm long and 2–10 mm thick, nearly equal, whitish at the apex, brownish below, bruising blue-black, covered with whitish fibrils that soon wear off. The base is sometimes enlarged and/or rooting. The partial veil is a white cortina leaving no ring on the stalk. **flesh** whitish to watery brown, bruising blue, as may the cap margin; odor farinaceous, taste not distinctive or bitter.
MICROSCOPIC FEATURES: Spores 6–8 × 4–6 µm, subrhomboid to subellipsoid, smooth, yellowish. Cheilocystidia fusoid with a flexuous neck 1–2.5 µm wide, pleurocystidia not obvious, but see Comments.
SPORE PRINT: Dark purplish brown.
HABIT, HABITAT, AND SEASON: Gregarious to caespitose on farmed or otherwise disturbed soils sometimes lacking in much herbaceous plant life; spring or fall.
EDIBILITY: Hallucinogenic.
COMMENTS: Possession of mushrooms containing psilocybin or related psychoactive compounds is generally considered illegal in the United States. If the gills have obvious pleurocystidia on microscopic examination, some authorities consider it a distinct species: *Psilocybe weilii* (not illustrated). *Psilocybe cubensis* occurs on livestock dung or manure-enriched soil.

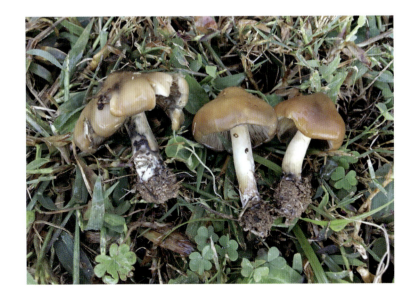

Psilocybe cubensis (Earle) Singer

= *Stropharia cyanescens* Murrill

COMMON NAMES: Magic Mushroom, Golden Tops

MACROSCOPIC FEATURES: cap 2.5–9 cm wide, initially conical to bell-shaped, then convex and flattening, with or without a retained umbo, sticky but soon dry, smooth, cinnamon brown at first, lightening away from the center to yellow-brown and whitish peripherally. The cap margin is often hung with white tags of partial veil. **gills** attached, close or crowded, gray, maturing to dark purplish gray or blackish with pale margins, often mottled. **stalk** 4–16 cm long and 4–15 mm thick, expanding downward to a swollen base, dry, smooth or with a striate apex, whitish or yellowed, bruising blue or greenish blue. The partial veil is membranous and white but bruises blue and is soon blackened by spores. **flesh** white, bruising blue or greenish blue; odor and taste not distinctive.

MICROSCOPIC FEATURES: Spores 11–17 × 7–12 µm, broadly elliptic to amygdaliform, smooth, purplish brown in water, yellowish in KOH, inamyloid. Pleurocystidia are pear-shaped or mucronate, cheilocystidia are fusoid-ventricose with an obtuse to subcapitate apex.

SPORE PRINT: Dark purplish brown.

HABIT, HABITAT, AND SEASON: Solitary to scattered in grassy pastures on cow dung or soil enriched with other herbivore dung; year-round in southern Georgia.

EDIBILITY: Hallucinogenic.

COMMENTS: This widely cultivated species remains illegal to possess in most American jurisdictions due to psychoactive amounts of psilocybin, psilocin, and related compounds. Cultivated forms are said to be generally more potent than naturally occurring specimens. A variety of mainstream medical studies have demonstrated the potential usefulness of psilocybin in the treatment of a variety of depressive, substance use, and anxiety disorders, including post-traumatic stress and end-of-life anxiety.

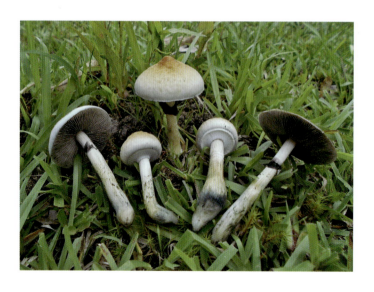

Psilocybe ovoideocystidiata Guzmán & Gaines

COMMON NAME: Blue-foot Psilocybe
MACROSCOPIC FEATURES: cap 1–4.5 cm wide, bell-shaped to convex, then flattening, sometimes with a small umbo, slippery or tacky, smooth, hygrophanous, orangish brown to yellowish brown, fading toward white, bruising blue. The cap margin is initially incurved, translucent-striate, often wavy at maturity. **gills** attached, close, pale brown, becoming dark purple-brown, uniformly colored. **stalk** 1.5–9 cm long and 1–7 mm thick, nearly equal with an expanded base, smooth above the partial veil, softly scaly below, whitish with irregular pale brown or violaceous areas, bruising blue, hollow. The base is covered in white mycelium, sometimes rooting. The flimsy partial veil is membranous, white, sometimes lost. **flesh** white, bruising blue or greenish; odor farinaceous.
MICROSCOPIC FEATURES: Spores 8–9 × 6–7 μm, rhomboid to broadly ellipsoid, smooth, yellowish brown, with walls 0.8–1.5 μm thick and an apical germ pore. Cheilocystidia and pleurocystidia each of two different types: short and relatively narrow or large and wide to subglobose.
SPORE PRINT: Purplish black.
HABIT, HABITAT, AND SEASON: Gregarious or clustered on wood or woody debris in disturbed areas or along trails in deciduous woods, sometimes on soil; spring or fall.
EDIBILITY: Hallucinogenic.
COMMENTS: This species has a paler cap than the larger *Psilocybe caerulescens* and differs microscopically as well. The bluing reaction distinguishes both from most but not all species of *Inocybe* and many other little brown mushrooms. But *Panaeolus cyanescens* = *Copelandia cyanescens* (not illustrated) is a bluing look-alike that fruits on dung. The cap is bell-shaped to convex, 1.5–4 cm wide, smooth, hygrophanous, pale brown fading to whitish, with a translucent-striate margin. The spores are black and larger, 12–14 × 7.5–11 μm.

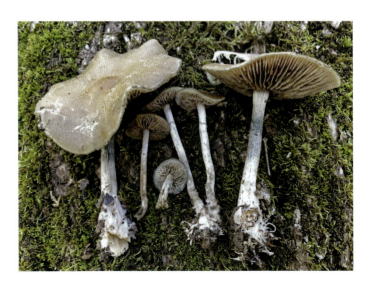

Resupinatus alboniger (Pat.) Singer

= *Pleurotus alboniger* Pat.

MACROSCOPIC FEATURES: **cap** 2–10 mm wide, convex, semicircular to fan-shaped or shallowly cup-shaped, dry, coated with tiny white to whitish gray fibers at first (use a hand lens), becoming bald, smooth to slightly striate, and dark bluish gray to grayish black with the margin remaining whitish longest. **gills** arising from the point of attachment, close to subdistant, grayish to blackish, usually retaining a pale edge. **stalk** absent. **flesh** thin, white at first, becoming blackish; odor and taste not distinctive.

MICROSCOPIC FEATURES: Spores 5.5–8 × 2–4 μm, cylindric to slightly curved, smooth, hyaline, inamyloid, with 1–3 oil drops.

SPORE PRINT: White.

HABIT, HABITAT, AND SEASON: Scattered in groups or in clusters on decaying broad-leaf wood; late spring–fall, sometimes year-round.

EDIBILITY: Unknown, but too small to be of culinary interest.

COMMENTS: *Resupinatus* means "directly attached to the substrate and lacking a stalk." The epithet *alboniger* means "white and black," a reference to the colors of the fruit body. Compare with *Resupinatus applicatus*.

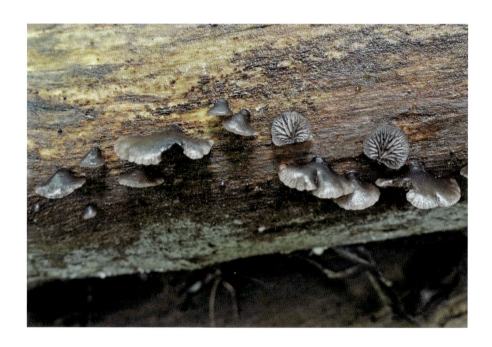

Resupinatus applicatus (Batsch) Gray

= *Pleurotus applicatus* (Batsch) P. Kumm.

COMMON NAME: Black Jelly Oyster
MACROSCOPIC FEATURES: cap 2–6 mm wide, convex to shallowly cup-shaped, dry, coated with tiny fibers (use a hand lens), dark bluish gray to grayish black. **gills** arising from the point of attachment, subdistant, pale grayish at first, becoming dark gray to blackish, with similarly colored edges. **stalk** tiny but present. **flesh** thin, rubbery-gelatinous, grayish black; odor and taste not distinctive.
MICROSCOPIC FEATURES: Spores 4–6 μm, globose to subglobose, smooth, hyaline, inamyloid.
SPORE PRINT: White.
HABIT, HABITAT, AND SEASON: Scattered, in groups or dense clusters on the underside of decaying broadleaf branches and logs; late spring–fall, sometimes year-round.
EDIBILITY: Unknown, but too small to be of culinary interest.
COMMENTS: This mushroom is easily overlooked unless you search the underside of branches and logs. The epithet *applicatus* means "closely attached." The Hairy Oysterling, *Resupinatus trichotis* (see Color Key), is very similar and has spores that are the same size and shape. The cap is larger, 5–12 mm wide, gray to black, distinctly hairy, with a bald marginal zone. It has gray to gray-brown gills, lacks a stalk, and grows on decaying broadleaf wood. Compare with *Resupinatus alboniger*.

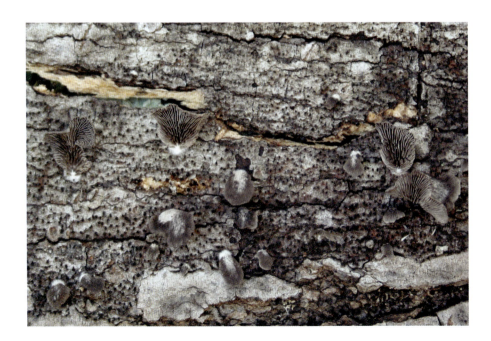

Rickenella fibula (Bull.) Raithelh.

= *Omphalia fibula* (Bull.) P. Kumm.

COMMON NAME: Orange Mosscap

MACROSCOPIC FEATURES: cap 3–15 mm wide, convex with a depressed center, moist or dry, striate or with shallow concentric grooves and ridges, yellowish orange to yellow, orangish brown to reddish brown over the center; margin incurved at first and remaining so well into maturity. **gills** strongly decurrent, distant, whitish. **stalk** 1–5 cm long and 0.5–1.5 mm thick, fragile, dry or moist, very finely hairy or bald (use a hand lens), smooth, hollow in age, colored like the cap. **flesh** extremely thin, whitish; odor and taste not distinctive.

MICROSCOPIC FEATURES: Spores 4–5 × 2–2.5 μm, elliptic, smooth, hyaline, inamyloid.
SPORE PRINT: White.
HABIT, HABITAT, AND SEASON: Scattered or in groups among mosses; late spring–fall.
EDIBILITY: Unknown, but too small to be of culinary interest.
COMMENTS: The epithet *fibula* means "pin-shaped," a reference to the appearance of the fruit body. This species might be confused with tiny moss-loving members of genus *Galerina*, which look similar but have browner gills and brown spores.

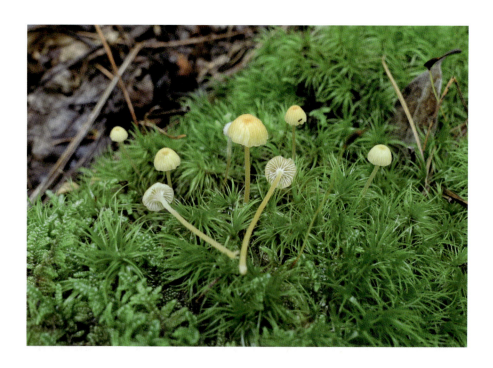

Russula aeruginea Lindblad ex Fr.

COMMON NAME: Tacky Green Russula
MACROSCOPIC FEATURES: cap 4–12 cm wide, convex, becoming nearly flat and depressed in age with an uplifted margin, slimy when moist, silky when dry, grayish green, darker centrally, whitish toward the margin, often with reddish brown to rusty spots, cuticle peeling halfway to the center. **gills** attached to slightly decurrent, forking near the stalk, white when young, pale to dark yellow when mature. **stalk** 5–7 cm long and 1.2–2 cm thick, equal, sometimes thickened in the middle or tapered downward, longitudinally lined, white, developing brownish spots toward the base. **flesh** white; odor not distinctive, taste initially mild, then slowly acrid.
MICROSCOPIC FEATURES: Spores 6.5–9 × 5.5–7 μm, elliptic; surface ornamented with warts and ridges not forming a reticulum, hyaline, amyloid.
SPORE PRINT: Cream to pale yellow.
HABIT, HABITAT, AND SEASON: Scattered or in groups in mixed woods; summer–fall.
EDIBILITY: Edible.
COMMENTS: The cap of the Variable Russula, *Russula variata* (see Color Key), has highly variable colors: reddish purple, lavender, green to olive green or yellowish green, or a mixture of these. The cuticle peels about halfway to the center, and it has crowded, repeatedly forked, white to cream gills. The caps of Quilted Russulas are often green (see the description and Comments for *Russula parvovirescens*). Whatever the color, the cap cuticle appears to have cracked like mosaic tiles. Caps in these species are dry, and colors tend to be comparatively dull with a matte finish.

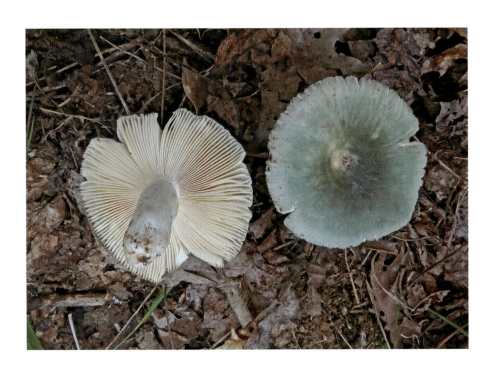

Russula albonigra (Krombh.) Fr.

= *Russula adusta* var. *albonigra* (Krombh.) Massee
= *Russula nigricans* var. *albonigra* (Krombh.) Cooke & Quél.

COMMON NAME: Menthol Brittlegill
MACROSCOPIC FEATURES: **cap** 7–15 cm wide, hemispherical to convex at first, becoming depressed at the center, dull, dry, white when young, becoming dark brownish gray to blackish; margin even, cuticle only slightly peelable. **gills** attached to slightly decurrent, crowded, narrow, frequently forked, white to pale creamy buff, staining blackish when bruised; short gills abundant. **stalk** 3–6 cm long and 1–2.5 cm thick, solid, white at first, soon becoming grayish to blackish. **flesh** white, staining violet-black without a red phase when cut; odor not distinctive, taste mild but with a menthol component that cools the tip of the tongue.
MICROSCOPIC FEATURES: Spores 7.5–10 × 6–8 µm, subglobose to elliptic, ornamented with warts and ridges that form a fine partial reticulum, hyaline, amyloid.
SPORE PRINT: White.
HABIT, HABITAT, AND SEASON: Solitary or in groups on the ground in mixed woods, often near pines; summer–fall.
EDIBILITY: Unknown.
COMMENTS: The epithet *albonigra* means "white and black," a reference to the colors of the fruit body. *Russula dissimulans* (not illustrated) is very similar, but its flesh is mild or acrid, lacks the menthol component, and stains strongly reddish before turning black.

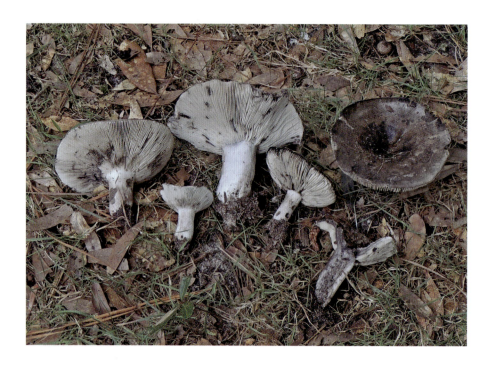

Russula atropurpurea Peck

COMMON NAMES: Blackish-red Russula, Purple Brittlegill

MACROSCOPIC FEATURES: cap 4–14 cm wide, convex, becoming nearly flat, with a depressed disc, bald to pruinose-velvety, dry or sticky when wet, dark reddish purple; disc almost black or olive green, becoming brownish drab to yellow-brown; margin even, slightly striate, cuticle peeling one-third to center. **gills** attached, subdistant, sometimes forking near the stalk, white, becoming pale yellow, then brownish when injured or on drying. **stalk** up to 6 cm long and 1–3 cm thick, spongy or firm, bald, white or pinkish, staining brownish where bruised. **flesh** brittle, white, changing from brownish drab to yellow-brown where bruised; odor sweet, fruity, or not distinctive, becoming disagreeable on drying, taste acrid or not distinctive.

MICROSCOPIC FEATURES: Spores 6.5–9 × 5.5–7 μm, elliptic to subglobose, ornamented with warts and ridges that form a partial reticulum, hyaline, amyloid.

SPORE PRINT: Whitish to pale yellow.

HABIT, HABITAT, AND SEASON: Scattered or in groups in broadleaf woods or mixed forests; late summer–early winter.

EDIBILITY: Unknown.

COMMENTS: The epithet *atropurpurea* means "dark reddish purple." *Russula subsericeonitans* (not illustrated) has a purplish cap with a cuticle that does not easily peel and a white spore print. *Russula mariae* has a 2–10 cm wide, wine red to purple or violet cap that may have tints of green or yellow and is dusted with a whitish bloom when fresh. *Russula rugulosa* (see Color Key) has a 5–10 cm wide, sticky or dry, yellowish red to deep red cap that becomes conspicuously radially wrinkled and tuberculate-striate on the margin when mature. The cuticle peels one-third to halfway to the center. It has a creamy white to ocher spore print and white flesh that tastes very slowly acrid, sometimes detectable only after about 1 minute of chewing.

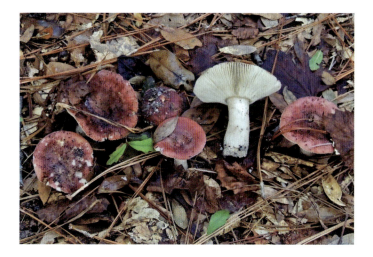

Russula ballouii Peck

COMMON NAME: Ballou's Russula
MACROSCOPIC FEATURES: cap 3–9.5(–15) cm wide, convex, becoming nearly flat, depressed at the center, dry, pale brick red at first and breaking up into small, yellow-brown patches, becoming yellowish ocher to brownish orange as it matures; margin even, not striate; cuticle does not peel. **gills** attached, close, white to pale buff. **stalk** 2–6.5 cm long and 0.8–2 cm thick, slightly tapered toward the apex, dry, bald, solid, whitish with yellow-brown scales and bands at the base. **flesh** brittle, whitish; odor not distinctive, taste acrid.
MICROSCOPIC FEATURES: Spores 7–9 × 5.5–7.5 µm, oval, ornamented with warts and ridges that form a partial reticulum, hyaline, amyloid.
SPORE PRINT: Creamy white.
HABIT, HABITAT, AND SEASON: Solitary or in groups on the ground in river and stream bottomland forests and mixed woodlands; summer–late fall.
EDIBILITY: Unknown.
COMMENTS: The epithet *ballouii* honors American mycologist W. H. Ballou (1857–1937). The Firm Russula, *Russula compacta* (see Color Key), is similarly colored, but its gills stain reddish brown when rubbed, and its firm, brittle flesh has a strong fishy odor. It grows on the ground in mixed conifer and broadleaf woods, often with pines. *Russula foetentula* (see Color Key), edibility unknown, has a prominently tuberculate-striate margin that peels halfway to the center. The white flesh has an oily or faint almond-like odor and tastes unpleasant and acrid. The gills are often forked near the stalk and develop brownish stains as they age. The stalk sometimes has reddish brown stains at the base. Spores are elliptic to subglobose, 7–9 × 5.5–7 µm, and are ornamented with isolated warts. It grows on the ground in broadleaf and mixed woods.

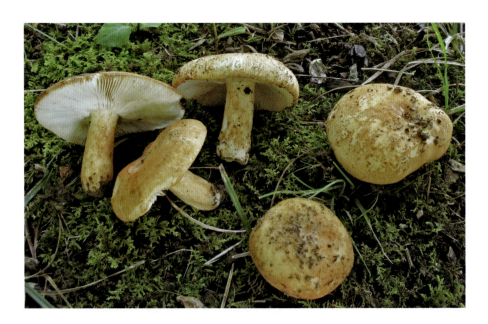

Russula earlei Peck

COMMON NAME: Beeswax Russula
MACROSCOPIC FEATURES: cap 3.5–7.5 cm wide, convex-depressed, becoming more depressed in age, bald or roughened and sometimes pitted, appearing waxy, becoming eroded, pale yellow to yellow, sometimes with yellowish brown tones; margin even, not striate; cuticle not readily peeling except at the margin. **gills** attached, distant to subdistant, thick, often forking, with few short gills, white with some brownish stains. **stalk** 1–5 cm long and 5–22 mm thick, tapered to the base, dry, bald, solid but soon becoming hollow, dingy white to pale yellowish. **flesh** 4–6 mm thick, brittle, white; odor not distinctive, taste mild to slightly acrid.
MICROSCOPIC FEATURES: Spores 4.5–5.2 × 3–4 µm, subglobose to short-ellipsoid, ornamented with short spines and ridges that don't form a reticulum, hyaline, amyloid.
SPORE PRINT: White.
HABIT, HABITAT, AND SEASON: Gregarious in river floodplain broadleaf or mixed forests; summer–fall.
EDIBILITY: Unknown.
COMMENTS: When first observed, this mushroom appears to be a species of *Hygrophorus*; however, the amyloid spores quickly eliminate this possibility. *Russula flavida* (see Color Key) has a 2–10 cm wide, obscurely striate, bright yellow to orange-yellow cap and a similarly colored stalk. The cap cuticle peels one-fourth to halfway to the center. It has white gills that become pale yellow and a yellow spore print, and it grows in broadleaf or mixed woods with oaks. The cap of *Russula ochroleucoides* (not illustrated) is as large and also a shade of yellow or orange-yellow, sometimes with a greenish tinge. The cuticle is not peelable, however, and the stalk is white. Fruitings are often gregarious near oaks and beeches from summer through early fall.

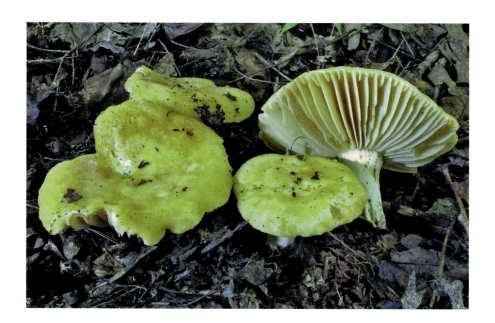

Russula grata Britzelm.

= *Russula laurocerasi* Melzer

COMMON NAME: Almond-scented Russula
MACROSCOPIC FEATURES: cap 4–11.5 cm wide, rounded, then convex, becoming broadly convex to nearly flat, often depressed at the center, sticky when moist, smooth, pale yellow to brownish yellow; margin tuberculate-striate at maturity; cuticle peels three-quarters of the way to the center. **gills** attached, close, whitish to creamy white, usually staining brown in age. **stalk** 2.5–10 cm long and 1–3 cm thick, equal or somewhat enlarged downward or in the middle, smooth or slightly wrinkled, white to pale yellow, usually bruising brown. **flesh** brittle, white to yellowish; odor like bitter almonds or marzipan, taste acrid or not distinctive.
MICROSCOPIC FEATURES: Spores 7–10.5 × 7–9 µm, subglobose, ornamented with warts and ridges that form a partial or complete reticulum, hyaline, amyloid.
SPORE PRINT: Creamy white to yellowish.
HABIT, HABITAT, AND SEASON: Scattered or in groups on the ground, mostly with broadleaf trees, sometimes in mixed woods; summer–fall.
EDIBILITY: Inedible.
COMMENTS: *Russula fragrantissima* (not illustrated) has a larger cap, 7–20 cm wide, a larger stalk, 8–15 cm long and 1.5–6 cm thick, and a fragrant, marzipan, then rancid odor. The spores are ornamented with warts and ridges that sometimes form a partial reticulum. *Russula mutabilis* (not illustrated) has a 3.5–8 cm wide, brownish orange to orange-brown cap with delicate yellow powder near the margin. The cap sometimes slowly bruises deep red when young. It has a yellow to orangish yellow stalk that is often whitish at the apex and soon stains scarlet to blackish red, especially at the base, when handled or bruised. The cuticle peels up to halfway to the center. The white flesh has a strong marzipan odor. The habitat is terrestrial, under oaks.

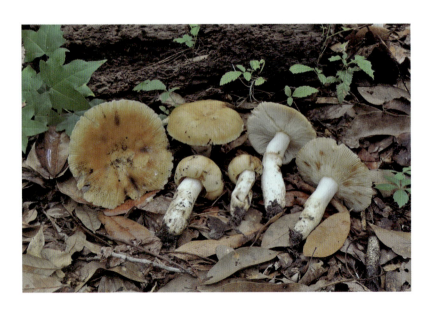

Russula hixsonii Murrill

MACROSCOPIC FEATURES: cap 6–20 cm wide, convex to depressed, dry, dull, smooth at first, becoming strongly pruinose-matted and woolly and finally cracking into quilt-like patterns at the center with age, white mottled with pinks and yellows when young, then turning an intense rose pink as it matures, with the center fading to whitish, mottled with brown; margin even or slightly comb-like; cuticle peels one-third to the center. **gills** attached to almost free, distant, many forked at the base, white to off-white, changing to grayish black in age or when handled. **stalk** 7–12 cm long and 2–3.5 cm wide, equal, solid, bald, white, and unchanging. **flesh** thick, brittle, white, strongly graying with age; odor not distinctive when fresh, very agreeable, like freshly baked cake when dried, taste not distinctive.

MICROSCOPIC FEATURES: Spores 9.2–10.9 × 7.6–9 μm, short-ellipsoid, ornamented with conical warts that sometimes form a partial reticulum, hyaline, amyloid.

SPORE PRINT: Golden yellow.

HABIT, HABITAT, AND SEASON: Scattered or in groups on the ground under oaks and pines; summer–fall.

EDIBILITY: Unknown.

COMMENTS: The epithet *hixsonii* honors former University of Florida entomology professor Homer R. Hixson (1926–1990), who first collected it. First described from Gainesville, Florida, in 1942, it was rediscovered by Arleen Bessette in southeastern Georgia in 2011. *Russula flavisiccans* (not illustrated) has a 2–11 cm broad, often areolate, pale pink to pale pinkish red cap with a cuticle that is not separable or just slightly so at the margin. The gills are white and become pale yellow on drying. The stalk is white, sometimes tinged pinkish, and the flesh has a bitter or disagreeable taste. Spores are yellow. This species grows in mixed pine and broadleaf forests during the summer.

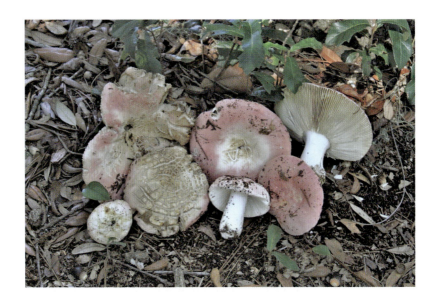

Russula mariae Peck

COMMON NAMES: Mary's Russula, Purple-bloom Russula

MACROSCOPIC FEATURES: cap 1.5–7(–10) cm wide, convex at first, soon depressed, color highly variable, wine red to purple or violet, sometimes with tints of yellow, olive, reddish or brown, and dusted with a whitish bloom when fresh; margin even, often radially striate when mature; cuticle peels two-thirds to the center. **gills** attached, close, often forked, white to yellowish buff, edges sometimes pink. **stalk** 2–6 cm long and 0.5–2 cm thick, white, often flushed pinkish purple. **flesh** white, not staining when exposed; odor not distinctive, taste slightly acrid or not distinctive.

MICROSCOPIC FEATURES: Spores 7.5–9.5 × 6.5–8 μm, globose to subglobose, ornamented with warts and ridges that form a partial or complete reticulum, hyaline, amyloid.

SPORE PRINT: White to creamy white.

HABIT, HABITAT, AND SEASON: Solitary or in groups on the ground in broadleaf or mixed woods, especially near oaks; summer–fall.

EDIBILITY: Edible.

COMMENTS: Because of the highly variable cap colors, several species and varieties were described for this mushroom. The application of KOH to the cap surface produces an orange reaction. The Crab Brittle Gill or American Shrimp Russula, *Russula xerampelina* (not illustrated), has a 3–25 cm wide cap. It is most likely a group of species with highly variable cap colors, purplish, reddish, brownish orange, yellow, or olive. The flesh is white, slowly stains yellowish brown when exposed, and has a distinctive odor that resembles shrimp or crab. The gills and stalk stain yellowish brown when handled or bruised, and the spore print is creamy white to yellow. Addition of $FeSO_4$ to the flesh or stalk surface produces a green reaction. It grows on the ground with conifers or broadleaf trees.

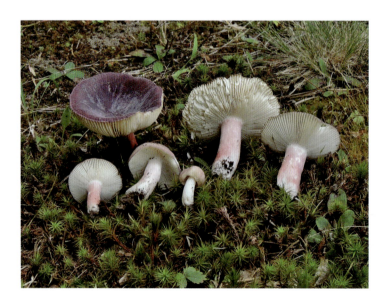

Russula parvovirescens Buyck, D. Mitch., & Parrent

MACROSCOPIC FEATURES: **cap** 4–8 cm wide, convex, becoming depressed, dry, felty to velvety, greenish brown to dark olive green or metallic bluish green, often darker over the disc in age; margin thin, even, weakly striate when mature; the cuticle is coarsely quilted, paler in the cracks, and peels one-third to halfway to the center. **gills** attached to nearly free, close, sometimes forked, white. **stalk** 3–6 cm long and 8–13 mm thick, nearly equal, solid, bald, white. **flesh** brittle, white; odor and taste not distinctive.

MICROSCOPIC FEATURES: Spores 6.7–9.1 × 5.7–7.2 μm, subglobose, ornamented with warts and ridges that sometimes form a reticulum, hyaline, amyloid.

SPORE PRINT: Pale cream.

HABIT, HABITAT, AND SEASON: Solitary, scattered, or in groups on the ground in mixed pine and broadleaf forests; summer–fall.

EDIBILITY: Unknown.

COMMENTS: Apart from *Russula parvovirescens*, which is fairly easy to recognize, quilted *Russula* species are harder to sort out than formerly thought. Classically, the Quilted Green Russula, *Russula virescens* (see Color Key), is dull green to yellowish green or grayish green over a white ground color and conspicuously cracked into small crusty patches that don't form a reticulate pattern. The cap cuticle peels halfway to the center. Spores are white or nearly so. The Brown Quilted Russula, *Russula crustosa* (see Color Key), is orange-yellow to brownish yellow, sometimes with greenish tints and a creamy rather than whitish spore print. Both species occur in broadleaf or mixed woods. However, Adamcik et al. (2018) suggest that this concept is a serious oversimplification involving several cryptic species. For now, it is probably better to refer to these quilted species as the *Russula crustosa-virescens* group.

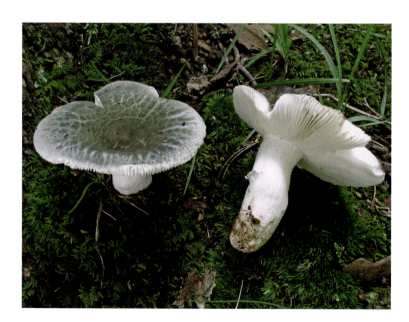

Russula perlactea Murrill

MACROSCOPIC FEATURES: cap 4–9 cm broad, convex to nearly flat or slightly depressed, bald, dry or somewhat sticky, white to creamy white; margin even, not striate; cuticle readily peels nearly to the center. **gills** attached, rather distant, rarely forked, white, and unchanging when bruised. **stalk** up to 7 cm long and 5–20 mm wide, enlarged downward or nearly equal, bald, solid, white, and not staining when bruised. **flesh** brittle, white, not staining when exposed; odor somewhat fruity or not distinctive, taste quickly acrid.

MICROSCOPIC FEATURES: Spores 9–11.5 × 8–10 µm, subglobose to broadly ellipsoid, ornamented with coarse warts and fine lines that sometimes form a partial reticulum, hyaline, amyloid.

SPORE PRINT: Chalk white.

HABIT, HABITAT, AND SEASON: Solitary or in groups on the ground with broadleaf trees or in mixed woods, especially with oaks; fall–winter.

EDIBILITY: Unknown.

COMMENTS: The epithet *perlactea* means "milk white throughout." The overall white color, very acrid taste, and late fruiting help to distinguish this species. *Russula albidula* (not illustrated) is macroscopically very similar, but the cuticle peels one-third to the center, it has close white gills that become yellowish as it ages, and the spore print is pale yellow. The spores are smaller, 7–9 × 5.5–7 µm, and don't form a reticulum. *Russula subalbidula* is generally larger, 5–15.5 cm wide, and the cap center is creamy yellow or brownish yellow. It has acrid-tasting flesh and smaller spores, 7–9 × 6–7.5 µm, that don't form a reticulum. Molecular analysis may eventually demonstrate that two or more of these species are identical.

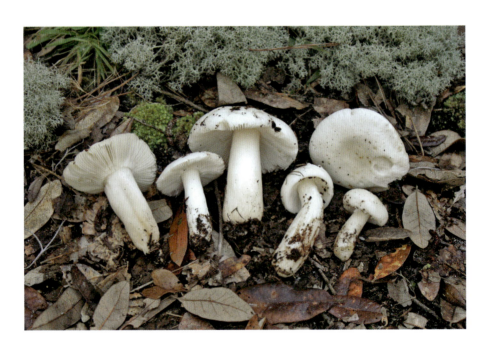

Russula redolens Burlingham

COMMON NAME: Parsley-scented Russula
MACROSCOPIC FEATURES: cap 4–8 cm wide, broadly convex to nearly flat, centrally depressed, smooth to slightly wrinkled, sticky when moist; margin radially lined, grayish blue-green to grayish green, sometimes with purplish tints, cuticle peeling two-thirds of the way to the center. **gills** attached, crowded, forked near the stalk, white. **stalk** 4–7 cm wide, 6–25 mm wide, equal or tapered downward, dry, smooth or slightly wrinkled, white to grayish. **flesh** brittle, whitish; odor unpleasant, fishy or resembling parsley when mature, taste disagreeable with an aftertaste of parsley or not distinctive.
MICROSCOPIC FEATURES: Spores 6–8 × 4.5–6 µm, elliptic, ornamented with warts and ridges. Hyaline, amyloid.
SPORE PRINT: White to cream.
HABIT, HABITAT, AND SEASON: Solitary, scattered, or in groups on the ground in broadleaf or mixed woods; summer–fall.
EDIBILITY: Unknown.
COMMENTS: The epithet *redolens* means "emitting a scent." Greenish look-alikes such as *Russula aeruginea* lack an odor. *Russula variata* (see Color Key and Comments under *Russula aeruginea*) also differs by having repeatedly forking gills. *Clitocybe odora* (see Color Key and Comments under *Clitopilus prunulus*) usually has a greenish cap and white gills but is not crumbly and smells at least faintly of anise.

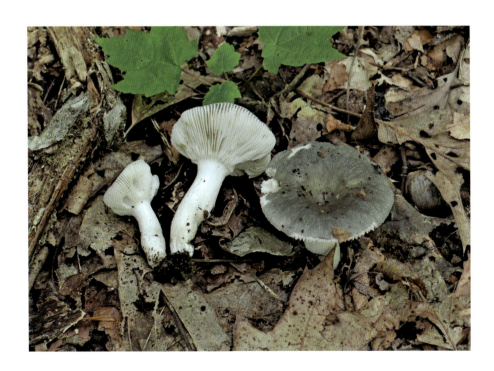

Russula sericeonitens Kauffman

COMMON NAME: Silky-shining Russula
MACROSCOPIC FEATURES: cap 4–9 cm wide, convex at first, becoming more or less flat or depressed at the center, smooth, bald, with a silky sheen when fresh, lilac purple or paler, with a darker purple to nearly blackish center, sometimes with brownish or yellowish tints; margin even, becoming tuberculate-striate in age; cuticle peels three-quarters or more to the center. **gills** attached, close to crowded, with some forking near the stalk, sometimes with crossveins, white to slightly grayish. **stalk** 3–7 cm long and up to 1.5 cm thick, nearly equal or slightly enlarged downward, smooth or slightly wrinkled, solid, white, grayish in age. **flesh** brittle, white to grayish, not staining when exposed; odor and taste not distinctive.
MICROSCOPIC FEATURES: Spores 7–8.5 × 5.5–7 μm, globose, ornamented with warts and ridges that don't form a reticulum, hyaline, amyloid.
SPORE PRINT: White.
HABIT, HABITAT, AND SEASON: Scattered or in small groups on the ground in broadleaf or mixed woods, often with oaks; summer–fall.
EDIBILITY: Unknown.
COMMENTS: *Russula subsericeonitens* (not illustrated) is very similar macroscopically and microscopically, but the cuticle does not easily peel. The gills are subdistant and not forking. The white flesh is mild-tasting at first but slowly becomes slightly acrid. It grows on the ground in mixed pine and broadleaf woods.

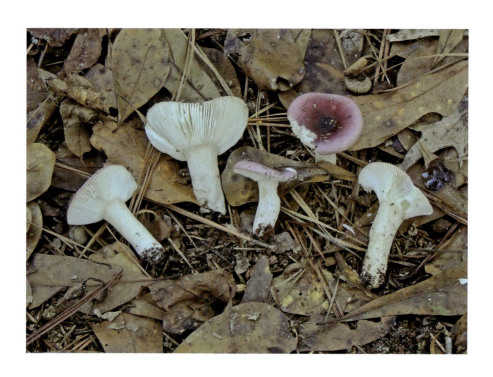

Russula subalbidula Murrill

MACROSCOPIC FEATURES: **cap** 5–15.5 cm wide, shallowly convex, often depressed in the center, dry, smooth, bald, white with yellow tints, especially when young; margin even, not striate; cuticle peels up to halfway to the center. **gills** attached, close to subdistant, pale cream. **stalk** 3–6.5 cm long and 1–4 cm thick, nearly equal or slightly enlarged downward, smooth, hollow when mature, white. **flesh** brittle, white, not staining when exposed; odor not distinctive, taste acrid.

MICROSCOPIC FEATURES: Spores 7–9 × 6–7.5 μm, broadly elliptic to subglobose, ornamented with warts and ridges that don't form a reticulum, hyaline, amyloid.

SPORE PRINT: Creamy white.

HABIT, HABITAT, AND SEASON: Solitary or in groups on the ground with oaks; summer–early winter.

EDIBILITY: Unknown.

COMMENTS: The epithet *subalbidula* means "almost or nearly white." *Russula perlactea* is generally smaller and white overall and has larger spores. *Russula albidula* (not illustrated) is macroscopically very similar, but the cuticle peels one-third to the center, and it has close white gills that become yellowish, a pale yellow spore print, and smaller spores, 7–9 × 5.5–7 μm, that don't form a reticulum. The Short-stemmed Russula, *Russula brevipes* (see Color Key), edible, has a 9–20 cm wide, dry, white to ocher-yellow cap that is depressed or funnel-shaped and covered by fine appressed fibrils. The cap cuticle stains yellowish to reddish brown and peels up to one-third to the center. The gills are attached, close, and white to cream, and they stain reddish brown to brown. The stalk is typically short and thick but occasionally up to 9 cm long and white, and it stains brown. The white flesh has an odor and taste that are either not distinctive or mildly like chlorine and becomes edible when lobsterized by *Hypomyces lactifluorum*. It grows with conifers or in mixed woods. Spores measure 8–11 × 6–8 μm.

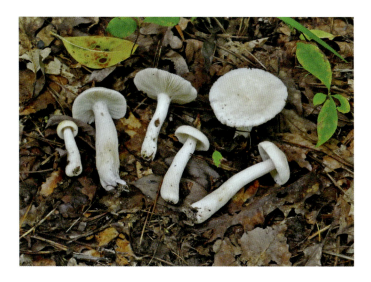

Russula subfragiliformis Murrill

MACROSCOPIC FEATURES: cap 4–9 cm wide, convex, becoming depressed at maturity, dry or slightly sticky, smooth, bald, red to pinkish red, darker over the center in age; margin even, entire, typically not striate, cuticle peels almost completely to the center. **gills** attached, close to subdistant, entire, whitish when young, becoming ochraceous as they age, not staining when bruised. **stalk** 2–5 cm long and 1–1.5 cm thick, nearly equal, smooth, bald, white overall or flushed with pink, especially toward the base. **flesh** white, unchanging on exposure; odor and taste not distinctive.
MICROSCOPIC FEATURES: Spores 6–8 × 5–7.5 μm, globose to subglobose; surface ornamented with warts and ridges not forming a reticulum, hyaline, amyloid.
SPORE PRINT: Cream to pale yellow.
HABIT, HABITAT, AND SEASON: Scattered or in groups in broadleaf or mixed woods, especially with oaks; summer–fall.
EDIBILITY: Edible.
COMMENTS: The epithet *subfragiliformis* means "having a somewhat fragile fruit body." Several other species differ by one or more macroscopic or microscopic features. The conifer-associated *Russula peckii* (not illustrated) has a blood red to ruby red cap and a white stalk flushed with pink. Its gills are serrated, and the cap cuticle peels about halfway to the center. *Russula pulchra* (not illustrated) favors oaks. It has a scarlet to pinkish red cap fading to orange-red or peach, often cracking at maturity. The cap margin is typically striate at maturity, and the cuticle usually peels only near the margin. It has a white stalk flushed with pink. *Russula tenuiceps* (not illustrated), which favors mixed woods or hemlocks, has a bright red cap and a white stalk flushed with pink. The cap margin is striate at maturity, and the cuticle peels about halfway to the center. The flesh tastes strongly acrid. *Russula sericeonitens* and *Russula mariae* are also similar but have darker purple caps.

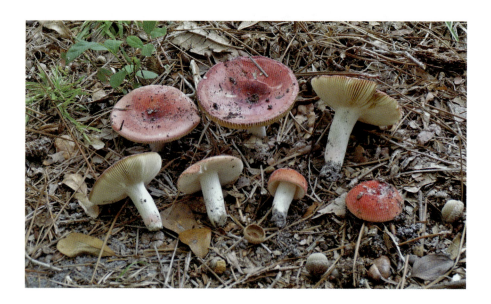

Simocybe centunculus (Fr.) P. Karst.

COMMON NAME: American Simocybe
MACROSCOPIC FEATURES: cap 1–3 cm wide, convex at first, becoming flat, dry, initially velvety or silky, becoming smooth in age, olive brown to olive, soon fading, the center remaining darkest; margin translucent-striate. **gills** attached, close, pale at first, darkening to a yellowish brown or grayish brown in age; gill edges white and appearing fringed or frayed (use a hand lens). **stalk** 1–4 cm long and 2–4 mm thick, equal, hollow, initially whitish, then becoming brown, faintly powdery or scurfy at the apex when young, with white basal mycelium. **flesh** thin, brown; odor and taste not distinctive.
MICROSCOPIC FEATURES: Spores 6–7.5 × 4–5 μm, elliptic or phaseoliform, smooth, pale brown.
SPORE PRINT: Brown.
HABIT, HABITAT, AND SEASON: Scattered on decaying broadleaf logs and stumps; spring–fall.
EDIBILITY: Unknown.
COMMENTS: The frayed/fringed gill edges are a distinctive feature of this otherwise easily overlooked little brown mushroom. The cap surface stains red with the application of KOH. Compare this with *Xeromphalina tenuipes* (see Color Key and Comments under *Xeromphalina campanella*), which also has a brown cap that stains red with KOH. It is generally more lightly built and has smooth gill edges and white spores. Various species of *Mycena*, such as *Mycena inclinata*, are similar as well but have white spores and even gill edges. The gills are typically white or at least paler than the other species discussed here.

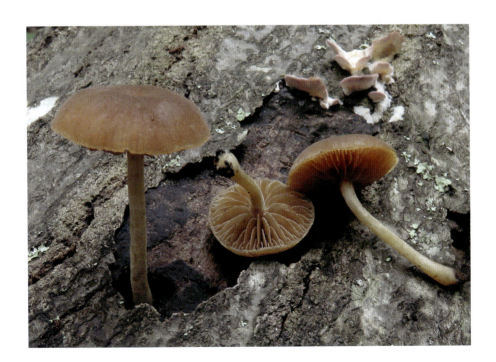

Strobilurus conigenoides (Ellis) Singer

COMMON NAME: Magnolia-cone Mushroom
MACROSCOPIC FEATURES: cap 5–20 mm wide, convex at first, then becoming flat, dry, white, covered with a dense layer of minute hairs; margin initially incurved, expanding upward as it matures. **gills** attached, close to nearly crowded, white. **stalk** 2.5–5 cm long and 0.75–2 mm thick, equal, hollow, whitish to pinkish brown, finely hairy, with coarse basal hairs that attach it to a magnolia cone. **flesh** thin, whitish; odor and taste not distinctive.
MICROSCOPIC FEATURES: Spores 6–7 × 3–3.5 µm, elliptic, smooth, hyaline, inamyloid.
SPORE PRINT: White.
HABIT, HABITAT, AND SEASON: In groups on magnolia cones or sweetgum balls; summer–winter.
EDIBILITY: Unknown.
COMMENTS: The Conifer-cone Cap, *Baeospora myosura* (see Color Key), is similar, but it has a larger cap, 5–20 mm wide, and amyloid spores, and it grows on conifer cones.

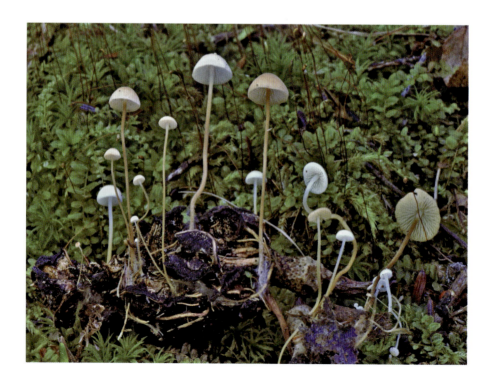

Stropharia hardii G. F. Atk.

COMMON NAME: Hard's Stropharia
MACROSCOPIC FEATURES: cap 2.5–10 cm wide, convex at first, becoming nearly flat in age, somewhat sticky or dry, nearly smooth when young, coated in age with tiny matted fibrils and scales, especially near the margin, ocher to brownish ocher, fading to ocher-yellow; margin hung with thin white pieces of veil fragments. **gills** attached, close, whitish when very young, soon becoming grayish brown, then purplish brown at maturity. **stalk** 4–12 cm long and 6–20 mm thick, nearly equal, sticky when young and fresh, becoming dry, slightly scaly to nearly smooth, white to pale ocher-yellow; base often slightly bulbous with white rhizomorphs; partial veil membranous, leaving a persistent ring on the upper portion of the stalk. **flesh** white; odor slightly farinaceous or not distinctive, taste not distinctive.
MICROSCOPIC FEATURES: Spores 6–9 × 3–5 μm, elliptic with an apical pore, smooth, pale purplish brown.
SPORE PRINT: Purplish brown.
HABIT, HABITAT, AND SEASON: Solitary, scattered, or in groups on the ground with woody debris in broadleaf or mixed woodlands, also on landscaping wood chip beds; summer–fall.
EDIBILITY: Unknown.
COMMENTS: Compare with *Stropharia rugosoannulata*, which has a larger, reddish brown to wine red cap and a partial veil that leaves a thick white ring with a grooved upper surface and cogwheeling splits underneath. Some species of *Agrocybe* fruit in wood chips and resemble Hard's Stropharia, but gills and spores are brown, never developing purplish tints.

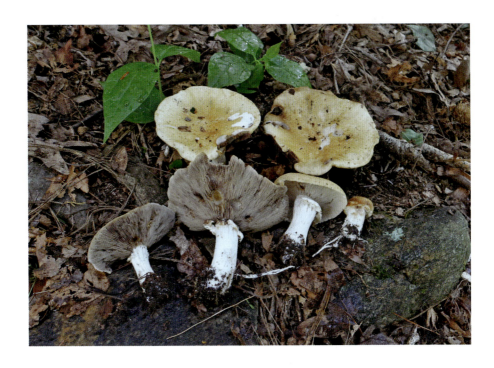

Stropharia rugosoannulata Farl. ex Murrill

COMMON NAMES: King Stropharia, Wine Cap
MACROSCOPIC FEATURES: cap 4–15 cm wide, hemispheric, then broadly convex with a small umbo, sticky initially, later dry, smooth, reddish brown or wine red, fading markedly in age; margin often hung with veil fragments. **gills** attached, crowded, white, becoming purplish black. **stalk** 7–20 cm long and up to 3 cm thick, equal or with a small bulb, solid, smooth or finely hairy, white, with white mycelium and rhizomorphs at the base. The partial veil leaves a thick white ring with a grooved upper surface and cogwheeling splits underneath. **flesh** white; odor and taste not distinctive.
MICROSCOPIC FEATURES: Spores 10–14 × 7–9 µm, elliptic, smooth, pale purplish brown.
SPORE PRINT: Purplish brown to black.
HABIT, HABITAT, AND SEASON: Scattered, in groups or clusters on wood chips, mulch, or straw, in gardens or on lawns; summer–fall.
EDIBILITY: Edible and choice, especially when young.
COMMENTS: The epithet *rugosoannulata* means "having a wrinkled ring." When this mushroom is old and faded, it can be confused with species of *Agaricus*, including the poisonous *Agaricus xanthodermus*. Gill color in *Agaricus* matures to chocolate brown without purple tones. Partial veils are flimsier. *Agaricus* mushrooms tend to have distinctive odors and may have yellow-staining flesh in the base as well.

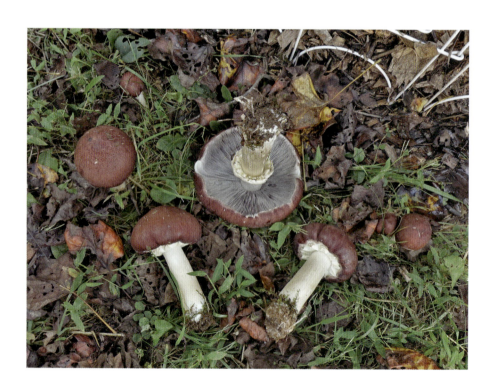

Tapinella atrotomentosa (Batsch)
Šutara

= *Paxillus atrotomentosus* (Batsch) Fr.

COMMON NAME: Velvet-footed Pax

MACROSCOPIC FEATURES: cap 4–15 cm wide, convex with an inrolled margin at first, becoming flat or centrally depressed, dry, finely hairy, yellowish brown to reddish brown, darkening with age. **gills** decurrent, close or crowded, forking or crossveined near the stalk, whitish to pale tan, separable as a layer. **stalk** 2–12 cm long and up to 3 cm thick, equal, eccentric to lateral, pale and smooth at the apex, with dark brown velvety or matted hairs below, lacking a partial veil. **flesh** whitish or pale yellow, tough, not staining; odor and taste not distinctive.

MICROSCOPIC FEATURES: Spores 5–7 × 3–4 μm, elliptic, smooth, hyaline or pale brown, dextrinoid.

SPORE PRINT: Pale yellow to yellowish brown.

HABIT, HABITAT, AND SEASON: Solitary or in clusters on conifer stumps or logs; summer–early winter.

EDIBILITY: Unknown.

COMMENTS: The Stalkless Paxillus, *Tapinella panuoides* (see Color Key), also grows on conifer wood. Caps are stalkless and shell-like, 3–11 cm wide, dry, fairly smooth, and dull yellowish to yellow-orange. The gills are typically crinkled near the point of attachment and can be peeled from the cap flesh as a layer. Gills of the similar *Pseudomerulius curtisii* are not peelable as a layer and tend to be brighter orange. It also has a sickly sweet odor evident to most people.

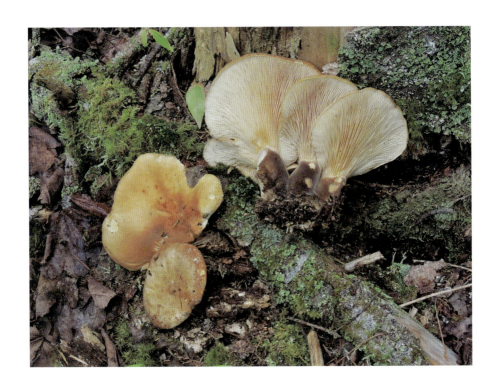

Tetrapyrgos nigripes (Fr.) E. Horak

= *Marasmiellus nigripes* (Fr.) Singer

COMMON NAME: Black-footed Marasmius
MACROSCOPIC FEATURES: cap 1–2 cm wide, convex at first, becoming flat, white with a grayish or brownish disc, finely dusted with white powder or bald, becoming grayish nearly overall and often wrinkling in age. **gills** attached or slightly decurrent, subdistant, crossveined and occasionally forked, white, sometimes with reddish stains. **stalk** 2–5 cm long and 1–1.5 mm thick, equal or tapering downward, white at first, blackened in age, tough, dry, coated with minute white hairs. **flesh** thin, rubbery, white; odor and taste not distinctive.
MICROSCOPIC FEATURES: Spores 8–9 × 8–9 μm, triangular to star-like and multipointed, smooth, hyaline.
SPORE PRINT: White.
HABIT, HABITAT, AND SEASON: Solitary or in groups on leaves, twigs, hickory nuts, and other woodland debris; summer–fall.
EDIBILITY: Unknown.
COMMENTS: The epithet *nigripes* means "having a black foot," a reference to the stalk, which blackens as this mushroom matures. *Marasmiellus candidus* (not illustrated) is very similar and also grows on broadleaf wood. It has a conspicuously pleated, shiny white cap, distant white to pinkish gills with crossveins, and a short stalk, 1–2 cm long. The stalk is bald and white and darkens to blackish from the base upward in age. *Marasmius capillaris* (not illustrated) also has a white cap and black stalk, but it grows on oak leaves rather than on woody debris. Its cap is pleated and has a depressed center.

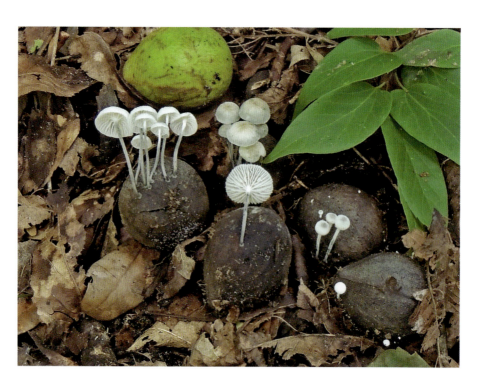

Tricholoma aurantium (Schaeffer) Ricken

= *Tricholoma aurantium* var. *olivascens* Mitchel & A. H. Sm.

COMMON NAME: Orange-sheathed Trich

MACROSCOPIC FEATURES: cap 4–8 cm wide, convex, becoming broadly convex to nearly flat in age, sticky to slimy when fresh, shiny when dry, covered with tiny flattened scales or fibrils, brownish gold to orange-brown or tawny ocher, often darker over the center; margin incurved when young. **gills** notched and narrowly attached, close, narrow, white, staining brownish red to brownish orange. **stalk** 4–8 cm long and 1–2 cm thick, nearly equal, solid, dry, smooth, and white at the apex, sheathed from the base up to an obscure ring zone with tiny bright orange-brown to reddish orange flattened scales; cortina thin and evanescent. **flesh** white; odor and taste strongly farinaceous or unpleasant.

MICROSCOPIC FEATURES: Spores 4–6 × 3–4 μm, elliptic, smooth, hyaline, inamyloid.

SPORE PRINT: White.

HABIT, HABITAT, AND SEASON: Solitary, scattered, or in groups under conifers and in mixed woodlands; summer–early winter.

EDIBILITY: Inedible because of the unpleasant taste.

COMMENTS: The epithet *aurantium* means "orange." *Tricholoma subluteum* (see Color Key) has a dull orange to golden yellow cap with long, radiating, yellowish fibrils on the margin. The gills are attached to nearly free, close and white. The stalk is yellow on the upper portion, white below, and not sheathed. It has white flesh with a farinaceous odor and taste and grows on the ground with conifers or in mixed woods. *Cortinarius armillatus* and a few others in that genus share the same basic colors, a scaly or banded stalk, and a cortina. However, the gills become rust-colored and produce orange-brown spores. Also compare with *Tricholoma caligatum*.

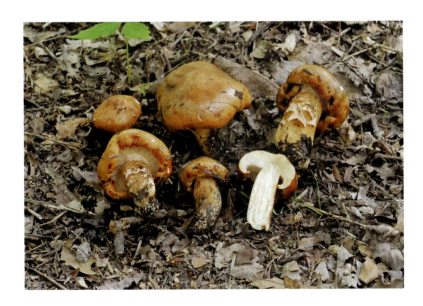

Tricholoma caligatum (Viv.) Ricken

COMMON NAME: Brown Matsutake
MACROSCOPIC FEATURES: cap 6–12 cm wide, broadly convex, dry, with flattened, coarse, pinkish brown to grayish brown scales over a paler ground color; margin inrolled and cottony when young, fringed with white remnants of partial veil. **gills** attached to nearly free, close, white, usually developing brownish stains. **stalk** 4–10 cm long and 1.5–3 cm thick, equal, dry, solid, covered with a membranous sheath that first leaves a white, flaring, cottony ring resembling a partial veil on the upper portion and finally breaks into patches; stalk white above the ring, colored like the cap below. **flesh** white to cream; odor farinaceous, unpleasant, or not distinctive, taste bitter or not distinctive.
MICROSCOPIC FEATURES: Spores 6–8 × 4.5–5.5 μm, elliptic, smooth, hyaline, inamyloid.
SPORE PRINT: White.
HABIT, HABITAT, AND SEASON: Scattered or in groups on the ground with conifers or broadleaf trees; fall–winter.
EDIBILITY: Edible if not too bitter.
COMMENTS: The epithet *caligatum* means "heavily shod," as in wearing a boot, referring to the prominent sheath on the stalk. This feature is lacking on the species mentioned below. The cap of the Soap-scented Trich, *Tricholoma saponaceum* (see Color Key), ranges from dingy greenish yellow to gray-green, blue-gray, or grayish brown. Flesh in the cap is white to pale green but typically pink to orange in the stalk base. The odor is soap-like or farinaceous, rarely not distinctive. It grows on the ground with conifers or sometimes broadleaf trees. *Tricholoma subresplendens* (not illustrated) has a white to creamy white cap that develops yellowish to tan or pale pinkish cinnamon tints or spots, especially over the center, and sometimes discolors blue-green. The white flesh has a farinaceous odor and taste. It grows on the ground with broadleaf trees or in mixed woods.

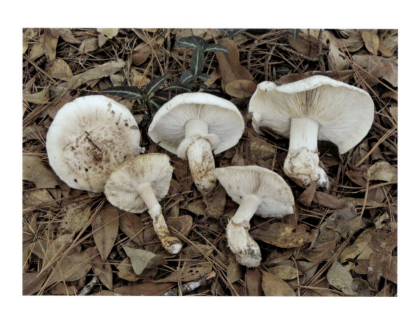

Tricholoma equestre (L.) P. Kumm.

= *Tricholoma flavovirens* (Pers.) S. Lundell

COMMON NAME: Canary Trich

MACROSCOPIC FEATURES: cap 5–10 cm wide, convex to broadly convex, sticky and smooth when fresh, becoming dry, usually developing small central scales, pale to sulfur yellow, often golden brown over the center. **gills** nearly free, close, pale to bright sulfur yellow. **stalk** 3–15 cm long and 1–3 cm thick, equal or enlarged downward, solid, dry, whitish, pale yellow, or sulfur yellow; partial veil absent. **flesh** white; odor farinaceous, taste farinaceous or not distinctive.

MICROSCOPIC FEATURES: Spores 6–7 × 4–5 µm, elliptic, smooth, hyaline, inamyloid.

SPORE PRINT: White.

HABIT, HABITAT, AND SEASON: Scattered or in groups with conifers or in mixed woods; fall–winter.

EDIBILITY: Although this mushroom is listed as edible in many field guides, we cannot recommend it, because varieties of this species have caused fatal poisonings in Europe.

COMMENTS: The cap of the edible *Tricholoma intermedium* (not illustrated) has tiny yellowish brown or reddish brown flat scales and short fibrils over a yellow ground color. The gills are attached, close, white to whitish, with several tiers of short gills; the edges usually erode in age. It has white flesh with a farinaceous odor and taste and grows on the ground with conifers. *Tricholoma subluteum* (see Color Key) has a dull orange to golden yellow cap with long, radiating, yellowish fibrils on the margin. The gills are attached to nearly free, close, and white. It has white flesh with a farinaceous odor and taste and grows on the ground with conifers or in mixed woods. *Tricholoma subsejunctum* (see Color Key) has a yellow or yellowish green cap with dark gray or black fibrils over the center and dark radial streaks toward the margin. Gills and stalk are white or tinged yellow, and the white flesh has a farinaceous odor and taste.

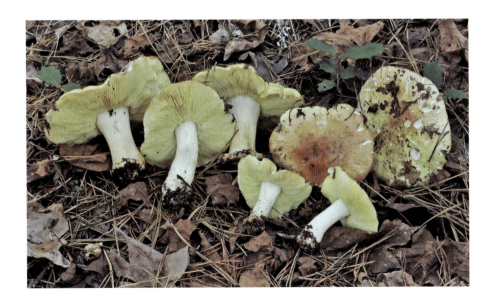

Tricholoma odorum group Peck

MACROSCOPIC FEATURES: cap 2–9 cm wide, convex, often with a broad umbo, becoming flat or shallowly depressed, dry, shiny or dull, smooth, whitish to yellowish buff or pale greenish yellow, sometimes brownish over the center; margin incurved, expanding upward in age. **gills** notched or attached, close, whitish to yellowish buff, developing pinkish tinges. **stalk** 4–12 cm long and 6–12 mm thick, nearly equal or enlarged toward the base, occasionally bulbous, solid, dry, smooth, sometimes longitudinally twisted, whitish to yellowish buff or pale greenish yellow; partial veil absent. **flesh** moderately thick, whitish; odor farinaceous or like coal tar or burnt rubber, taste farinaceous or unpleasant.
MICROSCOPIC FEATURES: Spores 7–11 × 5–7 μm, elliptic, spindle- or almond-shaped, smooth, hyaline, inamyloid.
SPORE PRINT: White.
HABIT, HABITAT, AND SEASON: Solitary, in groups or clusters with broadleaf trees or in mixed woods; fall–winter.
EDIBILITY: Inedible.
COMMENTS: The epithet *odorum* means "scented." The Sulfur Trich, *Tricholoma sulphureum* (not illustrated), also has a coal tar odor. The cap and stalk are pale to dark sulfur yellow sometimes streaked or spotted with reddish brown. Gills are subdistant. Another stinker, *Tricholoma sulphurescens* (not illustrated), has a white to creamy white cap that quickly stains yellow to brown when handled; the flesh is white. The edible Sticky Gray Trich, *Tricholoma portentosum* (see Color Key), has a sticky to slimy, gray, olive brown to gray-brown, or blackish cap, sometimes with faint yellow or purple tones, often streaked with radial, dark gray fibrils. The edible earth-colored Trich or Gray Trich, *Tricholoma terreum* (not illustrated), has a dry, matted and woolly, gray to gray-brown cap, a nearly equal white to grayish white stalk, and subdistant white gills with several tiers of short gills. It has thin, whitish flesh with an odor that is weakly farinaceous or not distinctive and occurs with conifers.

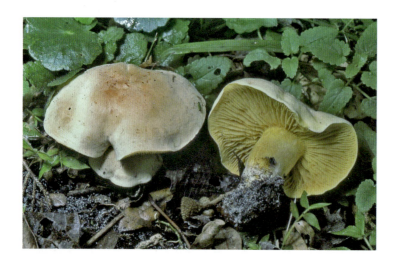

Tricholomopsis aurea (Beeli) Desjardin & B. A. Perry

= *Collybia aurea* (Beeli) Pegler
= *Marasmius aureus* Beeli

MACROSCOPIC FEATURES: cap 7–33 mm wide, convex to broadly convex, shallowly depressed or somewhat funnel-shaped in age, moist, bald, golden yellow to orangish yellow, hygrophanous and fading to yellow or light yellow; margin decurved, even, not striate, sometimes splitting. **gills** attached, sometimes with a short-decurrent tooth, crowded, narrow, yellow to orangish yellow, with 3–5 tiers of short gills. **stalk** 1–5 cm long and 2–5 mm thick, central to slightly eccentric, nearly equal, rounded or longitudinally compressed, hollow, dry, bald or nearly so, orangish yellow, sometimes white, matted and woolly at the base. **flesh** up to 1 mm thick, soft, yellow; odor not distinctive, taste not distinctive or faintly like bleach.

MICROSCOPIC FEATURES: Spores 5–6.5 × 4.5–5.2 μm, subglobose to ovoid or broadly ellipsoid, smooth, hyaline, inamyloid, thin-walled.

SPORE PRINT: White.
HABIT, HABITAT, AND SEASON: Scattered to gregarious on decaying wood in mixed broadleaf and conifer woods; summer–fall.
EDIBILITY: Unknown.
COMMENTS: The epithet *aurea* means "golden yellow." It is a pantropical species reported from Africa and the Caribbean and was originally described from the Belgian Congo in 1928. This is an uncommonly collected species known from Florida and southeastern Georgia. The reportedly poisonous Decorated Mop, *Tricholomopsis decora* (see Color Key), has a yellowish to greenish yellow cap with blackish fibers and scales. The gills are attached, crowded, and yellow. It has yellowish flesh without a distinctive odor or taste and grows on decaying conifer wood. Similarly colored species of *Tricholoma* grow on the ground, not on wood. *Pluteus chrysophlebius* (see Color Key) has a smooth, yellow to greenish yellow cap and stalk. The initially white gills pinken and produce pink spores, 5–7 × 4.5–6 μm.

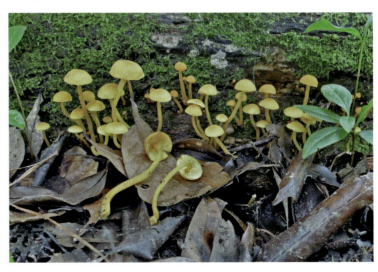

Tricholomopsis formosa (Murrill) Singer

= *Tricholoma formosa* (Murrill) Murrill

MACROSCOPIC FEATURES: cap 3–10 cm wide, convex to broadly convex, dry, covered with rusty brown to tawny fibers and scales over a cinnamon buff to dull yellow ground color; margin incurved and sometimes wavy. **gills** attached, close or crowded, whitish to pinkish cream. **stalk** 4–8 cm long and 5–10 mm thick, equal or tapered downward, dry, covered with tiny fibers and scales, colored like the cap; partial veil absent. **flesh** whitish; odor and taste disagreeable or not distinctive.

MICROSCOPIC FEATURES: Spores 5–7 × 5–6 μm, ovoid, smooth, hyaline, inamyloid.

SPORE PRINT: White.

HABIT, HABITAT, AND SEASON: Solitary, scattered, or in groups on decaying conifer wood; summer–early winter.

EDIBILITY: Unknown.

COMMENTS: The epithet *formosa* means "beautiful or lovely." The cap and stalk of the edible Plums and Custard, *Tricholomopsis rutilans* (see Color Key), have red to purplish red fibers and tiny scales over a yellowish ground color. The gills are yellow, attached, close, with several tiers of short gills. It has pale yellow flesh with an odor that is fragrant or not distinctive, sometimes with a radish-like taste. It grows on conifer wood, wood chips, sawdust, or the ground. The reportedly poisonous Decorated Mop, *Tricholomopsis decora* (see Color Key), has a yellowish to greenish yellow cap with blackish fibers and scales. The gills are attached, crowded, and yellow. It has yellowish flesh without a distinctive odor or taste and grows on decaying conifer wood.

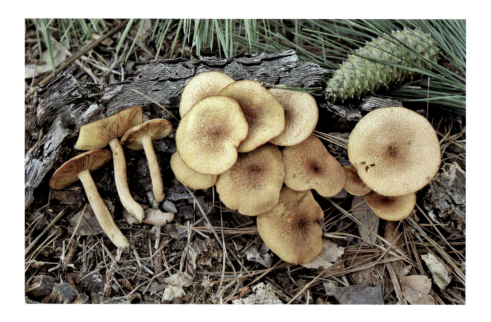

Volvariella bombycina (Schaeff.) Singer

COMMON NAME: Silky Rosegill
MACROSCOPIC FEATURES: cap 5–20 cm wide, oval at first, then expanding and becoming almost flat, dry, silky with fine hairs, white when young, becoming yellowish white, then brownish in age. **gills** free, crowded, initially white, then turning pink. **stalk** 6–20 cm long and 1–2 cm thick, enlarged downward, white, smooth, arising from a sturdy sac-like volva that is white to brown; partial veil absent. **flesh** white; odor and taste not distinctive.
MICROSCOPIC FEATURES: Spores 6.5–10.5 × 4.5–6.5 μm, elliptic, smooth, hyaline.
SPORE PRINT: Dull pink.
HABIT, HABITAT, AND SEASON: On hardwood trees, stumps, and logs; summer–fall.
EDIBILITY: Edible.
COMMENTS: The epithet *bombycina* means "silky," referring to the surface of the cap. It is crucial to remember that this edible species grows exclusively on wood. Several species of *Amanita*, including the deadly Destroying Angel, *Amanita bisporigera*, are also whitish and rise out of volval sacs, but they grow on soil.

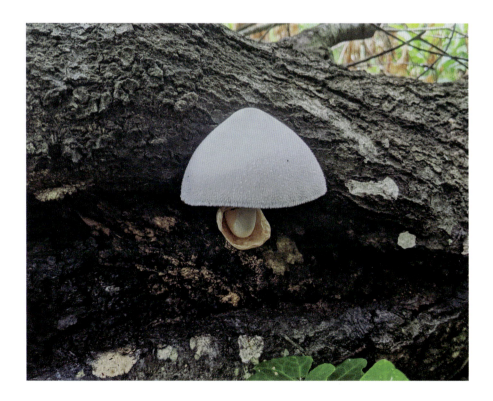

Xeromphalina campanella (Batsch) Kühner & Maire

COMMON NAMES: Fuzzy Foot, Golden Trumpets
MACROSCOPIC FEATURES: cap 3–25 mm wide, convex to broadly convex with a depressed or dimpled center, smooth, moist, yellowish orange to orange-brown; margin striate. **gills** decurrent, subdistant to distant, pale yellow to pale orange. **stalk** 1–5 cm long and 0.5–3 mm thick, dry, often strongly curved, yellow at the apex and shading downward to a dark reddish brown, with a dense tuft of long orangish hairs at the base; partial veil absent. **flesh** thin, yellowish to brownish yellow; odor and taste not distinctive.
MICROSCOPIC FEATURES: Spores 5–7 × 3–4 μm, elliptic to cylindric, smooth, hyaline, amyloid.
SPORE PRINT: Pale buff.
HABIT, HABITAT, AND SEASON: In dense clusters on well-decayed conifer wood; spring–fall.
EDIBILITY: Unknown.
COMMENTS: The epithet *campanella* means "little bells," referring to the shape of the caps and overall appearance of this little mushroom. *Xeromphalina kauffmanii* (not illustrated) is almost identical but grows on decaying broadleaf wood. *Xeromphalina tenuipes* (see Color Key) has a 2.5–7 cm wide cap, usually with a low, broad umbo. The cap is finely wrinkled, orange-brown at the center and brownish orange toward the striate margin. The stalk is velvety to hairy, tough, hollow, and colored like the cap. It has allantoid spores, 7–9 × 3.5–5 μm, and grows in much smaller groups on decaying broadleaf wood or surrounding litter.

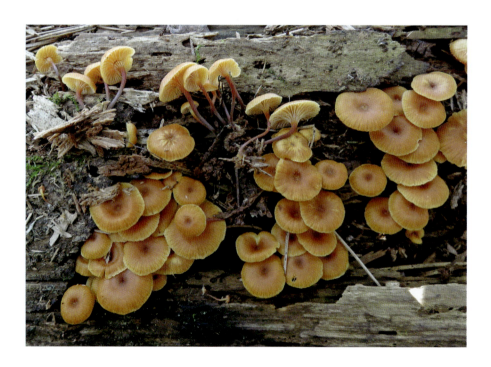

Xeromphalina cauticinalis ssp. *pubescentipes* (Peck) Redhead

= *Omphalina pubescentipes* Peck

MACROSCOPIC FEATURES: cap 8–25 mm wide, convex at first, becoming broadly convex, occasionally with a slightly depressed center, moist or dry, smooth, bald, slightly hygrophanous, honey yellow, typically with a darker brown center; margin weakly striate, often scalloped or uneven. **gills** slightly to distinctly decurrent, close to subdistant, pale yellow, sometimes with a greenish cast, with several rows of short gills. **stalk** 3–8 cm long and 1.5–5 mm thick, equal, straight, tough, finely velvety, whitish to yellowish near the apex, darkening downward and blackish toward the base, with a thick pad of yellowish brown basal mycelium; partial veil absent. **flesh** thin, pliant, whitish, staining red in KOH; odor slightly alkaline, taste bitter.

MICROSCOPIC FEATURES: Spores 4–7 × 2.5–3.5 μm, elliptic, smooth, hyaline, amyloid.
SPORE PRINT: White.
HABIT, HABITAT, AND SEASON: Solitary, scattered, or in groups on fallen seeds, needles, cones, and other woody debris in conifer or mixed woodlands; summer–early winter.
EDIBILITY: Unknown.
COMMENTS: *Xeromphalina cauticinalis* ssp. *cauticinalis* (not illustrated) is similar but occurs in western North America. The cap of *Xeromphalina campanella* has a depressed or dimpled center. It grows in dense clusters with shorter, recurved stalks and orange basal hairs on decaying conifer logs and stumps. *Xeromphalina kauffmanii* (not illustrated) is almost identical to *Xeromphalina campanella* but grows on decaying broadleaf wood.

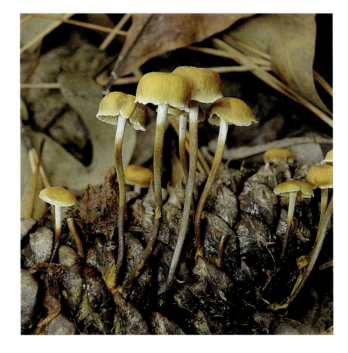

Zhuliangomyces illinitus (Fr.) Redhead

= *Limacella illinita* (Fr.) Maire
= *Agaricus illinitus* Fr.

COMMON NAME: Overflowing Slimy Stem
MACROSCOPIC FEATURES: cap 2–7 cm wide, convex before expanding to nearly flat, coated in clear slime when fresh, the underlying surface whitish with a pale yellowish or brownish center. The margin is incurved for a long time. **gills** free or nearly so, close, white. **stalk** 5–10 cm long and 3–10 mm thick, equal or expanding slightly downward, slimy, whitish, may bruise brown and/or show tinges of orange near the base, solid. A faint, fibrillose ring zone may persist on the stalk. **flesh** white; odor and taste not distinctive.
MICROSCOPIC FEATURES: Spores 4–6.5 μm, globose to broadly elliptic, smooth, hyaline, inamyloid.
SPORE PRINT: White.
HABIT, HABITAT, AND SEASON: Scattered or gregarious in woods, grassy areas near woods, or sand dunes; summer–early winter.
EDIBILITY: Unknown.
COMMENTS: This recently renamed but still gooey mushroom could more succinctly be termed the White Slimacella to separate it from the Coppery Slimacella, *Limacella glischra* (not illustrated). That species is coated with coppery slime. Its yellow-brown or red-brown cap runs a bit smaller, 2–4 cm. The stalk is whitish to pale brownish. Spores are globose, 3–5 μm. Fruiting habitats are similar. Genus *Amanita* is thought to be closely related to these slime-balls. Here, the universal veil is present in the form of glutinous rather than solid or fluffy tissue.

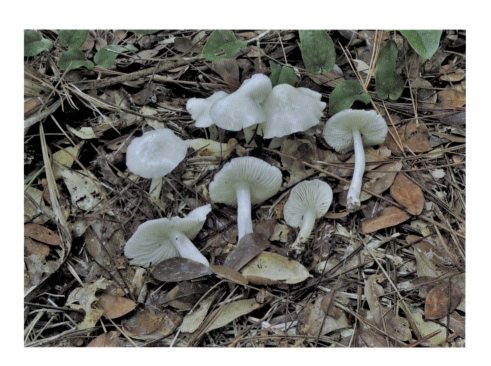

HYPOMYCES AND OTHER PARASITIC FUNGI

Fungi in this group include parasitic species that partially or completely cover and disfigure many types of fungi, most commonly gilled mushrooms, boletes, and polypores. Some coat their host organisms with a thin surface layer roughened like sandpaper. Others produce a powdery or moldy coating.

Hypomyces chrysospermus Tul. & C. Tul.

COMMON NAMES: Golden Hypomyces, Bolete Mold

MACROSCOPIC FEATURES: fruit body a parasitic mold that partially or completely covers its host and occurs in three developmental stages. **first stage** is a white mold producing elliptic asexual spores called conidia. **second stage** is powdery, yellow to golden yellow; this generates round, asexual aleuriospores. **third stage** is reddish brown and sexual. It produces ascospores within globose to flask-shaped perithecia embedded in the surface.

MICROSCOPIC FEATURES: Conidia 10–30 × 5–12 μm, elliptic, 1-celled, smooth, hyaline; aleuriospores 10–25 μm, globose, thick-walled, prominently warted, yellow to golden yellow or yellow-brown; ascospores 15–30 × 4–6 μm, 2-celled, fusiform, hyaline.

HABIT, HABITAT, AND SEASON: On various species of boletes; also reported on some gilled mushrooms and species of *Rhizopogon*.

EDIBILITY: Inedible.

COMMENTS: The epithet *chrysospermus* means "having golden spores." Some similar species can be distinguished microscopically. *Hypomyces microspermus* (not illustrated) is commonly encountered and nearly identical, but it has 8–15 μm globose aleuriospores and smaller ascospores, measuring 8–15 × 2.3–4 μm. *Hypomyces chlorinigenus* (not illustrated) has 10–11 × 4–5 μm ovoid to nearly cylindric conidia, 35–45 × 15–18 μm cylindric and longitudinally ridged aleuriospores, and elliptic-fusiform, 2-celled ascospores, 7.5–12 × 2.5–5 μm. Orange Polypore Mold, *Hypomyces aurantius* (not illustrated), parasitizes fungi typically growing on wood, often polypores and particularly species of *Trametes*. It initially appears as a thin, cobwebby layer that is whitish to buff. Later, the host's pore surface is typically covered by a thicker coating of yellowish orange, bright orange, or rusty red roughened by embedded perithecia. Ascospores are spindle-shaped and acutely apiculate and measure 20–25 × 4–6 μm.

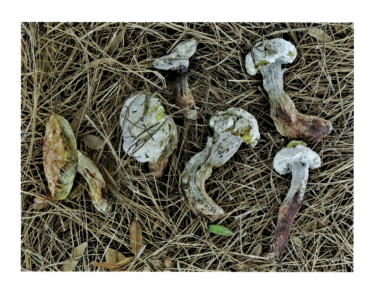

Hypomyces completus (G. R. W. Arnold) Rogerson & Samuels

= *Peckiella completa* G. R. W. Arnold

MACROSCOPIC FEATURES: **fruit body** a dense coating of mycelium covering the cap, stalk, and pore surface of *Suillus spraguei*, filling the tubes as well. It is white at first, then yellowish to brownish, and finally blackening as the anamorphic and teliomorphic reproductive structures are produced.

MICROSCOPIC FEATURES: Conidia 15–22 × 5.5–7 μm, elliptic-cylindric, 1-celled, hyaline; aleuriospores 15–25 μm, globose, smooth or verrucose, brown; ascospores (27–)35–40 × 4–6 μm, verrucose and apiculate, hyaline.

HABIT, HABITAT, AND SEASON: On fruit bodies of *Suillus spraguei*; summer–fall.

EDIBILITY: Unknown.

COMMENTS: Development and maturation of the anamorphic stage, *Sepedonium brunneum*, and the teliomorphic stage, *Hypomyces completus*, are responsible for the color transition from white to blackish. This species is easy to identify when partially parasitized or uninfected *Suillus spraguei* fruit bodies are present. *Dicranophora fulva* (see Color Key) is a bright yellow, fluffy mold that grows on several species of boletes, often *Suillus*, and a few varieties of gilled mushroom. Viewed with a hand lens it appears as a field of projecting hairs with tiny yellow to golden terminal knobs. Microscopically, it forms two types of sporangia: unispored sporangia on a solitary sporangiophore and multispored sporangia on a dichotomously branched sporangiophore.

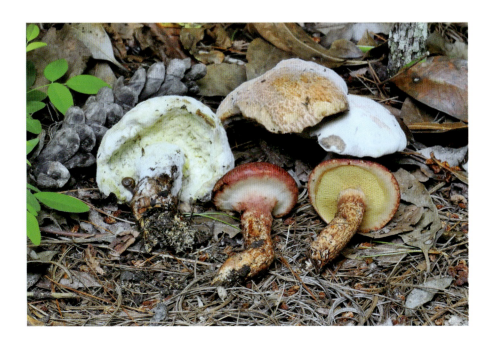

Hypomyces hyalinus (Schwein.) Tul. & C. Tull.

COMMON NAME: Amanita Mold
MACROSCOPIC FEATURES: fruit body and host organism 10–30 cm high and up to 7 cm thick, firm, solid, column- to club-shaped, usually quite phallic, chalky white, yellowish, pale orange, or pinkish, roughened like sandpaper; host cap, gills, and other structures are greatly distorted or no longer discernible; odor and taste not distinctive.
MICROSCOPIC FEATURES: Spores 15–20 × 4.5–6.5 μm, spindle-shaped, 2-celled, prominently warted, hyaline.
HABIT, HABITAT, AND SEASON: On *Amanita* species, commonly but not exclusively *Amanita rubescens*; late spring–early winter.
EDIBILITY: Reportedly edible if parasitizing an edible species such as *Amanita rubescens* but not recommended.
COMMENTS: If the host organism is dull pinkish to pinkish red, a second parasitic fungus, *Mycogone rosea* (see Color Key), might also be present. Its fruit body is a very thin layer, somewhat uneven and roughened, dull pinkish to pale pinkish red, covering the deformed gills, cap, and stalk of the host mushroom. The host is often a species of *Amanita*, especially *Amanita rubescens*, but numerous other species can become infected by this mold as well. It may act as a hyperparasite, growing on *Hypomyces hyalinus*. *Mycogone rosea* produces 2-celled spores from the ends of vegetative hyphae; basal cell (7–)9–23 × (6–)10–20 μm, globose to subglobose, hyaline, smooth; apical cell larger, (15–)21–35 × (13–)21–23 μm, globose to subglobose, thick-walled, reddish pigmented, warty. *Syzygites megalocarpus* (see Color Key) is a parasitic mold that attacks many different fungi but usually leaves them recognizable. It is yellow at first but soon darkens to a fluffy, bluish gray or dark gray mycelium on the host. Microscopically, it forms sporangia on dichotomously branched sporangiophores.

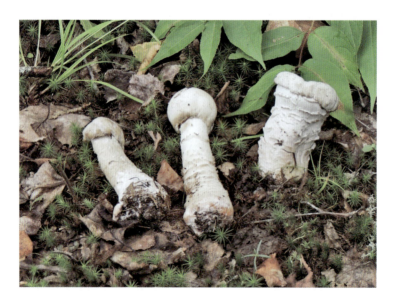

Hypomyces lactifluorum (Schwein.) Tul. & C. Tul.

COMMON NAMES: Lobster Fungus, Lobster Mushroom

MACROSCOPIC FEATURES: fruit body a thin, hard-surfaced mold covering the cap, stalk, and gills of its deformed host. The parasitic fungus is roughened like sandpaper, orange to reddish orange or dull red, sometimes with white areas, aging to purplish red. The host organism is up to 20 cm wide, usually partially buried in conifer debris or mosses. **flesh** of the host mushroom is very dense, firm, brittle, and white; odor not distinctive or fishy when fresh, pungently fishy or foul when old, taste not distinctive when raw.

MICROSCOPIC FEATURES: Spores 35–40 × 4.5–7 μm, fusiform, coarsely warted, 2-celled, hyaline.

HABIT, HABITAT, AND SEASON: Solitary or scattered on fruit bodies of *Russula* or *Lactarius* found under conifers; summer–fall.

EDIBILITY: Edible and good when cleaned and well-cooked.

COMMENTS: Lobster Mushroom is a popular edible, although unparasitized mushrooms of the host species are generally not tasty and might even contain toxins. This isn't really a problem, because although the host may not be identifiable, *Hypomyces lactifluorum* seems to remediate host toxicity, if present. Old, stinky Lobsters are often used as a source of dyes.

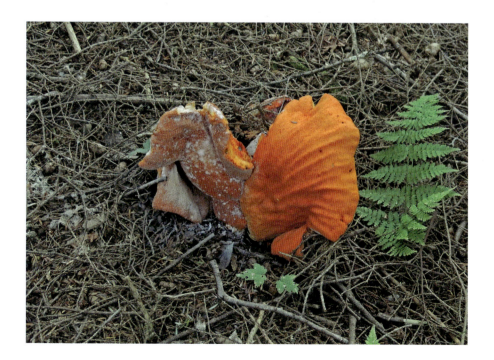

Hypomyces lateritius (Fr.) Tul. & C. Tul.

= *Hypomyces floccosus* (Fr.) Sacc.

COMMON NAME: Lactarius Mold

MACROSCOPIC FEATURES: fruit body a thin coating of mycelium covering and distorting the gills of various host species of *Lactarius*. **gills** markedly reduced, roughened and bumpy like sandpaper, white at first, sometimes becoming yellow to yellow-orange or brick red to brown in age, depending on the host species.

MICROSCOPIC FEATURES: Spores 15–21 × 3–5 μm, fusiform, 1-septate, strongly warted, hyaline.

HABIT, HABITAT, AND SEASON: On the deformed gills of *Lactarius* species; summer–fall.

EDIBILITY: Unknown.

COMMENTS: The epithet *lateritius* means "brick-colored," a reference to the color this parasitic fungus sometimes displays. The photograph shows *Hypomyces lateritius* on the deformed gills of *Lactarius quietus*. The fruit body of Russula Mold, *Hypomyces luteovirens* (see Color Key), forms a thin, rough, yellowish green to dark green layer covering the deformed gills, sometimes the stalk, and rarely also the cap of various *Russula* species. The spores are 28–35 × 4.5–5.5 μm, fusiform, 1-celled, often prominently warted but sometimes nearly smooth, and hyaline.

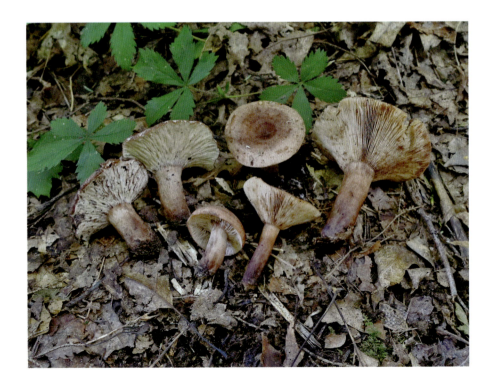

JELLY FUNGI

These distinctly gelatinous species may have a soft, rubbery, or leathery to fibrous-tough consistency. Most are cushion-shaped or brain-like. A few are erect and spike- to antler-like or irregular. They often grow on wood but sometimes envelop or encrust plant stems, leaves, cones, and other organic debris. If you don't find your mushroom here, also consult "Corals and Cauliflowers."

Auricularia fuscosuccinea (Mont.) Henn.

= *Exidia fuscosuccinea* Mont.

MACROSCOPIC FEATURES: fruit body up to 6.5 cm wide and 1–4 mm thick, ear-shaped to petal-like or irregularly cup-shaped, rubbery-gelatinous, stalkless or with a rudimentary stalk. **outer surface** rosy vinaceous brown, coated with soft, velvety, brownish gray hairs that measure 30–200 μm long. **inner surface** smooth or with occasional ridges or folds, moist and slippery, rosy vinaceous brown. **interior** thin, rubbery-gelatinous, brownish; odor and taste not distinctive.

MICROSCOPIC FEATURES: Spores 11–13.6 × 6.5–8.5 μm, allantoid, smooth, hyaline, with 1 or 2 oil drops; vinaceous brown to rosy brown, cross sections of cap transected by a thin, dark medullary zone.

HABIT, HABITAT, AND SEASON: Solitary to clustered on decaying broadleaf branches and logs, especially Sweetgum (*Liquidambar styraciflua*) and maple; summer–early winter.

EDIBILITY: Edible.

COMMENTS: The American Tree Ear = American Wood Ear, *Auricularia angiospermarum* (see Color Key), is very similar and also grows on broadleaf branches and logs, but it lacks a distinct medullary layer. Its spores measure 12–15 × 4–6 μm, with 1 or 2 oil drops. The Conifer Wood Ear, *Auricularia americana* (not illustrated), is also similar but grows on conifers. *Auricularia nigricans* = *Auricularia polytricha* (not illustrated) is similar as well, but its exterior is covered by a dense layer of fine grayish hairs greater than 600 μm long. The Tree Ear, *Auricularia auricula* (not illustrated), is misidentified in most American mushroom field guides. It is a European species.

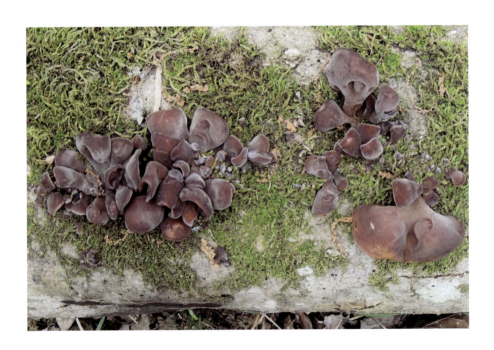

Bulgaria inquinans (Pers.) Fr.

= *Peziza inquinans* Pers.

COMMON NAMES: Black Jelly Drops, Poor Man's Licorice

MACROSCOPIC FEATURES: fruit body 2–4 cm wide, 1.5–3.5 cm high, nearly round to top-shaped when young, becoming saucer-shaped in age. **exterior** smooth, shiny, black on the upper surface and sides, scurfy and brown to blackish brown beneath. **interior** relatively thick, rubbery-gelatinous to tough, blackish; odor and taste not distinctive.

MICROSCOPIC FEATURES: Spores 9–16 × 6–7 µm, kidney-shaped to elliptic, smooth. Each ascus contains spores of two color forms: upper four (mature) dark brown, lower four (immature) hyaline.

HABIT, HABITAT, AND SEASON: In groups or clusters on decaying hardwoods, especially birches and oaks; summer–fall.

EDIBILITY: Unknown.

COMMENTS: This species may be confused with some species of cup fungi. We have placed it in the jelly fungi because of its rubbery-gelatinous consistency. Compare with *Exidia glandulosa* (see Color Key), which has a dark reddish brown to black, gland- to brain-like fruit body that is typically fused and forms extensive rows or masses.

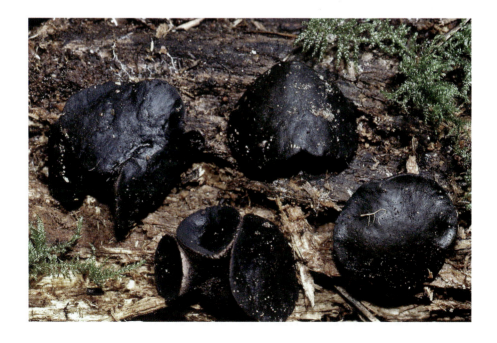

Calocera viscosa (Pers.) Fr.

COMMON NAME: Conifer Antler Jelly
MACROSCOPIC FEATURES: fruit body 1–8 cm high and 1–6 cm wide, consisting of erect, repeatedly forked, antler-like branches and a rooting, stalk-like trunk. **exterior** bald, smooth, golden yellow to orange-yellow with a paler yellow to whitish base. **interior** rubbery-gelatinous, colored like the exterior; odor and taste not distinctive.
MICROSCOPIC FEATURES: Spores 7–10 × 3.5–4.5 μm, elliptic to slightly allantoid, smooth, hyaline, with 1 or 2 oil drops and a single septum when mature.
HABIT, HABITAT, AND SEASON: Scattered or in groups on branches and logs of decaying conifer wood; summer–early winter.
EDIBILITY: Unknown.
COMMENTS: The Horn-like Tuning Fork, *Calocera cornea* (see Color Key), is up to 2 cm high and grows on decaying branches and logs of broadleaf trees. It has an erect, simple or sometimes branched, yellow to orange-yellow, horn-like fruit body. The White Green-algae Coral, *Multiclavula mucida* (not illustrated), appears as numerous tiny and usually unbranched white stalks sprouting from green algae on well-rotted logs in the summer or fall. Stalks are up to 15 mm tall, roughly 1 mm wide, and relatively tough. This is actually a coral fungus related to chanterelles. It lives in a symbiotic relationship with green algae.

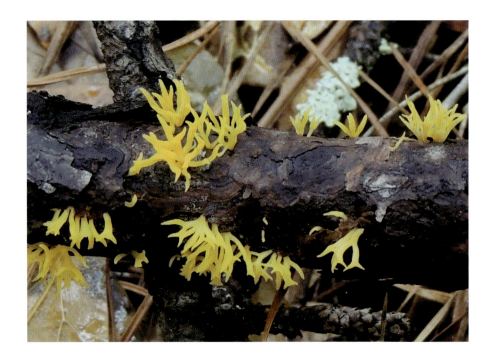

Dacrymyces chrysospermus Berk. & M. A. Curtis

= *Dacrymyces palmatus* Bres.

COMMON NAMES: Orange Jelly, Orange Witches' Butter

MACROSCOPIC FEATURES: fruit body up to 3 cm high and 1–6 cm wide, a stalkless, spreading, brain-like mass. **exterior** smooth, yellow-orange to orange or reddish orange, whitish near the point of attachment, fading to pale yellow in age. **interior** rubbery-gelatinous to soft, colored like the exterior, reduced to liquid during prolonged wet weather, hard and shriveled when dry but reviving after rains; odor and taste not distinctive.

MICROSCOPIC FEATURES: Spores 17–25 × 6–8 μm, cylindric to allantoid, 7–9-septate at maturity, smooth, yellowish.

HABIT, HABITAT, AND SEASON: Solitary, in groups or clusters on decaying conifer branches, logs, and stumps, often associated with *Stereum* species; year-round.

EDIBILITY: Edible but flavorless.

COMMENTS: The epithet *chrysospermus* means "having golden spores." Witches' Butter, *Tremella mesenterica* (see Color Key), edible, is similarly colored but leafier, like a head of leaf lettuce, and grows on decaying broadleaf wood. It has broadly elliptic spores measuring 10–18 × 8–12 μm. Quince Rust, *Gymnosporangium clavipes* (see Color Key), forms bright orange, slimy fruit bodies on standing trunks of junipers. To complete the life cycle, an alternate host, including an apple, hawthorn, pear, or quince tree, is required. Golden Ear, *Tremella aurantia* (see Color Key), edible, has a yellowish orange, brain-like to leafy fruit body that becomes paler when soaked or in age. It is parasitic on fruit bodies of *Stereum hirsutum* (not illustrated, see Comments under *Stereum complicatum*) attached to decaying broadleaf or conifer wood. Spores measure 8.5–10 × 7–8.5 μm. *Dacrymyces variisporus* (see Color Key) grows on decaying wood of pines and other conifers. It has a 2–5 mm wide, stalkless, yellow to yellow-orange fruit body that is knob- to lens-shaped when young and becomes saucer- to slightly cup-shaped with a depressed center as it ages.

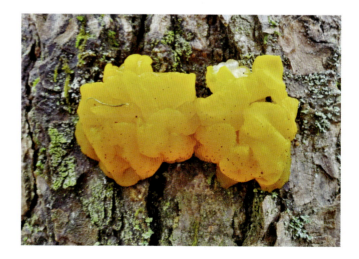

Dacryopinax spathularia (Schwein.) G. W. Martin

= *Guepinia spathularia* (Schwein.) Fr.

MACROSCOPIC FEATURES: fruit body up to 2.5 cm high and 5–10 mm wide, shoehorn- to spatula-shaped with a wavy margin or fan-shaped with deeply cut lobes, rubbery-gelatinous. **inner surface** smooth, yellow-orange to orange. **outer surface** longitudinally ribbed, colored like the inner surface. **stalk** round at the base, becoming flattened upward, colored like the inner and outer surfaces, darkening in age. **interior** rubbery-gelatinous, whitish to yellowish; odor and taste not distinctive.

MICROSCOPIC FEATURES: Spores 8–12 × 3.5–5 μm, allantoid, 1-septate at maturity, smooth, yellowish.

HABIT, HABITAT, AND SEASON: In groups or clusters on decaying wood; summer–fall.

EDIBILITY: Unknown.

COMMENTS: The epithet *spathularia* means "spoon-shaped." *Dacryopinax elegans* (see Color Key) is similar, but the fruit body is dark amber brown to blackish brown, lacks deeply cut lobes, and has larger spores, measuring 11–16 × 4.5–6.5 μm.

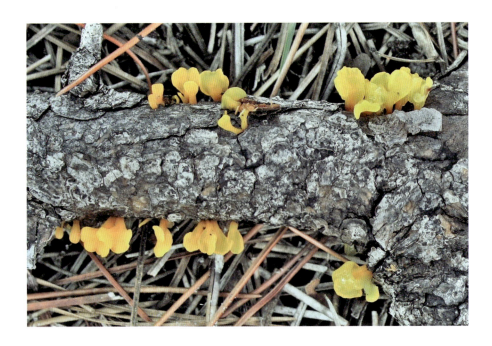

Ductifera pululahuana (Pat.) Donk

= *Sebacina pululahuana* (Pat.) D. P. Rogers

COMMON NAME: White Jelly Fungus
MACROSCOPIC FEATURES: fruit body 5–18 mm wide, a stalkless, laterally fused, convoluted, brain-like mass. **exterior** bald, smooth, translucent, whitish to creamy white or pale yellow. **interior** gelatinous to rubbery when fresh, hard and rigid when dry; odor and taste not distinctive.
MICROSCOPIC FEATURES: Spores 9–12 × 4.5–7 μm, allantoid to oval, smooth, hyaline.
HABIT, HABITAT, AND SEASON: In clusters on decaying broadleaf branches and logs; summer–fall.
EDIBILITY: Unknown.

COMMENTS: Although most references state that it grows on barkless wood, we have also found it growing on dead wood that retains bark. Compare with *Tremella fuciformis*, which has a more delicate, silvery white fruit body. The Collybia Jelly, *Syzygospora mycetophila* (not illustrated), has irregular cup-shaped to brain-like, pale yellow to brownish yellow fruit bodies that grow only on the cap, gills, or stalk of *Gymnopus dryophilus*, a gilled mushroom. The Jelly Tooth, *Pseudohydnum gelatinosum* (see Color Key), has a tongue- or spoon-shaped fruit body that is translucent, smooth to somewhat velvety on the upper surface, whitish to grayish or grayish brown, and it features similarly colored teeth on the underside. It fruits on dead wood and is edible but tasteless.

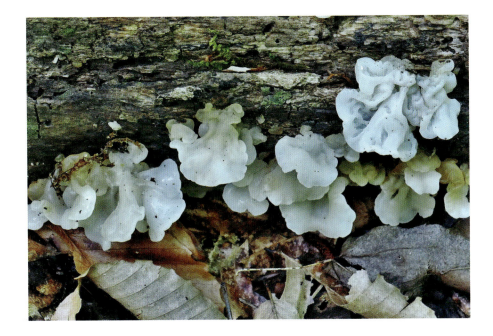

Exidia crenata (Schwein.) Fr.

= *Exidia recisa* (Ditmar) Fr.
= *Tremella crenata* Schwein.
= *Tremella recisa* Ditmar

COMMON NAME: Amber Jelly Roll
MACROSCOPIC FEATURES: fruit body up to 2 cm high and 1.5–3.5 cm wide, irregularly lobed with concave depressions, or cushion-shaped, somewhat erect, with a stalk-like base, forming extensive irregular clusters up to 12 cm or more wide. **exterior** shiny, bald, smooth to somewhat roughened, yellowish brown to purplish brown or cinnamon brown. **interior** rubbery-gelatinous, brownish; odor and taste not distinctive.
MICROSCOPIC FEATURES: Spores 11–15 × 3–5.5 μm, allantoid, smooth, hyaline.
HABIT, HABITAT, AND SEASON: In groups or clusters on decaying broadleaf branches and logs; year-round.
EDIBILITY: Unknown.
COMMENTS: The epithet *crenata* means "scalloped or notched," a reference to its cushion shape. Black Witches' Butter, *Exidia glandulosa* (see Color Key), forms rubbery-gelatinous, gland-like to blister-like fruit bodies that are dark reddish brown to blackish brown or black. Although they may become cramped or deformed, the individual fruit bodies retain their personal boundaries and do not coalesce. *Exidia nigricans* (see Color Key) produces black fruit bodies in clusters that quickly deform and coalesce into an effused, lobed mass. Spores are hyaline and allantoid and measure 10–16 × 3.5–5 μm. Although molecular analysis indicates that *Exidia glandulosa* and *Exidia nigricans* are distinct species, they are microscopically indistinguishable. Black Jelly Drops, *Bulgaria inquinans*, has larger fruit bodies, 2–4 cm wide and 1.5–3.5 cm tall. It grows on decaying oak wood. Fruit bodies are rounded to top-shaped, rubbery-gelatinous, moist, scurfy, with blackish to dark brown outer surfaces. The damp brown spores can stain fingers brown. Also consider *Camarops petersii* (see Color Key). It is discussed in Comments under the carbon fungus *Daldinia childiae*.

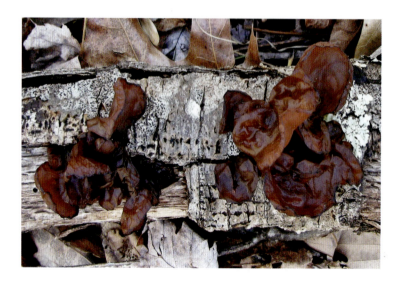

Helvellosebacina concrescens

(Schwein.) Oberw., Garnica, & K. Riess

= *Tremella concrescens* (Schwein.) Burt

MACROSCOPIC FEATURES: **fruit body** a soft, rubbery-gelatinous, irregular, membrane-like, spreading mass up to 15 cm or more wide. **exterior** bald, smooth or wrinkled, whitish to grayish. **interior** thin, rubbery-gelatinous, colored like the exterior or paler; odor and taste not distinctive.

MICROSCOPIC FEATURES: Spores 9–14 × 5–8 μm, elliptic to oval or subglobose, smooth, hyaline.

HABIT, HABITAT, AND SEASON: On the ground clasping and enveloping plant stems and leaves; summer and fall.

EDIBILITY: Unknown.

COMMENTS: The epithet *concrescens* means "curdled or congealed." Compare with *Sebacina incrustans*, which envelops plant stems, leaves, branches, and cones, but its fruit body is fibrous-tough and whitish to pale tan, and it forms small lateral projections. Both species are mycorrhizal fungi that partner with the roots of hardwoods, particularly oaks.

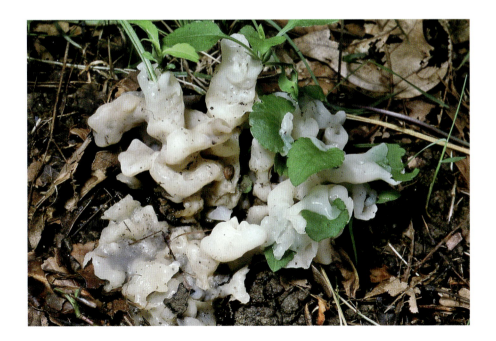

Myxarium nucleatum Wallr.

= *Exidia nucleata* (Schwein.) Burt

COMMON NAME: Granular Jelly Roll
MACROSCOPIC FEATURES: fruit body 6–20 mm wide, brain-like to somewhat lobed, fusing together and forming extensive irregular masses up to 10 cm or more across. **exterior** rubbery-gelatinous, translucent to whitish, pale yellow or brownish yellow at first, becoming reddish brown and drying to a thin, reddish brown membrane in age. **interior** soft and gelatinous but containing several hard, whitish to yellowish, seed-like granules up to 0.5 mm wide; odor and taste not distinctive.
MICROSCOPIC FEATURES: Spores 8–11.5 × 4–4.5 μm, allantoid, smooth, hyaline.
HABIT, HABITAT, AND SEASON: In groups or clusters on decaying broadleaf branches and logs; summer–early winter.
EDIBILITY: Unknown.
COMMENTS: The epithet *nucleatum* means "nucleus," a reference to the seed-like granules. *Exidia crenata* is similar to older fruit bodies of Granular Jelly Roll but lacks hard internal granules.

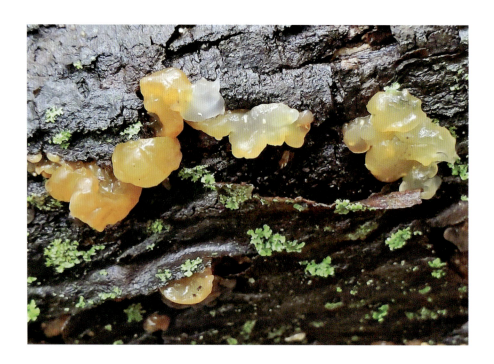

Sebacina sparassoidea (Lloyd) P. Roberts

= *Corticium reticulatum* (Berk.) Berk. & M. A. Curtis ex Cooke
= *Tremella reticulata* (Berk.) Farl.

COMMON NAMES: Dead Man's Rubber Glove, White Coral Jelly

MACROSCOPIC FEATURES: **fruit body** up to 16 cm wide, a compound mass of fused, erect, gelatinous, hollow but branched lobes that are typically finger-like with blunt tips. **exterior** somewhat translucent, white at first, becoming creamy white, then yellowish brown in age. **interior** gelatinous to rubbery, colored like the exterior or paler; odor and taste not distinctive.

MICROSCOPIC FEATURES: Spores 9–11 × 5–6 µm, broadly ovoid, smooth, hyaline.

HABIT, HABITAT, AND SEASON: Solitary or in groups on the ground or well-decayed wood in broadleaf or mixed woods; summer–fall.

EDIBILITY: Unknown.

COMMENTS: The epithet *sparassoidea* means "resembling *Sparassis*," the genus of cauliflower mushrooms.

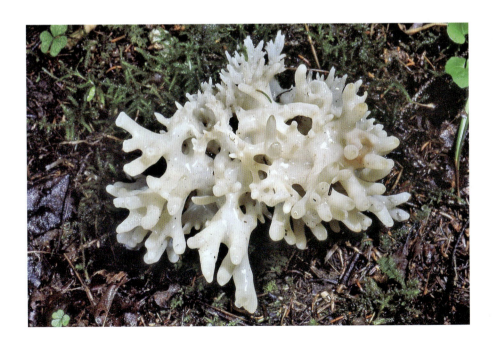

Tremella foliacea Pers.

= *Exidia foliacea* (Pers.) P. Karst.

COMMON NAME: Jelly Leaf
MACROSCOPIC FEATURES: fruit body up to 10 cm high and 25 cm wide, a lettuce-like cluster consisting of rubbery-gelatinous, leaf-like folds. **exterior** bald, smooth, pale to dark reddish brown or rarely pale brownish yellow. **interior** rubbery-gelatinous, colored like the exterior or paler; odor and taste not distinctive.
MICROSCOPIC FEATURES: Spores 8–12 × 7–9 μm, oval to subglobose, smooth, hyaline.
HABIT, HABITAT, AND SEASON: Solitary or scattered on decaying wood; summer–fall.
EDIBILITY: Edible.

COMMENTS: The epithet *foliacea* means "having leaves." Molecular analysis of mostly Eurasian *Tremella foliacea* specimens by Spirin et al. (2018) suggests that this is a species group. They propose retaining the name *Tremella foliacea* for specimens growing on conifers and calling those growing on broadleaf wood *Phaeotremella frondosa*. Additional analysis of American specimens needs to be performed for comparison. Witches' Butter, *Tremella mesenterica* (see Color Key and Comments under *Dacrymyces chrysospermus*), is similar but yellow. *Auricularia angiospermarum* (see Color Key) also resembles Jelly Leaf, but the fruit bodies are more distinctly separable ear-shaped to irregularly cups. Spores are hyaline microscopically and allantoid and measure 12–15 × 4–6 μm.

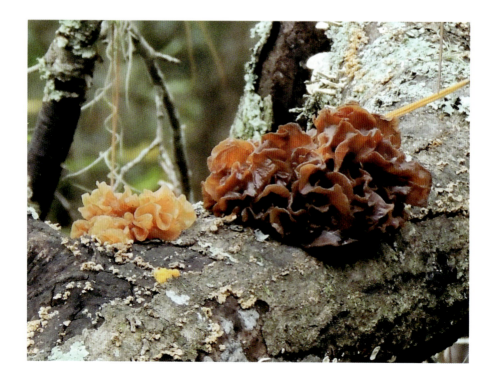

Tremella fuciformis Berk.

COMMON NAMES: Silver Ear, White Jelly Mushroom

MACROSCOPIC FEATURES: fruit body up to 3 cm high and 7 cm wide, a jelly-like mass of delicate, leaf-like, shiny lobes. **exterior** bald, smooth, shiny, translucent, silvery white. **interior** soft, gelatinous, colored like the exterior or paler, reduced to liquid during prolonged wet weather; odor and taste not distinctive.

MICROSCOPIC FEATURES: Spores 8–14 × 5–8 μm, elliptic, smooth, hyaline. Subglobose, hyaline conidia, up to 4.5 × 3 μm, are also sometimes present.

HABIT, HABITAT, AND SEASON: Solitary or scattered on decaying branches and logs of hardwoods, especially oaks; summer–early winter.

EDIBILITY: Edible.

COMMENTS: The epithet *fuciformis* means "shaped like seaweed." Silver Ear, also known as Snow Fungus or Snow Ear, is considered a medicinal and culinary delicacy in China and Japan. In the Western Hemisphere it is a tropical species with a geographic range extending northward into the subtropical southeastern United States. *Ductifera pululahuana* is similar but more brain-like and convoluted. Silver Ear is a mycoparasite of the wood decay fungus *Annulohypoxylon archeri* = *Hypoxylon archeri* (not illustrated), which fruits as gregarious and coalescing small, black, sandpaper-rough nodules on decaying wood.

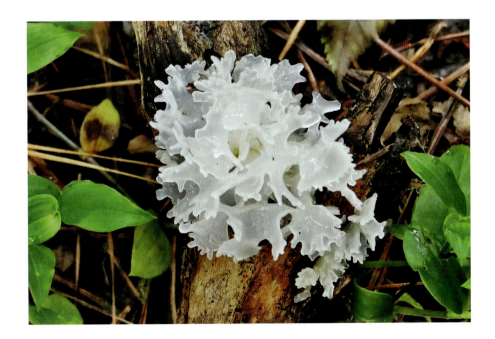

MORELS, FALSE MORELS, AND SIMILAR FUNGI

Fruit bodies have a distinct cap or sponge-like head and a conspicuous stalk. Caps or heads may be conic to bell-shaped with pits and ridges or brain-like, saddle-shaped, saucer-like, or irregularly lobed. Mature stalks are hollow or multichambered. They grow on the ground or on well-decayed wood. Edibility ranges from choice to deadly poisonous.

Gyromitra esculenta (Pers.) Fr.

COMMON NAMES: False Morel, Lorchel
MACROSCOPIC FEATURES: cap 3.5–10 cm wide and high, irregularly lobed, deeply wrinkled and convoluted; margin wavy to contorted, often curved toward the stalk. **upper surface** dark reddish brown to orange-brown, moist and slippery when fresh. **undersurface** pale pinkish tan to yellowish tan. **stalk** 2–7 cm long and 2–3 cm thick, usually with a few longitudinal ribs near the base, internally chambered and stuffed with cottony material when young, pinkish tan to yellowish tan. **flesh** thin, brittle; odor and taste not distinctive.
MICROSCOPIC FEATURES: Spores 16–28 × 7–13 μm, ellipsoid, smooth, with 2 oil drops, hyaline.
HABIT, HABITAT, AND SEASON: Solitary or in groups under conifers or in mixed woods; spring.
EDIBILITY: Can be deadly poisonous.
COMMENTS: Although this species is consumed by some individuals, it contains the toxin gyromitrin, which can cause serious illness or death. The cap of the larger Carolina False Morel, *Gyromitra caroliniana* (not illustrated), is 5–18 cm wide and tall, convoluted and brain-like with several prominent seam-like ridges. It has a reddish brown upper surface and a white, distinctly ribbed, multichambered stalk that is enlarged at the base. The Saddle-shaped False Morel, *Gyromitra infula* (see Color Key), has a saddle-shaped cap with a wrinkled or convoluted, dark brown to reddish brown or yellowish brown upper surface and a finely granular, hollow or chambered stalk that is not ribbed.

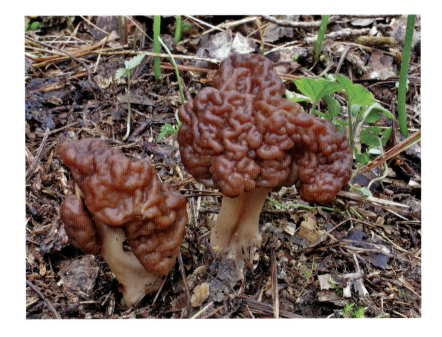

Helvella crispa (Scop.) Fr.

COMMON NAME: Fluted White Helvella
MACROSCOPIC FEATURES: cap 1–4 cm high and 2–6 cm wide, saddle-shaped to irregularly lobed, edges rolled under when young but flaring with maturity. The entire fruit body is creamy white to pale buff. **upper surface** smooth or slightly wrinkled and dry. **undersurface** finely hairy. **stalk** 2.5–9 cm long and 1–3 cm thick, heavily ribbed and pitted, internally chambered. **flesh** brittle; odor and taste not distinctive.
MICROSCOPIC FEATURES: Spores 16–22 × 10–14 μm, broadly elliptic, smooth, containing 1 large oil drop and sometimes smaller ancillary ones, hyaline.
HABIT, HABITAT, AND SEASON: Solitary, scattered, or in groups on the ground in woods; summer–early winter.
EDIBILITY: Not recommended.
COMMENTS: This is most likely a group and may not be the same species that occurs in Europe. Although Europeans eat *Helvella crispa*, the edibility of the North American variety has not been established. The Smooth-stalked Helvella, *Helvella elastica* (not illustrated), has a 2–4 cm wide, depressed saddle-shaped to irregularly lobed cap with a tan to pale grayish tan or dark grayish brown upper surface and a smooth, whitish to buff stalk that is typically enlarged downward. The spores measure 17–20 × 10–14 μm. *Helvella albella* (not illustrated) has a 1–2.5 cm wide, saddle-shaped cap with a pale gray-brown to brown upper surface and a smooth to finely powdery, whitish stalk that is typically round and sometimes enlarges downward. The spores measure 20–24 × 12–15 μm.

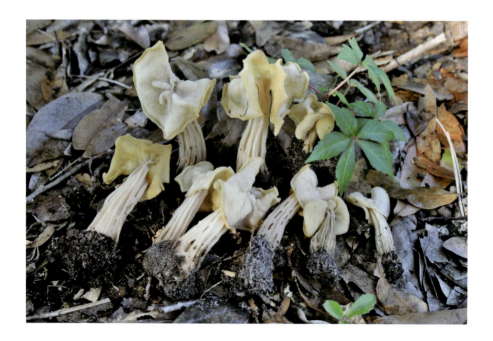

Helvella macropus (Pers.) P. Karst.

COMMON NAME: Long-stalked Gray Cup
MACROSCOPIC FEATURES: cap 4–12 mm high and 1.5–4 cm wide, deeply cup-shaped at first, becoming saucer-shaped at maturity; margin initially inrolled to incurved and expanded with age. **upper surface** grayish brown to dark brown, smooth or finely wrinkled. **undersurface** gray to grayish brown, densely fuzzy or hairy, especially near the margin. **stalk** 4–6 cm long and 1.5–4 mm thick, enlarging downward, fuzzy, solid, gray to gray-brown, whitening at the base. **flesh** thin; odor and taste not distinctive.
MICROSCOPIC FEATURES: Spores 18–25 × 10–12 μm, elliptic to almost spindle-shaped at maturity, smooth to slightly roughened, with 1 central oil drop flanked by two smaller ones, hyaline.
HABIT, HABITAT, AND SEASON: Solitary or in groups on the ground, in moss, or on decaying wood in forested areas; summer–fall.
EDIBILITY: Unknown.
COMMENTS: The epithet *macropus* means "having a long foot," a reference to the long, narrow stalk.

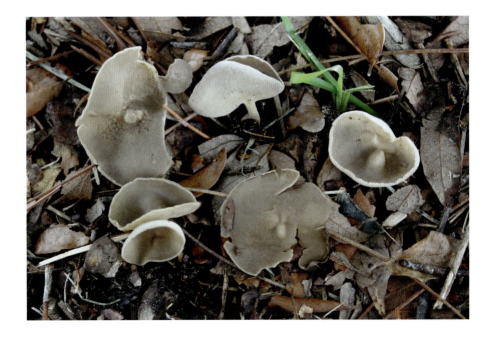

Morchella americana Clowez & Matherly

= *Morchella esculentoides* M. Kuo, Dewsbury, Moncalvo, & S. L. Stephenson

COMMON NAMES: Common Morel, Yellow Morel

MACROSCOPIC FEATURES: fruit body consisting of a sponge-like head and stalk. **head** up to 22 cm high and 13 cm wide, oval to conical or somewhat cylindric, hollow, divided into pits and ridges of variable color, continuous with the stalk below. **pits** grayish to brown, dark brown when young. **ridges** numerous and randomly arranged, anastomosing, whitish to pale yellow at first, becoming dull yellow to yellow-brown at maturity. **stalk** 2–12 cm or more long and 2–9 cm thick, nearly equal or enlarged downward, hollow; surface whitish, granular, often ribbed. **flesh** brittle; odor pleasantly earthy.

MICROSCOPIC FEATURES: Spores 17–24 × 11–15 μm, elliptic, smooth, hyaline.

HABIT, HABITAT, AND SEASON: Solitary, scattered, or in groups on the ground in various habitats, including mixed broadleaf woods, burned areas, and old railroad beds, or sometimes under conifers; late winter–spring.

EDIBILITY: Edible and choice.

COMMENTS: The epithet *americana* means "American." It is the most common yellow morel in North America. Compare with the darker *Morchella angusticeps*. The edible Half-free Morel, *Morchella punctipes* (see Color Key), also has a sponge-like head and hollow stalk. The head is up to 4 cm high and 4.5 cm wide, broadly conic with a round to blunt apex, hollow, divided into brown pits and ridges, attached to the stalk about midway and flaring below. The stalk is slightly granular, typically ribbed and whitish. Half-free morels occur on the ground under broadleaf trees or in old apple orchards at the same time as other morels.

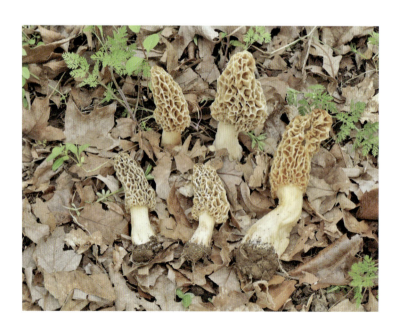

Morchella angusticeps Peck

COMMON NAME: Common Eastern Black Morel

MACROSCOPIC FEATURES: fruit body consisting of a sponge-like head and stalk. **head** up to 9 cm high and 6 cm wide, conical to oval or somewhat cylindric, hollow, divided into pits and ridges of variable color, separated from the stalk below in youth by a raised rim, later continuous. **pits** elongated and irregular, yellow-brown to gray-brown. **ridges** predominantly vertically oriented, anastomosing, dark brown to brownish black. **stalk** 2–10 cm long and 1–4 cm thick, nearly equal or enlarged downward, hollow; surface whitish to dingy yellow, granular, sometimes ribbed. **flesh** brittle; odor pleasantly earthy.

MICROSCOPIC FEATURES: Spores 22–28 × 11–15 μm, broadly elliptic, smooth, hyaline.

HABIT, HABITAT, AND SEASON: Solitary, scattered, or in groups on the ground in a variety of southern Appalachian habitats, including mixed woods, broadleaf woods with cherry trees and poplars, and burned areas, and with conifers, especially pines; spring.

EDIBILITY: Edible and choice, but must be thoroughly cooked.

COMMENTS: The epithet *angusticeps* means "having a narrow head." It is often the first morel to appear in spring. Morels, including this species, produce gastrointestinal distress in some individuals, especially when consumed with alcohol. Morels have also caused heavy metal poisoning if collected from old orchards, busy roadsides, or other areas with elevated concentrations of lead, arsenic, or other heavy metals.

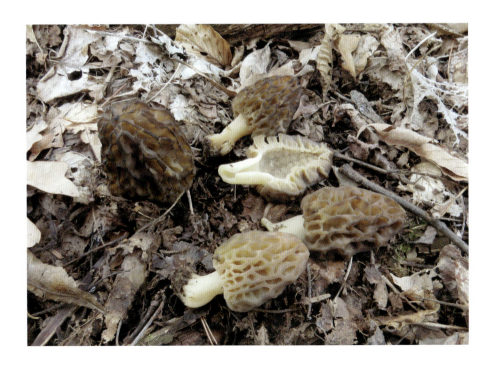

Morchella diminutiva M. Kuo, Dewsbury, Moncalvo, & S. L. Stephenson

COMMON NAMES: White Morel, Tulip Morel
MACROSCOPIC FEATURES: **fruit body** consisting of a sponge-like head and stalk. **head** up to 5 cm high and 3 cm wide, conical to oval, hollow, divided into pits and ridges of variable color, continuous with the stalk below. **pits** vertically elongated, smoky to grayish brown when young, becoming tan to yellowish at maturity. **ridges** relatively few and more or less vertically oriented, with sunken, horizontal to oblique connecting ridges, whitish, tan, or yellowish. **stalk** 1–7 cm long and 0.5–2 cm wide, enlarged downward or nearly equal, hollow; surface smooth or granular, whitish to cream or pale tan. **flesh** brittle; odor pleasantly earthy.
MICROSCOPIC FEATURES: Spores 18–26 × 10–18 μm, elliptic, smooth, hyaline.
HABIT, HABITAT, AND SEASON: Solitary to gregarious among leaves or in grassy areas under a variety of broadleaf trees, including tulip poplars, ash trees, and hickories; spring.
EDIBILITY: Edible.
COMMENTS: The epithet *diminutiva* means "very small." This morel is sometimes very difficult to spot due to its dried leaf-like colors and small stature. *Morchella americana* is similarly colored but larger and has a more convoluted ridge and pit system. *Morchella sceptriformis* = *Morchella virginiana* (see Color Key) has an egg-shaped to elliptic head with vertically arranged pits. It is fractionally larger than the cone-headed *Morchella diminutiva*, 5–12.5 cm tall and 2–3.5 cm wide at the widest point, but spore sizes are the same. *Morchella sceptriformis* is edible and occurs under tulip trees in river bottoms and other drainage areas. The epithet *sceptriformis* presumably references the scepter shape of the body plan, not skepticism about the legitimacy of the species.

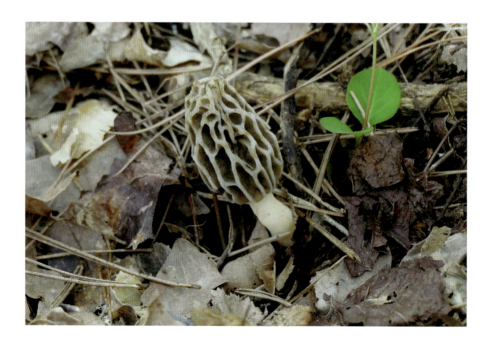

OTHER PLANT PATHOGENS

This section includes plant parasites from fungal groups not previously covered. Some cause gall-like swellings on flowers, leaves, and shoots, others produce tumor-like growths on ears of corn or jelly-like horns on cedar trees. One attacks the first-year cones of pine trees. If the plant disease you're trying to identify affects the twigs or branches of a cherry tree, check *Apiosporina morbosa*.

Cronartium quercuum (Berk.) Miyabe ex Shirai

= *Cronartium asclepiadeum* var. *quercuum* Berk.

COMMON NAMES: Eastern Pine Gall Rust, Pine-oak Rust

MACROSCOPIC FEATURES: **fruit body** initially occurs as a small hemispherical swelling on one side of a branch or trunk of the host pine tree. The swelling enlarges, becomes a spherical gall, eventually elongates, and becomes somewhat spindle-shaped. In spring, yellow-orange aecia break through the bark of the brown gall in a more or less brain-like arrangement and produce massive numbers of aeciospores.

MICROSCOPIC FEATURES: Aeciospores 24–29 × 15–18 μm, obovoid or ellipsoid, wall coarsely verrucose and flattened on one side, yellow-orange.

HABIT, HABITAT, AND SEASON: The aecial hosts are several species of pine trees, including Jack Pine (*Pinus banksiana*), Shortleaf Pine (*Pinus echinate*), and Virginia Pine (*Pinus virginiana*); spring–early summer.

EDIBILITY: Inedible.

COMMENTS: Eastern Pine Gall Rust is one of the major pathogens of pine trees in eastern North America, as well as Asia, Central America, the Caribbean, and South America. The epithet *quercuum* refers to oaks, the alternate host trees infected by this rust fungus. Wind-borne aeciospores released from diseased pine trees infect the leaves of oaks, especially northern red oak. Tiny lesions on their leaves at first produce urediospores, which infect additional leaves, and finally basidiospores ready to infect pine trees.

Cronartium strobilinum (Arth.) Hedgc. & G. Hahn

= *Caeoma strobilina* Arth.

COMMON NAMES: Pine Cone Rust, Southern Cone Rust

MACROSCOPIC FEATURES: fruit body a thin coating of orange-yellow spores that later become yellow-brown to reddish brown and cover the entire exterior of the cone. These wind-dispersed spores, called aeciospores, can reinfect other pine cones or infect and overwinter on the next host, species of evergreen oaks.

MICROSCOPIC FEATURES: Aeciospores 17–31 × 12–20 μm, obovate to ellipsoid, rarely subglobose, verrucose with small tubercles 1.5–2 μm wide, with a smooth area extending from the thickened base up one side.

HABIT, HABITAT, AND SEASON: On first-year cones of Loblolly (*Pinus taeda*), Longleaf (*Pinus palustris*), Slash (*Pinus elliottii*), and other species of pine trees; spring.

EDIBILITY: Inedible.

COMMENTS: This is an important pathogen of pine trees. The immature first-year cones become infected at an early stage in their development and often exceed the size of second-year cones in two or three months. The infected cones do not develop seeds; they fall to the ground prematurely. Aeciospores released from the diseased cones infect the leaves of evergreen oaks. Tiny lesions on their leaves at first produce urediospores, which infect additional leaves, and finally basidiospores ready to parasitize immature pine cones.

Exobasidium rhododendri (Fuckel) C. E. Cramer

COMMON NAME: Azalea Apples

MACROSCOPIC FEATURES: fruit body an irregular gall-like swelling on leaves, 1–4.5 cm wide. Exterior smooth, shiny, yellow-green at first, becoming pinkish, and finally whitish and powdery in age. **flesh** firm, juicy; odor not distinctive, taste tart to somewhat astringent.

MICROSCOPIC FEATURES: Basidiospores 12–16 × 2–4 μm, allantoid to nearly cylindric, with a single septum at maturity, hyaline, inamyloid. Aseptate hyaline conidia, 5–9 × 1.5–2 μm, may also be present.

HABIT, HABITAT, AND SEASON: Solitary or in groups on *Rhododendron* species, especially wild azalea, along streams and in bogs and moist woodlands; spring–summer.

EDIBILITY: Unknown.

COMMENTS: Some individuals believe the fruit-like galls are edible, but we cannot recommend eating them because of the documented toxicity of the host plant. The fruit body of Cedar-apple Rust, *Gymnosporangium juniperi-virginianae* (see Color Key), is a 2.5–5 cm wide gall when mature. It begins as a small, greenish brown swelling on the upper surface of a cedar needle and rapidly enlarges to form an overwintering stage that turns reddish brown to dark brown and has small, circular depressions on the surface. In spring the depressions give rise to conspicuous orange, jelly-like horns, 1–2 cm long, that become orange-brown at maturity.

Exobasidium symploci Ellis & G. Martin

COMMON NAMES: Bud Gall, Horse Sugar Gall
MACROSCOPIC FEATURES: fruit body an irregular gall-like swelling on leaf buds and flowers, 1.5–4 cm wide, rounded to highly irregular, often lobed, sometimes shaped like expanded and thickened leaf buds, stalkless. Exterior smooth or wrinkled and uneven, shiny or dull, moist, bright green to yellowish green, sometimes with a whitish bloom, becoming dry, conspicuously distorted, and yellowish brown to grayish brown. **flesh** chambered, firm, juicy, greenish at first, becoming dull brown and powdery at maturity; odor sweet, like apples, taste like sweet or sour apples.
MICROSCOPIC FEATURES: Spores 15–22 × 1.5–3 μm, cylindric, smooth, hyaline.
HABIT, HABITAT, AND SEASON: Solitary, in groups or clusters, parasitic on developing leaf buds and flowers of Common Sweetleaf (*Symplocos tinctoriae*); spring–early summer.
EDIBILITY: Reportedly edible.
COMMENTS: It is uncommon in the mountains, rare in the Piedmont, and more common in the Coastal Plain. The fruit body of Rusty Staggerbush Gall, *Exobasidium ferrugineae* (see Color Key), is a thin whitish to pinkish red gall, up to 6 cm long and wide, that forms on the hypertrophied flowers and leaves of its host plant, Rusty Staggerbush, *Lyonia ferruginea*. Two types of spores are produced, conidia and basidiospores. The conidia are 4–9.5 × 1–2.5 μm, bacilliform, ellipsoid or slightly clavate, aseptate, smooth, and hyaline, and they often have a few scattered oil drops. The basidiospores are 13.5–19 × 4–6.5 μm, ellipsoid, smooth, septate, and hyaline, and they have a prominent apiculus.

Exobasidium vaccinii (Fuckel) Woronin

COMMON NAME: Blueberry Gall

MACROSCOPIC FEATURES: fruit body mold-like, powdery, white to pale gray, greenish or reddish, surrounding and shrouding the developing leaves, shoots, and flowers of host plants, stimulating the infected parts to form swollen galls in which spores are produced.

MICROSCOPIC FEATURES: Spores 11–18 × 2.5–5 μm, nearly cylindric to allantoid, with 1–6 septa at maturity, hyaline, inamyloid. Aseptate hyaline conidia, 5–9 × 1–2 μm, may also be present.

HABIT, HABITAT, AND SEASON: Parasitic on members of the heath family, including blueberries, bilberries, and huckleberries; spring–fall.

EDIBILITY: Unknown.

COMMENTS: A serious pathogen of blueberries and a major concern of the blueberry industry in Georgia, the nation's top blueberry-producing state. Infected leaves develop light green to whitish spots. Infected fruit has firm green areas that do not mature with the rest of the berry, making them unmarketable. The fruit body of Corn Smut, *Ustilago maydis* (see Color Key), is an irregularly shaped tumor-like gall, 2–7.5 cm long and 1–6 cm wide, that swells and replaces normal corn kernels. The exterior is smooth, shiny, fragile, and whitish when very young and becomes silvery gray with black tints and finally blackish overall. The flesh is firm, moist, and whitish at first. It becomes black and juicy, then dry, powdery, and dark olive brown when mature, eventually rupturing and releasing spores.

Gymnoconia nitens (Schwein.) F. Kern & Thurst.

COMMON NAMES: Blackberry Orange Rust, Orange Rust

MACROSCOPIC FEATURES: **fruit body** initially consisting of a dense layer of rounded, waxy, blister-like pustules that soon expand up to 3 mm wide. The pustules become bright orange and powdery, appearing at first on the undersurface of the host plant leaves and eventually on the upper surface and the stems. The leaves become stunted, curled, or misshapen and eventually wither and drop. Infected plants do not produce flowers.

MICROSCOPIC FEATURES: Spores of highly variable size and shape, 18–26 × 9–23 μm, ellipsoid, obovoid, subglobose or irregular, verrucose, often with several oil drops, yellow-orange.

HABIT, HABITAT, AND SEASON: In dense clusters, partially embedded in the leaves and stems of rose family brambles; spring–fall.

EDIBILITY: Inedible.

COMMENTS: The epithet *nitens* means "bright or shining." Orange Rust completes all of its life cycle on a single host. This fungal pathogen attacks blackberries and dewberries. A very similar species, *Arthuriomyces peckianus = Puccinia peckiana* (not illustrated), causes Orange Rust of black raspberry. Cinquefoil Rust, *Pucciniastrum potentillae* (see Color Key), forms bright orange powdery pustules up to 6 mm wide, partially embedded in the leaves and stems of cinquefoil species. Jack-in-the-Pulpit Rust, *Uromyces ari-triphylli* (not illustrated), forms pale yellow to orange-yellow, then pale cinnamon brown powdery pustules less than 1 mm wide that are partially embedded in the leaves and stems of Jack-in-the-Pulpit.

POLYPORES

Fruit bodies in this group of fungi may be hard and woody, tough and leathery, or sometimes firm but flexible. They are often kidney-shaped to semicircular or fan-shaped but may be circular, irregular, or highly distorted. They vary in size from rather small to very large. Some polypores occur singly, while others form large clusters. Species in this group may be stalkless or centrally to laterally stalked. They usually grow on wood but sometimes on the ground. Most have obvious pores on their fertile surfaces, although these can be minute and often require a hand lens to visualize. At other times, the pore surface is modified to resemble gills or maze-like labyrinths intermediate between gills and pores. Because species included in this book are organized using macroscopic features, some polypores with distinctive gill-like pores are included in the Gilled Mushrooms group. Some species exhibit a phenomenon called glancing, whereby the fertile surface shines like highlights in polished wood when held at a certain angle. The tube layer is not easily separated from the cap tissue. If you are unable to find a match here, try the Carbon Fungi group; Crust, Cushion, and Parchment Fungi group; and Boletes group.

Key to the Polypores

In the following key, genus and species names that are fully described and illustrated are set in boldface italic. Partially described species, including those illustrated in the Color Key, are set in italic.

1a Pores notably elongated to maze-like and sometimes appearing gill-like or broken into tooth-like projections, not simply round, angular, sinuous, or irregular ... 2
1b Pores circular, angular, sinuous, or irregular, ranging in size from tiny to large ... 3

2a Flesh white to cream, buff or tan:
 Abortiporus biennis
 Cerioporus squamosus
 Cerrena unicolor
 Daedalea quercina
 Daedaleopsis confragosa
 Daedaleopsis septentrionalis
 Favolus tenuiculus
 Irpex lacteus
 Lenzites betulinus
 Pycnoporellus alboluteus
 Spongipellis pachyodon
 Trametes aesculin
 Trametes betulina
 Trametes gibbosa
 Trametopsis cervina
 Trichaptum abietinum
 Trichaptum biforme
 Xylodon paradoxus

2b Flesh dark ochraceous, yellow-brown to rusty brown or dark brown:
 Coltricia focicola
 Gloeophyllum sepiarium
 Gloeophyllum striatum
 Gloeophyllum trabeum
 Osmoporus mexicanus
 Porodaedalea pini
 Trichaptum perrottetii

3a Fruit body growing on the ground or appearing to grow on the ground but may be attached to buried roots ... 4
3b Fruit body growing on wood 6

4a Fruit body upper surface with a crusty or varnish-like coating:
 Ganoderma curtisii
 Ganoderma curtisii f. sp. *meredithiae*
 Ganoderma lobatoideum
 Ganoderma lobatum
 Heterobasidion irregulare
4b Fruit body upper surface lacking a crusty or varnish-like coating 5

5a Flesh white, whitish, ivory, cream, buff, or ochraceous:
 Abortiporus biennis
 Albatrellus confluens
 Albatrellus ovinus
 Bondarzewia berkeleyi
 Grifola frondosa
 Heterobasidion irregulare
 Laeticutis cristata
 Laetiporus persicinus
 Meripilus sumstinei

 Microporellus dealbatus
 Neoalbatrellus caeruleoporus
 Polyporus radicatus
 Polyporus umbellatus
 Scutiger pes-caprae
5b Flesh yellow-brown to rusty brown:
 Coltricia cinnamomea
 Coltricia focicola
 Coltricia perrenis
 Onnia circinata
 Onnia tomentosa
 Phaeolus schweinitzii

6a Fruit body distinctly stalked 7
6b Fruit body stalkless or with a rudimentary stalk 9

7a Fruit body fertile surface white to cream, buff, ochraceous, or tan, sometimes becoming brownish in age 8
7b Fruit body fertile surface yellowish brown or rusty brown to dark brown:
 Ganoderma curtisii
 Ganoderma curtisii f. sp. *meredithiae*
 Ganoderma sessile
 Ganoderma tsugae
 Onnia tomentosa
 Phaeolus schweinitzii
 Picipes badius

8a Fruit body upper surface with a crusty or varnish-like coating:
 Ganoderma curtisii
 Ganoderma curtisii f. sp. *meredithiae*
 Ganoderma martinicense
 Ganoderma sessile
 Ganoderma tsugae

8b Fruit body upper surface lacking a crusty or varnish-like coating:
 Bondarzewia berkeleyi
 Cerioporus leptocephalus
 Favolus brasiliensis
 Fomitopsis betulina
 Laetiporus cincinnatus
 Laetiporus persicinus
 Lentinus arcularius
 Lentinus brumalis
 Loweomyces fractipes
 Meripilus sumstinei
 Microporellus obovatus
 Neofavolus alveolaris
 Onnia tomentosa
 Panellus pusillus
 Piptoporellus species

9a Fruit body fertile surface white to cream, buff, yellow, ochraceous, ocher, orange, ocher-orange, rosy pink, orange-red, or red, sometimes becoming brownish or grayish in age 10
9b Fruit body fertile surface violet, orange-brown, yellow-brown, brown, purple-brown to dark brown, purplish gray to gray, or blackish 14

10a Fruit body with hexagonal pores that are sometimes radially arranged:
 Lentinus arcularius
 Neofavolus alveolaris
10b Fruit body lacking hexagonal pores 11

11a Fruit body upper surface with a crusty or varnish-like coating:
 Ganoderma applanatum
 Ganoderma lobatoideum
 Ganoderma lobatum
 Ganoderma sessile
 Heterobasidion irregulare
 Ischnoderma benzoinum
 Ischnoderma resinosum
 Porodaedalea pini
11b Fruit body upper surface lacking a crusty or varnish-like coating 12

12a Fruit body upper or fertile surface some shade of pink, orange, or red:
 Fistulina hepatica
 Hapalopilus croceus
 Inonotus hispidus
 Inonotus quercustris
 Laetiporus cincinnatus
 Laetiporus gilbertsonii var. pallidus
 Laetiporus sulphureus
 Phaeolus schweinitzii
 Piptoporellus species
 Pycnoporellus alboluteus
 Rhodofomes cajanderi
 Trametes cinnabarina
 Trametes sanguinea
12b Fruit body upper or fertile surface differently colored 13

13a Flesh white, ivory, cream, buff, pale yellow, pale orange, ochraceous, or grayish:
 Fomitopsis betulina
 Fomitopsis mounceae
 Fomitopsis ochracea
 Fomitopsis pinicola
 Fuscopostia fragilis
 Heterobasidion irregulare
 Ischnoderma benzoinum
 Ischnoderma resinosum
 Lentinus arcularius
 Neoantrodia serialiformis
 Niveoporofomes spraguei
 Oxyporus populinus
 Pappia fissilis
 Piptoporellus species
 Postia livens
 Pycnoporellus alboluteus
 Trametes aesculi
 Trametes conchifer
 Trametes gibbosa
 Trametes hirsuta
 Trametes lactinea
 Trametes suaveolens
 Trametes versicolor
 Trametes villosa
 Trametopsis cervina
 Trichaptum perrottetii
 Tyromyces chioneus
 Tyromyces fumidiceps
13b Flesh reddish, tawny, ocher, pale cinnamon to pinkish cinnamon, yellow-brown, rusty brown, reddish brown, or dark brown:
 Hapalopilus rutilans
 Inocutis ludoviciana
 Inonotus amplectens
 Ischnoderma benzoinum
 Onnia circinata
 Oxyporus populinus
 Phaeolus schweinitzii
 Pseudoinonotus dryadeus
 Trichaptum perrottetii

14a Fruit body upper surface with a crusty or varnish-like coating:
 Cryptoporus volvatus
 Fulvifomes everhartii
 Fulvifomes robiniae
 Ganoderma lobatoideum
 Ganoderma lobatum
 Ganoderma sessile
 Phellinus igniarius
 Porodaedalea pini
14b Fruit body upper surface lacking a crusty or varnish-like coating 15

15a Flesh whitish, buff, yellowish, ochraceous to ocher, or grayish:
 Bjerkandera adusta
 Cryptoporus volvatus
 Gelatoporia dichroa
 Inonotus hispidus
 Inonotus quercustris
 Trametes hirsuta
 Trametopsis cervina
 Trichaptum abietinum
 Trichaptum biforme
 Trichaptum perrottetii

15b Flesh tawny, dark chestnut, pale cinnamon, yellow-brown, brown, gray, or purplish black:
 Fomes fasciatus
 Fomitiporia calkinsii
 Fuscoporia gilva
 Globifomes graveolens
 Hapalopilus rutilans
 Hexagonia hydnoides
 Inocutis ludoviciana
 Inonotus amplectens
 Inonotus cuticularis
 Inonotus hispidus
 Inonotus quercustris
 Nigroporus vinosus
 Onnia circinata
 Phaeolus schweinitzii
 Pseudoinonotus dryadeus
 Trichaptum perrottetii
 Trichaptum sector

Abortiporus biennis (Bull.) Singer

= *Heteroporus biennis* (Bull.) Lázaro Ibiza
= *Polyporus biennis* (Bull.) Fr.

COMMON NAMES: Aborted Polypore, Blushing Rosette

MACROSCOPIC FEATURES: **fruit body** annual or biennial, occurring in two morphologically distinct forms: a distorted mass of whitish and brownish tissue covered with pores and a nondistorted form with a **cap** 8–16 cm wide, convex to nearly flat, almost circular to rosette-like at first, becoming irregularly wavy and lobed in age. **upper surface** smooth to slightly pitted, finely matted and woolly, whitish to pale yellow when very young, soon becoming ocher, then yellow-brown at maturity; margin thin, lobed to scalloped, paler than the center, staining reddish brown when bruised. **fertile surface** whitish, staining like the cap. **pores** elongate and wavy, somewhat decurrent, 1–3 per mm. **stalk** 4–7 cm long and 2–3 cm thick, central or lateral, buff or colored like the upper surface, typically with adhering debris. **flesh** duplex, white to creamy white or tan, soft on the outer portion, firm and corky on the inner portion, staining reddish when cut; odor unpleasant, taste not distinctive.

MICROSCOPIC FEATURES: Spores 4.5–6 × 3.5–4.5 μm, elliptic, smooth, hyaline, with oil drops.

HABIT, HABITAT, AND SEASON: Solitary, in groups, or in overlapping clusters on various broadleaf trees, rarely on conifers, often on the ground attached to buried roots; year-round.

EDIBILITY: Inedible.

COMMENTS: Pathogenic, causing a white trunk rot of living or dead broadleaf trees. The epithet *biennis* means "lasting for two years."

Albatrellus ovinus (Schaeff.) Kotl. & Pouzar

= *Polyporus ovinus* (Schaeff.) Fr.
= *Scutiger ovinus* (Schaeff.) Murrill

COMMON NAME: Sheep Polypore
MACROSCOPIC FEATURES: **fruit body** annual, consisting of a cap and stalk, growing on the ground with conifers. **cap** 5–16 cm wide, convex, circular to kidney-shaped, sometimes fused. **upper surface** dry, bald, smooth at first but cracked with white to pale yellow flesh showing in the cracks at maturity, white, becoming pale grayish or tan; margin incurved at first. **fertile surface** decurrent, white to pale yellow, sometimes with olivaceous or grayish tints, not staining when bruised. **pores** angular near the stalk, round near the margin, 2–4 per mm. **tubes** up to 4 mm deep. **stalk** 2.5–9 cm long and 1–3.5 cm thick, central or eccentric, enlarged downward or nearly equal, often with a swollen base, dry, bald, white to pale yellowish brown. **flesh** up to 2 cm thick near the stalk, firm, white to creamy white, drying yellowish; odor and taste not distinctive.
MICROSCOPIC FEATURES: Spores 3.5–5 × 2.5–3.5 μm, ovoid to subglobose, smooth, hyaline.
HABIT, HABITAT, AND SEASON: Scattered or in groups on the ground with conifers; summer–early winter.
EDIBILITY: Edible.
COMMENTS: Mycorrhizal, not a wood-rotting fungus. The epithet *ovinus* means "pertaining to sheep." It has a white spore deposit. *Albatrellus confluens* (see Color Key) has a pinkish buff to pale orange cap that is often fused with others and 3–5 pores per mm. It grows on the ground with conifers. The Blue Albatrellus or Blue-pored Polypore, *Neoalbatrellus caeruleoporus* (see Color Key), has a grayish blue to dull gray upper surface, a fertile surface and stalk, 2–3 angular pores per mm, and whitish flesh. It grows on the ground with conifers.

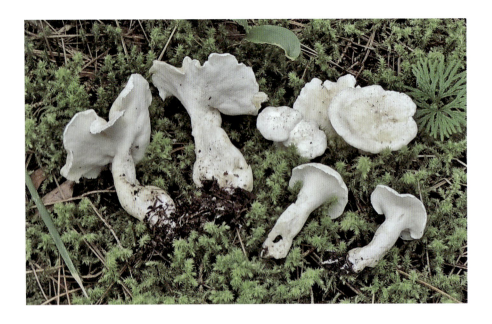

Bjerkandera adusta (Willd.) P. Karst.

= *Gloeoporus adustus* (Willd.) Pilát
= *Polyporus adustus* (Willd.) Fr.

COMMON NAMES: Scorched Bracket, Smoky Polypore
MACROSCOPIC FEATURES: fruit body annual, stalkless, broadly attached to wood, 2–7.5 cm wide and up to 8 mm thick, convex to nearly flat, shelf-like, often overlapping or sometimes forming rosettes, tough to somewhat woody. **upper surface** matted and woolly at first, becoming nearly bald in age, azonate to faintly zonate, whitish to tan or pale smoky gray; margin sharp, whitish when young, darkening when bruised. **fertile surface** pale gray at first, becoming dark smoky gray to blackish at maturity. **pores** angular to irregularly rounded, 4–7 per mm. **flesh** up to 6 mm thick, tough, pale buff, lacking a dark layer near the tubes; odor not distinctive, taste somewhat sour or not distinctive.
MICROSCOPIC FEATURES: Spores 5–6 × 2.5–3.5 μm, short-cylindric, smooth, hyaline.
HABIT, HABITAT, AND SEASON: Overlapping caps or rosettes on broadleaf trees or occasionally conifers, sometimes resupinate on the undersurface of decaying logs; summer–early winter.
EDIBILITY: Inedible.
COMMENTS: Saprotrophic on broadleaf logs and slash, sometimes on conifers. The epithet *adusta* means "scorched," a reference to the smoky gray colors. *Bjerkandera fumosa* (not illustrated) has a larger fruit body, up to 12 cm wide, with a slightly darker upper surface and a paler fertile surface with larger pores, 2–5 per mm. The flesh is thicker, up to 1.5 cm, with a thin dark line separating it from the tube layer, and sometimes an anise-like odor.

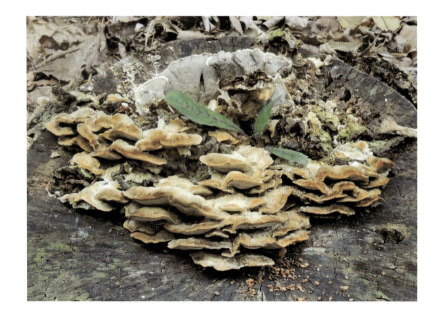

Bondarzewia berkeleyi (Fr.) Bondartsev & Singer

= *Grifola berkeleyi* (Fr.) Murrill
= *Polyporus berkeleyi* Fr.

COMMON NAME: Berkeley's Polypore
MACROSCOPIC FEATURES: **fruit body** annual, 20–75 cm wide, a compound rosette of overlapping caps attached to a central stalk. **cap** 6–25 cm wide, fan-shaped, convex to flattened, sometimes depressed, laterally fused. **upper surface** dry, radially wrinkled and shallowly pitted, obscurely to conspicuously zoned, whitish to grayish, pale yellow or tan; margin wavy and blunt. **fertile surface** white to creamy white. **pores** angular to irregular, 0.5–2 per mm. **stalk** 4–12 cm long and 3–5 cm thick, central, solid, roughened, dingy yellow to brownish, arising from an underground sclerotium. **flesh** up to 3 cm thick, corky to tough, white; odor not distinctive, taste mild when young, bitter in age.

MICROSCOPIC FEATURES: Spores 7–9 × 6–8 µm, globose, ornamented with prominent ridges and spines, hyaline, amyloid.
HABIT, HABITAT, AND SEASON: Solitary or scattered on the ground at the base of broadleaf trees and stumps, especially oaks; summer–fall.
EDIBILITY: Edible when young and tender, becoming tough and bitter in age.
COMMENTS: Pathogenic, causing a white stringy rot of the heartwood in roots and butt of living broadleaf trees. The epithet *berkeleyi* honors British mycologist Miles Joseph Berkeley (1803–1889). Although the typical fruit body diameter is 20–75 cm, mature specimens may be more than 100 cm wide. The globose, amyloid spores with spines and ridges are most unusual for polypores. Molecular analysis has confirmed that *Bondarzewia berkeleyi* is related to *Lactarius* and *Russula* and is classified in the Russulales. A look-similar, *Laetiporus persicinus*, is also found under oaks, but the fruit body and pores are smaller.

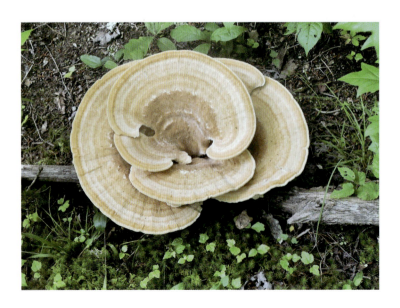

Cerioporus squamosus (Huds.) Quél.

= *Polyporus squamosus* (Huds.) Fr.

COMMON NAMES: Dryad's Saddle, Pheasant's-back Polypore, Scaly Polypore
MACROSCOPIC FEATURES: fruit body annual, with a cap and stalk. **cap** 5–30 cm wide, kidney- to fan-shaped or semicircular, fleshy when young, then tough. **upper surface** ground color whitish to dingy yellowish or pale yellow-brown with large, flattened, reddish brown scales often concentrically arranged; margin entire or lobed. **fertile surface** decurrent, white to yellowish. **pores** angular, 1–2 per mm; **tubes** up to 1 cm deep. **stalk** 1–6 cm long and up to 4 cm thick, lateral or eccentric, sometimes rudimentary, white on the upper portion, brown to blackish at the base. **flesh** up to 4 cm thick, soft-corky or tough, white; odor and taste farinaceous.
MICROSCOPIC FEATURES: Spores 10–18 × 4–7 μm, cylindric, smooth, hyaline.
HABIT, HABITAT, AND SEASON: Solitary, in groups, or in overlapping clusters on decaying broadleaf trees; spring–early winter.
EDIBILITY: Edible when young and tender.
COMMENTS: Pathogenic, causing a white heart rot of broadleaf trees. The epithet *squamosus* means "scaly." The Elegant Black-footed Polypore, *Cerioporus leptocephalus* (see Color Key), is much smaller. Caps are 3–6 cm wide, circular to kidney- or fan-shaped, tan to yellowish brown or chestnut brown with a central to lateral stalk colored like the cap on the upper portion and black at the base. It has a pale buff fertile surface, circular to angular pores, and pale buff flesh. The Bay-brown Polypore, *Picipes badius* (see Color Key), has a 4–20 cm wide, convex to centrally depressed, pale reddish brown cap with a darker center. It has a central or slightly eccentric stalk that is reddish brown near the apex and black below and attached to decaying broadleaf wood. It has a yellowish brown fertile surface with circular to angular pores and yellowish brown flesh. The cylindric, smooth, hyaline spores are 6–10 × 3–5 μm.

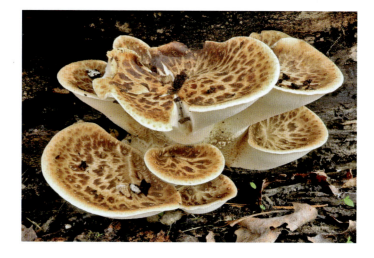

Cerrena unicolor (Bull.) Murrill

= *Daedalea unicolor* (Bull.) Fr.

COMMON NAME: Mossy Maze Polypore
MACROSCOPIC FEATURES: fruit body annual, 4–10 cm wide, stalkless, fan-shaped to semicircular or irregular in outline, sometimes laterally fused and often forming extensive rows. **upper surface** covered with coarse, elongated hairs, distinctly zonate, whitish to grayish, olivaceous, ochraceous, or pale brown, sometimes green with algae; margin sharp, often lobed and wavy. **fertile surface** initially whitish to pale buff, becoming gray to smoky gray or grayish brown at maturity. **pores** 1–4 per mm, maze-like, splitting and teeth-like in age. **tubes** up to 1 cm deep. **flesh** up to 3 mm thick, corky to fibrous-tough, whitish to pale brown with a thin dark zone separating the upper surface from the flesh; odor and taste not distinctive.
MICROSCOPIC FEATURES: Spores 5–7 × 2.5–4 µm, cylindric-ellipsoid, smooth, hyaline.
HABIT, HABITAT, AND SEASON: Typically in overlapping clusters, sometimes solitary or scattered, on broadleaf trees or rarely on conifers; year-round.
EDIBILITY: Inedible.
COMMENTS: Saprotrophic on decaying trees. The epithet *unicolor* means "one color." *Trametopsis cervina* (not illustrated) has a hairy, faintly zonate or azonate upper surface in shades of yellow, pinkish buff, pinkish cinnamon, or darker cinnamon, often with a whiter margin. The fertile surface is initially cinnamon buff, darker brown in age, with angular to maze-like pores that eventually break up and become teeth-like. There is no dark line between the upper surface and flesh. Spores measure 7–10 × 2–3 µm. The Mossy Maple Polypore, *Oxyporus populinus* (see Color Key), is perennial, often showing stacked layers of tubes near the point of attachment when vertically cut. The fruit body is 3–20 cm wide, stalkless, whitish to buff, often covered with mosses near the base or nearly overall when mature. It has circular to angular pores and grows on standing broadleaf trees, especially maples.

Coltricia montagnei (Fr.) Murrill

= *Cyclomyces greenei* Berk.
= *Polyporus greenei* Lloyd
= *Polyporus montagnei* Fr.

COMMON NAMES: Green's Polypore, Montagne's Polypore

MACROSCOPIC FEATURES: **fruit body** annual, with a cap and stalk, growing on the ground. **cap** 3.5–14 cm wide, circular to fan-shaped, convex to flat, sometimes depressed. **upper surface** azonate or inconspicuously zoned, velvety to hairy or fibrous-scaly, uneven or wrinkled, cinnamon to dark rusty brown; margin wavy, sometimes torn. **fertile surface** decurrent, yellow-brown to rusty brown or grayish brown, darkening in age. **pores** angular and radially elongated near the stalk, 1–3 mm wide, or gill-like and concentrically arranged, or a mixture of both types. **stalk** 3–7 cm long, tapered downward, central to eccentric, velvety, reddish brown to dark brown. **flesh** up to 2 cm thick, soft and spongy, becoming fibrous in age, cinnamon to rusty brown; odor and taste not distinctive.

MICROSCOPIC FEATURES: Spores 9–15 × 5–7.5 μm, ellipsoid, smooth, pale golden yellow to pale brown, slightly dextrinoid.

HABIT, HABITAT, AND SEASON: Scattered or in groups on the ground, usually under broadleaf trees; summer–early winter.

EDIBILITY: Inedible.

COMMENTS: Saprotrophic, not a wood-rotting fungus. All parts stain black with KOH. The epithet *montagnei* honors French mycologist Jean Pierre Montagne (1784–1866). *Polyporus radicatus* (see Color Key) has a fairly circular cap, 3–20 cm wide and 3–15 mm thick, that is azonate and yellow-brown to reddish brown, velvety to finely scaly or cracked. The fertile surface is decurrent, white to creamy yellow, with 2–3 angular pores per mm. The exposed portion of the central and deeply rooting stalk is 5–16 cm long and 6–25 mm thick, scurfy and yellowish brown, tapering underground as a long, black, root-like base. See *Onnia circinata* for other ground-dwelling look-alikes, all of which have small pores.

Coltricia perennis (L.) Murrill

= *Polyporus perennis* (L.) Fr.

MACROSCOPIC FEATURES: fruit body annual, consisting of a cap and stalk, growing on the ground, sometimes fusing with adjacent specimens when growing in groups. **cap** 2–11 cm wide, circular to irregular, flat to depressed or funnel-shaped, fibrous-tough. **upper surface** concentrically zoned, dull, velvety to felted, brownish orange to pale cinnamon brown, becoming dark brown or grayish in age; margin thin, sharp, wavy. **fertile surface** decurrent, grayish, becoming yellow-brown to dark brown in age, staining brown when bruised. **pores** angular, 2–4 per mm; **tubes** up to 3 mm deep. **stalk** 1.5–7 cm long and 3–10 mm thick, central, nearly equal, velvety, brown. **flesh** up to 1–2 mm thick, fibrous-tough, rusty brown, black in KOH; odor and taste not distinctive.

MICROSCOPIC FEATURES: Spores 6–10 × 3.5–5.5 μm, elliptic, smooth, pale yellowish brown, slightly dextrinoid.

HABIT, HABITAT, AND SEASON: Solitary, in groups, or sometimes fused together on the ground, usually with conifers; late spring–early winter.

EDIBILITY: Inedible.

COMMENTS: Probably mycorrhizal, since it is able to form mycorrhizae with tree roots under experimental conditions. The epithet *perennis* means "continually recurring." *Coltricia focicola* (not illustrated) has nondecurrent, angular, large, and often irregular pores and brown flesh, grows on burnt-over soil or firepits, and has spores measuring 7–11 × 4–5 μm. The Fairy Stool or Shiny Cinnamon Polypore, *Coltricia cinnamomea* (see Color Key), grows on the ground in woodlands or disturbed areas and has a shiny, bright reddish cinnamon to dark rusty brown cap, 1.2–5 cm wide, a nondecurrent fertile surface with angular pores, and rusty brown flesh. It has oblong to broadly ellipsoid, yellowish, weakly dextrinoid spores measuring 6–10 × 4.5–7 μm.

Daedaleopsis confragosa (Bolton) J. Schröt.

= *Daedalia confragosa* (Bolton) Pers.

COMMON NAME: Thin-maze Flat Polypore
MACROSCOPIC FEATURES: fruit body annual, stalkless, 3–16 cm wide and up to 3 cm thick, slightly convex to nearly flat, semicircular to kidney-shaped. **upper surface** coarsely wrinkled, rough and scaly at first, becoming finely velvety to nearly smooth in age, with concentric zones, yellow-brown to reddish brown or grayish brown; margin thin and wavy, white when actively growing. **fertile surface** tough, whitish to pale brown, bruising pinkish brown. **pores** variable, circular or radially elongated, sometimes maze-like, up to 1 mm wide; **tubes** up to 1 cm deep. **flesh** up to 2 cm thick, tough, whitish to pale brown; odor and taste not distinctive.
MICROSCOPIC FEATURES: Spores 7–11 × 2–3 μm, cylindric, slightly curved, smooth, hyaline, inamyloid.
HABIT, HABITAT, AND SEASON: Solitary, scattered, or in groups on decaying wood, especially broadleaf trees; year-round.
EDIBILITY: Inedible.
COMMENTS: Saprotrophic on decaying broadleaf trees and conifers. The epithet *confragosa* means "rough and scaly." The Thick-maze Oak Polypore, *Daedalea quercina* (see Color Key), has a larger and thicker fruit body with a coarsely maze-like fertile surface featuring tough, thick walls and spores measuring only 5–6 × 2–3.5 μm. The comparatively dainty *Trametes betulina* has thinner gill-like pores that sometimes fork. *Daedaleopsis septentrionalis* (not illustrated) also grows on decaying broadleaf wood, but its fruit body has a bald upper surface, grayish gill-like pores, and spores that measure 7–12 × 2–3.5 μm. When a maze-like fertile surface is golden brown to reddish brown, consider *Gloeophyllum sepiarium*.

Favolus tenuiculus P. Beauv.

= *Favolus brasiliensis* (Fr.) Fr.
= *Polyporus tenuiculus* (P. Beauv.) Fr.

MACROSCOPIC FEATURES: fruit body annual, a cluster of overlapping caps with short stalks attached to wood. **cap** 2–10 cm wide, fan-shaped to semicircular, soft and flexible when fresh, becoming brittle when dry. **upper surface** bald to slightly roughened, azonate, white, becoming creamy white to pale ochraceous; margin thin, sharp, often harry. **fertile surface** decurrent, white at first, becoming cream to pale ochraceous. **pores** hexagonal or radially elongated, sometimes finely notched, typically 1–3 per mm, but can be up to 2 mm wide. **stalk** short and lateral, sometimes rudimentary. **flesh** up to 3 mm thick, white to pale ochraceous; odor and taste not distinctive.

MICROSCOPIC FEATURES: Spores 9–12 × 2–3.5 μm, cylindric to somewhat boat-shaped with tapered ends, smooth, hyaline.

HABIT, HABITAT, AND SEASON: Usually in overlapping clusters, but sometimes solitary or in groups on decaying broadleaf logs and stumps; summer–early winter.

EDIBILITY: Unknown.

COMMENTS: Saprotrophic, causing a white rot of decaying broadleaf trees. This is a common tropical species that extends northward to the coastal states and Georgia. The epithet *tenuiculus* means "very thin," a reference to the cap. *Neofavolus alveolaris* has large, hexagonal pores as well. Its scaly or radially streaked cap is usually a shade of orange but can be whitish in age or wintertime.

Fistulina hepatica (Schaeff.) With.

= *Ceriomyces hepaticus* Sacc.
= *Fistulina hepatica* var. *monstrosa* Peck

COMMON NAME: Beefsteak Polypore
MACROSCOPIC FEATURES: **fruit body** annual, fan-shaped, 7–26 cm wide, fan- to spoon-shaped. **upper surface** smooth to velvety, gelatinous, often sticky to slimy, reddish orange to pinkish red or dark red, then brownish in age, typically exuding red juice when squeezed; margin rounded or sharp, wavy or lobed. **fertile surface** whitish to pinkish yellow, becoming reddish brown in age or when bruised. **pores** circular, 1–3 per mm; **tubes** up to 1.5 cm deep, crowded but distinctly independent and easily separable when viewed with a hand lens. **stalk** up to 8 cm long and 1.5–3 cm thick, lateral to eccentric or sometimes rudimentary, colored like the cap. **flesh** 2–5 cm thick, tender and juicy, becoming fibrous in age, dingy white to pinkish or reddish, with darker and paler zones, slowly darkening when exposed; odor not distinctive, taste acidic.
MICROSCOPIC FEATURES: Spores 4–6 × 2.5–4 µm, oval to lacrimoid, smooth, hyaline, inamyloid.
HABIT, HABITAT, AND SEASON: Solitary or in groups on oak trunks and stumps; summer–early winter.
EDIBILITY: Edible.
COMMENTS: Pathogenic, causing a brown rot. *Fistulina* means "having small, hollow tubes." The epithet *hepatica* means "resembling liver." The uncommonly collected *Pseudofistulina radicata* (not illustrated) has a smaller, 3–7.5 cm wide, pale yellowish brown cap, a whitish fertile surface, and a laterally placed rooting stalk attached to buried wood. The ovoid, smooth, hyaline spores are 3–4 × 2–3 µm.

Fomes fasciatus (Sw.) Cooke

= *Polyporus fasciatus* (Sw.) Fr.

COMMON NAME: Southern Clamshell
MACROSCOPIC FEATURES: fruit body perennial, stalkless, 7–18 cm wide, convex, hoof- to fan-shaped or semicircular. **upper surface** finely matted and woolly and slightly roughened when young, becoming hard and nearly smooth at maturity, concentrically grooved and ridged, grayish with concentric zones of reddish brown, grayish brown, or blackish brown, often darkening in age; margin curved and somewhat blunt, even. **fertile surface** pale brown to dark grayish brown, darkening in age, staining brown to dark brown when bruised. **pores** circular, 4–5 per mm. **flesh** up to 4 cm thick at the base, hard and crusty near the upper surface, fibrous to granular and corky below, lustrous golden brown; odor and taste not distinctive.

MICROSCOPIC FEATURES: Spores 10–14 × 4–5 µm, cylindric, smooth, hyaline, inamyloid.

HABIT, HABITAT, AND SEASON: Solitary, scattered, or in groups on living and dead broadleaf trees, especially oaks; year-round.
EDIBILITY: Inedible.
COMMENTS: Pathogenic, causing a white rot of broadleaf trees. The epithet *fasciatus* means "bundled or banded," a reference to the concentric zones of this polypore. The fruit body of *Fomitiporia calkinsii* (see Color Key), formerly identified as *Fomitiporia robusta*, is up to 18 cm wide and 7 cm thick, hoof-shaped to shelf-like, hard and woody. With the passage of years the youthfully matted, woolly, and rusty brown upper surface becomes nearly bald, blackish, and encrusted and cracked with concentric grooves and ridges. It has a grayish brown, nonstaining fertile surface with circular pores, 6–8 per mm. The flesh is shiny and rusty brown with white radial streaks near the point of attachment and has dextrinoid spores that measure 5–7 × 5–6 µm. Like the Southern Clamshell, it parasitizes broadleaf trees, especially oaks. See also *Phellinus igniarius*, *Ganoderma lobatum*, and their Comments sections for additional similar species.

Fomitopsis betulina (Bull.) B. K. Cui, M. L. Han, & Y. C. Dai

= *Fomes betulinus* (Bull.) Fr.
= *Piptoporus betulinus* (Bull.) P. Karst.

COMMON NAME: Birch Polypore
MACROSCOPIC FEATURES: fruit body annual, 5–26 cm wide, shell- to kidney-shaped, fibrous-tough to corky when fresh. **upper surface** smooth when young, often tearing or breaking into scales or patches in age, pale brown with darker brown streaks; margin inrolled and most obviously so at maturity. **fertile surface** depressed from the inrolled margin, white and smooth when young, pale brown to yellowish brown in age. **pores** circular to angular, becoming teeth-like or jagged on older specimens, 3–5 per mm; **tubes** up to 1 cm deep. **stalk** up to 6 cm long and thick, sometimes rudimentary, white to reddish brown or brown. **flesh** 1–5 cm thick, fibrous-tough, azonate, white; odor and taste not distinctive.

MICROSCOPIC FEATURES: Spores 5–6 × 1.5–2 μm, cylindric to allantoid, smooth, hyaline, inamyloid.
HABIT, HABITAT, AND SEASON: Solitary or in groups on decaying birch trees; year-round.
EDIBILITY: Edible, but fibrous-tough and somewhat bitter.
COMMENTS: Saprotrophic, causing a brown cubical rot of decaying birch trees. *Fomitopsis* means "having the appearance of a *Fomes*." The epithet *betulina* means "occurring on birch trees." The fruit body of the smaller Cryptic Globe Fungus or Veiled Polypore, *Cryptoporus volvatus* (see Color Key), is 1.5–8.5 cm wide, nearly round to hoof-shaped, stalkless, and attached to conifer trunks and stumps, especially pines. It has a whitish to tan or pale yellow-brown upper surface often coated with a clear, varnish-like layer. The circular pores of the pale to dark brown fertile surface are covered by a whitish to yellowish veil that tears open at maturity. The flesh is white.

Fomitopsis mounceae J.-E. Haight & Nakasone

COMMON NAME: Red-belted Polypore
MACROSCOPIC FEATURES: fruit body perennial, stalkless, up to 30 cm wide and 8(–13) cm thick, usually shelf-like, rarely triangular or hoof-shaped, hard and woody. **upper surface** bald, smooth to uneven, with concentric grooves and ridges, azonate or weakly zonate, often with a sticky resinous coating, color variable from brownish orange, reddish brown, or blackish, especially toward the point of attachment, usually displaying a shiny, resinous, reddish brown band near the margin; margin rounded, smooth, yellowish white to orange-white, pale orange or grayish orange. **fertile surface** not receding, whitish to pale orange or light ochraceous, sometimes staining yellow when bruised. **pores** circular, 3–5(–6) per mm. **flesh** up to 4 cm thick, woody, dense, azonate, creamy white to buff, becoming brown when dried; odor and taste not distinctive.
MICROSCOPIC FEATURES: Spores 5.8–7.1 × 3–4 μm, ellipsoid to cylindric, smooth, hyaline, inamyloid.
HABIT, HABITAT, AND SEASON: Solitary or in groups on conifer and standing broadleaf trees and logs; year-round.
EDIBILITY: Inedible.
COMMENTS: The epithet *mounceae* honors Canadian mycologist Irene Mounce (1894–1987) for her contributions to mycology, especially polypores. *Fomitopsis ochracea* is similar, but the upper surface lacks the reddish brown band near the margin. It has slightly different spores and sometimes a receding fertile surface. Older American field guides lump these two species together as *Fomitopsis pinicola*. However, *Fomitopsis pinicola* sensu stricto has a different genetic profile and a geographic range limited to Eurasia.

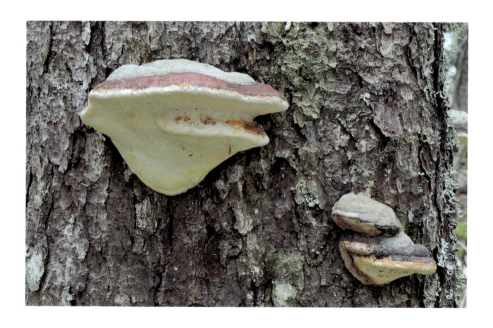

Fomitopsis ochracea Ryvarden & Stokland

MACROSCOPIC FEATURES: fruit body perennial, stalkless, up to 30 cm wide and 8(–13) cm thick, shelf-like to hoof-shaped, hard and woody. **upper surface** dull, smooth, bald, with concentric grooves and ridges, azonate, color ranging from whitish to grayish, cork-colored, ochraceous, brown, blackish, or a mix of these, but lacking a resinous, reddish brown band near the margin; margin thick, rounded. **fertile surface** sometimes receding, creamy white to cork-colored, not staining when bruised. **pores** circular, (3–)4–5(–6) per mm. **flesh** up to 4 cm thick, woody, dense, creamy white to pale brown; odor and taste not distinctive.

MICROSCOPIC FEATURES: Spores 4–7 × 3–5 μm, broadly ellipsoid, smooth, hyaline, inamyloid.

HABIT, HABITAT, AND SEASON: Solitary or in groups on standing conifer and broadleaf trees or logs; year-round.

EDIBILITY: Inedible.

COMMENTS: Pathogenic, causing a brown cubical rot of living and dead conifer and broadleaf trees. The epithet *ochracea* means "ocher-colored, yellowish buff." *Fomitopsis mounceae* is similar, but the upper surface usually has a conspicuous reddish brown band near the margin. Its fertile surface never recedes from the cap margin, spores are comparatively slimmer, and the resinous orange band melts when heated by a flame, while the nonresinous cap margin of *Fomitopsis ochracea* simply chars. The fruit body of Sweet Knot, *Globifomes graveolens* (see Color Key), is composed of small, overlapping, dull yellow-brown caps in a rounded to hoof-shaped or columnar mass reminiscent of half a pine cone, 5–21 cm wide and long glued to a living broadleaf tree trunk. The fertile surface is purplish gray at first, then dark grayish brown in age, and the circular pores measure 5–7 per mm. It has tough, yellowish brown flesh. When young and fresh it has a sweet odor resembling apples or green fodder, hence the common name.

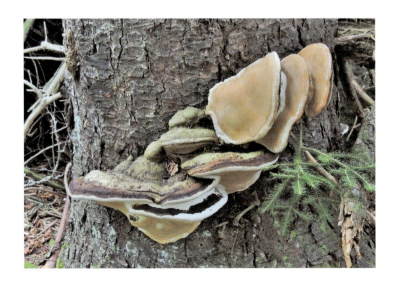

Fuscoporia gilva (Schwein.) T. Wagner & M. Fisch.

= *Hapalopilus gilvus* (Schwein.) Murrill
= *Phellinus gilvus* (Schwein.) Pat.

COMMON NAME: Mustard Yellow Polypore
MACROSCOPIC FEATURES: **fruit body** annual or perennial, stalkless, 3–12 cm wide, fan- to shell-shaped or semicircular, thickened at the point of attachment. **upper surface** nearly bald, often wrinkled and uneven, azonate or faintly zonate, brownish yellow to bright rusty yellow when young, soon dark yellowish brown to rusty brown; margin sharp, somewhat velvety and yellow at first, browning in age. **fertile surface** initially reddish brown, becoming dark purplish brown. **pores** variable, round to angular or irregular, 5–8 per mm; **tubes** up to 5 mm deep. **flesh** up to 5–20 mm thick, yellow to dull yellowish brown, staining black with KOH; odor and taste not distinctive.

MICROSCOPIC FEATURES: Spores 4–5 × 3–4 μm, ellipsoid to ovoid, hyaline, smooth, inamyloid; hymenial setae abundant, 20–30 × 5–6 μm, awl-shaped, sharp, thick-walled, dark reddish brown in KOH.

HABIT, HABITAT, AND SEASON: Solitary, in groups, or in overlapping clusters on living or dead broadleaf trees, especially oaks; year-round.

EDIBILITY: Inedible.

COMMENTS: Pathogenic and saprotrophic, causing a heart rot of living trees and a white rot of decaying wood. The epithet *gilva* means "pale yellow." When old and rusty brown all over, this species can be confused with *Hapalopilus rutilans*. A look at the fertile surface distinguishes the two. *Fuscoporia gilva* has tiny pores; those of *Hapalopilus rutilans* are twice as large, 2–4 per mm, easily counted without the aid of a hand lens.

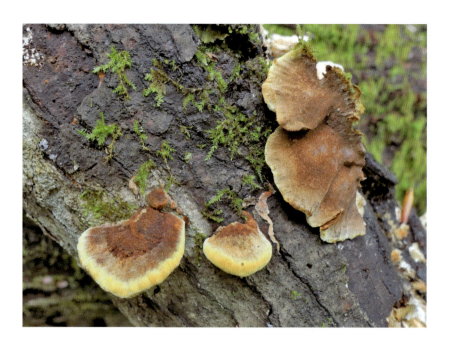

Fuscopostia fragilis (Fr.) B. K. Cui, L. L. Shen, & Y. C. Dai

= *Oligoporus fragilis* (Fr.) Gilb. & Ryvarden
= *Postia fragilis* (Fr.) Jülich
= *Tyromyces fragilis* (Fr.) Donk

COMMON NAME: Staining Cheese Polypore
MACROSCOPIC FEATURES: **fruit body** annual, stalkless, soft and spongy, up to 6 cm wide, shelf-like, semicircular, broadly convex to somewhat flattened, attached to wood. **upper surface** matted and woolly to bald, azonate, whitish to buff, staining reddish brown when bruised or drying; margin sharp, wavy. **fertile surface** whitish to buff, staining reddish brown when bruised or drying. **pores** circular to angular, 5–6 per mm; **tubes** up to 4 mm deep. **flesh** up to 1.5 cm thick, fibrous, azonate, white; odor and taste not distinctive.

MICROSCOPIC FEATURES: Spores 4–5 × 1–1.5 μm, allantoid to cylindric, smooth, hyaline, inamyloid.
HABIT, HABITAT, AND SEASON: Solitary, in groups, or in overlapping clusters on decaying conifers; summer–early winter.
EDIBILITY: Inedible.
COMMENTS: Saprotrophic on decaying conifer wood. The epithet *fragilis* means "easily broken or marked." Other cheese polypores, such as *Tyromyces chioneus* and *Postia livens*, are similar but do not bruise reddish brown.

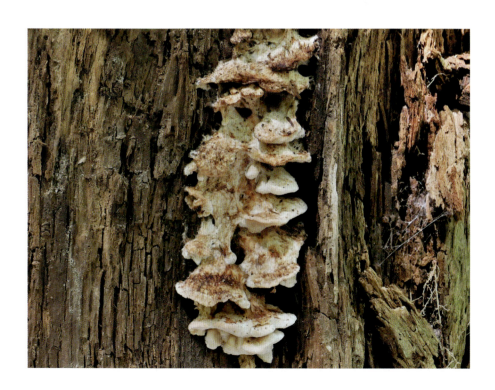

Ganoderma curtisii (Berk.) Murrill

= *Polyporus curtisii* (Berk.) Cooke

COMMON NAME: Golden Reishi

MACROSCOPIC FEATURES: fruit body annual, 3–20 cm wide, fan- to kidney-shaped. **upper surface** roughened and uneven with concentric zones and shallow furrows, covered with a thin, shiny crust and appearing varnished, bald, creamy white when very young, becoming ocher or reddish brown and retaining these colors well into maturity, dull brown when dusted with spores; margin sharp or blunt, yellow to ocher. **fertile surface** whitish to yellowish, becoming brownish in age, staining brown when bruised. **pores** circular or nearly so, 4–6 per mm. **stalk** 3–12 cm long and 1–3 cm thick, lateral to subcentral, varnished, shiny, dark ocher to dark reddish brown and darker than the cap. **flesh** up to 1.5 cm thick, leathery to corky when fresh, tough and rigid when dry, creamy white to buff, with black, shiny resinous deposits present; odor and taste not distinctive.

MICROSCOPIC FEATURES: Spores 9–13 × 5–7 μm, ovoid, with a truncate apex and apical germ pore, smooth but appearing roughened, light brown; wall 2-layered with interwall pillars.

HABIT, HABITAT, AND SEASON: Solitary, in groups, or in overlapping clusters on stumps, roots, and trunks of broadleaf trees, sometimes on the ground attached to buried wood; year-round.

EDIBILITY: Inedible.

COMMENTS: Opportunistic pathogen, causing a white rot. The epithet *curtisii* honors American mycologist Moses Ashley Curtis (1808–1872). *Ganoderma curtisii* f. sp. *meredithiae* (see Color Key) is morphologically indistinguishable but grows on pine stumps or on the ground attached to buried roots. Although the nearly identical *Ganoderma lucidum* is illustrated in many American field guides, molecular analysis reveals it to be native in Europe and Asia, not North America. However, according to Loyd et al. (2018), it and other *Ganoderma* look-alikes, especially the East Asian *Ganoderma lingzhi*, are widely cultivated here and marketed for medicinal purposes as *Ganoderma lucidum*.

Ganoderma lobatum (Cooke) G. F. Atk.

= *Fomes lobatus* Cooke

MACROSCOPIC FEATURES: fruit body perennial, up to 20 cm wide, stalkless or with a rudimentary stalk, shelf-like, semicircular or fan-shaped, sometimes lobed. **upper surface** bald, dull to slightly shiny, often concentrically zoned with pale yellow to darker orange-yellow bands or with concentric grooves and ridges, coated with a thin crust that is easily broken, rusty brown to dull yellowish brown, becoming rough, uneven, cracked, and darker brown in age; margin rounded, even, thick, and white when actively growing, sometimes lobed. **fertile surface** creamy white to yellowish buff at first, later dull purplish brown. **pores** 4–7 per mm; **tubes** up to 15 mm deep. **flesh** up to 2 cm thick, corky, brown; odor and taste not distinctive.

MICROSCOPIC FEATURES: Spores 7.5–11 × 5–7 µm, broadly ellipsoid to ovoid, with a truncate apex and an apical pore, smooth but appearing roughened, pale brown; wall 2-layered with interwall pillars.

HABIT, HABITAT, AND SEASON: Solitary or in groups on decaying broadleaf trees or on the ground attached to roots; year-round.

EDIBILITY: Inedible.

COMMENTS: Opportunistic pathogen, causing a white rot. The epithet *lobatum* means "having lobes." *Ganoderma lobatoideum* (see Color Key) is very similar but has a thinner white margin when actively growing, usually maturing to a yellow-ocher rim. The spores are slightly smaller, 6.5–9 × 4–6.5 µm. It grows on decaying broadleaf trees or on the ground attached to roots. The fruit body of the Artist Conk, *Ganoderma applanatum* (see Color Key), is shelf-like, 5–65 cm wide, and stalkless. The dull brown to gray upper surface has concentric grooves and ridges covered by a thin crust. The white fertile surface has 4–6 pores per mm and permanently stains brown when bruised. Flesh is reddish brown. It grows on a wide variety of broadleaf trees.

Ganoderma martinicense Welti & Courtec.

MACROSCOPIC FEATURES: fruit body annual, 6–30 cm wide, kidney-shaped to semicircular. **upper surface** uneven with wide concentric bumps and radial folds covered with a thin, varnish-like crust, reddish brown, becoming orange-brown toward the margin, then ocher, and finally creamy white at the margin when actively growing; margin uneven, wavy, sometimes lobed. **fertile surface** white, staining brown when bruised. **pores** circular to irregular, 4–5 per mm; **tubes** up to 1 cm deep, dark reddish brown. **stalk** 3–12 cm long and up to 3 cm thick, typically central, tapered downward, appearing varnished, dark brown to blackish. **flesh** up to 1 cm thick, easily compressed by finger pressure, dark reddish brown with resinous bands; odor described as resembling brioche bread.

MICROSCOPIC FEATURES: Spores 9.5–12 × 5–7 µm, broadly almond-shaped to oblong-ovoid, with a truncate apex and an apical pore, smooth but appearing roughened, pale brown; wall 2-layered with interwall pillars.

HABIT, HABITAT, AND SEASON: Solitary or in groups, sometimes fused laterally, on the roots or lower trunk of broadleaf trees; year-round.

EDIBILITY: Inedible.

COMMENTS: Opportunistic pathogen, causing a white rot. The epithet *martinicense* means "Martinique," where this polypore was first collected and described.

Ganoderma sessile Murrill

MACROSCOPIC FEATURES: **fruit body** 3–25 cm wide, semicircular or fan- to kidney-shaped or irregular, usually stalkless but sometimes with a rudimentary or short stalk. **upper surface** roughened and uneven, often with a few zones or shallow concentric grooves and ridges, covered with a thin, shiny crust and appearing varnished, bald, dark red to reddish brown but turning ochraceous toward the periphery; margin broad and white. **fertile surface** white at first, then yellowing, and finally dull brown, staining brown when bruised. **pores** more or less circular, 4–6 per mm; **tubes** up to 2 cm deep. **stalk** 2–6 cm long and 1–3 cm thick when present, lateral or subcentral, often twisted, varnished, shiny, dark reddish brown. **flesh** up to 3 cm thick, leathery to corky when fresh, becoming tough and rigid when dry, often zonate when thick, typically brown but sometimes yellowish; odor and taste not distinctive.
MICROSCOPIC FEATURES: Spores 9–12 × 5.5–8 μm, ellipsoid, with a truncate apex and apical germ pore; wall 2-layered with interwall pillars, appearing roughened, brown.
HABIT, HABITAT, AND SEASON: Solitary, in groups, or in overlapping clusters on stumps or roots or on the ground at the base of standing broadleaf trees; year-round.
EDIBILITY: Inedible.
COMMENTS: Opportunistic pathogen, causing a white rot. The epithet *sessile* means "attached without a stalk." In stalked specimens, internal zonation of the flesh, when present, and spore size differentiate it from *Ganoderma curtisii*, which has smaller spores and lacks the concentrically arranged internal zonation.

Ganoderma tsugae Murrill

= *Fomes tsugae* (Murrill) Sacc. & D. Sacc.
= *Polyporus tsugae* (Murrill) Overh.

COMMON NAME: Hemlock Varnish Shelf

MACROSCOPIC FEATURES: fruit body annual, 6–31 cm wide, fan- to kidney-shaped. **upper surface** smooth or with shallow concentric grooves and ridges, bald, often broadly zonate, covered with a thin, shiny crust and appearing varnished, brownish red to mahogany or reddish orange, rarely blue to bluish green, typically bright orange-yellow near the margin in youth; margin bright creamy white. **fertile surface** white to creamy white, browning in age or when bruised. **pores** circular to angular, 4–6 per mm; **tubes** up to 1.5 cm deep. **stalk** 3–15 cm long and 1–4 cm thick, usually lateral, varnished, brownish red to mahogany or reddish orange. **flesh** up to 5 cm thick, corky or tough, whitish; odor and taste not distinctive.

MICROSCOPIC FEATURES: Spores 13–15 × 7.5–8.5 μm, ellipsoid, with a truncate apex and apical germ pore; wall 2-layered with interwall pillars, appearing roughened, brown.

HABIT, HABITAT, AND SEASON: Solitary or in groups on several genera of living and decaying conifer wood, especially hemlocks and firs; year-round.

EDIBILITY: Inedible.

COMMENTS: Opportunistic pathogen, causing a white rot. The epithet *tsugae* refers to hemlock, the predominant host tree. *Ganoderma sessile* and *Ganoderma curtisii* grow on broadleaf trees. *Ganoderma curtisii* f. sp. *meredithiae* grows exclusively on pines and has slightly smaller spores. *Ganoderma tsugae* is often collected for medicinal use, although the medical research supporting this practice is far from conclusive at this writing.

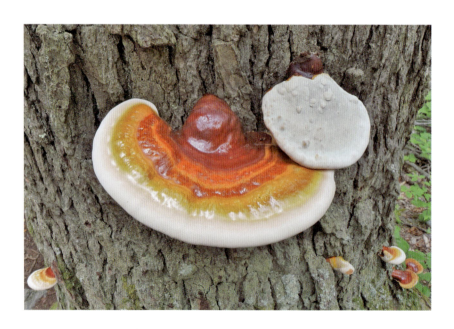

Gelatoporia dichroa (Fr.) Ginns

= *Gloeoporus dichrous* (Fr.) Bres.
= *Polyporus dichrous* Fr.

COMMON NAME: Bubble Gum Polypore
MACROSCOPIC FEATURES: fruit body annual, composed of stalkless, fused caps in rows or overlapping clusters. **cap** up to 10 cm wide and 5 mm thick at the base, variable from effused-reflexed to resupinate or shelf-like. **upper surface** finely matted and woolly to nearly bald, somewhat zonate, white to creamy white, becoming ochraceous or grayish ocher in age; margin sharp, wavy. **fertile surface** orange-brown to pinkish brown or purplish brown, with a whiter margin when actively growing, gelatinous and stretchable when fresh, drying hard and resinous. **pores** round to angular, 4–6 per mm; **tubes** up to 1 mm deep. **flesh** up to 4 mm thick, soft and fibrous or cottony, white; odor and taste not distinctive.
MICROSCOPIC FEATURES: Spores 3.5–5.5 × 0.5–1.5 μm, allantoid to cylindric, hyaline, smooth, inamyloid.
HABIT, HABITAT, AND SEASON: In overlapping fused groups on decaying broadleaf trees, sometimes on conifers or old, woody polypores; year-round.
EDIBILITY: Inedible.
COMMENTS: Saprotrophic, causing a white rot of decaying broadleaf trees or conifers. The epithet *dichroa* means "having two colors." The fertile surface and tubes are stretchable and separable from the flesh, hence the common name.

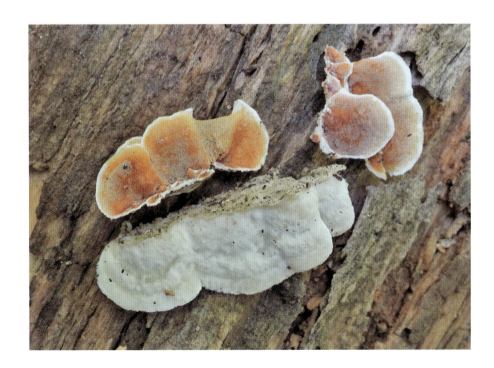

Gloeophyllum sepiarium (Wulfen) P. Karst.

= *Daedalea sepiaria* (Wulfen) Fr.
= *Lenzites sepiaria* (Wulfen) Fr.

COMMON NAMES: Rusty-gilled Polypore, Yellow-red Gill Polypore

MACROSCOPIC FEATURES: fruit body annual to perennial, 2.5–10 cm wide, semicircular to kidney-shaped, slightly convex or flat, stalkless, tough. **upper surface** covered with short, stiff hairs that become matted in age, concentrically zonate and grooved or ridged, bright yellowish red to reddish brown, becoming grayish or blackish in age; margin orange-yellow to brownish yellow or whitish, sometimes with tufts of tiny hairs. **fertile surface** golden brown to rusty brown. **pores** fairly thick, elongated and maze-like, 1–2 per mm; **tubes** up to 7 mm deep. **flesh** up to 6 mm thick, tough, yellow-brown to rusty brown; odor and taste not distinctive.

MICROSCOPIC FEATURES: Spores 9–13 × 3–5 μm, cylindric, smooth, hyaline, inamyloid; hymenial cystidia 25–95 × 3–7 μm, awl-shaped to obtuse, smooth, hyaline.

HABIT, HABITAT, AND SEASON: Solitary, in groups, or in overlapping, rosette-shaped clusters on decaying wood, including lumber; year-round.

EDIBILITY: Inedible.

COMMENTS: Saprotrophic, causing a brown rot of decaying wood. The epithet *sepiarium* means "reddish brown." Addition of KOH to the flesh produces a black stain. *Gloeophyllum trabeum* (not illustrated) has a smooth, weakly zonate to azonate, stalkless fruit body that is reddish brown to dark brown and becomes grayish in age. The flesh is brown, and the fertile surface consists of a few small, rounded pores, 2–4 per mm, and mostly maze-like or gill-like. The Zoned Gilled Polypore, *Gloeophyllum striatum* (see Color Key), has a semicircular to fan-shaped fruit body up to 8 cm wide. The upper surface is conspicuously zonate and pale yellowish brown to darker brown. Its fertile surface is brown to dark brown, gill-like, the "gills" sometimes forking or teeth-like in age. It has rusty brown flesh and grows on decaying wood.

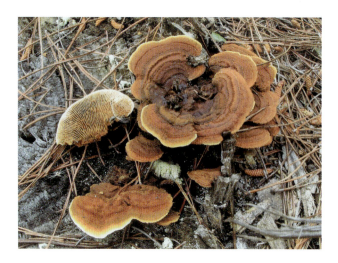

Grifola frondosa (Dicks.) Gray

COMMON NAMES: Hen of the Woods, Maitake

MACROSCOPIC FEATURES: fruit body annual, up to 60 cm wide, a dense cluster of overlapping and partially fused caps attached to branches arising from a short, thick, common stalk. **cap** 2–8 cm wide, fan- to petal-shaped, laterally attached. **upper surface** bald or finely matted and woolly, zonate, gray to brownish gray, becoming dark brown in age; margin thin, wavy. **fertile surface** white to creamy white. **pores** angular, 1–3 per mm, white. **stalk** 2–4.5 cm long and up to 10 cm thick, repeatedly branched, white. **flesh** up to 6 mm thick, firm, white; odor and taste pleasantly sweet or not distinctive.

MICROSCOPIC FEATURES: Spores 5–7 × 3.5–5 μm, oval to elliptic, smooth, hyaline.

HABIT, HABITAT, AND SEASON: Solitary or in groups on the ground at the base of broadleaf trees, especially oaks; late summer–fall.

EDIBILITY: Edible.

COMMENTS: Pathogenic, causing a white rot. The epithet *frondosa* means "full of leaves," a reference to the numerous caps. Whether or not the medicinal claims for this species pan out, it is choice in the skillet. The Black-staining Polypore, *Meripilus sumstinei* (see Color Key), has a fruit body of similar size and shape, with thicker, shelf-like caps and a white fertile surface that stains black when handled or in age. It has angular pores and white flesh, and it grows at the base of broadleaf trees and stumps or on the ground. The fruit body of the Umbrella Polypore, *Polyporus umbellatus* = *Cladomeris umbellata* (see Color Key), is also of similar size but consists of numerous circular caps, each with a central stalk attaching it to a common stalk. It has a white to creamy white fertile surface, angular pores, and whitish flesh. It grows on the ground, often near stumps in broadleaf or mixed woods, usually with beeches or oaks.

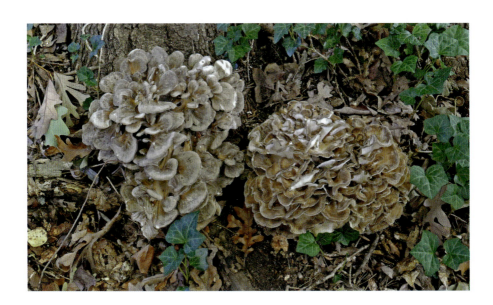

Hapalopilus rutilans (Pers.) Murrill

= *Hapalopilus nidulans* (Fr.) P. Karst.

COMMON NAME: Tender Nesting Polypore
MACROSCOPIC FEATURES: fruit body annual, stalkless, 3–15.5 cm wide, convex, fan-shaped to semicircular, thickened at the point of attachment, soft and watery when fresh, corky and brittle when dry. **upper surface** finely matted and woolly at first, becoming nearly smooth in age, sometimes with one or more shallow concentric furrows, pinkish brown to reddish brown or pale brown, sometimes with ochraceous tints when dry; margin sharp, curved, colored like the upper surface. **fertile surface** ochraceous to cinnamon brown. **pores** angular, 2–4 per mm; **tubes** up to 1 cm deep. **flesh** 1–3 cm thick at the base, soft and watery when fresh, pale cinnamon; odor not distinctive, taste slightly bitter or not distinctive.

MICROSCOPIC FEATURES: Spores 3.5–5 × 2–3 μm, ellipsoid to cylindric, hyaline, smooth, inamyloid.

HABIT, HABITAT, AND SEASON: Solitary or in groups on decaying broadleaf wood, very rarely reported on conifers; late spring–early winter.

EDIBILITY: Deadly poisonous.

COMMENTS: Saprotrophic, causing a white rot of decaying broadleaf trees. The epithet *rutilans* means "reddish or ruddy." The upper surface of the fruit body stains bright violet with KOH. This polypore is popular with wool dyers because it produces a rich, dark purple color. *Hapalopilus croceus* (see Color Key) has a 5–20 cm wide, stalkless, bright orange to brownish orange upper surface and bright reddish orange fertile surface, and it grows on decaying oaks or chestnut logs and stumps. The upper surface stains violet to purplish red with KOH. It has 2–3 angular pores per mm and bright to dark orange or brownish flesh.

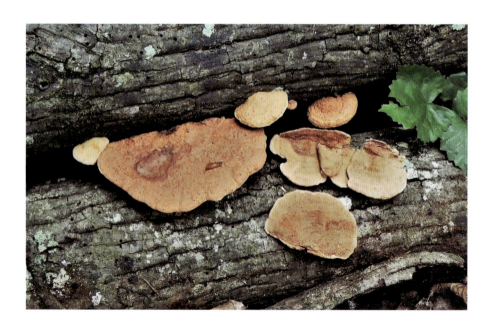

Heterobasidion irregulare Garbel. & Otrosina

= *Polyporus irregularis* Underw.

COMMON NAME: Conifer-base Polypore
MACROSCOPIC FEATURES: fruit body perennial, stalkless, 2.5–25 cm wide, variable from shelf-like to spreading in rows, semicircular to irregular, sometimes fused. **upper surface** uneven, roughened with shallow furrows, indistinctly zoned, velvety or bald, becoming encrusted, brown, then blackish in age; margin rounded, wavy. **fertile surface** ivory to pinkish cream, smooth, glancing. **pores** circular to angular or irregular, 4–5 per mm. **flesh** up to 1 cm thick, corky, azonate, ivory to pinkish cinnamon; odor and taste not distinctive.
MICROSCOPIC FEATURES: Spores 4.5–6.5 × 3.5–4.5 µm, subglobose, finely warted, hyaline, with oil drops.
HABIT, HABITAT, AND SEASON: Solitary or in groups on conifer stumps, trunks, or roots, which may be buried; year-round.
EDIBILITY: Inedible.

COMMENTS: Pathogenic, causing root rot. This is a major pathogen of North American conifers, especially Loblolly (*Pinus taeda*) and Slash Pine (*Pinus elliottii*). The epithet *irregulare* means "irregular," a reference to the shape of the pores. *Heterobasidion annosum*, a European species, doesn't occur in North America. Another conifer parasite, Dye Maker's Polypore, *Phaeolus schweinitzii* (see Color Key), has a fruit body 4–26 cm wide, circular to fan-shaped and nearly flat, with a central stalk-like base. Caps are solitary or sometimes form rosettes on exposed or buried roots. The upper surface is faintly to distinctly zonate, dull orange with a bright yellow margin at first, aging to rusty brown or dark brown. The fertile surface is initially yellow or orange, then greenish yellow, and finally brown. Spores are ellipsoid to ovoid, smooth, 6–9 × 2.5–5 µm. The Ocher-orange Hoof Polypore, *Porodaedalea pini* (see Color Key), has a stalkless, crusty fruit body up to 20 cm wide. It has an ocher to ocher-orange or yellow-brown fertile surface, circular to angular or maze-like pores, and brown flesh, and it grows on living conifers.

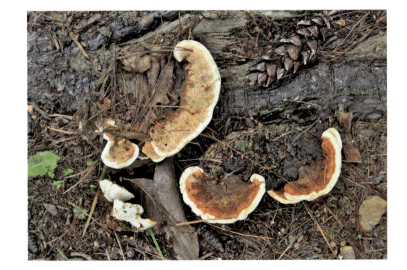

Hexagonia hydnoides (Sw.) M. Fidalgo

= *Cerrena hydnoides* (Sw.) Zmitr.
= *Pogonomyces hydnoides* (Sw.) Murrill
= *Trametes hydnoides* (Sw.) Fr.

MACROSCOPIC FEATURES: fruit body annual, stalkless, 3–20 cm wide, convex to nearly flat, fan-shaped to semicircular, sometimes laterally fused, flexible when fresh, rigid when dry. **upper surface** covered with conspicuous erect, stiff hairs that fall off in age, azonate, lacking concentric grooves and ridges, dark brown to blackish; margin thin, sharp. **fertile surface** reddish cinnamon to dark brown with a distinct grayish tint. **pores** round to somewhat irregular, 3–5 per mm; **tubes** 1–8 mm deep. **flesh** up to 1.5 cm thick but typically much thinner, cinnamon brown to dark brown; odor and taste not distinctive.

MICROSCOPIC FEATURES: Spores 11–14 × 3.5–5 μm, cylindric, smooth, hyaline, inamyloid.

HABIT, HABITAT, AND SEASON: Solitary, in groups, or in overlapping clusters on decaying broadleaf wood, especially oaks; year-round.

EDIBILITY: Inedible.

COMMENTS: Saprotrophic, causing a white rot of decaying broadleaf trees. The epithet *hydnoides* refers to its resemblance to species in the genus *Hydnum*, which have spine- or teeth-like fertile surfaces. The justification for that peculiar association is no longer apparent, because the fertile surface of *Hexagonia hydnoides* has pores, not spines.

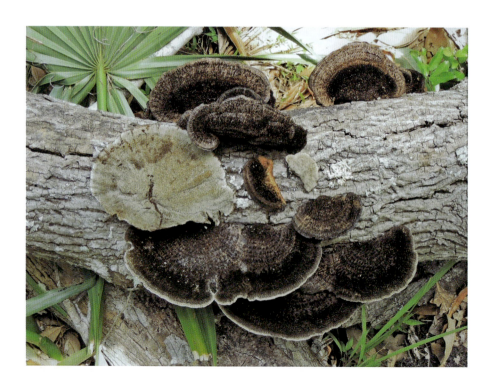

Inocutis ludoviciana (Pat.) T. Wagner & M. Fisch.

= *Inonotus ludovicianus* (Pat.) Bondartsev & Singer

MACROSCOPIC FEATURES: **fruit body** annual, stalkless or with a rudimentary stalk, consisting of a cluster or rosette of overlapping caps up to 50 cm wide that are attached to wood. **cap** 10–30 cm wide and 1–2.5 cm thick, fan-shaped, sappy and tough when fresh, brittle when dry. **upper surface** often zonate, wrinkled, warted, and radially lined, becoming matted and woolly toward the margin, lacking concentric grooves and ridges and not covered with a hard crust at any stage, rusty red to rusty brown; margin thin, sharp, buff to pale yellow when actively growing. **fertile surface** buff, becoming cinnamon to chestnut brown and darkening further in age, quickly staining dark brown when bruised, sometimes glancing. **pores** angular, thin-walled and eventually torn, 2–3 per mm, sometimes up to 1 mm wide; **tubes** up to 1 cm deep. **flesh** 0.5–2 cm thick, fibrous, rusty brown; odor and taste not distinctive.

MICROSCOPIC FEATURES: Spores 5–7 × 3.5–4.5 μm, ellipsoid to phaseoliform with one side flattened, smooth, rusty brown; setae lacking.

HABIT, HABITAT, AND SEASON: Typically a cluster of overlapping caps growing at the base of oaks, sweet gums, or tupelos; late spring–fall.

EDIBILITY: Inedible.

COMMENTS: Pathogenic, causing a white pocket rot in the butt and roots of living broadleaf trees. The epithet *ludoviciana* means "of Louisiana," a reference to where this species was collected and described. Handling the fertile surface often stains fingers dark brown. All parts stain black with KOH. *Ischnoderma resinosum* can also be sappy and has a pore surface that rapidly bruises dark brown, but it is usually smaller and darker brown, and the cap margin is thick rather than thin.

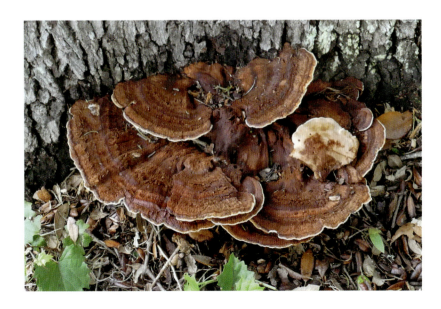

Inonotus cuticularis (Bull.) P. Karst.

= *Inonotus perplexus* (Peck) Murrill
= *Polyporus cuticularis* (Bull.) Fr.

COMMON NAME: Clustered Bracket
MACROSCOPIC FEATURES: fruit body annual, stalkless, typically growing in large overlapping clusters on wood, 4–16 cm wide, shelf-like, semicircular to fan-shaped. **upper surface** conspicuously woolly-matted or radially fibrillose, with rusty brown and yellowish brown zones, sometimes azonate, lacking concentric grooves and ridges, spongy, often with moisture drops when fresh, becoming cracked and blackened in age; margin typically sharp, sterile below, colored like the upper surface or paler. **fertile surface** glancing, pale brown at first, soon brown to dark grayish brown. **pores** angular, 3–5 per mm; **tubes** 2–10 mm deep. **flesh** 2–10 mm thick, fibrous-tough, bright yellowish brown to rusty brown; odor and taste not distinctive.
MICROSCOPIC FEATURES: Spores 5.5–8 × 4.5–5.5 μm, broadly ellipsoid to ovoid or subglobose, smooth, yellowish brown; setae usually not abundant, imbedded and inconspicuous, 15–30 × 5–11 μm, awl-shaped to ventricose, frequently hooked, sometimes absent.
HABIT, HABITAT, AND SEASON: Overlapping clusters on standing dead broadleaf trees or from wounds on living trees, especially oaks; year-round.
EDIBILITY: Inedible.
COMMENTS: Saprotrophic, causing a white rot of decaying broadleaf trees. The cap surface stains purple with KOH. *Inonotus* means "ear-shaped." The epithet *cuticularis* means "pertaining to the cuticle." The Pawpaw Polypore, *Inonotus amplectens* (not illustrated), has a 1–4 cm wide, hemispherical, stalkless fruit body that clasps and encircles living twigs of pawpaws (*Asimina* species). It has a dark yellowish orange to brown upper surface and a concave, honey yellow to reddish brown fertile surface initially covered by a yellowish membrane. The pores are circular and measure 2–4 per mm, larger when fused. It has rusty brown flesh, and the spores are 5–6.5 × 3.5–4 μm, ellipsoid, smooth, with 1 or 2 oil drops, hyaline, and inamyloid.

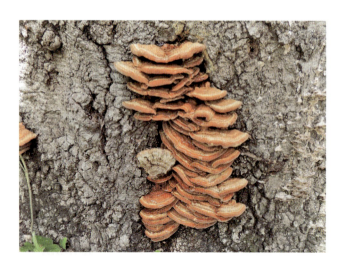

Inonotus hispidus (Bull.) P. Karst.

= *Polyporus hispidus* (Bull.) Fr.

COMMON NAMES: Shaggy Bracket, Shaggy Polypore

MACROSCOPIC FEATURES: fruit body annual, stalkless, shelf-like, 10–30 cm wide, convex, semicircular to fan-shaped, soft or tough. **upper surface** broadly attached, azonate, covered with stiff, bright reddish orange hairs that become reddish brown to blackish in age; margin rounded, bright sulfur yellow when young. **fertile surface** uneven, yellow, turning yellow-ocher, then brown or blackish in age. **pores** angular to irregularly rounded, 1–3 per mm, sometimes exuding clear droplets when moist and fresh; **tubes** up to 1.5 cm deep. **flesh** up to 7.5 cm thick, azonate or somewhat zonate, soft or tough, yellow to ocher near the margin and upper portion, dark rusty brown near the tubes, sometimes uniformly dark rusty brown throughout, immediately staining brownish when exposed; odor somewhat fruity and pleasant or not distinctive, taste not distinctive.

MICROSCOPIC FEATURES: Spores 8–11 × 6–8 μm, subglobose to ovoid, thick-walled, smooth, brown; setal hyphae lacking in the trama; setae sometimes present, 20–30 × 6–8 μm, dark brown.

HABIT, HABITAT, AND SEASON: Solitary or in groups on broadleaf trees, especially oaks and walnuts; summer–early winter.

EDIBILITY: Inedible.

COMMENTS: Pathogenic, causing a white rot in broadleaf trees, especially oaks. The epithet *hispidus* means "having stiff hairs." The flesh of mature or older specimens is often infested with small, pinkish larvae. *Inonotus quercustris* (see Color Key) is similar and has a velvety, golden yellow to orange cap that becomes rusty brown in age but lacks stiff hairs on its cap surface. It has conspicuous setal hyphae with pointed tips in its trama and lacks hymenial setae. The Weeping Polypore, *Pseudoinonotus dryadeus* (see Color Key), has a 13–36 cm wide, stalkless fruit body that usually grows at the base of oak trees or on stumps. The whitish to brown upper surface typically exudes amber droplets when fresh. It has a buff or dark brown fertile surface, circular to angular pores, and brown flesh.

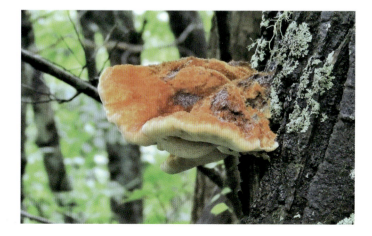

Ischnoderma resinosum (Schrad.) P. Karst.

= *Ischnoderma fuliginosum* (Scop.) Murrill
= *Polyporus resinosus* (Schrad.) Fr.

COMMON NAMES: Resinous Polypore, Steak of the Woods

MACROSCOPIC FEATURES: fruit body annual, stalkless, shelf-like, often growing in overlapping clusters, 7–26 cm wide, fan-shaped to semicircular, rarely effused-reflexed, convex to flattened, fleshy and sappy when young and fresh, becoming tough or brittle in age. **upper surface** concentrically and radially furrowed, faintly to distinctly zoned, velvety at first, covered with a thin, glossy, resinous crust on mature specimens, dull brownish orange to dark brown; margin thick, rounded, whitish to ocher, frequently exuding drops of amber, resin-like fluid when fresh. **fertile surface** white, aging to pale brown, rapidly staining dark brown when bruised. **pores** angular to circular, 4–6 per mm; **tubes** up to 1 cm deep. **flesh** up to 2.5 cm thick, soft or tough, whitish to pale yellow; odor faintly sweet or not distinctive, taste not distinctive.

MICROSCOPIC FEATURES: Spores 4.5–7 × 1.5–2.5 μm, cylindric to allantoid, smooth, hyaline, inamyloid.

HABIT, HABITAT, AND SEASON: Solitary, in groups, or in overlapping clusters, broadly attached to decaying broadleaf trees; year-round.

EDIBILITY: Edible.

COMMENTS: Saprotrophic, causing a white rot of decaying wood. *Ischnoderma* means "having wrinkled skin." The epithet *resinosum* means "having resin," a reference to the drops of amber fluid. *Ischnoderma benzoinum* (not illustrated) has a more northern distribution, a darker upper surface, a thinner sharp margin, and darker flesh in mature specimens, and it grows on conifers.

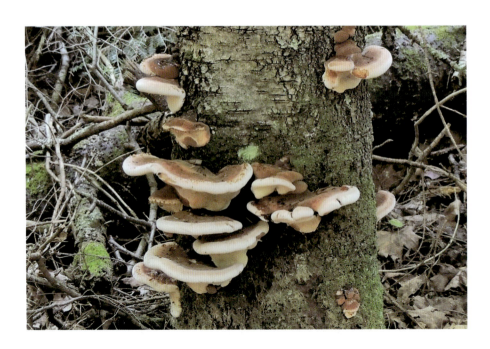

Laeticutis cristata (Schaeff.) Audet

= *Albatrellus cristatus* (Schaeff.) Kotl. & Pouzar
= *Polyporus cristatus* (Schaeff.) Fr.
= *Scutiger cristatus* (Schaeff.) Bondartsev & Singer

COMMON NAME: Crested Polypore

MACROSCOPIC FEATURES: fruit body annual, consisting of a cap and stalk, growing on the ground with broadleaf trees or conifers. **cap** 5–20 cm wide and up to 2 cm thick, convex to slightly depressed, irregularly rounded to fan-shaped. **upper surface** azonate, finely matted and woolly, often forming coarse scales or cracks, especially at the center, yellowish green to olive or brown; margin thin, incurved, wavy and often lobed. **fertile surface** decurrent, white to yellowish or greenish yellow. **pores** circular to angular, 2–4 per mm, becoming torn in age; **tubes** up to 6 mm deep. **stalk** 2.5–10 cm long and 1–2.5 cm thick, central or eccentric, simple or sometimes branched, smooth, whitish to greenish or olive brown. **flesh** tough, whitish, staining yellowish green; odor not distinctive, taste bitter or not distinctive.

MICROSCOPIC FEATURES: Spores 5–7 × 4–5 µm, broadly elliptic to subglobose, smooth, hyaline, weakly amyloid.

HABIT, HABITAT, AND SEASON: Solitary or in fused clusters on the ground with broadleaf trees or in mixed woods, especially with oaks, rarely with conifers; summer–early winter.

EDIBILITY: Inedible.

COMMENTS: Mycorrhizal, not a wood-rotting fungus. The epithet *cristata* means "crested." The Goat's Foot, *Scutiger pes-caprae* (not illustrated), has a woolly to scaly, reddish brown to dark brown cap. The fertile surface is subdecurrent, white to yellowish or pinkish, bruising grayish yellow or pale greenish yellow. It has large, angular to hexagonal pores, 1–2 mm wide, an eccentric or lateral stalk, white to yellowish or orangish and often enlarged at the base. Flesh is creamy white, staining pinkish. This species grows on the ground with conifer or broadleaf trees.

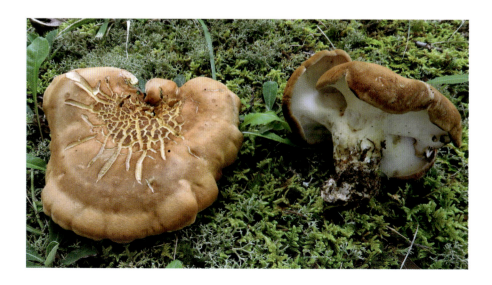

Laetiporus gilbertsonii var. *pallidus* Burds.

COMMON NAME: Southern Chicken
MACROSCOPIC FEATURES: fruit body a cluster of overlapping shelf-like caps on oak trees. **cap** up to 20 cm wide, fan- to hoof-shaped or an irregular mass, broadly convex or somewhat flattened. **upper surface** bald, smooth, orange to pale orange, becoming zonate, nearly white, then brown in age; margin thick, rounded, sharpening at maturity. **fertile surface** bumpy, uneven, orange to pale orange, turning cream to whitish and eventually browning. **pores** circular to angular, 2–4 per mm; **tubes** up to 6 mm deep. **stalk** lateral, rudimentary, narrowed at the point of attachment. **flesh** up to 2 cm thick, soft when young, brittle at maturity, pale yellow to whitish; odor and taste not distinctive.
MICROSCOPIC FEATURES: Spores 5–6.5 × 3.5–4.5 μm, broadly ovoid, smooth, hyaline, inamyloid.
HABIT, HABITAT, AND SEASON: In overlapping clusters or sometimes solitary on standing trunks or logs of oaks, especially Live Oak, *Quercus virginiana*; year-round.
EDIBILITY: Edible with caution. While this mushroom is not toxic, allergic reactions to it are more commonly reported than with *Laetiporus sulphureus*.
COMMENTS: Pathogenic, causing a brown rot. *Gilbertsonii* honors American mycologist Robert Lee Gilbertson (1925–2011). *Pallidus* means "pale." The White-pored Sulfur Shelf, *Laetiporus cincinnatus* (see Color Key), forms a large rosette cluster of stalked, fused, shelf-like caps with a bright orange to pinkish orange upper surface. It has a white to pale cream fertile surface that bruises brown and circular pores, and it grows on the ground attached to roots at the base of oak trees or stumps, rarely with other broadleaf trees. The Chicken Mushroom or Sulfur Shelf, *Laetiporus sulphureus* (see Color Key), has a bright to dull orange upper surface, a bright sulfur yellow fertile surface, and angular pores, and it grows on broadleaf trees, especially oaks. Both species are edible. Also compare with *Piptoporellus* species.

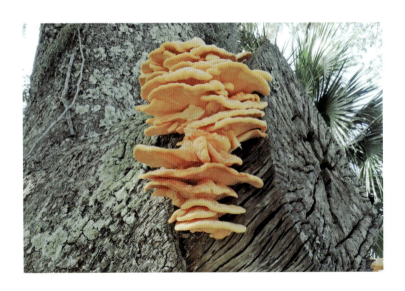

Laetiporus persicinus (Berk. & M. A. Curtis) Gilb.

= *Polyporus persicinus* Berk. & M. A. Curtis

MACROSCOPIC FEATURES: **fruit body** annual, a large cap with a central stalk usually attached to the roots of oak trees. **cap** 10–26 cm wide, circular to fan-shaped, soft and fleshy when young, tough in age. **upper surface** dry, matted and woolly, azonate to faintly zoned, smooth at first, becoming uneven with wart-like bumps in age, pinkish brown with a whitish to pinkish cream margin when young, becoming darker brown with a blackish brown margin at maturity. **fertile surface** strongly decurrent, whitish to pinkish cream, changing to pale pinkish yellow, then pale brown, quickly staining dark brown when bruised, sometimes exuding amber droplets. **pores** circular, 3–4 per mm; **tubes** up to 8 mm deep. **stalk** up to 10 cm long and 3–7 cm thick, solid, central, sometimes branched, dry, pinkish brown, often binding leaves and soil at the base. **flesh** up to 2 cm thick, soft, whitish; odor variously described as resembling ham or bacon or not distinctive, taste unpleasant or not distinctive.

MICROSCOPIC FEATURES: Spores 6.5–8 × 4–5 μm, ovoid to ellipsoid, smooth, hyaline, inamyloid.

HABIT, HABITAT, AND SEASON: Solitary, scattered, or in overlapping clusters, attached to exposed or buried roots at or near the base of living oaks or pine trees; year-round.

EDIBILITY: Edible. The taste is variously described as sour, like fermented ham, or delicious.

COMMENTS: Pathogenic, causing a brown root and butt rot of living trees. The vaguely similar Rooting Polypore, *Polyporus radicatus* (see Color Key), has a white to creamy yellow fertile surface, angular pores, and tough white flesh. Additional information about the Rooting Polypore is discussed in the Comments section for *Coltricia montagnei*.

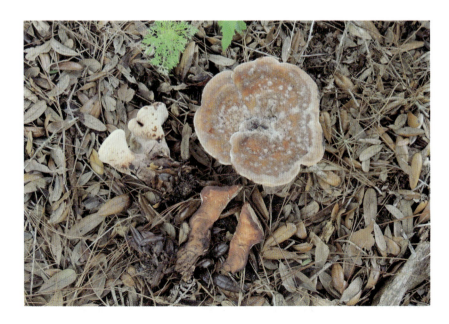

Lentinus arcularius (Batsch) Zmitr.

= *Polyporus arcularius* (Batsch) Fr.

COMMON NAME: Spring Polypore

MACROSCOPIC FEATURES: fruit body annual, consisting of a cap and prominent stalk attached to wood. **cap** 1.5–7.5 cm wide, circular or nearly so, broadly convex to shallowly funnel-shaped. **upper surface** dry, covered with small radiating scales, ocher-brown to dark yellow-brown; margin fringed with short hairs. **fertile surface** white to cream, darkening in age. **pores** angular to hexagonal and radially arranged like a honeycomb, decurrent, 1–2 per mm; **tubes** up to 2 mm deep. **stalk** up to 4 cm long and 2–5 mm thick, nearly equal or with an enlarged base, central, solid, scurfy, colored like the cap. **flesh** up to 1 mm thick, tough to leathery, creamy white; odor and taste not distinctive.

MICROSCOPIC FEATURES: Spores 7–11 × 2–3 μm, cylindric, smooth, hyaline, inamyloid.

HABIT, HABITAT, AND SEASON: In groups or clusters on fallen branches, logs, and stumps of decaying broadleaf trees; spring–early summer.

EDIBILITY: Inedible.

COMMENTS: Saprotrophic, causing a white rot. The epithet *arcularius* means "having chambers or vaults," a reference to the honeycomb fertile surface. *Neofavolus alveolaris* usually has an orange-yellow to reddish orange cap when fresh and a short lateral stalk.

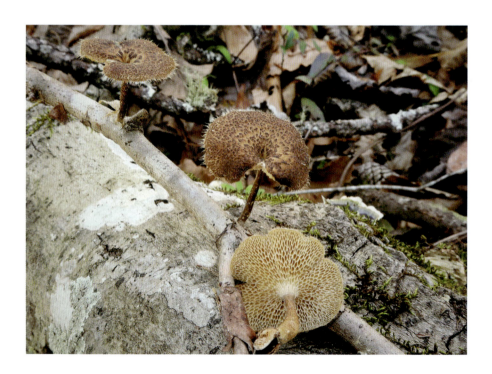

Lentinus brumalis (Pers.) Zmitr.

= *Polyporus brumalis* (Pers.) Fr.

COMMON NAME: Winter Polypore
MACROSCOPIC FEATURES: fruit body annual, consisting of a cap and prominent stalk attached to wood. **cap** 2.5–7.5 cm wide and 8 mm thick, convex to nearly flat or centrally depressed. **upper surface** finely hairy to minutely scaly, sometimes obscurely zonate, yellow-brown to gray-brown or blackish; margin incurved, often finely scalloped and appearing minutely fringed. **fertile surface** decurrent, glancing, white to creamy white. **pores** angular to irregular, 2–4 per mm, becoming torn; **tubes** up to 2 mm deep. **stalk** 1.2–5 cm long and up to 5 mm thick, central or slightly eccentric, nearly equal or enlarged at the point of attachment, smooth or finely hairy, colored like the cap or paler. **flesh** up to 3 mm thick, tough, corky, white; odor and taste not distinctive.
MICROSCOPIC FEATURES: Spores 6–8 × 2–2.5 µm, cylindric to slightly curved, smooth, hyaline, inamyloid.
HABIT, HABITAT, AND SEASON: Solitary, in groups, or in clusters on decaying broadleaf wood; late winter–spring.
EDIBILITY: Inedible.
COMMENTS: Saprotrophic, causing a white rot. The epithet *brumalis* means "occurring in winter." *Lentinus arcularius* is similar, but it has a paler cap surface and larger pores that are radially aligned.

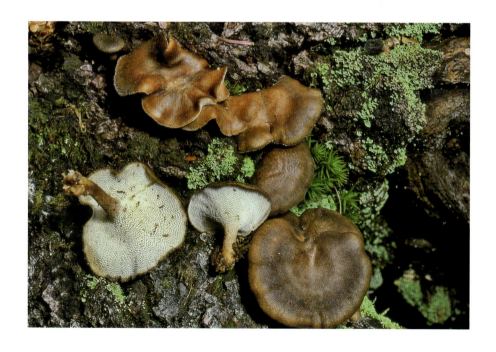

Microporellus obovatus (Jungh.) Ryvarden

= *Polyporus obovatus* (Jungh.) P. Karst.

MACROSCOPIC FEATURES: fruit body annual, with a cap and lateral stalk attached to wood. **cap** 2–7 cm wide, spoon- to fan-shaped, kidney-shaped or nearly circular, tough and brittle. **upper surface** finely velvety but nearly bald in age, white when young, becoming creamy white to ochraceous, sometimes zonate with darker grayish or brownish zones; margin thin, sharp. **fertile surface** initially white, then creamy white to pale straw-colored. **pores** angular, minute, 6–8 per mm; **tubes** up to 3 mm deep. **stalk** up to 7 cm long and 2–6 mm thick, lateral or eccentric, occasionally rudimentary, usually colored like the cap. **flesh** up to 3 mm thick, tough, white; odor and taste not distinctive.

MICROSCOPIC FEATURES: Spores 3.5–5 × 2–4.5 μm, subglobose to ellipsoid, smooth, hyaline, inamyloid.

HABIT, HABITAT, AND SEASON: Solitary, in small groups or clusters on dead wood in broadleaf or mixed woods; year-round.

EDIBILITY: Inedible.

COMMENTS: Saprotrophic on decaying broadleaf wood. *Obovatus* means "egg-shaped with the broad end up." *Microporellus dealbatus* (see Color Key) has a central or rarely lateral stalk and a darker, larger, 2–16 cm wide cap that is concentrically zoned. It has a white to ochraceous fertile surface, angular to rounded pores, and white flesh. It grows on the ground or well-decayed stumps and has slightly larger ellipsoid to lacrimoid spores, 4.5–6 × 3.5–4.5 μm. *Loweomyces fractipes* (see Color Key) has a 1–6 cm wide cap and is semicircular to fan- or kidney-shaped, azonate, white to straw-colored. The white to creamy fertile surface has larger pores, 4–5 per mm. Its stalk is up to 6 cm long, central or lateral, tapered downward, and white or ochraceous. Spores are ovoid to broadly ellipsoid, 4.5–6 × 4–5 μm. It grows on branches and logs of broadleaf trees or from buried wood or roots.

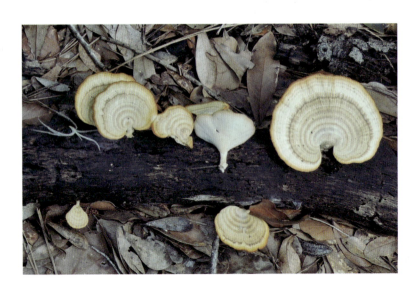

Neoantrodia serialiformis (Kout & Vlasák) Audet

= *Antrodia serialiformis* Kout & Vlasák

MACROSCOPIC FEATURES: **fruit body** perennial, effused-reflexed with small, stalkless caps in the upper part, often elongated 20 cm or more on the substrate. **cap** up to 2 cm wide, very tough; margin narrow, sharp, white. **upper surface** slightly matted and woolly to bald, azonate or faintly zonate, uniformly dark brown. **fertile surface** white, becoming sordid brown in age. **pores** circular, 3–4 per mm; **tubes** up to 5 mm deep. **flesh** up to 1 mm thick, white; odor and taste not distinctive.

MICROSCOPIC FEATURES: Spores 4.5–6 × 2–2.5 μm, ellipsoid to subfusiform, hyaline.

HABIT, HABITAT, AND SEASON: On barkless oak trunks and logs; fall–spring, sometimes year-round.

EDIBILITY: Inedible.

COMMENTS: Saprotrophic, causing a white rot of oaks. *Neoantrodia serialis* (not illustrated) is initially resupinate, then forms an effused-reflexed fruit body that is knobby or rounded and sloped forward. The upper surface is slightly matted and woolly or bald, faintly zonate, and ochraceous to pale cinnamon brown. The fertile surface is white to buff. Pores are slightly larger at 2–3 per mm, and the white to ocher flesh is 1–4 mm thick. Spores are larger at 6.3–8(–10) × 2.2–4 μm. While this species is usually saprotrophic on conifer wood, causing a brown cubical rot, it occasionally appears on broadleaf logs, especially aspens. It typically occurs in habitats at higher elevations.

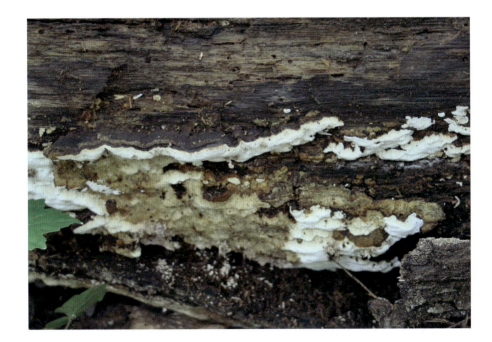

Neofavolus alveolaris (DC.) Sotome & T. Hatt.

= *Hexagonia alveolaris* (DC.) Murrill
= *Polyporus alveolaris* (DC.) Bondartsev & Singer

COMMON NAME: Hexagonal-pored Polypore
MACROSCOPIC FEATURES: fruit body annual, consisting of a cap and short stalk attached to wood. **cap** 2–6.5 cm wide, convex, often centrally depressed, circular to fan- or kidney-shaped. **upper surface** coated with flattened scales or radial fibers, azonate, orange-yellow to reddish orange, fading to pale yellow, tan, or whitish in age; margin inrolled when young, somewhat fringed when mature. **fertile surface** decurrent, creamy white to pale yellow or tan. **pores** angular to hexagonal and radially arranged, 1–2 per mm, becoming torn in age; **tubes** up to 5 mm deep. **stalk** up to 2 cm long, but typically shorter, 3–7 mm thick, lateral or sometimes central, nearly equal, solid, whitish. **flesh** tough, creamy white to buff; odor and taste not distinctive.
MICROSCOPIC FEATURES: Spores 11–14.5 × 4–5 μm, cylindric, smooth, hyaline, inamyloid.
HABIT, HABITAT, AND SEASON: Solitary or in groups on fallen branches of broadleaf trees, especially beeches and oaks; spring–late fall.
EDIBILITY: Edible but tough.
COMMENTS: Saprotrophic on decaying broadleaf wood. The epithet *alveolaris* means "having small pits or hollows." *Lentinus arcularius* has a darker brownish cap and a longer stalk.

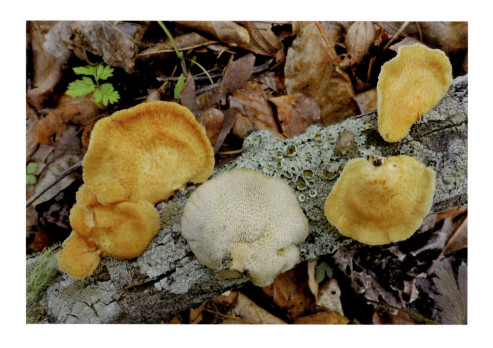

Nigroporus vinosus (Berk.) Murrill

= *Polyporus vinosus* Berk.

COMMON NAME: Dark Violet Polypore

MACROSCOPIC FEATURES: fruit body annual, stalkless, shelf-like, 2–12 cm wide, up to 1 cm thick, semicircular to fan- or kidney-shaped, tough or leathery, becoming brittle as it dries. **upper surface** velvety to nearly bald, typically zonate, with shallow concentric grooves and ridges, violet to vinaceous brown at first, purplish brown to dark violet at maturity; margin sharp, whitish when actively growing. **fertile surface** purplish brown to dark violet. **pores** irregularly rounded, 7–8 per mm; **tubes** up to 4 mm deep. **flesh** up to 6 mm thick, vinaceous brown or paler; odor and taste not distinctive.

MICROSCOPIC FEATURES: Spores 3.5–4.5 × 1–1.5 μm, allantoid to cylindric, smooth, hyaline, inamyloid.

HABIT, HABITAT, AND SEASON: Solitary, in groups, or in overlapping clusters on broadleaf wood or sometimes on conifers; late spring–early winter.

EDIBILITY: Inedible.

COMMENTS: Saprotrophic on decaying wood. *Nigroporus* means "having a dark fertile surface." The epithet *vinosus* means "wine red." The Parchment Fungus *Xylobolus subpileatus* is similar but thinner and lacks pores on its fertile surface; use a hand lens to be sure.

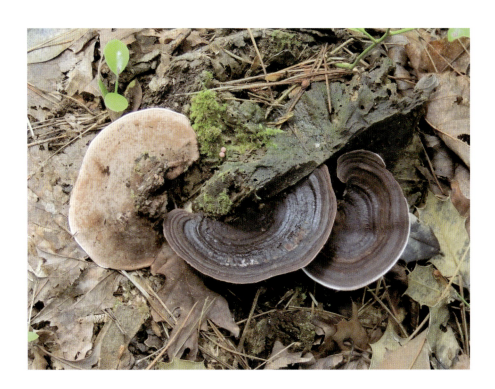

Onnia circinata (Fr.) P. Karst.

= *Inonotus circinatus* (Fr.) Teng

MACROSCOPIC FEATURES: fruit body annual, up to 20 cm wide and 2 cm thick, usually stalkless, semicircular to fan-shaped. **upper surface** matted and woolly or bald, light buff to tan or reddish brown, azonate or faintly zonate; margin blunt, sometimes lobed. **fertile surface** buff to yellowish brown, becoming darker brown when bruised or in age. **pores** angular, 3–4 per mm; **tubes** up to 1 cm deep. **stalk** when present rudimentary, lateral or central, matted, woolly, ochraceous to dark rusty brown. **flesh** up to 1 cm thick, spongy or firm and corky, brown.

MICROSCOPIC FEATURES: Spores 5–7 × 3–4 μm, ellipsoid to ovoid, smooth, hyaline, inamyloid; setae 50–80 × 12–20 μm, awl-shaped, mostly hooked, scattered, frequent.

HABIT, HABITAT, AND SEASON: Solitary or in groups on conifer trunks or stumps, especially pines, or on the ground at the base of those trees; year-round.

EDIBILITY: Inedible.

COMMENTS: Pathogenic, causing a white rot of conifers. The epithet *circinata* means "curled inward or hooked," a reference to the setae. *Onnia tomentosa* (see Color Key) has a 4–17 cm wide, tan to ochraceous or rusty brown, circular to fan-shaped fruit body with a short stalk, nearly identical spores, and setae that are straight, not hooked. It usually grows attached to the roots or trunks of conifers. Recent molecular analysis suggests that *Onnia tomentosa* associates only with spruces, while similar *Onnia subtriquetra* (not illustrated) associates exclusively with pines. Also, *Onnia subtriquetra* has hooked setae. The Dye Maker's Polypore, *Phaeolus schweinitzii* (see Color Key), has a 4–26 cm wide, circular to fan-shaped, nearly flat fruit body with a rudimentary or distinct stalk up to 7 cm long. It is solitary or sometimes forms rosettes on conifer roots or on the ground attached to buried roots. It has an orange or brown fertile surface, angular pores, and brown flesh.

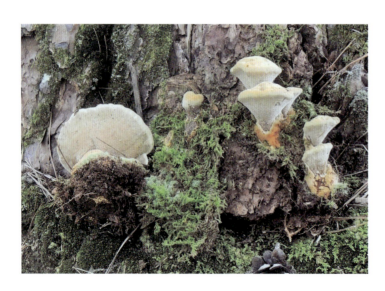

Osmoporus mexicanus (Mont.) Y. C. Dai & S. H. He

= *Gloeophyllum mexicanum* (Mont.) Ryvarden
= *Lenzites mexicana* Mont.

MACROSCOPIC FEATURES: **fruit body** annual or perennial, 3–10 cm wide, stalkless, fan-shaped, often laterally fused and elongated on the substrate, broadly attached, tough to woody. **upper surface** finely matted and woolly when young, especially along the margin, soon becoming bald and roughened, often shallowly furrowed, grayish at first, developing concentric zones of dull brown to rusty brown, gray, or blackish; margin thin, sharp, often wavy. **fertile surface** ochraceous to reddish brown. **pores** distinctly gill-like and maze-like, fairly thick-walled and sometimes forked, occasionally rounded near the margin, 0.5–1.2 per mm, up to 1 cm deep. **flesh** 2–6 mm thick, leathery, tough, yellow-brown to pale rusty brown; odor and taste not distinctive.

MICROSCOPIC FEATURES: Spores 9–12.5 × 3.5–4 μm, cylindric, slightly curved, smooth, hyaline, inamyloid; cystidia 20–60 × 3.5–6 μm, awl-shaped to obtuse, hyaline to pale brown, walls thicker toward the base.

HABIT, HABITAT, AND SEASON: Solitary, in groups, or in overlapping clusters on decaying conifer wood, especially pines, often on processed timbers, including posts, poles, and railway ties; year-round.

EDIBILITY: Inedible.

COMMENTS: Saprotrophic, causing a brown rot. The epithet *mexicanus* means "of Mexico," referring to where this polypore was first collected and described. The very similar *Gloeophyllum sepiarium* differs by having more brightly colored caps and cap margins in young specimens and a typically more labyrinthine fertile surface. *Trametes betulina* is more colorful yet thinner and almost always grows on the wood of broadleaf trees.

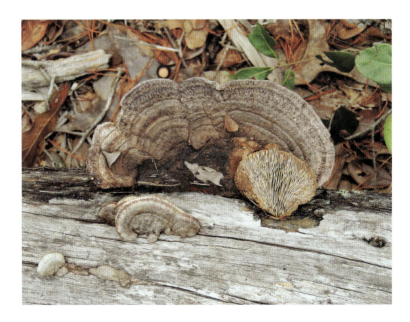

Panellus pusillus (Pers. ex Lév.) Burds. & O. K. Mill.

= *Dictyopanus pusillus* (Pers. ex Lév.) Singer
= *Gloeoporus pusillus* Pers. ex Lév.

MACROSCOPIC FEATURES: **fruit body** annual, a small cap with an eccentric to lateral stalk attached to decaying broadleaf wood. **cap** 3–16 mm wide, convex, semicircular to kidney- or fan-shaped. **upper surface** moist or dry, bald or finely velvety, smooth or finely wrinkled, sometimes with 1 or 2 very shallow concentric furrows, white to whitish when young, later pinkish buff to pale salmon; margin incurved, sometimes concentrically furrowed or splitting. **fertile surface** whitish to pale pinkish buff. **pores** angular, somewhat radially aligned, 2–5 per mm; **tubes** up to 1 mm deep. **stalk** up to 6 mm long and 1–2 mm thick, enlarged downward or nearly equal, finely velvety, colored like the cap. **flesh** up to 2 mm thick, firm, white; odor and taste not distinctive.

MICROSCOPIC FEATURES: Spores 4.5–6 × 2–3 µm, oblong to ellipsoid, smooth, hyaline.

HABIT, HABITAT, AND SEASON: In dense groups and overlapping clusters on decaying broadleaf branches, logs, stumps, and trunks; summer–fall, sometimes year-round in coastal areas.

EDIBILITY: Unknown.

COMMENTS: Saprotrophic on decaying broadleaf wood. The epithet *pusillus* means "very small." It is bioluminescent.

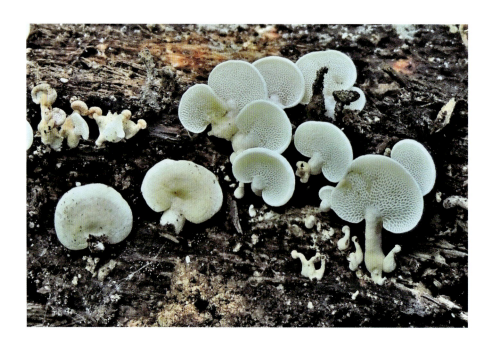

Pappia fissilis (Berk. & M. A. Curtis) Zmitr.

= *Aurantiporus fissilis* (Berk. & M. A. Curtis) H. Jahn ex Ryvarden
= *Polyporus fissilis* Berk. & M. A. Curtis
= *Tyromyces fissilis* (Berk. & M. A. Curtis) Donk

MACROSCOPIC FEATURES: fruit body annual, stalkless, broadly attached to wood, up to 20 cm wide, 4–13 cm thick at the base, shelf-like to hoof-shaped, sappy to waxy and tough when fresh. **upper surface** matted and woolly or covered with short, soft, downy hairs, typically rough and tufted, uneven and wavy, white at first, becoming creamy white to ochraceous, sometimes with a pinkish tinge; margin variable, thick or thin, rounded or sharp. **fertile surface** white at first, then creamy white or tinged with pink, often splitting when mature. **pores** round to angular, 2–3 per mm; **tubes** up to 1 cm deep. **flesh** up to 5 cm thick, white to creamy white or with a pinkish tint, often with fine radial zones; odor slightly sweet or not distinctive, taste not distinctive.

MICROSCOPIC FEATURES: Basidiospores 4–6 × 3–4 µm, ellipsoid to subglobose, smooth, hyaline, inamyloid; chlamydospores present in the flesh, 4–10 µm, globose, slightly thick-walled, smooth, inamyloid.

HABIT, HABITAT, AND SEASON: Solitary or overlapping along a common base on broadleaf trees, especially oaks, not known to occur on locust trees; late spring–fall, sometimes year-round.

EDIBILITY: Inedible.

COMMENTS: Pathogenic, causing a white rot. The epithet *fissilis* means "tending to split." Other cheese polypores native to Georgia, including *Tyromyces chioneus*, *Postia livens*, and *Fuscopostia fragilis*, lack pinkish tinges and differ in other details as well.

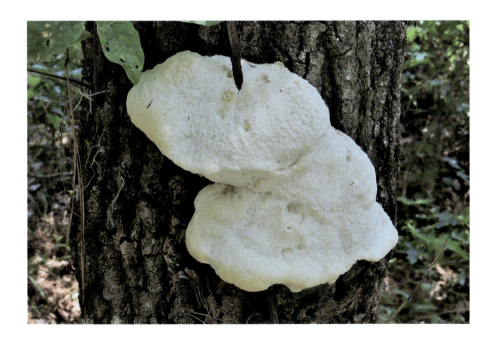

Phellinus igniarius (L.) Quél.

= *Fomes igniarius* (L.) Fr.

COMMON NAME: Flecked-flesh Polypore
MACROSCOPIC FEATURES: **fruit body** perennial, stalkless, hoof-shaped to shelf-like, up to 20 cm wide and 8 cm thick. **upper surface** bald and smooth at first, developing concentric grooves and ridges, encrusted and deeply cracked in age, gray or blackish; margin thick, rounded, colored like the upper surface or yellowish brown. **fertile surface** pale brown to dark purplish brown. **pores** circular, 5–6 per mm; **tubes** up to 4 mm deep. **flesh** up to 2 cm thick, hard and woody, zonate, dark reddish brown with white flecks; odor and taste not distinctive.
MICROSCOPIC FEATURES: Spores 9–10 × 6–7 µm, broadly ovoid to subglobose, thick-walled, smooth, hyaline, inamyloid; setae 14–17 × 4–6 µm, ventricose to awl-shaped.
HABIT, HABITAT, AND SEASON: Solitary or in groups on broadleaf trees; year-round.
EDIBILITY: Inedible.

COMMENTS: Pathogenic, causing a white rot. The epithet *igniarius* means "pertaining to fire." Similar parasites of broadleaf trees include the Cracked-cap Polypore, *Fulvifomes robiniae* = *Phellinus robiniae* (see Color Key), a Black Locust (*Robinia pseudoacacia*) specialist, which is up to 40 cm wide, hoof- or shelf-like, and woody. The upper surface is dull, encrusted, with concentric grooves and ridges, deeply cracked and yellowish brown to blackish. It has a brown fertile surface, circular pores, 7–8 per mm, and brown flesh without white flecks. *Fulvifomes everhartii* = *Phellinus everhartii* (see Color Key) is stalkless, woody, and hoof-shaped, up to 13 cm wide and 8 cm thick. The upper surface is finely matted or bald, encrusted, with concentric grooves and ridges, cracked, and yellowish brown to black in age. It has a brown fertile surface, 5–6 circular pores per mm, and reddish brown flesh without white flecks. The spores are 4–5 × 3–4 µm, and it grows on broadleaf trees. See also *Fomes fasciatus*.

Piptoporellus species

COMMON NAME: Mystery Chick

MACROSCOPIC FEATURES: fruit body annual, up to 30 cm wide and 3.5 cm thick, attached to wood. **cap** convex to nearly flat, often laterally fused, 5–15 cm wide, shelf-like, semicircular to fan-shaped or triangular, soft when young, becoming tough in age. **upper surface** dry, often wrinkled, roughened and pitted, azonate or faintly zoned, bright orange, fading to orange-yellow, then whitish with brownish hues, and finally brown in age; margin inrolled at first, blunt, wavy, often lobed, often becoming markedly distorted as it ages, pale to dark orange. **fertile surface** pale orange, becoming whitish as it matures. **pores** circular to angular, 4–5 per mm, sometimes becoming lacerate and teeth-like in age; **tubes** less than 1 mm deep. **stalk** often absent or rudimentary, sometimes up to 6 cm long and 4 cm wide, colored like the cap. **flesh** up to 2.5 cm thick, woody or tough, faintly zonate, pale orange, darkest toward the margin, staining darker orange when exposed; odor sweet or not distinctive, taste tart and astringent.

MICROSCOPIC FEATURES: Spores 3.5–5.5 × 2.5–3.5 µm, ellipsoid, smooth, hyaline, inamyloid.

HABIT, HABITAT, AND SEASON: Solitary, in groups, or in overlapping clusters on decorticated trunks, logs, and stumps of Live Oaks (*Quercus virginiana*); year-round.

EDIBILITY: Edible.

COMMENTS: Saprotrophic on decaying wood. It is an undescribed species that commonly occurs in Georgia and throughout the Gulf Coast states. At the time of this writing, it has not been formally published. Compare with *Laetiporus sulphureus* (see Color Key), which has a bright sulphur yellow fertile surface, tubes up to 4 mm deep, white flesh, and larger spores that measure 5–8 × 3.5–5 µm. Also compare with *Laetiporus gilbertsonii* var. *pallidus*, which has orange upper and fertile surfaces, pale yellow to whitish flesh, and larger pores with deeper tubes.

Postia livens group Vlasák & Miettinen

COMMON NAME: Blue Cheese Polypore
MACROSCOPIC FEATURES: fruit body annual, stalkless, 2–8 cm wide, shell-shaped, broadly convex to somewhat flattened, soft and spongy, attached to wood. **upper surface** matted and woolly to hairy or sometimes nearly bald, smooth, whitish, typically with bluish tints, sometimes bruising intensely blue; margin sharp. **fertile surface** whitish to pale gray, usually staining blue. **pores** angular, sometimes split or torn, 4–6 per mm; **tubes** up to 6 mm deep. **flesh** up to 1.5 cm thick, soft, spongy, watery when fresh, white, becoming yellowish or grayish in age; odor usually fragrant but not always distinctive, taste not distinctive.
MICROSCOPIC FEATURES: Spores 4–7 × 1–2 μm, cylindric to allantoid, smooth, hyaline, inamyloid.
HABIT, HABITAT, AND SEASON: Solitary or in groups on conifer or broadleaf wood; summer–early winter.
EDIBILITY: Inedible.
COMMENTS: Saprotrophic on decaying conifers and broadleaf trees. The epithet *livens* means "grayish bluish." *Postia caesia* is a European species that does not occur in North America. A recent publication by Miettinen et al. (2018) demonstrates that what has been called *Postia caesia* in eastern North America is a group of at least four macroscopically and microscopically similar species. *Postia livens* may be the most commonly occurring member of this group. Sprague's Polypore, *Niveoporofomes spraguei* (see Color Key), has a firm and tough, stalkless, whitish to ivory fruit body, usually with greenish blue stains. It has a white to buff or pale brown fertile surface, corky to tough, white to pale ochraceous flesh, circular to angular pores, and a predilection for broadleaf wood. *Fuscopostia fragilis* has a whitish to buff cap and fertile surface that bruises or dries reddish brown.

Spongipellis pachyodon (Pers.) Kotl. & Pouzar

= *Sarcodontia pachyodon* (Pers.) Spirin

COMMON NAMES: Marshmallow Polypore, Spongy Toothed Polypore

MACROSCOPIC FEATURES: fruit body a leathery to tough spreading crust of effused-reflexed overlapping caps on wood. **cap** 2–5 cm wide, fan-shaped, convex. **upper surface** azonate, nearly bald, white to creamy white, becoming ochraceous to brownish in age; margin sharp and somewhat incurved. **fertile surface** white to creamy white, darkening in age, often gill-like or poroid near the margin but not always readily apparent, even on young specimens, soon breaking up and forming conspicuous flattened teeth, teeth up to 1.5 cm long. **flesh** 3–8 mm thick, leathery to tough, white to pale cream; odor and taste not distinctive.

MICROSCOPIC FEATURES: Spores 5–7 × 5–6.5 μm, subglobose, thick-walled, smooth, hyaline, inamyloid, with a large oil drop, cyanophilous in cotton blue.

HABIT, HABITAT, AND SEASON: Solitary, in groups, or in overlapping clusters on living broadleaf trees, especially oaks; year-round.

EDIBILITY: Inedible.

COMMENTS: Pathogenic, causing a white trunk rot. The epithet *pachyodon* means "thick teeth." The Milk-white Toothed Polypore, *Irpex lacteus* (see Color Key), is similar but has much smaller teeth, up to 3 mm long. *Xylodon paradoxus* is similar as well, but its fruit body is a white to creamy white spreading crust that is flat or somewhat projecting and bracket-like and that darkens in age. It usually has small nodules on the upper surface and tiny hairs on the margin, and the creamy white undersurface is maze-like with irregular and angular elongated pores that sometimes form teeth-like projections. Also see the Comments under *Xylodon paradoxus* for mention of *Radulomyces copelandii* (not illustrated).

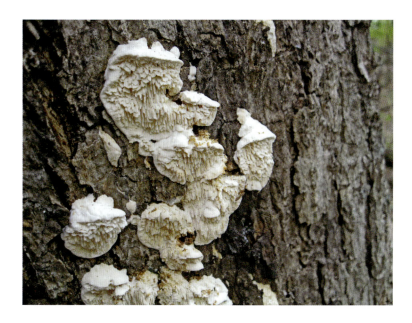

Trametes betulina (L.) Pilát

= *Lenzites betulina* (L.) Fr.
= *Lenzites betulinus* (L.) Fr.

COMMON NAMES: Gilled Bracket, Multicolor Gill Polypore

MACROSCOPIC FEATURES: **fruit body** annual, 3–10 cm wide, stalkless, kidney-shaped to semicircular, nearly flat, tough and flexible. **upper surface** velvety to hairy with distinct multicolored concentric zones of variable color, often white, pink, gray, yellow, orange, or brown, sometimes green when covered with algae; margin sharp. **fertile surface** white to creamy white. **pores** thin, gill-like, sometimes forking, occasionally with elongated pores near the margin. **flesh** up to 2 mm thick, tough, white; odor and taste not distinctive.

MICROSCOPIC FEATURES: Spores 4–6 × 2–3 µm, cylindric to allantoid, smooth, hyaline, inamyloid.

HABIT, HABITAT, AND SEASON: Solitary or in groups on decaying broadleaf trees, especially birches, oaks, and willows, rarely on conifers; summer–early winter, sometimes year-round.

EDIBILITY: Inedible.

COMMENTS: Saprotrophic, causing a white rot. The epithet *betulina* means "associated with birch trees." It was originally described as growing on birch trees but is now known to fruit on many broadleaf species. *Daedaleopsis septentrionalis* (not illustrated) also grows on decaying birch wood, but its fruit body has a bald upper surface, grayish gill-like pores, and much larger spores measuring 7–12 × 2–3.5 µm. *Gloeophyllum* species have brown gill-like pores.

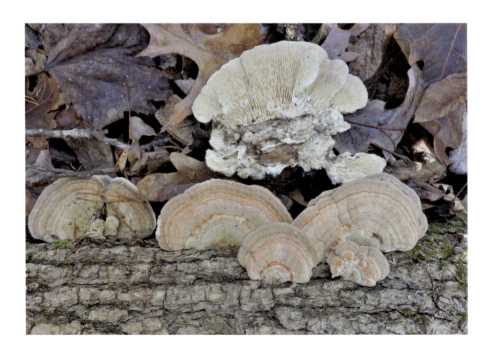

Trametes conchifer (Schwein.) Pilát

= *Poronidulus conchifer* (Schwein.) Murrill

COMMON NAME: Little Nest Polypore

MACROSCOPIC FEATURES: fruit body annual, stalkless, at first a small cup- to saucer-shaped sterile structure, after which a thin polypore cap develops out of one side. **cup** up to 1.6 cm wide, bald, smooth, concentrically zoned, brown at first, then white and brown. **cap** 1–5 cm wide, fan- to kidney-shaped, flattened, fibrous-tough. **upper surface** slightly velvety, smooth to radially wrinkled, concentrically zoned in contrasting colors, white to grayish white, yellowish or pale brown, sometimes forming secondary cups; margin thin, wavy. **fertile surface** white to yellowish tan. **pores** angular, 2–4 per mm; **tubes** up to 2 mm deep. **flesh** less than 1 mm thick, fibrous-tough, white; odor and taste not distinctive.

MICROSCOPIC FEATURES: Spores 5–7 × 1.5–2.5 μm, cylindric, smooth, hyaline, inamyloid.

HABIT, HABITAT, AND SEASON: In groups on decaying broadleaf branches; late spring–early winter.

EDIBILITY: Inedible.

COMMENTS: Saprotrophic on decaying broadleaf branches. The epithet *conchifer* means "shell-bearing," a reference to the tiny cups in the caps.

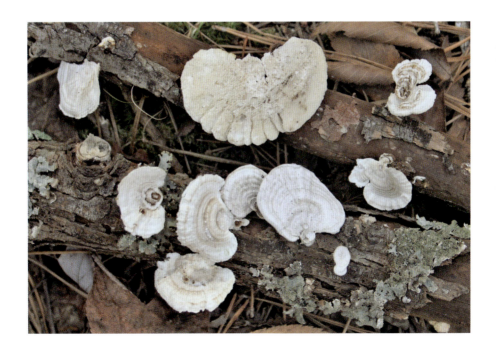

Trametes gibbosa (Pers.) Fr.

= *Daedalea gibbosa* (Pers.) Pers.

COMMON NAME: Lumpy Bracket
MACROSCOPIC FEATURES: fruit body annual to perennial, 5–20 cm wide and up to 3 cm thick, shelf-like, semicircular to fan- or kidney-shaped, corky when fresh, rigid when dry, attached to wood, sometimes by a short, stalk-like, thickened base. **upper surface** warted and uneven, distinctly velvety or fuzzy when observed with a hand lens, often concentrically zoned or with concentric grooves and ridges, sometimes nearly smooth near the margin, white to creamy white, buff, or very pale ochraceous, occasionally developing gray tints as it ages, frequently covered from the base outward with green algae; margin thin, sharp, even or lobed, whitish or brownish. **fertile surface** whitish to cream-colored, becoming grayish ocher in age. **pores** radially elongated and sometimes maze-like or nearly gill-like, especially near the margin, 1–3 per mm; **tubes** up to 5 mm deep. **flesh** up to 1.5 cm thick, tough to woody, white to pale cream; odor and taste not distinctive.
MICROSCOPIC FEATURES: Spores 4–5.5 × 2–2.5 μm, elliptic-cylindric, smooth, hyaline, inamyloid.
HABIT, HABITAT, AND SEASON: Solitary, scattered, or in groups on decaying broadleaf wood; year-round.
EDIBILITY: Inedible.
COMMENTS: The colors and fertile surface of *Trametes aesculi* (not illustrated) are very similar, but the upper surface is typically finely matted and woolly, rarely nearly bald. Spores are larger too, at 5–7 × 2–3 μm. See also *Trametes lactinea*. The perennial Mossy Maple Polypore, *Oxyporus populinus* (see Color Key), has a 3–20 cm wide, whitish to buff fruit body that is broadly attached to the substrate and often covered with mosses near the base or almost overall in age. It has circular to angular pores and stratified layers of tubes visible when the mature fruit body is vertically sectioned. It grows on standing broadleaf trees, especially maples.

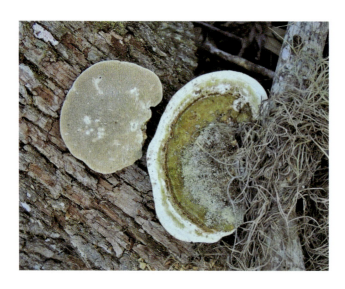

Trametes hirsuta (Wulfen) Lloyd

= *Polyporus hirsutus* (Wulfen) Fr.

COMMON NAME: Hairy Bracket
MACROSCOPIC FEATURES: fruit body annual, stalkless, 2–10 cm wide, shelf-like, semicircular, leathery and flexible when fresh. **upper surface** covered with coarse hairs, zonate, often with concentric grooves and ridges, sometimes bumpy and uneven, pale gray or brown, usually with darker or paler bands, occasionally with yellowish tints, sometimes greenish gray when coated with algae; margin thin, typically pale gray or yellowish brown. **fertile surface** white to tan, becoming grayish to dark gray in age. **pores** circular to angular, 3–4 per mm; **tubes** up to 6 mm deep. **flesh** up to 8 mm thick, duplex, upper layer soft-fibrous, grayish, separated from the lower layer by a thin black line at least at the base, lower layer corky, whitish; often with a pronounced anise odor when fresh but disappearing when dry, taste not distinctive.
MICROSCOPIC FEATURES: Spores 5–9 × 2–2.5 μm, cylindric, smooth, hyaline, inamyloid.
HABIT, HABITAT, AND SEASON: Solitary or in overlapping clusters on decaying broadleaf wood, rarely on conifers; year-round.
EDIBILITY: Inedible.
COMMENTS: Saprotrophic on decaying broadleaf wood. The epithet *hirsuta* means "having coarse hairs." The flesh of *Trametes pubescens* (see Color Key) is not duplex and lacks a thin black line. It also has slightly smaller spores, 5–7 × 1.5–2 μm.

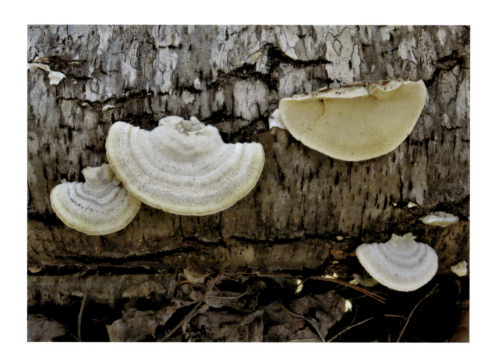

Trametes lactinea (Berk.) Sacc.

= *Leiotrametes lactinea* (Berk.) Welti & Courtec
= *Polyporus lactineus* Berk.

MACROSCOPIC FEATURES: **fruit body** annual, 5–25 cm wide, shelf-like, semicircular to fan- or kidney-shaped, sometimes forming rosettes of overlapping caps, stalkless. **upper surface** uneven and conspicuously warted to nearly smooth, bald, concentrically zoned and often shallowly furrowed, color highly variable with pale to dark brown or grayish bands on a whitish to grayish background, sometimes whitish nearly overall; margin variable, fairly thick and blunt or rounded on some specimens, thin on others, especially thin when growing on conifers, brown or whitish. **fertile surface** white to creamy white, becoming dull pale yellow to brownish in age. **pores** initially round, becoming angular at maturity, 2–3 per mm; **tubes** up to 1.5 cm deep. **flesh** 0.5–2.5 cm thick, corky, white to yellowish; odor and taste not distinctive.

MICROSCOPIC FEATURES: Spores 5–7 × 2.5–3.2 μm, oblong-elliptic to cylindric, smooth, hyaline, inamyloid.

HABIT, HABITAT, AND SEASON: Solitary, in groups, or in overlapping clusters broadly attached to trunks, logs, and stumps of decaying broadleaf trees or pines, sometimes on the ground arising from buried wood; year-round.

EDIBILITY: Inedible.

COMMENTS: Saprotrophic on decaying wood. Numerous publications and Internet postings have mistakenly identified this species as *Trametes cubensis*, a species that appears to be either very rare or absent in North America. See also *Trametes gibbosa*. The fruit body of Sweet Trametes, *Trametes suaveolens* (not illustrated), is up to 14 cm wide and 1.4 cm thick, semicircular or elongated, and stalkless, and it grows on broadleaf wood. The upper and fertile surfaces are creamy white to pale buff. The pores are circular to angular, 2–3 per mm, and the flesh is white to creamy white with a pleasant, anise-like odor. The spores are larger, 9–12 × 4–4.5 μm.

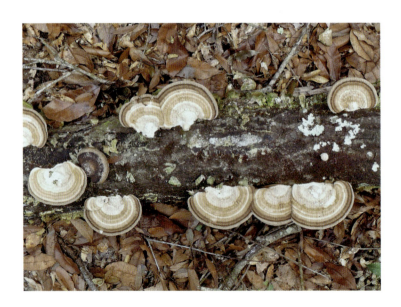

Trametes sanguinea (L.) Lloyd

= *Polyporus sanguineus* (L.) Fr.
= *Pycnoporus sanguineus* (L.) Murrill

COMMON NAMES: Cinnabar Bracket, Orange Polypore

MACROSCOPIC FEATURES: fruit body annual, stalkless, tough, up to 8 cm wide, typically less than 5 mm thick, convex to nearly flat and shelf-like, semicircular. **upper surface** dry, usually zonate, finely matted and woolly or nearly bald, typically roughened to wrinkled but sometimes smooth, orange-red to orange, fading to salmon buff in age; margin sharp, pale orange or whitish when actively growing. **fertile surface** dark red. **pores** circular, 5–6 per mm; **tubes** up to 2 mm deep. **flesh** up to 3 mm thick, fibrous-tough, zonate or azonate, orange-buff; odor and taste not distinctive.

MICROSCOPIC FEATURES: Spores 5–6 × 2–2.5 μm, cylindric to slightly allantoid, smooth, hyaline, inamyloid.

HABIT, HABITAT, AND SEASON: Solitary or in groups on broadleaf logs and branches; year-round.

EDIBILITY: Inedible.

COMMENTS: Saprotrophic, causing a white rot of decaying broadleaf trees. The epithet *sanguinea* means "blood red." The Cinnabar-red Polypore, *Trametes cinnabarina* = *Pycnoporus cinnabarinus* (see Color Key), has a larger and thicker, stalkless fruit body, up to 2 cm thick, and larger spores that measure 4.5–8 × 2.5–4 μm. It has an orange-red fertile surface, circular to angular pores, and reddish orange flesh, and it fruits on decaying broadleaf logs and branches. The Rosy Polypore, *Rhodofomes cajanderi* (see Color Key), has a 3–14(–20) cm wide, pinkish brown to reddish brown or grayish brown, stalkless fruit body that grows on decaying conifer wood. It has a rosy pink to pinkish brown fertile surface, angular pores, rosy pink to pinkish brown flesh, and allantoid spores that measure 4–7 × 1.5–2 μm.

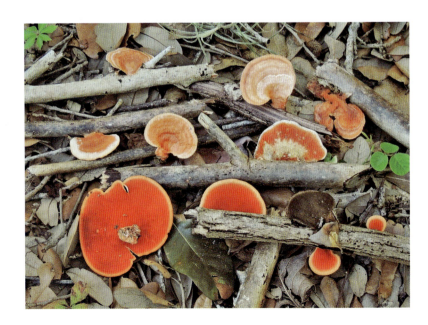

Trametes versicolor (L.) Lloyd

= *Polyporus versicolor* (L.) Fr.

COMMON NAME: Turkey-tail
MACROSCOPIC FEATURES: fruit body annual, stalkless, 2–10 cm wide, fan- to kidney-shaped, thin, tough, flexible, flattened, sometimes laterally fused and forming extensive rows. **upper surface** covered with silky to velvety, delicate, soft hairs, conspicuously zonate in a variable palette of colors: shades of orange, green, blue, brown, or gray; margin thin, sharp, wavy, sometimes folded or lobed. **fertile surface** white to buff or sometimes pale grayish. **pores** circular to angular, 4–5 per mm, often becoming slightly jagged as they age; **tubes** up to 3 mm deep. **flesh** up to 3 mm thick, tough, white to creamy white, with a thin brown to blackish layer between the upper surface and the flesh at least near the point of attachment, visible when the specimen is cut; odor and taste not distinctive.
MICROSCOPIC FEATURES: Spores 5–6 × 1.5–2 μm, cylindric to allantoid, smooth, hyaline.
HABIT, HABITAT, AND SEASON: Solitary, in groups, or in overlapping clusters, rows, or rosettes on wood; year-round.
EDIBILITY: Inedible.
COMMENTS: Pathogenic, causing white rot, as well as paperbark and sapwood rot syndrome on apple trees. The epithet *versicolor* means "of various colors." Turkey-tail is believed by many to have medicinal properties, but the scientific evidence remains incomplete. Beginners often confuse Turkey-tail with *Stereum* species, which lack pores on the fertile surface. *Trametes hirsuta* has a hairier cap and a fertile surface turning grayish in age. *Trametes pubescens* (see Color Key) has a finely hairy to smooth, azonate or faintly zoned cap, creamy white to yellowish buff. The upper surface of *Trametes versicolor* may have Fairy Pins, fruit bodies of *Phaeocalicium polyporaeum* (not illustrated), which resemble minuscule dark olive brown to blackish matchsticks. See the Comments section of *Trichaptum biforme* for additional information.

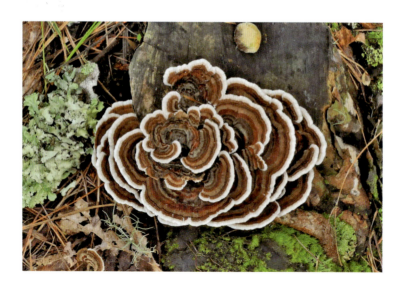

Trametes villosa (Sw.) Kreisel

= *Polyporus villosus* (Sw.) Fr.

MACROSCOPIC FEATURES: fruit body annual, stalkless, up to 7 cm wide and 1–2 mm thick, semicircular to fan-shaped, often fused laterally, flexible. **upper surface** covered with coarse, elongated, upright or somewhat flattened hairs, distinctly zonate, white to grayish or brown; margin thin, wavy or lobed. **fertile surface** white to cream, becoming brownish in age. **pores** angular, thin-walled, 1–3 per mm, often breaking up and becoming teeth-like; **tubes** up to 1 mm deep. **flesh** 1.5–3 mm thick, tough, flexible, white; odor and taste not distinctive.

MICROSCOPIC FEATURES: Spores 5.5–8.5 × 2.5–3.5 μm, cylindric to allantoid, smooth, hyaline.

HABIT, HABITAT, AND SEASON: In groups or clusters on decaying conifers or broadleaf wood; year-round.

EDIBILITY: Inedible.

COMMENTS: Saprotrophic on decaying conifers and broadleaf trees. The epithet *villosa* means "hairy or shaggy." This species is usually easy to recognize because of the thin, flexible fruit body with a hairy cap and large pores that become teeth-like in age. *Trametes hirsuta* has thicker and larger caps with smaller pores. *Trametopsis cervina* (not illustrated) is larger, thicker, more rigid, and also stalkless. The upper surface is covered with short, coarse hairs, faintly zonate or azonate, in shades of pinkish buff, pinkish cinnamon, or darker cinnamon. The fertile surface is buff to tan at first, then darker brown, and the angular to irregular pores become maze-like, then teeth-like. It has white to buff flesh and fruits on decaying wood.

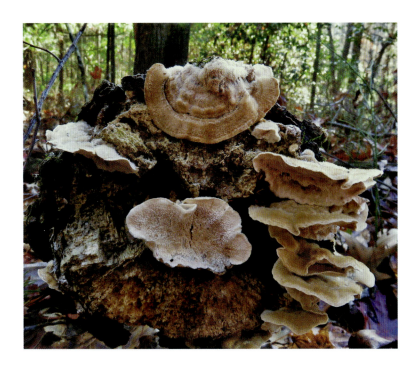

Trichaptum biforme (Fr.) Ryvarden

= *Polyporus biformis* Fr.

COMMON NAMES: Parchment Bracket, Violet Toothed Polypore

MACROSCOPIC FEATURES: fruit body annual, stalkless, 2–8 cm wide and up to 3 mm thick, semicircular to kidney- or fan-shaped, convex to nearly flat, often laterally fused, flexible or stiff. **upper surface** finely velvety at first, nearly bald in age, distinctly zonate, grayish or reddish brown, later whitened and often green with algae; margin thin, wavy, typically violet when young. **fertile surface** violet to purple-brown, usually fading to buff in age. **pores** angular, 2–5 per mm, splitting and becoming teeth-like or jagged in age; **tubes** up to 2 mm deep. **flesh** up to 1.5 mm thick, tough, white to pale buff; odor and taste not distinctive.

MICROSCOPIC FEATURES: Spores $5–8 \times 2–2.5$ µm, cylindric to slightly allantoid, smooth, hyaline, inamyloid; cystidia abundant, $20–35 \times 3–5$ µm, fusoid, apically encrusted, slightly thick-walled.

HABIT, HABITAT, AND SEASON: In overlapping clusters on decaying broadleaf wood; year-round.

EDIBILITY: Inedible.

COMMENTS: Saprotrophic, causing a white pocket rot in sapwood of decaying broadleaf trees. The Fir Polypore, *Trichaptum abietinum* (not illustrated), is very similar but smaller and grows on conifer wood. The upper surface of these two *Trichaptum* species, especially when colonized by green algae, may be studded with Fairy Pins, fruit bodies of *Phaeocalicium polyporaeum* (not illustrated), which resemble dark olive brown to blackish matchsticks, 0.4–0.9 mm tall with a clubbed head, best seen with a hand lens. These are the sexual reproductive structures of a parasitic, nonlichenized fungus.

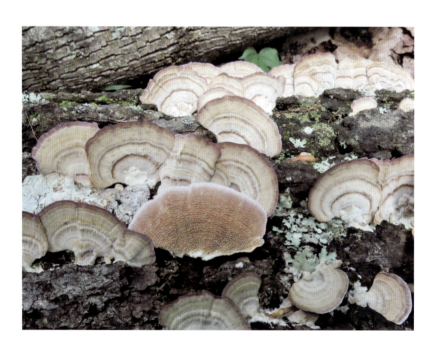

Trichaptum perrottetii (Lév.) Ryvarden

= *Trametes perrottetii* Lév.

MACROSCOPIC FEATURES: fruit body annual, stalkless, up to 15 cm wide and 8 mm thick, shelf-like, semicircular to elongated, usually broadly attached. **upper surface** covered with a dense layer of coarse, stiff, erect or flattened, forked hairs that are brownish or grayish and darkest near the point of attachment, weakly zonate or azonate; margin sharp, entire. **fertile surface** violet at first, becoming brown as it dries. **pores** angular or circular, splitting, coalescing and becoming sinuous to maze-like and teeth-like in age, 2–3 per mm; **tubes** 2–5 mm deep. **flesh** typically less than 1 mm thick, dark ochraceous to brown; odor and taste not distinctive.

MICROSCOPIC FEATURES: Spores 5–7 × 2–3.5 μm, cylindric to oblong-elliptic, smooth, hyaline, inamyloid; cystidia 10–18 μm, clavate to ventricose with a tapered apex, smooth or with an apical crown of crystals, abundant in the hymenium.

HABIT, HABITAT, AND SEASON: In overlapping groups or clusters on decaying broadleaf wood, especially oaks, also on old, creosote-treated railroad ties used to make garden beds; fall–winter.

EDIBILITY: Inedible.

COMMENTS: Saprotrophic, causing a white rot of broadleaf trees. It is a tropical species that occurs in Florida and extreme southeastern Georgia.

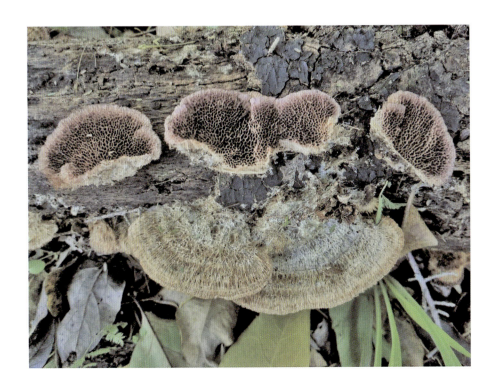

Trichaptum sector (Ehrenb.) Kreisel

= *Polyporus sector* (Ehrenb.) Fr.

MACROSCOPIC FEATURES: fruit body annual, stalkless, up to 5 cm wide and 1–4 mm thick, semicircular to fan-shaped, broadly attached, often fused laterally, leathery and flexible. **upper surface** matted and woolly to velvety, zonate, white to ochraceous buff; margin thin, wavy or curled, distinctly fringed (use a hand lens). **fertile surface** gray or dark purplish brown to nearly black. **pores** angular, 3–6 per mm, often slightly toothed on mature specimens; **tubes** up to 1 mm deep. **flesh** 1–3 mm thick, gray to purplish brown; odor and taste not distinctive.

MICROSCOPIC FEATURES: Spores 6–7 × 2–2.5 μm, cylindric-oblong to ellipsoid, smooth, hyaline, inamyloid; cystidia abundant, 15–20 × 4–7 μm, clavate to fusiform, apically encrusted, thick-walled.

HABIT, HABITAT, AND SEASON: Solitary or in overlapping clusters on broadleaf wood; year-round.

EDIBILITY: Inedible.

COMMENTS: Saprotrophic on decaying broadleaf wood. The epithet *sector* means "section of a circle," a reference to the semicircular to fan-shaped fruit body. *Trichaptum sector* represents a portion of a circle.

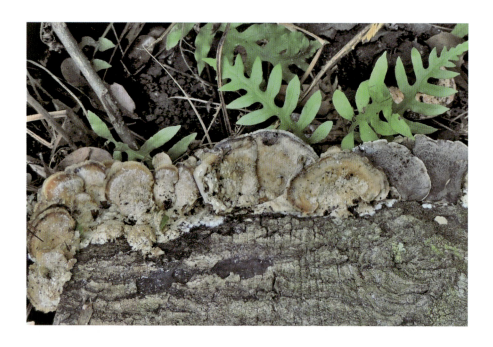

Tyromyces chioneus (Fr.) P. Karst.

= *Polyporus albellus* Peck
= *Tyromyces albellus* (Peck) Bondartsev & Singer

COMMON NAME: White Cheese Polypore
MACROSCOPIC FEATURES: fruit body annual, stalkless, 2–10 cm wide, semicircular, convex to nearly flat, broadly attached, soft and spongy, easily detached. **upper surface** slightly velvety or bald, dry or moist, azonate, sometimes uneven or warted, white at first, becoming pale yellow to pale grayish in age; margin thin, fairly sharp, sometimes uneven. **fertile surface** white to creamy white. **pores** angular to circular, 3–5 per mm; **tubes** up to 8 mm deep. **flesh** up to 2 cm thick, soft, spongy, white; odor fragrant when fresh, taste not distinctive.
MICROSCOPIC FEATURES: Spores 4–5 × 1.5–2 µm, cylindric to slightly allantoid, smooth, hyaline, inamyloid.

HABIT, HABITAT, AND SEASON: Solitary or in groups on broadleaf wood; summer–early winter.
EDIBILITY: Inedible.
COMMENTS: Saprotrophic on decaying broadleaf wood. *Tyromyces* means "having a cheesy consistency." The epithet *chioneus* means "snow white." The Smoky Cheese Polypore, *Tyromyces fumidiceps* (not illustrated), has a stalkless, semicircular to fan-shaped, grayish to buff, creamy tan, or pale grayish brown fruit body, 2–6 cm wide, that is soft and watery when fresh, more rigid when dry, and easily detached from the substrate. The fertile surface is dull white to ochraceous buff, with a pale olive tint when mature. It has crumbly, white, typically odorless flesh and ovoid spores that measure 3–4 × 2–3 µm, and it grows on decaying broadleaf wood.

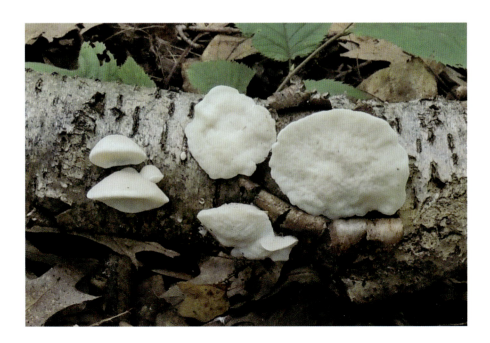

Tyromyces kmetii (Bres.) Bondartsev & Singer

= *Leptoporellus kmetii* (Bres.) Spirin
= *Polyporus kmetii* Bres.

MACROSCOPIC FEATURES: fruit body annual, stalkless, up to 12 cm wide, shelf-like, semicircular, broadly attached, fleshy and sappy when fresh. **upper surface** finely velvety at first, soon uneven and slightly warted or roughened with small, projecting, pointed fascicles of bright orange hyphae over a pale orange to whitish background. The fascicles become agglutinated in age or when dry and fade to apricot orange, pale ochraceous, or creamy white; margin thin, slightly wavy. **fertile surface** pale orange-buff to creamy white or light straw-colored. **pores** angular, 3–4 per mm, enlarging when tubes begin to dry; **tubes** up to 1 cm deep. **flesh** up to 1.5 cm thick, soft and watery when fresh, white; odor and taste not distinctive.
MICROSCOPIC FEATURES: Spores 4–4.5 × 2–3 μm, broadly ellipsoid, smooth, hyaline, inamyloid.
HABIT, HABITAT, AND SEASON: Solitary or overlapping on standing broadleaf trees, stumps, and logs; year-round.
EDIBILITY: Inedible.
COMMENTS: Pathogenic, causing a white rot of broadleaf trees. The Orange Sponge Polypore, *Pycnoporellus alboluteus* (not illustrated), has a stalkless, soft and spongy fruit body up to 15 cm or more wide that is initially resupinate, then effused-reflexed and crust-like to cushion-shaped. The upper surface is dry, azonate, hairy to scaly, and bright orange. The fertile surface is bright orange, then yellow-orange to dull yellow as it ages. The young angular pores are 1–3 mm wide, then soon split and become teeth-like or jagged. It has pale orange flesh, up to 3 mm thick, that lacks a distinctive odor or taste. The cylindric, smooth, hyaline, inamyloid spores measure 6–10 × 2.5–4 μm. This species fruits along the lower sides of decaying conifer logs and branches, especially pines, from spring through fall. All tissues quickly stain cherry red in KOH.

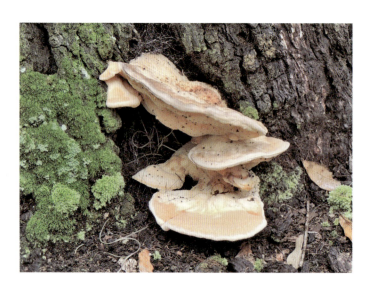

Xylodon paradoxus (Schrad.) Chevall.

= *Hydnum paradoxum* Schrad.
= *Schizopora paradoxa* (Schrad.) Donk

COMMON NAME: Split Pore Crust

MACROSCOPIC FEATURES: fruit body annual, resupinate, effused, 1–5 mm thick, consisting of uneven, rounded, nodular mounds of various lengths and widths. **fertile surface** poroid at first, white to creamy white or grayish, becoming darker gray or brownish in age. **pores** highly variable in size and shape, angular, irregular or maze-like, becoming split and irregularly teeth-like in age. **teeth** up to 3 mm long, flattened. **flesh** up to 2 mm thick, tough, whitish to buff; odor and taste not distinctive.

MICROSCOPIC FEATURES: Spores 5.5–6.5 × 3.5–4.5 µm, ellipsoid, smooth, usually with 1 oil drop, hyaline, inamyloid.

HABIT, HABITAT, AND SEASON: On decaying broadleaf branches, logs, and stumps; summer–early winter.

EDIBILITY: Inedible.

COMMENTS: Saprotrophic, causing a white rot on decaying broadleaf wood. The epithet *paradoxus* means "strange or contrary to expectation." *Spongipellis pachyodon* is one potential look-alike. Another is an invasive Asian species, *Radulomyces copelandii* (not illustrated), that may soon find its way into northern Georgia if it is not already there. This teeth mushroom is resupinate without forming caps and may appear as small tufts in bark cracks or extensive and peelable sheets up to 30 cm wide. The fertile surface is covered with conical or flattened teeth, 5–10 mm long, initially whitish but yellowing, then light orange-brown in age. Spores are subglobose, 6–7.2 × 5.4–6.6 µm, smooth, hyaline, inamyloid. Cystidia are lacking. It fruits on dead broadleaf trees and logs, especially maples and oaks.

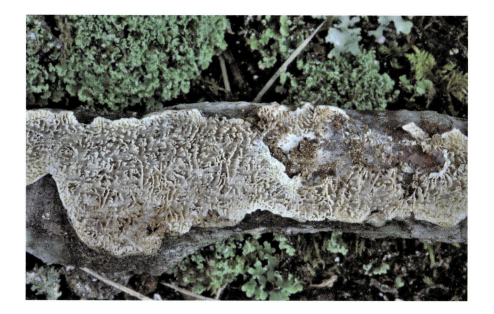

PUFFBALLS, EARTHBALLS, EARTHSTARS, AND SIMILAR FUNGI

Fruit bodies are rounded, oval, pear- to turban-shaped or star-shaped. Most are stalkless, but some species have a short stalk or stalk-like base. The interior is usually white when immature but may be orange to reddish or black. The mature interior (gleba) often becomes powdery and yellow, purple, brown, or black. They grow on the ground, underground, or on wood. If you cannot identify your unknown mushroom in this section, try comparing it to the species listed in the Truffles and Other Hypogeous Fungi group.

Apioperdon pyriforme (Schaeff.) Vizzini

= *Lycoperdon pyriforme* Schaeff.

COMMON NAME: Pear-shaped Puffball
MACROSCOPIC FEATURES: fruit body 2–5 cm high and 1.5–4.5 cm wide, consisting of a peridium with a compressed, sterile, stalk-like base. **peridium** whitish at first, becoming reddish brown to yellow-brown, with tiny warts and granules or spines, forming an apical pore mouth at maturity, lower portion tapered downward. **gleba** firm and white at first, becoming greenish yellow, finally dark olive brown and powdery at maturity. Odor not distinctive.
MICROSCOPIC FEATURES: Spores 3–4.5 μm, globose, smooth, pale brown.
HABIT, HABITAT, AND SEASON: Scattered or in dense clusters on decaying wood, sawdust, wood chips, and organic debris; year-round.
EDIBILITY: Edible when the gleba is white.
COMMENTS: The epithet *pyriforme* means "pear-shaped." Fruit bodies of this species often crowd like bubble bread on rotting logs. The spinier Gem-studded Puffball, *Lycoperdon perlatum*, occasionally occurs on wood as well, but fruit bodies maintain some personal space. The Common Stalked Puffball, *Tulostoma brumale*, has a small peridium, up to 2 cm wide, with a pore-like mouth that is supported by a slender stalk up to 5 cm long. It grows on sandy soil.

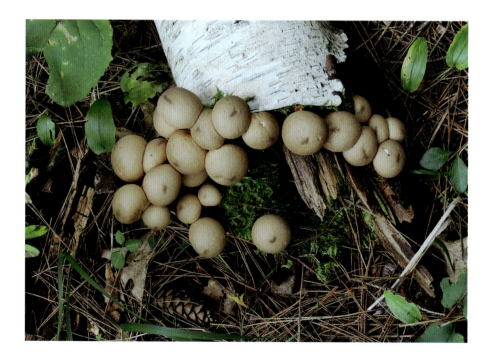

Arachnion album Schwein.

MACROSCOPIC FEATURES: fruit body 5–15 mm wide, irregularly globose to subglobose, tapering to a point of attachment, with white, root-like rhizomorphs, lacking a sterile base. **peridium** white when young, becoming yellowish to buff, smooth at first, becoming areolate, thin-walled, fragile, breaking into fragments and exposing peridioles at maturity. **gleba** white at first, becoming grayish to brownish, composed of numerous hollow chambers (peridioles) that eventually break down, leaving granular, spore-containing particles. Odor not distinctive when young, becoming pungent and somewhat unpleasant at maturity.

MICROSCOPIC FEATURES: Spores 4.5–6 × 3.5–5 μm, short-elliptic to subglobose with a short pedicel, thick-walled, smooth.

HABIT, HABITAT, AND SEASON: Gregarious on soil in grassy areas, on disturbed ground, along paths, in flower beds, and in open groves of broadleaf trees; summer–early winter.

EDIBILITY: Unknown.

COMMENTS: When immature, this species is easily mistaken for other small puffballs, but cutting them in half will reveal the distinctive granular mass of peridioles. The Acorn Puffball or Sand Case Puffball, *Disciseda candida* (not illustrated), is similar but lacks the distinctive peridioles. Its base is coated with a sand layer, giving it an acorn-like appearance.

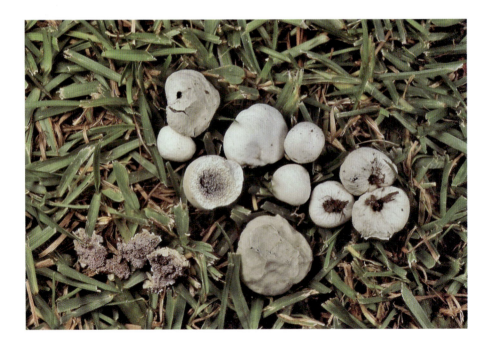

Astraeus smithii Watling, M. P. Martin, & Phosri

MACROSCOPIC FEATURES: fruit body up to 8 cm wide and 1–1.5 cm high when fully expanded, consisting of a rounded peridium and star-like rays. **peridium** nearly round or somewhat flattened, finely roughened, with 1 irregular, pore-like mouth, whitish to grayish or grayish brown, attached to the ground by several nearly blackish rhizoids that extend radially from the base. **gleba** white at first, becoming brown and powdery at maturity. **rays** number 6–15, hygroscopic, up to 3 cm long, yellow-brown to reddish brown or grayish; inner surface often rimose like mosaic tiles, darker in the cracks. Odor not distinctive.

MICROSCOPIC FEATURES: Spores 7.5–12.5 μm, globose, with a hyaline sheath overlying a thickened warty layer composed of blunt pegs, brown.

HABIT, HABITAT, AND SEASON: Solitary, scattered, or in groups on sandy soil along the edges of woodlands and open areas; year-round.

EDIBILITY: Inedible.

COMMENTS: *Astraeus smithii* honors American mycologist Alexander Hanchett Smith (1904–1986). In dry weather the extended rays curl up to clasp the peridium, opening again when wet. It has been reported only a few times from more northern states, but the southern distribution range extends into Florida. The Barometer Earthstar, *Astraeus morganii* (see Color Key), is very similar, with 6–12 rays that are also hygroscopic. It has slightly smaller, 7.5–10 μm, globose, minutely warted spores that lack a hyaline sheath. American collections of *Astraeus morganii* and *Astraeus smithii* have traditionally been called *Astraeus hygrometricus*, which is a European species. *Geastrum arenarium* also has hygroscopic rays, but its fruit body is smaller, the inner surface of the rays is not rimose, and the spores are smaller.

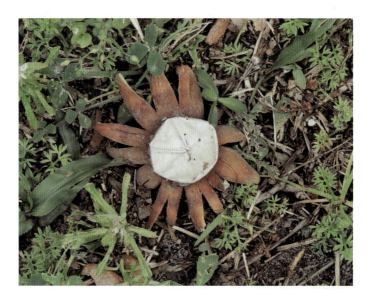

Bovista pusilla (Batsch) Pers.

= *Lycoperdon pusillum* Batsch

MACROSCOPIC FEATURES: fruit body 6–15 mm, rarely up to 20 mm wide, consisting of a peridium with a small, pinched, cord-like, rooting base. **peridium** nearly round or somewhat flattened, forming a small apical pore at maturity, covered with a fine, fibrous flocculence that collapses and separates into very small patches or becomes powdery, white at first, becoming dull olivaceous yellow at maturity, and finally often dark brown in age. **gleba** fills the entire peridium, white when young, becoming yellow to greenish yellow, finally brown and powdery at maturity. Odor not distinctive.
MICROSCOPIC FEATURES: Spores 3.2–4.3 μm, globose, smooth or finely tuberculate, with a very short pedicel, often with 1 large oil drop, brownish.

HABIT, HABITAT, AND SEASON: Scattered or in groups in cemeteries, lawns, fields, yards, and other open grassy areas; year-round.
EDIBILITY: Unknown.
COMMENTS: The epithet *pusilla* means "very little," an appropriate name for this easily overlooked puffball. *Arachnion album* is similar, but the peridium contains granular peridioles rather than a uniform spore mass. *Bovista acuminata* = *Lycoperdon acuminatum* (not illustrated) is very small, 3–9 mm wide, and shaped like an inverted top or pointed egg with a sharply pointed pore mouth. The peridium is white, and the globose spores have a short pedicel and measure 3.3–4 μm. It grows in mossy areas on the bark of living broadleaf or conifer tree trunks.

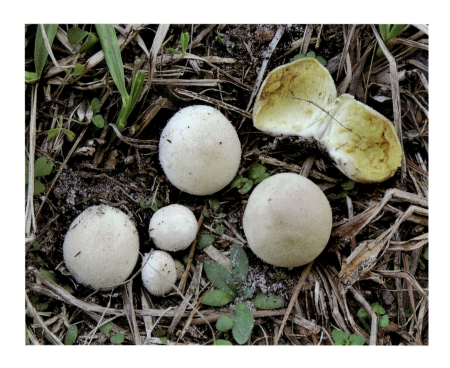

Calostoma cinnabarinum Desv.

COMMON NAMES: Hot Lips, Red Slimy-stalked Puffball

MACROSCOPIC FEATURES: fruit body a peridium with an outer and inner layer supported by a thick, short stalk. **peridium** 1–2 cm wide and high, oval to nearly globose, sometimes collapsed. **outer layer** thick, translucent, gelatinous, with small, orange-red, seed-like pieces. **inner layer** smooth, thin-walled, bright reddish orange, fading to orange or orange-yellow in age, with an irregular slit-like mouth surrounded by elevated, bright red, lip-like ridges. **gleba** white at first, becoming buff and powdery at maturity. **stalk** 1.5–4 cm long and 1–2 cm thick, nearly equal, spongy, coarsely reticulate and pitted, reddish orange to pale reddish brown, covered with a thick, gelatinous layer that is often coated with debris. Odor not distinctive.

MICROSCOPIC FEATURES: Spores 14–22 × 6–9 μm, oblong-elliptic, pitted, hyaline.

HABIT, HABITAT, AND SEASON: Solitary, scattered, or in groups on the ground under broadleaf trees, especially oaks, or in mixed woods, often buried up to the peridium; summer–winter.

EDIBILITY: Inedible.

COMMENTS: The epithet *cinnabarinum* means "bright red tinted with orange." *Calostoma lutescens* is very similar, but the inner peridium is yellow and has a distinct collar. *Calostoma ravenelii* (not illustrated) is also similar, but it has a scurfy, grayish to straw-colored outer peridium that lacks a gelatinous layer in all stages, and the outer layer breaks up irregularly without leaving a collar at the base of the inner layer. These are mycorrhizal species, usually with broadleaf trees, and while this is not obvious from their appearance, they are related to *Pisolithus* and *Scleroderma*.

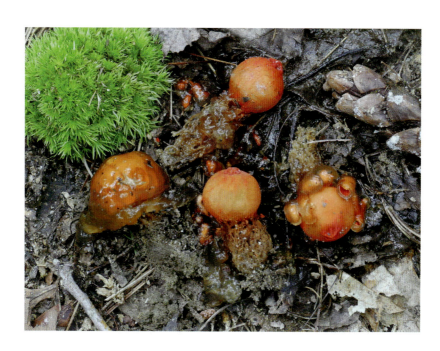

Calostoma lutescens (Schwein.) Burnap

COMMON NAME: Collared Calostoma
MACROSCOPIC FEATURES: fruit body a peridium with an outer and inner layer supported by an elongated stalk. **peridium** 1.5–2 cm wide and high, oval to nearly globose. **outer layer** thin, gelatinous, with a torn, ring-like collar at the base of the peridium after the gelatinous layer disappears. **inner layer** smooth, thin-walled, yellow, with a slit-like mouth surrounded by lip-like, elevated, bright red ridges. **gleba** white at first, becoming buff and powdery. **stalk** 5–9 cm long and 1.5–2 cm thick, spongy, coarsely reticulate and pitted, pale yellow to brown, covered with a gelatinous layer that is often coated with debris. Odor not distinctive.

MICROSCOPIC FEATURES: Spores 5.5–8 × 5.5–8 µm, globose, pitted, hyaline.
HABIT, HABITAT, AND SEASON: Scattered or in groups on the ground or on well-decayed stumps in woodlands; summer–early winter.
EDIBILITY: Inedible.
COMMENTS: The epithet *lutescens* means "becoming yellow." *Calostoma cinnabarinum* is very similar, but the inner peridium is reddish orange, and it lacks a collar. *Calostoma ravenelii* (not illustrated) is also similar, but it has a scurfy, grayish to straw-colored outer peridium that lacks a gelatinous layer in all stages and leaves no collar around the base of the inner peridium.

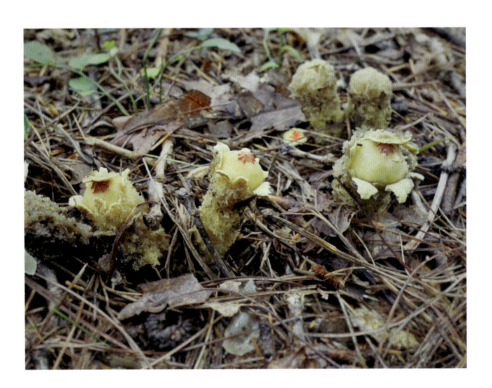

Calvatia candida (Rostk.) Hollós

= *Calvatia rubroflava* (Cragin) Lloyd

COMMON NAME: Orange-staining Puffball

MACROSCOPIC FEATURES: fruit body 3–12 cm wide and 2–8 cm high, nearly round to pear-shaped, often flattened somewhat at the apex, with a large, sterile base and typically attached to the substrate with white rhizomorphs. **peridium** nearly white with pinkish or lavender tints when young, becoming yellow to bright yellow or orange when bruised, cut, or rubbed, smooth to finely areolate. **gleba** white with minute cavities when young, becoming bright yellow-orange to dull orange and powdery in age. Odor strong and unpleasant at maturity.

MICROSCOPIC FEATURES: Spores 3–4 μm, globose, minutely warted, olive brown.

HABIT, HABITAT, AND SEASON: Scattered or in groups on the ground in gardens, grassy areas, and woodlands; summer–early winter.

EDIBILITY: Edible when the gleba is white.

COMMENTS: The epithet *candida* means "white," a reference to the color of the peridium when immature. The bright yellow to orange staining of the peridium is a diagnostic feature. Compare with *Rhizopogon roseolus*, which is often partially buried and stains reddish when bruised.

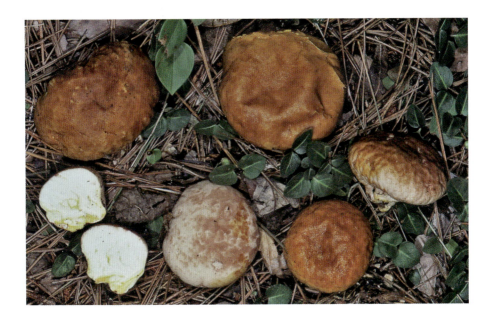

Calvatia craniiformis (Schwein.) Fr.

COMMON NAME: Skull-shaped Puffball
MACROSCOPIC FEATURES: fruit body up to 20 cm high and wide, consisting of a peridium with a conspicuous sterile base attached to the ground by white rhizomorphs. **peridium** skull- to pear-shaped or somewhat rounded, typically furrowed or scalloped over the top portion but sometimes nearly smooth, bald at first, cracking into irregular patches as it matures, white at first, becoming grayish to pale tan in age. **gleba** white and firm when young, becoming yellow to greenish yellow, and finally dingy yellow-brown to olive brown and powdery at maturity. **sterile base** large, occupying most of the lower one-third of the fruit body, chambered, white at first, becoming yellow-brown, and finally dark brown in age. Odor not distinctive.
MICROSCOPIC FEATURES: Spores 2.5–3.5 μm, globose, nearly smooth or with minute spines, with a very short pedicel, yellowish.
HABIT, HABITAT, AND SEASON: Solitary, scattered, or in groups in grassy areas or woodlands; summer–fall.
EDIBILITY: Edible when the gleba is white. Some individuals have experienced gastrointestinal upset after eating this puffball when the gleba is yellow or brown.
COMMENTS: The epithet *craniiformis* means "skull-shaped." The Purple-spored Puffball, *Calvatia cyathiformis* (see Color Key), is similar, but it has a smaller, cup-shaped, sterile base. The mature gleba is dull purple to purple-brown at maturity, and it has larger spores that measure 4–7 μm.

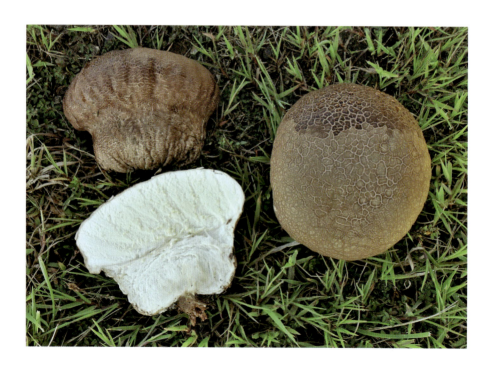

Geastrum arenarium Lloyd

= *Geaster arenarius* Lloyd

MACROSCOPIC FEATURES: fruit body up to 6 cm high and wide when fully expanded, consisting of a rounded peridium and star-like rays. **peridium** 1.2–2.2 cm high and wide, rounded or somewhat flattened, bald, tan to pale grayish or whitish, with a single, apical, conical pore mouth. **gleba** firm and whitish at first, becoming brown and powdery at maturity. **rays** 5–10, hygroscopic, up to 2.5 cm long, acute, pale brown to darker reddish brown or grayish brown, usually coated with a thin layer of sand. **inner surface** smooth, not rimose. Odor not distinctive.

MICROSCOPIC FEATURES: Spores 3–4 μm, globose, slightly roughened, brownish.

HABIT, HABITAT, AND SEASON: Scattered or in groups in sandy soil in various habitats, usually under broadleaf trees, especially oaks; year-round.

EDIBILITY: Inedible.

COMMENTS: The epithet *arenarium* means "in sandy areas." The hygroscopic rays curl up around the peridium when humidity is low, then reexpand in wet weather. *Astraeus morganii* (see Color Key) is similar, but its fruit body is larger, and the inner surface of the rays is rimose, cracking like mosaic tiles. It has much larger, globose spores that measure 7–11 μm.

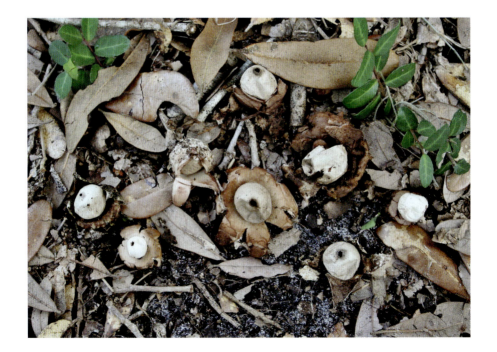

Geastrum fornicatum (Huds.) Hook.

COMMON NAME: Arched Earthstar
MACROSCOPIC FEATURES: fruit body up to 6 cm wide when fully expanded, consisting of a peridium and star-like rays. **peridium** 2–2.5 cm high and wide, rounded or somewhat flattened, attached to a short stalk that may be surrounded at the base by a tiny collar, splitting open and forming a large pore-like mouth at the top when mature, whitish at first, becoming brown. **gleba** firm and whitish at first, becoming blackish brown and powdery. **rays** usually 4–5, up to 5 cm long, bent strongly backward and downward, clasping a thick mass of hyphae and debris, brown, not hygroscopic. Odor not distinctive.
MICROSCOPIC FEATURES: Spores 3.5–4.5 μm, globose, warted, dark brown.
HABIT, HABITAT, AND SEASON: Scattered or in groups among leaves or organic debris in landscaped areas or woodlands; summer–early winter.
EDIBILITY: Inedible.
COMMENTS: *Geastrum coronatum* (not illustrated) is very similar, but its pore mouth is sharply defined by a silky area outlined by a shallow groove.

Geastrum saccatum Fr.

COMMON NAME: Rounded Earthstar
MACROSCOPIC FEATURES: fruit body up to 5 cm wide, consisting of a broadly conic to rounded peridium and star-like rays. **peridium** 1.2–2 cm wide and high, broadly conic to rounded, brownish to grayish brown, stalkless, splitting open and forming a large, pore-like mouth surrounded by a conspicuous, paler, disc-like zone. **gleba** white and firm at first, becoming brown to purplish brown and powdery at maturity. **rays** 5–7, bent strongly backward and downward at maturity, forming a distinct, sac-like container surrounding the peridium, brown, not hygroscopic. Odor not distinctive.

MICROSCOPIC FEATURES: Spores 3.5–4.5 µm, globose, finely warted, brown.
HABIT, HABITAT, AND SEASON: Solitary, scattered, or in groups among leaf litter in woodlands; summer–early winter.
EDIBILITY: Inedible.
COMMENTS: *Geastrum fimbriatum* (not illustrated) is similar, but the pore-like mouth lacks a conspicuous, paler, disc-like zone. The Saltshaker Earthstar, *Myriostoma coliforme* (not illustrated), has a finely roughened, silvery brown to grayish brown peridium with several pore mouths that open at maturity.

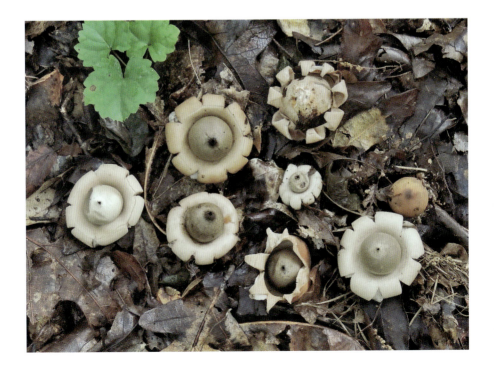

Geastrum triplex Jungh.

COMMON NAME: Collared Earthstar

MACROSCOPIC FEATURES: fruit body 1–4.5 cm high and 7–10 cm wide when fully expanded, stalkless, consisting of a rounded peridium and star-like rays. **peridium** 2–3 cm wide, nearly round or somewhat flattened, sitting in and surrounded by a bowl-like to saucer-shaped collar. It is whitish at first, becomes brownish to grayish as it matures, and has a single, elevated, pore-like mouth encircled by a paler zone. **gleba** firm and white when young, becoming dark brown and powdery when mature. **rays** 4–8, thick, fleshy, brittle, pointed and decurved at their tips, bending downward, cracking to give the appearance of a bowl-like collar for the peridium. They are pale to dark tan at first and become yellowish brown to pinkish brown as they age, not hygroscopic. Odor not distinctive.

MICROSCOPIC FEATURES: Spores 3–4.5 µm, globose, distinctly warted, brown.

HABIT, HABITAT, AND SEASON: Solitary, scattered, or in groups on the ground, mulch, or wood chips, usually in broadleaf woods; summer–early winter.

EDIBILITY: Inedible.

COMMENTS: The epithet *triplex* means "3 pieces." *Geastrum quadrifidum* (see Color Key) is 2.5–4.5 cm high and 1.5–3.5 cm wide when fully expanded and consists of a rounded peridium with a short stalk and nonhygroscopic, star-like rays. The peridium is round to acorn-shaped with an inflated collar, brown, usually coated with minute, glistening particles. Rays number 4–8. The gleba is dark brown to purplish brown. Spores are globose and warted, measuring 4–6 µm.

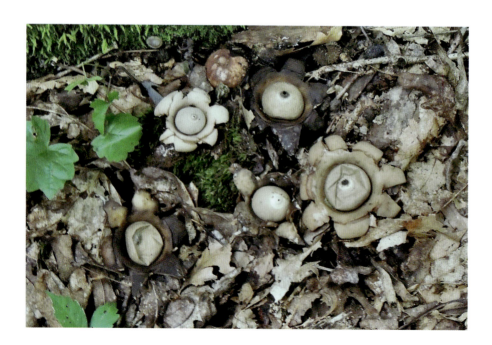

Lycoperdon marginatum Vittad.

COMMON NAME: Peeling Puffball
MACROSCOPIC FEATURES: fruit body 1–5 cm wide, consisting of a peridium and a somewhat tapered, sterile, stalk-like base. **peridium** subglobose at first, becoming slightly flattened to pear-shaped at maturity, white and covered with short spines or warts that break off in irregular sheets, exposing the nearly smooth, pale to dark olive brown or reddish brown inner surface, with a single apical pore mouth. **gleba** firm and white at first, becoming olive brown to grayish brown and powdery at maturity. Odor unpleasant or not distinctive.
MICROSCOPIC FEATURES: Spores 3.5–4.5 μm, globose, minutely speckled to nearly smooth, sometimes with a short pedicel, pale brown.

HABIT, HABITAT, AND SEASON: Solitary, scattered, or in groups on the ground, usually in mixed oak and pine woods or on nutrient-poor soil; summer–early winter.
EDIBILITY: Unknown.
COMMENTS: Other white puffballs may be similar, but their spines or warts do not break off in sheets.

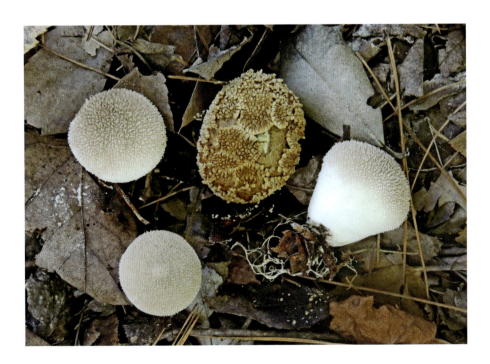

Lycoperdon perlatum Pers.

= *Lycoperdon gemmatum* Batsch

COMMON NAMES: Gem-studded Puffball, Devil's Snuffbox

MACROSCOPIC FEATURES: fruit body 2.5–8 cm high and 2–6.5 cm wide, consisting of a peridium with a large, stalk-like, sterile base. **peridium** pear- to turban-shaped, covered with short spines and granules that easily break off, white at first, becoming pale brown, then yellow-brown in age, with a rounded, apical pore mouth at maturity. **gleba** firm and white when young, becoming yellow to olive, and finally olive brown and powdery at maturity. Odor not distinctive.

MICROSCOPIC FEATURES: Spores 3.5–4.5 μm, globose, weakly echinulate, pale brown.

HABIT, HABITAT, AND SEASON: Solitary, scattered, or gregarious on the ground under conifers or broadleaf trees, sometimes on mulch, sawdust piles, or rotting tree branches; summer–early winter.

EDIBILITY: Edible when the gleba is white.

COMMENTS: The epithet *perlatum* means "widespread," a reference to the distribution of this common puffball. The Spiny Puffball, *Lycoperdon americanum* = *Lycoperdon echinatum* (see Color Key), is coated with clusters of long, white spines with fused tips that turn brown in age and fall off, leaving a net-like pattern on the surface of the peridium. The Lawn Puffbowl, *Lycoperdon pratense* = *Vascellum pratense* (not illustrated), has a turban- to pear-shaped fruit body with a sterile, stalk-like base. It has a white to pale yellowish peridium covered with granules and fine spines that soon wear away, exposing a shiny, brownish peridium. A pore mouth is formed at maturity and disintegrates down to a sterile base, causing the fruit body to appear bowl-like.

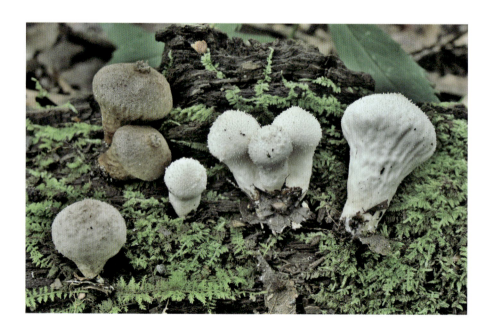

Lycoperdon subincarnatum Peck

= *Morganella subincarnata* (Peck) Kreisel & Dring

COMMON NAME: Ruddy Puffball

MACROSCOPIC FEATURES: fruit body 1–3 cm wide and high, nearly round to pear-shaped, often laterally flattened when growing in clusters. **peridium** coated with short, purplish brown to reddish brown spines over a pale pinkish brown ground color, becoming pitted after the spines have fallen off at maturity, with or without a sterile base, splitting irregularly to release spores. **gleba** whitish at first, becoming purplish brown and powdery at maturity. Odor not distinctive.

MICROSCOPIC FEATURES: Spores 3.5–4 μm, globose, weakly echinulate to smooth, brownish.

HABIT, HABITAT, AND SEASON: Scattered, in groups, or in clusters on decaying, mossy, broadleaf logs and stumps; summer–fall.

EDIBILITY: Unknown.

COMMENTS: The epithet *subincarnatum* means "almost flesh-colored." *Apioperdon pyriforme* also grows on wood but differs in the color of the peridium and mature gleba.

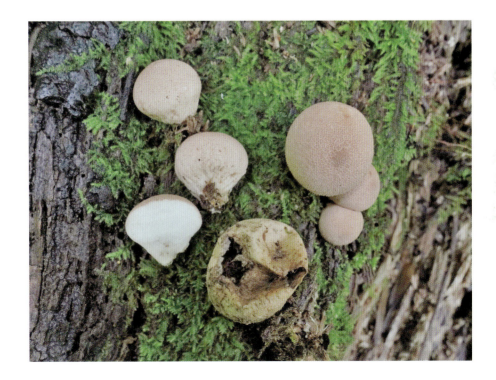

Lycoperdon umbrinum Pers.

COMMON NAME: Umber-brown Puffball
MACROSCOPIC FEATURES: fruit body 1.5–3.5 cm wide and up to 4.5 cm high, nearly round to somewhat flattened with an abrupt base or pear-shaped with a tapered base. **peridium** lightly covered with minute spines and granules or scurfy scales that slowly wear away, white or light brownish gray at first, becoming grayish tan to dull brown, typically smooth and shiny when mature, splitting open to release spores. **gleba** pale olivaceous brown, becoming darker brown and powdery as it ages. Odor not distinctive.
MICROSCOPIC FEATURES: Spores 3.7–4.5 µm, globose, with a short pedicel, minutely warted, hyaline to pale brown.
HABIT, HABITAT, AND SEASON: Scattered or in groups on the ground in conifer or broadleaf woodlands, sometimes in landscaped areas among pine straw or leaf litter; summer–early winter.
EDIBILITY: Unknown.
COMMENTS: The epithet *umbrinum* means "dull brown." The fruit body of *Lycoperdon mole* (not illustrated) is similar. It is 2.5–7 cm high and 2–6 cm wide and consists of a peridium and a distinctive, sterile, stalk-like base. The peridium is rounded to pear- or top-shaped, dull white to yellow-brown or grayish brown, granular, and covered at first by short, soft, grayish brown spines. It becomes smooth after the spines fall off. It has globose, coarsely warted, light brown spores that measure 4–6 µm, and it grows with conifers or broadleaf trees from summer through early winter.

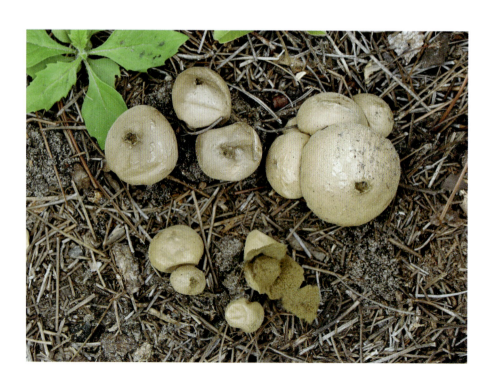

Pisolithus arenarius Alb. & Schwein.

COMMON NAME: Dye-maker's False Puffball
MACROSCOPIC FEATURES: fruit body 5–15(–25) cm high and 3.5–12 cm wide, consisting of a peridium and stalk-like, rooting base. **peridium** tapered downward, pear-shaped to oval or club-shaped, thin, smooth, shiny, dingy yellow to yellow-brown, splitting irregularly at maturity and exposing numerous tiny yellowish to brownish peridioles embedded in a black, gelatinous matrix. **gleba** produced by the disintegrating peridioles, reddish brown to dark brown and powdery at maturity. Odor pungent and unpleasant or not distinctive.
MICROSCOPIC FEATURES: Spores 7–12 μm, globose, echinulate, brownish.

HABIT, HABITAT, AND SEASON: Solitary, scattered, or in groups in sandy soil, usually under oaks and pines, typically partially buried; summer–early winter.
EDIBILITY: Inedible.
COMMENTS: It is sometimes used to dye silk and wool various shades of brown or black. The epithet *arenarius* means "growing in sand." Most modern field guides call this mushroom *Pisolithus arhizus* or *Pisolithus tinctorius*, but recent molecular analysis has demonstrated that *Pisolithus arhizus* occurs in Africa, Asia, and Europe and that *Pisolithus tinctorius* is an illegitimate name. *Scleroderma polyrhizum* is also large, but the peridium splits into rays, and the gleba is of a more uniform color and consistency.

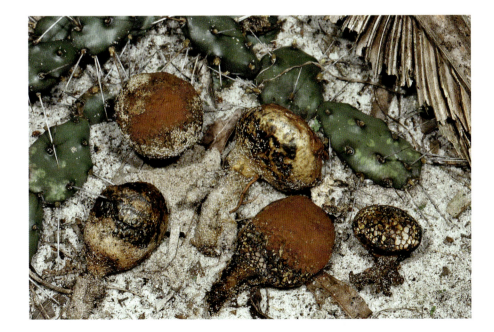

Rhopalogaster transversarius (Bosc) J. R. Johnst.

= *Lycoperdon transversarium* Bosc

MACROSCOPIC FEATURES: fruit body 3–9.5 cm high and 1.5–4.5 cm wide, club-shaped to oval, consisting of a peridium, a narrowed stalk with several basal rhizomorphs, and a central columella. **peridium** granular-roughened to scurfy with scattered, matted, brownish fibers when young, becoming nearly smooth in age, pale reddish brown to yellow-brown or olive brown, becoming pale brownish orange as the ground color is exposed, rupturing irregularly and exposing the gleba at maturity. **columella** central, extending upward from the base of the stalk throughout most of the peridium, extensively branching crosswise, whitish. **gleba** distinctly chambered like a honeycomb, at first watery-gelatinous, meat-like, conspicuously marbled or veined, dull red to reddish brown, slowly staining blackish when exposed, becoming olive brown to darker brown and powdery in age. Odor not distinctive.

MICROSCOPIC FEATURES: Spores 5.5–7.5 × 3–4.5 μm, elliptic, smooth, pale brown.

HABIT, HABITAT, AND SEASON: Solitary, scattered, or in groups on decaying organic matter, including leaf litter, mulch, and wood chips, in oak and pine woods; summer–winter.

EDIBILITY: Unknown.

COMMENTS: The epithet *transversarius* means "lying across or crosswise," a reference to the branches of the columella. To demonstrate columella features, cut the fruit body vertically into halves. $FeSO_4$ applied to the surface of the fruit body produces a green staining reaction. This species is related to *Suillus* and is mycorrhizal with pines. Molecular analysis strongly indicates that it should be transferred to the genus *Suillus*.

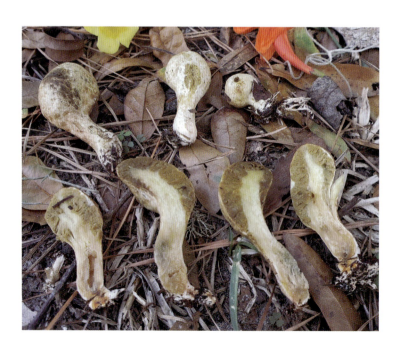

Scleroderma areolatum Ehrenb.

= *Scleroderma lycoperdoides* Schwein.

COMMON NAME: Puffball-like Scleroderma

MACROSCOPIC FEATURES: fruit body 1–4.5 cm wide, consisting of a peridium attached to the ground by a short, stalk-like base. **peridium** oval to broadly rounded or irregular, often somewhat flattened, up to 1 mm thick, firm; surface dry, smooth when young, soon cracking and dividing into small patches, slightly scaly in age, light brown to yellowish brown, becoming darker reddish brown as it matures, splitting irregularly over the top in age. **stalk-like base** composed of numerous white rhizomorphs with trapped sand. **gleba** firm and watery cream when very young, soon becoming purplish and eventually grayish brown and powdery in age. Odor not distinctive.

MICROSCOPIC FEATURES: Spores (7.5–)11–14(–18.5) μm excluding spines, globose, not reticulated, brownish, spines 0.2–1.8 μm.

HABIT, HABITAT, AND SEASON: Scattered or in groups, sometimes fused, on the ground or in grassy areas; summer–early winter.

EDIBILITY: Unknown.

COMMENTS: The epithet *areolatum* means "cracked," a reference to the peridium.

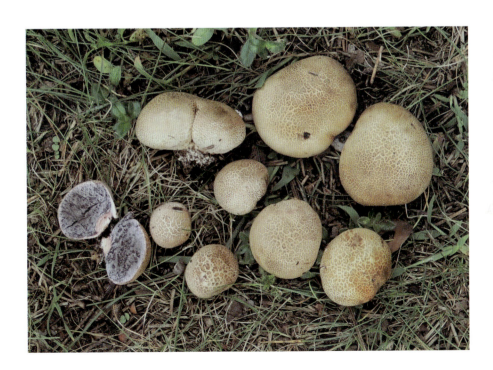

Scleroderma bovista Fr.

COMMON NAME: Potato Earthball
MACROSCOPIC FEATURES: fruit body 1.5–4.5 cm wide, consisting of a peridium attached to the ground by a thick, stalk-like base. **peridium** spherical, often somewhat flattened in age, up to 2 mm thick, firm; surface dry, smooth when young, soon cracking and dividing into small patches, slightly to distinctly scaly in age, straw yellow to pale orange-yellow when young, becoming reddish brown with olive gray tints at maturity, splitting irregularly over the top and sides in age. **stalk-like base** composed of a dense mass of rhizomorphs with trapped sand. **gleba** firm and whitish at first, becoming dark blackish brown and powdery at maturity. Odor not distinctive.

MICROSCOPIC FEATURES: Spores 9–16 µm, globose, with a partial to fully developed reticulum, brownish.
HABIT, HABITAT, AND SEASON: Solitary, scattered, or in groups in oak and pine woods, in waste areas, or on sandy soil in grassy areas; summer–early winter.
EDIBILITY: Poisonous, causing gastrointestinal upset.
COMMENTS: The epithet *bovista* means "puffball." Application of KOH to the peridium produces a red reaction. Compare with *Scleroderma cepa*.

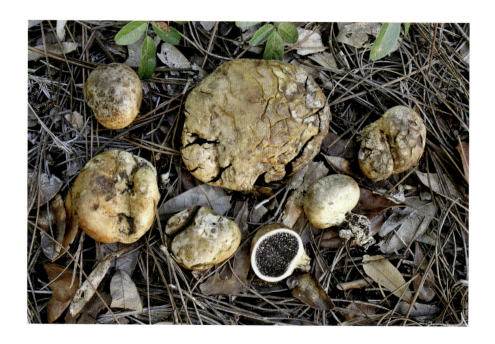

Scleroderma cepa Pers.

MACROSCOPIC FEATURES: fruit body 1.5–6 cm wide, stalkless, rounded or irregularly lobed, often flattened, consisting of a peridium attached to the ground by a thick mass of mycelium with trapped sand. **peridium** up to 1.5 mm thick; surface dry, smooth or sometimes with tiny scales, often finely cracked, whitish at first, soon straw-colored to pale yellowish brown or pale brown, staining vinaceous when rubbed, sometimes slowly, becoming darker brown where handled. **gleba** firm and whitish at first, becoming blackish with a purple tint, then paler and powdery at maturity. Odor not distinctive.

MICROSCOPIC FEATURES: Spores 7–12.5 μm including spines, globose, covered with pointed spines up to 2 μm, lacking reticulation, brownish.

HABIT, HABITAT, AND SEASON: Solitary, scattered, or in groups on the ground in landscaped areas, woodlands, or disturbed areas; summer–early winter.

EDIBILITY: Unknown.

COMMENTS: The epithet *cepa* means "onion or head." Compare with *Scleroderma bovista* and *Scleroderma michiganense*, neither of which stains vinaceous when rubbed. Also compare with *Rhizopogon roseolus*, which is often partially buried and stains reddish when bruised.

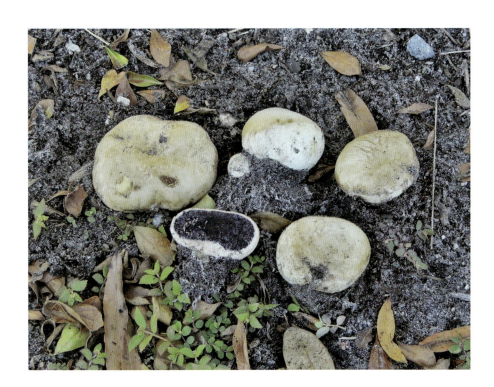

Scleroderma citrinum Pers.

COMMON NAMES: Common Earthball, Pigskin Poison Puffball

MACROSCOPIC FEATURES: fruit body consisting of a peridium and gleba attached to the substrate by a thick, stalk-like mycelial base. **peridium** 2.5–10 cm wide and high, nearly round or somewhat flattened, thick and rind-like, pale brown to golden brown, finely cracked and covered with coarse warts. The peridium wall is white in cross section, slowly stains pinkish when rubbed, and eventually forms an irregular pore mouth on the upper surface. **gleba** firm and white only when very young, soon turning dark gray to purplish black and becoming powdery at maturity. Odor not distinctive.

MICROSCOPIC FEATURES: Spores 8–12 μm, globose, strongly reticulate, dull brown.

HABIT, HABITAT, AND SEASON: Scattered or in groups on the ground or decaying wood; summer–fall.

EDIBILITY: Poisonous, causing gastrointestinal distress.

COMMENTS: This is one of the most commonly encountered and easily identified earthballs. It is sometimes parasitized by a small bolete, *Pseudoboletus parasiticus*, with a tawny olive cap, a similarly colored stalk, pale lemon yellow flesh, and a yellowish to olive brown pore surface.

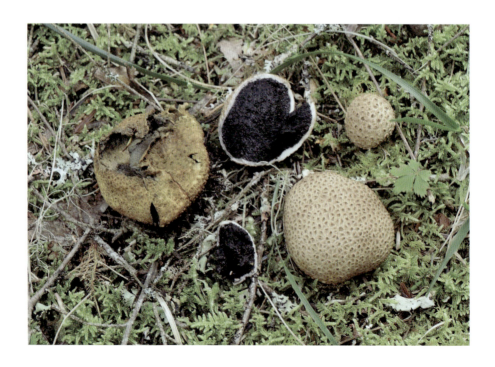

Scleroderma meridionale Demoulin & Malençon

MACROSCOPIC FEATURES: fruit body consisting of a rounded to irregularly lobed peridium and gleba attached to the substrate by a thick, stalk-like, rooting base. **peridium** 2–6 cm wide and up to 2 mm thick; outer surface dry, roughened, conspicuously cracked and warted at maturity, ochraceous tan to bright ochraceous yellow, with dull grayish to yellowish brown warts, slowly splitting into irregular lobes and exposing the gleba at maturity. **stalk-like base** 2.5–9 cm long and 2–4.5 cm thick, tapered in either direction, with coarse, irregular, roughened, blunt projections, dull ochraceous orange to ocher-yellow or brownish, typically coated with sand. **gleba** firm and whitish at first, becoming brownish gray to blackish gray and coarsely powdery at maturity. Odor not distinctive.

MICROSCOPIC FEATURES: Spores 12–20 μm, globose, echinulate, reticulate, dark brown.

HABIT, HABITAT, AND SEASON: Solitary, scattered, or in groups, partially buried in sand; summer–early winter.

EDIBILITY: Unknown.

COMMENTS: Recent molecular analysis of American collections indicates that they are not the same species as the European *Scleroderma meridionale*.

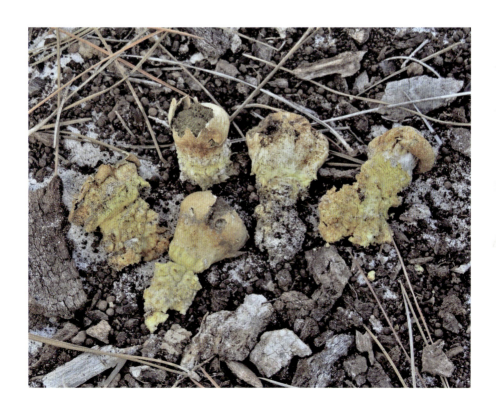

Scleroderma michiganense (Guzmán) Guzmán

MACROSCOPIC FEATURES: fruit body consisting of a peridium and gleba attached to the soil by white rhizomorphs. **peridium** 2.5–6 cm wide and high, rounded to somewhat flattened or shaped like an inverted pear, yellowish, then reddish brown in age, staining reddish brown when bruised, smooth to finely cracked, splitting irregularly in age. The wall of the peridium is 1–2.5 mm thick, whitish to yellowish. **gleba** firm and white when young, becoming blackish and powdery when mature. Odor not distinctive.

MICROSCOPIC FEATURES: Spores 14–20 μm including spines, globose, with long spines and a complete reticulum, dull brown.

HABIT, HABITAT, AND SEASON: Scattered or in groups on sandy soil or organic debris in broadleaf woods; summer–fall.

EDIBILITY: Unknown, but likely poisonous.

COMMENTS: Compare with *Scleroderma cepa*, which has a rounded to flattened, pale pinkish brown to pale yellowish brown peridium that stains vinaceous when rubbed, sometimes slowly. It has smaller spores with sharp spines but lacking in reticulation.

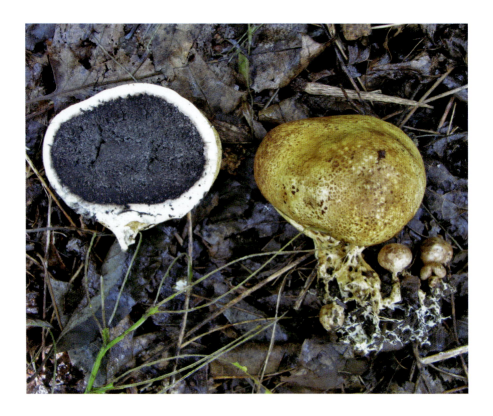

Scleroderma polyrhizum (J. F. Gmel) Pers.

= *Scleroderma geaster* Fr.

COMMON NAMES: Dead Man's Hand, Earthstar Scleroderma

MACROSCOPIC FEATURES: fruit body 4–12 cm wide when closed, expanding to 16 cm and resembling a giant earthstar when fully open, attached to the ground by a root-like mass of tough fibers. **peridium** round to oval or irregular, 3–10 mm thick, hard, rind-like, rough, areolate to somewhat scaly, whitish to straw-colored or pale yellow-brown, splitting open into rays and exposing the gleba. **rays** 4–8, thick, brown to blackish brown. **gleba** firm and white at first, becoming brown to purplish brown, finally blackish brown and powdery at maturity. Odor not distinctive.

MICROSCOPIC FEATURES: Spores 5–10 μm, globose, echinulate, sometimes forming a partial reticulum, purple-brown.

HABIT, HABITAT, AND SEASON: Solitary or in groups, often partially buried in sandy soil; summer–early winter.

EDIBILITY: Poisonous, causing gastrointestinal upset.

COMMENTS: The epithet *polyrhizum* means "many roots," a reference to the mass of tough fibers that anchor the fruit body. Application of KOH to the peridium produces a red reaction. *Scleroderma floridanum* (see Color Key) is similar but smaller, 3–8.5 cm wide when closed, with a thinner, yellowish brown peridium and larger spores, 9–12 μm.

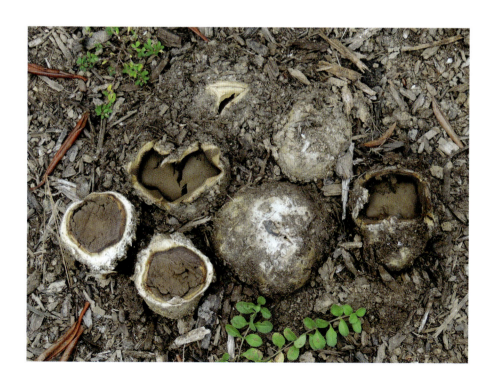

Tulostoma brumale Pers.

COMMON NAME: Common Stalked Puffball
MACROSCOPIC FEATURES: fruit body consisting of a small peridium and gleba supported by a slender stalk. **peridium** 1–2 cm wide and high, nearly round to somewhat flattened, sometimes collapsed, double-layered, with a circular pore-like mouth elevated by a short, whitish, cylindric, tube-like collar. The outer layer is yellow-brown, often coated with sand, and peels away, exposing a brownish to whitish inner layer. **stalk** 2–5 cm long and 3–5 mm thick, nearly equal down to a slightly bulbous base, rusty brown to yellow-brown, paler toward the apex, often coated with sand. **gleba** firm and whitish at first, becoming rusty salmon and powdery at maturity. Odor not distinctive.
MICROSCOPIC FEATURES: Spores 3–5 μm, subglobose, minutely warted, some with a short pedicel, hyaline to pale yellow.
HABIT, HABITAT, AND SEASON: Scattered or in groups on sandy soil, often in nutrient-poor habitats; fall–early winter.
EDIBILITY: Inedible.
COMMENTS: The epithet *brumale* means "occurring in winter."

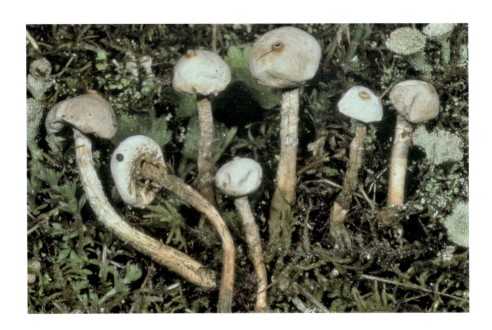

SPLIT GILL AND CRIMPED GILL

Species in this group have fruit bodies that are stalkless or have only a short lateral stalk and grow on wood. Their fertile surfaces are gill-like and split longitudinally or are distinctly crimped, often forked and vein-like.

Plicaturopsis crispa (Pers.) D. A. Reid

= *Trogia crispa* (Per.) Fr.

COMMON NAME: Crimped Gill
MACROSCOPIC FEATURES: cap 1–2.3 cm wide, fan- to shell-shaped, concentrically zonate, dry, finely matted and woolly, yellow-orange to reddish brown or yellow-brown. Cap margin wavy, lobed, scalloped, decurved to inrolled, whitish to pale yellow. **gill-like folds** crimped, often forked and vein-like, frequently anastomosing, subdistant, narrow, whitish to grayish. **stalk** very short, a narrow central extension of the cap, sometimes absent. **flesh** thin, membranous, flexible when moist, hard and brittle when dry. Odor and taste not distinctive.
MICROSCOPIC FEATURES: Spores 3–4 × 1–1.5 μm, allantoid to elliptic, smooth, hyaline, often containing 2 oil drops.
SPORE PRINT: White.
HABIT, HABITAT, AND SEASON: In overlapping clusters or groups on branches and trunks of broadleaf trees; year-round.
EDIBILITY: Inedible.
COMMENTS: The epithet *crispa* means "curly or crisped," a reference to the crimped gill-like folds. *Pseudomerulius curtisii* has a stalkless, fan- or shell-shaped fruit body with yellow-orange, crinkled, crossveined gills. The Stalkless Paxillus, *Tapinella panuoides* (see Color Key), also has a fan- to shell-shaped fruit body. It has straight or sometimes crinkled, forked, and crossveined gills that are pale yellow to yellow-orange. Both of these species grow on conifer wood.

Schizophyllum commune Fr.

COMMON NAME: Common Split Gill
MACROSCOPIC FEATURES: cap 1–4.5 cm wide, fan- to shell-shaped, white to grayish white or pinkish gray, covered with a dense layer of fine hairs, dry. Cap margin incurved to inrolled, becoming nearly flat when moist, wavy and usually torn in age. **gill-like folds** split lengthwise along the free edge, often serrated or torn, subdistant, narrow, white to gray or pinkish gray. **stalk** absent or a short, narrow extension of the cap. **flesh** thin, leathery, flexible, whitish or grayish, often with brownish tones in age. Odor and taste not distinctive.
MICROSCOPIC FEATURES: Spores 5–7.5 × 2–3 µm, cylindric, smooth, hyaline.
SPORE PRINT: White.
HABIT, HABITAT, AND SEASON: Solitary, scattered, or in overlapping clusters on decaying broadleaf branches, trunks, and stumps; year-round.
EDIBILITY: Inedible.
COMMENTS: *Schizophyllum commune* means "split gills growing in groups." It is one of the most widely distributed mushrooms in the world. The upper surfaces of dried-up polypores such as *Trametes versicolor* and *Trichaptum biforme* sometimes look very similar, but the fertile surfaces are distinctly poroid.

STINKHORNS

Species in this group have fruit bodies that are egg-shaped when young. They "hatch" to become erect and phallic with a head and stalk, or pear-shaped to nearly round with or without a stalk, or squid-like with arched, tapered arms. Parts of the fruit body are usually coated with a foul-smelling, slimy gleba that attracts a variety of arthropods. Stinkhorns grow on the ground, mulch, wood chips, or decaying wood. Although stinkhorn "eggs" are edible, the experience tends to be poorly reviewed, and there is a risk of misidentification with other species such as puffballs and *Amanita* "eggs," some of which are deadly poisonous. When sectioned vertically an *Amanita* "egg" will reveal the outline of a small, gilled mushroom inside.

Aseroe rubra Labill.

COMMON NAMES: Starfish Stinkhorn, Fungus Flower

MACROSCOPIC FEATURES: fruit body consisting of an egg-like, immature stage that ruptures and gives rise to the mature stage with a central stalk, radiating forked arms, and a volva. **immature stage** 2–4 cm wide, globose to egg-shaped with basal rhizomorphs, white to cream or pale grayish brown, sometimes with grayish spots, and a gelatinous interior. **mature stage** a cylindric stalk and central disc with radiating tapered arms and spore mass at the stalk apex, leaving a sac-like volva at the base. **stalk** 4–6.5 cm high, 1.5–3 cm wide, sponge-like, hollow, pinkish to reddish, forming a flattened disc with 5–11 radiating, chambered arms that are often forked near the midportion and curled at the tip, with a volva at the base. **arms** up to 4.5 cm long, radiating, tentacle-like, typically forked, bright red. **volva** sac-like, white. **gleba** dark olive brown, covering the disk and interior base of the arms, slimy, fetid.

MICROSCOPIC FEATURES: Spores 4.5–7 × 1.7–2.5 μm, elliptic-cylindric with a truncate base, smooth, hyaline to pale brownish.

HABIT, HABITAT, AND SEASON: Solitary or in groups on wood mulch, leaf litter, or the ground; year-round.

EDIBILITY: Inedible.

COMMENTS: *Aseroe* means "disgusting juice," referring to the stinking, slimy, olive brown gleba. The epithet *rubra* means "red," a reference to the color of the arms. It was originally described from Australia and has spread into many parts of the world, including the southeastern United States. The floral shape immediately distinguishes this species from other stinkhorns found in Georgia. Compare with the similar *Clathrus columnatus*, which is stalkless and has a lattice-like fruit body with spongy, erect columns that are fused at their tips.

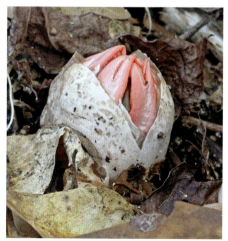
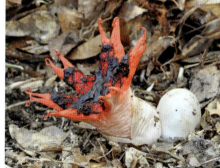

Clathrus columnatus Bosc

= *Linderia columnata* (Bosc) G. Cunn.

COMMON NAME: Columned Stinkhorn

MACROSCOPIC FEATURES: fruit body egg-like at first, rupturing and giving rise to the stalkless mature stage, consisting of columns and a volva. **immature stage** up to 7 cm wide, subglobose, whitish, with a gelatinous interior, attached to the ground by one or more whitish rhizomorphs. **columns** 2–5, up to 16 cm high, spongy, erect, curved, delicate, fused at their tips, orange to reddish orange or rosy red. **volva** sac-like, wrinkled and tough, whitish. **gleba** olive brown, slimy, fetid, deposited on the underside of the columns.

MICROSCOPIC FEATURES: Spores 3.5–5 × 1.5–2.5 μm, smooth, elliptic, yellowish brown.

HABIT, HABITAT, AND SEASON: Solitary, scattered, or in groups on the ground in grassy areas, woodlands, or marginal woodland areas; year-round.

EDIBILITY: Inedible.

COMMENTS: The genus name *Clathrus* is a variation of the Latin *clathros*, meaning "latticed," which describes the open structure of this species. It sometimes fruits in very large numbers in wood chips used for landscaping. The similar *Aseroe rubra*, inedible, has an egg-shaped, white to cream or pale brown fruit body when immature that ruptures and gives rise to the mature stage. The mature stage consists of a pinkish to red cylindric stalk and central disc with radiating, tapered, bright red arms and olive brown gleba at the stalk apex, leaving a white, sac-like volva at the base. The tapered arms are typically forked. It grows on wood mulch, leaf litter, or soil, year-round.

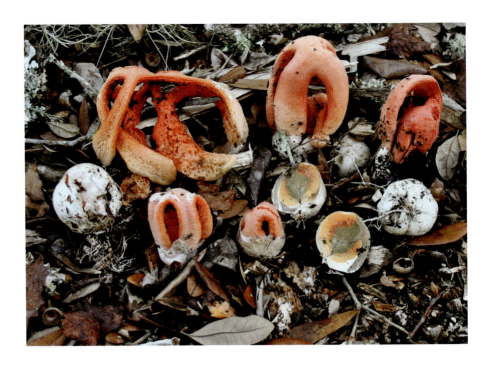

Mutinus elegans (Mont.) E. Fisch.

COMMON NAME: Elegant Stinkhorn
MACROSCOPIC FEATURES: fruit body egg-like at first, rupturing and giving rise to the mature stage, consisting of a stalk and volva. **immature stage** up to 2.5 cm wide, nearly round to oval or somewhat elongated, with a gelatinous interior, white, attached to the substrate by a white basal rhizomorph. **stalk** up to 18 cm high and 1.2–2.5 cm wide, tapered from the middle in both directions, lacking a clearly defined head, apex with a narrow opening, roughened, spongy, hollow, orange to pinkish orange, rarely pinkish red. **volva** sac-like, wrinkled, tough, whitish. **gleba** covering the upper third or more of the stalk, olive green to dull greenish, slimy, fetid.
MICROSCOPIC FEATURES: Spores 4–7 × 2–3 µm, elliptic, smooth, pale yellowish green.
HABIT, HABITAT, AND SEASON: Scattered, in groups, or sometimes densely clustered on wood chips, leaf litter, or the ground; year-round.
EDIBILITY: Inedible.
COMMENTS: The epithet *elegans* means "elegant." *Mutinus ravenelii* (see Color Key) is similar, but it has a clearly defined head and a conspicuously pitted, pinkish red to pale purplish red stalk. The Devil's Stinkhorn, *Phallus rubicundus* (not illustrated), has a smooth to slightly roughened, flaring, thimble-like cap coated with an olive brown to dark brown gleba. It has an orange to reddish orange or sometimes pinkish stalk that is coarsely marked with elongated pits.

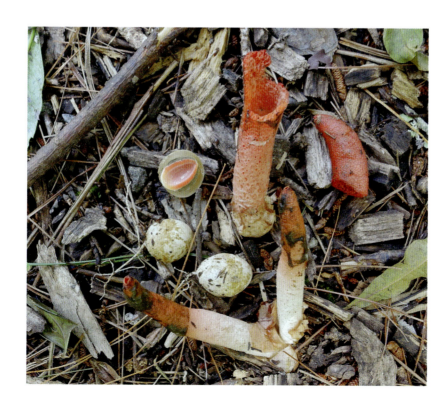

Phallus duplicatus Bosc

= *Dictyophora duplicata* (Bosc) E. Fisch.

COMMON NAME: Netted Stinkhorn

MACROSCOPIC FEATURES: fruit body an egg-like immature stage that ruptures, giving rise to the mature stage, consisting of a head, stalk, and volva. **immature stage** 4.5–7 cm wide, resembling a small puffball, nearly round to somewhat flattened, whitish to pale pinkish brown, often grooved on the lower portion, with one or more thick, whitish to pinkish, often branched rhizomorphs, internally gelatinous. **stalk** 9–18.5 cm long and 3.5–6 cm wide, nearly equal, roughened, spongy, hollow, whitish, surrounded at the apex by a white, net-like, flaring veil that emerges from beneath the head. **head** 5–7 cm high, 3.5–5 cm wide, oval to conic or bell-shaped, pendant, deeply pitted, with a white-rimmed opening at the apex, white, covered with the gleba. **volva** tough, wrinkled, whitish to pinkish brown. **gleba** greenish brown to brownish olive, slimy, fetid.

MICROSCOPIC FEATURES: Spores 3.5–4.5 × 1–2 μm, elliptic, smooth, hyaline.

HABIT, HABITAT, AND SEASON: Solitary or in groups on the ground in broadleaf or mixed woods; late spring–early winter.

EDIBILITY: Inedible.

COMMENTS: Some sources, including Index Fungorum, treat *Phallus duplicatus* as a synonym of *Phallus indusiatus*, which is a similar tropical stinkhorn with a larger and more flaring, net-like veil. To date, it has not been reported to occur in the United States. *Phallus hadriani* (see Color Key) is similar but smaller and lacks a veil. It has a membranous volva that is white with pinkish to pinkish purple tints. *Phallus impudicus* (not illustrated) is nearly identical to *Phallus hadriani*, but the volva is white.

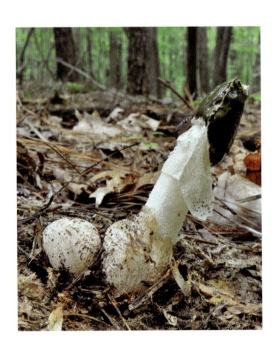

Phallus ravenelii Berk & M. A. Curtis

COMMON NAME: Ravenel's Stinkhorn
MACROSCOPIC FEATURES: fruit body an egg-like immature stage that ruptures, giving rise to the mature stage, consisting of a head, stalk, and volva. **immature stage** up to 4.5 cm wide, oval to pear-shaped, whitish to pinkish lilac, with a gelatinous interior, attached to the substrate with pinkish lilac rhizomorphs. **head** up to 4.5 cm high and 1.5–4 cm wide, conical to ovoid, with a white-rimmed apical opening, granular to wrinkled or finely reticulate, lacking distinct pits, covered with gleba. **stalk** up to 16 cm high and 1.5–3 cm wide, roughened, pitted, spongy, hollow, whitish. **volva** tough, wrinkled, whitish to pinkish lilac. **gleba** slimy, greenish brown to olive brown, fetid.
MICROSCOPIC FEATURES: Spores 3–4 × 1–1.5 μm, cylindric, smooth, hyaline.
HABIT, HABITAT, AND SEASON: Scattered or in groups on or near woody debris in gardens and landscape areas; year-round.
EDIBILITY: Inedible.
COMMENTS: The epithet *ravenelii* honors Henry William Ravenel (1814–1887), South Carolina mycologist and botanist. *Phallus hadriani* (see Color Key) is similar, but the head is conspicuously pitted. It has a membranous volva that is white with pinkish to pinkish purple tints. *Phallus impudicus* (not illustrated) is nearly identical to *Phallus hadriani*, but the volva is white. *Phallus duplicatus* is a little larger than *Phallus hadriani* and features a white, netted veil emerging from beneath the pitted head.

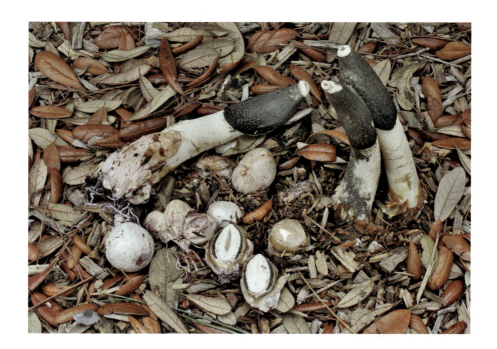

Pseudocolus fusiformis (E. Fisch.) Lloyd

= *Pseudocolus schellenbergiae* (Sumst.) M. M. Johnson

COMMON NAME: Stinky Squid

MACROSCOPIC FEATURES: fruit body an egg-like immature stage that ruptures, giving rise to the mature stage, consisting of a stalk, arms, and volva. **immature stage** 2–3.5 cm wide, resembling a small puffball, oval to pear-shaped, grayish brown to pale gray or sometimes whitish, often finely cracked on the upper portion, with white rhizomorphs, internally gelatinous. **stalk** 2–4.5 cm long and 1.5–3 cm thick, roughened, spongy, hollow, with 3–5 arms, whitish at the base, yellow to orange above. **arms** 2–7 cm long, arched, pitted, tapered upward and often united at their apices, yellow to orange. **volva** tough, wrinkled, grayish brown to pale gray or whitish. **gleba** olive green to dark green, drying nearly black, slimy, fetid, borne on the inner side of the arms.

MICROSCOPIC FEATURES: Spores 4.5–5.5 × 2–2.5 μm, elliptic to ovoid, smooth, hyaline.

HABIT, HABITAT, AND SEASON: Scattered or in groups on the ground in conifer or mixed woods or in landscaping wood chips; summer–fall.

EDIBILITY: Inedible.

COMMENTS: The epithet *fusiformis* means "spindle-shaped and fused," a reference to the arms.

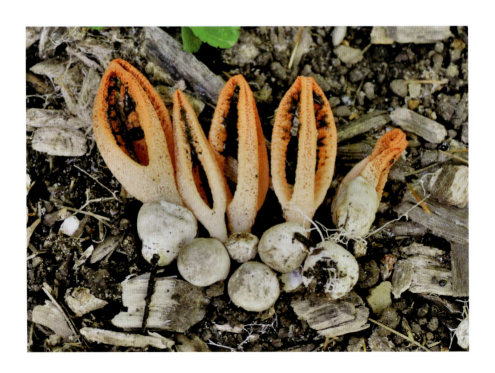

TOOTH FUNGI

Fleshy, leathery, or tough fungi with downward-oriented, uniformly shaped, soft spines. Some species have a cap and stalk, while others are fan-shaped to shelf-like or icicle-like. They grow on the ground or on wood.

Climacodon septentrionalis (Fr.) P. Karst.

= *Hydnum septentrionale* Fr.
= *Steccherinum septentrionale* (Fr.) Banker

COMMON NAME: Northern Tooth
MACROSCOPIC FEATURES: cap 10–30 cm wide and 2.5–5 cm thick, fan-shaped, stalkless. **upper surface** hairy to roughened and uneven, whitish to creamy yellow when young, becoming yellow-brown in age. **fertile surface** composed of crowded, flexible spines, 6–20 mm long, whitish with torn tips. **flesh** tough, flexible, zonate, whitish. Odor and taste not distinctive when young, becoming like spoiled ham and bitter in age.
MICROSCOPIC FEATURES: Spores 4–5.5 × 2.5–3 µm, elliptic, thick-walled, smooth, hyaline.
HABIT, HABITAT, AND SEASON: In dense, overlapping clusters up to 80 cm high, growing from a common base on wounds of standing broadleaf trunks, especially maples and beeches; summer–fall.
EDIBILITY: Inedible.
COMMENTS: *Climacodon* means "ladder tooth," a reference to the overlapping layers of spines. The epithet *septentrionalis* means "northern."

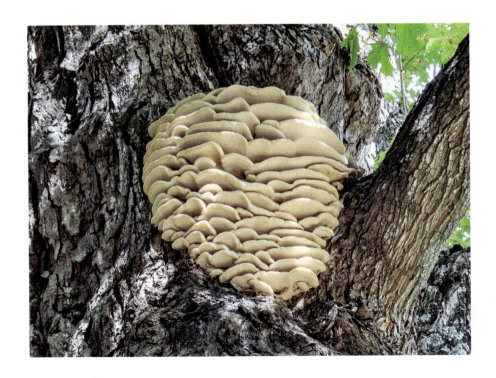

Donkia pulcherrima (Berk. & M. A. Curtis) Pilát

= *Climacodon pulcherrimus* (Berk. & M. A. Curtis) Nikol.
= *Steccherinum pulcherrimum* (Berk. & M. A. Curtis) Banker

COMMON NAME: Charming Tooth
MACROSCOPIC FEATURES: cap 3–10 cm wide, fan-shaped to semicircular, stalkless, arising from a confluent, spreading base. **upper surface** dry, covered with dense woolly or matted hairs, whitish to pale tan or pinkish tan; margin often wavy or lobed. **fertile surface** covered with crowded short spines, 2.5–5 mm long, whitish at first, becoming pinkish tan in age. **flesh** flexible, fibrous, white, sometimes exuding a creamy white, sticky sap when squeezed. Odor variously described as woody or resembling preserved figs, taste not distinctive.
MICROSCOPIC FEATURES: Spores 4–6 × 1.5–3 μm, elliptic, smooth, hyaline.
HABIT, HABITAT, AND SEASON: Overlapping or fused clusters on decaying broadleaf wood; year-round.
EDIBILITY: Inedible.
COMMENTS: The epithet *pulcherrima* means "beautiful." The upper surface and flesh stain pinkish to red with KOH.

Hericium americanum Ginns

COMMON NAME: Bear's Head Tooth
MACROSCOPIC FEATURES: fruit body 15–30 cm wide and high, consisting of a loosely packed grouping of white to yellowish branches arising from a common base, with spines arranged in clusters at the branch tips. **spines** up to 4 cm long, hanging downward, white. **flesh** thick, soft, white. Odor and taste not distinctive.
MICROSCOPIC FEATURES: Spores 5–7 × 4.5–6 μm, subglobose, very finely warted, hyaline.
SPORE PRINT: White.
HABIT, HABITAT, AND SEASON: Solitary or sometimes in clusters on trunks, logs, or stumps of broadleaf trees; late spring–fall.
EDIBILITY: Edible.

COMMENTS: The epithet *americanum* means "American." *Hericium coralloides* is similar but has spines rather evenly distributed along the branches. The Lion's Mane or Satyr's Beard, *Hericium erinaceus* (see Color Key), consists of a white to yellowish cushion-shaped mass with long spines, up to 9 cm, that resemble a beard. Like the other two species, *Hericium erinaceus* is edible; however, when consumed with alcohol, it has caused severe stomach pain and vomiting in some individuals.

Hericium coralloides (Scop.) Pers.

= *Hericium ramosum* (Bull.) Letell.

COMMON NAME: Comb Tooth

MACROSCOPIC FEATURES: **fruit body** 7–25 cm wide and 7–20 cm high, consisting of a loosely packed cluster of white to salmon or pinkish spreading branches arising from a common base, with spines arranged in rows along the branches like teeth on a comb. **spines** up to 2.5 cm long, white, rather evenly distributed along the branches. **flesh** thick, soft, white. Odor and taste not distinctive.

MICROSCOPIC FEATURES: Spores 3–5 × 3–4 μm, oval to globose, slightly roughened, hyaline.

SPORE PRINT: White.

HABIT, HABITAT, AND SEASON: Solitary or in groups hanging on decaying broadleaf logs and stumps; late spring–fall.

EDIBILITY: Edible.

COMMENTS: The epithet *coralloides* means "resembling coral." *Hericium americanum* is similar but has spines arranged in clusters at the branch tips.

Hydnellum concrescens (Pers.) Banker

= *Hydnellum fasciatum* (Peck) Coker & Beers
= *Hydnellum scrobiculatum* var. *zonatum* (Batsch) K. A. Harrison

COMMON NAMES: Zoned Hydnellum, Zoned Tooth Fungus

MACROSCOPIC FEATURES: cap up to 12 cm wide, broadly convex or irregularly flat, sometimes depressed. **upper surface** conspicuously concentrically zonate, uneven, wrinkled or nearly smooth, radially fibrillose, somewhat felted, sometimes roughened with irregular projections, reddish brown and darkest toward the disc, with a whitish marginal zone when growing. Cap margin thin, wavy, irregularly lobed, pale orange-white or whitish. **fertile surface** covered with decurrent, reddish brown spines up to 3 mm long that are pale orange-white near the margin when young. **stalk** up to 3 cm long and 0.5–2 cm thick, solitary or fused, eccentric to lateral, often with a thick coating of humus, colored like the cap. **flesh** up to 5 mm thick, zonate, homogeneous or with granules, colored like the cap or blackish in the stalk. Odor and taste not distinctive.

MICROSCOPIC FEATURES: Spores 5–6 × 4–6 μm, subglobose, tuberculate, pale brown.

SPORE PRINT: Brown.

HABIT, HABITAT, AND SEASON: Usually in clusters or groups with fused caps on the ground in conifer or broadleaf woods; summer–early winter.

EDIBILITY: Inedible.

COMMENTS: The epithet *concrescens* means "fused together." The Rough Hydnellum, *Hydnellum scrobiculatum* (see Color Key), is nearly identical and may only be a morphological variant. It has tuberculate-echinulate spores and a less conspicuously zonate cap, and it stains brown on the margin. The Spongy-footed Tooth, *Hydnellum spongiosipes* (see Color Key), has an azonate, reddish brown cap that darkens when wet, a very broad bulbous base, and duplex flesh, and it grows on the ground in broadleaf woods, especially with oaks. Squeezing the basal bulb usually expresses several drops of clear fluid. *Hydnellum pineticola* (not illustrated) is nearly identical to *Hydnellum spongiosipes*, but it occurs on the ground with conifers.

Hydnellum cristatum (Bres. ex G. F. Atk.) Stalpers

= *Hydnum cristatum* Bres. ex G. F. Atk.
= *Sarcodon cristatus* (Bres.) Coker

MACROSCOPIC FEATURES: **cap** 3–10 cm wide, convex to broadly convex or nearly flat. **upper surface** azonate, often with irregular projections, when very young covered with a soft, creamy white, matted layer, then erect, stiff, yellowish to buffy straw hairs, especially along the margin, that collapse and become spongy-pitted and eroded, exposing the brownish orange to dark brown ground color as it ages, bruising black. Cap margin entire, typically appearing lobed from fused caps or indeterminate growth, whitish to cream. **fertile surface** covered with decurrent, crowded spines up to 5 mm long. The spines are pale orange to brownish orange at first and become dark brown with paler tips as they mature. **stalk** up to 7 cm long and 2 cm thick, solitary or fused, central or eccentric, equal or somewhat enlarged downward, nearly smooth, pale orange to dark brown, often with white basal mycelium. **flesh** up to 1 cm thick, zonate, flexible or brittle, homogeneous, colored like the cap. Odor somewhat fragrant or farinaceous, taste strongly acrid.

MICROSCOPIC FEATURES: Spores 4.5–6 × 4–5 μm, subglobose to globose, strongly warted, pale brown.

SPORE PRINT: Brown.

HABIT, HABITAT, AND SEASON: Solitary or in groups, often fused, under hardwoods; summer–fall.

EDIBILITY: Inedible.

COMMENTS: The epithet *cristatum* means "having crests or tufts," a reference to the cap margin. *Hydnellum geogenium* (not illustrated) has a tomentose, pale yellow to bright sulphur yellow or olive cap with a dark brown disc in age. The strongly decurrent spines are pale yellow at first and become brown in age with yellow or blackened tips. It grows on the ground in conifer woods. The brown, subglobose spores are weakly tuberculate and measure 4–5 × 3–4 μm.

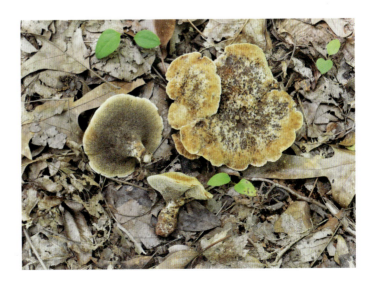

Hydnellum ferrugipes Coker

= *Calodon ferrugipes* (Coker) Snell
= *Sarcodon alachuanum* Murrill

MACROSCOPIC FEATURES: cap 4–13 cm wide, convex to broadly convex or irregularly flat, sometimes depressed. **upper surface** uneven, wrinkled, and bumpy, occasionally pitted, finely matted and woolly, especially on the actively growing margin, azonate or weakly zonate, light brown to yellowish brown or orange-brown, growing portions brownish yellow to creamy white, becoming blackish when rubbed. Cap margin entire, often lobed, frequently with concentric ridges of secondary growth, often misshapen when fused with other caps. **fertile surface** covered with decurrent spines up to 4 mm long, brown with paler tips when young, brown overall when mature, with a narrow, buff, sterile margin. **stalk** 2–4 cm long and 1–1.5 cm thick, central, nearly equal or enlarged downward, spongy, orange-brown to rusty brown, sometimes fused. **flesh** duplex, upper layer thick, spongy, weakly zonate, pale brown, lower layer thin, tough, dark brown. Odor somewhat musty or not distinctive, taste not distinctive.
MICROSCOPIC FEATURES: Spores 4.5–6.5 × 4–5.5 μm, subglobose, moderately tuberculate, pale brown.
SPORE PRINT: Brown.
HABIT, HABITAT, AND SEASON: Solitary, scattered, in groups or fused clusters on the ground in broadleaf or mixed woods; summer–early winter.
EDIBILITY: Inedible.
COMMENTS: The epithet *ferrugipes* means "having a rusty foot," a reference to the stalk. The dried flesh sometimes shows dark slate blue areas. Some sources list *Hydnellum caeruleum* as a synonym, which it clearly is not. The Bluish Tooth, *Hydnellum caeruleum* (see Color Key) has bluish or whitish spines when young, bluish areas in the cap and stalk flesh, and a distinctive farinaceous odor and taste. *Hydnellum aurantiacum* (see Color Key) is similar, but it has a more rusty brown to rusty orange cap and stalk, orange basal mycelium, pungent and disagreeable-tasting flesh, and slightly larger spores, and it grows with conifers or in mixed woods.

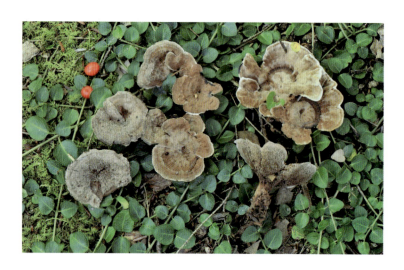

Hydnellum piperatum Coker ex Mass Geest.

= *Sarcodon piperatus* Coker ex Maas Geest.

MACROSCOPIC FEATURES: **cap** up to 14 cm wide, circular or lobed, convex to broadly convex or nearly flat with a central depression. **upper surface** finely powdered and whitish overall when young, remaining so along the margin as it matures, shallowly pitted or nearly smooth in the center, occasionally with radiating streaks, azonate at first, becoming weakly zonate toward the margin, grayish brown or orange-brown over the central area in age. Cap margin entire, often curved downward, lobed, typically white, staining blackish. **fertile surface** covered with crowded decurrent spines up to 5 mm long, grayish brown with paler tips that become darker brown overall, bruising dark brown, with a whitish, sterile margin. **stalk** up to 5 cm long and 3 cm thick, with a spongy, bulbous base, central or eccentric, colored like the cap. **flesh** up to 3 mm thick at the margin, homogeneous, zonate, sometimes with conspicuous dark grayish brown concentric zones in the stalk, dull straw-colored or whitish; odor fragrant or not distinctive, taste acrid.

MICROSCOPIC FEATURES: Spores 4–6 × 4–5 μm, subglobose, strongly tuberculate, pale brown.

SPORE PRINT: Brown.

HABIT, HABITAT, AND SEASON: In groups or clusters on the ground in broadleaf or mixed woods; summer–fall.

EDIBILITY: Inedible.

COMMENTS: The epithet *piperatum* means "peppery." The Red-juice Tooth, *Hydnellum peckii* (see Color Key), has a whitish to pinkish cap that exudes drops of red juice when young and fresh. The cap soon becomes tinged pinkish and finally turns dull brown to purplish black. It has decurrent spines that are pinkish when young and become blackish brown with paler tips in age. The flesh is faintly zoned and reddish brown with an odor variously described as fragrant, unpleasant, or not distinctive and a strongly acrid taste.

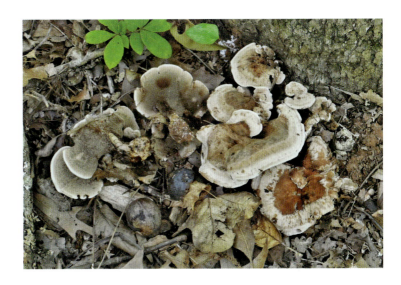

Hydnum alboaurantiacum Swenie & Matheny

COMMON NAME: Peaches and Cream Hedgehog

MACROSCOPIC FEATURES: cap 2–7 cm wide, convex, becoming shallowly convex to depressed, occasionally deeply depressed. **upper surface** dry, matted, white to creamy white, quickly staining orange when bruised. Cap margin incurved at first, thin, becoming wavy or lobed. **fertile surface** covered with spines, 1–7 mm long, attached or subdecurrent, brittle and easily broken, white to creamy orange. **stalk** 1.7–5 cm long and 0.6–2.1 cm thick, central or eccentric, enlarged downward or nearly equal, colored like the cap, quickly staining orange when bruised. **flesh** firm, thin, creamy white, staining orange, especially in young specimens, at the stalk base within 5 minutes when cut in half. Odor sweet and fruity or not distinctive, taste not distinctive.

MICROSCOPIC FEATURES: Spores 4–6(–7) × 3–5(–6) μm, globose to ellipsoid, smooth, hyaline.

SPORE PRINT: White.

HABIT, HABITAT, AND SEASON: Solitary, scattered, or in groups on the ground in mixed woods; spring–fall.

EDIBILITY: Edible.

COMMENTS: The epithet *alboaurantiacum* means "having white and orange coloration." *Hydnum albidum* (not illustrated) is very similar both macroscopically and microscopically, but it has a smaller cap, 1.5–5 cm wide, and slowly stains lighter brown-orange when bruised. It has white to pale cream flesh that slowly stains orange after 5 minutes and tastes mild or slowly acrid. *Hydnum subtilior* (not illustrated) is also similar, but the cap is 2–9 cm wide and colored a light shade of yellow, peach, or tan. It bruises yellow to rusty orange-brown and has a creamy white stalk that is often longer than the cap diameter and slowly stains rusty orange-brown. It has white to pale orange-cream, mild-tasting flesh that slowly stains orange throughout after 5 minutes where cut.

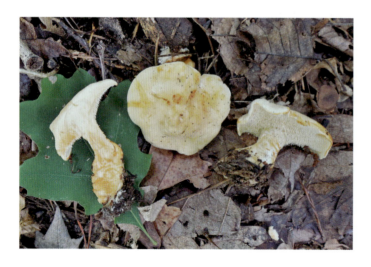

Hydnum subolympicum Niskanen & Liimat.

= *Hydnum repandum* sensu Coker & Beers

MACROSCOPIC FEATURES: cap 8–13 cm wide, convex, becoming nearly flat. **upper surface** dry, bald, dull reddish orange at first, becoming creamy white to peach or dull orange and sometimes cracked in age. Cap margin incurved and entire when young, very slowly staining ocher to rusty brown after handling. **fertile surface** covered with subdecurrent spines, 1–7 mm long, brittle and easily broken, creamy yellow to pinkish cream. **stalk** 3–10 cm long and 2–4 cm thick, central or eccentric, tapered downward to a slightly bulbous base, white to off-white, staining orange-cream to rusty orange, then yellow-brown when handled. **flesh** firm, brittle, white to creamy white. Odor fruity like apricots or not distinctive, taste mild or slowly acrid or bitter.

MICROSCOPIC FEATURES: Spores 6–9 × 5–7 μm, subglobose to broadly ellipsoid, smooth, hyaline.

SPORE PRINT: White.

HABIT, HABITAT, AND SEASON: Solitary, scattered, or in groups on the ground in broadleaf and mixed woods; summer–fall.

EDIBILITY: Edible.

COMMENTS: Numerous field guides describe and illustrate this species as *Hydnum repandum* or *Hydnum rufescens*. Recent molecular analysis has demonstrated that neither occurs in North America. *Hydnum albomagnum* (not illustrated) has a 6–11 cm wide cap that is creamy white with cottony white patches, becomes light tan in age, and has adhering leaf or needle litter. It has white, mild-tasting flesh that does not stain. The broadly ellipsoid spores measure 5.5–7 × 3–5 μm. *Hydnum subconnatum* (see Color Key) has a peach orange to reddish brown cap up to 7.5 cm wide and a white to dull tan stalk that is often conjoined with others at their bases. The globose to subglobose spores measure 8.5–10 × 7.5–10 μm. It is known only from the southeastern United States.

Hydnum umbilicatum group Peck

= *Dentinum umbilicatum* (Peck) Pouzar

COMMON NAMES: Depressed Hedgehog, Sweet Tooth

MACROSCOPIC FEATURES: cap 2–7 cm wide, convex to nearly flat, with a shallow to deep central depression that often continues into the stalk, or sometimes lacking a depression. **upper surface** dry, felty, becoming somewhat wrinkled and pitted in age, reddish orange to brownish orange or pale dull orange. Cap margin incurved and entire at first, often wavy or slightly irregular in age. **fertile surface** covered with spines, 1–8 mm long, not decurrent, brittle and easily broken, creamy white to pale orange-yellow, darkening when bruised. **stalk** 2–7 cm long and 5–10 mm thick, central or eccentric, enlarged slightly downward or nearly equal, white with orange tints or colored like the cap, staining darker orange when bruised. **flesh** thick, firm, brittle, white to pale orange, staining darker orange when cut and rubbed. Odor not distinctive, taste nutty or not distinctive.

MICROSCOPIC FEATURES: Spores 7.5–9.5 × 7–9 μm, globose to subglobose, smooth, hyaline.

SPORE PRINT: White.

HABIT, HABITAT, AND SEASON: Solitary, scattered, or in groups on the ground or among mosses with conifers or in mixed woods; summer–fall.

EDIBILITY: Edible.

COMMENTS: The epithet *umbilicatum* means "having a sunken, central, navel-like depression." We have treated *Hydnum umbilicatum* as a group because more than one species fits the macroscopic and microscopic description, and they are most reliably distinguished by molecular analysis. *Hydnum mulsicolor* (see Color Key) has a 3–4.5 cm wide, bright orange to tan cap, a 5–8 mm thick, creamy white stalk that stains orange when handled, and a dense mat of white basal mycelium. It has pinkish cream spines that are conspicuously decurrent and mild-tasting flesh. The subglobose spores measure 6.5–8.5 × 5.5–8.5 μm.

Mycorrhaphium adustum (Schwein.) Maas Geest.

= *Hydnum adustum* Schwein.

COMMON NAME: Kidney-shaped Tooth
MACROSCOPIC FEATURES: cap 2.5–7.5 cm wide, kidney- to fan-shaped or nearly circular, broadly convex to nearly flat. **upper surface** finely roughened to somewhat velvety, whitish to tan, staining smoky gray when bruised. Cap margin thin, wavy, faintly zonate, sometimes blackish in age. **fertile surface** covered with spines up to 3 mm long, somewhat flattened, often fused and appearing forked at their tips, white at first, becoming pinkish brown to cinnamon brown at maturity. **stalk** up to 3 cm long and 1–2 cm thick, eccentric to lateral or rudimentary, sometimes absent, somewhat velvety, whitish to dull cream. **flesh** thin, tough, white. Odor and taste not distinctive.
MICROSCOPIC FEATURES: Spores 2.5–4 × 1–1.5 μm, cylindric, smooth, hyaline.
SPORE PRINT: White.
HABIT, HABITAT, AND SEASON: Solitary, scattered, or in groups, often fused and overlapping, on decaying broadleaf branches and logs, especially oaks; summer–early winter.
EDIBILITY: Inedible.
COMMENTS: The epithet *adustum* means "scorched," a reference to the upper surface staining smoky gray when bruised and sometimes becoming blackish in age.

Phellodon alboniger (Peck) Banker

= *Hydnum albonigrum* Peck
= *Phellodon niger* var. *alboniger* (Peck) K. A. Harrison

COMMON NAME: Black Tooth
MACROSCOPIC FEATURES: cap 3–9 cm wide, broadly convex to nearly flat. **upper surface** finely velvety, grayish white with a gray center when young, becoming brownish to blackish. Cap margin blue-gray, sometimes with salmon tints, becoming paler at maturity, staining blackish when bruised. **fertile surface** covered with decurrent spines up to 4 mm long, pale grayish. **stalk** 4–10 cm long and 1–2 cm thick with a bulbous base, felty, pale to dark brown. **flesh** up to 1 cm thick, duplex with a spongy gray or brown upper layer and a lower layer that is firm and black. Odor of fenugreek at least when dry, taste bitterish to slightly acrid or not distinctive.
MICROSCOPIC FEATURES: Spores 3.5–5.5 μm, globose to subglobose, coarsely echinulate, prominently apiculate, hyaline.
SPORE PRINT: White.
HABIT, HABITAT, AND SEASON: Scattered or in groups in broadleaf or conifer woods; summer–late fall.
EDIBILITY: Inedible.
COMMENTS: The epithet *alboniger* means "white and black." *Phellodon niger* (not illustrated) has a dark smoky brown to blackish cap and thinner flesh, up to 3 mm thick, that is less obviously duplex.

Phellodon melaleucus (Sw. ex Fr.) P. Karst.

= *Phellodon graveolens* (Pers.) P. Karst.

COMMON NAME: Gray Tooth

MACROSCOPIC FEATURES: **cap** 2–8 cm wide, broadly convex or irregularly flat, sometimes depressed. **upper surface** uneven, wrinkled, and bumpy or nearly smooth, finely matted and woolly, azonate or weakly zonate; marginal areas whitish, becoming grayish brown to blackish brown, the central area darker brown to blackish. Cap margin entire, often lobed, often misshapen when fused with other caps. **fertile surface** covered with crowded, decurrent, short spines up to 2 mm long, pale grayish brown to ashy gray, with paler tips when young, with a narrow, buff, sterile margin. Stalk 1.5–3 cm long and 3–4 mm thick, central or eccentric, equal or tapered downward, colored like the cap, sometimes fused. **flesh** about 2–3 mm thick, homogeneous, light fawn, quickly changing to darker brown when exposed. Odor of fenugreek and intensifying when dry, taste not distinctive.

MICROSCOPIC FEATURES: Spores 3–4 μm, globose, tuberculate, hyaline.

SPORE PRINT: White.

HABIT, HABITAT, AND SEASON: Solitary or in fused clusters on the ground in broadleaf or mixed woods; summer–early winter.

EDIBILITY: Inedible.

COMMENTS: The epithet *melaleucus* means "black and white," a reference to the colors of the fruit body. Species in the genus *Phellodon* have an odor of fenugreek that becomes more intense on drying. *Phellodon ellisianus* (not illustrated) is very similar to *Phellodon melaleucus* but smaller, up to 4 cm wide, and it lacks a white margin. *Phellodon brunneoolivaceus* (not illustrated) is also very similar and lacks a white margin. It is nearly identical to *Phellodon ellisianus* but slightly smaller, up to 2 cm wide. Although molecular analysis suggests that they are distinct species, this is based on the use of internal transcribed spacers (ITS) only. It is quite likely that all three are the same.

Sarcodon atroviridis (Morgan) Banker

= *Hydnum atroviride* Morgan

MACROSCOPIC FEATURES: cap 2.5–8 cm wide, convex to nearly flat. **upper surface** dry, smooth to felty, color variable, pale yellowish tan to grayish tan with olive green and black tints when young, becoming grayish black to olivaceous black at the center and grayish yellow toward the margin, sometimes grayish black to olivaceous black overall, staining black when bruised. The margin is strongly incurved when young and remains so well into maturity, entire, yellow to yellow-brown with grayish black stains. **fertile surface** covered with long, stout spines, 6–16 mm long, grayish brown when young, dark brown with paler tips when mature. **stalk** 5–10 cm long and 6–16 mm thick, nearly equal, hollow in age, smooth, colored like the cap and staining black when bruised. **flesh** thick, firm, brittle, pale grayish white, staining pinkish gray, then blackish when exposed. Odor not distinctive, taste bitter.

MICROSCOPIC FEATURES: Spores 6–8.5 μm, oval to globose, strongly warted, pale brown.

SPORE PRINT: Brown.

HABIT, HABITAT, AND SEASON: Solitary, scattered, or in groups on the ground in broadleaf and mixed woods; summer–fall.

EDIBILITY: Edible, but of poor quality.

COMMENTS: The epithet *atroviridis* means "blackish green." Compare with *Sarcodon imbricatus*. *Sarcodon amarescens* (not illustrated) has a dull brown to purple-brown cap that is often depressed at the center, with pinkish violet to vinaceous purple flesh that tastes acrid or bitter and is exceedingly unpleasant and astringent. A section of the flesh immediately stains blue-green in KOH. The decurrent spines are dark brown with whitish tips and measure 1.5–5 mm long. It has a central stalk that tapers downward with white basal mycelium. The spore print is pale brown with strongly warted inamyloid spores that measure 4.8–6 × 4–5 μm. It grows on the ground with oaks and pines.

Sarcodon imbricatus (L.) P. Karst.

= *Hydnum imbricatum* L.

COMMON NAMES: Scaly Tooth, Shingled Hedgehog

MACROSCOPIC FEATURES: **cap** 5–20 cm wide, convex with a depressed center when young, becoming deeply depressed at maturity. **upper surface** dry, cracked, and conspicuously scaly, pale brown becoming dark brown; scales erect, pointed, arranged more or less concentrically, and less erect toward the margin. Cap margin incurved at first, becoming cracked or torn at maturity. **fertile surface** covered with spines 6–10 mm long, grayish brown when young, becoming reddish brown to dark brown in age. **stalk** 4–10 cm long and 1.5–3.5 cm thick, enlarged downward, dry, smooth, typically hollow at maturity, pale to dark brown, not grayish or greenish black to black at the base. **flesh** 1–1.5 cm thick, firm but brittle, white to brownish. Odor not distinctive, taste not distinctive or somewhat bitter.

MICROSCOPIC FEATURES: Spores 6–8 × 5–7.5 μm, subglobose, coarsely tuberculate, pale brown.

SPORE PRINT: Brown.

HABIT, HABITAT, AND SEASON: Solitary, scattered, or in groups on the ground with conifers or broadleaf trees; late spring–early winter.

EDIBILITY: Edible.

COMMENTS: The epithet *imbricatus* means "covered with tiles or scales like shingles." *Sarcodon scabrosus* (not illustrated) is similar, but the base of the stalk is grayish or greenish black to black, and its flesh has a farinaceous odor and tastes bitter. *Sarcodon underwoodii* (not illustrated) is also similar, but the stalk base is abruptly pointed and whitish. The flesh is fragrant, farinaceous, or sometimes not distinctive, and the taste is extremely bitter.

Steccherinum ochraceum (Pers.) Gray

= *Climacodon ochraceus* (Pers.) P. Karst.
= *Irpex ochraceus* (Pers.) Kotir. & Saaren

MACROSCOPIC FEATURES: **fruit body** annual, stalkless, 5–15 cm or more long, forming resupinate patches or becoming effused-reflexed on decaying wood. **upper surface** zonate with matted and woolly to velvety grooves and ridges ochraceous to grayish orange or dull white; margin rounded, wavy, lobed, whitish when actively growing. **fertile surface** consisting of spines 1–2.5 mm long, crowded, sometimes fused, orange to salmon. **flesh** thin, dry, fibrous-tough, white. Odor and taste not distinctive.

MICROSCOPIC FEATURES: Spores 3–5 × 2–2.5 μm, oval to oblong-ellipsoid, smooth, hyaline, inamyloid, with 1 oil drop; cystidia on the spines, thick-walled, projecting beyond the basidia, hyaline, typically encrusted.

HABIT, HABITAT, AND SEASON: In overlapping clusters or spreading patches on decaying broadleaf trunks, logs, and branches, often on the underside; year-round.

EDIBILITY: Inedible.

COMMENTS: The epithet *ochraceum* means "pale brownish orange-yellow." *Irpex lacteus* (see Color Key) is similar but has a white to creamy white fruit body.

Steccherinum subrawakense Murrill

= *Hydnum subrawakense* (Murrill) Murrill
= *Irpex subrawakensis* (Murrill) Saaren & Kotir.

MACROSCOPIC FEATURES: fruit body annual, consisting of a stalkless cap attached to decaying wood. **cap** up to 6 cm wide, shell- to fan-shaped or semicircular. **upper surface** uneven, with small, rounded bumps, whitish to grayish with concentric grooves and ridges at first, becoming conspicuously zonate with bands of tan, ocher, buff, and brown; margin thin, sterile, entire, wavy or slightly lobed. **fertile surface** consisting of crowded teeth, 2–10 mm long, firm and tough, rounded or flat, pointed, simple or divided at the tip, yellow-brown or grayish brown, staining darker brown when bruised. **flesh** 2–4 mm thick, tough, yellowish brown to brown. Odor of cinnamon or black cherries, especially when drying or placed on a dehydrator, taste not distinctive.

MICROSCOPIC FEATURES: Spores 2.5–3 × 1–1.5 μm, ellipsoid, smooth, hyaline, with 1 oil drop.

HABIT, HABITAT, AND SEASON: In groups or overlapping clusters, often fused laterally, on broadleaf branches and logs; fall–early winter.

EDIBILITY: Inedible.

COMMENTS: Saprotrophic on decaying wood. It was first collected by E. West and W. A. Murrill near Gainesville, Florida, in 1938. Additional images of this unusual fungus photographed by Bill Sheehan and others may be seen on the website Mushroom Observer. Recent unpublished molecular analysis results suggest that what has been called *Steccherinum subrawakense* in eastern North America may actually be *Metuloidea reniformis*. Alternatively, it is possible that *Steccherinum subrawakense*, as described by Murrill, is a different species. More research is needed to clarify this issue.

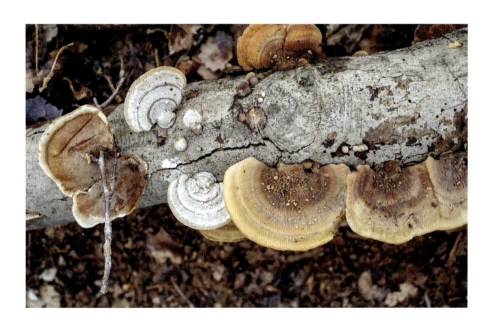

TRUFFLES AND OTHER HYPOGEOUS FUNGI

Because they are mostly under-ground fungi, these fungi are not commonly collected. Most species in this group must be excavated, although species of *Rhizopogon* and *Zelleromyces* are sometimes found partially buried or wholly aboveground. They are nearly round or lobed, and their smooth or roughened to warted, outer, rind-like surface is often thickened. Although they sometimes resemble puffballs or earthballs, their interior is usually chambered, marbled, or somewhat hollow. If you cannot identify your unknown mushroom in this section, try comparing it to the species listed in the Puffballs, Earthballs, Earthstars, and Similar Fungi group.

Rhizopogon nigrescens Coker & Couch

MACROSCOPIC FEATURES: fruit body 1–4 cm wide, rounded to top-shaped or somewhat flattened, lacking a stalk. **outer surface** a thin peridium of sterile tissue, somewhat sticky when young, becoming matted and woolly to felty at maturity, yellowish when young, becoming brownish orange to grayish brown, and finally dark brown to blackish in age, staining dull red to reddish brown, then brown when bruised. **interior** composed of minute, spore-bearing chambers that are best observed with a hand lens. **gleba** firm and whitish when young, becoming grayish yellow to olive brown at maturity.

MICROSCOPIC FEATURES: Spores 6–9 × 2–3.5 μm, subfusoid to oblong, smooth, hyaline to pale yellow.

HABIT, HABITAT, AND SEASON: Scattered or in groups, often partially buried, in sandy soil under pines; summer–early winter.

EDIBILITY: Unknown.

COMMENTS: The epithet *nigrescens* means "blackening," a reference to the color of the mature peridium. *Rhizopogon atlanticus* (not illustrated) is similar, but its peridium is whitish when young and becomes pinkish cinnamon to yellowish brown in age or on drying. The gleba is whitish to buffy brown, and its spores measure 7–8.5 × 3–4 μm.

Rhizopogon roseolus (Corda) Th. Fr.

= *Rhizopogon rubescens* (Tul. & C. Tul.) Tul. & C. Tul.

MACROSCOPIC FEATURES: fruit body 1.5–6 cm wide, irregularly subglobose to somewhat lobed, stalkless. **outer surface** a thin peridium of sterile tissue, bald, nearly smooth except for a few ridges and depressions, dry or moist but not sticky, white when very young and underground, becoming yellowish with an olive tint, and finally reddish brown or darker brown in age, staining reddish when bruised. **interior** composed of minute, spore-bearing chambers that are best observed with a hand lens. **gleba** firm and white at first, becoming granular and olive buff at maturity, staining reddish when cut.

MICROSCOPIC FEATURES: Spores 6–10.5 × 2.5–4.5 μm, elliptic, smooth, brownish yellow.

HABIT, HABITAT, AND SEASON: Scattered or in groups under conifers, especially pines, often partially buried, sometimes partially fused; summer–winter.

EDIBILITY: Unknown.

COMMENTS: The epithet *roseolus* means "pinkish red," a reference to the color produced when the peridium is bruised or the gleba is exposed. What has been described as *Rhizopogon roseolus* from North America may not be the same as that found in Europe and may be a new species.

Tuber brennemanii A. Grupe, Healy, & M. E. Smith

MACROSCOPIC FEATURES: fruit body 1.1–2.6 × 0.8–1.6 cm, somewhat rounded and knobby, stalkless. **outer surface** a thin peridium of sterile tissue, creamy yellow to brown with lighter-colored furrows. **interior** composed of minute, spore-bearing chambers that are best observed with a hand lens. **gleba** firm and whitish at first, becoming grayish to brown with white marbling at maturity, powdery in age. Odor pleasant, taste nutty.

MICROSCOPIC FEATURES: Spores 28–61 × 20–36 μm, ellipsoid to broadly ellipsoid, pitted like a honeycomb, reticulate, reddish brown to yellow-brown in KOH.

HABIT, HABITAT, AND SEASON: Solitary or scattered, hypogeous with pecan or oak trees, more common in disturbed landscapes such as pecan orchards; year-round.

EDIBILITY: Edible.

COMMENTS: The epithet *brennemanii* honors mycologist and plant pathologist Timothy Brenneman, who collected the holotype. The Fragrant Eastern Truffle, *Tuber canaliculatum* (see Color Key), has a 2–7 cm wide fruit body that has a yellow-orange to orange-brown or reddish brown outer surface covered with conspicuous low warts. The interior is marbled and gray to brownish gray with maze-like whitish veins.

Tuber lyonii group Butters

= *Tuber texense* Heimsch

COMMON NAME: Pecan Truffle
MACROSCOPIC FEATURES: fruit body 1–4 cm wide, globular, lobed, stalkless. **outer surface** a thin, smooth peridium of sterile tissue, roughened in the furrows, orangish brown to reddish brown. **interior** composed of minute, spore-bearing chambers that are best observed with a hand lens. **gleba** firm and white at first, becoming brown with white marbling at maturity, powdery in age. Odor a complex mixture of spices, garlic, and cheese.
MICROSCOPIC FEATURES: Spores 30–37 × 22–24 μm, elliptic, with tall spines connected by low lines when mature, hyaline.

HABIT, HABITAT, AND SEASON: Solitary or in groups, hypogeous under pecan trees; year-round.
EDIBILITY: Edible and choice when mature.
COMMENTS: It is often raked up when pecans are harvested. Compare with *Tuber brennemanii*, which also occurs with pecan trees. The fruit bodies of the false truffles = deer truffles, *Elaphomyces* species (see Color Key), are 2–4 cm wide and consist of a peridium and a mycelial base. The peridium is rounded, often warted, and yellow-brown, reddish brown, or blackish, and it has a thick rind. The gleba is brown or black and powdery when mature. They grow underground with conifers or broadleaf trees year-round and are commonly encountered by spotting the *Tolypocladium* species that parasitize them.

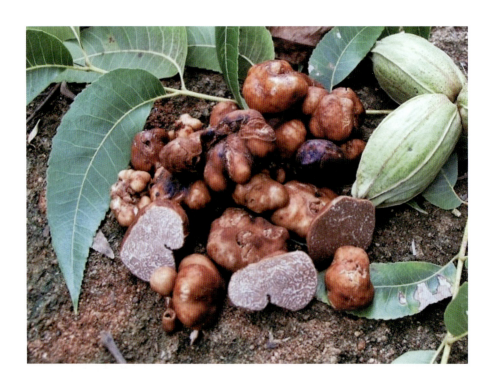

Zelleromyces cinnabarinus Singer & A. H. Sm.

COMMON NAME: Milky False Truffle

MACROSCOPIC FEATURES: fruit body 1–3 cm wide, consisting of a peridium with a small, white, basal knob of mycelium at the point of attachment, subglobose to irregularly compressed and lobed, often flattened, stalkless. **outer surface** dry, smooth, brick-red to dull orange-brown, sometimes mottled with orange and white. **interior** chambered or marbled with sterile tissue, with a distinct branching columella. **gleba** firm and orangish white at first, exuding a white latex when fresh specimens are cut, becoming granular and brownish in age. Odor pungent, like rubber or not distinctive, taste not distinctive.

MICROSCOPIC FEATURES: Spores 12–18 × 11–16 μm, globose to broadly elliptic, thick-walled, ornamented with warts and ridges that form a broken to nearly complete reticulum, hyaline to pale yellow, amyloid.

HABIT, HABITAT, AND SEASON: Scattered, in groups, or clustered on the ground, often partially buried, mycorrhizal with pines; summer–winter.

EDIBILITY: Unknown.

COMMENTS: The epithet *cinnabarinus* means "the color of cinnabar," a reference to the outer surface of the peridium. *Rhizopogon* species are similar and are also mycorrhizal with pines, but they lack latex and a columella.

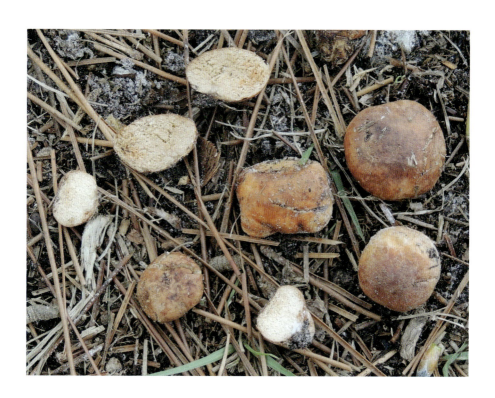

GLOSSARY

acidic: having a sour or sharp taste
acrid: having an unpleasantly sharp and burning taste or smell
aecial: pertaining to an aecium
aeciospore: an asexual spore usually borne as chains in an aecium
aecium, aecia: the cup-shaped fruit body of a rust fungus
aleuriospore: a stalkless asexual spore borne laterally
allantoid: sausage-shaped
amygdaliform: almond-shaped
amyloid: staining grayish to blue-black in Melzer's reagent
anamorphic: pertaining to the asexual stage
anastomosing: connecting in a network-like pattern
angular-ovoid: somewhat egg-shaped with one or more angles
anise: a sweet, licorice-like odor
annual: completing growth in one season
apex, apical, apically: the uppermost portion
apical pore: a small opening in the uppermost portion of the spore wall
apiculus, apiculi, apicular, apiculate: a projection at or near the base of a spore
appendage: a structure attached to the main body, such as wings, legs, and mouth parts
appendiculate: hung with fragments of the partial veil
appressed: closely flattened down
aquamarine: light bluish green

areolate: marked out by cracks or crevices
arthropod: an invertebrate animal that has an exoskeleton, a segmented body, and jointed appendages
ascomycete: a fungus in which the spores are produced in asci
ascospore: a spore borne in an ascus
ascus, asci: sac-like structures in which ascospores are produced
aseptate: lacking crosswalls
asexual: produced without the exchange of genetic information
astringent: tending to cause the mouth to pucker
asymmetrical: not identical on both sides
attached (gills): joined to the stalk
axil: the upper angle between branches
azonate: lacking bands or zones
bacilliform: rod-shaped
bald: lacking fibers, hairs, scales, etc.
basal, basally, base: the lowest portion
basal mycelium: a mass of hyphae located at the stalk base
basidiomycete: a fungus in which the spores are produced on basidia
basidiospore: a sexual spore formed in groups on a club-shaped cell called a basidium
basidium, basidia: a typically club-shaped cell on which basidiospores are formed
bay: reddish brown or chestnut color
beaded: having a row of exuded droplets
bearded: adorned with hairs
beveled: slanted or sloped

bifurcated: forking by twos

bioluminescence, bioluminescent: the biochemical emission of light by various organisms

bloom: a dull, thin coating that is typically whitish

bog, boggy: a poorly drained, spongy, wet area composed primarily of sphagnum mosses and peat, usually surrounding a body of water

bracket: a fruit body having one or more shelf-like projections

brick red: a rusty red to dull rusty red

broadleaf: referring to any non-cone-bearing deciduous tree or shrub

broom cell: a cell with several apical appendages that give a broom-like appearance

buff: dull white to very pale yellow

bulb, bulbed, bulbous: a somewhat rounded swelling

burgundy: deep red to reddish purple

button: the immature stage of a mushroom

caespitose: occurring in clusters with stalk bases fused or nearly so

canescence: a whitish to grayish covering of fine, silky down

cap: the upper part of a fruit body that supports gills, spines, tubes, or a smooth surface on its underside

cartilaginous: tough and fibrous, often splitting lengthwise in strands

caulocystidia: cystidia found on the stalk

central (stalk): located at the middle

chambered: divided into distinct compartments

chamois: grayish yellow

cheilocystidia: cystidia found on the outer edge of the tubes or gills

chlamydospore: a thick-walled, typically rounded, secondary asexual spore

cinnabar: vivid reddish orange

clavate: club-shaped

close (gills): spacing that is halfway between crowded and subdistant

coalesce, coalescing: coming together to form a mass or whole

cogwheel, cogwheeling: a toothed wheel

columella: a persistent sterile column within a spore case

columnar: having the form of a column

compressed: flattened longitudinally

concave: shaped like a bowl

concentric, concentrically: having rings or zones within one another in a series

confluent: merging and becoming continuous together

conical: having the shape of an inverted cone

conidiophore: a tiny stalk that supports a conidium

conidium, conidia: an asexual spore supported by a tiny stalk

conifer: a cone-bearing tree with needle-like leaves, such as pine

conjoined: linked together, usually at the tips

contorted: twisted or bent out of the normal shape

convex: curved or rounded like an inverted bowl

convex-depressed: curved or rounded and sunken in the middle

convoluted: intricately folded

copious: having a large quantity

corniculate: having small horns

corrugated: coarsely wrinkled or ridged

cortina: a spiderweb-like partial veil

crescent: resembling a half-moon or sickle-shaped

crested (branch tips): having a showy tuft of projecting teeth

crimped: having small, regular folds

crimson: deep purplish red

crossveined: having tiny wrinkles or raised ridges that connect adjoining gills

crowded (gills): having little or no space between gills or pores

cuticle: the outermost tissue layer of the cap or stalk

cyanophilus: staining blue in a solution of cotton blue

cylindric: having the same diameter throughout the length

cylindric-ellipsoid: nearly having the same diameter throughout the length and resembling an elongated oval with similarly curved ends

cylindric-oblong: nearly having the same diameter throughout the length, longer than wide, and with somewhat flattened ends

cylindric-subclavate: somewhat cylinder-like to somewhat club-shaped

cystidia: sterile cells that project between and usually beyond the basidia or on the cap or stalk surface

deciduous: having leaves that fall off every year

decorticated: lacking a layer of bark

decurrent: running down the stalk

decurrent tooth: a narrow extension of a gill or tube that extends a short distance down the stalk apex

deliquesce, deliquescing: dissolving into an inky fluid

depressed (pore surface): somewhat sunken

dextrinoid: staining orange to orange-brown or dark red to reddish brown in Melzer's reagent

dichotomously: divided into two portions

disc: the central area of the surface of a cap

distal: farther away from the center

distant (gills): widely spaced

drab: a dull light brown

duff: decaying plant matter on the ground in woodlands

duplex: consisting of two distinct layers of different textures

eccentric, eccentrically (stalk): away from the center but not lateral

echinulate: having small spines

ecological niche: the place or function of a given organism within its ecosystem

ecosystem: a biological community of interacting organisms and their physical environment

edges (gills): the sharp, free, lower portion most distant from the cap

effused-reflexed: spread out over the substrate and turned outward at the margin

ellipsoid or elliptic: resembling an elongated oval with similarly curved ends

ellipsoid-cylindric: elongated and somewhat cylindric

ellipsoid-fusoid: elongated and somewhat spindle-shaped

ellipsoid-inequilateral: resembling an elongated oval with unequal sides

ellipsoid-oblong: resembling an elongated oval but longer than it is wide and with somewhat flattened ends

elliptic-cylindric: having nearly the same diameter throughout and slightly oval

elliptic-fusiform: more or less elliptic and somewhat spindle-shaped

elliptic-inequilateral: more or less elliptic with unequal sides

elongate-fusoid: elongated and somewhat spindle-shaped

encrust: to cover with a thin, hard crust

entire: having the margin or edges not lobed, toothed, torn, or uneven

ephemeral: lasting for a very short time

epithet: the second part of a Latin binomial scientific name

erumpent: breaking through or bursting out

evanescent: slightly developed and soon disappearing

even: not extending beyond or covering over

exoskeleton: a hard outer shell-like layer that supports and protects invertebrates

exuding: very slowly releasing

face: each side of a gill

fairy ring: a distribution of mushrooms in a circle that widens from year to year

farinaceous: an odor variously compared to sliced watermelon rind, cucumber, meal, bread dough, or farina

fascicle: a tiny bundle

felty: having a texture that resembles a soft, nonwoven, matted fabric

fenugreek: a Eurasian plant with a distinctive sweet odor resembling maple syrup

ferruginous: smoky yellow to rusty

fertile surface: portion of the fruit body containing reproductive structures

FeSO4: ferrous sulfate, also called iron salt, usually a 10% solution
fetid: having an offensive odor
fibril: a tiny fiber
fibrillose: composed of fibrils
fibrous: composed of fibers
filamentous: composed of tiny threads
filiform: thread-like
fimbriate: minutely fringed
flesh: the inner supporting tissue of a fruit body
floccose: tufted like tiny cotton balls
floccose-scaly: having scales that are tufted like tiny cotton balls
flocculence: having minutely scaly tufts resembling cotton balls
fork, forked, forking: divided into two or more branches
free (gills): not attached to the stalk
fruit body: the reproductive stage of a fungus, sometimes called a mushroom
fulvous: reddish cinnamon; colored like a red fox
furrow, furrowed: marked by grooves
fusiform: spindle-shaped
fusiform-elliptic: mostly spindle-shaped and somewhat elongated
fusoid: somewhat spindle-shaped
fusoid-ampullaceous: swollen and somewhat spindle-shaped
fusoid-subventricose: enlarged in the middle and slightly spindle-shaped
fusoid-ventricose: enlarged in the middle and somewhat spindle-shaped
gall: a type of swelling growth on the external tissues of plants caused by various parasites, including bacteria, fungi, and viruses
gelatinous: having the consistency of jelly
germ pore: a thin portion of the spore wall through which the hypha passes during germination
germ slit: a fissure or crack in the spore wall that facilitates germination
gill: a thin or thick, knifeblade-like structure on the undersurface of the cap of some mushrooms

glancing: shining like highlights in polished wood when held at a certain angle
gleba: the spore-bearing tissue of stinkhorns and puffballs, also called a spore mass
globose: round, resembling a globe
gregarious, gregariously: closely scattered over a small area
habit: the general appearance or manner of growth of a fungus
habitat: the natural place where a fruit body grows
hardwood: any non-cone-bearing tree with broad leaves, such as beech or oak
hemispherical: shaped like one-half of a sphere
hexagonal: having six angles and six sides
hispid: covered with stiff, bristle-like hairs that are usually visible to the naked eye
hyaline: clear and nearly colorless
hydrazine: a toxic liquid or gaseous chemical used in making rocket fuel that may damage the nervous system, liver, or kidneys
hygrophanous: fading markedly as the cap dries
hygroscopic: readily absorbing water
hymenial cystidia: sterile cells located in the spore-bearing layer of a fungus
hymenial setae: sharply pointed, microscopic, sterile cells located in the spore-bearing layer of a fungus
hymenium: the spore-bearing layer of a fungus
hyperparasite: a parasite that is parasitic on another parasite
hypertrophied: enlarged and appearing abnormal
hypha, hyphae: a microscopic, thread-like filament composed of fungal cells
hypogeous: occurring below the ground surface
inamyloid: unchanging or staining pale yellow in Melzer's reagent
incurved: bent inward toward the stalk
indeterminate: without a definite margin or edge
inrolled: bent inward and upward toward the stalk
interwall pillar: a microscopic extension that connects two layers of spore walls

invertebrate: any animal that lacks a backbone
KOH: potassium hydroxide, usually a 3%–5% concentration in water
lacerated: appearing as if torn
lacrimoid: shaped like a teardrop
lanceolate: of much greater length than width and tapering
lateral, laterally: on the side or edge
latex: a watery or milk-like fluid that exudes from some mushrooms when cut or bruised
lavender: a pale tint of purple
Lepidella: a section of the genus *Amanita*
lichenized: adaptive to live as a beneficial partner in a lichen
lilac: pale bluish purple
lobe, lobed: a subdivision with a rounded margin
longitudinal, longitudinally: oriented along the vertical axis of the stalk
lubricous: smooth and slippery
lustrous: shiny and bright
magenta: purplish red
marbling (flesh): having flecks or streaks of a different color
margin: the edge of a mushroom cap
marginate: having gill edges that are darker than the faces
maroon: dark reddish purple
marzipan: a confection consisting primarily of honey or sugar and almond paste with a distinctive odor of almond extract
mawkish: lacking flavor or having an unpleasant taste
maze: a complex network of interconnected pathways
median (ring): located approximately at the middle of the stalk
medullary layer or zone: the inner middle portion
Melzer's reagent: a solution containing iodine, potassium iodide, chloral hydrate, and water used to test spores and tissues for color reactions
membranous: having a membrane

mottled: having spots or blotches of different colors
mucronate: tipped with an abrupt, short, sharp point
multichambered: divided into many small compartments
multiseptate: having several or many crosswalls
myceliated: having a mass of mycelia
mycelium, mycelia: a mass of hyphae, typically hidden in a substrate
mycorrhiza, mycorrhizae, mycorrhizal: when the mycelium of a fungus has a mutually beneficial relationship with the roots of a tree or other plant
NH4OH: ammonium hydroxide used to test color reactions or as a mounting fluid
nocturnal: occurring during the night
nodular: occurring as small bumps or lumps
oblique: in a slanting direction
oblong: longer than wide and with somewhat flattened ends
oblong-elliptic: longer than wide and somewhat elliptic
oblong-fusoid: longer than wide and somewhat spindle-shaped
obovate, obovoid: egg-shaped, with the broader end opposite to the point of attachment
obtuse: rounded or blunt
ocher: brownish orange-yellow
ochraceous: pale brownish orange-yellow
olivaceous: having olive tints
opportunistic pathogen: an organism that exists harmlessly as part of the normal human body and becomes a health threat when the immune system fails
ostiole: a mouth-like opening
oval: egg-shaped
ovoid: somewhat egg-shaped
pallid: having a pale or whitish appearance
pantherine: species of *Amanita* containing significant amounts of ibotenic acid and muscimol, similar to *Amanita pantherina* and *Amanita muscaria*

papilla: a small nipple-shaped elevation
papillate: having a small nipple-shaped elevation
paraphysis, paraphyses: a distinctive sterile cell that keeps an ascus erect
parasite: an organism that obtains nutrients from a living host
parasitic, parasitized: obtaining nutrients from a living host
partial veil: a layer of tissue that covers the gills or pores of some immature mushroom species
part-spore: a single aseptate spore detached from a larger multiseptate spore
pathogenic: pertaining to a disease-producing organism
pedicel: a slender stalk
pendant: hanging downward
perennial: continuing to grow from year to year
peridiole: a tiny egg-like structure that contains spores
peridium: one or more layers that form the wall of a spore case
peripheral, peripherally: located on the edge of something
perithecia: minute, flask-shaped structures containing asci and ascospores
phallic: shaped like an erect penis
phaseoliform: bean-shaped
phylogenetic: pertaining to the inferred evolutionary relationships among various biological species
pileipellis: the outer surface layer of the cap, sometimes called a cuticle
pip-shaped: shaped like an apple seed
pith: soft tissue that often disappears
pleated: arranged in folds
pleurocystidia: cystidia found along the inner surface of the tubes
plicate: folded like a fan
pore, pore mouth: the open end of a tube, also called the tube mouth
pore surface: the undersurface of a mushroom cap composed of vertically oriented tubes
poroid: resembling pores or composed of pores
porose: having pores

pruinose: appearing finely powdered
pruinose-matted: appearing powdered and flattened down
pseudoamyloid: reacting strongly and actively to the iodine in Melzer's reagent by staining a deep purplish brown
pseudoreticulate: falsely reticulate because of anastomosing, slightly raised, longitudinal lines or ridges
puckered: a tightly gathered wrinkle or small fold
pulvinate: cushion-shaped, slightly convex
punctae: tiny, dry, nearly flattened dots or scales
punctate: marked by tiny, dry, nearly flattened dots or scales
pungent: sharp or irritating
pupae: the nonfeeding, immature stage of an insect between the larval stage and the adult stage
pyramidal: shaped like a pyramid
radially: pointed away from a common central point, like the spokes of a wheel
ray: the pointed piece of a split spore case
recurved: curved backward or downward
reflexed: turned up or back
resinous (dots and smears): small marks or patches of a sticky resin
resinous (odor): resembling a type of tree sap such as pine or balsam fir
resupinate: spread out on the substrate without any shelf-like portion
reticulum, reticulate, reticulation: raised, net-like ridges found on the stalk surface or spores of some fungi
rhizoid: a thickened, radiating hypha extending into the substrate from the base of a fruit body
rhizomorph: a thick, cord-like strand of hyphae growing together as a unit
rhomboid: resembling a rhombus
rhombus: a flat, four-sided geometric figure with sides of equal length and angles of other than 90 degrees, that is, not a square.
rimose: having small cracks or crevices
rimose-areolate: cracked in a manner that marks out distinctive patches or areas

ring: remnants of a partial veil that remains attached to the stalk after the veil ruptures

ring zone: faint remnants of a partial veil, usually composed of tiny fibers, attached to the stalk

rooting: extending downward and penetrating some distance into the substrate

rosette: arranged in the shape of rose petals

rudimentary: having a very small stature

saccate: having a sac

sappy: containing a lot of sap

saprobe, saprotroph, saprotrophic: an organism that lives off dead or decaying matter

scaber: a small, stiff, granular projection on the stalk of some boletes

scale, scaly: a flattened, erect, or recurved projection or torn portion of a cap or stalk surface

scalloped: having a wavy outer edge

scarlet: bright red to slightly orange-tinted red

sclerotium, sclerotia: a small, rounded to irregular structure composed of dormant hyphae

scruffy: roughened and uneven

scurfy: roughened by tiny flakes or scales

season: period during which a fungus appears and reproduces

seceding (gills): attached at first and then separating from the stalk

segmented: divided into successive parts

septum, septa, septate: a crosswall, or divided by crosswalls

serpentine: appearing somewhat snake-like

serrated: jagged or toothed like a saw blade

seta, setae: a sharply pointed, microscopic, sterile cell that is usually brown or yellow

setal hyphae: thick-walled, pointed hyphae found in the tissue between tubes in some fungi

sexual: produced with the exchange of genetic information

short gill: a gill that does not reach the stalk, often of varying lengths

sinuate (gills): having a concave indentation near the stalk

sinuous: somewhat wavy

sordid: of a dirty or dingy color

spermatic: having the odor of semen, male reproductive fluid containing sperm cells in suspension

spindle-shaped: having a circular cross section and tapering toward each end

sporangiophore: a modified hypha that supports a sporangium

sporangiospore: an asexual spore produced in a sac-like structure by some species of aseptate fungi

sporangium, sporangia: a sac-like structure in which sporangiospores are produced

spore: a microscopic reproductive cell produced by a fungus

spore case: a sac-like structure that contains the spore mass

spore mass: a dense layer of spores produced by puffballs or stinkhorns, also called a gleba

spore print: a deposit of spores on paper, glass, or other surface

stalactite: a tapering structure hanging like an icicle

stalk: the erect structure that supports the cap, head, or spore case of a fruit body

sterile margin: having cuticle tissue that extends beyond the gills, tubes, or other reproductive structures on the underside of the cap

stipitipellis: the outer surface layer of the stalk

striation, striate: having small and more or less parallel lines or furrows

stroma: a cushion-like mass of fungal cells and host tissue containing reproductive structures

subapical: located somewhat down from the apex but above the center

subcentral: located slightly away from center

subcylindric: having nearly the same diameter throughout the length

subdecurrent: extending slightly down the stalk

subdistant (gills): halfway between close and distant

subellipsoid: somewhat like an elongated oval

subelliptic: pertaining to a somewhat elongated oval

subfusiform, subfusoid: nearly spindle-shaped

subfusoid-ellipsoid: nearly spindle-shaped to somewhat elongated and oval

subglobose: nearly round

subhygrophanous: fading somewhat as the cap dries

suboblong: somewhat longer than wide and with more or less flattened ends

subpellis: the layer of tissue immediately below the cuticle

subrhomboid: somewhat shaped like a rhombus

subspherical: nearly round

substrate: organic matter that serves as a food source for fungal mycelium, such as soil, leaves, or wood

subterranean: located underground

subulate: shaped like an awl

sulfur yellow: bright yellow

superior (ring): located on the upper portion of the stalk

tag: a piece of torn partial veil adhering to the cap margin

tatter: a torn remnant of the partial veil

tawny: dull yellowish brown

taxon, taxa: a distinct species

teliomorphic: pertaining to the sexual stage

terrestrial: growing on the ground

tiers: a series of rows of different lengths

trama: the sterile tissue supporting the spore-bearing layer

translucent: allowing light to pass through while causing structures on the other side not to be sharply visible

translucent-striate: appearing to have lines or furrows when gill edges are viewed through moist, nearly transparent cap tissue

truncate, truncated: appearing cut off at the end

tube: a narrow, parallel, spore-producing cylinder on the underside of the cap of a bolete or polypore

tube layer: numerous tubes that make up the fertile surface of a bolete or polypore

tuberculate: having small warts or bumps

tuberculate-striate: having lines or furrows that are roughened by small bumps

tubular: cylindric and hollow

tuft: a short, compact cluster arising from a common base

umbilicate: having a central, funnel-shaped depression

umbo, umbonate: a rounded or pointed elevation at the center of some mushroom caps

universal veil: a layer of tissue that completely encloses the immature stage of some mushrooms

urediospores: asexual summer spores arranged in chains, produced during the life cycle of rust species

vegetative hypha: a nonreproductive hypha that supports or takes up nutrients

ventricose: swollen in the middle and tapered in both directions

verrucose: covered or marked with small, rounded processes or warts

vinaceous: having the colors of red wines

violaceous: having a bright bluish purple color

volva, volval: the remains of a universal veil at the stalk base of some gilled mushrooms or the base of some stinkhorns

warted: having small patches of tissue on the top of some mushroom caps or blunt projections on the wall of some spores

whey-like: watery white

zone, zonate, zoned: concentric rings or bands on the cap or stalk of some mushrooms

REFERENCES AND RESOURCES

Adamcik, S., S. Jančovičová, and B. Buyck. 2018. The russulas described by Charles Horton Peck. *Cryptogamie Mycologie* 39(1): 3–108.

Alvarado, P., G. Moreno, A. Vizzini, G. Consiglio, J. L. Manjón, and L. Setti. 2015. *Atractosporocybe*, *Leucocybe* and *Rhizocybe*: three new clitocyboid genera in the Tricholomatoid clade (Agaricales) with notes on *Clitocybe* and *Lepista*. *Mycologia* 107(1): 123–136.

Arora, D. 1979. *Mushrooms Demystified*. Berkeley, Calif.: Ten Speed Press. 959 pp.

Babikova, Z., L. Gilbert, T. J. A. Bruce, M. Birkett, J. C. Caulfield, C. Woodcock, J. A. Pickett, and D. Johnson. 2013. Underground signals carried through common mycelial networks warn neighboring plants of aphid attack. *Ecology Letters* 16:835–843. doi:10.1111/ele.12115 [PubMed].

Benjamin, D. R. 1995. *Mushrooms: Poisons and Panaceas*. New York: W. H. Freeman and Company. 422 pp.

Bessette, A. E., A. R. Bessette, and D. W. Fischer. 1997. *Mushrooms of Northeastern North America*. Syracuse, N.Y.: Syracuse University Press. 584 pp.

Bessette, A. E., A. R. Bessette, and M. W. Hopping. 2018. *A Field Guide to Mushrooms of the Carolinas*. Chapel Hill: University of North Carolina Press. 432 pp.

Bessette, A. E., A. R. Bessette, and D. P. Lewis. 2019. *Mushrooms of the Gulf Coast States: A Field Guide to Texas, Louisiana, Mississippi, Alabama, and Florida*. Austin: University of Texas Press. 614 pp.

Bessette, A. E., A. R. Bessette, D. P. Lewis, and S. H. Metzler. 1993. A new substrate for *Strobilurus conigenoides* (Ellis) Singer. *Mycotaxon* 68:299–300.

Bessette, A. E., A. R. Bessette, W. C. Roody, and S. A. Trudell. 2013. *Tricholomas of North America: A Mushroom Field Guide*. Austin: University of Texas Press. 208 pp.

Bessette, A. E., D. B. Harris, and A. R. Bessette. 2009. *Milk Mushrooms of North America: A Field Identification Guide to the Genus Lactarius*. Syracuse, N.Y.: Syracuse University Press. 299 pp.

Bessette, A. E., O. K. Miller, A. R. Bessette, and H. H. Miller. 1995. *Mushrooms of North America in Color: A Field Guide Companion to Seldom Illustrated Fungi*. Syracuse, N.Y.: Syracuse University Press. 188 pp.

Bessette, A. E., W. C. Roody, and A. R. Bessette. 2000. *North American Boletes: A Color Guide to the Fleshy Pored Mushrooms*. Syracuse, N.Y.: Syracuse University Press. 400 pp.

———. 2016. *Boletes of Eastern North America*. Syracuse, N.Y.: Syracuse University Press. 469 pp.

Bessette, A. E., W. C. Roody, A. R. Bessette, and D. L. Dunaway. 2007. *Mushrooms of the Southeastern United States*. Syracuse, N.Y.: Syracuse University Press. 375 pp.

Bessette, A. E., W. C. Roody, W. E. Sturgeon, and A. R. Bessette. 2012. *Waxcap Mushrooms of Eastern North America*. Syracuse, N.Y.: Syracuse University Press. 179 pp.

Bessette, A. E., D. G. Smith, and A. R. Bessette. 2021. *Polypores and Similar Fungi of Eastern and Central North America*. Austin: University of Texas Press. 430 pp.

Bessette, A. R., and A. E. Bessette. 2001. *The Rainbow Beneath My Feet: A Mushroom Dyer's Field Guide*. Syracuse, N.Y.: Syracuse University Press. 176 pp.

Beug, M. W. 2009. Worldwide mushroom poisoning, diagnosis and treatment: comments on some of the recent research. *Fungi* 2(3): 11–15.

Beug, M. W., A. E. Bessette, and A. R. Bessette. 2014. *Ascomycete Fungi of North America: A Mushroom Reference Guide*. Austin: University of Texas Press. 488 pp.

Bigelow, H. E. 1982. *North American Species of Clitocybe. Part I*. Berlin: J. Cramer. 280 pp.

Binion, D. E., S. L. Stephenson, W. C. Roody, H. H. Burdsall Jr., L. N. Vasilyeva, and O. K. Miller Jr. 2008. *Macrofungi Associated with Oaks of Eastern North America*. Morgantown: West Virginia University Press. 467 pp.

Birkebak, J. M., J. R. Mayor, K. M. Ryberg, and P. B. Matheny. 2013. A systematic, morphological and ecological overview of the Clavariaceae (Agaricales). *Mycologia* 105(4): 896–911.

Both, E. E. 1993. *The Boletes of North America: A Compendium*. Buffalo, N.Y.: Buffalo Museum of Science. 436 pp.

Brietenbach, J., and F. Kränzlin. 1984–1995. *Fungi of Switzerland*. 6 vols. Lucerne, Switzerland: Verlag Mykologia.

Brundrett, M. C., and B. Kendrick. 1987. The relationship between the Ash-tree Bolete (*Boletinellus merulioides*) and an aphid parasitic on ash tree roots. *Symbiosis* 3:315–320.

Bunyard, B., and J. Justice. 2020. *Amanitas of North America*. Batavia, Ill.: Fungi Press. 336 pp.

Burdsall, H. H., Jr., and M. T. Banik. 2001. The genus *Laetiporus* in North America. *Harvard Papers in Botany* 6:3–55.

Buyck, B., C. Cruaua, A. Couloux, and V. Hofstetter. 2011. *Cantharellus texensis* sp. nov. from Texas, a southern lookalike of *C. cinnabarinus* revealed by *tef-1* sequence data. *Mycologia* 103(5): 1037–1046.

Buyck, B., and V. Hofstetter. 2011. The contribution of *tef-1* sequences to species delimitation in the *Cantharellus cibarius* complex in the southeastern USA. *Fungal Diversity* 49:35–46.

Buyck, B., V. Hofstetter, U. Eberhardt, A. Verbeken, and F. Kauff. 2008. Walking the thin line between *Russula* and *Lactarius*: the dilemma of *Russula* subsect. Ochricompactae. *Fungal Diversity* 28:15–40.

Buyck, B., V. Hofstetter, and I. Olariaga. 2016. Setting the record straight on North American *Cantharellus*. *Cryptogamie Mycologie* 37(3): 405–417.

Buyck, B., I. Olariaga, J. Justice, D. Lewis, W. Roody, and V. Hofstetter. 2016. The dilemma of species recognition in the field when sequence data are not in phase with phenotypic variability. *Cryptogamie Mycologie* 37(3): 367–389.

Buyck, B., I. Olariaga, B. Looney, J. Justice, and V. Hofstetter. 2016. Wisconsin chanterelles revisited and first indications for very wide distributions of *Cantharellus* species in the United States east of the Rocky Mountains. *Cryptogamie Mycologie* 37(3): 345–366.

Coker, W. C. 1974. *The Club and Coral Mushrooms (Clavarias) of the United States and Canada*. Reprint. New York: Dover. 209 pp.

Coker, W. C., and A. H. Beers. 1970. *The Stipitate Hydnums of the Eastern United States*. Berlin: J. Cramer. 86 pp.

Coker, W. C., and J. N. Couch. 1974. *The Gasteromycetes of the Eastern United States and Canada*. Reprint. New York: Dover. 283 pp.

Davoodian, N., K. Hosaka, O. Raspé, O. A. Asher, A. R. Franck, A. De Kesel, T. P. Delaney, et al. 2020. Diversity of *Gyroporus* (Gyroporaceae, Boletales): *rpb2* phylogeny and three new species. *Phytotaxa* 434(3): 208–218.

Desjardin, D. E. 1989. The genus *Marasmius* from the southern Appalachian Mountains. PhD dissertation, University of Tennessee.

Desjardin, D. E., A. G. Oliveira, and C. V. Stevani. 2008. Fungi bioluminescence revisited. *Photochemical and Photobiological Sciences* 7(2): 170–182.

Desjardin, D. E., and B. A. Perry. 2017. The gymnopoid fungi (Basidiomycota, Agaricales) from the Republic of São Tomé and Príncipe, West Africa. *Mycosphere* 8(9): 1317–1391.

Elliott, T. F., and S. L. Stephenson. 2018. *Mushrooms of the Southeast*. Portland, Oreg.: Timber Press. 407 pp.

Frank, J. L., A. R. Bessette, and A. E. Bessette. 2017. *Alessioporus rubriflavus* (Boletaceae), a new species from the eastern United States. *North American Fungi* 12(2): 1–8.

Freeman, A. E. H. 1979. *Agaricus* in the southeastern United States. *Mycotaxon* 8:50–115.

Gilbertson, R. L., and L. Ryvarden. 1986. *North American Polypores. Vol. 1*. Oslo: Fungiflora. 433 pp.

———. 1987. *North American Polypores. Vol. 2*. Oslo: Fungiflora. 451 pp.

Gorzelak, M. A., A. K. Asay, B. J. Pickles, and S. W. Simard. 2015. Inter-plant communication through mycorrhizal networks mediates complex adaptive behaviour in plant communities. *AoB Plants* 7:plv050. https://www.ncbi.nlm.nih.gov/pmc/articles/PMC4497361/.

Halford, B. 2011. The Angel's Wing mystery. *Chemical and Engineering News* 89(13): 38–39.

Hallock, R. M. 2019. *A Mushroom Word Guide*. Published by the author. 152 pp.

Hesler, L. R. 1960. *Mushrooms of the Great Smokies: A Field Guide to Some Mushrooms and Their Relatives*. Knoxville: University of Tennessee Press. 289 pp.

———. 1967. *Entoloma in Southeastern North America*. Berlin, Del.: Cramer. 195 pp.

Hesler, L. R., and A. H. Smith. 1965. *North American Species of Crepidotus*. New York: Hafner. 168 pp.

Jenkins, D. T. 1986. *Amanita of North America*. Eureka, Calif.: Mad River Press. 198 pp.

Justo, A., E. Malysheva, T. Bulyonkova, E. C. Vellinga, G. Cobain, N. Nguyen, A. M. Minnis, and D. S. Hibbett. 2014. Molecular phylogeny and phylogeography of Holarctic species of *Pluteus* section *Pluteus* (Agaricales: Pluteaceae), with description of twelve new species. *Phytotaxa* 180(1): 1–85.

Kauffman, C. H. 1932. Cortinarius. *North American Flora* 10(5): 314.

Kerrigan, R. W. 2016. *Agaricus of North America*. Bronx: New York Botanical Garden Press. 572 pp.

Largent, D. L., D. Johnson, and R. Watling. 1977. *How to Identify Mushrooms to Genus III: Microscopic Features*. Eureka, Calif.: Mad River Press. 148 pp.

Lincoff, G. H. 1981. *The Audubon Society Field Guide to North American Mushrooms*. New York: Alfred A. Knopf. 926 pp.

Lodge, D. J., M. Padamsee, P. B. Matheny, M. C. Aime, S. A. Cantrell, D. Boertmann, A. Kovalenko, A. Vizzini, B. T. M. Dentinger, P. M. Kirk, et al. 2013. Molecular phylogeny, morphology, pigment chemistry and ecology in Hygrophoraceae (Agaricales). *Fungal Diversity* 64:1–99.

Looney, B. P., J. M. Birkebak, and P. B. Matheny. 2013. Systematics of the genus *Auricularia* with an emphasis on species from the southeastern United States. *North American Fungi* 8(6): 1–25.

Loyd, A. L., B. S. Richter, M. A. Jusino, C. Truong, M. E. Smith, R. A. Blanchette, and J. A. Smith. 2018. Identifying the "mushroom of immortality": assessing the *Ganoderma* species composition in commercial reishi products. *Frontiers in Microbiology* 9: article 1557 1–14.

Mata, J. L., and R. H. Petersen. 2001. Type specimens studies in New World *Lentinula*. *Mycotaxon* 79:217–229.

Mata, J. L., R. H. Petersen, and K. W. Hughes. 2001. The genus *Lentinula* in the Americas. *Mycologia* 93(6): 1102–1112.

Matheny, P. B., and R. A. Swenie. 2018. The *Inocybe geophylla* group in North America: a revision of the lilac species surrounding *I. lilacina*. *Mycologia* 110(3): 618–634.

Miettinen, O., J. Vlasák, B. Rivoire, and V. Spirin. 2018. *Postia caesia* complex (Polyporales, Basidiomycota) in temperate Northern Hemisphere. *Fungal Systematics and Evolution* 1:101–129.

Miller, A. N., and A. S. Methven. 2000. Biological species concepts in eastern North American populations of *Lentinellus*. *Mycologia* 92(6): 792–800.

Mueller, G. M. 1992. Systematics of *Laccaria* (Agaricales) in the continental United States and Canada, with discussions on extralimital taxa and descriptions of extant types. *Fieldiana*. Series 30. Publication 1435. Field Museum of Natural History, Chicago, Ill. 158 pp.

Nguyen, N. H., E. C. Vellinga, T. D. Bruns, and P. G. Kennedy 2016. Phylogenetic assessment of global *Suillus* ITS sequences supports morphologically defined species and reveals synonymous and undescribed taxa. *Mycologia* 108(6): 1216–1228.

Nuhn, M. E., M. Binder, A. F. S. Taylor, R. E. Halling, and D. S. Hibbett. 2013. Phylogenetic overview of the Boletineae. *Fungal Biology* 117:479–511.

Ortiz-Santana, B., W. C. Roody, and E. E. Both. 2009. A new arenicolous *Boletus* from the Gulf Coast of northern Florida. *Mycotaxon* 107:243–247.

Pegler, D. N., D. J. Lodge, and K. K. Nakasone. 1998. The pantropical genus *Macrocybe* gen. nov. *Mycologia* 90(3): 494–504.

Petersen, R. H., and K. Hughes. 2014. Cauliflower tales. *McIlvainea* 23:13–15.

Redhead, S. A., R. Vilgalys, J.-M. Moncalvo, J. Johnson, and J. S. Hopple Jr. 2001. *Coprinus* Pers. and the disposition of *Coprinus* species sensu lato. *Taxon* 50:203–241.

Rogers, J. D., F. San Martín, and Y.-M. Ju. 2002. A reassessment of the *Xylaria* on *Liquidambar* fruits and two new taxa on magnolia fruits. *Sydowia* 54(1): 91–97.

Roody, W. C. 2003. *Mushrooms of West Virginia and the Central Appalachians*. Lexington: University Press of Kentucky. 520 pp.

Schmitt, C. L., and M. L. Tatum. 2008. The humongous fungus on the Malheur National Forest. United States Department of Agriculture. https://www.fs.usda.gov/Internet/FSE DOCUMENTS/fsbdev3.pdf.

Singer, R., J. Garcia, and L. D. Gomez. 1990. *The Boletineae of Mexico and Central America I and II*. Berlin: J. Cramer. 73 pp.

———. 1991. *The Boletineae of Mexico and Central America III*. Berlin: J. Cramer. 128 pp.

———. 1992. *The Boletineae of Mexico and Central America IV*. Berlin: J Cramer. 62 pp.

Singer, R., and A. H. Smith. 1943. A monograph on the genus *Leucopaxillus* Boursier. *Papers of the Michigan Academy of Sciences, Arts and Letters* 28:85–132.

Singer, R., and R. Williams. 1992. Some boletes from Florida. *Mycologia* 84:724–728.

Smith, M. E., and D. H. Pfister. 2009. Tuberculate ectomycorrhizae of angiosperms: the interaction between *Boletus rubropunctus* (Boletaceae) and *Quercus* species (Fagaceae) in the United States and Mexico. *American Journal of Botany* 96(9): 1665–1675.

Snell, W. H., and E. A. Dick. 1957. *A Glossary of Mycology*. Cambridge, Mass.: Harvard University Press. 181 pp.

Spirin, V., V. Malysheva, A. Yurkov, O. Miettinen, and K. H. Larsson. 2018. Studies in the *Phaeotremella foliacea* group (Tremellomycetes, Basidiomycota). *Mycological Progress* 17:451–466.

Spoerke, D. G., and B. H. Rumack. 1994. *Handbook of Mushroom Poisoning: Diagnosis and Treatment*. Boca Raton, Fla.: CRC Press. 456 pp.

Stamets, P. 1996. *Psilocybin Mushrooms of the World*. Berkeley, Calif.: Ten Speed Press. 245 pp.

Taylor, T. N., M. Krings, and E. L. Taylor. 2015. Fungal diversity in the fossil record. In:

McLaughlin, D. J., Spatafora, J. W., editors. *Systematics and Evolution*. 2nd ed. The Mycota VII Part B. Berlin: Springer-Verlag. https://www.researchgate.net/publication/275654617.

Thorn, R. G., and G. L. Barron. 1984. Carnivorous mushrooms. *Science*, n.s., 224(4644): 76–78.

Weber, N. S., and A. H. Smith. 1985. *A Field Guide to Southern Mushrooms*. Ann Arbor: University of Michigan Press. 280 pp.

Woehrel, M. L., and W. H. Light. 2017. *Mushrooms of the Georgia Piedmont and Southern Appalachians*. Athens: University of Georgia Press. 647 pp.

Wolfe, C. B., Jr., and R. E. Halling. 1989. *Tylopilus griseocarneus*, a new species from the North American Atlantic and Gulf Coastal Plain. *Mycologia* 81:342–346.

Websites

Index Fungorum: www.indexfungorum.org

MushroomExpert.com: www.mushroomexpert.com

Mushroom Observer: www.mushroomobserver.org

Studies in the Amanitaceae: http://www.amanitaceae.org

IMAGE CREDITS

All images are by the authors, except as noted here.

Geoffrey R. Balme: *Phallus duplicatus*

Giff Beaton: *Aseroe rubra, Cronartium quercuum, Nectria peziza,* parasitic fungus on a Carolina leaf-roller, *Trichoderma alutaceum*

Jason A. Bolin: *Boletellus ananas, Cyanoboletus cyaneitinctus, Suillus hiemalis*

James Craine: *Morchella sceptriformis, Psilocybe caerulescens, Psilocybe ovoideocysdiata*

Anthoni Goodman: created all of the line drawings

Rosanne Healy: *Elaphomyces* species

Mitch Hopping: photo of author Mike Hopping

Joan S. Knapp: *Irpex lactea, Pleurotus levis, Resupinatus trichotis, Tremella aurantia, Xeromphalina cauticinalis* ssp. *pubescentipes*

David P. Lewis: *Amanita hesleri, Amanita volvata* group

Jared McRae: *Ganoderma martinicense, Phallus hadriani*

Curtis Peyer: *Volvariella bombycina*

Sarah Prentice: *Sphaerobolus stellatus*

David J. Raney: *Piptoporellus* species, *Porphyrellus sordidus*

Bill Roody: *Abortiporus biennis, Amanita parcivolvata, Boletus abruptibulbus, Boletus auripes, Boletus variipes, Buchwaldoboletus lignicola, Caloboletus inedulis, Cerioporus squamosus, Ganoderma sessile, Gloeophyllum sepiarium, Grifola frondosa, Gyromitra esculenta, Hemileccinum hortonii, Humaria hemisphaerica, Hygrophoropsis aurantiaca, Laeticutis cristata, Laetiporus cincinnatus, Lentinus arcularius, Lentinus brumalis, Lycoperdon americanum, Multifurca furcata, Neoalbatrellus caeruleoporus, Psathyrella delineata, Russula ballouii, Russula earlei*

Bill Sheehan: *Ceriporia purpurea, Phlebiopsis crassa, Skeletocutis lilacina, Steccherinum subrawakense*

Dianna G. Smith: *Albatrellus confluens, Climacodon septentrionalis, Coltricia perennis, Oxyporus populinus, Panus conchatus, Polyporus umbellatus*

Joseph and Frances Smith: *Amanita williamsiae*

Matthew E. Smith: *Tuber brennemanii, Tuber canaliculatum, Tuber lyonii*

Luke Smithson: *Dacryopinax elegans, Tylopilus ballouii*

Walt Sturgeon: *Calvatia cyathiformis, Gyromitra infula, Plicaturopsis crispa*

Huafang Su: *Agrocybe firma, Chlorencoelia versiformis, Coprinus comatus, Exidia glandulosa, Gymnosporangium juniperivirginianae, Hydnellum spongiosipes, Inocybe lacera, Lactarius atroviridis, Lepiota cristata, Morchella punctipes, Mutinus ravenelii, Myxarium nucleatum, Phliota aurivella, Plicaturopsis crispa, Pluteus chrysophlebius, Spongipellis pachyodon*

David Tate: *Psilocybe cubensis*

Phillip Thompson: *Calocera cornea, Rhopalogaster transversarius*

Dave Wasilewski: *Lentinellus vulpinus, Mycena epipterygia* var. *lignicola*

INDEX TO COMMON NAMES

Aborted Polypore, 497
Abortive Entoloma, 317
Abruptly Bulbous Sand Bolete, 73
Acorn Puffball, 562
Adder's Tongue, 186
Alcohol Inky, 292
Almond-scented Russula, 434
Amanita Mold, 462
Amber Jelly Roll, 472
American Abrupt-bulbed Lepidella, 244
American Amidella, 275
American Caesar, 255
American Cauliflower Mushroom, 182
American Club-footed Lepidella, 268
American Shrimp Russula, 436
American Simocybe, 443
American Slippery Jack, 126
American Tree Ear, 466
American Wood Ear, 466
Amethyst Laccaria, 352
Angel's Wing, 414
Anise and Raspberry Limbed-Lepidella, 260
Anise-scented Clitocybe, 289
Appalachian Chanterelle, 160
Appalachian Yellow-brown Bolete, 138
Apricot Milk Cap, 372
Arched Earthstar, 570
Aromatic Milky, 364
Artist Conk, 515
Ashtray Bolete, 109
Ash Tree Bolete, 78

Asian Beauty, 192
Azalea Apples, 488

Bacon of the Woods, 205
Baggy-veiled Suillus, 127
Ballou's Russula, 432
Barometer Earthstar, 563
Bay Bolete, 106
Bay-brown Polypore, 501
Bear Lentinellus, 374
Bear's Head Tooth, 600
Beefsteak Polypore, 507
Beeswax Russula, 433
Beetle Cordyceps, 185
Berkeley's Polypore, 500
Beveled-cap Bolete, 136
Big Laughing Gym, 327
Birch Polypore, 509
Bitter Bolete, 91, 137, 142
Bitter Spotted Cort, 301
Blackberry Orange Rust, 491
Black Earth Tongue, 225
Black-eyed Marasmius, 391
Black-footed Marasmius, 448
Blackish-red Russula, 431
Black Jelly Drops, 212, 467
Black Jelly Oyster, 427
Black Knot, 149
Black-staining Polypore, 521
Black Tooth, 610
Black Trumpet, 165
Black Velvet Bolete, 134
Black Witches' Butter, 472
Bladder Cup, 213
Bleeding Mycena, 393
Blewit, 380

Blue Albatrellus, 498
Blueberry Gall, 490
Blue Cheese Polypore, 544
Blue-foot Psilocybe, 425
Blue-pored Polypore, 498
Blue-stain Fungus, 211
Blue-staining Peppery Bolete, 95
Blue-staining Slippery Jack, 126
Blue-toothed Entoloma, 320, 321
Bluish Tooth, 604
Blusher, 270
Blushing Rosette, 497
Bolete Mold, 460
Booted Suillus, 127
Bootlace Fungus, 279
Both's Bolete, 128
Bracelet Cort, 297
Bradley, 372
Brick Cap, 346
Broadgill, 397
Brown Birch Bolete, 111
Brown Dunce Cap, 281
Brown-haired White Cup, 216
Brownish Chroogomphus, 287
Brown Matsutake, 450
Brown Otidea, 208
Brown Quilted Russula, 437
Brown Sugar Waxcap, 402
Brown-toothed Crust, 192
Bruising Lepidella, 263
Bubble Gum Fungus, 206
Bubble Gum Polypore, 519
Bud Gall, 489
Buff Fishy Milky, 368
Bulbous Honey Mushroom, 278
Burnsite Pholiota, 410

Burnt Orange Bolete, 134
Butterball, 132
Butter Foot Bolete, 80

Canary Trich, 451
Candlesnuff Fungus, 157
Cannon Fungus, 63
Carbon Balls, 150
Carbon Cushion, 152
Carolina False Morel, 479
Carrot-foot Amanita, 250
Cauliflower Mushroom, 182
Cedar-apple Rust, 488
Celandine Lactarius, 355
Ceramic Parchment, 205
Chalk-white Bolete, 146
Chanterelle, 163
Charcoal Psathyrella, 418
Charming Marasmius, 389
Charming Tooth, 599
Chestnut Bolete, 100
Chicken-fat Suillus, 126
Chicken Mushroom, 530
Chrome-footed Bolete, 102
Chunky Monkey, 129
Cinnabar Bracket, 551
Cinnabar Chanterelle, 160
Cinnabar Oysterling, 309
Cinnabar-red Polypore, 551
Citron Amanita, 256
Cleft-foot Amanita, 248
Club-footed Clitocybe, 277
Clustered Bracket, 526
Clustered Brown Bolete, 72
Clustered Collybia, 290
Clustered Waxcap, 339
Coker's Lavender Staining Amanita, 256
Coker's Lepidella, 249
Collared Calostoma, 566
Collared Earthstar, 572
Collybia Jelly, 331, 471
Columned Stinkhorn, 592
Comb Tooth, 601
Common Bird's Nest, 62
Common Brown Cup, 214
Common Earthball, 582

Common Eastern Black Morel, 483
Common Fiber Vase, 229
Common Funnel Cap, 347
Common Morel, 482
Common Scaber Stalk, 111
Common Split Gill, 589
Common Stalked Puffball, 561, 586
Cone Flickers, 157
Conical Shaggy-capped Bolete, 144
Conifer Antler Jelly, 468
Conifer-base Polypore, 523
Conifer-cone Cap, 444
Conifer Wood Ear, 466
Coppery Slimacella, 458
Coral-pink Merulius, 196
Corn Smut, 490
Corrugated Bolete, 103
Corrugated-cap Milky, 368
Crab Brittle Gill, 436
Cracked-cap Polypore, 542
Crampballs, 150
Crested Coral, 173
Crested Polypore, 529
Crimped Gill, 588
Crowded Parchment, 201
Crown-tipped Coral, 170
Cryptic Globe Fungus, 509

Dark Bolete, 115
Dark Violet Polypore, 537
Deadly Galerina, 278, 323
Dead Man's Fingers, 156
Dead Man's Hand, 585
Dead Man's Rubber Glove, 475
Dead Moll's Fingers, 156
Deceiver, 353
Deceptive Milky, 371
Decorated Mop, 453, 454
Decorated Pholiota, 322, 411
Deer Mushroom, 415
Deer Truffles, 181
Depressed Hedgehog, 608
Destroying Angel, 455
Devil's Snuffbox, 574

Devil's Stinkhorn, 593
Devil's Urn, 218
Dirty Southern Waxcap, 314
Dog-legged Lepidella, 257
Dog's Nose Fungus, 150
Dryad's Saddle, 501
Dune Witch's Hat, 341
Dung-loving Bird's Nest, 62
Dye-maker's False Puffball, 577
Dye Maker's Polypore, 523, 538

Earth-colored Trich, 452
Earth Fan, 229
Earthstar Scleroderma, 585
Eastern Destroying Angel, 247
Eastern King, 88
Eastern Panther, 274
Eastern Pine Gall Rust, 486
Elegant Black-footed Polypore, 501
Elegant Stinkhorn, 593
Elm Oyster, 413
Enoke, 323
Enotake, 323
European Golden Chanterelle, 163
Evasive Agaric, 311
Eyelash Cup, 216
Eyespot Milky, 364

Fairy Bonnet, 291
Fairy Club, 220
Fairy Pins, 552, 554
Fairy-ring Mushroom, 392
Fairy Stool, 504
False Black Velvet Bolete, 134
False Chanterelle, 403
False Coral Mushroom, 181
False Morel, 479
False Saffron Milkcap, 359
False Turkey-tail, 202
Fawn Mushroom, 415
Fetid Marasmius, 333
Fire Crust, 205
Firm Russula, 432
Fir Polypore, 554
Flame Chanterelle, 166

INDEX TO COMMON NAMES

Flaming Gold Bolete, 70
Flat-cap Agaric, 240
Flat Crep, 308
Flecked-flesh Polypore, 542
Flowerpot Parasol, 409
Fluted White Helvella, 480
Fly Agaric, 262
Forest Funnelcap, 347
Forked Clavaria, 174
Fox Lentinellus, 374
Fragrant Chanterelle, 162
Fragrant Eastern Truffle, 619
Fried Chicken Mushroom, 384
Fringed Sawgill, 376
Frost's Bolete, 98
Funeral Bell, 323
Fungus Flower, 591
Fused Marasmius, 388
Fuzzy Foot, 456

Garlic Mushroom, 390
Gem-studded Puffball, 561, 574
Gerard's Milky, 361
Giant Gilled Mushroom, 385
Gilled Bolete, 114
Gilled Bracket, 546
Giraffe Spots, 203
Goat Cheese Webcap, 298
Goat's Foot, 529
Goblet Fungus, 191
Gold Drop Milk Cap, 356
Golden Chanterelle, 163
Golden Ear, 469
Golden Fairy Club, 175
Golden-gilled Gerronema, 420
Golden Hypomyces, 460
Golden Pholiota, 411
Golden Scruffy Collybia, 315
Golden-thread Cordyceps, 186
Golden Tops, 424
Golden Trumpets, 456
Golden Underskirt Blusher, 270
Golden Waxcap, 337
Golden Yellow Bolete, 79
Graceful Bolete, 75, 100
Granular Jelly Roll, 474
Granulated Slippery Jack, 132

Grass Marasmius, 390
Gray Bolete, 119
Gray Coral, 173
Grayling, 284
Gray Stalked Cup, 217
Gray Tooth, 611
Gray Trich, 452
Great Funnel-veil Amanita, 274
Green-capped Jelly Baby, 221
Green-foot Inocybe, 348, 349
Green's Polypore, 503
Green-spored Lepiota, 286
Green-stain Fungus, 211
Grisette, 273
Gunpowder Lepidella, 261
Gypsy, 299

Hairy Bracket, 549
Hairy Oysterling, 427
Hairy Panus, 408
Hairy Rubber Cup, 212
Hairy-stalked Collybia, 334
Half-free Morel, 482
Half Yellow Powdery Bolete, 92
Hard's Stropharia, 445
Hated Caesar, 272
Hemlock Varnish Shelf, 518
Hen of the Woods, 521
Hesler's Amanita, 254
Hexagonal-pored Polypore, 533
Honeydew Eater, 198
Honey Mushroom, 279, 339
Horn-like Tuning Fork, 468
Horse Sugar Gall, 489
Horton's Bolete, 103
Hot Lips, 565
Hygrophorus Milky, 369
Hypoxylon Canker of Oak, 189

Indigo Milk Cap, 363
Indigo Milky, 363
Irregular Earth Tongue, 222

Jack-in-the-Pulpit Rust, 491
Jack O'Lantern, 403
Japanese Umbrella Inky, 409
Jellied False Coral, 181

Jelly Babies, 221
Jelly Crep, 310
Jelly Leaf, 476
Jelly Tooth, 471

Kidney-shaped Tooth, 609
King Alfred's Cakes, 150
King Bolete, 85
King Stropharia, 446

Lactarius Mold, 464
Landslide Mushroom, 423
Late Autumn Oyster, 414
Lawnmower's Mushroom, 404
Lawn Puffbowl, 574
Lilac Blewit, 381
Lilac Bolete, 88
Lilac-brown Bolete, 133
Lilac Fiber Head, 350
Lilac Mycena, 401
Lion's Mane, 600
Little Bitter Bolete, 137
Little Nest Polypore, 547
Lobster Fungus, 463
Lobster Mushroom, 463
Long-legged White Foot, 84
Long-stalked Gray Cup, 481
Lorchel, 479
Luminescent Panellus, 407
Lumpy Bracket, 548
Lurid Bolete, 97

Magenta Coral, 172
Magic Mushroom, 424
Magnolia-cone Mushroom, 444
Magnolia Cone Xylaria, 157
Maitake, 521
Marshmallow Polypore, 545
Mary Banning Slender Caesar, 246
Mary's Russula, 436
Meadow Mushroom, 239
Meadow Waxcap, 313
Menthol Brittlegill, 430
Mica Cap, 291
Milking Lilac Cup, 213
Milk-white Toothed Polypore, 192, 545

Milky False Truffle, 621
Miller, The, 289
Montagne's Polypore, 503
Mossy Maple Polypore, 502, 548
Mossy Maze Polypore, 502
Moth Akanthomyces, 184
Multicolor Gill Polypore, 546
Mustard Yellow Polypore, 512
Mystery Chick, 543

Netted Stinkhorn, 594
Noble Bolete, 82
Northern Tooth, 598

Oak-loving Collybia, 331
Ocher Jelly Club, 221
Ocher-orange Hoof Polypore, 523
Old Man of the Woods, 123
Orange Earth Tongue, 222
Orange Eyelash Cup, 216
Orange-gilled Waxcap, 337
Orange Jelly, 469
Orange-latex Milky, 359
Orange Mock Oyster, 412
Orange Mosscap, 428
Orange Peel, 208
Orange Pinwheel Marasmius, 394
Orange Polypore, 551
Orange Polypore Mold, 460
Orange Rust, 491
Orange-sheathed Trich, 449
Orange Spindle Coral, 171, 175
Orange Sponge Polypore, 558
Orange Spot, 195
Orange-staining Puffball, 567
Orange Witches' Butter, 469
Orange-yellow Marasmius, 395
Ornate-stalked Bolete, 120
Overflowing Slimy Stem, 458
Oyster Mushroom, 414

Painted Bolete, 131
Painted Suillus, 131
Palamino Cup, 214
Pale Bitter Bolete, 140
Pale Rose Bolete, 76
Pale Violet Bitter Bolete, 139

Pallid Bolete, 107
Parasitic Bolete, 116
Parasol, 386
Parchment Bracket, 554
Parchment Fungus, 537
Parrot Waxcap, 326
Parsley-scented Russula, 439
Patriotic Bolete, 81
Pawpaw Polypore, 526
Peach Chanterelle, 164
Peach-colored Fly Agaric, 264
Peaches and Cream Hedgehog, 606
Peanut Butter Cup Fungus, 212
Pear-shaped Puffball, 561
Pecan Truffle, 620
Peck's Milky, 372
Peeling Puffball, 573
Peppery Bolete, 95
Peppery Milky, 371
Peppery White Milk Cap, 371
Petticoat Mottlegill, 405
Pheasant's-back Polypore, 501
Pigskin Poison Puffball, 582
Pineapple Bolete, 77
Pine Cone Bolete, 123
Pine Cone Lepidella, 266
Pine Cone Rust, 487
Pine-loving King Bolete, 85
Pine-oak Rust, 486
Pine Spikes, 351
Pink Bottom, 239
Pink Mycena, 401
Pinwheel Marasmius, 389
Plate Full of Pyramids, 265
Platterful Mushroom, 397
Pleated Inky Cap, 409
Pleated Pluteus, 416
Plums and Custard, 454
Poison Pie, 335
Poison Pigskin Puffball, 116
Poor Man's Licorice, 467
Porcupine Inocybe, 348
Potato Earthball, 580
Powder-cap Amanita, 251
Powder-scale Pholiota, 322
Powdery Xylaria, 206

Puffball-like Scleroderma, 579
Pungent Fiber Head, 422
Purple-bloom Russula, 436
Purple Brittlegill, 431
Purple-gilled Laccaria, 352
Purple Jelly Drops, 209
Purple-spored Puffball, 568

Quilted Green Russula, 437
Quince Rust, 469

Ravenel's Bolete, 70
Ravenel's Stinkhorn, 595
Recurved Cup, 214
Red and Olive Velvet-cap, 87
Red and Yellow Bolete, 76
Red-belted Polypore, 510
Red Carbon Cushion, 194
Reddening Lepiota, 382
Reddish-brown Bitter Bolete, 142
Red-Gilled Cort, 303
Red Gyroporus, 100
Red-juice Tooth, 605
Red-mouth Bolete, 125
Red Slimy-stalked Puffball, 565
Red-speckled Bolete, 147
Resinous Polypore, 528
Rib-capped Pluteus, 416
Ringless False Fly Agaric, 262
Ringless Honey Mushroom, 316
Ringless Panther, 245
Roody's Bolete, 86
Rooted Collybia, 343
Rooting Polypore, 531
Rose Coral, 180
Rose-tinted Amanita, 269
Rosy-footed Oak Bolete, 94
Rosy Polypore, 551
Rough Black Earth Tongue, 225
Rough Hydnellum, 602
Rounded Earthstar, 571
Round-headed Cordyceps, 186
Rubies, 117
Ruby Bolete, 105
Ruddy Panus, 408
Ruddy Puffball, 575
Russell's Bolete, 74

Russula-like Amanita, 271
Russula-like Waxcap, 342
Russula Mold, 464
Rusty-gilled Polypore, 520
Rusty Staggerbush Gall, 489

Saddle-shaped False Morel, 479
Salmon Unicorn Entoloma, 319
Salmon Waxcap, 313
Saltshaker Earthstar, 571
Sand Case Puffball, 562
Sandy Laccaria, 352
Satyr's Beard, 600
Scaly Inkcap, 292
Scaly Pholiota, 411
Scaly Polypore, 501
Scaly-stalked Hebeloma, 335
Scaly Tooth, 613
Scaly Vase Chanterelle, 168
Scarlet Cup, 215
Scarlet Waxcap, 340
Scorched Bracket, 499
Scotch Bonnets, 392
Semi-ovate Panaeolus, 406
Sensitive Bolete, 87
Shaggy Bracket, 527
Shaggy Mane, 293
Shaggy Parasol, 285, 286
Shaggy Polypore, 527
Shaggy-stalked Bolete, 71
Sheep Polypore, 498
Shingled Hedgehog, 613
Shiny Cinnamon Polypore, 504
Short-stemmed Russula, 441
Short-stemmed Slippery Jack, 132
Showy Orange Bolete, 70
Shrimp of the Woods, 317
Silky Parchment, 202
Silky Rosegill, 455
Silky-shining Russula, 440
Silver-blue Milky, 355
Silver Ear, 477
Silvery-violet Cort, 295
Skull-shaped Puffball, 568
Slender Red-pored Bolete, 125
Slimy-bitter Cort, 306
Slippery Jack, 127, 132

Small Funnel-veiled Amanita, 258
Smoky Cheese Polypore, 557
Smoky-gilled Hypholoma, 344
Smoky Polypore, 499
Smooth Black Earth Tongue, 225
Smooth Chanterelle, 162
Smoothish-stemmed Bolete, 104
Smooth-stalked Helvella, 480
Snakeskin Grisette, 267
Snow Ear, 477
Snow Fungus, 477
Snowy Waxcap, 314
Soap-scented Trich, 450
Sour-cap Suillus, 130
Southern Chicken, 530
Southern Clam Shell, 508
Southern Cone Rust, 487
Southern Gold, 79
Southern Jack O'Lantern, 403
Sphere Thrower, 13
Spicy Milk Cap, 364
Spider Cordyceps, 187
Spindle-shaped Yellow Coral, 171, 175
Spiny Puffball, 574
Splash Cups, 62
Split Pore Crust, 559
Split-skin Carbon Cushion, 150
Spongy-footed Tooth, 602
Spongy Toothed Polypore, 545
Spotted Cort, 301
Sprague's Polypore, 544
Spring Polypore, 532
Springtime Entoloma, 318
Staining Blue Bolete, 99
Staining Cheese Polypore, 513
Stalked Hairy Fairy Cup, 211, 217
Stalked Scarlet Cup, 215
Stalkless Paxillus, 447, 588
Star-bearing Powder Cap, 280
Starfish Stinkhorn, 591
Steak of the Woods, 528
Sticky Gray Trich, 452
Stinky Squid, 596
Straight-branched Coral, 179
Straw-colored Fiber Head, 351
Sulfur Shelf, 530

Sulfur Trich, 452
Sulfur Tuft, 345, 346
Summer Oyster, 414
Swamp Beacon, 221
Sweetbread Mushroom, 289
Sweetgum Xylaria, 155
Sweet Knot, 511
Sweet Tooth, 608
Sweet Trametes, 550

Tacky Green Russula, 429
Tar Spot of Maple, 153
Tawny Grisette, 253
Tender Nesting Polypore, 522
The Miller, 289
Thick-maze Oak Polypore, 505
Thin-maze Flat Polypore, 505
Tobacco-brown Tylopilus, 143
Tree Ear, 466
Trembling Merulius, 196
Trooping Cordyceps, 185
Trumpet Chanterelle, 167
Tufted Collybia, 330
Tulip Morel, 484
Turkey-tail, 552
Two-colored Bolete, 76

Umber-brown Puffball, 576
Umbrella Polypore, 521

Variable Brown-net Bolete, 137
Variable Pholiota, 410
Variable Russula, 429
Variable-stalk Bolete, 91
Variegated Milky, 355
Vase Thelephore, 229
Veiled Oyster, 413
Veiled Polypore, 509
Velvet Blue Crust, 203
Velvet Foot, 323
Velvet-footed Pax, 447
Velvety Fairy Fan, 223
Velvety Psathyrella, 418
Violet Collybia, 350
Violet Cort, 307
Violet-gray Bolete, 139
Violet Gymnopus, 401

Violet Toothed Polypore, 554
Voluminous-latex Milky, 372

Waxy Laccaria, 353
Weeping Polypore, 527
Weeping Widow, 418
White Cheese Polypore, 557
White Coarsely-ribbed Bolete, 75
White Coral, 176
White Coral Jelly, 475
White Dunce Cap, 281
White-egg Bird's Nest, 62
White Fibercap, 350
White Green-algae Coral, 170, 224, 468
White Hardwood Leucopax, 383
White Jelly Fungus, 471
White Jelly Mushroom, 477
White Marasmiellus, 387
White Marasmius, 387
White Morel, 484
White-pored Sulfur Shelf, 530
White Slimacella, 458
White Suillus, 130
White Worm Coral, 171
Williams' Great Ringless Amanita, 276
Willow Glue, 193
Willow Tar Spot, 153
Wine Cap, 446
Wine-cap Chroogomphus, 287
Winter Polypore, 533
Witches' Butter, 476
Witch's Hat, 341
Wolf Asterophora, 280
Wood Clitocybe, 420
Woolly Oyster, 336
Wrinkled Cort, 300
Wrinkled Leccinum, 110

Yellow Antler Coral, 174, 175
Yellow Blusher, 270
Yellow Bolbitius, 281
Yellow Caesar, 246
Yellow Fairy Cups, 208, 210
Yellow Fly Agaric, 259
Yellowfoot Bolete, 102
Yellow-gilled Gymnopilus, 327
Yellow-headed Hymenoptera Cordyceps, 185
Yellowing Curtain Crust, 202
Yellow Morel, 482
Yellow Patches, 252
Yellow-red Gill Polypore, 520
Yellow Sap Cup, 213
Yellow Spot, 195
Yellow Stainer, 241
Yellow-stalked Mycena, 399
Yellow-tipped Coral, 178
Yellow Unicorn, 319

Zoned Crinipellis, 376, 377
Zoned Gilled Polypore, 520
Zoned Hydnellum, 602
Zoned Tooth Fungus, 602

INDEX TO SCIENTIFIC NAMES

Page numbers of fully described and illustrated species are set in **boldface**. Page numbers of partially described species, including synonyms and those illustrated in the Color Key, are set in regular type.

Abortiporus
 biennis, **497**
Agaricus
 abruptibulbus, 25, 241
 americanus, 382
 campestris, **239**
 geophyllus var. lilacinus, 350
 illinitus, 458
 petasatus, 417
 placomyces, **240**
 pocillator, 240
 xanthodermus, 239, **241**, 446
Agrocybe
 dura, 243
 firma, **242**
 molesta, 239, **243**, 404
 pediades, 25, 243, 404
 praecox, 243
 smithii, 242
Akanthomyces
 aculeatus, **184**
Albatrellus
 confluens, 48, 498
 cristatus, 529
 ovinus, **498**
Alessioporus
 rubriflavus, **69**
Aleuria
 aurantia, **208**, 210
Amanita
 abrupta, **244**, 249, 265
 albocreata, **245**, 258, 274
 amerifulva, 253
 amerivirosa, 247
 arkansana, 246, 255
 atkinsoniana, 25, 261

aureosubucula, 270
baningiana, **246**, 255, 276
bisporigera, 239, **247**, 455
brunnescens, 244, **248**, 258, 267, 272, 397
brunnescens var. pallida, 248
ceciliae, 267
chlorinosma, 257, 265
cinereoconia, 251, 261
cinereopannosa, 254
citrina, 256
citrina f. lavendula, 256
citrina var. lavendula, 256
cokeri, 244, **249**
cothurnata, 258
daucipes, **250**, 268
farinosa, **251**, 267, 273
flavoconia, **252**, 255, 262
flavorubens, 252, 270
flavorubescens, 25
frostiana, 252, 255, 262
fulva, **253**, 272, 273, 276
gemmata, 271
hesleri, 251, **254**, 261
jacksonii, 246, **255** 262
komarekensis, 269
lavendula group, 245, **256**, 271
levistriata, 256
longipes, **257**
mappa var. lavendula, 256
microlepis, 263
multisquamosa, 245, 256, **258**, 271
muscaria var. formosa, 259
muscaria var. guessowii, 250, **259**, 264, 274

muscaria var. muscaria, 262
muscaria var. persicina, 264
mutabilis, **260**
onusta, 251, 254, **261**
pantherina var. multisquamosa, 258
pantherina var. velatipes, 274
parcivolvata, 252, 255, 259, **262**
peckiana, 260, 269, 275
pelioma, **263**
persicina, 250, 259, **264**
polypyramis, 244, 249, **265**
praecox, 25, 245, 253, 271
pseudovolvata, 26, 266, 275
radicata, 268
ravenelii, 244, 250, **266**, 268
rhacopus, 253, **267**
rhoadsiae, 257
rhopalopus, 244, 250, **268**
rhopalopus f. turbinata, 268
roseitincta, **269**
rubescens group, **270**, 462
rubescens var. alba, 260
russuloides group, 245, 256, **271**
species ARB1328, 26, 255
spreta, 246, 253, **272**, 299
subcokeri, 26, 249
submaculata, 248, 272
tephrea, 257
umbonata, 255
vaginata group, 251, 253, 267, **273**
vaginata var. alba, 273
velatipes, 258, 264, **274**
virosa, 247

volvata group, 260, **275**
whetstoneae, 275
williamsiae, **276**
Amanitopsis
albocreata, 245
Ampulloclitocybe
clavipes, **277**, 284, 347
Anellaria
sepulchralis, 406
Annulohypoxylon
annulatum, 189
archeri, 477
cohaerens, 20, 189
Anthracophyllum
lateritium, 26, 310
Antrodia
serialiformis, 535
Apioperdon
pyriforme, **561**, 575
Apiosporina
morbosa, **149**
Arachnion
album, **562**
Armillaria
gallica, **278**
gemina, 278
mellea, **279**, 339
raphanica, 375
tabescens, 316
Arrhenia
epichysium, 373, 378
Arthuriomyces
peckianus, 491
Artomyces
pyxidatus, **170**
Ascocoryne
cylichnium, **209**
sarcoides, 209
Aseroe
rubra, **591**, 592
Asterophora
lycoperdoides, **280**
parasitica, 280
Astraeus
hygrometricus, 563
morganii, 54, 563, 569
smithii, **563**

Aurantiporus
fissilis, 541
Aureoboletus
auriflammeus, **70**
auriporus, 72, 73
betula, **71**, 74
innixus, 72
projectellus, 71, 74, 84
pseudoauriporus, **73**
russellii, 71, **74**
Auricularia
americana, 466
angiospermarum, 44, 466, 476
auricula, 466
fuscosuccinea, **466**
nigricans, 466
polytricha, 466
Austroboletus
betula, 71
gracilis, 14, 75, 100
subflavidus, **75**

Baeospora
myosura, 26, 280, 399, 444
Baorangia
bicolor group, **76**
Beauveria
bassiana, 185
Biscogniauxia
atropunctata, **189**
Bisporella
citrina, 22, 195, 208, 210
Bjerkandera
adusta, **499**
fumosa, 499
Bolbitius
titubans, **281**, 404, 405
variicolor, 281
vitellinus, 281
Boletellus
ananas, **77**
chrysenteroides, 77
russellii, 74
Boletinellus
merulioides, **78**
Boletinus
decipiens, 128

pictus, 131
Boletus
abruptibulbus, 14, **73**
affinis, 145
affinis var. *maculosus*, 145
albisulphureus, 146
alboater, 134
americanus, 126
ananas, 77
aurantiosplendens, **70**
aureissimus, **79**, 80
auriflammeus, 70
auripes, 79, **80**
auripes var. *aureissimus*, 79
auriporus, 72, 73
bicolor, 76
bicolor var. *subreticulatus*, 76
caespitosus, 72
carminiporus, 124
chromapes, 102
decipiens, 128
edulis, 85
edulis f. *pinicola*, 85
eximius, 133
flammans, 90
floridanus, 97
fraternus, 105
frostii, 98
harrisonii, 105
hemichrysus, 92
hirtellus, 130
hortonii, 103
hypocarycinus, 124
indecisus, 136
inedulis, 94
innixus, 72
lignicola, 93
longicurvipes, 109
luridellus, **81**
luteus var. *cothurnatus*, 127
miniato-olivaceus, 81, 87
miniato-olivaceus var. *sensibilis*, 87
minor, 137
morrisii, 147
nobilis, **82**, 91
ochraceoluteus, 14, 79

oliveisporus, **83**, 96
ornatipes, 120
pallidus, 107
parasiticus, 81, 116
patrioticus, 14
peralbidus, 138
pictus, 131
pinicola, 85
pinophilus, 85
piperatoides, 95
plumbeoviolaceus, 139
projectelloides, **84**
pseudopinophilus, **85**
pseudoseparans, 88
rhoadsiae, 140
roodyi, 86
rubellus, 105
rubissimus, **86**
rubricitrinus, 117
rufomaculatus, 76
sensibilis, 76, **87**
sensibilis var. *subviscidus*, 87
separans, **88**, 103
sordidus, 115
stramineus, 146
subglabripes, 104
subgraveolens, **89**
subluridellus, **90**
subsensibilis, 81
subvelutipes, 125
variipes, 82, **91**
variipes var. *fagicola*, 91
variipes var. *variipes*, 91
vermiculosoides, 89
vermiculosus, 89
viscidocorrugis, 109
Bondarzewia
 berkeleyi, **500**
Bothia
 castanella, 15, 128
Bovista
 acuminata, 564
 pusilla, **564**
Buchwaldoboletus
 hemichrysus, **92**, 93
 lignicola, 92, **93**
 sphaerocephalus, 92

Bulgaria
 inquinans, 209, 212, **467**, 472
 rufa, 212
Butyriboletus
 floridanus, 97
 frostii, 98
 roseopurpureus, 86, 117
Byssomerulius
 incarnatus, 196

Caeoma
 strobilina, 487
Callistosporium
 luteofuscum, 282
 luteo-olivaceum, **282**
 purpureomarginatum, **283**
Caloboletus
 firmus, 94
 inedulis, **94**
 peckii, 94
Calocera
 cornea, 44, 468
 viscosa, **468**
Calodon
 ferrugipes, 604
Calostoma
 cinnabarinum, **565**, 566
 lutescens, 565, **566**
 ravenelii, 565, 566
Calvatia
 candida, **567**
 craniiformis, **568**
 cyathiformis, 54, 568
 rubroflava, 567
Camarophyllopsis
 deceptiva, 402
Camarops
 petersii, 17, 150, 472
Cantharellula
 umbonata, **284**, 312
Cantharellus
 altipes, **159**, 160, 163, 164
 appalachiensis, 159, **160**, 166, 167
 cibarius, 163
 cinnabarinus, 17, 160
 deceptivus, 163

flavolateritius, 162, 164
flavus, 163
floccosus, 168
infundibuliformis, 167
iuventateviridis, 159, 160, **161**, 284
lateritius, **162**, 164
minor, 159
odoratus, 162
persicinus, 159, 164
phasmatis, 163
septentrionalis, 159
tenuithrix, **163**
tubaeformis, 167
umbonatus, 284
velutinus, 162, 163, **164**
Ceriomyces
 aureissimus, 79
 cyaneitinctus, 96
 hepaticus, 507
 inedulis, 94
 oliveisporus, 83
 rubricitrinus, 117
Ceriporia
 purpurea, **190**, 197, 200
Cerioporus
 leptocephalus, 48, 501
 squamosus, **501**
Cerrena
 hydnoides, 524
 unicolor, **502**
Chalciporus
 piperatoides, **95**
 piperatus, 95
 rubinellus, 95
Chlorencoelia
 versiformis, **210**
Chlorociboria
 aeruginascens, **211**
 aeruginosa, 211
 versiformis, 210
Chlorophyllum
 hortense, **285**
 humei, 285
 molybdites, 285, **286**, 382, 386
 rhacodes, 285, 286, 382
 subrhacodes, 26, 285, 286, 382

Chlorosplenium
 aeruginascens, 211
 chlora, 210
 versiforme, 210
Chondrostereum
 purpureum, 20, 190, 197, 200
Chroogomphus
 ochraceus, 27, 287, 351
 rutilus, 287
 vinicolor, **287**, 351
Chrysomphalina
 chrysophylla, 420
 strombodes, 324
Cladomeris
 umbellata, 521
Clathrus
 columnatus, 591, **592**
Clavaria
 amethystina, 172
 angulispora, 177
 cinerea, 173
 corniculata, 174
 cylindrica, 171
 formosa, 178
 fragilis, **171**
 fusiformis, 175
 lavandula, 172
 micheneri, 177
 mucida, 170
 muscoides, 174
 phycophila, 224
 pulchra, 175
 stricta, 179
 subbotrytis, 180
 vermicularis, 171
 zollingeri, **172**
Clavariadelphus
 americanus, 168, **220**
 pistillaris, 220
 truncatus, 220
Clavicorona
 pyxidata, 170
Clavulina
 amethystina, 172
 amethystinoides, 172
 cinerea, **173**
 connata, 177
 coralloides, 173
 cristata, 173
 rugosa, 173
Clavulinopsis
 aurantiocinnabarina, 18, 171
 corniculata, **174**, 175
 fusiformis, 171, **175**
 laeticolor, 175
Climacodon
 ochraceus, 614
 pulcherrimus, 599
 septentrionalis, **598**
Clitocybe
 amethystina, 352
 clavipes, 277
 dealbata, 392
 ectypoides, 420
 gibba, 347
 nuda, 380
 odora, 27, 289, 439
 peralbida, **288**, 314
 rivulosa, 392
 squamulosa, 347
 subconnexa, 347, 384
 tarda, 381
Clitopilus
 abortivus, 317
 prunulus, **289**, 439
Collybia
 acervata, 290
 amethystina, 352
 aurea, 453
 biformis, 329
 confluens, 330
 dryophila, 331
 dysodes, 332
 luteo-olivacea, 282
 nigrodisca, 391
 spongiosa, 334
 zonata, 377
Collybiopsis
 dichroa, 329
 dysodes, 332
Coltricia
 cinnamomea, 48, 504
 focicola, 504
 montagnei, **503**
 perennis, **504**
Connopus
 acervatus, **290**, 330
Conocybe
 apala, 27, 281, 404
 tenera, 281
Copelandia
 cyanescens, 425
Coprinellus
 disseminatus, 27, 291
 domesticus, 291
 micaceus, **291**
 radians, 291
 truncorum, 291
Coprinopsis
 atramentaria, 27, 292
 lagopus, 292
 variegata, **292**
Coprinus
 comatus, **293**
 micaceus, 291
 plicatilis, 409
 sterquilinus, 293
 variegatus, 292
Cordyceps
 arachnophila, 187
 militaris, **185**
 olivascens, 19, 184
 ophioglossoides, 186
Corticium
 coeruleum, 203
 incrustans, 199
 reticulatum, 475
Cortinarius
 albidus, **294**
 alboluteus, 302
 alboviolaceus, **295**, 296, 380, 381
 argentatus, 295, **296**
 armillatus, **297**, 449
 atrotomentosus, 307
 bolaris, 27, 297
 camphoratus, 295, **298**, 305
 caperatus, **299**
 collinitus, 301
 corrugatus, **300**
 cyanites, 296, 307

delibutus, 299
distans, 28, 300
hesleri, 28, 303
iodeoides, **301**, 350, 381
iodes, 301
lewisii, **302**, 306
limonius, 306
luteus, 306
marylandensis, **303**
mucosus, 28
obliquus, 295
olearioides, **304**
pyriodorus, 295, 298, **305**
sanguineus, 303
semisanguineus, 303
sphaerosporus, 299
squamulosus, 28, 307
subfulgens, 304
traganus, 298, 305
vibratilis, 299, **306**
violaceus, 296, **307**
Cotylidia
diaphana, 191
Craterellus
cornucopioides, 165
fallax, **165**
ignicolor, **166**, 167, 324, 420
lateritius, 162
odoratus, 17, 162
tubaeformis, 160, 166, **167**
Crepidotus
applanatus, **308**
cinnabarinus, **309**, 310
croceitinctus, 308
crocophyllus, 310
herbarum, 311
malachius, 308
mollis, **310**, 336
nyssicola, 309
stipitatus, 407
versutus, **311**
Crinipellis
zonata, 322, 376, 377
Cronartium
asclepiadeum var. *quercuum*, 486
quercuum, **486**

strobilinum, **487**
Crucibulum
laeve, 13, 62
Cryptoporus
volvatus, 48, 509
Cuphophyllus
colemannianus, 28, 312
lacmus, **312**
pratensis, **313**
virgineus, **314**
Cyanoboletus
cyaneitinctus, 83, **96**
pulverulentus, 96
Cyathus
annulatus, 62
stercoreus, **62**
striatus, 13, 62
Cyclomyces
greenei, 503
Cymatoderma
amianthinum, 28
caperatum, **191**
Cyptotrama
asprata, **315**
chrysopepla, 315

Dacrymyces
chrysospermus, **469**, 476
palmatus, 469
variisporus, 44, 469
Dacryopinax
elegans, 44, 470
spathularia, **470**
Daedalea
confragosa, 505
gibbosa, 548
quercina, 49, 505
sepiaria, 520
unicolor, 502
Daedaleopsis
confragosa, **505**
septentrionalis, 505, 546
Daldinia
childiae, **150**, 472
concentrica, 150
Dasyscyphus
virgineus, 211, 217

Dendrophora
albobadia, 20, 203
Dentinum
umbilicatum, 608
Dermocybe
marylandensis, 303
Desarmillaria
caespitosa, **316**
tabescens, 316
Diatrype
atropunctata, 189
stigma, **151**, 152, 189
Dibotryon
morbosum, 149
Dicranophora
fulva, 43, 461
Dictyopanus
pusillus, 540
Dictyophora
duplicata, 594
Disciseda
candida, 562
Donkia
pulcherrima, **599**
Ductifera
palulahuana, **471**, 477

Echinoderma
asperum, 386
Elaphocordyceps
ophioglossoides, 186
Elaphomyces
species, 59, 186, 620
Entoloma
abortivum, 279, 289, **317**, 415
conicum, **318**
incanum, 326
luteum, 319
murrayi, 29, 319
quadratum, **319**, 337
rhodopolium, 384
serrulatum, **320**, 321
sinuatum, 289
strictius, 29, 318
subsinuatum, 289, 317, 415
velutinum, 320, **321**
vernum, 318

Entonaema
 liquescens, 204
Exidia
 crenata, 209, **472**, 474
 foliacea, 476
 fuscosuccinea, 4, 466
 glandulosa, 44, 467, 472
 nigricans, 45, 472
 nucleata, 474
 recisa, 472
Exobasidium
 ferruginea, 47, 489
 rhododendri, **488**
 symploci, **489**
 vaccinii, **490**
Exsudoporus
 floridanus, **97**
 frostii, **98**

Favolus
 brasiliensis, 506
 tenuiculus, **506**
Fistulina
 hepatica, **507**
 hepatica var. monstrosa, 507
Fistulinella
 conica var. conica, 144
 conica var. reticulata, 144
Flammula
 liquiritiae, 328
Flammulaster
 erinaceellus, **322**, 334
Flammulina
 velutipes, **323**
Fomes
 betulinus, 509
 fasciatus, **508**, 542
 igniarius, 542
 lobatus, 515
 tsugae, 518
Fomitiporia
 calkinsii, 49, 508
 robusta, 508
Fomitopsis
 betulina, **509**
 mounceae, **510**, 511
 ochracea, 510, **511**

pinicola, 510
Frostiella
 betula, 71
 russellii, 74
Fulvifomes
 everhartii, 49, 542
 robiniae, 49, 542
Fuscoporia
 gilva, **512**
Fuscopostia
 fragilis, **513**, 541, 544

Galactinia
 michelii, 213
Galerina
 marginata, 29, 278, 323, 344
Galiella
 rufa, **212**
Ganoderma
 applanatum, 49, 515
 curtisii, **514**, 517, 518
 curtisii f. sp. meredithiae, 49, 514, 518
 lingzhi, 514
 lobatoideum, 50, 515
 lobatum, **515**
 lucidum, 514
 martinicense, **516**
 sessile, **517**, 518
 tsugae, **518**
Geaster
 arenarius, 569
Geastrum
 arenarium, 563, **569**
 coronatum, 570
 fimbriatum, 571
 fornicatum, **570**
 quadrifidum, 54, 572
 saccatum, **571**
 triplex, **572**
Gelatoporia
 dichroa, **519**
Geoglossum
 affine, 227
 alveolatum, 226
 difforme, 225, 227
 fallax, 226

glabrum, 227
glutinosum, 226
intermedium, 226
pygmaceum, 227
simile, 227
umbratile, 227
walteri, 225
Gerronema
 chrysophylla, 420
 strombodes, 161, **324**, 373, 420
Gliophorus
 irrigatus, 326
 laetus, **325**, 326, 399
 perplexus, 325, 326, 399
 psittacinus, **326**
Globifomes
 graveolens, 50, 511
Gloeophyllum
 mexicanum, 539
 sepiarium, 412, 505, **520**, 539
 striatum, 50, 520
 trabeum, 520
Gloeoporus
 adustus, 499
 dichrous, 519
 purpureus, 190
 pusillus, 540
Gomphidius
 foliiporus, 113
 vinicolor, 287
Gomphus
 floccosus, 168
Grifola
 berkeleyi, 500
 frondosa, **521**
Guepinia
 spathularia, 470
Gymnoconia
 nitens, 491
Gymnopilus
 armillatus, 29, 327
 junonius, **327**
 lepidotus, 29, 328
 liquiritiae, 282, 283, **328**
 luteopholius, 29, 327
 luteus, 327
 penetrans, 328

INDEX TO SCIENTIFIC NAMES 651

 sapineus, 30, 282, 328
 spectabilis, 327
 spectabilis var. *junonius*, 327
Gymnopus
 acervatus, 290
 biformis, **329**
 confluens, 329, **330**
 dichrous, 30, 329, 471
 dryophilus, **331**, 388, 395
 dysodes, **332**, 333
 foetidus, 332, **333**
 iocephalus, 30, 329, 350, 401
 luxurians, 332
 nigrodiscus, 391
 semihirtipes, 388
 spongiosus, 329, **334**
 subnudus, 329
 subsulphureus, 30, 331
Gymnosporangium
 clavipes, 45, 469
 juniperi-virginianae, 47, 488
Gyrodon
 merulioides, 78
Gyromitra
 caroliniana, 479
 esculenta, **479**
 infula, 46, 479
Gyroporus
 borealis, 100
 castaneus, 100
 cyanescens, 15, 99
 phaeocyanescens, **99**
 purpurinus, 100
 rhoadsiae, 140
 smithii, **100**
 subalbellus, **101**, 146
 umbinisquamosus, 99

Hapalopilus
 croceus, 50, 522
 gilvus, 512
 nidulans, 522
 rutilans, 512, **522**
Harrya
 chromapes, **102**
Hebeloma
 crustuliniforme, **335**

 mesophaeum, 335
 sinapizans, 30, 335
Heimioporus
 betula, 71
Helicogloea
 compressa, 63
Helminthosphaeria
 clavariarum, 173
Helotium
 macrosporum, 217
Helvella
 albella, 480
 crispa, **480**
 elastica, 480
 macropus, **481**
Helvellosebacina
 concrescens, 199, **473**
Hemileccinum
 hortonii, 91, **103**
 rubropunctum, 15, 109, 147
 subglabripes, 103, **104**
Hericium
 americanum, **600**, 601
 coralloides, 600, **601**
 erinaceus, 57, 600
 ramosum, 601
Heterobasidion
 annosum, 523
 irregulare, **523**
Heteroporus
 biennis, 497
Hexagonia
 alveolaris, 536
 hydnoides, **524**
Hjortstamia
 crassa, 197
Hohenbuehelia
 angustata, 308
 mastrucata, 310, **336**
 petaloides, 309
Hortiboletus
 campestris, 105
 rubellus group, **105**
Humaria
 hemisphaerica, 22, 216
Humidicutis
 marginata var. *concolor*, 337

 marginata var. *marginata*, 319, **337**
 marginata var. *olivacea*, 337
Hydnellum
 aurantiacum, 57, 604
 caeruleum, 57, 604
 cristatum, **603**
 concrescens, **602**
 fasciatum, 602
 ferrugipes, **604**
 geogenium, 603
 peckii, 57, 605
 pineticola, 602
 piperatum, **605**
 scrobiculatum, 58, 602
 scrobiculatum var. *zonatum*, 602
 spongiosipes, 58, 602
Hydnochaete
 olivacea, 192
Hydnoporia
 corrugata, 20, 193
 olivacea, **192**
 tabacina, **193**
Hydnum
 adustum, 609
 albidum, 606
 alboaurantiacum, **606**
 albomagnum, 607
 albonigrum, 610
 atroviride, 612
 cristatum, 603
 imbricatum, 613
 mulsicolor, 58, 608
 paradoxum, 559
 repandum, 607
 rufescens, 607
 septentrionale, 598
 subconnatum, 58, 607
 subolympicum, **607**
 subrawakense, 615
 subtilior, 606
 umbilicatum group, **608**
Hydropisphaera
 peziza, 195
Hygrocybe
 acutoconica, **338**
 caespitosa, **339**

cantharellus, 30, 340
coccinea, **340**
conica, 338, 341
conicoides, 341
deceptiva, 402
flavescens, 31, 337
lacmus, 312
laeta, 325
marginata, 337
miniata, 340
nitrata, 402
ovina, 402
persistens, 338
pratensis var. *pratensis*, 313
psittacina, 326
punicea, 340
subovina, 402
subviolacea, 312
virginea, 314
Hygrophoropsis
aurantiaca, 31, 403
Hygrophorus
acutoconicus, 338
caespitosus, 339
coccineus, 340
conicus, 341
hypothejus, 342
laetus, 325
marginatus, 337
pratensis, 313
psittacinus, 326
russula, 313, **342**
subovinus, 402
subsordidus, 31, 294, 314
tennesseensis, 31, 342
Hymenochaete
tabacina, 193
Hymenochaetopsis
olivacea, 192
tabacina, 193
Hymenopellis
furfuracea, **343**
incognita, 343
megalospora, 343
rubrobrunnescens, 343
Hypholoma
capnoides, **344**, 345, 346

fasciculare, 344, **345**, 346
lateritium, 344, 345, **346**
sublateritium, 346
subviride, 31, 345
Hypocrea
alutacea, 224
latizonata, 62
peltata, 204
Hypomyces
aurantius, 460
chlorinigenus, 460
chrysospermus, **460**
completus, 131, **461**
floccosus, 464
hyalinus, **462**
lactifluorum, 441, **463**
lateritius, **464**
luteovirens, 43, 464
microspermus, 460
stephanomatis, 216
Hypoxylon
archeri, 477
atropunctatum, 189
cohaerens, 189
fragiforme, 194
howeianum, **194**
multiforme var. *australe*, 194
Hypsizygus
ulmarius, 413

Imleria
badia, 106
floridana, **106**
pallida, **107**, 140
Infundibulicybe
gibba, **347**, 384
squamulosa, 277, 347
Inocephalus
luteus, 319
murrayi, 319
quadratus, 319
Inocutis
ludoviciana, **525**
Inocybe
calamistrata, 348, 349
fastigiata, 351
geophylla, 350

geophylla var. *lilacina*, 350
hystrix, **348**
lacera, 31, 351
lanatodisca, **349**
lilacina, 301, **350**, 381, 401
rimosa, **351**
rimosoides, 422
sororia, 422
tahquamenonensis, 348
Inonotus
amplectens, 526
circinatus, 538
cuticularis, **526**
hispidus, **527**
ludovicianus, 525
perplexus, 526
quercustris, 50, 527
Inosperma
calamistratum, 32, 349
rimosoides, 422
Irpex
cinnamomeus, 192
lacteus, 50, 192, 545, 614
ochraceus, 614
subrawakensis, 615
Ischnoderma
benzoinum, 528
fuliginosum, 528
resinosum, 525, **528**

Kretzschmaria
deusta, 151, **152**

Laccaria
amethystina, 301, 350, **352**, 381, 401
laccata, 353
laccata var. *decurrens*, 353
laccata var. *pallidifolia*, **353**
ochropurpurea, 32, 296, 352
trichodermophora, 32, 353
trullisata, 32, 352
Lachnocladium
semivestitum, 181
Lachnum
virgineum, 211, 217
Lacrymaria

lacrymabunda, 32, 405, 418
Lactarius
 alachuanus, 362
 areolatus, **354**, 365
 argillaceifolius, 32, 366
 atroviridis, 33, 363
 camphoratus, 364
 chelidonium, **355**, 359
 chrysorrheus, **356**
 cokeri, 367
 corrugis, 368
 croceus, **357**, 359
 delicatus, **358**
 deliciosus, 359
 deterrimus, **359**
 dispersus, **360**
 furcatus, 398
 gerardii, 277, **361**, 370
 gerardii var. *subrubescens*, 361
 hygrophoroides, 369
 imperceptus, **362**
 indigo var. *indigo*, **363**
 lignyotus, 361
 maculatipes, 33, 358
 mutabilis, 365
 oculatus, 354, **364**
 paradoxus, 33, 355
 peckii, 33, 372
 peckii var. *glaucescens*, 372, 398
 petersenii, 370
 piperatus, 371
 proximellus, 33, 356
 psammicola, 33, 356
 pseudodeliciosus, 34, 357, 359
 purpureoechinatus, 365
 quietus, 354, **365**, 464
 quietus var. *incanus*, 365
 rimosellus, 354
 salmonius, 357
 speciosus, 360
 subdulcis var. *oculatus*, 364
 subpalustris, 360
 subplinthogalus, 34, 367
 subpurpureus, 34, 355
 subserifluus, **366**
 subvernalis var. *cokeri*, 314, 367
 tomentosomarginatus, 371
 vinaceorufescens, 356
 volemus, 372
 yazooensis, 34, 358
Lactifluus
 allardii, 34, 366
 corrugis, **368**
 deceptivus, 34, 371
 glaucescens, 371
 hygrophoroides, **369**
 luteolus, 35, 368
 petersenii, 361, **370**
 piperatus, **371**
 rugatus, 369
 subvellereus, 35, 371
 volemus var. *flavus*, 35, 372
 volemus var. *volemus*, 368, **372**
Laeticutis
 cristata, **529**
Laetiporus
 cincinnatus, 51, 530
 gilbertsonii var. *pallidus*, **530**, 543
 persicinus, 500, **531**
 sulphureus, 51, 530, 543
Lanmaoa
 pallidorosea, 15, 76
Laxitextum
 crassum, 197
Leccinellum
 albellum, 15
Leccinum
 albellum, 108, 111
 chalybaeum, **108**, 111
 chromapes, 102
 crocipodium, 103
 eximium, 133
 longicurvipes, **109**
 roseoscabrum, **110**
 rubropunctum, 109
 rugosiceps, 110
 scabrum group, 108
 subglabripes, 104
Leiotrametes
 lactinea, 550
Lentaria
 byssiseda, 173, **176**, 177
 micheneri, 173, 176, **177**
Lentinellus
 angustifolius, 374
 micheneri, 324, **373**, 377, 378, 413, 420
 omphalodes, 373
 subaustralis, 373
 urcinus, 374
 urcinus f. *robustus*, 374
 vulpinus, 336, **374**, 412
Lentinula
 boryana, 375
 detonsa, 375
 raphanica, **375**
Lentinus
 arcularius, 376, 378, **532**, 533, 536
 berteroi, **376**, 377
 brumalis, 378, **533**
 crinitus, 376, **377**
 crinitus var. *berteroi*, 376
 levis, 413
 strigosus, 408
 tigrinus, 373, 377, **378**
 torulosus, 408
Lenzites
 betulina, 546
 betulinus, 546
 mexicana, 539
 sepiaria, 520
Leotia
 atrovirens, 221
 lubrica, **221**
 viscosa, 221
Lepiota
 americana, 382
 aspera, 386
 asprata, 315
 besseyi, 379
 cristata, 35, 379
 molybdites, 286, 382
 mucrocystis, **379**, 382
 procera, 386
Lepista
 nuda, 295, **380**, 381
 sordida, 380, **381**
 subconnexa, 35, 347, 384
 tarda, 381

Leptonia
 serrulata, 320
 velutina, 321
Leptoporellus
 kmetii, 558
Leucoagaricus
 americanus, 285, 379, **382**, 386
 hortensis, 285
 leucothites, 35, 247
 meleagris, 382
 rubrotinctus, 269, 382
Leucocoprinus
 birnbaumii, 36, 409
 cepistipes, 36, 379
 fragilissimus, 36, 409
Leucopaxillus
 albissimus, 383
 gracillimus, 383
 laterarius, 294, **383**
Leucopholiota
 decorosa, 322, 411
Limacella
 glischra, 458
 illinita, 458
Linderia
 columnata, 592
Loweomyces
 fractipes, 51, 534
Lycoperdon
 acuminatum, 564
 americanum, 54, 574
 echinatum, 574
 gemmatum, 574
 marginatum, **573**
 mole, 576
 perlatum, 561, **574**
 pratense, 574
 pusillum, 564
 pyriforme, 561
 subincarnatum, **575**
 transversarium, 578
 umbrinum, **576**
Lyophyllum
 decastes, 330, **384**

Macrocybe
 titans, **385**

Macrolepiota
 procera, 285, **386**
Marasmiellus
 albocorticis, 387
 candidus, 288, **387**, 448
 luxurians, 36, 332
 nigripes, 448
 praeacutis, 36, 389
Marasmius
 aureus, 453
 bellipes, 393
 biformis, 329
 candidus, 387, 448
 capillaris, 389, 448
 cohaerens, 330, 331, **388**
 delectans, 387, **389**
 foetidus, 333
 fulvoferrugineus, 36, 394
 graminum, **390**
 nigrodiscus, **391**, 395
 oreades, 391, **392**
 pulcherripes, **393**, 401
 rotula, 37, 389
 scorodonius, 390
 siccus, **394**
 spongiosus, 334
 strictipes, 391, **395**
 sullivantii, 388, 396
 vagus, 388, **396**
Megacollybia
 platyphylla, 397
 rodmanii, **397**, 415
 rodmanii f. *murina*, 407
Meiorganum
 curtisii, 421
Melanoleuca
 alboflavida, 395
Meripilus
 sumstinei, 51, 521
Merulioporia
 purpurea, 190
Merulius
 incarnatus, 196
Metuloidea
 reniformis, 615
Microglossum
 rufum, **222**, 223

Micromphale
 foetidum, 333
Microporellus
 dealbatus, 51, 534
 obovatus, **534**
Mitrula
 elegans, 221
 lunulatospora, 221
Morchella
 americana, 46, **482**, 484
 angusticeps, 482, **483**
 diminutiva, **484**
 esculentoides, 482
 punctipes, 46, 482
 septriformis, 46, 484
 virginiana, 484
Morganella
 subincarnata, 575
Mucilopilus
 conicus, 144
Multiclavula
 mucida, 170, 224, 468
Multifurca
 furcata, **398**
Mutinus
 elegans, **593**
 ravenelii, 56, 593
Mycena
 epipterygia var. *lignicola*, **399**
 epipterygia var. *viscosa*, 399
 galericulata, 400
 haematopus, 37, 393, 401
 inclinata, 290, **400**, 443
 leptocephala, 400
 pseudoinclinata, 400
 pura, 301, 350, 381, **401**
 semivestipes, 400
 subcaerulea, 320
Mycetinus
 opacus, 37, 389
 scorodonius, 390
Mycogone
 rosea, 43, 462
Mycorrhaphium
 adustum, **609**
Myriostoma
 coliforme, 571

Myxarium
 nucleatum, **474**

Naematoloma
 capnoides, 344
 fasciculare, 345
 sublateritium, 346
Nectria
 peziza, **195**
Neoalbatrellus
 caeruleoporus, 51, 498
Neoantrodia
 serialiformis, **535**
 serialis, 535
Neoboletus
 luridiformis, 125
 pseudosulphureus, 69
Neofavolus
 alveolaris, 506, 532, **536**
Neohygrocybe
 nitrata, 402
 ovina, 402
 subovina, **402**
Neolecta
 irregularis, 23, 222
 vitellina, 222
Neolentinus
 lepidius, 37, 373, 413
Nidularia
 stercorea, 62
Nigroporus
 vinosus, **537**
Niveoporofomes
 spraguei, 52, 544
Nolanea
 conica, 318
 murrayi, 319
 quadrata, 319
 salmonea, 319
Nomuraea
 atypicola, 185

Oligoporus
 fragilis, 513
Omphalia
 fibula, 428
 strombodes, 324

Omphalina
 ectypoides, 420
 pubescentipes, 457
 strombodes, 324
Omphalotus
 illudens, 37, 403
 subilludens, 163, **403**
Onnia
 circinata, 503, **538**
 subtriquetra, 538
 tomentosa, 52, 538
Ophiocordyceps
 gracilioides, 186
 melolonthae, 19, 185
 sphecocephala, 185
Osmoporus
 mexicanus, **539**
Otidea
 unicisa, 22, 208
Oudemansiella
 canarii, 37, 375
 furfuracea, 343
Oxyporus
 populinus, 52, 502, 548

Panaeolina
 foenisecii, 281, **404**, 405
Panaeolus
 cinctulus, 404
 cyanescens, 425
 foenisecii, 404
 papilionaceus, **405**, 419
 semiovatus, 405, 406
 sepulchralis, 406
 solidipes, **406**
 subbalteatus, 404
Panellus
 pusillus, **540**
 serotinus, 414
 stipticus, **407**
Panus
 conchatus, 38, 408
 crinitus, 377
 lecomtei, **408**
 neostrigosus, 408
 nidulans, 412
 rudis, 408

Pappia
 fissilis, **541**
Paragalactinia
 michelii, **213**
Parasola
 auricoma, 409
 plicatilis, **409**
Paxillus
 atrotomentosus, 447
 curtisii, 421
Peckiella
 completa, 461
Peniophora
 albobadia, 203
Perenniporia
 subacida, 20, 189
Peziza
 aurantia, 208
 badioconfusa, 214
 craterium, 218
 cylichnium, 209
 inquinans, 467
 michelii, 213
 occidentalis, 215
 phyllogena, **214**
 repanda, 214
 scutellata, 216
 succosa, 213
 varia, 22, 214
 vesiculosa, 213
Phaeocalicium
 polyporaeum, 552, 554
Phaeolus
 schweinitzii, 52, 93, 523, 538
Phaeomarasmius
 erinaceellus, 322
Phaeotremella
 frondosa, 476
Phallus
 duplicatus, **594**
 hadriani, 56, 594, 595
 impudicus, 594, 595
 indusiatus, 594, 595
 ravenelii, **595**
 rubicundus, 593
Phanerochaete
 crassa, 197

Phellinus
 everhartii, 542
 gilvus, 512
 igniarius, **542**
 robiniae, 542
Phellodon
 alboniger, **610**
 brunneoolivaceus, 611
 ellisianus, 611
 graveolens, 611
 melaleucus, **611**
 niger, 610
 niger var. alboniger, 610
Phlebia
 incarnata, **196**
 tremellosa, 21, 196
Phlebiopsis
 crassa, 190, **197**, 200
Phlegmacium
 albidum, 294
Pholiota
 aurivella, 38, 411
 castanea, **410**, 418
 erinaceella, 322
 highlandensis, 410
 polychroa, 38, 283, 410
 squarrosa, 279, **411**
 squarrosoides, 411
Phylloporopsis
 boletinoides, **112**
Phylloporus
 boletinoides, 112
 foliiporus, **113**, 114
 leucomycelinus, 112, 113, **114**
 rhodoxanthus, 112, 113, 114
 rhodoxanthus ssp.
 albomycelinus, 114
 rhodoxanthus ssp. foliiporus, 113
Phyllotopsis
 nidulans, **412**, 421
Picipes
 badius, 52, 501
Piptoporellus species, **543**
Piptoporus
 betulinus, 509

Pisolithus
 arenarius, **577**
 arhizus, 577
 tinctorius, 577
Pleurocolla
 compressa, 63
Pleurocybella
 porrigens, 38, 414
Pleuropus
 abortivus, 317
Pleurotus
 alboniger, 426
 applicatus, 427
 dryinus, 413
 levis, **413**
 ostreatus, 414
 pulmonarius, 308, 336, **414**
Plicaturopsis
 crispa, 55, **588**
Pluteus
 atromarginatus, 415
 cervinus group, 242, **415**, 417
 chrysophlebius, 38, 315, 453
 flavofuligineus, 38, 315
 granularis, 416
 hongoi, 415, 417
 longistriatus, **416**
 pellitus, 417
 petasatus, **417**
 thomsonii, 39, 416
 umbrosus, 416
Podostroma
 alutaceum, 224
Pogonomyces
 hydnoides, 524
Polyporus
 adustus, 499
 albellus, 557
 alveolaris, 536
 arcularius, 532
 berkeleyi, 500
 biennis, 497
 biformis, 554
 brumalis, 533
 cristatus, 529
 curtisii, 514

 cuticularis, 526
 dichrous, 519
 fasciatus, 508
 fissilis, 541
 greenei, 503
 hirsutus, 549
 hispidus, 527
 irregularis, 523
 kmetii, 558
 lactineus, 550
 montagnei, 503
 obovatus, 534
 ovinus, 498
 perennis, 504
 persicinus, 531
 radicatus, 52, 503, 531
 resinosus, 528
 sanguineus, 551
 sector, 556
 squamosus, 195, 501
 tenuiculus, 506
 tsugae, 518
 umbellatus, 53, 521
 versicolor, 552
 villosus, 553
 vinosus, 537
Porodaedalea
 pini, 53, 523
Poronidulus
 conchifer, 547
Porostereum
 crassum, 197
Porphyrellus
 sordidus, **115**
 subflavidus, 75
Postia
 caesia, 544
 fragilis, 513
 livens, 513, 541, **544**
Psathyrella
 candolleana, 39
 carbonicola, 418
 delineata, 39, 300
 hydrophila, 419
 pennata, 405, 410, **418**
 piluliformis, 418

septentrionalis, **419**
velutina, 418
Pseudoarmillariella
 ectypoides, 324, 373, **420**
Pseudoboletus
 parasiticus, **116**, 582
Pseudoclitocybe
 cyathiformis, 284
Pseudocolus
 fusiformis, **596**
 schellenbergii, 596
Pseudofistulina
 radicata, 507
Pseudohydnum
 gelatinosum, 45, 471
Pseudoinonotus
 dryadeus, 53, 527
Pseudomerulius
 curtisii, **421**, 447, 588
Pseudosperma
 sororium, 422
Psilocybe
 caerulescens, **423**, 425
 cubensis, 423, **424**
 ovoideocytidiata, 404, **425**
 weilii, 423
Puccinia
 peckiana, 491
Pucciniastrum
 potentillae, 47, 491
Pulcherricium
 coeruleum, 203
Pulchroboletus
 rubricitrinus, **117**
 sclerotiorum, **118**
Pulveroboletus
 auriflammeus, 70
 curtisii, 70
 hemichrysus, 92
 lignicola, 93
 ravenelii, 15, 70
Purpureocillium
 atypicola, 185
Pycnoporellus
 alboluteus, 558
Pycnoporus

 cinnabarinus, 551
 sanguineus, 551

Radulodon copelandii, 192
Radulomyces
 copelandii, 192, 545, 559
Ramaria
 aurea group, 18, 178
 botrytis, 180
 concolor, 179
 conjunctipes, 178
 formosa, **178**, 180
 stricta, 170, 178, **179**
 subbotrytis, 178, **180**
Ramariopsis
 corniculata, 174, 175
 kunzei, 176
Resupinatus
 alboniger, **426**, 427
 applicatus, 426, **427**
 trichotis, 39, 427
Retiboletus
 fuscus, 119
 griseus, 102, 119, 120, 121, 140
 griseus var. *fuscus*, 119
 ornatipes, 79, **120**
 retipes, 120
 vinaceipes, **121**
Rhizina
 undulata, 205
Rhizomarasmius
 pyrrhocephalus, 388
Rhizopogon
 atlanticus, 617
 nigrescens, **617**
 roseolus, 567, 581, **618**
 rubescens, 618
Rhodocollybia
 butyracea, 39, 331
 maculata, 39, 331
Rhodofomes
 cajanderi, 53, 551
Rhodophyllus
 abortivus, 317
Rhopalogaster
 transversarius, **578**

Rhytisma
 americanum, 151, **153**
 salicinum, 153
Rickenella
 fibula, 399, **428**
Ripartitella
 brasiliensis, 40, 333
Rozites
 caperatus, 299
Russula
 adusta var. *albonigra*, 430
 aeruginea, **429**, 439
 albidula, 438, 441
 albonigra, **430**
 atropurpurea, **431**
 ballouii, **432**
 brevipes, 40, 441
 compacta, 40, 432
 crustosa, 40, 437
 dissimulans, 430
 earlei, 313, **433**
 flavida, 40, 433
 flavisiccans, 435
 foetentula, 40, 432
 fragrantissima, 434
 grata, **434**
 hixsonii, **435**
 laurocerasi, 434
 mariae, 431, **436**, 442
 mutabilis, 434
 nigricans var. *albonigra*, 430
 ochroleucoides, 433
 parvovirescens, 429, **437**
 peckii, 442
 perlactea, **438**, 441
 pulchra, 442
 redolens, **439**
 rugulosa, 41, 431
 sericeonitans, **440**, 442
 subalbidula, 438, **441**
 subfragiliformis, **442**
 subsericeonitans, 431, 440
 tenuiceps, 442
 variata, 41, 429, 439
 virescens, 41, 437
 xerampelina, 436

Rutstroemia
 macrospora, 217

Sarcodon
 alachuanum, 604
 amarescens, 612
 atroviridis, **612**
 cristatus, 603
 imbricatus, 612, **613**
 piperatus, 605
 scabrosus, 613
 underwoodii, 613
Sarcodontia
 pachyodon, 545
Sarcomyxa
 serotina, 414
Sarcoscypha
 austriaca, 215
 dudleyi, 215
 occidentalis, **215**
Schizophyllum
 commune, 55, **589**
Schizopora
 paradoxa, 559
Scleroderma
 areolatum, **579**
 bovista, **580**, 581
 cepa, 580, **581**, 584
 citrinum, 116, **582**
 floridanum, 55, 585
 geaster, 585
 lycoperdoides, 579
 meridionale, **583**
 michiganense, 581, **584**
 polyrhizum, 577, **585**
Scorias
 spongiosa, **198**
Scutellinia
 erinaceus, 216
 scutellata, 195, **216**
 setosa, 216
Scutiger
 cristatus, 529
 ovinus, 498
 pes-caprae, 529
Scytinopogon
 angulisporus, 18, 177

Sebacina
 incrustans, **199**, 473
 pululahuana, 471
 schweinitzii, **181**, 199
 sparassoidea, **475**
Sepedonium
 brunneum, 461
Simocybe
 centunculus, **443**
Skeletocutis
 lilacina, 190, 197, **200**
Sowerbyella
 unicisa, 208
Sparassis
 americana, 18, 182
 herbstii, 182
 spathulata, **182**
Spathularia
 flavida, 223
 velutipes, 223
Spathulariopsis
 velutipes, **223**
Sphaerobolus
 dentatus, 63
 stellatus, 13, 61, **63**
Spongipellis
 pachyodon, **545**, 559
Steccherinum
 ochraceum, **614**
 pulcherrimum, 599
 septentrionale, 598
 subrawakense, **615**
Stereum
 caperatum, 191
 complicatum group, **201**, 469
 fasciatum, 202
 frustulatum var. subpiliatum, 205
 gausapatum, 201
 hirsutum, 201, 469
 lobatum, 202
 ostrea group, 196, **202**
 striatum, 21, 202
 subtomentosum, 202
 tabacinum, 193
Strobilomyces
 confusus, 122, 123
 dryophilus, **122**, 123

 floccopus, 123
 strobilaceus, 122, **123**
Strobilurus
 conigenoides, **444**
Stropharia
 cyanescens, 424
 hardii, **445**
 rugosoannulata, 445, **446**
Suillellus
 floridanus, 97
 hypocarycinus, **124**
 luridus, 97
 subluridus, 90, 98
 subvelutipes, 90, **125**
Suillus
 acidus, 130
 americanus, **126**
 brevipes, 132
 cothurnatus, **127**, 129
 cothurnatus ssp. hiemalis, 129
 decipiens, **128**
 granulatus, 132
 hiemalis, 127, **129**
 hirtellus, 126, **130**, 132
 lactifluus, 132
 luteus, 127, 132
 pictus, 131
 placidus, 130, 132
 spraguei, **131**, 144, 461
 subalbellus, 101
 tomentosus, 16, 126
 weaverae, **132**
Sutorius
 eximius, **133**
Syzygites
 megalocarpus, 43, 462
Syzygospora
 mycetophila, 331, 471

Tapinella
 atrotomentosa, 412, 421, **447**
 panuoides, 41, 412, 421, 447, 588
Tatraea
 macrospora, **217**
Terana
 coerulea, 190, 197, 200, **203**

Tetrapyrgos
 nigripes, 387, 389, **448**
Thelephora
 anthocephala, 24, 229
 caperata, 191
 palmata, 24, 229
 terrestris, 24, 229
 terrestris f. *concrescens*, 24, 229
 vialis, 181, **229**
Tolypocladium
 capitatum, 19, 186
 ophioglossoides, **186**
Torrubiella
 arachnophila var. *leiopus*, **187**
Trametes
 aesculi, 548
 betulina, 505, 539, **546**
 cinnabarina, 53, 551
 conchifer, **547**
 cubensis, 550
 gibbosa, **548**, 550
 hirsuta, 549, 552, 553
 hydnoides, 524
 lactinea, 548, **550**
 perrottetii, 555
 pubescens, 53, 549, 552
 sanguinea, **551**
 suaveolens, 550
 versicolor, 195, 202, **552**, 589
 villosa, **553**
Trametopsis
 cervina, 502, 553
Tremella
 aurantia, 45, 469
 concrescens, 473
 crenata, 472
 foliacea, **476**
 fuciformis, 471, **477**
 mesenterica, 45, 469, 476
 recisa, 472
 reticulata, 475
Tremellodendron
 pallidum, 181
 schweinitzii, 181
Tremellodendropsis
 semivestita, 181
Trichaptum

 abietinum, 554
 biforme, 552, **554**, 589
 perrottetii, **555**
 sector, **556**
Trichoderma
 alutaceum, 23, 219, **224**
 peltatum, **204**
Trichoglossum
 farlowii, 186, 225
 hirsutum, 226
 tetrasporum, 226
 variabile, 226
 velutipes, 226
 walteri, **225**
Tricholoma
 aurantium, **449**
 aurantium var. *olivascens*, 449
 caligatum, 449, **450**
 equestre, **451**
 flavovirens, 451
 formosa, 454
 intermedium, 451
 odorum group, **452**
 portentosum, 41, 452
 russula, 342
 saponaceum, 41, 450
 subluteum, 42, 449, 451
 subresplendens, 450
 subsejunctum, 42, 451
 sulphurescens, 452
 sulphureum, 452
 terreum, 452
 titans, 385
Tricholomopsis
 aurea, **453**
 decora, 42, 282, 315, 453, 454
 formosa, 315, **454**
 rutilans, 42, 454
Trogia
 crispa, 588
Tuber
 brennemanii, **619**, 620
 canaliculatum, 59, 619
 lyonii group, **620**
 texense, 620
Tulostoma
 brumale, 561, **586**

Turbinellus
 floccosus, **168**
 kauffmanii, 168
Tylopilus
 alboater, **134**, 135
 appalachiensis, 16, 138
 atronicotianus, 134
 badiceps, 136
 balloui, 16, 134
 chromapes, 102
 conicus, 144
 eximius, 133
 felleus, 91, 137, 142, 143
 ferrugineus, 136
 griseocarneus, 133, **135**
 indecisus, **136**
 minor, **137**
 peralbidus, 101, **138**, 140, 141
 plumbeoviolaceus, 133, **139**, 142
 porphyrosporus, 115
 rhoadsiae, 75, 107, 138, **140**
 rhodoconius, 140, **141**
 rubrobrunneus, 136, **142**
 sordidus, 115
 subflavidus, 75
 subpunctipes, 136
 tabacinus, **143**
 tabacinus var. *amarus*, 143
 variobrunneus, 16, 137
 violatinctus, 139, 142
 williamsii, 134
Typhrasa
 gossypina, 300
Tyromyces
 albellus, 557
 chioneus, 513, 541, **557**
 fissilis, 541
 fragilis, 513
 fumidiceps, 557
 kmetii, **558**

Urnula
 craterium, **218**
Uromyces
 ari-triphylli, 491
Ustilago
 maydis, 47, 490

Ustulina
 deusta, 152

Vascellum
 pratense, 574
Veloporphyrellus
 conicus, **144**
Volvariella
 bombycina, 417, **455**

Wolfina
 aurantiopsis, 212

Xanthoconium
 affine, 88, 106, **145**
 purpureum, 16, 88
 separans, 88
 stramineum, **146**
Xerocomus
 hortonii, 103
 hypoxanthus, 147
 illudens/tenax group, 16, 147
 morrisii, **147**
 parasiticus, 116
Xeromphalina
 campanella, 290, 443, **456**, 457
 cauticinalis ssp. *cauticinalis*, 457
 cauticinalis ssp. *pubescentipes*, 457
 kauffmanii, 456, 457
 tenuipes, 42, 322, 334, 443, 456

Xerula
 furfuracea, 343
Xylaria
 allantoidea, **154**
 cubensis, 156, 206
 hypoxylon, 17, 157, 185
 liquidambar, **155**
 longipes, **156**
 magnoliae, **157**, 185
 oxyacanthae, 155
 persicaria, 155
 poitiei, 156
 polymorpha, 156
Xylobolus
 frustulatus, 21, 205
 subpileatus, **205**, 537
Xylocoremium
 flabelliforme, **206**
Xylodon
 paradoxus, 545, **559**

Zelleromyces
 cinnabarinus, **621**
Zhuliangomyces
 illinitus, **458**

INFORMATION ABOUT THE AUTHORS

Alan E. Bessette, PhD, is a professional mycologist and emeritus professor of biology at Utica College of Syracuse University. He has published numerous papers in the field of mycology and has authored or coauthored more than twenty-five books, including *Boletes of Eastern North America*, *Mushrooms of Northeastern North America*, and *Ascomycete Fungi of North America: A Mushroom Reference Guide*. His latest book is *Polypores and Similar Fungi of Eastern and Central North America*. Alan was the scientific advisor to the Mid-York Mycological Society and served as a consultant for the New York State Poison Control Center for more than twenty years. He has been the principal mycologist at national and regional forays and was the recipient of the 1987 Mycological Foray Service Award and the 1992 North American Mycological Association Award for Contributions to Amateur Mycology. He teaches and lectures regionally and nationally. Alan's interests center on the fungi of eastern North America with a primary focus on subtropical and tropical fungi.

Arleen R. Bessette, MA, is a psychologist, mycologist, and botanical photographer who has been collecting and studying wild mushrooms for more than forty years. She has published several papers in the field of mycology and has authored or coauthored more than fifteen books, including *Mushrooms of the Southeastern United States*, *The Rainbow Beneath My Feet: A Mushroom Dyer's Field Guide*, and *A Field Guide to Mushrooms of the Carolinas*. Her latest book is *Polypores and Similar Fungi of Eastern and Central North America*. Arleen has won several national awards for her photography, including highest honors in both the documentary and the pictorial divisions in the North American Mycological Association's annual photography competition. Arleen teaches courses on mycology, dyeing with mushrooms, and the culinary aspects of mycophagy on both national and regional levels. Her current interests, combining her experiences as a psychotherapist and mycologist, relate to the effects of psychedelic substances on consciousness.

Michael W. Hopping is an amateur mycologist, writer, and retired medical doctor. He has been a member of the Asheville Mushroom Club since 2011, when he first became interested in mushrooms. For several years he chaired the club's foray committee and produced a Mushroom of the Month feature for its newsletter, *Sporadic News*. More recently, he and another senior club member launched an ongoing training program for the AMC's next generation of mushroom identifiers. In collaboration with that ID group and the Matheny Lab at the University of Tennessee, Knoxville, he was principal investigator on a three-year project to provide the state of North Carolina with an inventory of macrofungi found in Mount Mitchell State Park. He is also a coauthor of *A Field Guide to the Mushrooms of the Carolinas*.

PLATE 3. Stalk Shapes

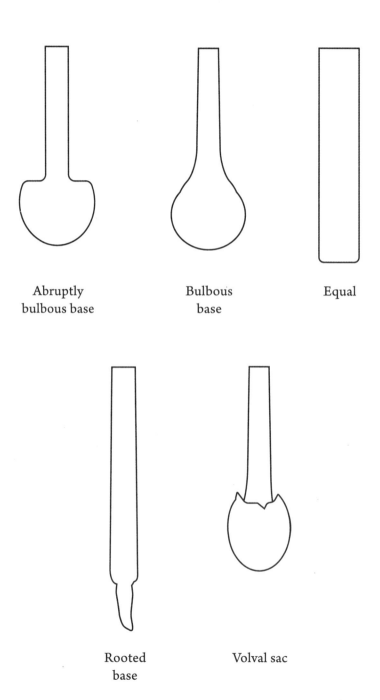